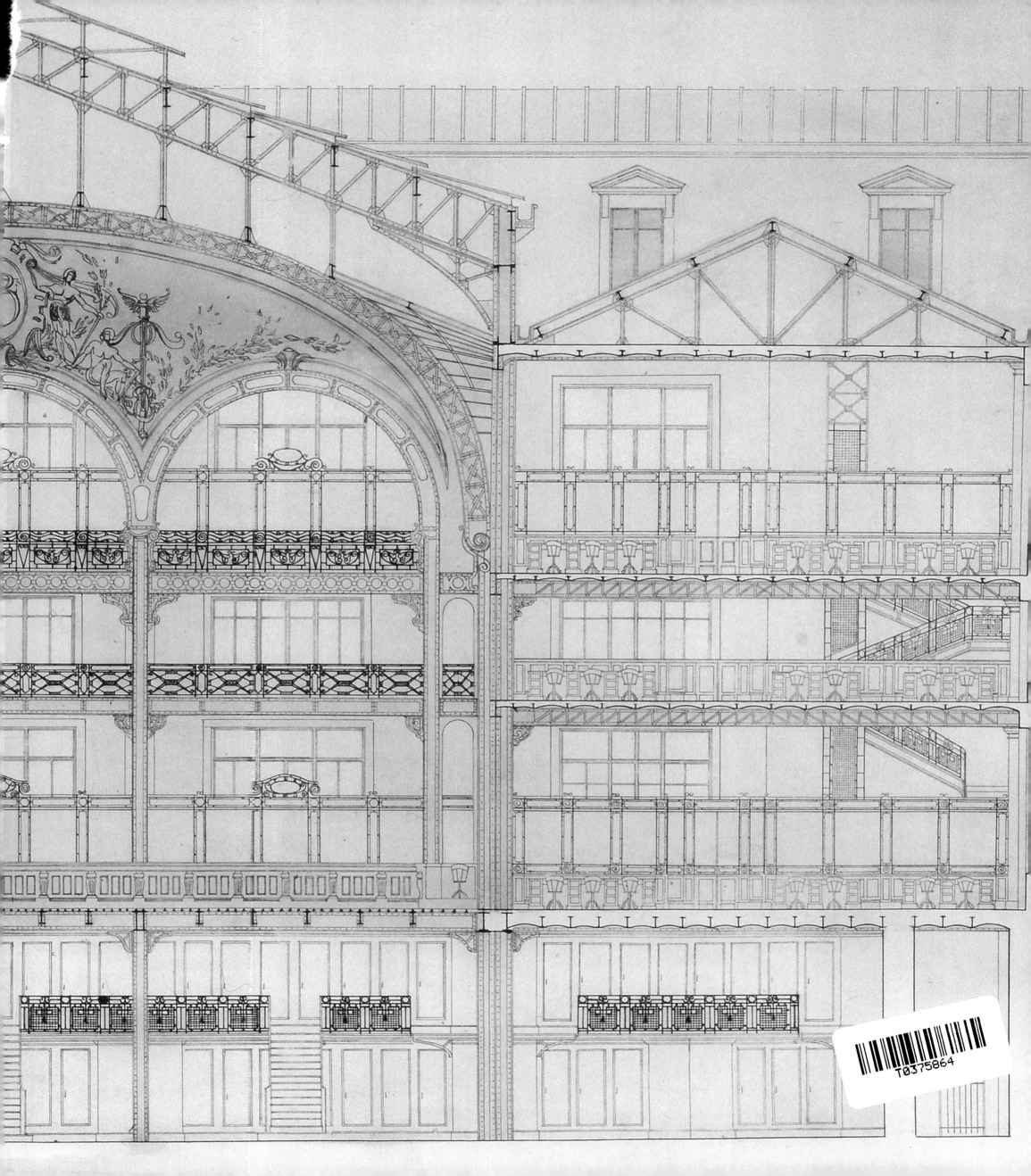

LIVING WITH
ARCHITECTURE AS ART

VOLUME I

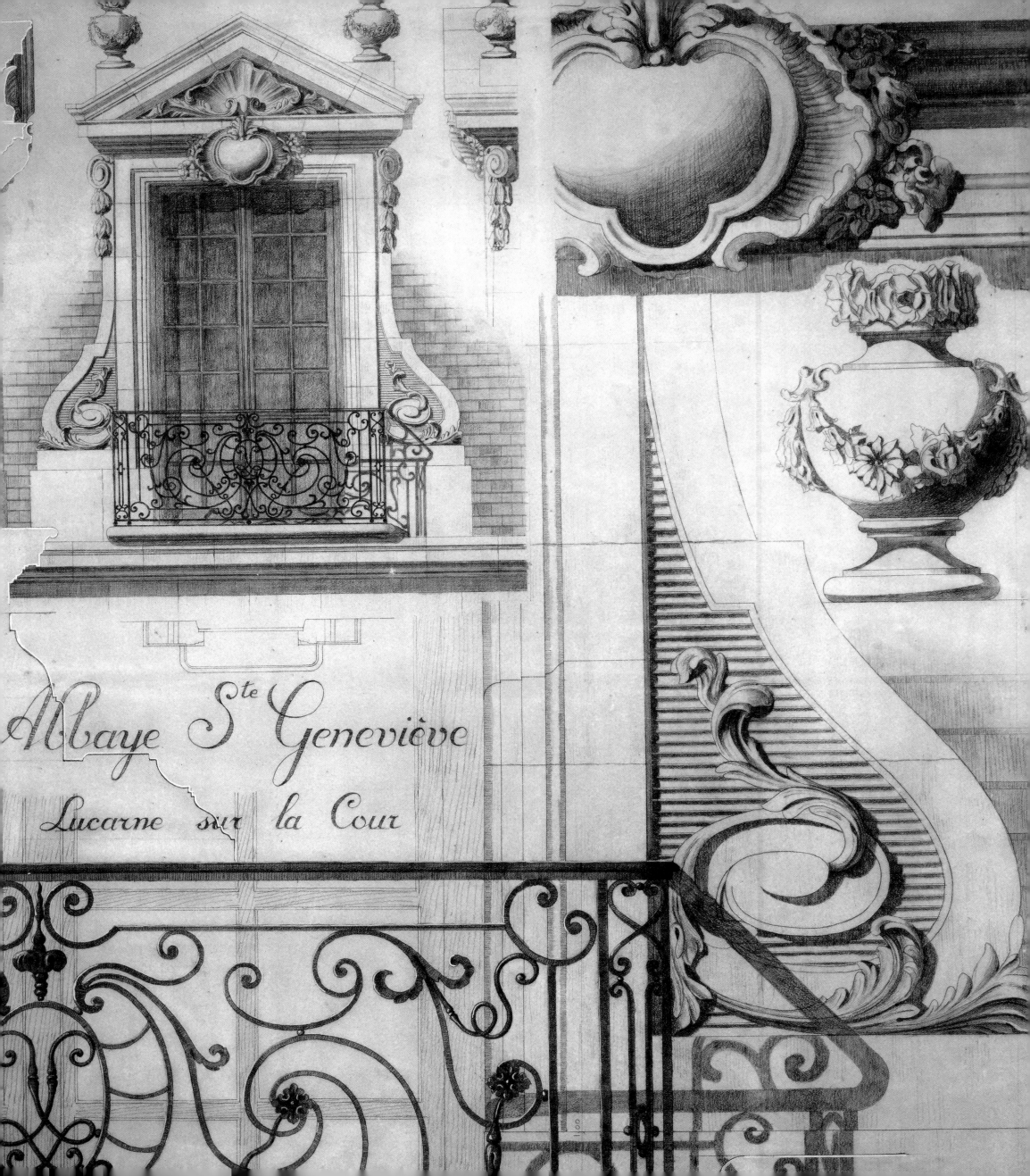

LIVING WITH
ARCHITECTURE AS ART

*The Peter W. May Collection of
Architectural Drawings, Models, and Artefacts*

VOLUME I

EDITED BY
Maureen Cassidy-Geiger

AD ILISSVM

AD ILISSVM: 'By the banks of the Ilissus', where Socrates bathed his feet in Plato's *Phaedrus*, 230b, remarking καλή γε ἡ καταγώγη (This is a beautiful place to settle)

Copyright © 2021
Texts copyright © the authors

All rights reserved. No part of this publication may be transmitted in any form or by any means, electronic or mechanical, including photocopy, recording or any storage or retrieval system, without the prior permission in writing from the copyright holder and publisher.

ISBN 978-1-912168-19-4

British Library Cataloguing in Publication Data

A catalogue record for this book is available from the British Library

Ad Ilissvm is an imprint of
Paul Holberton Publishing
89 Borough High Street
London SE1 1NL
WWW.PAULHOLBERTON.COM

Designed by Laura Parker
Printing by e-Graphic Srl, Verona

Jacket: May Collection 1991.388a (cat. 6.5)
Front endpapers: May Collection 1988.135 (cat. 14.5)
Frontispiece: May Collection 1987.30 (cat. 8.73)
Catalogue opener: May Collection 1990.297c (cat. 12.12)
Back endpapers: May Collection 1987.32 (cat. 11.6)

VOLUME I

ix	Foreword	PETER MAY
xiii	Acknowledgments	PETER MAY
xv	Editor's Acknowledgments	MAUREEN CASSIDY-GEIGER
1	Introduction: The Art of Architecture	MAUREEN CASSIDY-GEIGER
19	The Beaux-Arts Tradition: "Everything that is made or studied is competition, the student does not make a pencil stroke which is not the result of a competition"	BASILE BAUDEZ AND MAUREEN CASSIDY-GEIGER
47	Architectural Education and the Art of Drawing in Britain	CHARLES HIND
61	The Architectural Drawings Market, Past and Present: Architects, Collectors, Scholars, and Decorators	CHARLES HIND
77	Carpenters and Craftsmen, Architects and Collectors: A Short History of the Architectural Model	MATTHEW WELLS

The Catalogue

DRAWINGS, PAINTINGS, AND PASTEL

97	1.	Theaters, Museums, and Clubs
157	2.	Schools and Centers of Learning
195	3.	Government Buildings
235	4.	Places of Worship
255	5.	Train Stations
281	6.	Hotels and Spas
301	7.	Commerce

VOLUME II

335	8.	Private and Royal Residences, Urban and Suburban Housing
451	9.	Interiors, Interior Design and Decoration
523	10.	Construction Drawings
543	11.	Reconstruction Drawings
581	12.	Landmarks, Monuments, and Mausolea
631	13.	Landscape Design and Garden Architecture
681	14.	Cast-iron Architecture and Design
705	15.	A Plantar Archive
715		ARCHITECTURAL MODELS
747		BOOKLETS OF DRAWINGS

Afterwords, Concordance, and Indexes

762	Afterword I	MARK FERGUSON
767	Afterword II	BUNNY WILLIAMS
768	Concordance	
769	Indexes	
772	Photographic Credits	

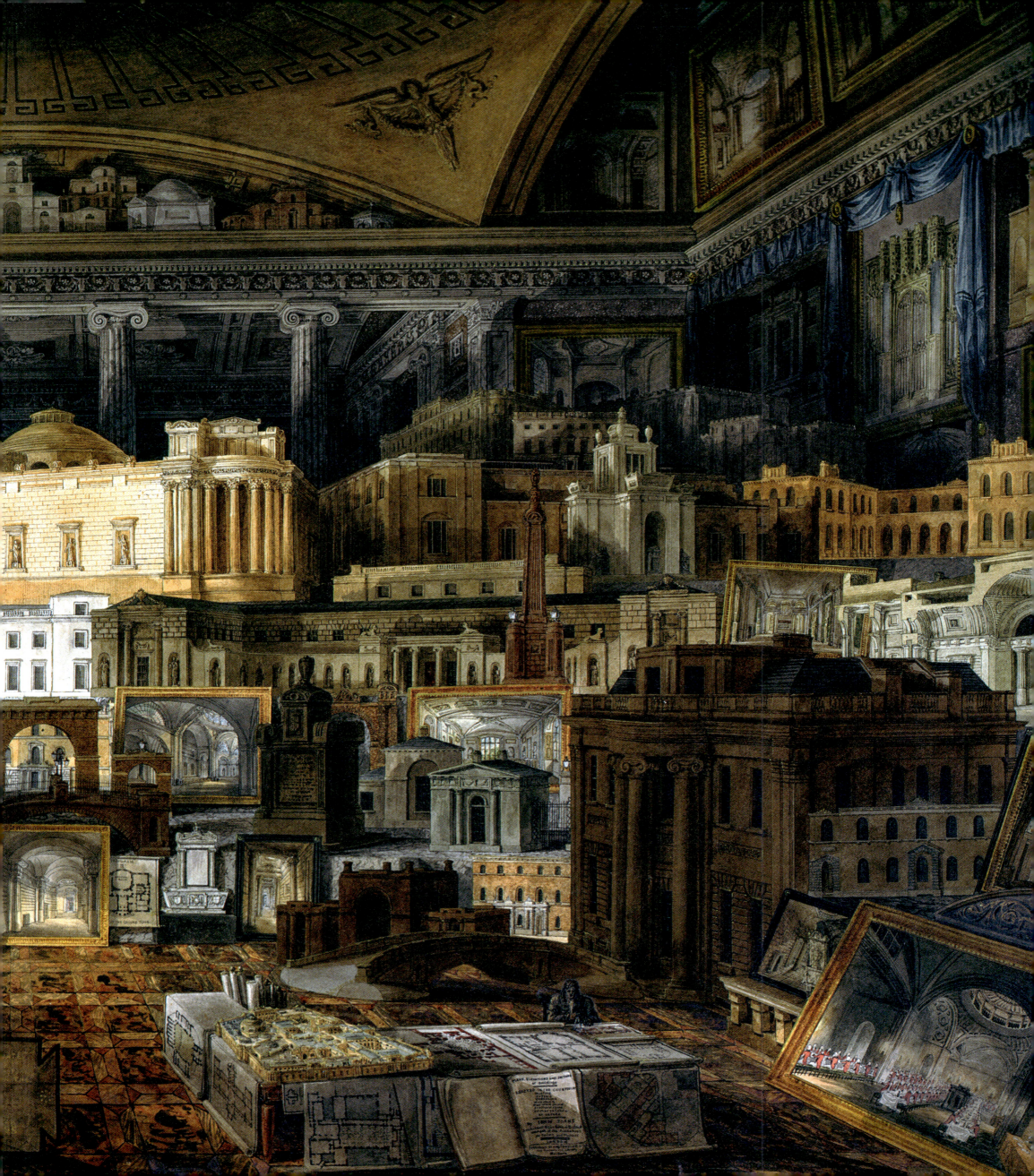

In Memory of Steve (Stephenson) Boone Andrews
1959–2016

who shared my passion for architectural drawings
and for Sir John Soane's Museum

Joseph Michael Gandy (1771–1843)
Portrait of Sir John Soane amid his Public
and Private Buildings, watercolor, 1818
Sir John Soane's Museum, inv. P87 (detail)

FOREWORD

PETER MAY

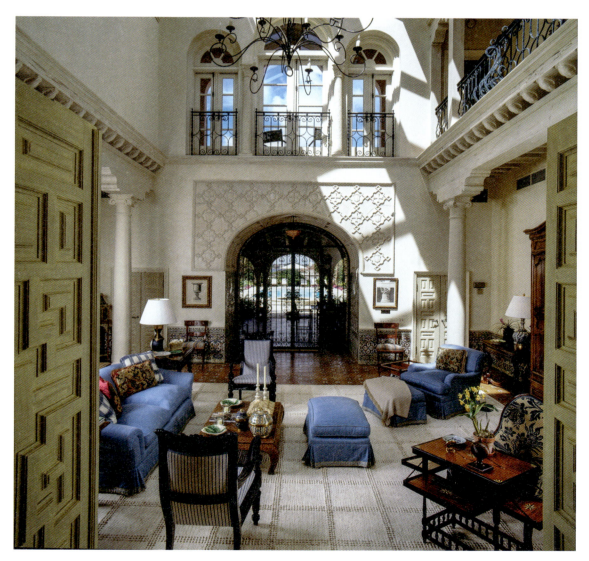

Interior views, 'Casa Sud', former May residence, Palm Beach, Florida

I FIRST BECAME INTERESTED IN ARCHITECTURE, gardening and design when I was pretty young. When I was about age 13, my parents moved to a wonderful, big house on the south shore of Long Island that was on the water. It was an English Tudor that had been the main house of a large estate and was built in the 1920s. The estate had been broken up, but our house and about three acres with waterfront and a boat house were intact, as were some beautiful mature gardens. The house had a lot of detail, including a grand room that had been copied or imported from a house in Italy by the previous owners. Learning to appreciate the history of that house and observing as it was being decorated made me aware of architecture and interior design, and I found I really cared how the house was being treated. I was attracted as well to the landscaping, which included a formal sunken rose garden with a fountain in the middle, and a copper beech allée that went from the terrace down to the water. I never knew who designed the estate but living there was very special. Certainly the age and formality of the place has had an influence on my taste and interest in classical architecture.

This attention to architecture expanded in high school. I was in a senior class where we were required to write an extensive paper on a person in the arts and I chose Frank Lloyd Wright, who was in his heyday at that time (this was 1959/60). I did research at what was then the Donell Branch of the New York Public Library

Main entrance, 'Maywood', May residence, Bridgewater, Connecticut

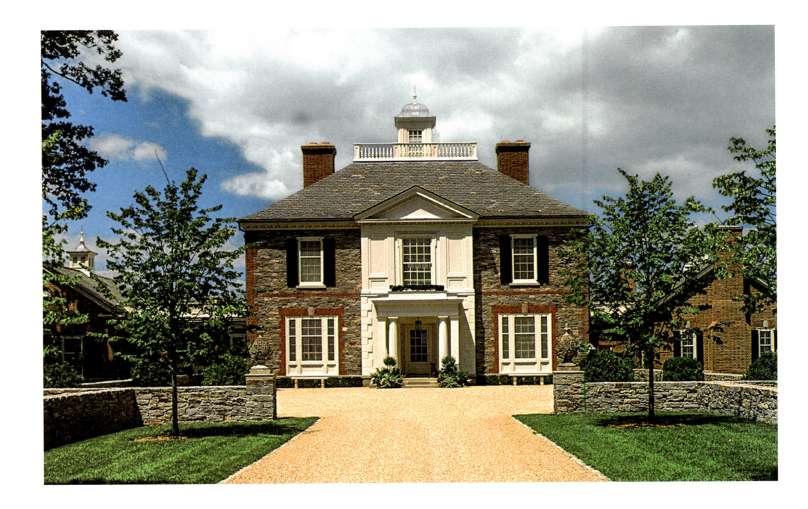

and became fascinated with Wright, his ideas and his work. I also learned about his training, particularly his days in Chicago, where Louis Sullivan and Daniel Burnham and other Chicago School architects were big influences. Ironically, I even moved to the city to attend the University of Chicago, which is located in Hyde Park and has a lot of historic buildings, including one of Wright's most famous, the Robie House. I ended up living practically next door to that fabulous building.

Freshmen were required to take a course in humanities which included trips downtown to the Art Institute and to many of Chicago's architectural treasures such as Sullivan's Roosevelt Auditorium. I also, on my own, traveled around the area—to Oak Park where Wright did a lot of his early work and to Racine, Wisconsin, to see the Johnson Wax Co. headquarters, a major Wright landmark. All these early experiences fostered my interest in architecture. Unfortunately (or perhaps fortunately), the University of Chicago did not have an architecture school so I was unable to enroll in that course of study. I chose finance and business instead. If I had become an architect, I probably wouldn't have been fortunate enough ultimately to be able to build the beautiful homes that our family has lived in.

My interest in collecting architectural drawings began when my wife and I were decorating our first major apartment in New York City, which was around 1985. We were lucky to have been introduced to Bunny Williams, who at the time was a Principal of Parish Hadley decorators. Bunny accompanied us to London to buy furniture for the apartment and took us to a gallery to look at some botanical drawings as decorations for a hallway. The gallery was the Hoppen Gallery, owned by Stephanie Hoppen. While there, I noticed a couple of architectural drawings she had on display and I immediately fell in love with the genre. We bought all she had and that was the beginning.

It wasn't long before Stephanie came to visit me in New York. She realized how much I loved the design drawings and wanted to help me find more of them. She told me about a big collection coming to auction and that exposed me to the notion of becoming a collector of this material. As I started to learn about the genre, I realized that what caught my eye the most were drawings primarily from the Beaux Arts period. The architecture students who studied at the École de Beaux Arts in Paris were required to complete their very precise elevations, cross-sections and plans with watercolor effects, like landscapes and often people, so they became works of art.

At the time I was building the collection, I also began building and renovating homes. First we purchased a 1926 Marion Sims Wyeth house in Palm Beach and invited Bunny Williams to decorate it and Mark Ferguson to do the extensive renovation and additions we wanted. Both Bunny and Mark had been at Parish Hadley and then left to start their own design firms.

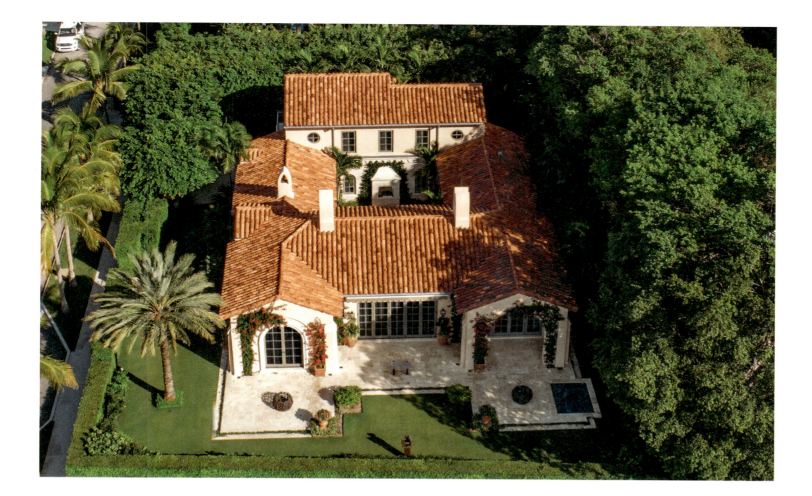

May residence, Palm Beach, Florida

The Palm Beach home, 'Casa Sud', was one of their first major assignments and the result ended up on the cover of *Architectural Digest* when it was completed. That home displayed drawings which really complemented the décor and design. We followed that property with a vintage John Volk-designed home across the street and, once again, Bunny and Mark worked their magic. My collecting had really accelerated by that time and the results covered the walls. Next came a rustic, chalet-style mountain retreat in Beaver Creek, Colorado, and we also began to expand our weekend property in Bridgewater, Connecticut, by adding a new colonial-style home and other structures as well as a series of gardens.

As the collection grew, I asked Stephanie Hoppen to help me find a curator to look after it and she introduced me to Steve Andrews, to whom this book is dedicated. Steve was a wonderful, funny, artistic and incredibly knowledgeable young man who had a great eye. We really built the collection together. He would source drawings at galleries and auction houses and then present them to me. Steve was brilliant in determining the perfect frame for each drawing and was a genius when it came to hanging the right drawing in the right location. Our collaboration continued for many years, as new homes or apartments were built or acquired, and the placement of the art was always Steve's responsibility. Tragically, Steve succumbed to cancer in 2016 but even as he was being treated for that awful disease he planned out the selections and locations for the art in our most recent project, a Ferguson- and Williams-designed home in Palm Beach. Steve never got the see the finished product and yet he is present in every hanging scheme. We all miss him very much.

I want to take this opportunity to thank Maureen Cassidy-Geiger, who is actually responsible for the execution of this book. Her work in finding the writers, researching the collection and coordinating the design and printing have been extraordinary.

It was actually Bunny Williams who first suggested the idea of this book. In putting it together I've had the chance to revisit some of my favorite drawings on the page, so to speak, since so many are now in storage. In fact, the collection numbers over 700 works on paper and as many as possible fill the walls of our homes and even the walls of our offices in New York. Some were on long-term loan to the May Gallery and Patron's Lounge at the Vilar Center in Beaver Creek and a dozen selected drawings still decorate the public spaces at the neighboring Chateau chalet complex. I am even fortunate that one elevation for a university building hangs in the office of the President of the University of Chicago.

I have been blessed to work with great people who really appreciated the creation of this collection. The ability to live on a daily basis with so many beautiful pieces has significantly enriched my life and love of architecture.

ACKNOWLEDGMENTS

PETER MAY

THERE ARE A LOT OF PEOPLE TO THANK AND acknowledge in both assembling the collection and the production of this book. Bunny Williams was the first to suggest I publish a catalogue and my curator, the late Steve Andrews, heartily embraced the idea. Unfortunately, he passed away before we were even able to get started, but he had introduced me to Maureen Cassidy-Geiger, who so ably ran with the idea and to whom I owe most of the results of this publication.

My wife Leni and I have been working with Bunny since the mid-1980s and have done over ten projects together. Over time, a friendship was forged with Bunny and her husband, antiques dealer John Rosselli, whose great eye steered us to many treasured objects and murals in our homes. We met Mark Ferguson through Bunny when they were both at Parish Hadley. Mark originally worked with me and my business partner Nelson Peltz on designing family homes in Greenwich, CT. Once Bunny began Bunny Williams, Inc. and Mark started his own firm, our ocean-front home in Palm Beach, Marion Wyeth's 1920s 'Casa Sud', was one of their first commissions. Thereafter we worked with Mark on almost all of our other projects and are so pleased to count him and his wife Natalie Jacobs, also an architect, at Ferguson Shamamian, as friends. I am gratified by the great success both Bunny and Mark have enjoyed as they established international reputations for their respective firms.

I need to thank Stephanie Hoppen for showing me my first architectural drawings, helping assemble the early part of the collection and introducing me to Steve Andrews. Greg Bollard, who manages all our properties and essentially runs our lives, has been key to making many aspects of our construction projects and the lives of our entire family run smoothly. All of the staff at Maywood, our home in Connecticut, contribute to its beauty. John and Jill Harrison of the Vail Valley in Colorado kept our property there in great shape. Also the Vail Valley Foundation, which owns the Vilar Center, where many of the drawings were displayed, were good shepherds of the art.

I am grateful to my Partners at Trian for allowing me the indulgence of having our offices filled with my drawings. I like to believe they have enhanced the atmosphere in the workplace.

Most important I want to thank my family. My children, son Jon and daughter-in-law Juliana and daughter Leslie and son-in-law Andrew Blauner have allowed me to include some of my drawings in their homes, even if they are not exactly their taste.

Of course the most important person in my life is my wife Leni (56 years and counting), who has been my greatest collaborator not only in growing the collection but in the creation of our wonderful family.

Steven Polson, *Portrait of Peter May*, 2020, oil on linen (Mount Sinai Hospital)

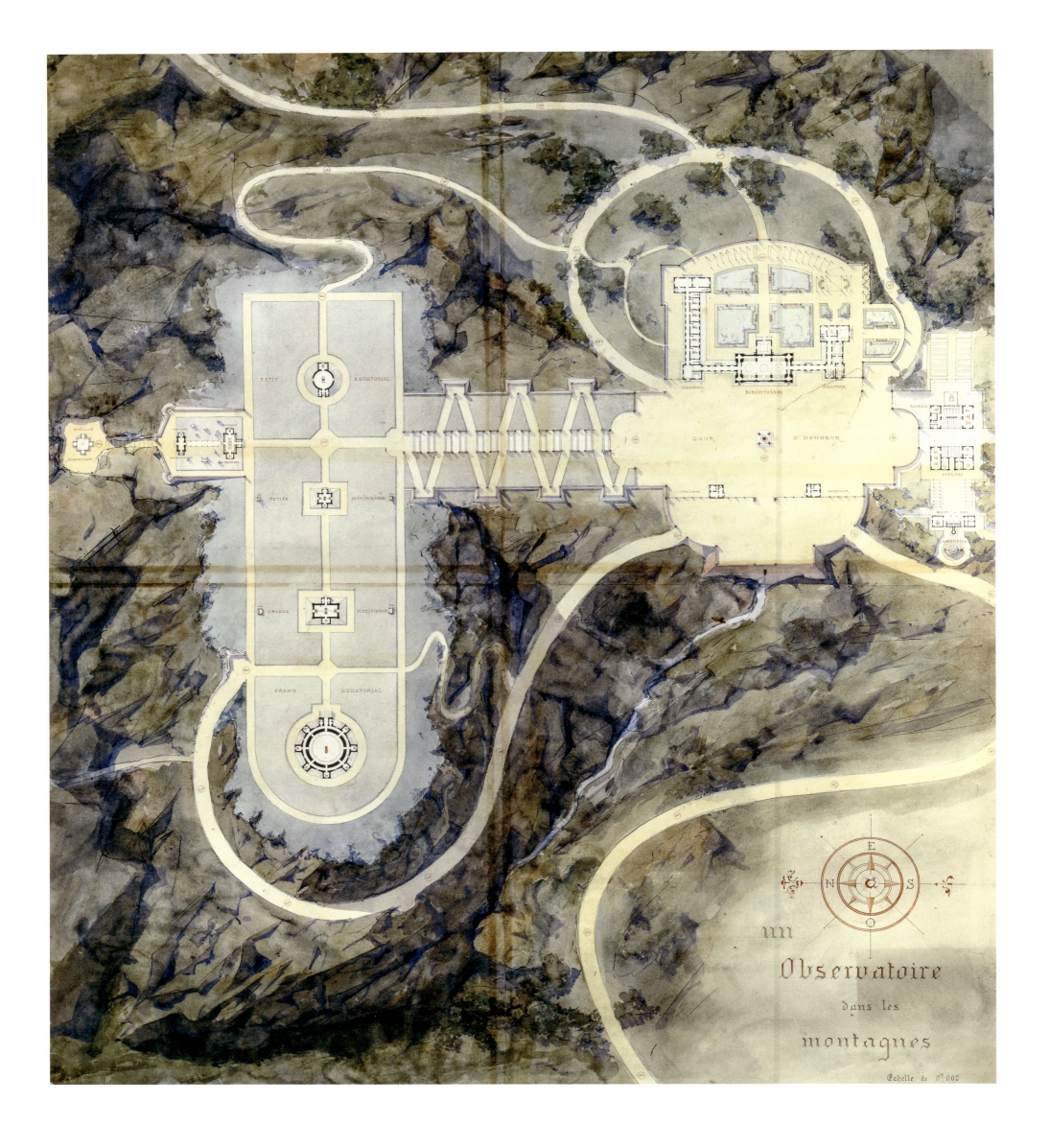

EDITOR'S ACKNOWLEDGMENTS

MAUREEN CASSIDY-GEIGER

I AM TRULY HONORED THAT PETER MAY ENTRUSTED to me this testament to his passion for architecture, which serves as well as a tribute to his gifted former curator, the late Steve Andrews (1959–2016). Steve and I met on the Attingham Summer School English Country House course in 1985. Years later, when in the final stages of cancer, he anointed me to be his successor in time for us to spend a few precious months working together. Steve's partner, Terry Cook, welcomed me into their lives and was much in mind throughout the process of bringing Peter May's vision to life.

This landmark publication presents a collection formed over more than three decades, yet was itself completed in just three short years. Retired curator of architecture at the Getty Research Institute Wim de Wit, Drawing Matter founder and architectural drawing champion and collector Niall Hobhouse and V&A Keeper of Word & Image Julius Bryant were early advisors, who steered me to co-authors Charles Hind and Basile Baudez and to publisher Paul Holberton. Hind is responsible for bringing Matthew Wells onto the team. Ideas for the content and organization of the book emerged from collegial conversations in New York and London that also included Bruce Boucher, among others. Much insightful backstory was provided by Bunny Williams, Mark Ferguson and Stephanie Hoppen, and by the collector himself and his wife, Leni May. I am indebted to May's peerless project manager Greg Bollard and his genial staff for consistently offering good-humored assistance. Working with like-minded and apparently imperturbable publisher Paul Holberton has been a delight as has every interaction with his spirited Art Director Laura Parker and the very able multitaskers Katherine Bogden Bayard and Kristen Wenger, who manage marketing and distribution. The practiced team at E-Graphic, Verona, was responsible for reproduction, printing and binding. Picture researchers Elizabeth Savage and Lisa Dallavalle are commended for so tirelessly fielding unrelenting requests for the many disparate auxiliary images required for the essays and catalogue. It is gratifying to look forward to an exhibition of selected drawings from the May collection at the New-York Historical Society in 2021; we thank Louise Mirrer, Margi Hofer and Marilyn Kushner for this opportunity.

I would like further to acknowledge, in the United States: Jeffrey Collins, Melissa Gagen, Anne-Lise Desmas, Nadine Orenstein, Femke Speelberg, Ken Soehner, Martin Chapman, Will Strafford, Natalie Jacobs, David Mayernik, Stan Allen, Colin Stair, Jeffrey Keil, Jeffrey Hoffeld, Norman Brosterman, Carol Mattusch, Mark Karnett, Douglas Klahr, Duncan Horner, Beth Pond, Dean Davis, Jeannette Schulze, Alister Alexander, Bernadette Espinosa, Lynsey Sczechowicz, James Garfinkel, Elio Tzipora Weiss, Bernard Goldberg and his staff, Michael Rawlings,

Architect unknown, Prix de Rome competition drawing for an observatory, plan, 1907 (May Collection 1987.80; cat. 2.23)

Alphonse-Alexandre Defrasse, Canal façade of the Ca' d'Oro, Venice, ca. 1900 (May Collection, 1990.291; cat. 8.1)

Peter Harholdt, J. R. Martin and his associates at Duggal Visual Solutions, Alvarez Conservation, APF Mund Framemakers, and the staff of the President's office at the University of Chicago, of the Columbia University and Metropolitan Museum of Art libraries and of Day & Meyer. Many at Trian Partners also helped the project progress, notably Brian Schorr, Greg Essner and Debra Warnock. I would also like to acknowledge the Steve Andrews fan club at the office: John Bender, Jane Singletary, Louise Doktor, Tonsie McAden and Rita Scalzo. In Austria: Gernot Meyer, Richard Kurdiovsky. In Canada: Martien de Vletter. In England: Dame Amelia Fawcett, Stephanie Hoppen, Niall Hobhouse, Rufus Bird, Jonathan Marsden, David Beevers, Peter Kerber, Jane and Timothy Lingard, Rachel and David Blissett, Liz Taylor, Anthony Verschoyle, Cristiana Romalli, Helen Dorey, Rosie Llewellyn-Jones, Nicholas Olsberg, and the staffs at RIBA, the V&A, Sir John Soane's Museum and Royal Horticultural Society. In France: Bertrand Rondot, Christiane Desgrez and her staff, Yves Carlier, Alexandre Gady, Justine Gain, Sophie Mouquin, John Whitehead, Peter Fuhring, Paul Micio, Brigitte Cannard, Vincent Bidault, and the staffs of the ENSBA and INHA. In Germany: Samuel Wittwer, Marcus Koehler, Martin Schuster, Cord Panning, Judith Rüber, Antje Vanhoefen. In Italy: Christian Biggi, Andrea Maglio, Angela Carola-Perrotti, Evelyn Korsch; Librarian Sebastian Hierl and the staff and administrators at the American Academy in Rome; Librarian Valerie Scott and the staff at the British School in Rome; Alessandra Gariazzo, Jerome dela Planche, and Raffaella Carchesio at the French Academy in Rome; Simone Guerriero, Ilaria Turetto, Laura Brunello, Massimo Busetto, and the staff and administrators at Fondazione Giorgio Cini, Venice. In The Netherlands: Reinier Baarsen. In Poland: Grzegorz Ostrowski. In Russia: Svetlana Zuzeva. In Asia and Australia: Nathalie Leung Shing, Ian Stephenson.

As always, family and friends are vital to enduring the often quite solitary processes of researching and writing. I am so thankful for the love and support of James Geiger and McCahey Townsend Geiger, Lily Geiger Kast and Will Kast, B. Martha Cassidy and Susan Gardner, Tracy and Len Czarnecki, and my nieces and nephew; I am also happy to feel a connection to my father, architect and wordsmith Hugh Cassidy, who would have been so touched and surprised by my recent forays into his field, notwithstanding my own training in the history and practice of architecture at Wellesley College, M.I.T., and Parsons School of Design. Indeed, I am better known as a nimble curator and scholar specializing in 17th- and 18th-century European court culture and the history of the decorative arts and collecting with a partiality for paper, whether drawings, inventories or prints. It has therefore been a particular pleasure to merge so many interests into the pages of this book.

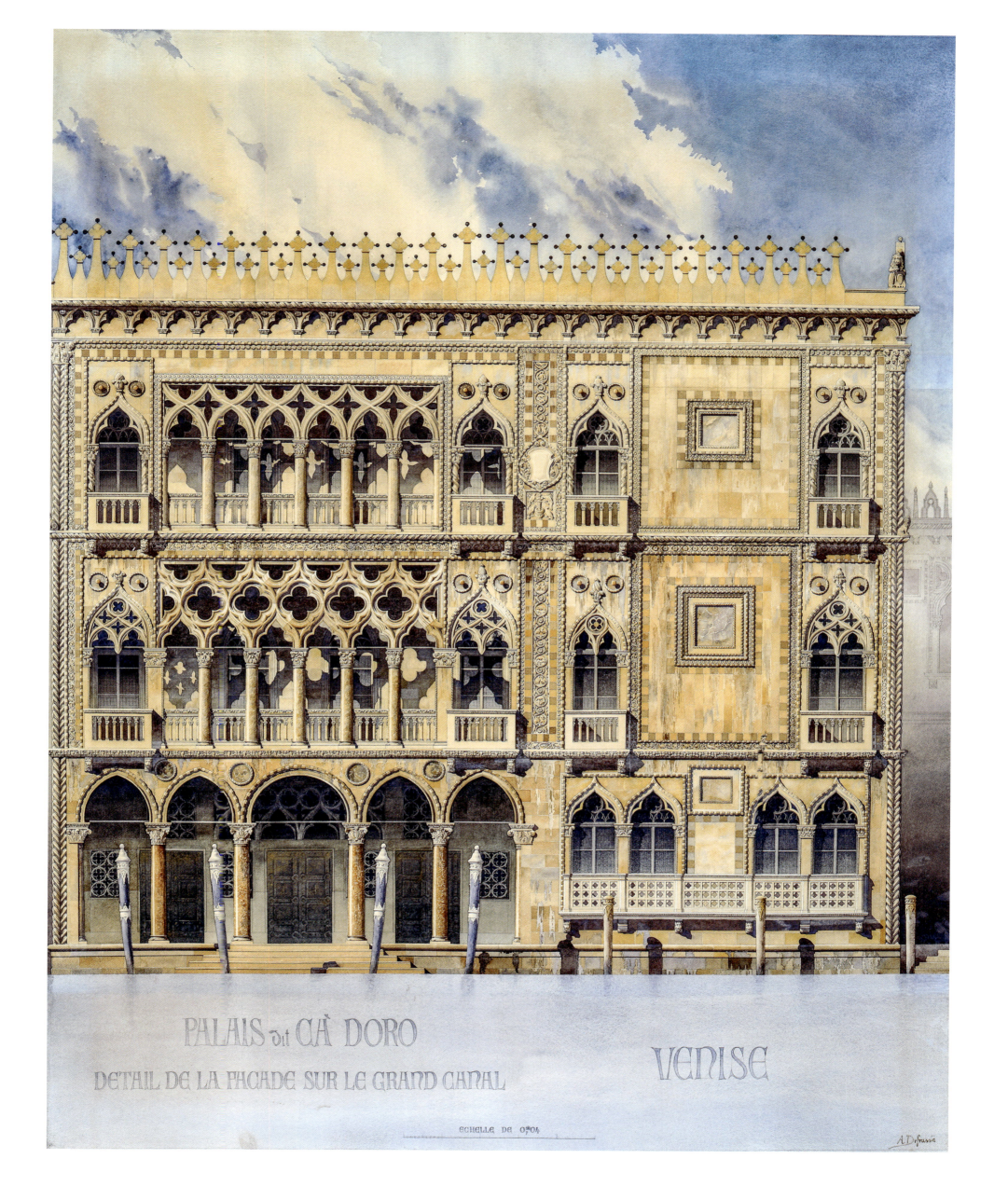

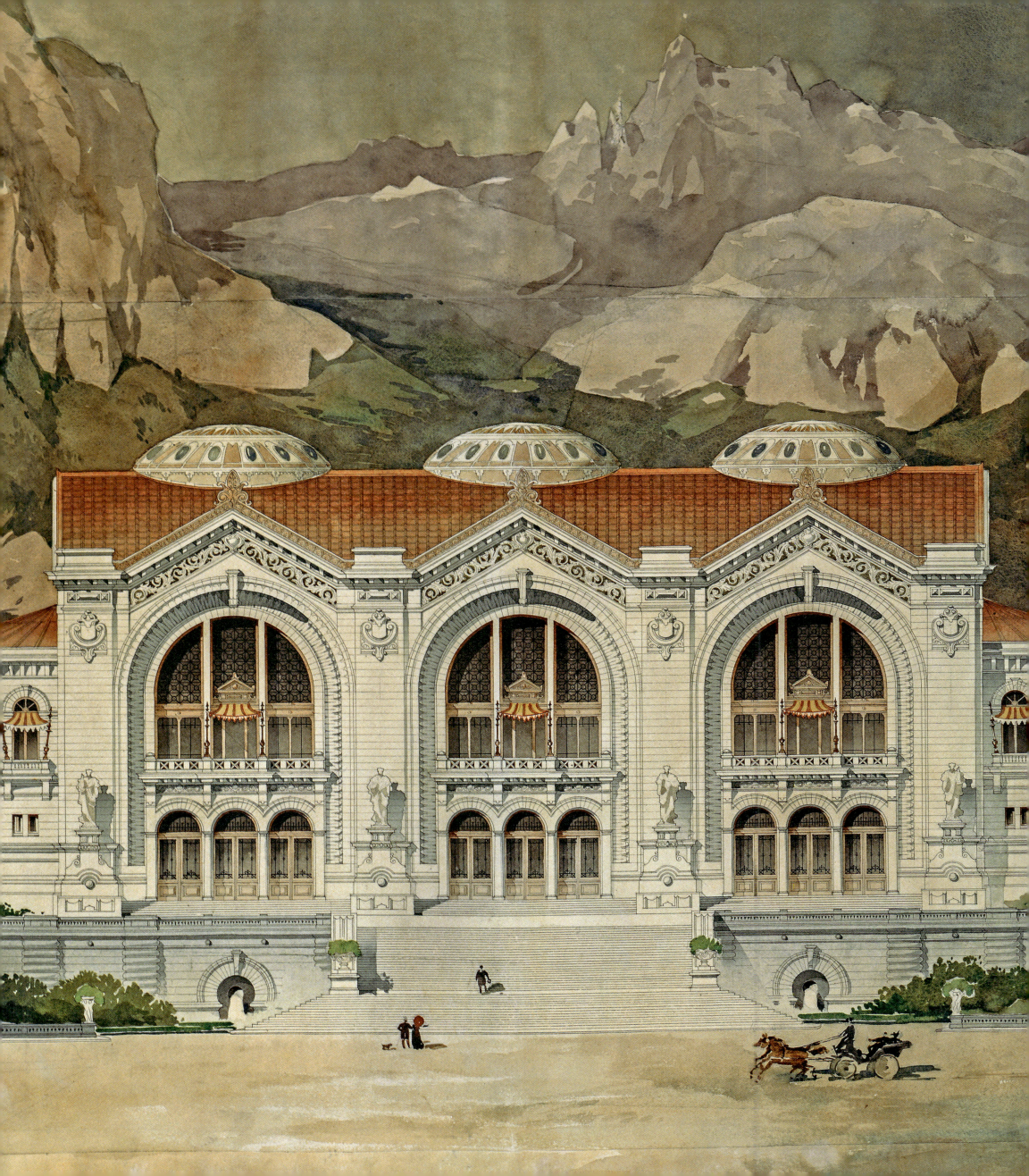

INTRODUCTION

The Art of Architecture

MAUREEN CASSIDY-GEIGER

THE PETER MAY COLLECTION WAS JUMPSTARTED in 1987 with the acquisition of 130 architectural drawings sourced by London-based gallerist Stephanie Hoppen. May was passionate about architecture from a young age and understood the design process from personal experience, having worked closely with Mark Ferguson of Ferguson & Shamamian on a succession of building projects in New York, Connecticut, Colorado, and Florida. He met Ferguson as well as Hoppen through celebrated decorator Bunny Williams. Indeed, it is Williams who deserves credit for planting the seed that grew into one of the largest private collections of its type by suggesting May decorate the walls of his homes and offices with architectural drawings (figs. 2–6, 11, 12, 14, 20, 25). An unconventional choice then as now, the art of architecture married well with Williams's masterfully understated interiors (fig. 3). Different genres were earmarked for different settings; drawings that were Mediterranean in flavor suited Palm Beach whereas rustic buildings, country houses, and châteaux held court in Beaver Creek (fig. 4). Banks and exchanges were for the firm, where there was also more wall space for the grand-scale works (figs. 2, 5, 6).

In 1987, Stephanie Hoppen was the go-to dealer for the hand-colored botanical prints so beloved by interior designers and their clients. In response to the burgeoning interest in collecting the relatively

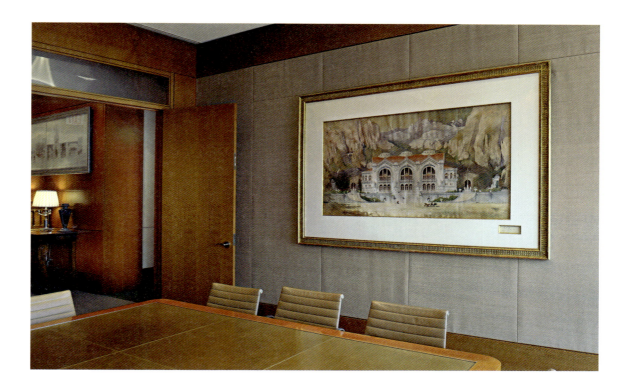

FIG. 1
Achille Proy, Competition drawing for a spa and casino: frontal elevation (detail), 1900 (May Collection, 1989.214; cat. 6.4)

FIG. 2
Peter May Office, New York City (showing cat. 6.4 in the conference room)

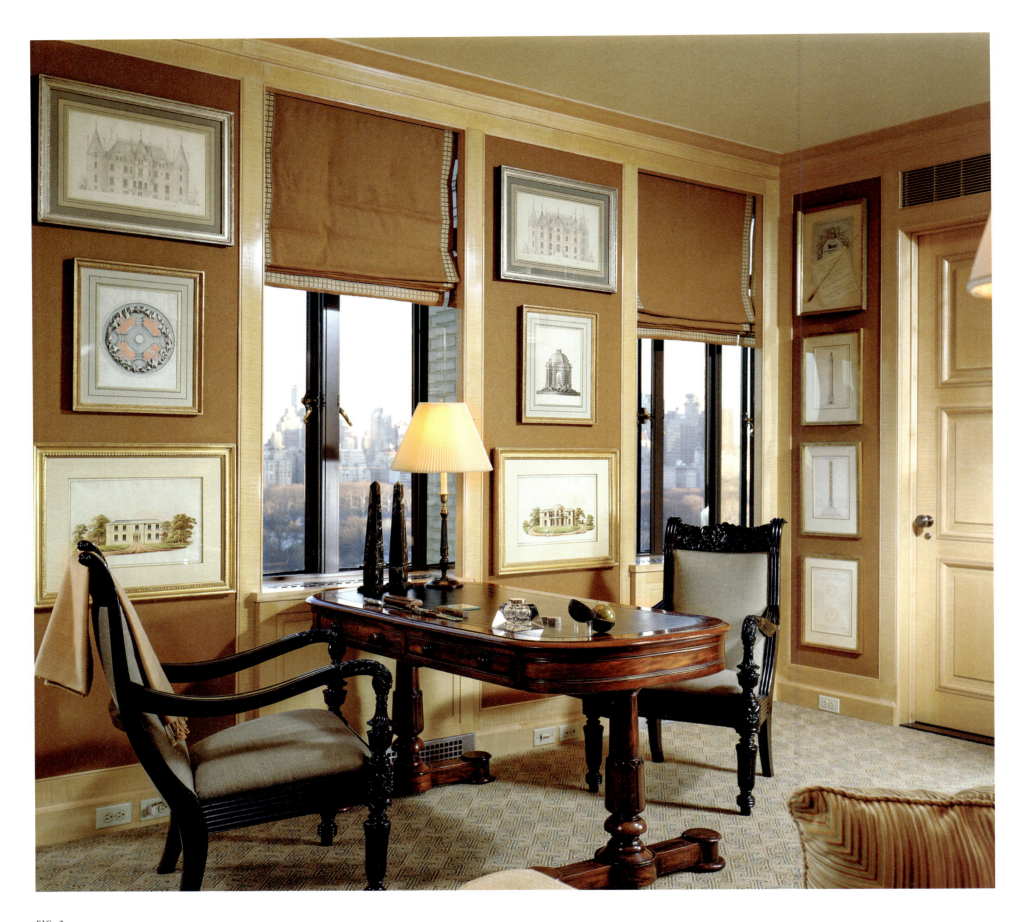

FIG. 3
Peter May Study, San Remo,
New York City

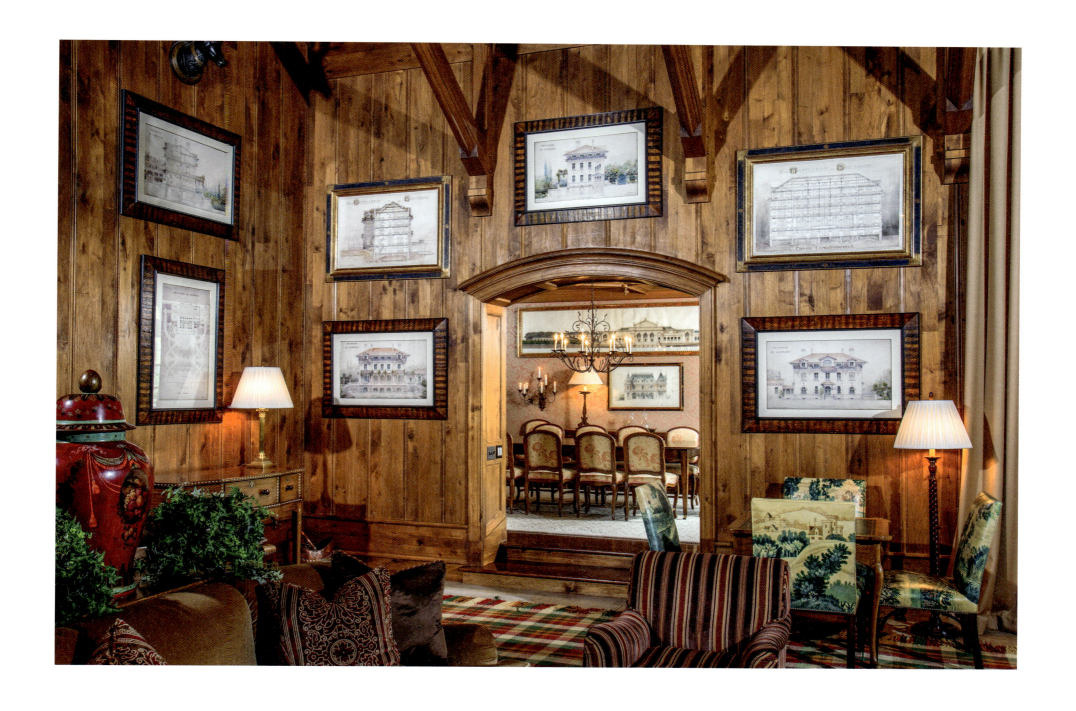

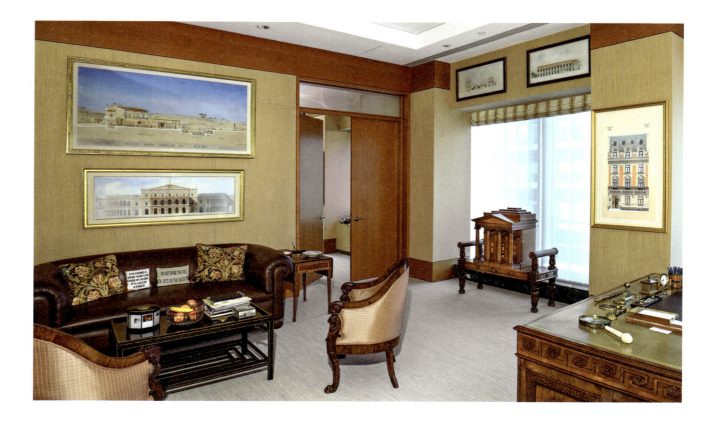

FIG. 4
Interior view, 'The Chateau', former May residence, Beaver Creek, Colorado

FIG. 5
Peter May Office, New York City

INTRODUCTION 3

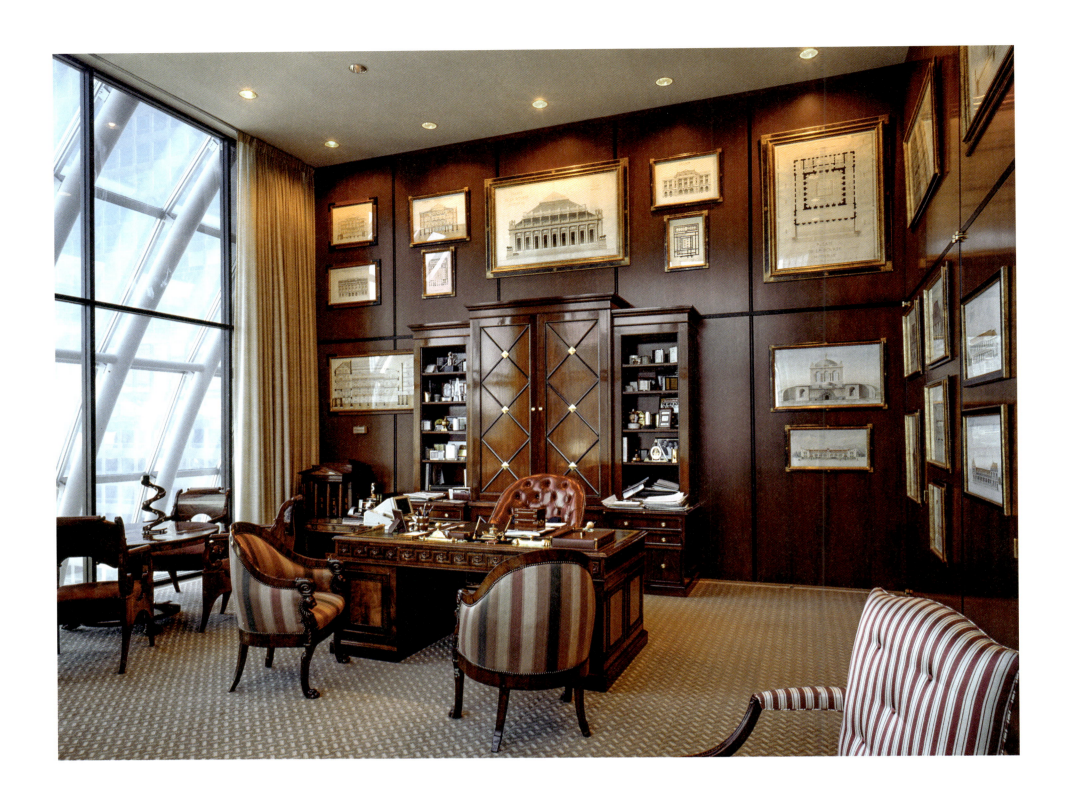

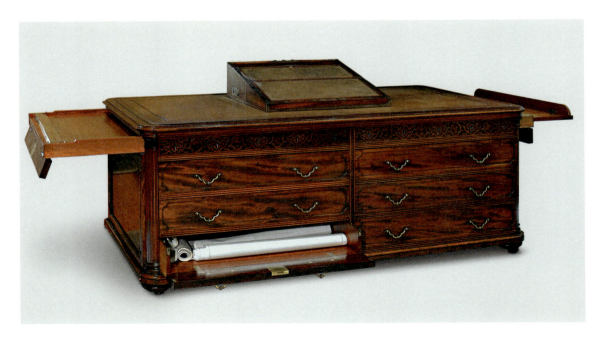

FIG. 6
Former Peter May Office,
New York City

FIG. 7
Architect's cabinet, mahogany,
British, ca. 1910 (May Collection)

FIG. 8
Cover of Alain Cambon Gallery catalogue no. 14, 2010

obscure design drawings that began to trickle onto the marketplace, she broadened her scope as well as her reach, opening an outpost in New York and exhibiting at American art fairs. Hoppen worked with American Steve Andrews to publish illustrated booklets about decorating with the sorts of antique and modern works she stocked; some pages featured her clients' interiors, including Peter May's (fig. 6). Andrews quite naturally became the liaison between Hoppen in London and May in New York, overseeing the shipping and receiving, documentation, conservation, framing, and hanging of his acquisitions. Some of these arrived in mailing tubes, having been rolled and stored in attics and cellars for generations before seeing the fresh light of day. Hoppen's mandate was to source for May within Europe "architecture, interior design, garden design, furniture design, carpet and fabric design and other spectacular items in adjoining fields." She influenced May to consider architectural models and sold him a handsome architect's cabinet (fig. 7).

The acquisitions process was laborious and intense, involving a steady exchange of handwritten or typed correspondence and photographs across the Atlantic; Hoppen and Andrews too traveled back and forth with frequency, and artworks were sometimes sent to New York on approval. Hoppen wrote effusively in a blousy cursive, communicating offers and opinions while sharing snippets of her day, as in May 1988: "Thank you for your prompt reply. Isn't fax wonderful? [...] chaos was everywhere yesterday as in the middle of our madly successful show at Mallets [sic] we were getting ready for a photographer who is to photograph the gallery + display at Mallet for an American magazine this afternoon. I am going to tell him to take a good transparency of the Banque de Victoire and will courier it over to you." In October 1989, she exclaimed: "I AM FEELING RATHER SHATTERED AS THERE HAS BEEN NO LET UP OF PRESSURE OR ACTIVITY SO IF TYPING OR SPELLING FAIL YOU WILL KNOW WHY!"

By 1995, Andrews, a disarming Southerner or Anglophile, depending on his audience, was solely responsible for sourcing material for May, buying directly from the leading dealers in London, Paris and New York and at auction (fig. 8). The two men shared a passion and an eye and their definition of architecture was fluid. Under Andrew's watch, in fits and starts, the collection grew in size, range, and quality, especially with the acquisition in 2000 of an outstanding private collection of 123 drawings. Undaunted by scale, fascinated by detail, May trusted his curator's instincts implicitly in conservation and framing and often indulged his recommendations, once stating for the record, "It's too big. It's too expensive. I'll take it." He bought from what came to market and was brought to his attention, easily amassing as many tiny gems as

INTRODUCTION 5

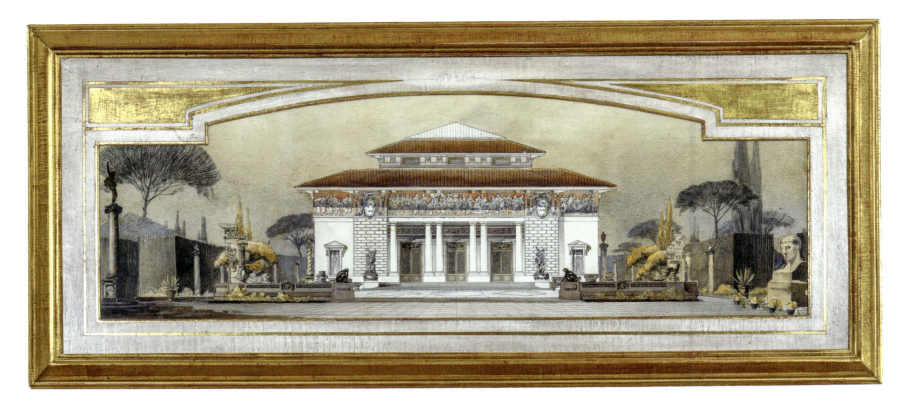

FIG. 9
Specialty framing for May Collection
1988.127 (cat. 1.20)

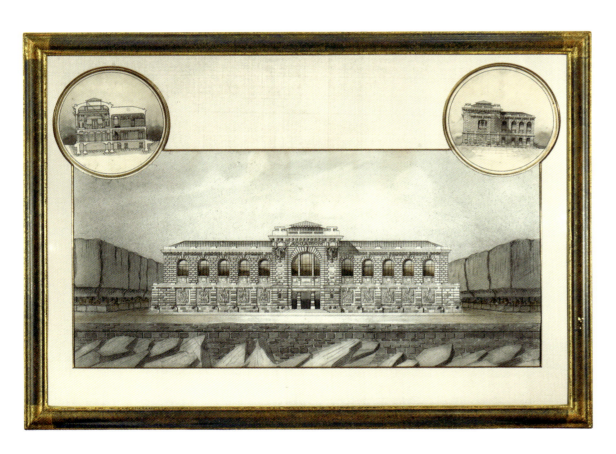

FIG. 10
Specialty framing for May Collection
1987.25a (cat. 1.29)

FIG. 11
In situ view of May Collection 1987.43
(cat. 14.13), as trimmed, framed and
exhibited in the dining room, May
Residence, Palm Beach

oversize and grandiloquent statements. May was enticed by sets of drawings like the anonymous designs for the Palladian Villa Syam in the Jura mountains (cat. 9.6 and in fig. 20), Émile Camut's (1849–1905) prize-winning proposal for the restoration of the Mont-Dore spa (cat. 6.6), the mouthwatering reconstruction drawings by Harold Bradshaw (1893–1943) for the Villa Giulia in Rome (cat. 11.4 and in fig. 5) and by Jules Formigé (1879–1960) for the Roman arena at Arles (cat. 11.3). Charles Georges's (1869–1970) disparate certificate assignments also appealed (cat. 11.19) as did the gouaches of the palace of Sagan, Poland, sold at Sotheby's Monaco in 1989 (cat. 8.34) and Émile Jacques Gilbert's (1793–1874) precise studies of frescoes at Herculaneum and Pompeii (cat. 11.11).

Most of the drawings were photographed in their original condition before being shipped to New York for conservation, while custom frames were ordered by Hoppen or Andrews from British or French suppliers. Thus marginalia and other sorts of peripheral evidence that might be hidden by a mat were fortuitously recorded in 4 × 6 in. ektachromes, which were scanned for this publication. French competition drawings that were tacked to a panel for judging, for example, have pinholes in the corners, and the students usually presented their designs within a suggestive framing device, such as a metallic tape or a watercolor border, elements that are often obscured by the mats. Framing

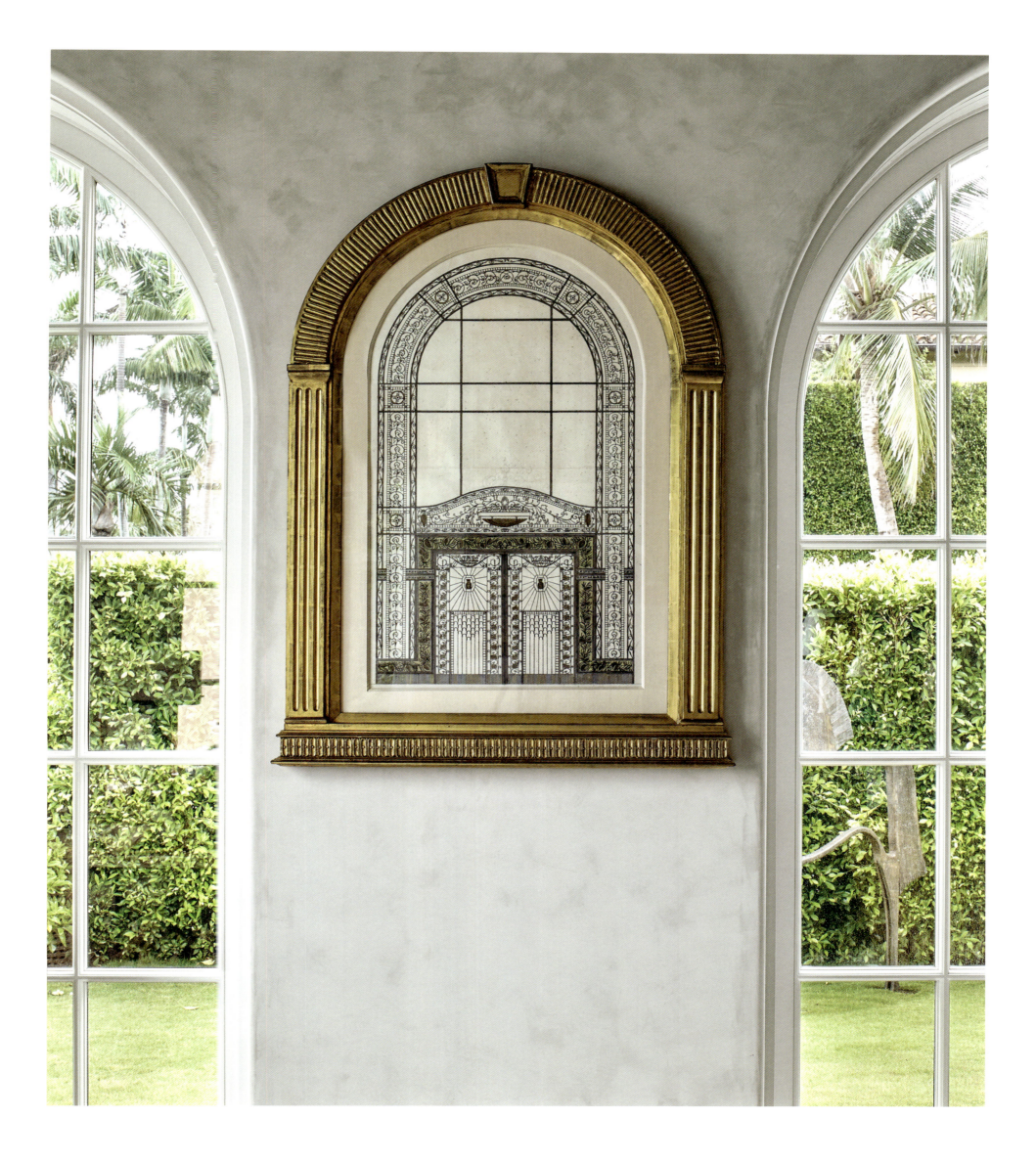

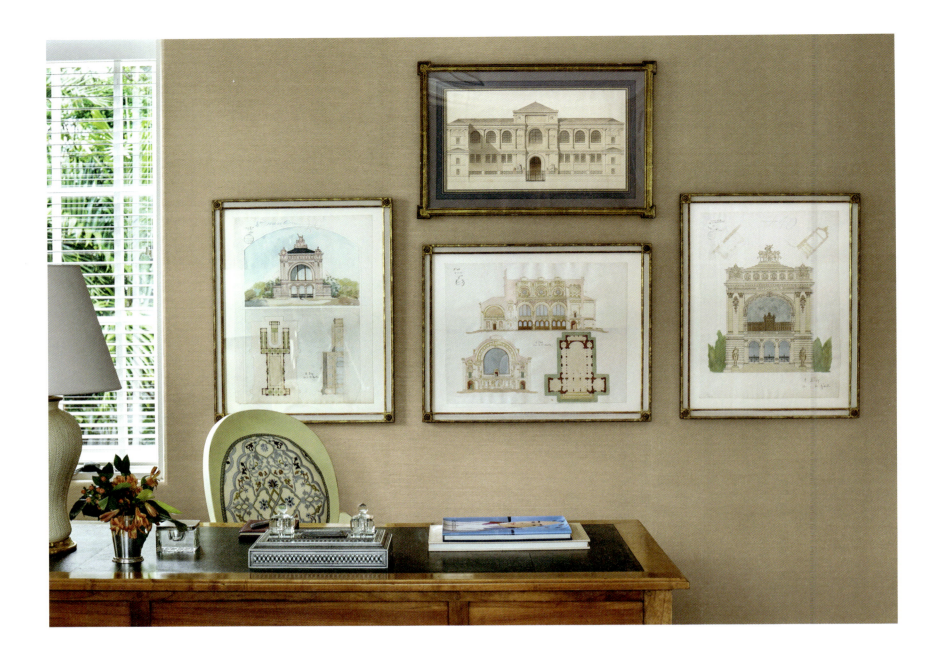

FIG. 12
Peter May Study, Palm Beach, Florida, showing two arched renderings (May Collection 1989.228a,b; cat. 1.32) in rectangular frames to reveal marginalia

FIG. 13
Specialty APF frame for May Collection 1991.371 (cat. 11.9)

FIG. 14
Dining Room (detail), San Remo, New York City, showing Salon-style hanging

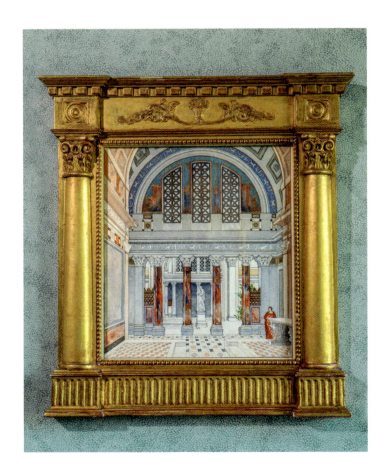

might likewise hide notations and marks by the jury or even signatures and attributions that were added later. Given the vagaries of the original sheets, creative framing solutions were sometimes required (figs. 9 and 10). In one instance, for example, an arched design on a rectangular sheet was trimmed to fit within a similarly shaped frame that corresponded as well to the architecture of the room (fig. 11). More typically, an arched composition and its marginalia were left exposed in rectilinear frames (fig. 12). Hoppen supplied many of the boldly patterned DELF frames used for the Colorado house (fig. 4), where the framing strategy also extended to presenting multiple sheets from a set within a single frame for a stronger statement. Gradually, New York framer APF took over, working with Andrews to achieve elegant, timeless solutions for drawings large and small (fig. 13). The collector, as much as Andrews and Williams, favored salon-style hangings (fig. 14).

Although May concentrated on antique drawings, he was receptive to modern renderings, such as Teddy Millington-Drake's (1932–1994) watercolor interiors

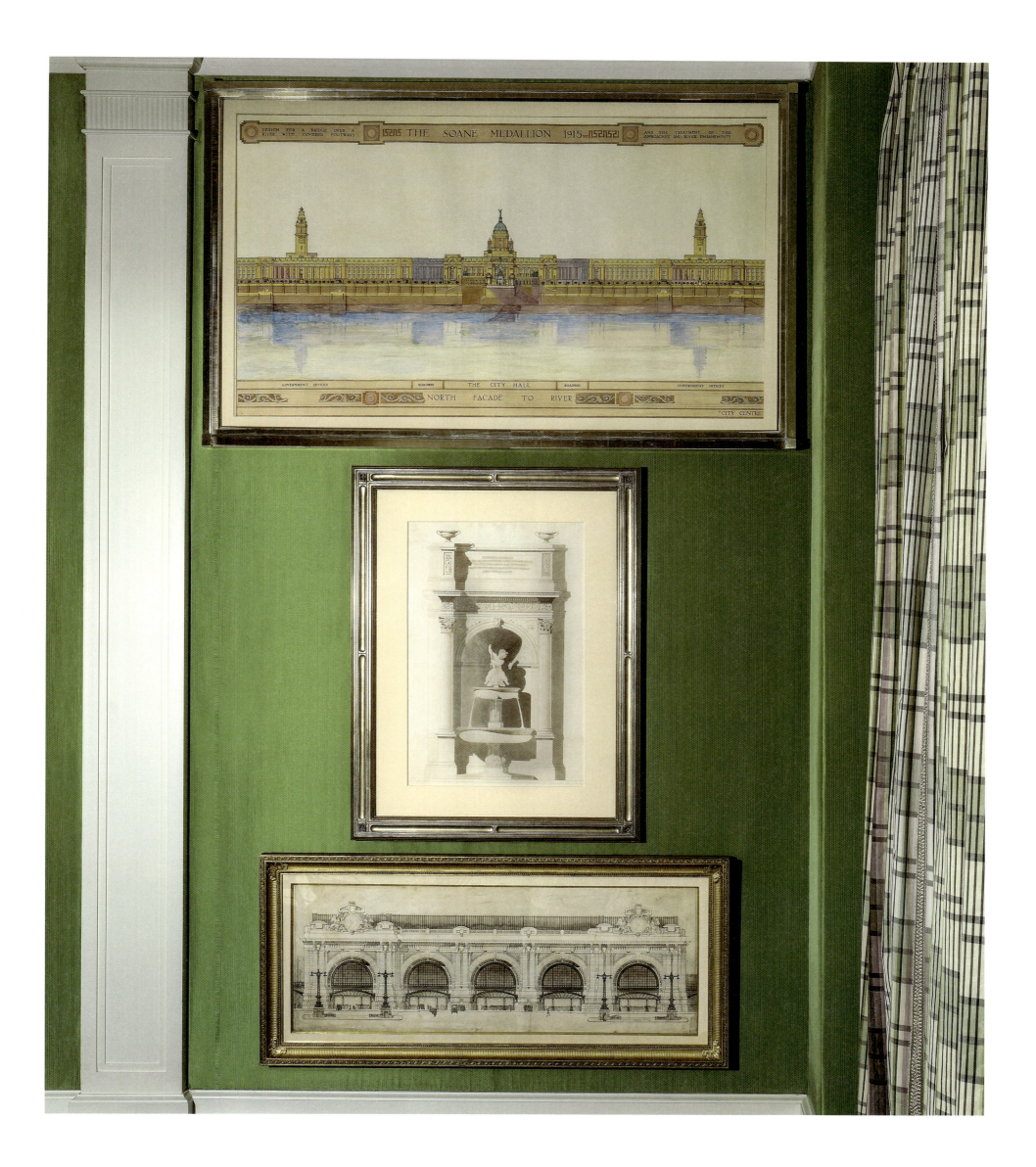

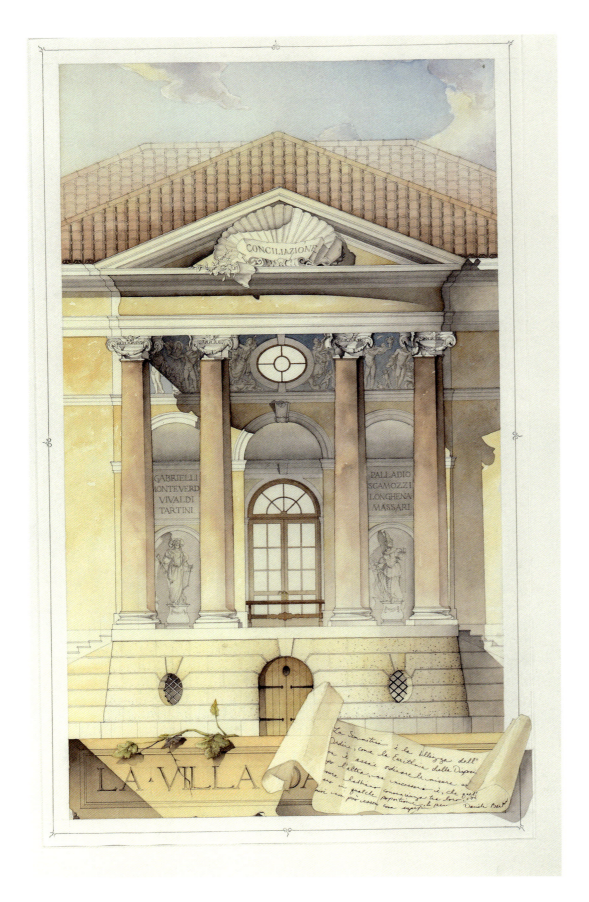

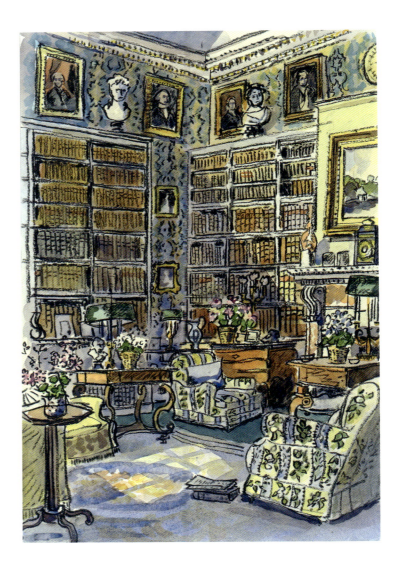

FIG. 15
David Mayernick, *Portico of a villa* (pencil, ink, watercolor), 1990 (May Collection 1990.330)

FIG. 16
Teddy Millington Drake, *Interior, Petworth*, watercolor, 1987 (May Collection)

of Petworth (fig. 16). When, in 1990, Stubbs Books & Prints, the legendary Union Square home-cum-shop-cum-salon run by Jane and John Stubbs, mounted an exhibition of the work of practicing architects like David Mayernik (b. 1952) and Thomas Norman Rajkovich (b. 1960) to benefit the American Academy in Rome, May readily purchased eight pieces (fig. 15). David Connell's delightful homage to Sir John Soane's Museum appealed to the collector's affinity for the celebrated architect's eccentric and beloved London home (fig. 17). He also acquired Frederick Brosen's (b. 1954) watercolors of New York and in 2007 commissioned from Glen Hansen (b. 1961) two views of The San Remo in Manhattan, his home for eighteen years (fig. 18). A lost jewelry box by David Linley in the form of the collector's country home, Maywood, is recorded in the furniture maker's preparatory drawing mounted with samples of different wood veneers (fig. 19). The precise renderings of European opera houses and Gotham landmarks by Hungarian-British architect Andras Kaldor (b. 1938) were also attractive to the music lover who calls New York City home. Many were included in May's generous loan of 63 drawings to the May Gallery Patron's Lounge in the Vilar Center in Beaver Creek (fig. 21).

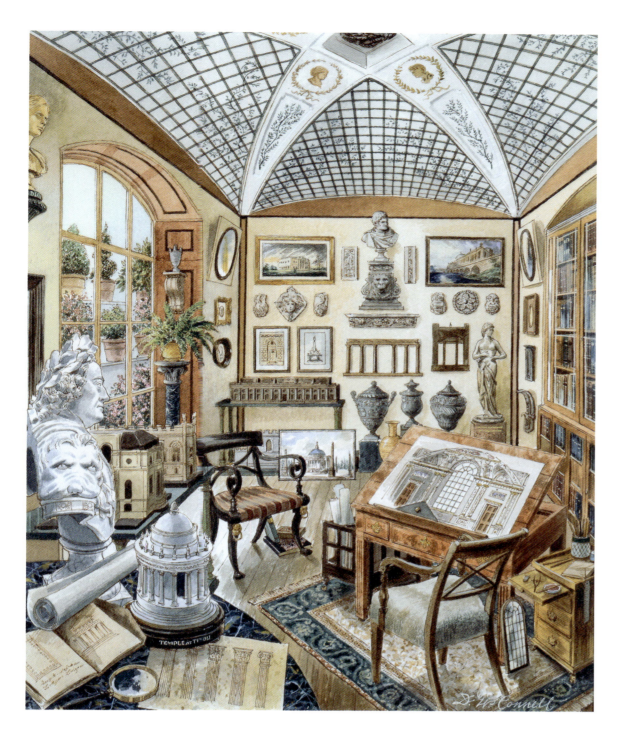

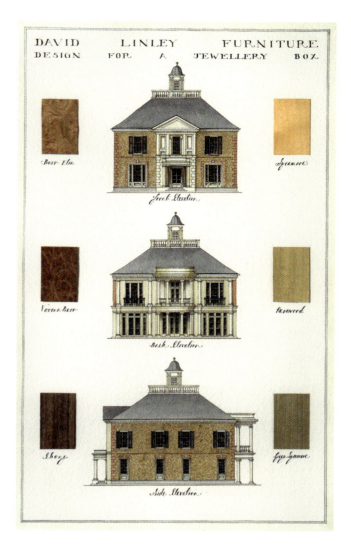

FIG. 17
David Connell, *Capriccio of an Architect's Studio*, watercolor, ca. 1998 (May Collection 1998.407)

FIG. 19
David Linley Furniture, Design for a jewelry box in the form of 'Maywood', watercolor with applied wood veneer samples, 1994 (May Collection)

FIG. 18
Glen Hanson, *The San Remo, New York City*, oil on panel, 2007 (May Collection)

INTRODUCTION 11

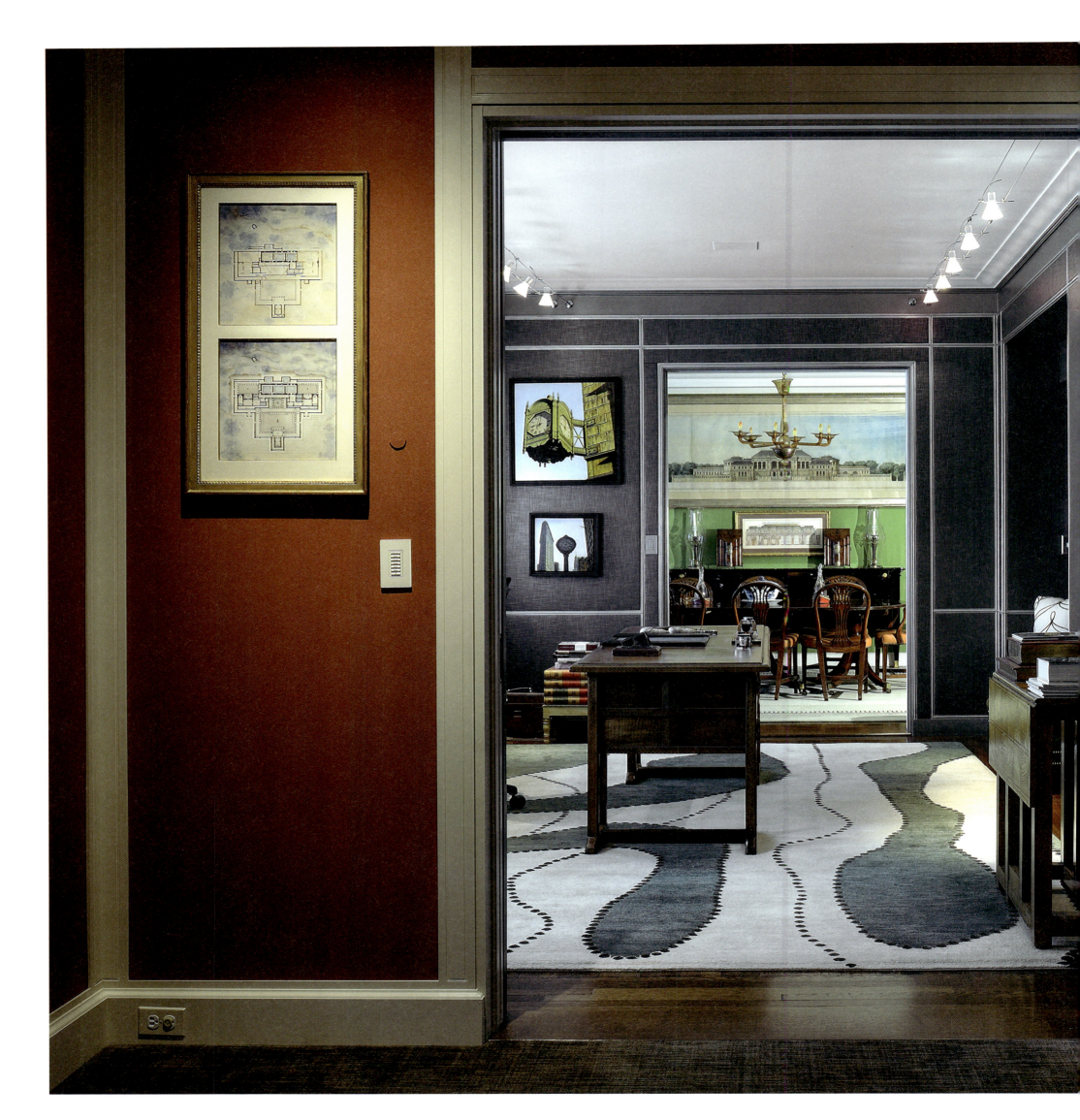

FIG. 20
View from the media room to the dining room, The San Remo, New York City, including at right May Collection 1990.323 (cat. 9.6)

INTRODUCTION 13

FIG. 21
May Gallery Patron's Lounge, Vilar Center, Beaver Creek, Colorado, showing watercolors of historic European theaters by Andras Kaldor (May Collection)

FIG. 22
Frank Lloyd Wright, Chair for the Usonian Exhibition House, plywood, 1953 (May Collection)

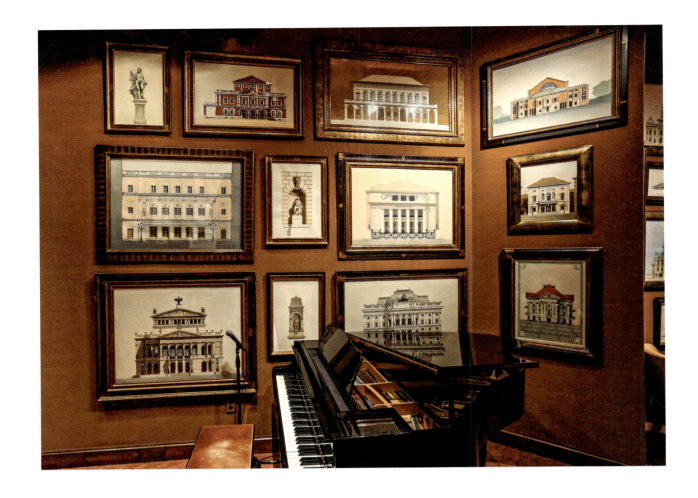

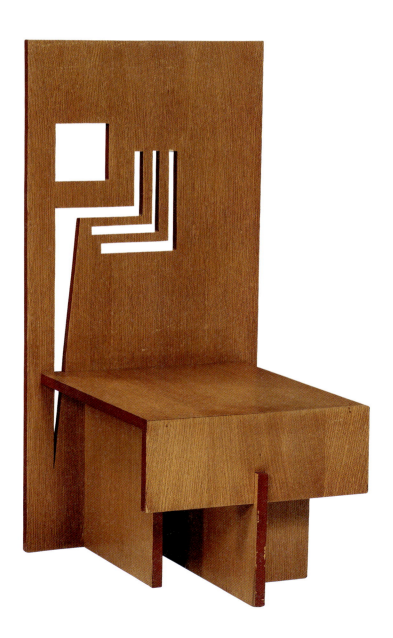

May's eye extended beyond architectural drawings and models to include a plywood dining chair designed by Frank Lloyd Wright for his Usonian Exhibition House constructed on the site of the Guggenheim Museum in New York in 1959, one of a pair (fig. 22). He also succumbed to a newel post from Adler & Sullivan's 1894 Chicago Stock Exchange building, which was demolished in 1972 (figs. 23 and 24). Lithographs by Le Corbusier (1887–1965) and a few printed books entered the collection as well, including W. H. Pyne, *The History of the Royal Residences* (2 vols., London, 1819); John Soane's *Plans – Elevations – and – Sections – of – Buildings* (London, 1788); the delightful *Verzaameling van alle de huizen […] der Stadt Amsteldam* (1768; fig. 25); *XVIII et XIX Cahier des jardins anglais* (1787), and *New Horizon's Buildings Plans and Designs* by Frank Lloyd Wright (1963).

This publication documents the Peter May collection as of 2020, comprising over 700 design drawings, nearly fifty oil sketches, watercolors, and pastels, two sketchbooks and seventeen models. The earliest sheets are designs for the marble flooring of the Invalides in Paris dated 1691, while the most recent item acquired is a 1952 presentation drawing by Lloyd Wright for Price Tower (cat. 7.19). The largest representation is 19th-century and French. The reach of the French training system established in 1671 is reflected in the drawings by non-French practitioners in North and South America, Belgium, Denmark and Russia. Small

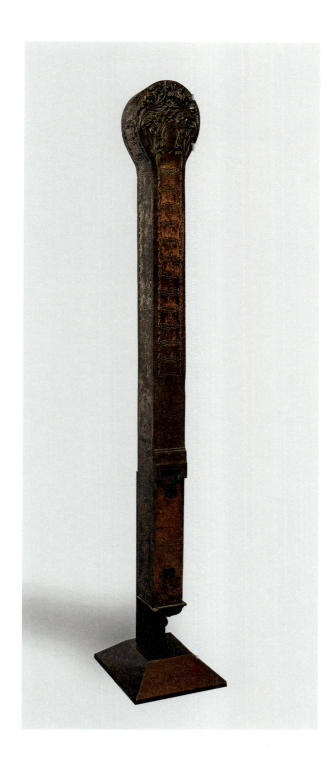

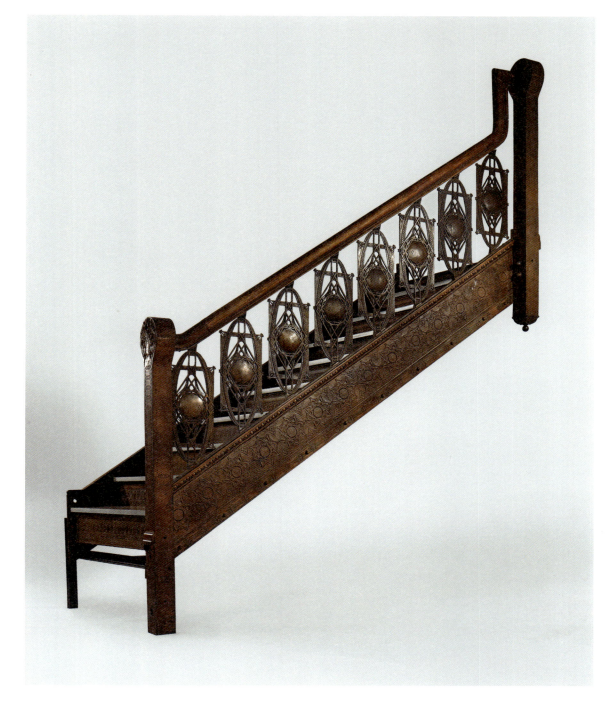

archives were assembled of the work of Prosper Etienne Bobin (1844–1923), Jean-Baptiste Plantar (1790–1879) and Leon Keach (1893–1991). Individual sheets by such notable British practitioners as Robert Adam (1728–1792), Thomas Cubitt (1788–1855), Michael Gandy (1778–1862), Sir John Soane (1753–1837), Cyril Farey (1888–1954) and Edwin Lutyens (1869–1944) were also acquired. Although most of the collection speaks to the education of architects and the practice of architecture, research has demonstrated that some renderings were executed for publications. The 19th-century fashion for documenting royal residences in watercolor ahead of the discovery of photography is reflected by several French and German interiors and views. The British and Commonwealth material includes alluring perspective views.

FIG. 23
Dankmar Adler and Louis Sullivan, Newel post from the Chicago Stock Exchange (demolished 1972), copper over cast-iron, 1893 (May Collection)

FIG. 24
Staircase from the Chicago Stock Exchange, 1893 (Two Red Roses Foundation, Palm Harbor, FL)

INTRODUCTION 15

FIG. 25
Interior view, 'Casa Sud', former
May Residence, Palm Beach, Florida

FIG. 26
Caspar Philip Jacobsz (1732–1789), *Verzaameling van alle de Huizen en Prachtige Gebouwen langs de Keizers en Heere-Grachten der Stadt Amsteldam*, Amsterdam, ca. 1768, plate 22 (May Collection)

The reader is invited to experience Peter May's vision of the art of architecture in word and image. It is hoped the essays will satisfy the amateur and specialist alike by presenting innovative histories of the production, function and collecting of architectural drawings and models. In a departure from tradition, the catalogue is organized according to the genres that captivated the collector and suited his homes and offices. Within each section, building types are clustered together and laid out whenever possible by nationality or chronologically. Section 1, Theaters, Museums and Clubs, comprises cultural institutions ranging from learned societies and libraries to arenas for performances. Section 3, Government Buildings, encompasses city halls, post offices, a fire station and hospitals. Section 7, Commerce, is a catchall for banks and exchanges as well as small shops, department stores and factories. The construction and reconstruction drawings are so eye-catching and distinctive that they warrant their own categories. Section 12, Landmarks, Monuments, and Mausolea, presents atypical building types like towers, memorials, bridges and gateways.

May's affinity for gardening led him to collect related visual material that falls into Section 13, Landscape Design and Garden Architecture. Likewise, his pronounced interest in structural ornament is evident in Section 14, Cast-Iron Architecture and Design. The serendipitous opportunity to amass a small archive of work by the prolific Plantar invited a dedicated section. The catalogue lets the drawings do the talking while catalogue entries and remarks are kept to a minimum; inscriptions and stamps are carefully noted.

Peter May is a visionary collector who has embraced living with architecture as art in the most personal and exemplary way by sheltering within works of architectural expression that are also containers for the full range of by-products of the design process. This book is both a record of a single-minded yet open-minded way of life and a crash-course in architectural history as taught and practiced on four continents over three hundred years. It also honors the memory of Steve Andrews, who first introduced May to Sir John Soane's Museum and helped support his architectural habit over nearly thirty years.

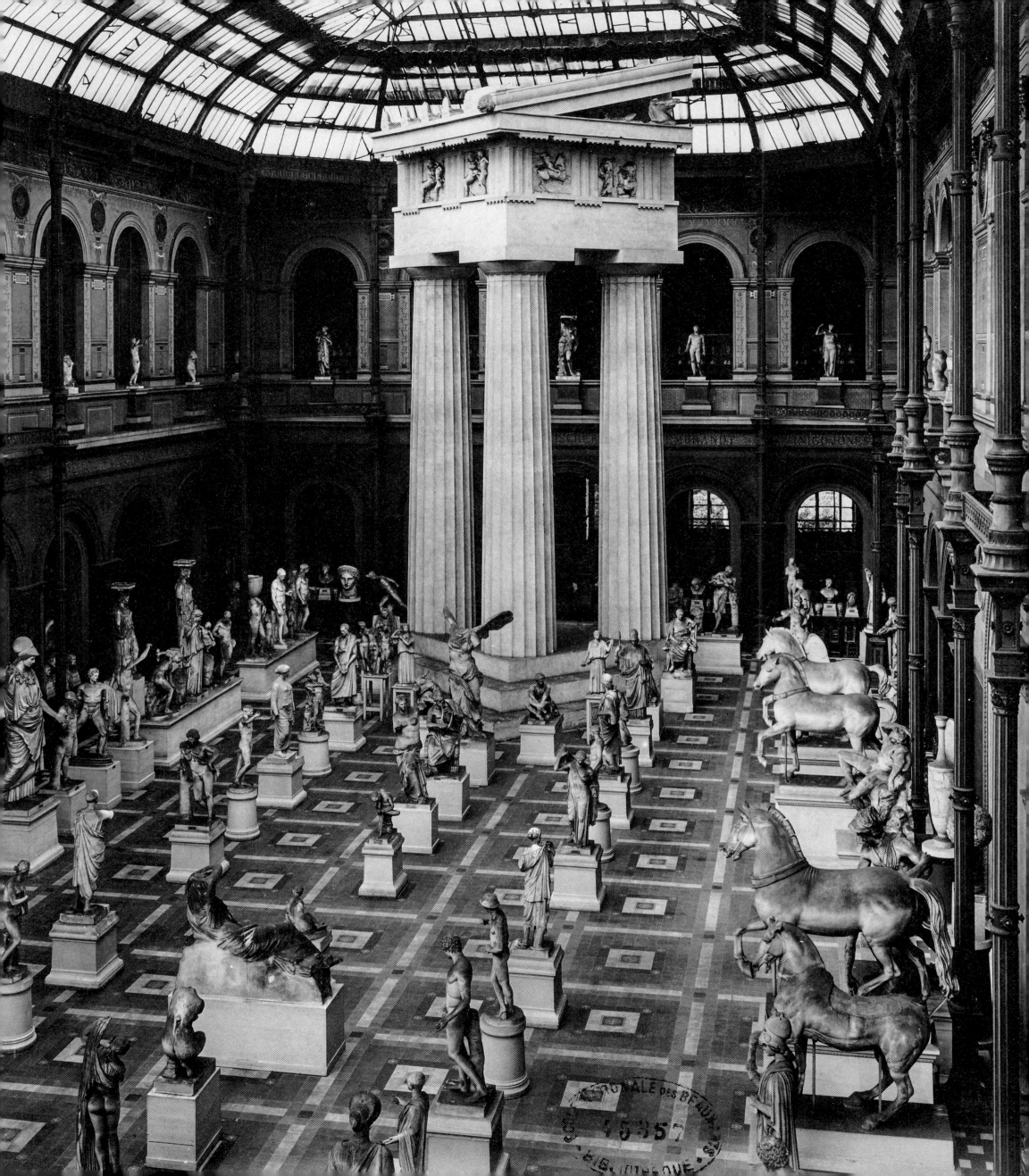

THE BEAUX-ARTS TRADITION

"Everything that is made or studied is competition, the student does not make a pencil stroke which is not the result of a competition"[1]

BASILE BAUDEZ AND MAUREEN CASSIDY-GEIGER

THE MAJORITY OF THE FRENCH ARCHITECTURAL drawings in the Peter May collection are in the classical Beaux-Arts style that flourished in France for nearly three hundred years, from the establishment of the Académie Royale d'Architecture in Paris in 1671 until the mid-twentieth century.[2] The architecture school merged with the Académie des Beaux-Arts in 1816, known from 1865 as the École des Beaux-Arts and from 1968 to the present day as the École nationale supérieure des Beaux-Arts (ENSBA). An emblem of the state, the French system was modeled after the famous renaissance art schools of Florence and Rome, the Accademia del Disegno founded by Cosimo I de' Medici in 1563 and the Accademia di San Luca opened in 1577, which were enlightened alternatives to the old-fashioned guild system.[3] The École was initially located in the Palais du Louvre and moved to its present site in Saint-Germain-des-Prés in 1816, with an entrance at 14 rue Bonaparte and a campus that runs along Quai Malaquais (fig. 3). The main building was designed by Félix Duban (1798–1870) as an architectural model, backdrop and showroom for fragments from the defunct Musée des Monuments Français as well as a large teaching collection of plaster casts and building models (fig. 2). The renaissance portico of the ruined Château de Gaillon dominated the forecourt until 1977, when it was restored to its original position in Normandy (fig. 4).

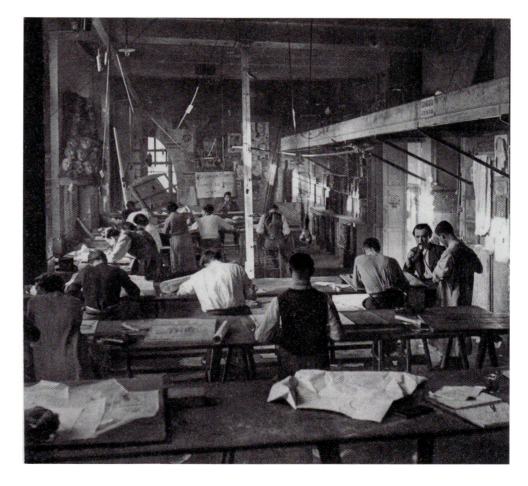

FIG. 1
Central courtyard of the École des Beaux-Arts with plaster casts and architectural models, 1937

FIG. 2
Architecture Atelier, École des Beaux-Arts, 1937

FIG. 3
École nationale supérieure des Beaux-Arts, Paris

FIG. 4
Achille-Laurent Proy, View of the portal of the Chateau de Gaillon installed in the courtyard of the École des Beaux-Arts, 1890 (May Collection, 1990.221; cat. 2.11)

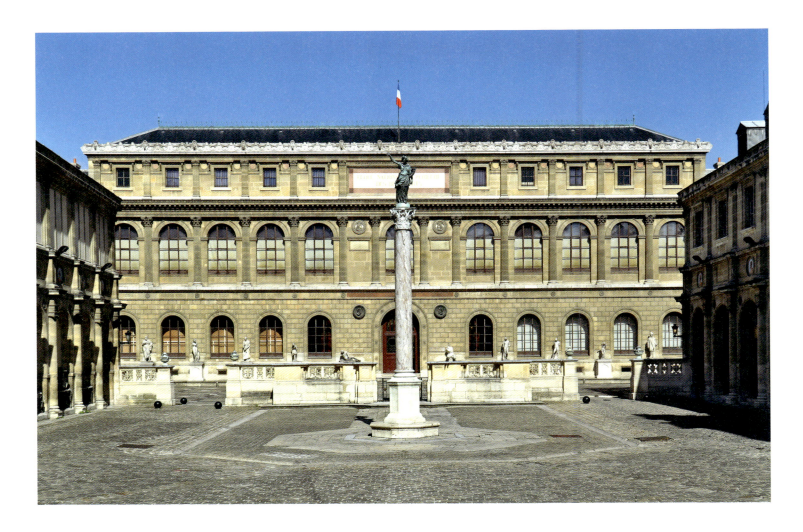

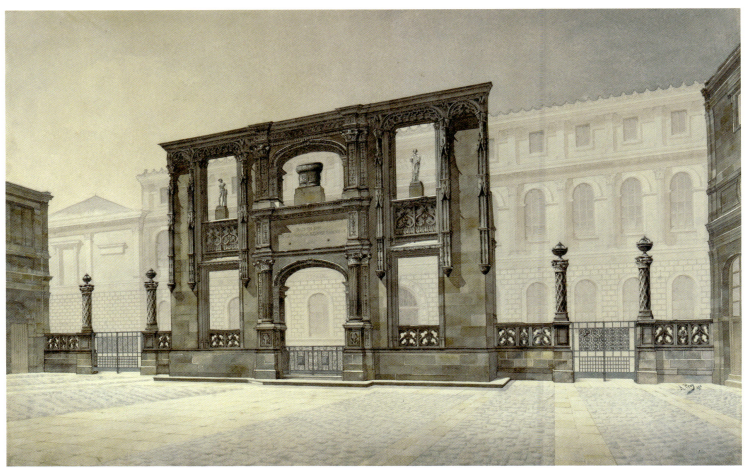

FIG. 5
Bernard Tabuteau, Competition drawing for a train station (detail), 1913 (May Collection, 1987.8; cat. 5.3)

Beaux-Arts draughtsmanship is characterized by its lack of perspectival geometry. Thus, a building is rendered in orthogonal lines and any sense of volume is supplied by the strategic use of shadows. Sometimes broad gestural washes of color were added to the sheet, to situate a building in its imagined topography or urban environment, transforming the otherwise flat orthographic designs into grand architectural paintings. The staffage might even extend to the inclusion of animating human figures, vehicles and animals, as in Bernard Tabuteau's (1892–1977) design for a railroad station, which was enlivened by a cast of colorful characters including a man rushing with his heavy luggage and a dachshund, a couple trying to persuade a donkey to pull their overloaded cart, a photographer plying his trade and a fancy blue sports car (fig. 5).

Admission to the school was by recommendation of a sponsor until 1823, when entrance exams were introduced. Students attended lectures on mathematics, architectural theory, and construction in the academy building, studied and sketched the fragments and plaster casts and had access to the library. Practical architectural skills, however, were acquired outside the school in private *ateliers*, run by leading practitioners, many with affiliations to the Academy. Gabriel Pierre Martin Dumont (1721–1791), for example, would teach paying students the principles of geometry and arithmetic, the correct use and drawing of the five classical orders, perspective drawing and even such basic skills as working with inks, washes and watercolors. The more advanced students would then practice selected simple types of architecture, perhaps also copying drawings like the design (fig. 6) for a fountain by Dumont, which incorporates traditional elements borrowed from ancient and renaissance models and the architecture of the *ancien régime*. *Atelier* training prepared the *logistes*, as they were known, for the regular drawing competitions, the *concours*, held at the Academy, by which students would advance at their own pace from the second or lower class to the first or upper class by accruing *valeurs* (points) awarded by a blind jury. The ultimate goal was to win enough points to qualify for the prestigious Prix de Rome, which provided the prizewinner with a scholarship to the French Academy in Rome for three to five years. This rigid system of education, consisting of

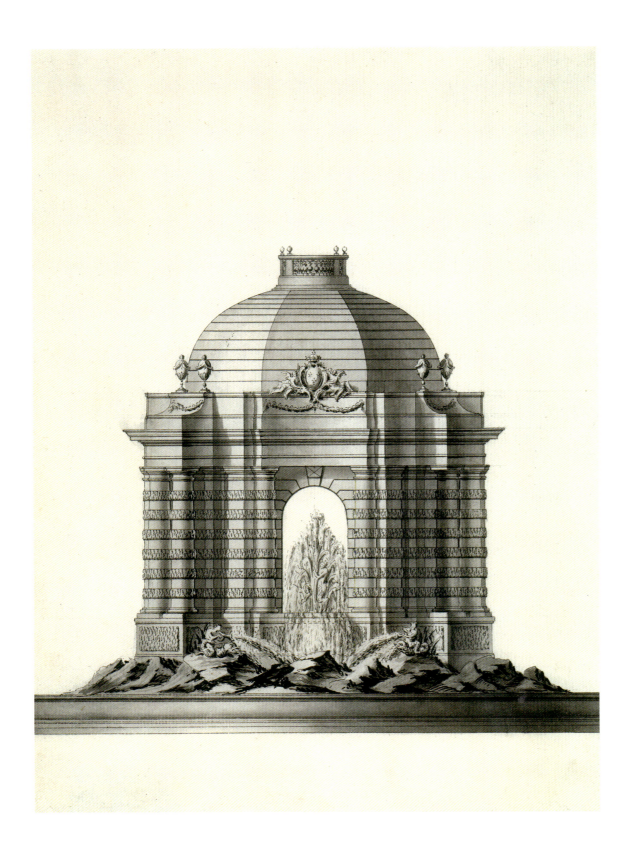

FIG. 6
Gabriel Pierre Martin Dumont,
Elevation for a Fountain, 1743 (May
Collection, 2000.478a; cat. 12.10)

atelier training and drawing competitions, with some supplementary lectures and coursework, formed the essence of architectural training in France until the 1960s. Students did not per se graduate from the École until 1867, when diplomas were finally introduced, and in 1943 the title of architect was approved by law. Nevertheless, the institution prepared students to enter the professional world and ensured those who had secured the Prix de Rome, or at least the *diplôme*, a successful career.

Two grandiose drawings by Georges Pradelle (1865–1934) in the May Collection exemplify Beaux-Arts draftsmanship and training (fig. 7). In 1890, after five years at the École des Beaux-Arts in the *atelier* of Julien Guadet, twenty-five-year-old Pradelle was one of the eight contenders for the Prix de Rome. That year, the professional jury overseeing the competition chose a 'Monument in honor of Joan of Arc' as the assignment. Jules Lenepveu (1819–1898), former Director of the French Academy in Rome, had just finished his cycle of paintings for the Panthéon in Paris on the life of the famous fourteenth-century martyr who would soon become the symbol of French patriotism following the disastrous conclusion of the Franco-Prussian War (1870–71). The student project was assigned in the form of a printed pamphlet which laid out the rules and formal instructions for the competition, including a short introduction, the building's requirements, dimensions, and site, and the number and scale of the drawings required. In this instance, four large-format drawings were required: a plan, elevation, cross-section, and longitudinal section. When the competition was judged, Emmanuel Pontremoli (1865–1956) was awarded first prize, while second and third went to Louis Varcollier (1864–1948; figs. 8 and 9) and Louis Sortais (1860–1911) and Pradelle took fourth place. As was customary, the drawings were exhibited to the public for three days before judging and Pontremoli's winning designs remained with the École des Beaux-Arts while Pradelle's were retained by the architect and at some point sold.[4]

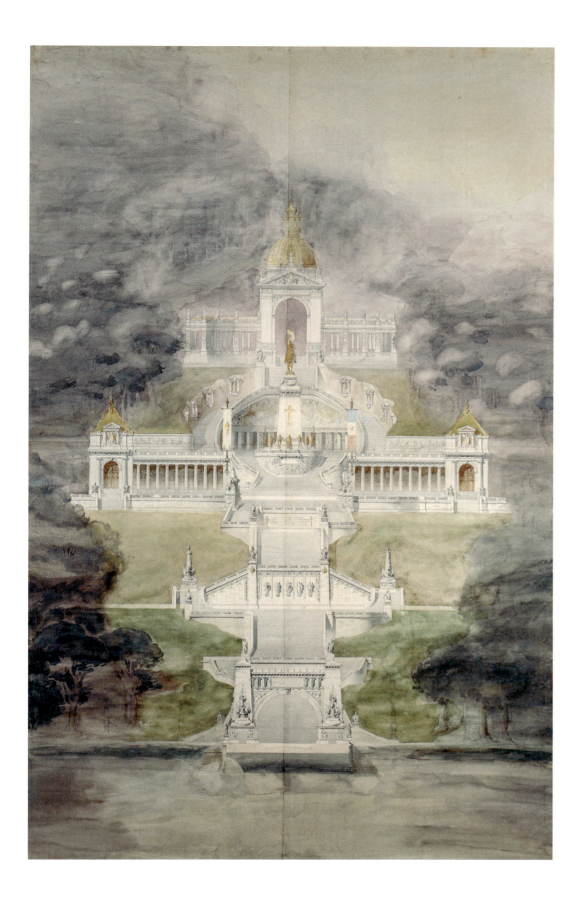

FIG. 7
Amet Georges Alexandre Pradelle, Prix de Rome competition drawing showing the elevation of a monument to Joan of Arc, 1890 (May Collection, 1987.61b; cat. 12.34)

FIG. 8
Louis Charles Marie Varcollier, Prix de Rome competition drawings showing a plan of a monument to Joan of Arc, 1890 (ENSBA, PRA-312-1)

FIG. 9
Louis Charles Marie Varcollier, Prix de Rome competition drawings showing a cross-section of a monument to Joan of Arc, 1890 (ENSBA, PRA-312-3)

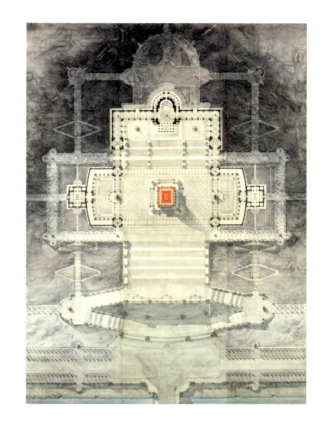

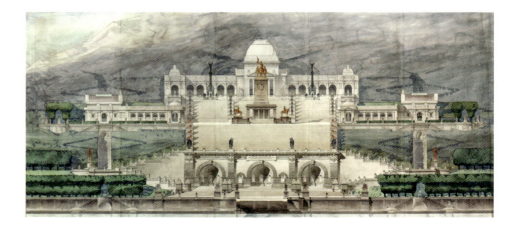

THE BEAUX-ARTS TRADITION 23

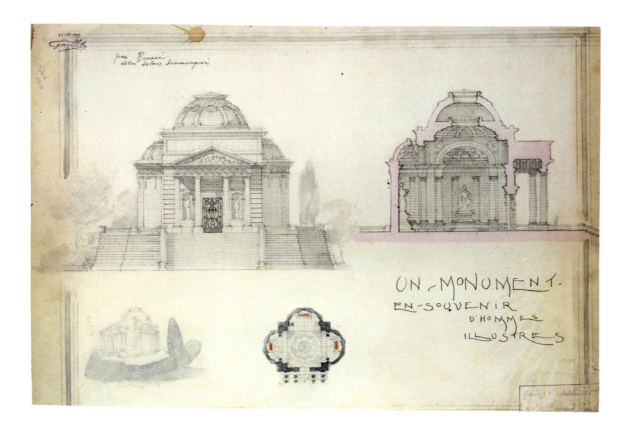

THE ATELIERS

FIG. 10
Jean Béraud, Competition drawings for admission to the École des Beaux Arts: elevations, cross-sections, plans, and perspective for a pantheon, 1903 (May Collection 1989.236d; cat. 12.33)

FIG. 11
Jean Béraud, Competition drawing for the roof of a campanile: elevation and plan (detail), ca. 1903 (May Collection 1989.237 verso; cat. 12.32)

FIG. 12
Photograph of the students in the atelier of Victor Laloux, 1890–91

FIG. 13
Jehan Valentin, Frontal elevation for the Hotel Gallia in Cannes (detail), ca. 1900 (May Collection 1990.305; cat. 6.2)

The *ateliers* were an eighteenth-century phenomenon that flourished in Paris as the profession gained legitimacy, and they quickly became integral to the existence of an architecture program at the École. They might prepare a student for admission or, more typically, for the *concours*. The *patron*, as the head of the workshop was known, would come into the *atelier* two or three times a week to tutor the *logistes* and critique their drawings. Jean Béraud (1882–1954) was enrolled in the *atelier* of Victor Laloux (1850–1937; fig. 12) and was jointly taught by Laloux's assistant and successor Charles Lemaresquier (1870–1972), so he inscribed both names on the small-scale projects prepared in 1903 for admission to the École (fig. 10 and 11). According to an eyewitness, when Laroux critiqued the *logistes*, he was followed from table to table, "giving his judgement to each student in turn. Having made the rounds, he would bow, put on his silk hat and quietly leave the room, but no sooner was the door shut than pandemonium would break loose and a noisy discussion of what he had said would ensue."[5]

Exceptionally, on Béraud's drawing of a roof topped by a bell-tower, we find Laloux's handwritten comments in red pencil, for example, "*ombre mauvaise*" (poorly rendered shadow) and "*ces cartouches ne s'adaptent pas*" (these cartouches don't work), when it was more customary for the patron to deliver such feedback verbally or on tracing paper (fig. 11). Accordingly, the drawing was given a "1c" for tenth place.

Some young men bypassed the *ateliers* by working for an architectural firm for wages. It was probably in the office of Jules Stoecklin (1837–1919) and his son Henri (1872–1957) that the young Jean Valentin (1884–1965) drew the facade of their famous Hôtel Gallia in Cannes, in the South of France (fig. 13). The Stoecklins established themselves in this resort city of the Côte d'Azur in 1877, and rebuilt the Casino des Fleurs in 1888. In 1900 they were commissioned to design the Gallia, which served an international clientele. Before entering the Stoecklin office, Jean Valentin most likely learned the basics of architectural drawing from his father, André-Jules Valentin (b. 1845–after 1906), a

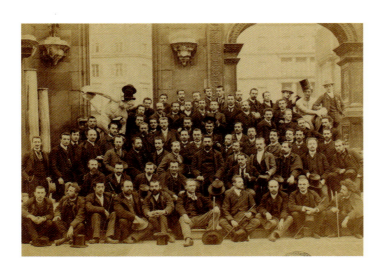

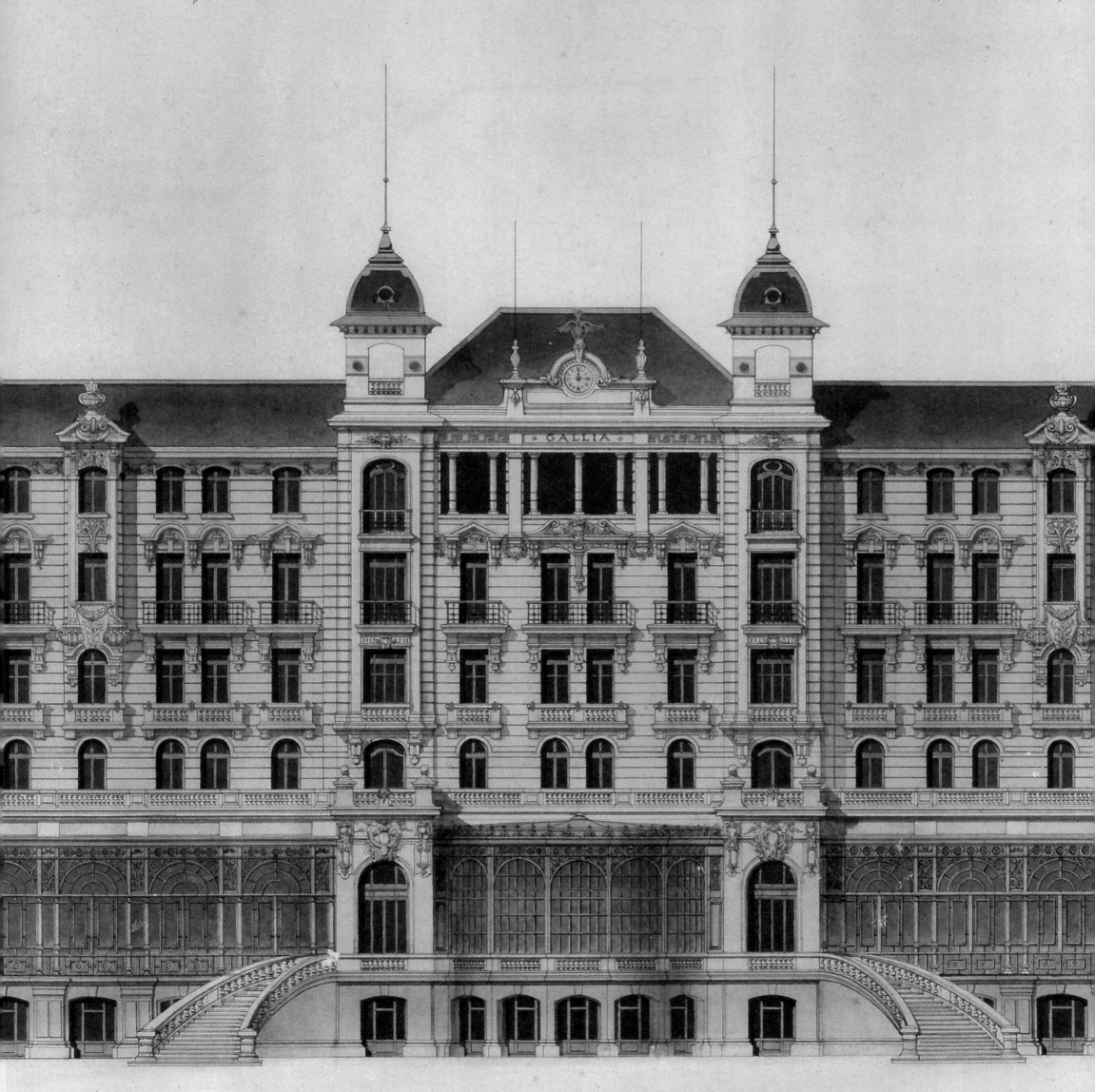

FIG. 14
Jean Marcel Carteron, Competition drawing for a postage stamp commemorating the Beaux-Arts Exposition, 1930 (May Collection 1990.282; cat. 2.14)

FIG. 15
Architect unknown, Competition drawing for a postage stamp commemorating a Beaux-Arts Exposition, early 20th century (May Collection, 1991.324; cat. 2.13)

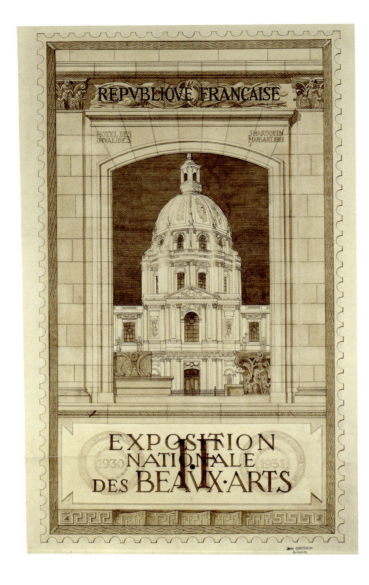

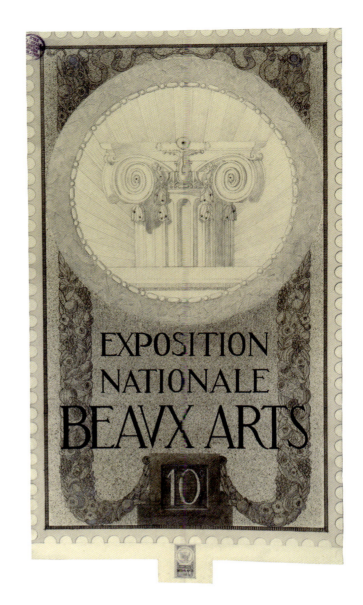

successful provincial practitioner who made his entire career in Avignon.⁶ It is possible the young Valentin found in the Stoeklin father-and-son team an echo of his own family practice, leading him to sign his drawing of the hotel "Jehan Valentin" plus "Jehan Valentin fils," 'Jehan' a rendering of 'Jean' in Old French. Valentin later enrolled in the national architectural school in Marseilles, one of a handful of regional schools established by the government under the authority of the École des Beaux-Arts of Paris, which judged all regional competitions. Among the offshoots were schools in Rouen, Rennes, Lille and Lyon.

THE CONCOURS AND THE PRIX DE ROME

Students at the Academy progressed from the second level to the first level, and from the first level to the Prix de Rome competition, by winning points in the *concours*. Twelve-hour *concours d'essai* or *esquisse* (sketching competitions) alternated with more challenging multi-week *concours rendus* (rendering projects); at least two *concours* were required of the students annually. The subjects of the assignments were determined by an academic committee and many were repeated over time or new building types emerged. Some assignments even moved beyond the realm of architecture, extending to poster and stamp designs (figs. 14 and 15). Notations added later in pencil, ink, or crayon might give the name of the author, *atelier*, date and award; some drawings are also stamped with the seal of the school (see figs. 16–17). *Valeurs* were accrued for winning a first- or second-place *mention* (award). In 1819, six *valeurs* were required to advance from the second to the first level; by the end of the century, twenty-one points were needed.

The *concours d'esquisse* comprised an elevation, cross-section and one or more plans for a small

building composed on a single sheet of paper in pencil, ink and watercolor. The garden kiosk designed in September 1846 by second-level student Louis-Alfred Perrot (1828–1870) is an example of this type yet shows him struggling as much with his pencil and as with his paintbrush (fig. 16). Just a few years later, Perrot had made spectacular progress in drawing and painting, as demonstrated by his designs for a morgue of 1848 and for a hospital of 1851 (cat. 3.17, and see fig. 17). Arched compositions came into vogue as the century progressed and monochrome drawings in grey or sepia wash supplanted the use of watercolors, as in the designs for "Un Campanile ou Tour pour les cloches" (Bell-tower or clock-tower) dated March 2, 1881, which received a second-place *mention* (fig. 18). The handwritten assignment for the first level project specified:

This tower, which would be the complement of a parochial church of the first order, would be independent and placed either in front of the church, or behind it, or to the side, like the campanile of Santa Maria dei Fiori in Florence.

It will include, in its lower part, a room for the ropes for small bells, and one or more sets of stairs. In its upper part, there will be one or two floors for big and small bells. One or more clock dials will be placed on the facades.

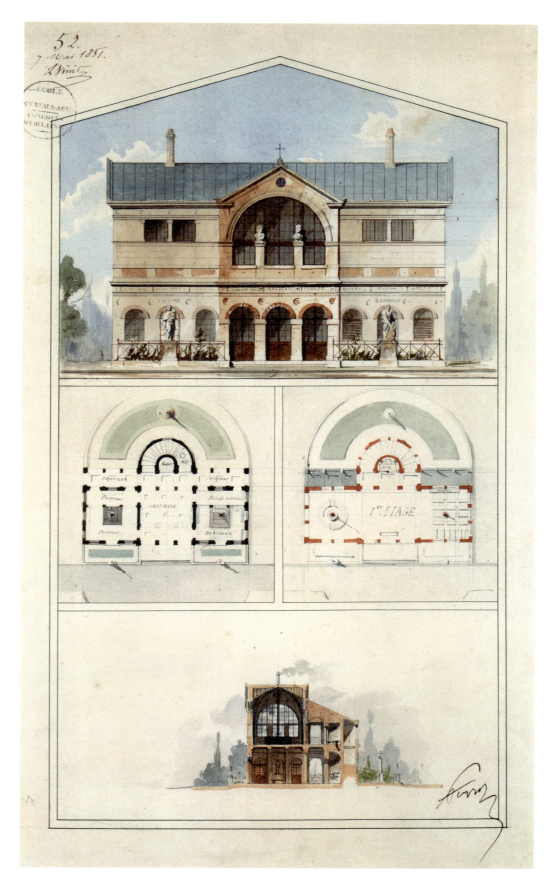

FIG. 16
Louis-Alfred Perrot, Competition drawing for a garden folly: elevation, plan, and cross-section, 1846 (May Collection, 1987.23g; cat. 13.24)

FIG. 17
Louis-Alfred Perrot, Frontal elevation, two plans, and cross-section of a hospital, 1848–51 (May Collection; 2000.429; cat. 3.17)

THE BEAUX-ARTS TRADITION 27

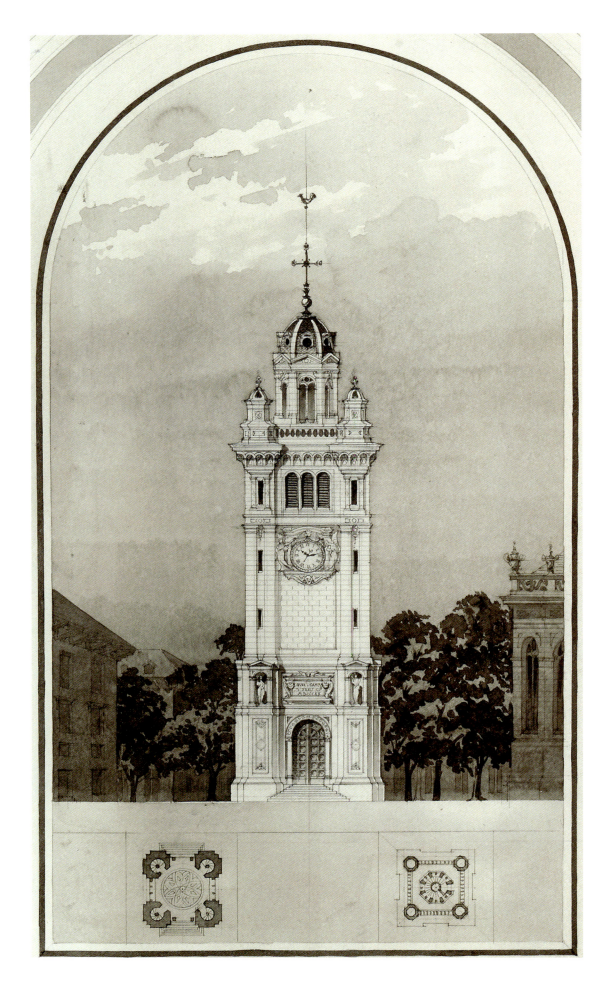

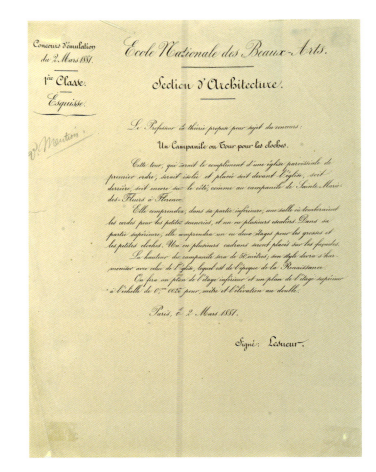

FIG. 18
J. Vegund [?], Competition drawing for a bell tower: elevation, and two plans, 1881 (May Collection, 1990.300; cat. 12.30)

FIG. 19
Printed assignment for the *Concours d'émulation* of 2 March 1881 (May Collection)

The height of the campanile will be 50 meters; its style should be in harmony with that of the church, which is from the Renaissance period.

The plan of the lower floor and the plan of the upper floor should be executed to the scale of 0.0025 to 1 meter and the elevation double that.

Paris, 2 March 1881

Lesueur.[7] (fig. 19)

Drawings that did not meet the formal requirements were rejected. Apart from the traditional *concours*, students were also tested in mathematics and perspective drawing.

The field for the annual Prix de Rome competition was reduced from thirty *aspirants* to eight on the basis of a twelve-hour *concours d'esquisse*. The eight winners were then assigned a two-part *concours rendus*. First, the *logiste* executed a preliminary rendering of the assigned subject in strict privacy, *en loge* (in their room). Next, he prepared an elevation, cross-section, plan, and alternate view of his initial design on large pieces of paper of an assigned dimension and scale. Between 1701 and 1966, the Prix de Rome subjects ranged from palaces, cathedrals, hospitals, spas, and schools to triumphal arches, theaters, hotels, government and commercial buildings, and museums. Students were allowed several weeks for the *rendus*, working at first *en loge* and later in the *atelier*, where they received advice from the patron

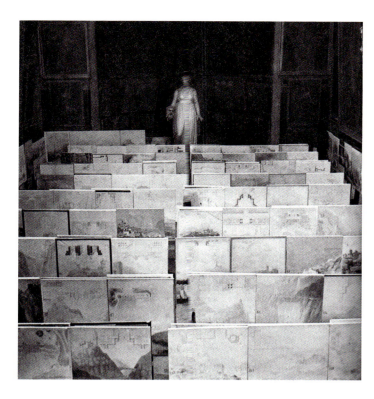

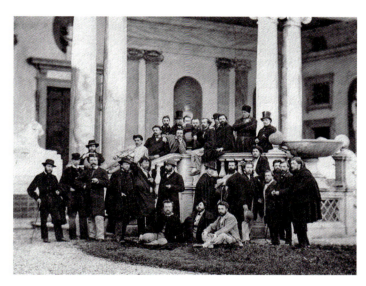

FIG. 20
Photograph of the temporary exhibition of drawings in the Salle de Melpomène in the École, ca. 1920–30

FIG. 21
Early 20th-century photograph of Prix de Rome winners outside the Villa Medici, home to the French Academy in Rome from 1803 to the present day

FIG. 22
Émile Camut, Elevation detail of the Caesar spring in the antechamber with the (now lost) fresco by Hector d'Espouy in the Mont-Dore spa, Auvergne, France, ca. 1887 (May Collection 1997.403a; cat. 6.6)

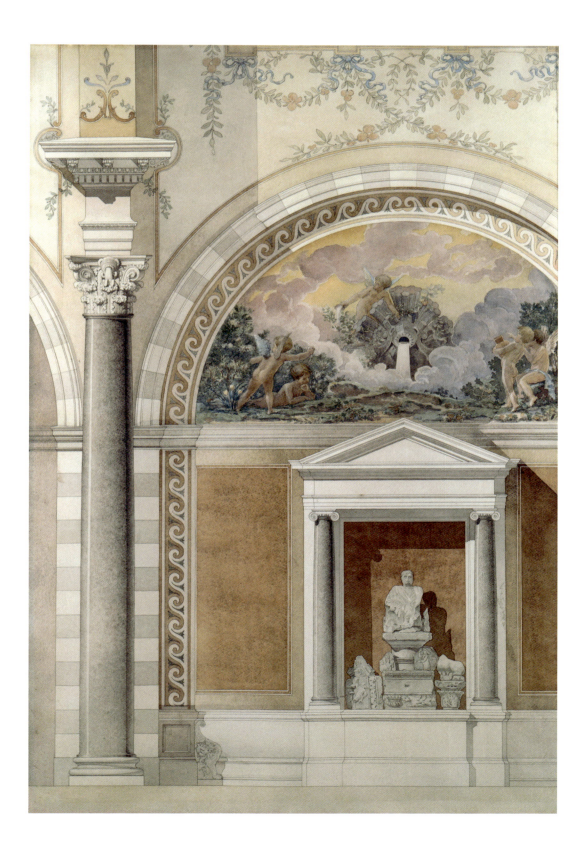

and assistance from the other students. Sometimes a more gifted associate would be enlisted to apply the shadows or watercolor while younger students would prepare the canvas and paper on to which the large sheets of paper were glued for display. Some designs were edged with hand-drawn borders or metallic tape. For transparency in the judging of the submissions, none of the drawings were signed; rather they were assigned a letter before being exhibited in the Salle de Melpomène in the École (fig. 20). The public and press had access to the exhibition for three days before the jury met to deliberate. The winner was entitled to a three- to five-year fellowship at the French Academy in Rome, where he would study antique ruins and the architectural creations of the Eternal City and beyond (fig. 21).

In the nineteenth century, further cash prizes were introduced, such as the Rougevin, Godeboeuf, Chaudesaignes and Duc prizes, the last won by Émile

THE BEAUX-ARTS TRADITION

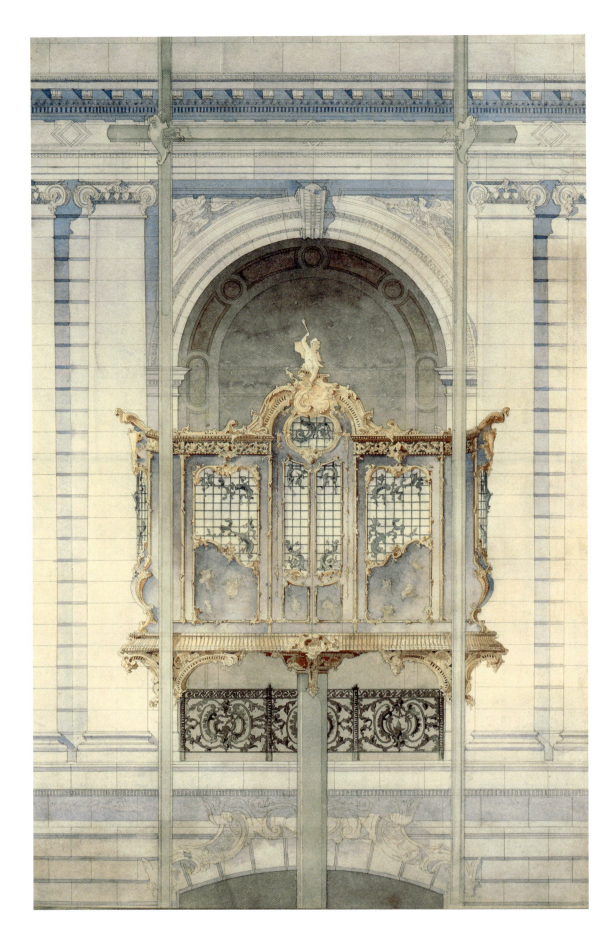

FIG. 23
Unknown (French), Godeboeuf
competition drawing for an elevator
cabin: elevation, 1890 (May Collection,
1990.280; cat. 9.53)

Camut (1849–1905) in 1893 for his striking designs (fig. 22) for the Mont-Dore spa in the Auvergne region of France. Some of these competitions involved the study of a particular element of decoration or construction, for example a retardataire Chambre d'Apparat (state bedroom) (fig. 24). The 1890 Godeboeuf competition was for an elegant yet modern hydraulic elevator cabin in the rococo-revival taste (fig. 23):

> *Metal decoration of the cabin of an elevator. Assumed to be in a rich traveler's hotel, a large elevator connects the floors in a glassed courtyard serving as a central hall. The cabin is visible throughout its route and must be elegantly decorated. On a frame of iron and wood there is fine relief in copper; it is therefore in the use of metal thus worked that the ingenuity of the elements and artistry will be observed. The metal can be gilded, silvered and even enamelled in some parts. Conditions to observe: the distance between the vertical runners will be exactly three meters. There will be no ceiling; the walls will nowhere be less than 2 meters high and may include openwork, without, however, any possibility of reaching hands through. There will be a door with two small panels. The maneuvering conditions of this elevator allow moreover animated silhouettes. Elevators have so far been treated only from a utilitarian point of view; there is no doubt, however, that there is here an occasion for designing an elegant and graceful composition and an attractive program*

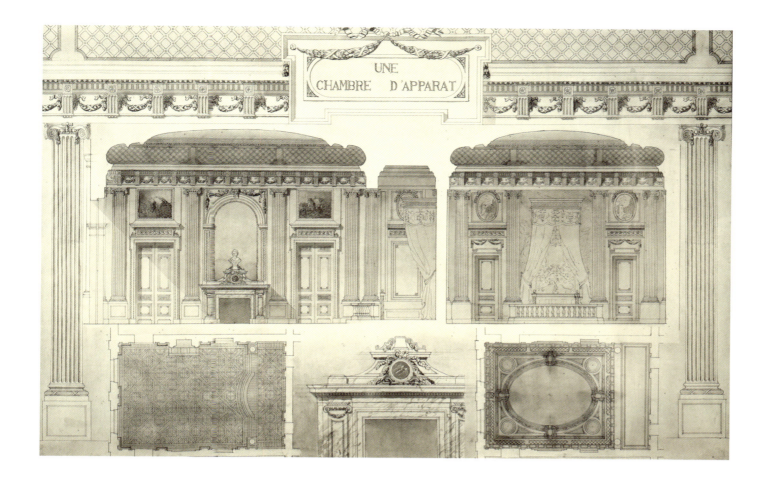

FIG. 24
Unknown (French), Competition composite drawing for a state bedroom: elevations, ceiling and flooring plans, profiles, late 19th century (May Collection, 1987.31; cat. 9.29)

FIG. 25
Architect unknown (French), Composite study of Abbey Sainte Geneviève, Paris, ca. 1900 (May Collection, 1987.30; cat. 8.73)

for artists. For the sketch the facade is required on the side of the door at 0.04 to 1 meter and the plan at 0.02 to 1 m. For the rendering, a plan to 0 05 to 1 m, the same facade to the tenth and a detail of one's choosing at the quarter of the execution. The sketches will be drawn in pen and ink, any sketch which does not conform will be struck from the competition."[8]

Analytical drawings were also assigned which required students to create an architectural still life composed of differently scaled fragments from local buildings. A masterful rendering of one of the dormers of the Abbey of Saint-Geneviève in Paris, for example, shows a full elevation in the upper left with a section on the left edge, a plan below and a lateral elevation on the right (fig. 25). These are flanked by large-scale drawings of the decorative elements: the railing, cartouche, vase, and volute. Further, the railing is shown in profile at the lower right and its shadow is projected on to the volute.

Construction drawings for masonry, carpentry, and cast ironwork, akin to structural drawings provided to builders, were assigned from the nineteenth century onwards, leading up to the annual general construction competition.[9] A set of highly detailed designs for the Banque de France competition in 1909 indicate the structure of the foundations and footings, basement and roof. Further, the building materials were color-coded: red and pink wash for the rubble

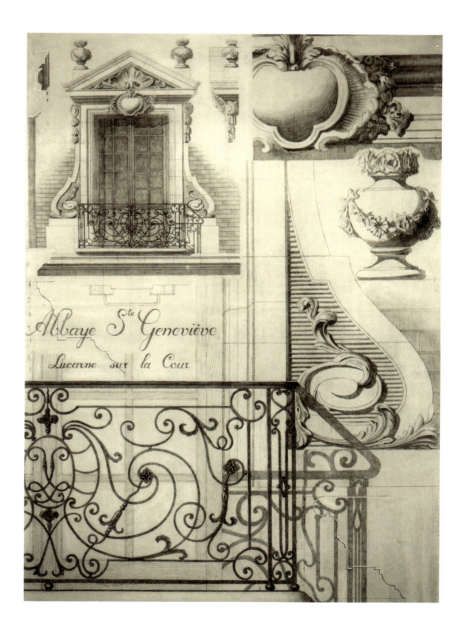

THE BEAUX-ARTS TRADITION 31

FIG. 26
Architect unknown (French),
Competition drawings for a French
national bank (May Collection
1987.33b; cat. 7.1)

FIG. 27
Architect unknown (French),
Competition drawings for
an hotel in Brittany, France: cross-
section, ca. 1900 (May Collection,
1988.103a; cat. 6.1)

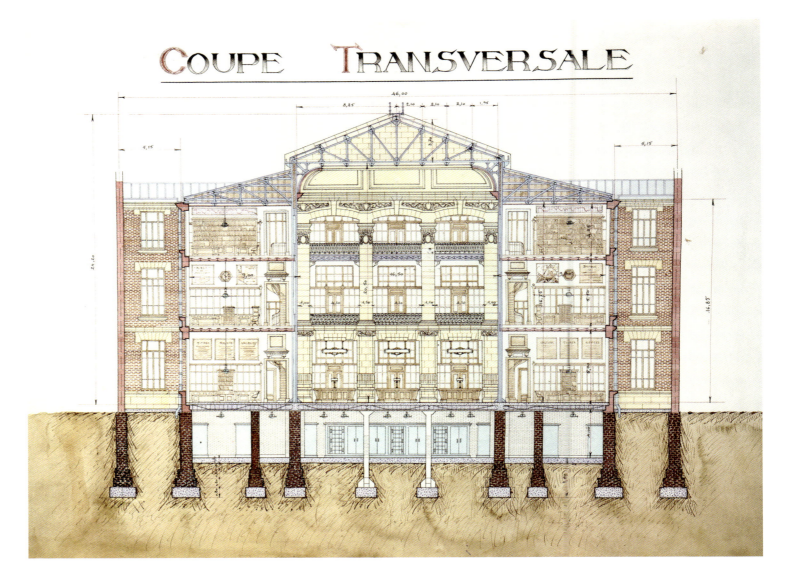

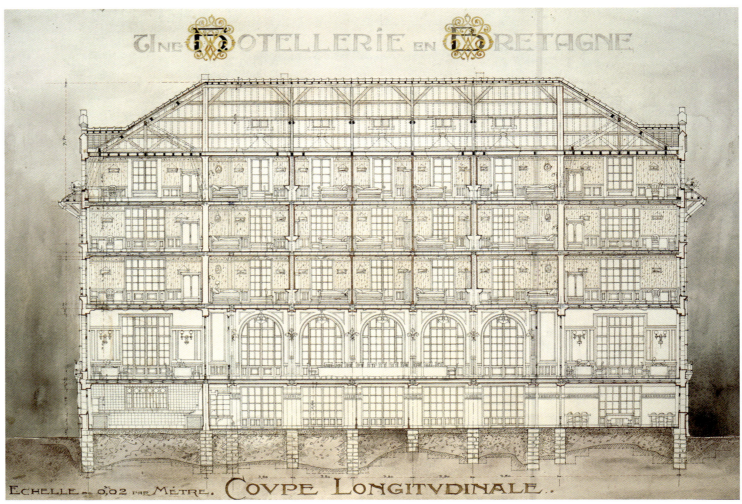

and brickwork, blue ink for the structural ironwork, black ink for the ornamental metalwork and brown wash for the woodwork (fig. 26). Furniture and lighting was indicated as well as the flooring and, on the plans, arrows indicate the direction of the stairs.

A pair of designs for a hotel even indicate the artwork, wallpaper and the mattresses and pillows on the beds (fig. 27). Construction drawings of great complexity were also assigned, such as the stonework ceiling assigned in 1901 and again in 1907 (fig. 28). Beyond titles and units of measure, texts characteristically were kept to a minimum and the inclusion of a legend was rare.

THE DIPLÔME

The *diplôme* was not instituted until 1867. Students with nine *valeurs* (points) and six *projets rendus* were eligible for this distinction upon completion of an oral exam and a drawing assignment for a realistic building project as opposed to the grandiose Prix de Rome programs. Hence, Jacques-Maurice Prévot (1874–1950) received his diploma for the country house he designed in 1900 (figs. 29–31). Prévot's early professional biography was typical of École students at the end of the century. Born in Bordeaux, he first trained with his father, an

FIG. 28
Architect unknown (French), Composite study for a stonework ceiling, ca. 1900 (May Collection, 1989.165; cat. 3.5)

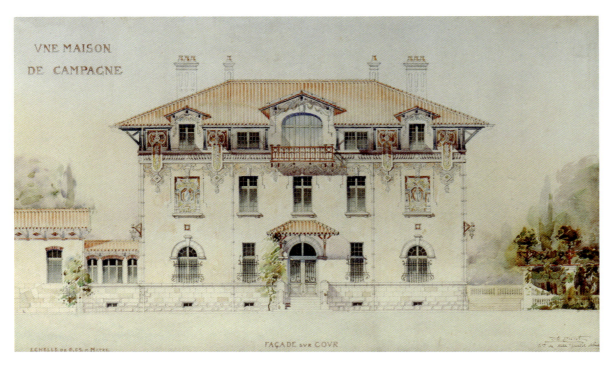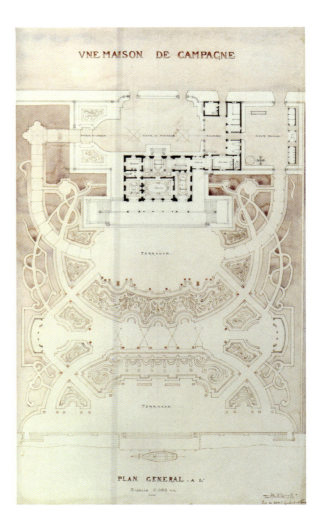

FIGS. 29–31
Jacques Maurice Prévot, Diploma drawings for a country house: main facade elevation, general plan, and transverse cross-section, 1900 (May Collection 1991.368a,d,e; cat. 10.1)

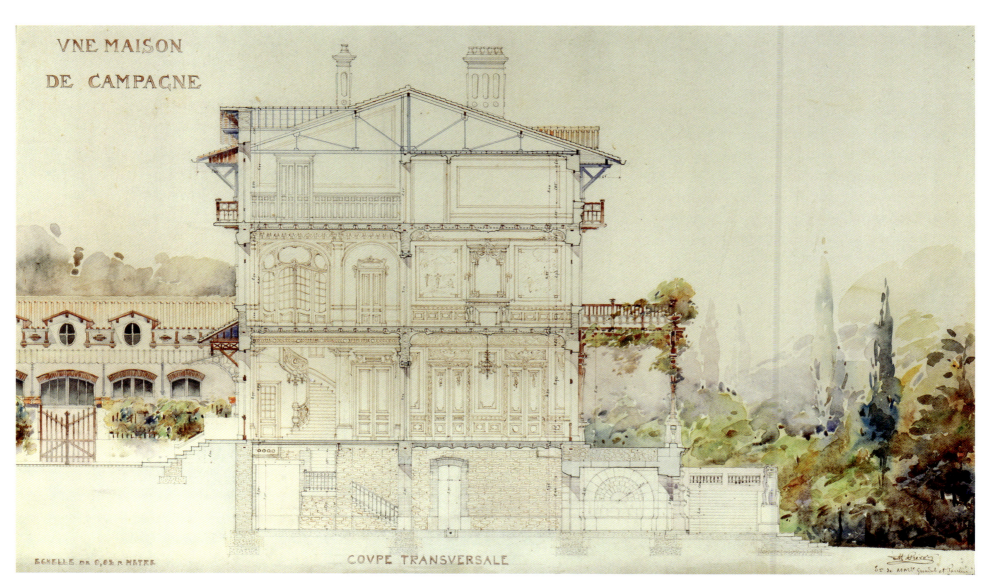

FIG. 32
Pierre Ferret, Diploma drawings for the panelling of a country house, 1900 (May Collection 1991.368n; cat. 10.1)

architect for the Compagnie des Chemins de fer du Sud de la France (Railway Company of the South), and uncle, a successful architect with a large private practice in Aquitaine. In May 1893, Prévot entered the *atelier* of Julien Guadet (1834–1908) and was admitted to the École three months later. In March 1897 he advanced from the entry level to the first and received his diploma on June 22, 1900 with the country house project. Prévot's *diplôme* drawings include elevations of the front facade (fig. 29), of the garden facade and of one of the sides; an estate plan with the grounds (fig. 30); plans of the basement, ground floor, the second and third floor; transversal and lateral sections (fig. 31); the assignment also included plans of the carpentry work with details of the beams, joist system, and flooring with construction details. When the Prévot drawings were acquired by Peter May they were found to include others for the masonry and joinery of a country house by Jean Hébrard (1878–1960) and Pierre Ferret (1877–1949), who received his diploma in the same year with the same country house program. These orphaned sheets nevertheless can be seen to represent lost sheets by Prévot for his project (fig. 32).

Prévot tried unsuccessfully to win the Prix de Rome before being hired by Cornell University in 1905. As the *Annual Report of the President of Cornell University* for 1905 states:

Monsieur Prévot arrived in September from Paris, where he had made a brilliant career at the École des Beaux Arts, to assume the duties of the professorship of design, for which he had been recommended by the ever helpful friend and former Director of the College, Professor Alexander Buel Trowbridge. At his coming, Professor Prévot knew little English, but his talent as an artist, his skill as a teacher, and the charm of his personal and social characteristics soon won for him the hearts and minds of the students and rendered him a universally welcome member of the University community.[10]

Trowbridge (1868-1950), who graduated from Cornell in architecture in 1890, had been at the École des Beaux-Arts in 1893-95, where he befriended Prévot. The reputation of the École was sufficient to hire the Frenchman despite his lack of English. Prévot stayed at Cornell for four years before moving to New York, where he practiced in the office of McKim, Meade and White and on his own before returning to France probably after the First World War.

THE BEAUX-ARTS TRADITION 35

FIG. 33
Gabriel Auguste Ancelet, *Envois de Rome* assignment [?]: restoration drawing of ruins in the Roman Forum, 1853 (May Collection 1990.276a; cat. 11.12)

FIG. 34
Émile Jacques Gilbert, Wall painting from Pompeii from an album, 1824 (May Collection 1990.333c; cat. 11.11)

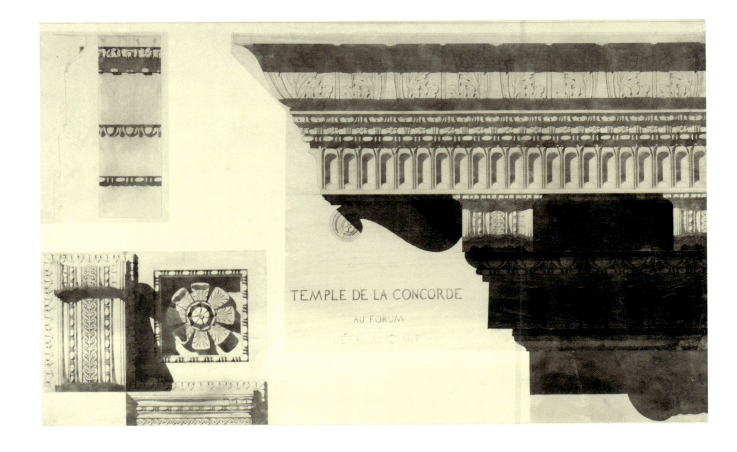

ENVOIS DE ROME

Envois de Rome were drawings sent to Paris annually by Prix de Rome winners to demonstrate their evolving knowledge and understanding of ancient architecture abroad. Auguste Ancelet (1829–1895), for example, sent studies of the Temple of Concordia and of Jupiter Stator in the Roman Forum to the Academy in 1853 during his second year in Rome (fig. 33). By the fourth year, *pensionnaires* were asked for drawings of an ancient monument of their choice, surveyed and drawn in person, in its present condition together with a reconstruction drawing accomplished through careful study of the history of the building.[11] The remarkable frescoes excavated at Pompeii and Herculaneum evidently fascinated the *pensionnaires*, who rendered them in watercolor and gouache as if restored.[12] Five sheets from an album by Émile-Jacques Gilbert (1793–1874) in the May Collection include a study of a wall painting in the House of Pansa at Pompeii (fig. 34). Students also took advantage of their time in Italy to study other types of architecture beyond Rome. Alphonse Defrasse (1860–1939), for example went, to Venice in 1891 and made beautiful renderings of local landmarks. A small watercolor of the celebrated facade of the Ca d'Oro was the basis for a large-scale restoration drawing exhibited at the Salon of 1900, for which he received a gold medal

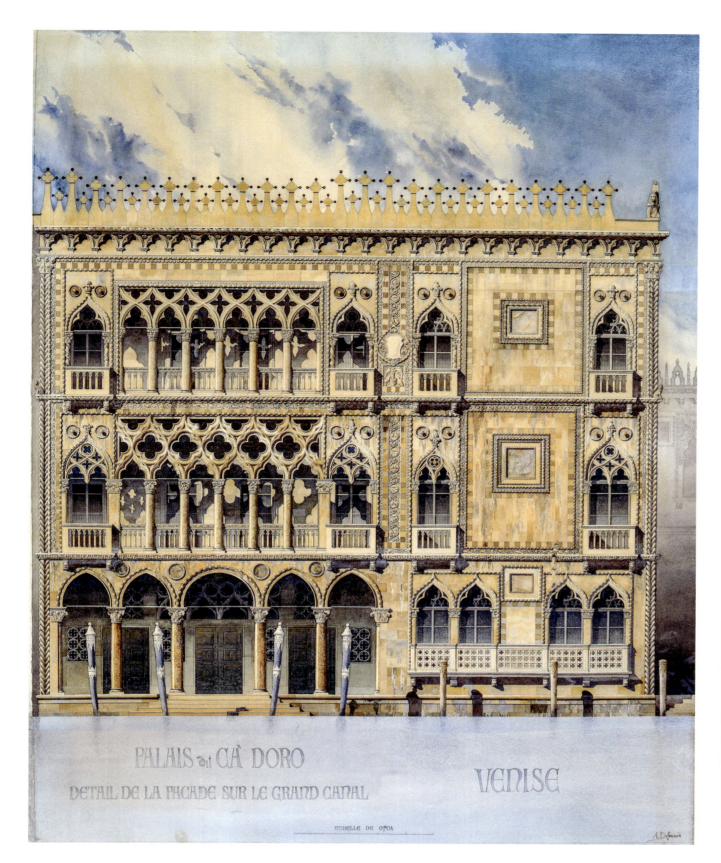

FIGS. 35, 36
Alphonse-Alexandre Defrasse,
Canal façade of the Ca' d'Oro, Venice,
finished painting and preparatory
sketch, ca. 1900 (May Collection
1990.291a,b; cat. 8.1)

(figs. 35 and 36). Though the École retained some of the *envois* for their archives, a resource which survives and is accessible today to students and researchers, students generally kept most of their foreign studies, and sometimes exhibited them at the Salon in Paris upon their return.

SPOTLIGHT ON PROSPER BOBIN

Prosper Étienne Bobin (1844–1923) was born in a small village in the north of France into a family of building contractors. He learned the basics of draftsmanship and mathematics from his father, who sent him to Paris, where he continued his studies in the private practice of Jules Saulnier (1817–1881) while also attending lectures by Alexis Paccard (1813–1867), Léon Vaudoyer (1803–1872) and Ernest Coquart (1831–1902). Bobin does not seem to have been officially integrated into an *atelier*. On November 1862, he was admitted to the École and accumulated a total of nineteen *valeurs* in his first years, earning a medal in the 1864 construction competition. The next year he began competing unsuccessfully for the Prix de Rome, until 1874, when he turned thirty and became ineligible. Though his professional life might have progressed more swiftly had he won the Prix de Rome, Bobin's career was impressive. A government architect from 1875 to 1898, he was an inspector at the École des Ponts et Chaussées (School of Bridges and Roads), Cour de cassation (Appeals Court) and École des Beaux-Arts. In 1887 he became one of the chief architects at the Bâtiments Civils et Palais Nationaux and was later assigned to the ministry of Colonies. In 1893 the government awarded him the Légion d'Honneur. In 1902 he joined the Conseil des Bâtiments civils, the highest administrative council of architecture in the country, and was elected to the jury of the École. Remarkably, he was nearly sixty before he took the exams to earn his diploma in 1909.

Over the course of his professional life, Bobin regularly exhibited his designs at the Salon in order to gain commissions and to display his architectural innovations. Some of these were for unrealized projects. For example, in 1882, the year of a stock market crash in France, he exhibited designs for a *Palais de la Bourse Moderne* (modern stock exchange) at the Salon des Artistes Français in Paris (fig. 37). Loosely inspired by Alexandre Théodore Brongniart's (1739–1813) neoclassical Paris Bourse completed in 1826, in the plan Bobin drew the walls and columns in black *poché* and the pedestals of the statues in pink, as he had learned to do at the École. He also showed his submissions for the rebuilding of the Sorbonne at the same Salon, though the commission went to the young Henri-Paul Nénot (1853–1934), who won the Prix de Rome in 1877 (fig. 38). The competition to replace the two-hundred-year-old university complex on the Left Bank, excepting the 1635 church built for Cardinal Richelieu, was announced in 1880. Bobin was one of twenty-eight architects to respond with a solution that incorporated more of the original buildings than others yet his design did not even warrant a mention.

Doubtless disappointed, Bobin nevertheless had the consolation of being appointed the primary architect of the Compagnie des Chemins de fer du

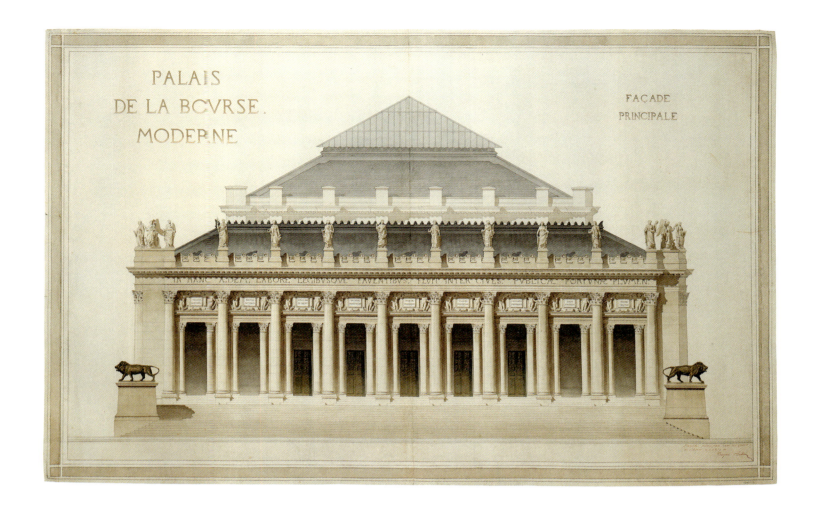

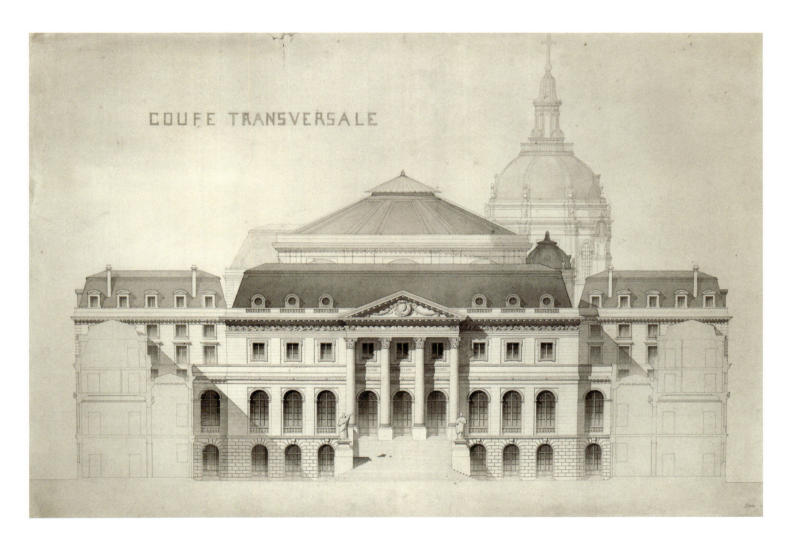

FIG. 37
Prosper Étienne Bobin, Elevation of the facade of a modern stock exchange for Paris, 1882 (May Collection 1988.100a; cat. 7.3)

FIG. 38
Prosper Étienne Bobin, Transverse section for the rebuilding of the Sorbonne, 1880 (May Collection 1988.101b; cat. 2.17)

THE BEAUX-ARTS TRADITION 39

FIG. 39
Prosper Étienne Bobin, Presentation plan for the Dijon tram station, 1892 (May Collection 1988.107a; cat. 5.2)

FIG. 40
Prosper Étienne Bobin, Presentation elevation for the Dijon tram station, 1892 (May Collection 1988.107b; cat. 5.2)

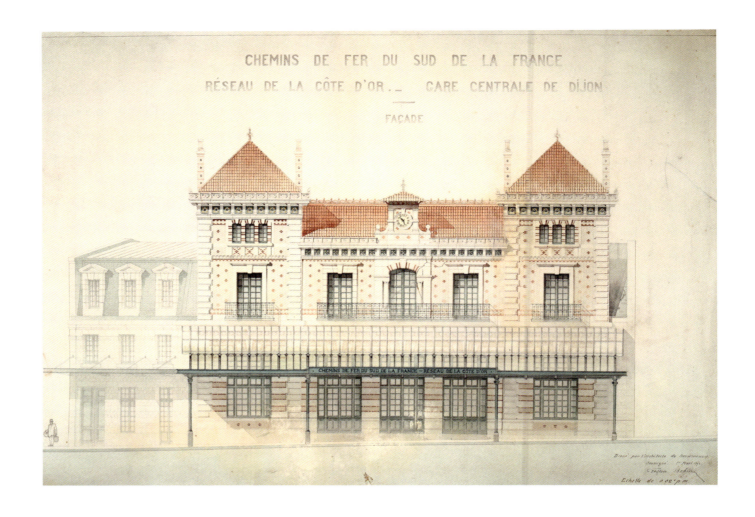

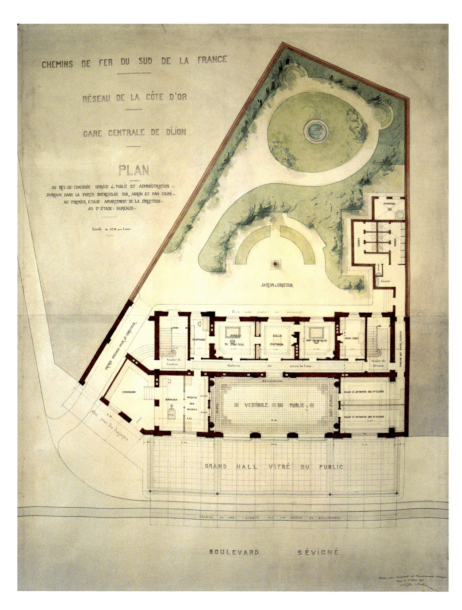

Sud de la France, for which he designed new railway stations for Dijon in Burgundy and for Nice on the Côte d'Azur in Provence. The station for Dijon was relatively small as it was for a local tramway network, which operated from 1895 until 1961 (figs. 39 and 40). Unlike a train station, it had no platforms but the plan indicates ticket counters, waiting rooms and administrative offices, as well as an apartment for the director of the network on the second floor. A deep glass awning provided shelter for passengers moving between the station and the tram. The main facade is in the local vernacular style, in yellow and red bricks and stones, with a frieze of enameled tiles that runs under the roof cornice, as was the fashion in the 1890s. The station for Nice, completed in 1892, was much larger, with two passenger platforms, one for departures and one for arrivals (fig. 41). Travelers entered through the main facade, modeled like a triumphal arch and reminiscent of the central part of the Gare du Nord in Paris designed by Jacob-Ignaz Hittorff (1792–1867) and completed in 1865. Beyond the spacious vestibule were a ticket counter, waiting rooms, luggage rooms and other service areas. Once more, Bobin clad the exterior of his station with brickwork and glazed tiles. The glass shed over the railway lines was designed by Gustave Eiffel for the Paris Exposition Universelle of 1889 and relocated to the station in 1891. A hundred years later, in 1991, the station was abandoned and slated

40 PETER MAY COLLECTION I

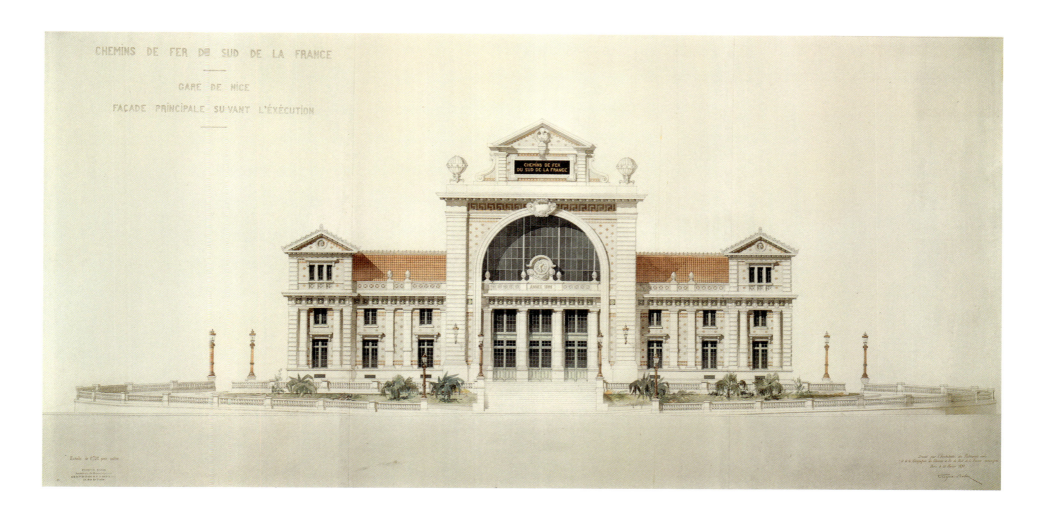

for demolition before being landmarked, restored and reopened as a cultural and public space in 2014.

At the end of his career, just before the First World War, Bobin was commissioned to design the armorial pedestal for a monument to Cardinal Richelieu, prime minister to Louis XIII, for the model city of Touraine (fig. 42). Nearly three dozen sketches for this straightforward commission were acquired by Peter May in 1989 as part of a Bobin 'archive,' yet all show the pedestal topped by a sculpture which is not the one by Claude Ramey (1754–1838) that was lent by the French government for the finished memorial.

THE BEAUX-ARTS TRADITION BEYOND PARIS

The reputation of the École des Beaux-Arts extended well beyond the boundaries of France and Europe and, by the late nineteenth century, architectural students from countries that lacked a tradition of formalized training were making their way to Paris.[13] Richard Morris Hunt (1827–1895) was the first American to be admitted to the École, in 1846, and thereafter until the First World War American students comprised ten to twenty per cent of incoming students.[14] Also, the first architectural departments in the United States modeled their curricula on that of the École, with a competition-

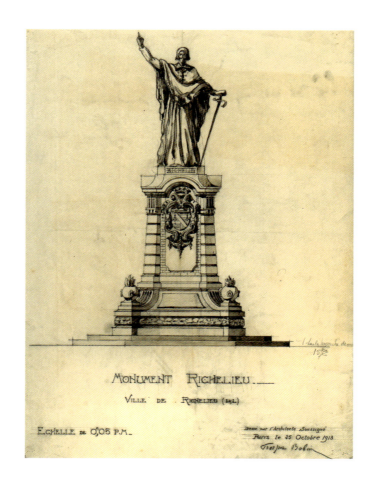

FIG. 41
Prosper Étienne Bobin, Presentation elevation for the Nice railroad station, 1892–93 (May Collection 1988.104c; cat. 5.04)

FIG. 42
Prosper Étienne Bobin, Pedestal for a monument to Cardinal Richelieu, 1914 (May Collection 1989.197; cat. 12.38)

THE BEAUX-ARTS TRADITION 41

FIG. 43
Leon Keach, Study of a Doric column from the Parthenon, ca. 1915–16 (May Collection, 1996.401f; cat. 11.13)

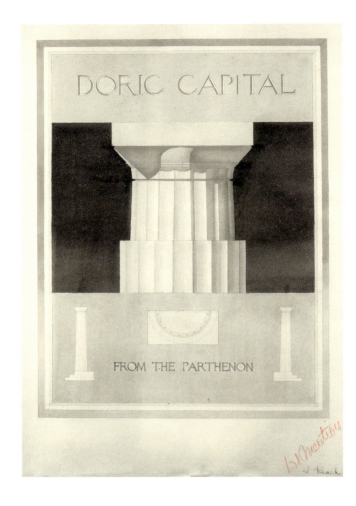

based pedagogy, the two-step design process of the *esquisse* and the *rendu*, and the implementation of the style and drawing conventions of the Paris school. The earliest design program was established at the Massachusetts Institute of Technology in 1868 by William Robert Ware (1832–1915), who had been trained by Hunt.[15] Students in MIT's department of architecture followed a curriculum defined by Prix de Rome winner Constant-Désiré Despradelles (1862–1912), who would teach there from 1893 until his death. Bostonian Leon Keach (1893–1991) entered the program in 1913 and advanced quickly, winning awards for drawings that were then published in the volumes of the *Technology Architectural Record*.[16] In 1918 he won the silver medal for a prize from the Société des Architectes Diplômés par le Gouvernement Français, the professional society of École architects founded in 1877.[17] Ten Keach drawings in the May Collection aptly represent the classicizing tendencies and artistic conventions of the École tradition as taught and practiced in America. First he learned to render simple elements like classical orders, mastering shadows and washes, and receiving a first mention for his "Doric Capital from the Parthenon" (fig. 43). Next came a series of analytical studies for small buildings, such as a sketch for a Club House dated November 10, 1915, which presented an elevation, floor plans, and a longitudinal cross-section all on one sheet of paper with muted staffage and the dark *poché* indicating loadbearing walls (cat. 1.37). In 1916, when a restaurant was the assigned building type, Keach drew inspiration from the Villa Medici in Rome, home to the French Academy, mimicking its iconic garden facade (fig. 44).

The Beaux-Arts program served not only as an educational model but also as a compelling architectural style for burgeoning cities around the world. This is evinced by Camille Gardelle's (1866–1947) sophisticated designs for clients in Montevideo, the capital of Uruguay. Gardelle was the son of the city architect of Montauban, in the south of France, and entered the École in 1887, aiming without success for the Prix de Rome in 1894. After working for private clients in and around Paris, he decided to emigrate to Montevideo in 1910. There, he worked principally for the industrialist Francisco Piria (1847–1933), for whom he designed the Palacio Piria, home today to the Uruguayan Supreme Court (fig. 45).[18] Gardelle's training is especially visible in the virtuosity of his subtle use of washes for the glass window-panels, the mastery of the projected shadows on the facade, and the *soufflé* (blown) background, a painting technique in vogue at the École at the turn of the century. We find the same skill in Gardelle's measured drawing for the Palacio A. Heber Jackson dated March 15, 1918 (fig. 46). Now known as the Palacio Brazil, the building was both a theater, El Teatro Zabala (named after Bruno Mauricio

de Zabala, founder of the city), and an apartment building. It was commissioned by Arturo Heber Jackson (1861–1942), one of the richest landowners in the country. Even in a measured drawing like this one, Gardelle is artful in the way he arranges the profiles of the facade on either side of the elevation to accentuate the verticality of the design.

It was the mastery and efficiency of this exquisite form of draftsmanship, acquired during the years of incessant design competitions at the École, that enabled Gardelle to make a successful career in Montevideo. More than just a style of architecture or a set of conventions—the reliance on classical examples, monumentality achieved through clear lines and symmetry, and the profusion of ornaments—the legacy of the Beaux-Arts lies in the proficiency of its students, who could conceive an extremely clear and enticing rendering of any architectural project in two dimensions. That is what makes these drawings so appealing to us in general, and to Peter May in particular.

FIG. 44
Leon Keach, Competition drawing for a dining hall: frontal elevation, plan, and cross-section, 1916 (May Collection 1996.401g; cat. 2.27)

THE BEAUX-ARTS TRADITION

FIG. 45
Camille Gardelle, Frontal elevation of the Francisco Piria residence, 1916 (May Collection 1988.125; cat. 8.83)

FIG. 46
Camille Gardelle, Frontal elevation of the A. Heber Jackson residence, 1918 (May Collection 1988.124, cat. 8.83)

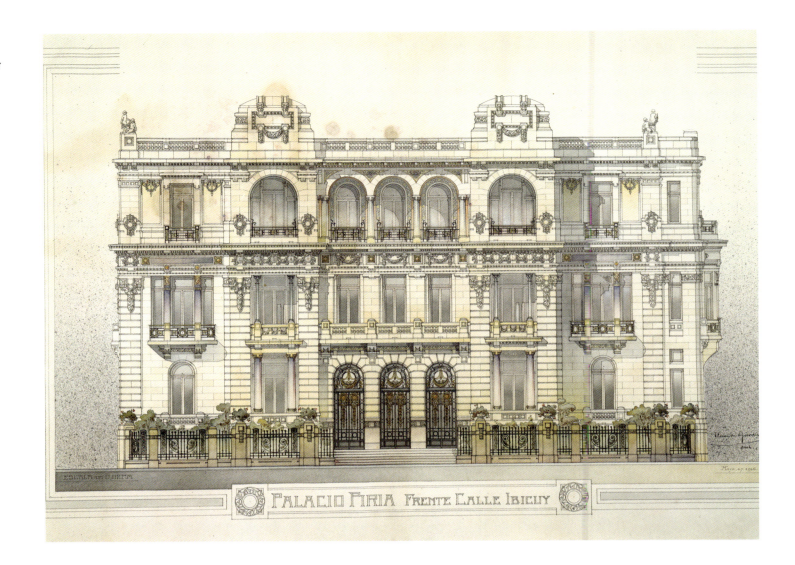

NOTES

1 "*Tout ce qui se fait et s'étudie est concours, l'élève ne donne pas un coup de crayon qui ne soit œuvre de concours*": Julien Guadet, "Les jurys de l'École des beaux-arts et les professeurs." *L'Architecte* (1906), p. 39.

2 Many academies of the arts, including dance, music and literature, and of history and science, as well as the French Academy in Rome, were founded under Louis XIV and continue to the present day.

3 See Nikolaus Pevsner, *Academies of Art. Past and Present* [1941] (Cambridge, 2014).

4 Pontremoli designs ENSBA (École Nationale supérieure des Beaux-Arts de Paris), PRAe 310-1, 2, 3, 4.

5 Quoted in Arthur Drexler (ed.), *The Architecture of the École des Beaux Arts* (New York, 1977), p. 94, footnote 143.

6 'André Jules Valentin,' in *Répertoire des architectes diocésains*, ed. Jean-Michel Leniaud (Paris, 2003), online publication: http://elec.enc.sorbonne.fr/architectes/486?q=Valentin (accessed April 22, 2018).

7 "*Cette tour, qui serait le complement d'une église paroissiale de premier ordre, serait isolée et placée soit devant l'église, soit derrière, soit encore sur le côté, comme au campanile de Sainte Marie-des-Fleurs à Florence.*

Elle comprendra, dans sa partie inférieure, une salle où tomberaient les cordes pour les petites sonneries, et un ou plusieurs escaliers. Dans sa partie supérieure, elle comprendra un ou deux étages pour les grosses et les petites cloches. Un ou plusieurs cadrans seront placés sur les façades.

La hauteur du campanile sera de 50 mètres; son style devra s'harmoniser avec celui de l'église, lequel est de l'époque de la Renaissance.

On fera un plan de l'étage inférieur et un plan de l'étage supérieur à l'échelle de 0.m0025 pour mètre et l'élévation au double.

Paris, le 2 Mars 1881.
Signé : Lesueur."

8 *Programme des concours Godeboeuf* (Paris: Bibliothèque nationale, 1901):
"*10. Décoration métallique de la cabine d'un ascenseur. On suppose dans un hôtel de riches voyageurs qu'un grand ascenseur relie les étages dans une cour vitrée servant de hall central. La cabine est visible dans tout son parcours et doit être élégament décorée. Sur une armature en fer et en bois, elle est revêtue de cuivre repoussé; c'est donc dans l'emploi du métal ainsi travaillé que doivent être cherchés les éléments de combinaisons ingénieuses et artistiques. Le métal pourra être doré, argenté, et même émaillé dans certaines parties. Conditions à observer : la distance dans œuvre entre les guidages sera exactement de 3 mètres. Il n'y aura pas de plafond; les parois n'auront nulle part moins de 2 mètres de haut et pourront comporter des parties ajourées, sans cependant qu'on puisse sortir les mains au dehors. Il y aura une porte à deux petits vantaux. Les conditions de manœuvre de cet ascenseur autorisent d'ailleurs des silhouettes mouvementées. Les ascenseurs n'ont été jusqu'ici traités qu'au point de vue utilitaire; il n'est pas douteux cependant qu'il n'y ait là un motif à composition élégante et gracieuse et un programme attrayant pour des artistes. On fera pour les esquisses, la façade sur le côté de la porte à CT04 pour mètre et le plan à 0 m,02. Pour le rendu, un plan à 0 m,05, la même façade au dixième et un détail au choix au quart de l'exécution. Les esquisses seront au trait à l'encre; toute esquisse négligée entraînera la mise hors du concours.*" Another submission, signed by Henri-Paul Hannotin, is found in Annie Jacques and Riichi Miyake, *Les Dessins d'Architecture de l'École des Beaux-Arts* (Paris, 1988), p. 91, no. 40.

9 Robin Middleton and Marie-Noelle Baudouin Matuscek, *Jean Rondelet, the Architect as Technician* (New Haven, 2007), p. 255.

10 *Annual Report of the President of Cornell University* (Ithaca NY, 1905), p. 57.

11 Joachim le Breton, *Institut de France. Notice sur les travaux de la classe des Beaux-Arts depuis le 1er octobre 1808 au 1er octobre 1809* (Paris, 1809), pp. 5–6.

12 See Cabinet des dessins Jean Bonna–Beaux-Arts de Paris, *Pompéi à travers le regard des artistes français du XIXe siècle* (Paris, 2016).

13 See especially James Philip M. Noffsinger, *The Influence of the École des Beaux Arts on the Architects of the United States* (Washington, 1955); David Brain, 'The École des Beaux-Arts and the Social Production of an American Architecture,' *Theory and Society*, 18.6 (November 1989), pp. 807–68; Joan Oakman, ed., *Architectural Schools. Three Centuries of Educating Architects in North America* (Cambridge, MA, 2012), and, for a broader context, Mary N. Woods, *From Craft to Profession: The Practice of Architecture in Nineteenth Century America* (Berkeley, 1999).

14 Marie-Laure Crosnier Leconte and Isabelle Gournay, 'American Architecture Students in Belle Époque Paris: Scholastic Strategies and Achievements at the École des Beaux-Arts,' *The Journal of the Gilded Age and Progressive Era*, 12.2 (April 2013), pp. 154–98; Jean Paul Carlhian and Margot M. Ellis, *Americans in Paris. Foundations of America's Architectural Gilded Age. Architecture Students at the École des Beaux-Arts, 1846–1946* (New York, 2014).

15 Paul R. Baker, *Richard Morris Hunt* (Cambridge, MA, 1980); Richard Chafee, 'Hunt in Paris,' in *The Architecture of Richard Morris Hunt*, ed. Susan R. Stein (Chicago, 1986), pp. 13–45; Michael Pause, *Teaching the Design Studio: A Case Study of MIT's Department of Architecture, 1865–1974*, PhD diss., MIT, 1976; John Andrew Chewning, *William Robert Ware and the Beginnings of Architectural Education in the United States, 1861–1881*, Ph.D. dissertation, MIT, 1986.

16 "Study of the Doric Order: an Entrance to an Embassy," 1915, *Technology Architectural Record* 8 (1915), p. 36, or "A Reception Suite for an Embassy" in 1917, for which he received a medal, for example, *Technology Architectural Record* 10 (1917), p. 19. See Course Catalogue of the Massachusetts Institute of Technology, years 1913–16.

17 *Reports of the President and Treasurer Massachusetts Institute of Technology: Office of the President*, January 1919), p. 54.

18 César J. Lousteau, *Influencia de Francia en la arquitectura de Uruguay* (Montevideo, 1995), pp. 81–90.

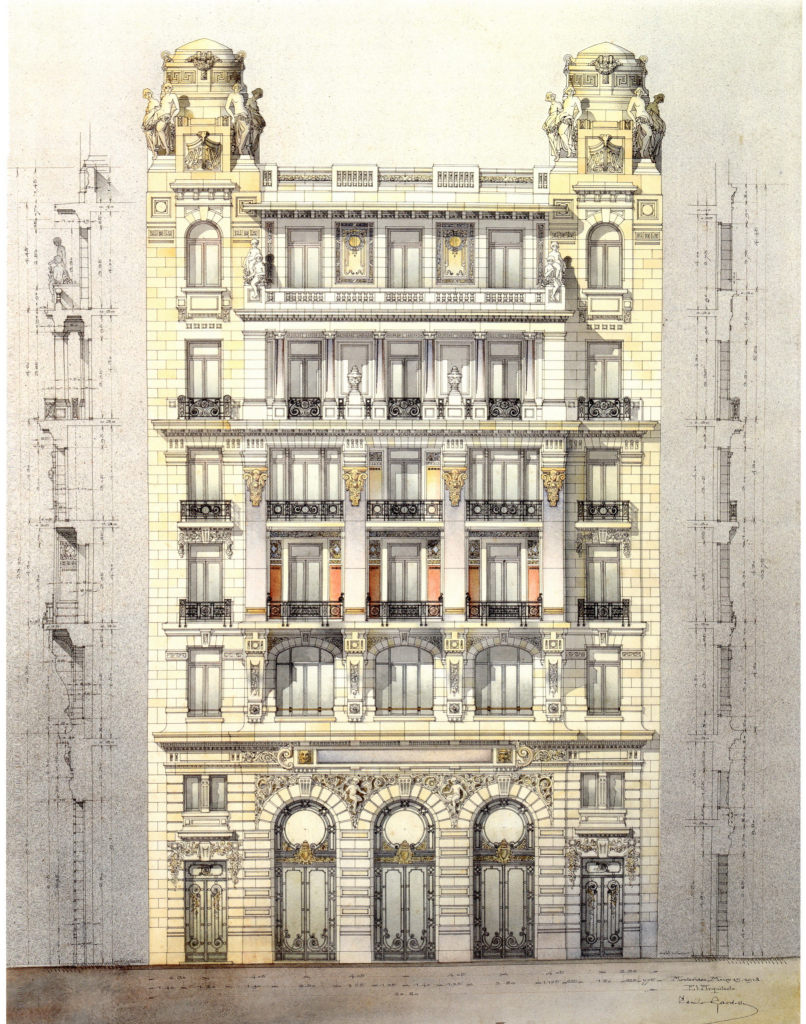

ARCHITECTURAL EDUCATION AND THE ART OF DRAWING IN BRITAIN

CHARLES HIND

BRITISH PRACTICES IN ANY DISCIPLINE ARE OFTEN pragmatic and relatively informal when compared with the norms on the Continent. Thus the education of architects in Britain from the seventeenth century onward was quite different from that established at the French Académie Royale d'Architecture, founded in 1671. Even if the Royal Academy of Arts established in London in 1768 was inspired by the Académie, the British iteration was never in effective control of the education of young designers, who, almost within living memory, were still being apprenticed to architects and learning their profession on the job. Indeed, it was only from the 1890s onwards that academic institutions in Britain gradually came to assume responsibility for the architectural training of students who, upon completion of a recognized course of study and competitive examinations, could call themselves 'architects.' Unique in European culture was the British tradition in the late Stuart and Georgian periods of the amateur or gentleman architect, as exemplified by Richard Boyle, 3rd Earl of Burlington (1694–1753), among others, who played a central role in the spread of Anglo-Palladianism in the 1720s and 1730s.

BEGINNINGS OF THE ARCHITECTURAL PROFESSION IN BRITAIN

One must be cautious about the early use of the term 'architect' in Britain, at least before the seventeenth century. In the Middle Ages and into the early Renaissance, responsibility for design as well as construction was in the hands of a master craftsman, typically the master mason or the master carpenter. One of the earliest representative drawings of this type of architecture is the design of ca. 1513 by William Vertue (d. 1527), the King's Master Mason, for Bishop Richard Fox's Chantry Chapel in Winchester Cathedral (fig. 2). By the early 1500s, a master could produce designs for others to build as well as for himself. Central to this concept was the King's Works or Office of Works, responsible for all royal building works and their maintenance. Favoured courtiers were able to employ the royal master craftsman in a private capacity for design work and he could also assemble the required construction crew. From 1547, the Office of the King's Works was headed by the Surveyor, a post that survived into the nineteenth century.

The talented designer Inigo Jones (1573–1652) was the first non-master craftsman to be appointed Surveyor (in 1615), a position he held until the Civil War caused court appointments effectively to lapse from 1643. Jones was freshly returned from a study tour of Palladio's work in the Veneto (1613–14) and, although he appears to have trained as a joiner, his position at court hitherto

FIG. 1
Charles William English for Arthur Thomas Bolton and Henry Stock of the firm Stock Page Stock, Perspective of the headquarters of the Hamburg Amerika Line, 16 Cockspur Street, London (detail), ca. 1907 (May Collection 1987.89; cat. 7.16)

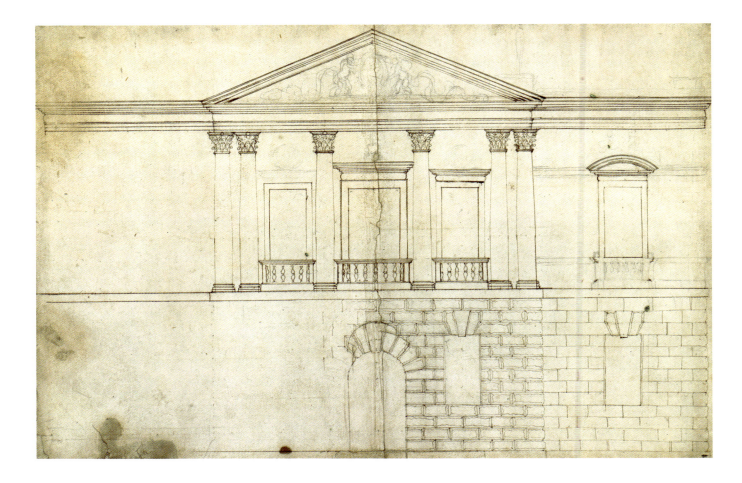

FIG. 2
William Vertue, design for a bay of Bishop Fox's Chantry Chapel, Winchester Cathedral, ca. 1513, pen and ink on vellum (RIBA Collections)

FIG. 3
Inigo Jones, preliminary design for the north front of the Queen's House, Greenwich, ca. 1616, pen and ink (RIBA Collections)

had been as a designer of masques and art adviser to the King and various courtiers. Although he must have been heavily dependent on his craftsmen colleagues for their knowledge of construction, he is generally regarded as England's first true architect. One of his earliest commissions as Surveyor was for the Queen's House at Greenwich, which stood as a manifesto for the Italian and more particularly Palladian traditions he brought home from Italy (fig. 3).[1] Jones even reinvented his drawing style to mimic that of Palladio's. Later prominent architects working for the British Crown included Sir Christopher Wren (1632–1723), William Kent (ca. 1685–1748), Sir William Chambers (1723–1796), James Wyatt (1746–1813) and Sir John Soane (1753–1837).

For nearly a century after the Civil War (1642–1648), amateur architects from the gentry classes with no connection to the building trades began and continued to flourish. It seems these men were largely self-taught as draughtsmen and, whatever their deficiencies in knowledge of construction, these must have been sorted out either by assistants or by the craftsmen whom they were directing. Sir Christopher Wren and Sir John Vanbrugh (1664–1726), for example, were of this dilettante type, and from the 1690s they often relied on Nicholas Hawksmoor (1661–1736), whose design contributions have consequently been obscured or overlooked until recently. Few drawings are known by many of the amateur architects despite their evident influence on seventeenth-century design. Sir Roger Pratt (1620–1685), for one, built four major houses, most notably the influential Clarendon House in Piccadilly, while Hugh May (1621–1684) largely rebuilt Windsor Castle.

For aspiring architects without private means in this period, the Office of Works provided the greatest number of salaried posts, either as surveyors or as clerks of the works. With such designers as Wren, William Talman (1650–1719) and Vanbrugh on its board, the latest ideas in architecture and interior design quite naturally filtered down the ranks, making the Office of Works until quite late in the eighteenth century a sort of unofficial substitute for the French Académie Royale d'Architecture in Paris. Lord Burlington, the amateur architect and leading promoter of Palladianism, used his influence at court to secure for his protégés important posts in the Office of Works, and thus ensured that through the Office he could control the style of public architecture as well as influencing private building. Burlington's designs (fig. 4) were typically drawn by Henry Flitcroft (1697–1769), who occupied increasingly important posts at the Office of Works from 1726 until his death over forty years later.

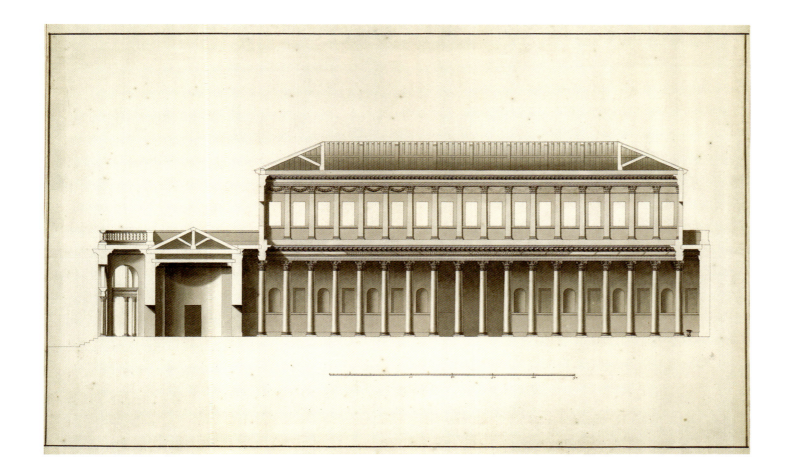

FIG. 4
Richard Boyle, Earl of Burlington, section design for the Assembly Rooms, York, ca. 1730, drawn by Henry Flitcroft, pen and ink (RIBA Collections)

FIG. 5
Sir John Soane and C. J. Richardson, Design for a small villa, ca. 1811 (May Collection 2003.524a recto; cat. 10.3)

TRAINING WITHIN ARCHITECTS' OFFICES IN BRITAIN

Although young architects were certainly being trained by their seniors, there was no recognized '*atelier*' system in place as in France until well into the eighteenth century. Sir Robert Taylor (1714–1788) appears to have been the first English architect to take pupils, and his example was soon followed by others. These young men were both students and assistants and the pay rates were low. Indeed, in their earliest years, when they lacked experience, their families actually paid for them to be employed. Training began at about age sixteen and lasted for five or six years,[2] by which time the pupil was expected to know the essentials of architectural draughtsmanship and professional practice. Skills included knowledge of the five classical orders of architecture and how to render the orders, elevations, plans and perspectives in pencil, ink and watercolor. Geometry, arithmetic, techniques of construction and the properties of stone, brick and wood were also taught. This training is well represented in a construction drawing prepared in Sir John Soane's Office for a small villa (fig. 5). With the establishment of the Royal Academy Schools in London in 1768, the apprentice might attend lectures in his spare time or even exhibit some examples of his designs in the annual exhibition, where exceptional drawings might win a gold or silver

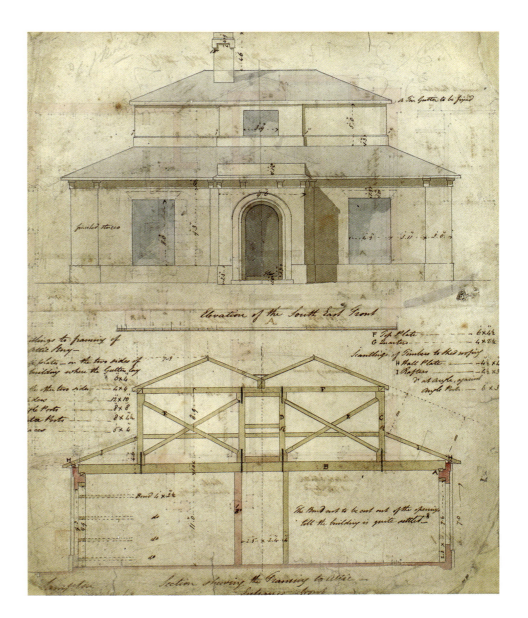

ARCHITECTURAL DRAWING IN BRITAIN 49

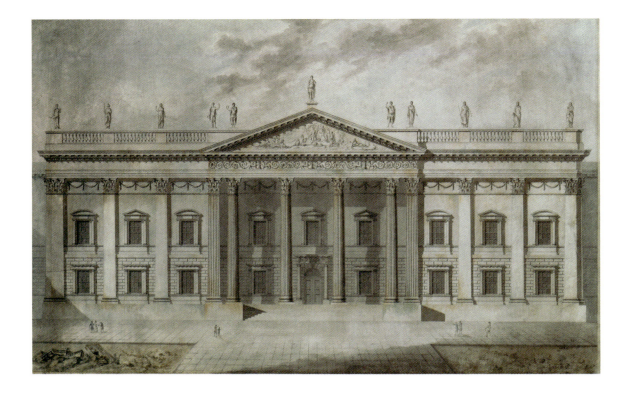

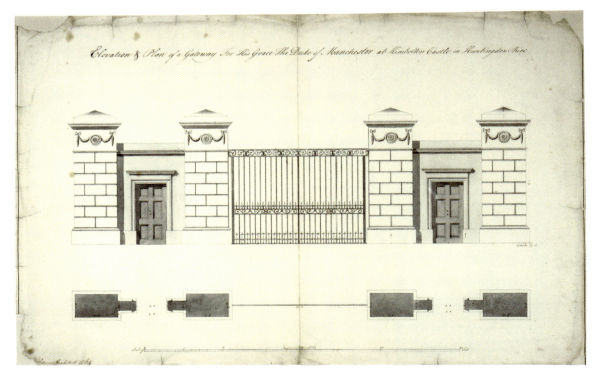

FIG. 6
Thomas Hardwick, Jr., Elevation for a University Senate House, ca. 1800 (May Collection 1999.416; cat. 2.10)

FIG. 7
Robert Adam, Presention drawing for a gate for the 4th Duke of Manchester for Kimbolton Castle, Huntingdonshire, UK, 1764 (May Collection 1988.110; cat. 8.47)

medal. This route is epitomized by Thomas Hardwick (1752–1829). The son of a master mason, he studied under Sir William Chambers in 1767 and two years later began attending the Academy Schools, where he won the first Silver Medal for Architecture that year. Hardwick's style echoes Chambers's French neoclassical manner, which he had learned in Paris and under French drawing masters in Rome in the early 1750s (fig. 6). Chambers's great rival Robert Adam preferred foreign draughtsmen, principally Italians, rather than English pupils, and he developed a different sort of 'office' style, quite dry and precise and not pictorial (fig. 7).

By the early 1840s Sir Charles Barry (1795–1860) was running one of the largest offices in Europe and the commission to rebuild the Palace of Westminster was practically a full-time task for his team. Barry appears to have let his pupils trace drawings as part of their training and, as the office archive itself has vanished, these volumes of tracings in various collections represent a shadow archive. William Henry Brakspear (1818–1898) worked in Barry's office between 1836 and 1844, first as a pupil and then as an assistant. The draughtsmanship of his design for a royal duke's palace (fig. 8), exhibited at the Royal Academy in 1843, imitates Barry's nervous and flickering penwork. The apprentice or pupillage system continued into the twentieth century.

ARCHITECTURE SCHOOLS IN BRITAIN

When the Royal Institute of British Architects (RIBA) was established in 1834, its founding principle was the encouragement of interest in and knowledge of architecture. Yet it also sought to improve the quality of architectural education and to set standards.[3] A voluntary system of RIBA examinations became compulsory for associate membership in 1881, although the Institute was not a teaching body, so it was left to the candidates to ensure that they learned enough to pass the examinations. Only in 1892 was the first full-time course in architectural education set up, at

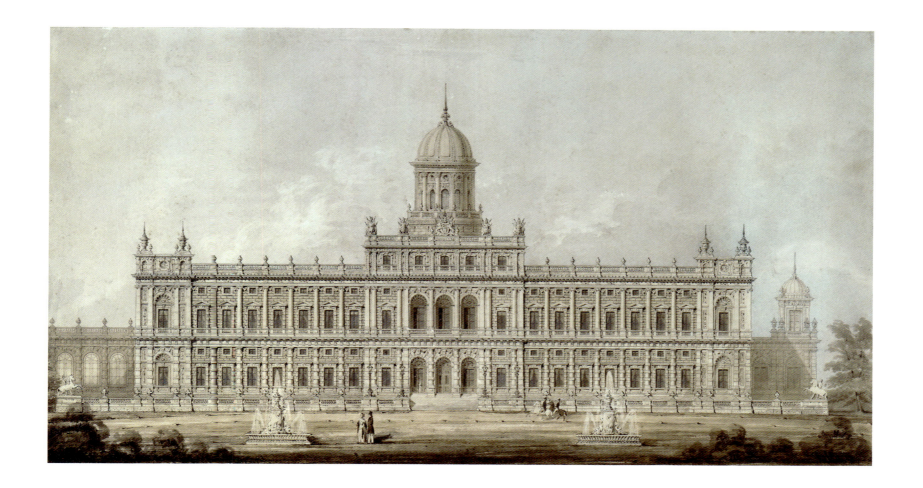

King's College London. This was soon followed by others running four- to six-year courses, such as the Architectural Association and the Bartlett School of Architecture in London, and the technical schools in Birmingham and Liverpool, soon absorbed into their budding universities. For a time, in many smaller towns and cities there were also evening classes for articled pupils and assistants, which enabled them to sit the RIBA external examinations. Each school evolved a theoretical style of instruction. The Liverpool School of Architecture under Sir Charles Reilly, for example, favored classical architecture in the American manner and eschewed the gothic still being taught at other schools. Harold Bramhill was a student of Reilly's, according to the notations on the fourth-year designs he submitted around 1927–28 (fig. 9).

In 1931, after more than forty years of continuous and often ill-tempered debate, Parliament passed the Architects (Registration) Act, which restricted use of the term 'architect' to those who had passed the necessary exams. This law remains in place today. The RIBA has long since given up examinations itself but acts as a validating body monitoring compliance with internationally recognized minimum standards in architectural education in over a hundred architecture schools worldwide.

In the British dominions and colonies, more local architectural institutes allied to the RIBA imitated the

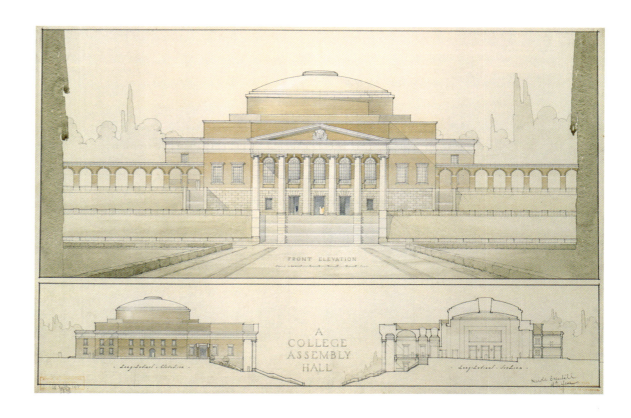

FIG. 8
William Henry Brakspear, Design for a royal residence, 1843 (May Collection 1990.299; cat. 8.39)

FIG. 9
Harold Bramhill, A College assembly hall, 1927–28 (May Collection 2000.521; cat. 2.26)

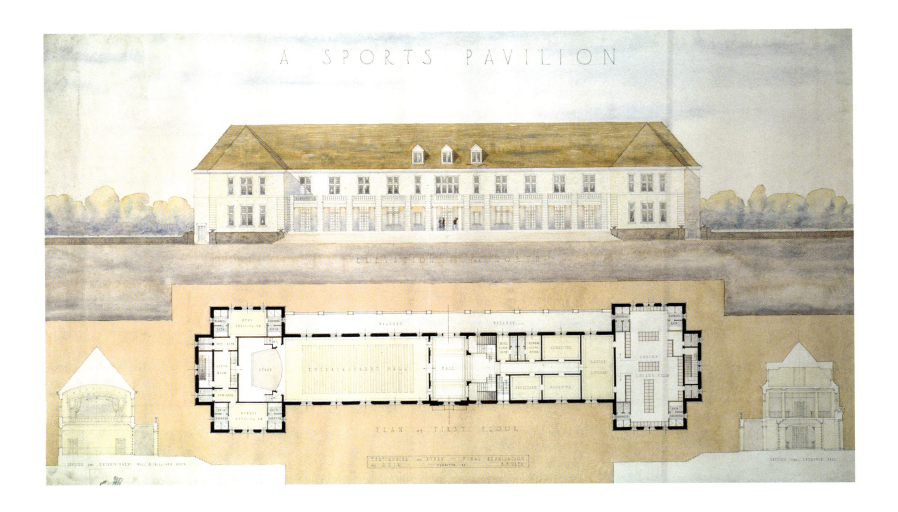

FIG. 10
Reginald Uren, Plan and elevation drawing of a sports pavilion, ca. 1928 (May Collection 2000.469a; cat. 1.40)

motherland in their methods. New Zealand modernist Reginald Harold Uren (1906-1988) trained at the New Zealand Institute of Architects and his student drawing (fig. 10) anticipates his buildings in Britain after 1929, which show the influence of Dutch and Swedish modernism.

BRITISH ARCHITECTURAL DRAWINGS OUTSIDE THE DESIGN PROCESS

PRIZE DRAWINGS COMPETITIONS

From the 1830s, these were mostly arranged by the Royal Institute of British Architects. The May Collection contains at least two entries for the most important British prize drawing competition, the Soane Medallion. This commemorated Sir John Soane, one of the original benefactors of the RIBA, and was instituted in 1838. It was not awarded every year during its history but sometimes annually and sometimes every other year. The award was for the best set of architectural design drawings on a given subject and, from 1863, the Medallion was accompanied by a bursary for foreign travel. Not many of the entries before the early twentieth century seem to survive, and the May Collection is fortunate to have a set from 1869, when the subject was a Metropolitan Railway Station (fig. 11). Unfortunately, the artist is unknown and it does not seem to fit the description of the drawings submitted by the winner, Henry Louis Florence (1843-1916). The Gothic Revival style is in sharp contrast with that of a fine part set of drawings made fifty years later by George Alfred Rose (1894-1977) for 'A bridge over a wide river' (fig. 12). Originally intended for the 1915 subject, the First World War caused the competition to be delayed until 1920. The winner was Arthur Shoosmith (1888-1974), later to achieve eminence as the executant architect for Sir Edwin Lutyens's work in New Delhi, and, as his Medallion drawings are lost, the evidence for their high quality lies in Rose's superb entry only achieving an Honourable Mention.[4]

ROME SCHOLARSHIP IN ARCHITECTURE

A particularly marked difference between the French and British systems of architectural education in the nineteenth century was that in France a student was prepared for a career in government service, whereas the articled pupil in Britain was usually destined for a career in private practice, independent architects being more highly esteemed than those in official employment. An attempt to counteract this tendency, led by a number of architects who had studied in Paris, resulted in the Commissioners of the 1851 Exhibition (who administered the financial legacy of the Great Exhibition) funding a scholarship at the newly founded British School at Rome, each scholarship tenable

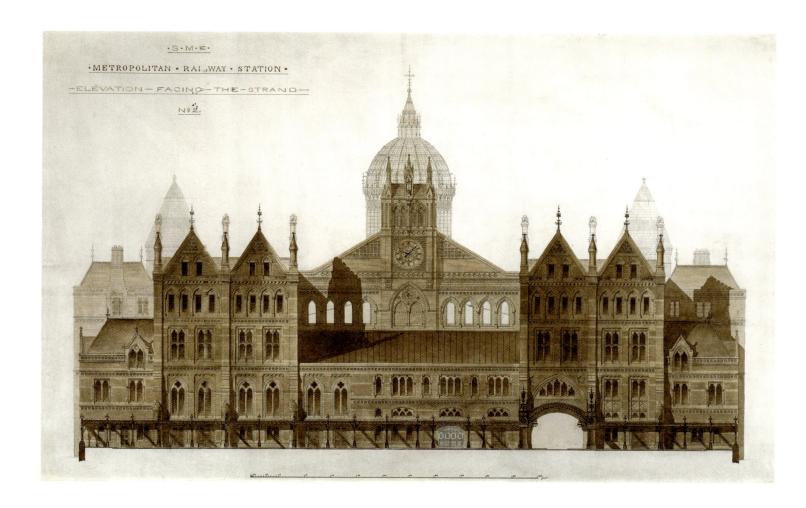

FIG. 11
Architect unknown (British), One of a set of designs for a Metropolitan Railway Station entered for the Soane Medallion competition, 1869 (May Collection 2000.517b; cat. 5.10)

FIG. 12
George Alfred Rose, One of a set of designs for a City Hall approached by a bridge entered for the Soane Medallion competition, 1915–20, pen and watercolour (May Collection 1990.297a; cat. 12.12)

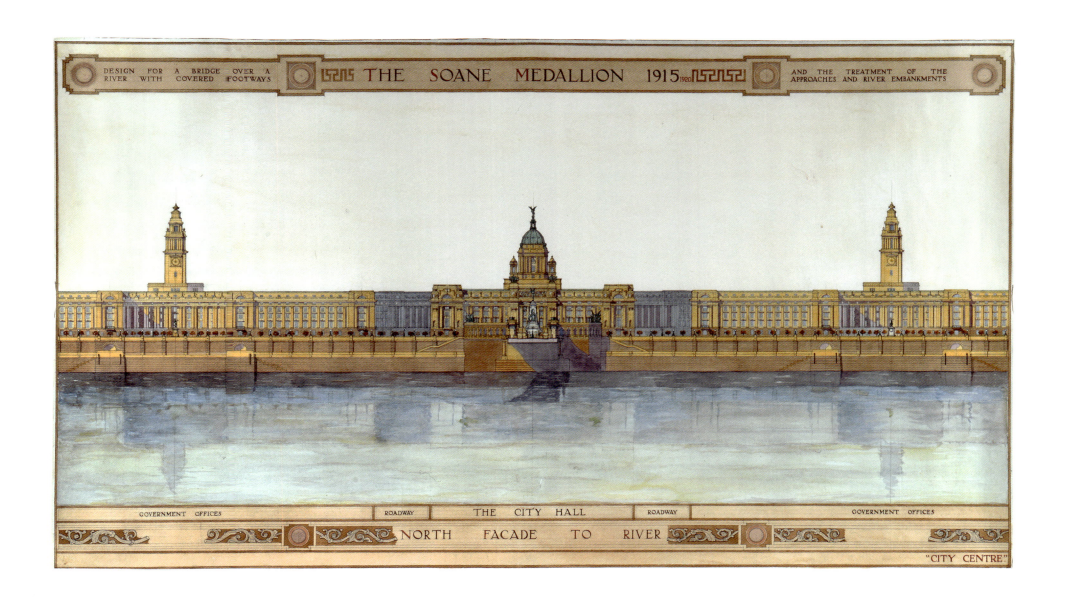

ARCHITECTURAL DRAWING IN BRITAIN 53

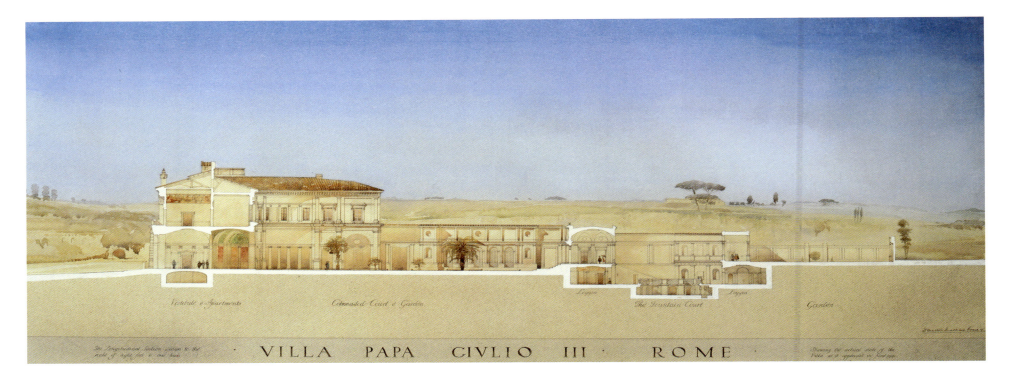

FIG. 13
Harold Chalton Bradshaw, Drawing of the Villa Giulia, Rome, built ca. 1550 for Pope Julius III, 1914–15 (May Collection 1992.392c; cat. 11.4)

for three years. The idea was that this would be the pinnacle of an ascending ladder of prizes for design, of which the Soane Medallion was one, and would encourage "systematic working methods, clarity of planning and good draughtsmanship."[5] In the end, the Scholarship became bogged down in a fruitless debate about Modernism versus Classicism, but the early scholars produced many fine drawings, focusing primarily on reconstructions of Roman ruins or the occasional Renaissance building. The May Collection contains a fine set of drawings (fig. 13) by the first Rome Scholar,[6] Harold Chalton Bradshaw (1893–1943), for a restoration and completion of the sixteenth-century villa designed for Pope Julius III by Giacomo Barozzi da Vignola and Bartolomeo Ammannati.

ARCHITECTURAL COMPETITIONS
Architectural competitions, initially held by municipalities for new types of public buildings, appear to have begun in Britain in the mid-eighteenth century. Among the entries in the competition for the Royal Exchange in Dublin in February 1769 was a submission (fig. 14) by Thomas Sandby (1721–1798).[7] By the early nineteenth century, as the growth of national wealth produced a huge investment in new public buildings, both national and civic as well as ecclesiastical, these contests became more common. The major competition of the 1830s was for the rebuilding of the Palace of Westminster, which had burned down in 1834. There were an unprecedented 97 entries, the majority by young and relatively inexperienced architects. The assignment specified a scale of 20 feet to one inch, a monochrome palette and three perspectives only from set viewpoints, while parts of the old building were to be preserved. Neither models nor estimates as to cost were required. This did not provide a very practical template for the future. As the century wore on, competitions became a byword for corruption. The RIBA tried to improve matters by issuing guidelines but there was always a risk that the local man would get the job and the other competitors would have wasted their time and money. Of this, a famous example was the Bristol Assize Court competition of 1866, when Edward William Godwin (1833–1886) won first, second and third places in the competition but a second-rate local architect still got the commission. Over 2,500 competitions are recorded between 1843 and 1900 and that figure comes from the files of *The Builder* alone.[8]

PERSPECTIVES
Perspectives as a means of indicating to clients what a building will really look like in its setting, as opposed to an orthogonal view that looks at an elevation head on, first begin to appear as a tool in the architect's arsenal in the 1790s. A particularly fine early example is the perspective for Hammerwood Lodge, Sussex,

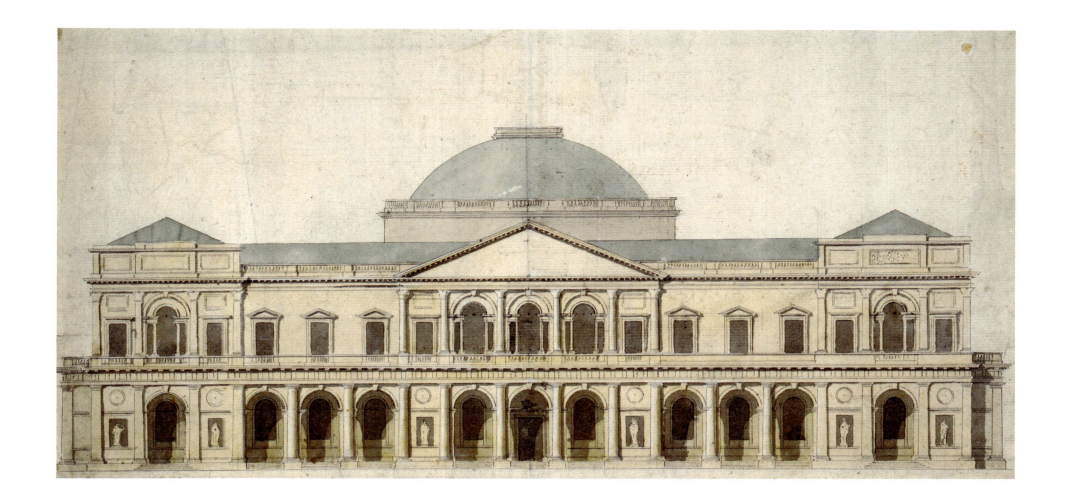

by Benjamin Henry Latrobe (1764–1820), drawn in 1792, the year before he emigrated to the USA (fig. 15). The archetypal British perspective is a watercolour view set in a pictorial landscape with roots in the romantic Italianate or French traditions of such men as William Kent, Chambers and the Adam brothers. Many architects had difficulties drawing properly delineated figures to scale, so the architecture was drawn in the office while the trees, figures and street life were added later by professional artists, their work lying over the lines drawn by the architectural draughtsman. The trade card of the minor architect John Blore (1812–1882) demonstrates that he supplemented his income by acting as a drawing master and would for a price doubtless have produced a perspective (fig. 16).9 Some artists, such as James Duffield Harding (1798–1863), John Wilson Carmichael (1800–1868) and Thomas Shotter Boys (1803–1874) built up a specialty in perspective work, but they were rarely allowed to sign what they produced and attributions are therefore difficult. A few architects were so talented that they made all their own perspectives. Despite his huge practice, Alfred Waterhouse (1830–1905), one of the giants of High Victorian architecture, always insisted on doing presentation perspectives himself. Newly qualified architects waiting to make a reputation for themselves towards the end of the nineteenth century began advertising themselves as perspectivists (it was

FIG. 14
Thomas Sandby, Competition drawing of the facade for the Royal Exchange, Dublin, 1769 (May Collection 1991.381; cat. 7.14)

FIG. 15
Benjamin Henry Latrobe, Perspective of a design for Hammerwood Lodge, Sussex, 1792, watercolor over pencil (RIBA Collections)

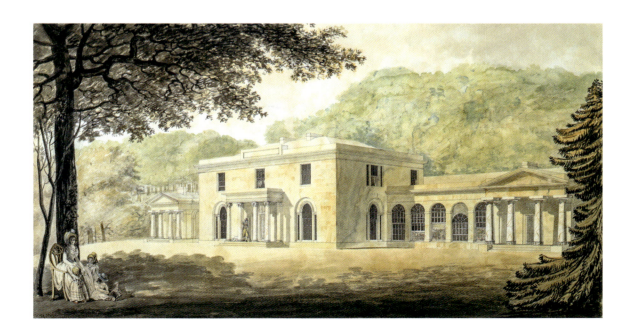

ARCHITECTURAL DRAWING IN BRITAIN 55

FIG. 16
Trade card of John Blore, ca. 1840
(RIBA Collections)

FIG. 17
David Brandon, Perspective view of the Marlborough Club, 52 Pall Mall, London, ca. 1870 (May Collection 1987.77; cat. 1.38)

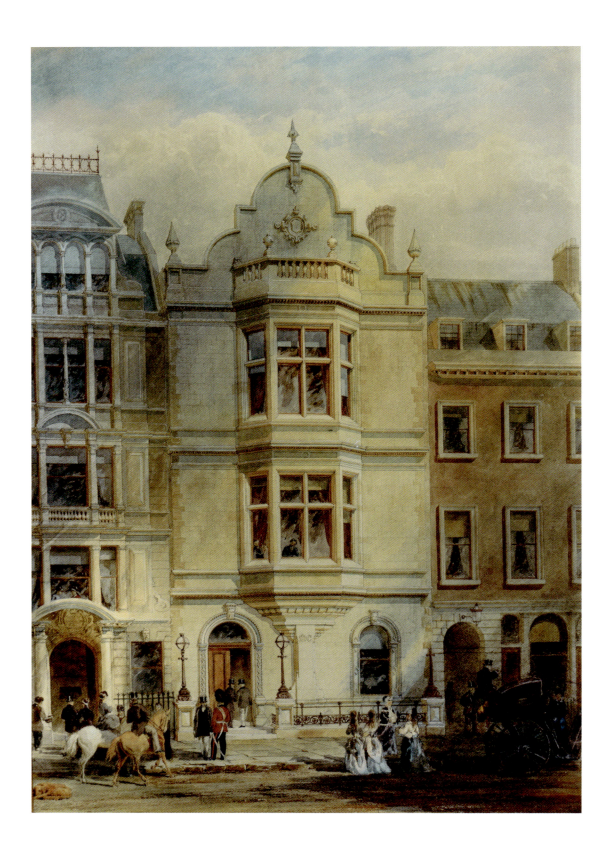

nicknamed "devilling"). One such was Stanley Adshead (1868–1946), who drew perspectives in the 1890s but by 1909 was Professor of Town Planning in Liverpool and had no need of supplementary income. Sir Basil Spence (1907–1976) was another struggling young architect in the 1930s who sold his devilling skills before becoming a senior figure in the architectural profession post-war.

The proliferation of illustrated building and architectural journals from the 1840s onwards was a boon to perspectivists, as architects sought to advertise their abilities to the widest audience. The results can be seen in the growing number of them shown at the Royal Academy of Arts, often commissioned after the job had been accepted by the client and sometimes made to mark the end of the building process. The May Collection contains several very high-quality perspectives from the mid-nineteenth century onwards. An example of the anonymous type is the splendid vision of the proposed Marlborough Club in Pall Mall by David Brandon (1813–1897) (fig. 17). This must have been commissioned from a professional perspectivist in order to make an impact at the Royal Academy, where it was exhibited in 1871, the year after the club opened. It is all of a piece because of the careful integration of staffage (the fashionable figures and hackney carriage in front) with the architecture and yet a slight feebleness in the figures as compared to the rendering of the buildings suggests that it is an architect at work rather than an artist.

A generation later the architect Charles William English (1862–1933) found he could earn more from perspective work than he could by designing. His grand manner was ideally suited to showing off the new stone-fronted buildings on steel frames that were rising in central London, with facades that can only be described as Edwardian Baroque.[10] A good example is his perspective of the new offices for the Hamburg-Amerika Line by Arthur Thomas Bolton (1864–1945), begun in 1906 and completed in 1908 (see above, fig. 1, p. 47 and cat. 7.15), which was exhibited at the Royal Academy that year and published in *The Builder*. Bolton was a good draughtsman himself and won the Soane Medallion in 1893, but does not seem to have worked on perspectives of his own buildings. The two leaders in the field from the early twentieth century were William Walcot (1874–1943)[11] and Cyril Farey (1888–1954), one eventually crossing the line from architecture to art and the other gradually dropping design work entirely to concentrate on perspectives and presentation drawings.

Farey's smooth polished work suiting the Art Deco of the inter-war years is evident in several works in the May Collection, such as a house in Hampshire designed by Unsworth & Goulder (fig. 18). Tucked decoratively into the foreground are plans, compass points, scale and title. Although usually "devilling" was done anonymously, Farey became so well known that his work rarely lacked his signature. One year, upon walking into the Architecture Room of the Royal Academy Summer Exhibition, the irrepressible Sir Edwin Lutyens exclaimed: "Ah, it's Fareyland," so many of Farey's perspectives were on display. Carrying the tradition forward as late as the 1960s, the softer and more romantic style of John Dean Monroe Harvey (1895–1978) was better suited to vernacular and revival styles of building (fig. 19) and, although he worked for modernists latterly, he never quite seemed to regain the charm of his more youthful work.

In a league of his own was Thomas Raffles Davison (1853–1957), whose long working life comes towards the middle and end of the tradition. He is recognized as perhaps the most prolific architectural draughtsman in history, with at least 15,000 drawings to his credit, largely because of his association with various building journals for which he provided illustrations. Although he qualified as an architect he never practiced and relied on his draughtsmanship to earn his living. Compared to those colleagues who worked in full watercolour, Davison was inexpensive, preferring to work in a very personal style once described as "a fluent pen and ink hatching method, sprinkled with impressionistic dots and flicks."[12] He was especially employed in drawing competition entries. Sir Aston Webb (1849–1930) often used him from the 1890s. Davison's work in the May Collection is for the new front of Buckingham Palace (fig. 20), which replaced the old one during the

FIG. 18
Cyril Arthur Farey for Unsworth & Goulder, Presentation drawing and two plans for a house called Rake Holt at East Liss near Petersfield, 1930 (May Collection 2000.463; cat. 8.66)

FIG. 19
Edward Guy Dawber and John Dean Monroe Harvey, Presentation drawing for 'Berry Leas', Elton, Huntingdonshire (now Cambridgeshire), UK (May Collection 1987.68; cat. 8.65)

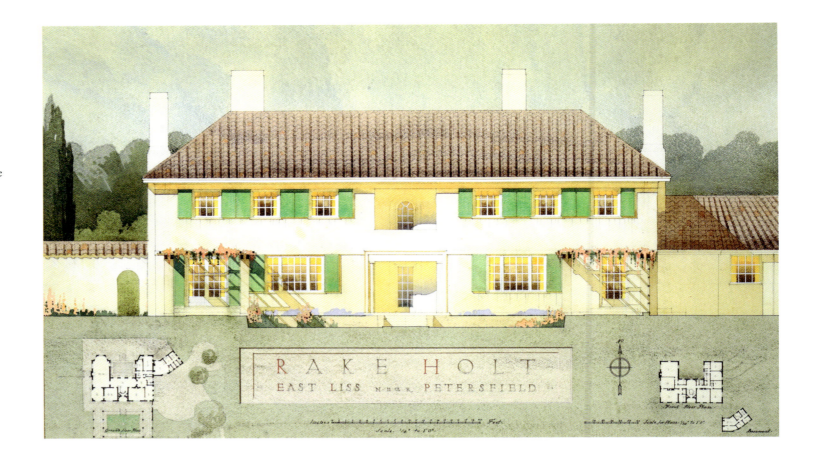

FIG. 20
Aston Webb and Thomas Raffles Davison, Presentation drawing for remodeling Buckingham Palace, ca. 1912 (May Collection 1987.88; cat. 8.38)

CONCLUSION

three summer months of 1913. There was no flexibility in the design because it was simply a new stone skin being applied to the 1840s building behind, retaining the joinery and glazing of every window. Webb's best-known work is the Queen Victoria Memorial, which is a linked design connecting the Admiralty Arch at one end of the Mall and the Palace at the other.

In his collecting of English designs, Peter May has focused less on the constructional aspects of architectural drawing, of which there are relatively few examples, but more on the representational methods by which either the appearance of a building has been sold to the client or the architect's skill as a designer in exhibitions or reproduction has been advertised. Although religious buildings have been excluded and there is little Gothic Revival, it is a remarkable assembly of illustrations of the architect's art over a century and a half and a useful reminder of how much is lost in an increasingly digital age when hand drawing skills are harder to learn.

NOTES

1 The Queen's House was begun for the consort of King James I, Anne of Denmark, but it was discontinued after her death in 1619 and was completed to a revised design in the 1630s for Charles I's wife, Henrietta Maria of France.
2 By the early nineteenth century, it had been established as six years.
3 J.A. Gotch, ed., *The Growth and Work of the Royal Institute of British Architects 1834–1934* (London 1934).
4 A lengthy criticism of the designs by Shoosmith and Rose was published in the *RIBA Journal*, 3rd ser., vol. XXVII (1919–20), p. 149. The critic was Arthur Davis of Mewès & Davis.
5 Louise Campbell, 'A call to order: the Rome Prize and early 20th century architecture,' *Architectural History*, vol. 32 (1989), pp. 131–51.
6 Bradshaw won the Scholarship in 1913 but his tenure was interrupted by the First World War and he resumed it in 1919–21.
7 Two other drawings from the set are in the Royal Institute of British Architects, London, and Vassar College, USA.
8 Roger H. Harper, *Victorian Architectural Competitions. An Index to British and Irish Architectural Competitions in The Builder, 1843–1900* (London, 1982), p. xi.
9 Blore exhibited regularly at the Royal Academy of Arts between 1831 and 1856 but almost all his exhibits were either topographical views or speculative designs for competitions or exhibition purposes. None of his drawings are known to survive.
10 English did most of Richard Norman Shaw's later perspectives once Shaw moved into his imperial classical manner.
11 Not represented in the May Collection.
12 *Catalogue of the Drawings Collection of the Royal Institute of British Architects C-F* (Farnborough, 1972), p. 77.

THE ARCHITECTURAL DRAWINGS MARKET, PAST AND PRESENT

Architects, Collectors, Scholars, and Decorators

CHARLES HIND

PATTERNS OF COLLECTING

The development of a specialist market in architectural drawings is very much a twentieth-century phenomenon. In late medieval times, such by-products of the building trades were handed down from generation to generation within a workshop.[1] During the Renaissance, private collectors emerged, who purchased design drawings from dealers in books and prints, art agents, or at auction. Architects instinctively collected design and construction drawings as educational tools and exemplars for the atelier. Connoisseurs collected drawings as aesthetic artifacts, examples of beautiful draughtsmanship, or for their historical interest. Of course some architects were connoisseurs and collected for aesthetic reasons, notably William Talman (1650–1719), Lord Burlington (1694–1753) and Sir John Soane (1753–1837). Art academies like the Accademia di San Luca founded in Rome in 1578 and the École des Beaux Arts founded in Paris in 1682 usually held on to prize-winning drawings, resulting in collections that continue to grow organically (albeit very slowly and with a narrow focus) and serve as artistic resources and historical archives. In similar fashion, London's Royal Academy of Arts, founded in 1768, primarily collects Diploma Works (fig. 1), single drawings given when Academicians are elected, and only relatively recently has begun to acquire drawings by past Academicians. With the emergence of design museums in the mid-nineteenth century, institutional repositories were formed to train and inspire generations of students and amateurs. These collections solicited donations and acquired by purchase from the trade. It was not until the late 1950s that specialist architectural drawings dealers began to emerge, just as private as opposed to institutional collectors began to lead the market. Indeed, the appetite for architectural drawings grew so quickly that Sotheby's began annual specialist sales in 1978 in London and Monaco and continued until the market collapsed in 1991. Apart from the Albert Richardson Collection in 1983, Christie's only had a few sales in the late 1980s.[2]

THE EARLY AESTHETIC COLLECTORS

The earliest collectors appeared in Italy during the Renaissance. Giorgio Vasari (1511–1575) and Jacopo Strada (1515–1588) seem to have collected architectural drawings largely for aesthetic reasons. Vasari was a painter, architect, writer, and historian, most famous for his *Le Vite de' più eccellenti pittori, scultori, ed architettori* (Lives of the Most Excellent Painters, Sculptors, and Architects), first published in 1550, which today is considered to be the foundation of art-historical writing. In association with his *Lives*, Vasari collected drawings by masters ranging from Domenico

FIG. 1
Alfred Waterhouse (1830–1905), Perspective of Manchester Town Hall, 1887 (Royal Academy of Arts, 03/6166). This was Waterhouse's Diploma Work, presented to the Royal Academy of Arts, London, following his election as a full Academician in 1885. Waterhouse had won the competition to design the building in 1868 and it was completed a decade later, so this is a record of the Town Hall, not part of the design process. The success of Manchester Town Hall elevated Waterhouse from being a regional architect to one of national importance. He was also one of the most brilliant architectural watercolourists of his generation.

61

FIG. 2
Sheet of drawings from Giorgio Vasari's *Libro de' Disegni* (National Gallery of Art, Washington DC, Woodner Collection, Patrons' Permanent Fund, NGA 1991.190.1). The sheet contains 10 drawings, recto and verso, by artists who include Filippino Lippi, Botticelli and Raffaellino del Garbo, of the period 1480–1504. Vasari mounted them and added the framework in pen and ink in the mid-1520s.

Ghirlandaio to Federico Zuccaro, probably to show the evolution of art and architecture in the fifteenth and sixteenth centuries. At his death there were nearly 600 drawings in his so-called *libro de' disegni* (Book of Drawings; fig. 2). When compared to the far wider chronological spread of the painters and sculptors, the architects were all more or less contemporaries, from Antonio da Sangallo and Michelangelo to Andrea Palladio and Vincenzo Scamozzi. Lacking evidence as to how Vasari acquired these drawings, one imagines that for the most part they must have been gifts from the architects or perhaps their families.[3] Strada was a painter, architect, inventor, goldsmith, and art dealer from Mantua, much sought after as an art expert, primarily in the art of antiquity. He ended up working in Vienna for the Holy Roman Emperors Maximilian I, Ferdinand II, and Rudolf II. A somewhat shady character, to judge by the comments of his contemporaries, he is known to have bought drawings directly from Sebastiano Serlio and the estate of Giulio Romano (in whose studio he had trained).

Two Venice-based collectors with no connection to the practice of architecture were Giacomo Contarini (1536–1595) and the Englishman Sir Henry Wotton (1568–1639), a politician, diplomat, and author who was the English Ambassador in Venice 1604–12, 1616–19 and 1621–24. Contarini was a great collector of sculpture, paintings, and scientific instruments as

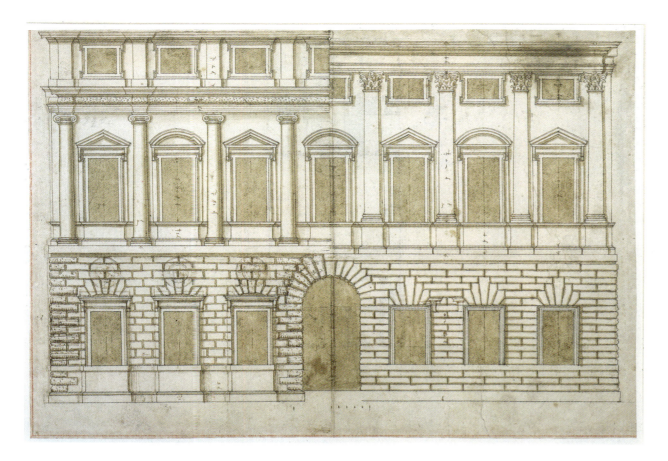

well as architectural drawings. Although he apparently never commissioned any design work from Palladio, he managed to amass a large number of highly finished drawings by the architect,[4] perhaps in return for Palladio living as a guest in his house on the Grand Canal for nearly a decade. Wotton had a passion for architecture and wrote a free English translation of Vitruvius's Latin treatise *De architectura* (Ten Books of Architecture), which he published in 1624. There is evidence that Wotton perhaps also acquired drawings by Palladio, from the architect Vincenzo Scamozzi, who also sold drawings to Thomas Howard, Earl of Arundel (1586–1646). Arundel, nicknamed "the Collecting Earl," was the patron and friend of English architect Inigo Jones (1574–1653), who travelled with him to the Veneto to study the work of Palladio in 1613–14. The large collection of drawings by Palladio now in the Royal Institute of British Architects (RIBA) in London is traditionally believed to have been acquired by Jones during that sojourn in Italy (fig. 3), though they could have been among the drawings known to have been bought by Lord Arundel.[5]

The English architects William Talman (1650–1719), his son John Talman (1677–1726), and Sir John Soane (1753–1837) collected architectural drawings for their aesthetic qualities.[6] William Talman was effectively Sir Christopher Wren's deputy in the Office of the King's Works, until he was dismissed in 1702. Nevertheless, he had the means to assemble a remarkable collection of British and European architectural drawings, aided and abetted by his son John, who sent back from Italy large numbers of prints and drawings to serve as the nucleus of a Talman museum of architecture, sculpture, and the allied arts that would serve artists and antiquaries in London.[7] Within two years of William Talman's death, however, his son sold a large group of drawings by Palladio, Inigo Jones, and John Webb to Lord Burlington for £170; and, after the younger Talman's death in 1726, there were two auction sales that included over 1200 architectural drawings, now scattered in public and private collections worldwide. Many can be recognized by their distinctive gilt mounts and/or a collector's mark of a triple conjoined T, as well as annotations in a code that has not yet been deciphered (fig. 4).

Like the Talmans, John Soane bought at auction, from dealers, and privately, acquiring some 900 drawings by Robert Adam (1728–1792) from Adam's improvident brother William in 1833 as well as buying the office archive of George Dance Senior (1695–1768) and George Dance Junior (1741–1825) from Dance Junior's son in 1836 (for £500). Soane's remarkable collection survives intact in Sir John Soane's Museum, London.

FIG. 3
Andrea Palladio (1508–1580), Alternative designs for the facade of the Palazzo Porto Festa, Vicenza, Italy, ca. 1546 (RIBA Collections). This is one of a group of drawings probably bought in Italy by Lord Arundel in 1614 and subsequently owned by a number of architects before being sold by John Talman to Lord Burlington in 1721.

FIG. 4
Edward Pearce (ca. 1630–1695), Design for a pulpit (RIBA Collections). Although this does not bear the Talman collector's mark, it does have the gilt border associated with the Talman collection. Pearce was a mason and contractor who did a lot of work for Wren. In his will, he directed that from his "Clositt of Books, prints and drawings," "his good freind" William Talman could have "the choise and picking of what therein shall seeme worthy to make up the worthy collection he intends".

THE EARLY EXEMPLAR COLLECTORS

One of the earliest of the exemplar collectors was John Webb (1611–1672). The large group of Palladio drawings that arrived in England in the possession of either Inigo Jones or Lord Arundel were sold or given to Webb, who had also inherited Jones's library and archive of drawings in 1652. The Palladio and Jones drawings continued to inspire Webb and were available to his contemporaries. Despite Webb's injunction in his will that the collection be kept together as an heirloom, his by then widowed daughter-in-law started to disperse this rare accumulation from 1675 onward. The books and some drawings eventually went to the amateur architect Dr George Clarke (1661–1736),[8] while the rest of the drawings were acquired by John Oliver (ca. 1616–1701), one of the four surveyors appointed by the City of London authorities to supervise the rebuilding of the city after the Great Fire of 1666. From Oliver, they passed to William Talman and, as noted above, in 1721 William's son John sold them on to Lord Burlington, who had acquired other drawings by Palladio in Venice in 1719. Thus for at least a century and perhaps for 140 years (until Burlington's death in 1753), many of Palladio's drawings were available to a succession of architects, from Webb and Roger Pratt in the 1650s to Wren, Hawksmoor, and Vanbrugh in the following decades and the group of Anglo-Palladians promoted by Lord Burlington in the 1720s and 1730s. Arguably, this is the single most influential archive in the history of architecture. Other than these two major groups of drawings bought in 1719 and 1721, Burlington does not seem to have been a significant collector of individual drawings, although he appears to have bought a few things in the Talman sales of the late 1720s.

Probably about the time that Webb acquired the Palladio collection, the Swede Nicodemus Tessin (1615–1681) began collecting French and Italian architectural drawings and his collection was much enlarged by his son, also Nicodemus (1654–1728). The Tessins collected a wide range of contemporary French drawings for Sweden that informed their decoration of the Royal Palace in Stockholm. It is uncertain quite how large the collection was at the younger man's death but it was certainly well in excess of a thousand drawings.[9]

MODERN COLLECTORS AND THE MARKET

Before the nineteenth century, there were no design museums, so the collectors for architectural drawings were principally private individuals, whether architects or connoisseurs. In Britain, the Royal Institute of British Architects (RIBA) from 1834[10] and the Victoria and Albert Museum (V&A) from the 1860s were the first institutions to acquire architectural drawings in significant quantities. The RIBA was interested in

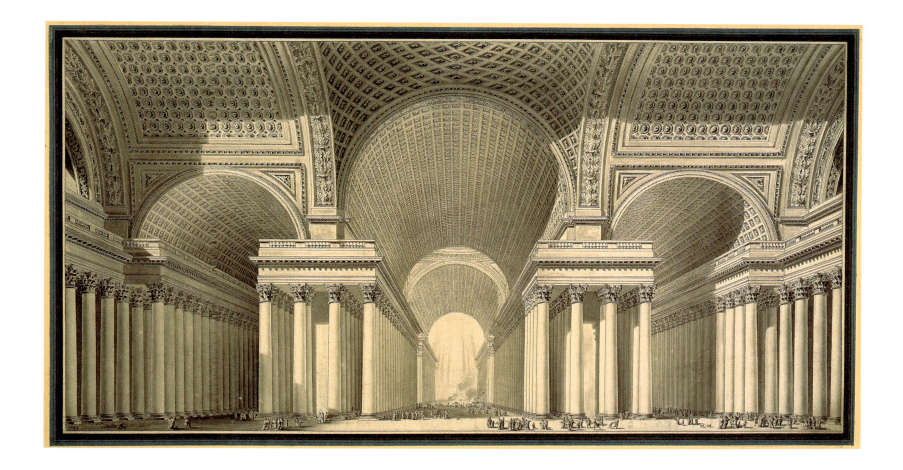

acquiring both historical material, to form the basis of a study collection for the history of architecture, and contemporary drawings, acquired by gift from practicing architects. Its first major acquisition of a historical collection was a gift of the Scottish baronet Sir John Drummond-Stewart (1794–1838) in 1837. Comprising seventeenth- and eighteenth-century French, German, and Italian drawings assembled in Paris over the previous decade, presumably from dealers, his collection favored perspective drawings. It included the only Étienne-Louis Boullée drawing in Britain (fig. 5).[11]

The market was essentially in individual drawings that surfaced from time to time with dealers and auction houses. As in other collecting fields, it was the dealers who bought at auction and sold to the collectors.[12] Complete archives of individual architects do not seem to have been of much interest to anyone, and Soane's purchase of the Adam and Dance archives was exceptional. Architectural drawings collectors were few in number and, as far as can be ascertained, all male.

Between about 1870 and 1950, the only institutional collectors of any size were, in New York, the Cooper Union Museum for the Arts of Decoration (today the Cooper Hewitt Museum, Smithsonian Design Museum), the Avery Library at Columbia University, and The Metropolitan Museum;[13] in London, the RIBA and the V&A; in Berlin, the Kunstgewerbe-Museum; in Paris, the Musée des Arts Decoratifs; and, until 1914,

in St Petersburg the Stieglitz Museum.[14] Only the Americans, the Germans, and, intermittently, the V&A bought significant quantities of foreign drawings, the RIBA's Drummond-Stewart Collection being a gift. The dealers, like the auction houses in the eighteenth century, tended to be French or Dutch, although the buyers were likely to be Italian and French and, in the early twentieth century, American. They catered to a market that, driven by historicism, needed authentic examples to adapt or copy, and they found plenty of buyers. The only specialist dealer in London at this time, and that in an unfocused way, was Batsford, primarily a publishing house and dealer in architectural books but with a side line in drawings.[15]

French nineteenth-century architects in particular built up notable collections of exemplar drawings, particularly Hippolyte Destailleur (1822–1893),[16] the father-and-son architects André-Denis Bérard (d. 1873) and Charles-Eugène Bérard (1838–1890),[17] and Charles-Edouard Mewès (1889–1968) of Mewès & Davis. In Britain, the only significant architect to buy architectural drawings was Sir Albert Richardson (1880–1964), who concentrated on British architects of the late eighteenth and early nineteenth centuries, while also acquiring a small but significant group by Giacomo Quarenghi (1744–1817), an Italian architect working in the Anglo-Palladian tradition whose career was largely spent in Russia. But there were growing numbers of collectors

FIG. 5
Étienne-Louis Boullée (1728–1799), Design for a Metropolitan Cathedral, Paris, c.1782 (RIBA Collections), one among a group of architectural drawings purchased by Sir John Drummond Stuart in Paris during the 1830s

FIG. 6
Vincenzo dal Rée (1700–1762), Design for a church ceiling, probably in Naples (Metropolitan Museum of Art, 69.590). Dal Rée was primarily a theatre architect and stage designer, first in Turin and then in Naples. This drawing was in the Fatio collection until its dispersal in 1959 and was bought by the William H. Schab Gallery in New York before being sold on to the Metropolitan Museum of Art.

FIG. 7
Nicholas Hawksmoor (1661–1736), Unexecuted design for the lantern, St. Augustine, Watling Street, London, ca. 1692 (RIBA Collections). This is one of the large collection of drawings by Wren and his contemporaries sold in the famous Bute sale at Sotheby's, London, in 1951.

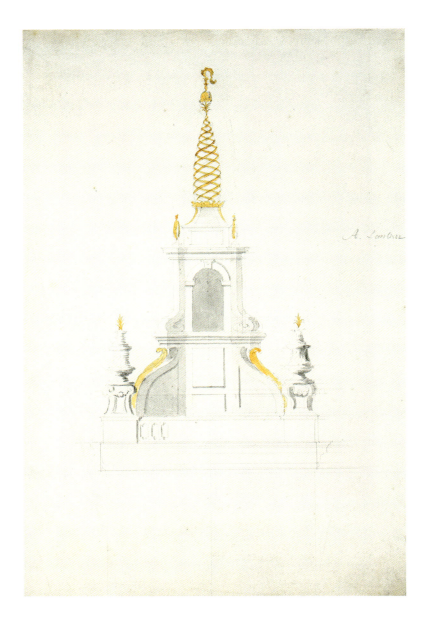

not connected directly with the process of designing, notably the Italian painter and engraver Giovanni Piancastelli (1845–1926), most of whose vast collections ended up in the Cooper Union Museum, and the French lawyer Eugène Rodriques (1853–1928). Nearly all these collections had been broken up or had passed into institutional care before the Second World War.

In the last seventy years, the market for architectural drawings has changed dramatically. This process began with the sale of the Marquess of Bute's collection of architectural drawings by Sotheby's in 1951. Put together by John Campbell, 2nd Duke of Argyll (1680–1743) and his nephew, John Stuart, 3rd Earl of Bute (1713–92) in the eighteenth century, the collection contained 271 seventeenth- and eighteenth-century English drawings,[18] by, among others, Christopher Wren (fig. 7), Nicholas Hawksmoor, John Vanbrugh, James Gibbs, and William Chambers.[19] There were a number of private buyers from both sides of the Atlantic, as well as the trade and British and American institutions. The next major sale was the collection of the architect and connoisseur Edmond Fatio (1871–1959), sold in Geneva the year of his death (fig. 6). Containing nearly 2000 drawings (of both ornament and architecture), in the opinion of John Harris, distinguished former Curator of Drawings at the RIBA, this was the real catalyst for collectors and curators, especially in New York and London.

HISTORICAL AND HISTORICIST ARCHITECTURAL DRAWINGS

In New York City, there were two streams of interest in architectural drawings running in parallel, without much cross-over between them. On the one hand there was the growing appeal of architectural drawings dating from before the modern age, let us say pre-1920, representing a historicist tradition of design. On the other hand, there was a growing appreciation of the contemporary (post–1920) architectural drawing as an aesthetic object in its own right and not just part of a process of design. Although both interests collapsed at about the same time in the commercial sense, they need to be examined separately.

By the late 1950s, curators at several key institutions were writing on and exhibiting architectural and design drawings. John Harris spent six months in New York in late 1959 and found the place bubbling.[20] He particularly remembers A. Hyatt Mayor, Curator of Prints at the Metropolitan Museum of Art from 1946, his Associate Curator Carl J. Weinardt, Richard (Dick) Wunder, Curator of Drawings and Prints at the then Cooper Union, and Agnes Mongan at the Fogg Art Museum, Harvard.[21] These curators and others promoted a series of exhibitions from their collections[22] or those of private collectors such as Donald Oenslager,[23] which stimulated further interest among collectors and encouraged specialist dealers to emerge. These included Sven Gahlin in the 1950s, Ben Weinreb in 1960, followed by Paul Grinke, Christopher Powney, and William Drummond. Yvonne ffrench and Wynne Jeudwine enriched the trade with their joint exhibitions—Jeudwine's coup was to acquire a large chunk of the collection of Charles-Frédéric Mewès (1858–1914), the famous Beaux-Arts architect. In Amsterdam, Lodewijk Houthakker, though a dealer himself in old master drawings, began to scour the stock of his colleagues from 1959, not least ffrench, Jeudwine, Gahlin, and Weinreb, to form an amazing collection, since broken up. Within ten years Weinreb was the paramount dealer in architectural books and drawings, and it is from the early Weinreb catalogues that the Canadian architect and philanthropist Phyllis Lambert began to collect, moving from early photography and fine scenographic designs to embrace the whole gamut of architecture. Her massive and enthusiastic buying was a catalyst for collectors in the subject, as indeed was the effect of Paul Mellon's buying of British art. So far as architecture was concerned, Mellon specialized in eighteenth- and early nineteenth-century British drawings,[24] now treasured at the Yale Center for British Art in New Haven, while Phyllis Lambert was for many years an omnivorous collector whose prizes formed the basis for the Canadian Centre for Architecture in Montreal.[25] With the break-up after the Second World War of the collections of many British country houses, huge amounts of largely British material had emerged on to the market, often at very low prices.

FIG. 8
Mary L. Myers, *Architectural and Ornament Drawings: Juvarra, Vanvitelli, the Bibiena Family, & other Italian draughtsmen*, catalogue of an exhibition in The Metropolitan Museum of Art, New York, 1975. The cover features a detail of a drawing in an album of works by Filippo Juvarra sold at auction in Italy in 1966, catalogued incorrectly as Filippo Vasconi, bought by a London collector, and sold on to the Metropolitan Museum.

FIG. 9
The RIBA Heinz Gallery at 21 Portman Square, London, designed by Stefan Buzas and Alan Irvine (photograph RIBA Collections). The first exhibition held there, *Great Drawings from the Collection*, was opened by H. M. Queen Elizabeth II in May 1972. The Heinz Gallery was the first gallery in the world purpose-made for the display of architectural drawings.

Quite soon after the great initiating decade in the market, in the 1960s, there followed consolidation of scholarly interest. At The Metropolitan Museum of Art, Mary Myers kept up the Hyatt Mayor tradition with the exhibition *Architectural and Ornament Drawings* (fig. 8) in 1975,[26] the year that Dick Wunder compiled his catalogue *Architectural, Ornament, Landscape, and Figure Drawings collected by Richard Wunder* for Middlebury College, Vermont. Across the Atlantic, from the early 1970s the RIBA began to publish its holdings (in twenty-three large volumes), and from 1972 to 1999 the RIBA Heinz Gallery at Portman Square (fig. 9) housed an extraordinary series of 135 exhibitions, many with catalogues. John Harris at the RIBA was a particularly prolific author and one who was extremely generous with his knowledge. His transatlantic connections through his friendships with scholars and dealers, his American wife Eileen (also a distinguished architectural historian) and his persuasive relationships with wealthy donors were key elements in the development of the market, which occasionally worked to the detriment of the perennially cash-strapped RIBA Drawings Collection. Further enthusiasm was generated by the growing interest in architectural history as a subject, reflected in the foundation of the Society of Architectural Historians of Great Britain in 1958, inspired by the success of the American Society of Architectural Historians, which had been founded in 1940.

All this ferment of activity encouraged the auction houses to step into the market, accompanied by a growing number of specialist dealers. The first specialist sale by Sotheby's in London in 1979 was following the market,[27] not leading it, and in its wake were sales at Sotheby's New York and Monte Carlo (fig. 10) and in Paris at various firms operating under the umbrella of the Hotel Drouot. Surprisingly perhaps, Christie's in London barely got involved at all, apart from the great coup of the Albert Richardson Collection in 1983 (fig. 11), to which they succeeded in adding material from other sources. Leslie Hindman Auctioneers in Chicago also had some specialist sales, mostly relating to Chicago. One minor London auction house, Onslow's, carved out a niche with several sales devoted to engineers' drawings, particularly relating to railways, bridges, and machinery. All these auctions served the useful function of flushing out a lot of wonderful material otherwise previously languishing in booksellers' attics or on market stalls or with the families of architects. Besides the Sir Albert Richardson sale, two single-owner sales in London were particularly significant: Sotheby's sold the designs for the private apartments at Windsor Castle by Sir Jeffry Wyatville in 1970, and in 1980 architectural drawings related to the life and residences of the 1st Duke of Wellington.[28] But the key players in these years were the dealers. In New York, these were principally Armin B. Allen, the

FIG. 10
Cover of the catalogue of the Sotheby's sale in Monaco on June 17, 1988, featuring an architectural fantasy by Charles Percier. The catalogue contained 125 lots of almost entirely French drawings of the late 17th to early 20th centuries.

FIG. 11
Catalogue cover of the architectural drawings sale held by Christie's, London, in 1983. The sale comprised 132 lots from the Sir Albert Richardson Collection followed by 83 lots from various sources. Five lots of Italian drawings were being sold by the liquidator of Good Golly Products Ltd., a manufacturing company that had bought art works as an investment. The remainder of the sale included material ranging in date from the early 18th century to the 1930s but the majority were decorative 18th-century works. The cover lot depicts the elevation and park plan of the English Palace at Peterhof, Russia, by Giacomo Quarenghi (1744–1817).

Shepherd Gallery and the Artis Group Ltd. In London, there was of course Ben Weinreb, but also Hazlitt, Gooden & Fox, the Clarendon Gallery, Fischer Fine Art, Jeremy Cooper and Christopher Wood (both Victorian era), Gallery Lingard (nineteenth- and twentieth-century drawings), with Yu-Chee Chong (fig. 12) and Henry Potts occupying more specialist niches. Potts dealt from home, exhibiting at fairs or in association with London and New York dealers. He concentrated on a more traditional market of eighteenth- and nineteenth-century British drawings, principally of country houses, while Chong dealt in industrial design drawings. Some of the English dealers had transatlantic linkages, the Clarendon Gallery and Christopher Wood with the Shepherd Gallery, for example, or Hazlitt, Gooden & Fox (fig. 13) and Hobhouse Ltd. with Armin B. Allen, or among themselves, such as Clarendon with Fischer Fine Art in London.

It could become rather confusing, with galleries (and catalogues) in London and New York featuring the same drawings. A number of drawings from the Richardson Collection, for example, crossed and re-crossed the Atlantic in pursuit of a buyer. Fischer Fine Art added to the confusion with their travelling exhibition of architectural drawings and work by Frank Lloyd Wright in 1985.[29] This included loans from private owners and even the V&A, but was largely a selling show that travelled on to the Deutscher Architekturmuseum

FIG. 12
Front cover of the catalogue of *Design Documents: Drawings and Design documentation for the Applied Arts 1840–1940*, issued by Yu-Chee Chong Fine Art, 1990. The cover item was a Fabergé design for a guilloché enamel dish, c.1900. The catalogue included designs for jewellery, cutlery, furniture, interior schemes, textile, ceramics, and gardens, demonstrating the eclectic nature of some of the dealers' stock.

ARCHITECTURAL DRAWINGS MARKET 69

FIG. 13
Titlepage and frontispiece of a 1989 exhibition catalogue by the London dealers Hazlitt, Gooden & Fox, in association with the New York dealer Armin B. Allen. The cataloguing was to the standard of a museum exhibition and was written by the scholar Peter Fuhring.

FIG. 14
Suburban America 1945–1970. Drawings of Buildings and Automobiles which changed the face of American Suburbs. The front cover of this exhibition catalogue written by Frederic A. Sharf illustrates advertising artwork for the Ford Fairlane 500.

in Frankfurt-am-Main, then to Galerie Knoedler in Zurich and Galerie Wurthle in Vienna. Although, at an elite level, museums and dealers do still lend to each other, such a combination of museum-owned objects and items for sale travelling to both a museum and dealers' premises would probably happen rarely today. Several of the specialist dealers produced really scholarly catalogues (fig. 13), with introductions written by such scholars as Sir Howard Colvin and John Harris or freelance curators such as David Hanks and Jennifer Toher. The academic heights were scaled by Peter Fuhring's remarkable and hefty two-volume catalogue *Design into Art*,[30] which described Lodowijk Houthakker's private collection; two of these drawings are now in the May collection (cat. nos. 9.3 and 12.29).[31] Once the catalogue was published, the drawings began to filter back on to the market, until Niall Hobhouse bought the remainder outright. Hobhouse is a dealer but he is also now one of the most important private collectors of architectural drawings internationally and of all periods.

It was sometimes very difficult to know who the collectors were, because they bought through intermediaries, whether from the gallery exhibitions or at auction, where they got dealers to bid on their behalf. Peter May was one such 'invisible' collector operating under the radar then and still. His collection was curated by the remarkable Steve Andrews, to whom this catalogue is dedicated, and his acquisitions at auction were largely fronted by the dealer/decorator Stephanie Hoppen, who was also the intermediary for the acquisition of other items sourced from dealers in Britain and on the Continent.

Other important American collectors were Eugene Thaw,[32] a well-known dealer and philanthropist, and Frederic A. Sharf. Fred Sharf thought like a curator and, although initially attracted to handsome presentation drawings of buildings of the period 1890 to 1940,[33] by the late 1990s was willing to buy complete archives of the post-war years and then work out how to turn them into exhibitions (with excellent catalogues) to be shown in unlikely places. For example, his acquisition of the archive of a minor Californian architect, Vincent Raney (1905–2001), reinforced by related material by Raney's contemporaries, led to *Suburban America 1945–1970. Drawings of Buildings and Automobiles which changed the face of American Suburbs* (fig. 14), shown over six months 2002–03 in the Sharf Admitting Center of the Brigham and Women's Hospital in Boston.

In retrospect, at the risk of shocking the curatorial world, despite the scholarly nature of the dealers' catalogues, despite the effect on the market of such collectors as Paul Mellon, Phyllis Lambert, and, from about 1984, the Getty Research Institute,[34] the engine of the whole historic drawings market was really the interior decorator.[35] From the time the auction houses

came into the market from the late 1970s until 1990, the purchasers of historic materials were too rarely the museums and archives.[36] If you examine the catalogues, whether they be of designs for ornament, machinery, silverware, or buildings, it was the drawings with 'wall power' that sold, not the plans or the material that was historically interesting but without visual appeal. It is also significant that the Sotheby's and Christie's sales already mentioned, of Wyatville and Wellington drawings and the Richardson Collection, presented historic material that was very attractive. Architectural drawings had to work in a frame on a wall, whether it was a perspective for a 1950s power station or an eighteenth-century Russian palace. A group of elegant neoclassical designs by Robert Mylne (1733–1811) for Tusmore Park, Oxfordshire, in southern England, passed from the Richardson Collection at Christie's through Fischer Fine Art to the American designer Bill Blass and were hung in his apartment in New York. All fashions change and about 1989, before the crash that brought down the art market, interior decorators moved on to something else.

In 1989, I was allowed to take a selection of the finest drawings from that year's architectural drawings sale to Sotheby's New York for a week's view. It included an album of 151 former Talman drawings that later sold for £80,000, twice the bottom estimate. I did not realise until later the significance of a remark made to me by a private client who had been a steady buyer until then. "Well, Mr Hind," she sighed, "you have brought over some lovely things, but I don't think I'll be buying this year. My decorator tells me that architectural drawings are passé." The sale did well, but not quite as well as expected. The sale the following year was a disaster and proved to be Sotheby's last. That client's decorator and his fellows had pronounced doom on the market. Between 1991 and 1995, almost all the specialist dealers left the field, on both sides of the Atlantic, and the seemingly endless supply of architectural drawings on to the market dried up as well. The Pearce drawing in fig. 4 above charts the collapse. Offered at Sotheby's in 1992, the estimate was what then seemed a sensible £3–5,000. There were no bids and it was re-offered in 1997 at only £1–1,500. It sold on the reserve at £900 to the only bidder, the RIBA, where, by now, I was Curator of Drawings!

Of course, some drawings continued to appear on the market and found new homes: after Bill Blass's death in 2002, the Mylne drawings returned to England and appropriately enough belong to the owner of a new Tusmore Park.[37] But these days, the significant collectors are confined to the institutions and to two individuals, Niall Hobhouse in Britain and Sergei Tchoban in Berlin. Interestingly, both regard themselves as having a public duty in making their collections available for exhibitions and as resources

for research on the history and nature of architectural drawing, Hobhouse through *Drawing Matter* and Tchoban through his Foundation in Berlin. *Drawing Matter* describes itself as "a public forum for examining the architectural drawing, not only as an object or means to an end but as an active way of thinking about, expressing and making architecture," while the overall aim of the Tchoban Foundation is to present the imaginative and emotionally charged world of architectural drawing to a broad public through regular exhibitions—both a far cry from the closed world of previous private collectors.

POST-WAR ARCHITECTURAL DRAWINGS

The market in post-war architectural drawings was very slow to develop. A key figure was the American dealer Max Protetch, who was very successful in persuading elderly major architects, such as Mies van der Rohe, and their heirs (particularly Frank Lloyd Wright's widow) to sell material from their archives.[38] Two particular coups were the brokering of the archives of Luis Barragan[39] and Aldo Rossi. His stock and connections were widely publicized through a succession of scholarly exhibitions (about five a year) in New York from 1979 to 1989. The market (and indeed the collecting) of late twentieth-century architectural drawings as objects rather than archives was primarily American and north European, missing London almost completely. The key figures in Europe in the 1980s and early 1990s were the Galleria Antonia Jannone in Milan,[40] Aedes: Galerie für Architektur und Raum in Berlin, and Galerie van Rooy in Amsterdam. Interestingly, in a very male-dominated section of the art market, two of the three were run by women and the third was half-owned by a woman.[41] Of the collectors, one of the most significant is Barbara Pyne, who does not interact much with the trade, and consequently her drawings were very largely acquired directly from architects.[42]

The decline in the contemporary drawings market occurred for quite different reasons from those in the historical market. By the 1990s, a number of the architects whose drawing abilities made their work very much aesthetic objects found themselves with too many commissions and insufficient time to draw. The growing use of computers in architects' offices also had a deleterious effect, creating problems for those with traditional views on connoisseurship and attribution. Today, only a handful of older architects still work primarily on paper, Norman Foster in London and Steven Holl in New York, for example. Still only in his sixties is the exceptional draughtsman Eric Parry in London.[43] However, the pendulum has swung away from the extreme prejudice against drawing and

FIG. 15
Giovanni Battista da Sangallo (1496–1548), Reconstruction (plan, front elevation and details) of the Temple of Minerva in the Forum of Nerva, Rome, ca. 1520s (RIBA Collections). This is a leaf from a codex of 43 drawings discovered in an English country house library in 2005, sold at auction in Edinburgh, purchased by a dealer whose request for an export licence was deferred, and subsequently acquired by the RIBA in 2006 for £274,000. Formerly attributed to Raphael, it had last been seen and described in 1760 in the collection of the Jacobite double-agent and collector Philipp von Stosch in Florence.

younger architects are increasingly demonstrating in drawing competitions that what once seemed dying skills are being relearned and once again are an essential part of the design process. Norman Foster has endowed a drawing prize for the RIBA, the old drawings prizes from the nineteenth century having been abolished in the 1960s.

CONCLUSION

From the mid-1990s, the market for architectural drawings fell into three distinct parts, which remain so today. There is still a market, much reduced, for individual drawings from the Renaissance to the 1960s but it helps if a drawing is rare, in first-rate condition and (preferably) has a great provenance (fig. 15). But this applies only to a few items each year and it is quite possible to acquire drawings sold in the 1980s for a lot less than they cost then.[44] Secondly, there are the drawings by today's "starchitects," such as Norman Foster, Frank Gehry, or the late Zaha Hadid. Hadid's reputation is such that her drawings are considered to be as much contemporary art as architectural drawings and are treated accordingly.

Lastly there are the archives. During the 1980s, new institutions were set up to collect contemporary design, including post-war architectural drawings. Among the most active were, in France, the Centre Pompidou in Paris and FRAC Aquitaine in Bordeaux, in Germany the Deutsche Architekturmuseum in Frankfurt, and in Montreal the Canadian Centre for Architecture (CCA). All collect internationally. The Getty Research Institute in Los Angeles still collects both historic and occasionally contemporary material, most recently acquiring by part-purchase and part-donation the archive of Frank Gehry. Most of their acquisitions have come from direct approaches to architects and generous budgets have allowed them to outbid such institutions as the RIBA, which since the 1980s has had a policy of not buying direct from living architects, following the controversial purchase of the archive of Ernö Goldfinger. Fortunately, the RIBA in the last few years has been able to use a particular tax break called Acceptance in Lieu to acquire such key post-war archives as those of Sir Leslie Martin and Sir Denys Lasdun, as well as some important eighteenth- and nineteenth-century collections. The RIBA also received in 2019 by bequest the archive of Sir Colin St Wilson & Partners and its successor practice Long & Kentish, and architects are generous with their donations. In America, a number of institutions have long-standing arrangements with some architects, and thus the Venturi Scott Brown Associates archive went to the School of Design at the University of Pennsylvania, while I. M. Pei's archive is promised to the Library of

Congress. However, the French, German, Canadian, and American purchases from architects have been cloaked in secrecy and it is very hard to assess the state of the market when so few figures are available.

This was an area that the Canadian Center for Architecture and the Getty made their own since they were in a position to outbid anyone else. Phyllis Lambert caused fury in some quarters when she acquired the James Stirling archive and a substantial body of material from Cedric Price, both of which were considered by many to be part of the British patrimony but whose likely purchase price put them well outside what any British institution could afford. But times change and neither the Getty nor the Canadian Center have the resources to compete on the level they once did. However, their activities roused hopes in the breasts of many architects that their archives were worth large sums of money. It helps if there is competition.[45] Some years ago, Rem Koolhaas received what to many people seemed a very generous offer from the Netherlands Architecture Institute in Rotterdam (since 2013 part of Het Nieuwe Instituut) for his archive, which he refused.[46] Most recently, the Archigram Archive, essentially a historic, theoretical, post-war archive rather than a contemporary practice archive, was sold for £1.8 million to M+, the Hong Kong design museum, a prize that many institutions would have liked and a significant cultural loss to the United Kingdom.[47]

Despite the fact that, as far as the dealers and auction houses are concerned, the market for architectural drawings is gloomy and unlikely to change, the climate seems healthier than in the feverish days of the 1980s. Fashion might dictate a change but this seems unlikely in the short term and presently the market is limited to a few private individuals and a greater number of institutions who want material for pleasure and research rather than status. From a museum curator's perspective, long may this continue.

NOTES

1. The largest surviving such collection is for the fourteenth- and fifteenth-century building works at the Stefansdom, Vienna, housed today in the Kupferstichkabinett of the Austrian Academy of Fine Arts.
2. The author's own involvement with the market began in 1986, when he joined Sotheby's to run their architectural and design drawings sales. He has maintained an interest in the market ever since, for both scholarly and professional reasons. This essay is based loosely on a paper given by the author at a conference, *Ascribing Value*, organized by the Royal Institute of British Architects (RIBA) and the Victoria and Albert Museum (V&A) in February 2006, held at the V&A. He is very grateful to John Harris, Curator Emeritus of the RIBA Drawings Collection, for his advice and recollections of the drawings market in the 1960s and 1970s.
3. His collection of drawings was broken up after 1638 and is now spread through many great European and American institutional collections.
4. Now in the Museo Civico, Vicenza.
5. These alternative possibilities will be discussed in the RIBA's forthcoming *Catalogue of Drawings by Andrea Palladio in English Collections*.
6. John Talman certainly made architectural designs, but he does not appear to have built anything. He made a Grand Tour in Europe, including Italy, 1698–1702, and then lived in Italy, 1709–17.
7. The best brief accounts of William and John Talman are their entries in Sir Howard Colvin's *Biographical Dictionary of British Architects 1600–1840* (New Haven and London, 2008). For a variety of contributions on John Talman, see C.M. Sicca, *John Talman: An early-18th-century connoisseur* (London, 2009).
8. Clarke bequeathed the books and drawings to Worcester College, Oxford, where they remain.
9. Since 1775 they have belonged to the Nationalmuseum, Stockholm. The lack of certainty about the size is partly due to the lack of clarity in Tessin the Younger's own catalogue and the amalgamation of other collections with it since 1775 by the Nationalmuseum without adequate documentation as to source. In 1999, the Nationalmuseum initiated the project *Nicodemus Tessin the Younger—Sources, Works, Collections*, which aims at a systematic analysis and publication of the manuscripts and collections of Tessin the Younger, and volumes are still forthcoming.
10. For an overview of the RIBA's collecting in its first century of existence, see J. Lever and M. Richardson, *The Art of the Architect: Treasures from the RIBA's Collections* (1984), pp. 22–23.
11. Although documentation is lacking, the gift to the RIBA the year before he died may have been prompted by Drummond-Stewart's desire to keep the collection together while ensuring that his estranged wife derived no benefit from his estate beyond her marriage portion. His will makes this quite clear. His widow remarried less than four months after his death.
12. This was the case from quite early times and remained so until the 1970s. For example, 44 seventeenth-century designs for church monuments sold by Sotheby's in 1861 for £1/3/- were bought by a dealer called Parsons and finally sold to the V&A in 1898 for £3/10/-. Parsons was the major source of the architectural drawings in the V&A in the nineteenth century, apart from nearly 550 drawings bought privately in several groups from Charles James Richardson in the 1850s and 1860s. Richardson was a pupil of and until his death in 1837 an assistant to Sir John Soane and was a not particularly successful architect. He is remembered primarily as a draughtsman, writer on architectural history and a collector. For a model owned by Richardson, see cat. M1 (1990.10505).
13. The Metropolitan Museum only began collecting architectural and ornament drawings in the 1920s and its first major purchase was in 1934, with the acquisition of a large scrapbook of English drawings containing designs by Robert and James Adam, Sir William Chambers, James Wyatt, and Thomas Hardwick.
14. In the 1920s, the greater part of the Steiglitz collections were transferred to the Hermitage Museum.
15. In the 1950s, they stopped the trade side and concentrated on publishing.
16. Destailleur actually built up two collections. The first he sold *en bloc* to the Kunstgewerbe-Museum in Berlin in 1879, whereupon he began a second and larger collection.
17. Their collections were dispersed at auction in 1891 after the younger Bérard's death.
18. Uncle and nephew seem to have been the only eighteenth-century British collectors of architectural drawings with no professional involvement in architecture, except as patrons. There is no evidence for the manner in which each man collected but, as they only possessed drawings by their contemporaries, one must assume that some at least came direct from architects. Drawings were included in the sales of the libraries of Wren, Hawksmoor, and Gibbs but would most likely have gone first to the bookdealers.
19. The sale was on May 23, 1951. Prices were not particularly high. The total for 59 designs by Wren for London City churches was only £434. According to an online purchasing power converter in February 2019, that would be less than £13,000 today.
20. Appointed to the RIBA Library in 1956 as a library assistant and very soon heavily involved in its Drawings Collection, Harris became its first Curator in 1962.
21. Although it is far from historicist, mention should be made of the Bauhaus collection, assembled with the advice of Walter Gropius, in Harvard's Busch-Reisinger Museum. The archive contains more than 30,000 objects, ranging from paintings, textiles, and photographs to periodicals and class notes, relating to the fourteen years of the Bauhaus's existence in Germany, 1919–33. The archive includes some architectural drawings.
22. For example, *Five Centuries of Drawings* (Cooper Union, 1959), entirely devoted to architecture, ornament, and theatre, *Extravagant Drawings of the Eighteenth Century*, and *The Architect's Eye* (both Cooper Union, 1962).
23. In connoisseur circles, Oenslager was a force to be reckoned with, for, as a designer who had become Professor of Scenic Design at Yale in 1925, he had been building up a magisterial collection for nearly forty years—a collection now in the Pierpont Morgan Museum & Library, New York. In 1963, the American public was introduced to the *Donald Oenslager Collection* by an American Federation of Arts touring exhibition (at ten venues) with a catalogue by Dick Wunder.
24. His collection contains about 1,200 drawings.
25. Even after her collections passed to the CCA, its former director Nicholas Olsberg (in post 1989–2005) recalls the continuing influx of material on a huge scale. In one case a consignment of over 400 drawings was received from Fischer Fine Art.
26. Mary L. Myers, *Architectural and Ornament Drawings: Juvarra, Vanvitelli, The Bibiena Family, and Other Italian Draughtsmen* (New York, Metropolitan Museum, 1975).
27. Apart from the Richardson sale, Christie's in London lagged far behind with only a handful of sales in the late 1980s. The remnants of Richardson's drawings collection were sold by Christie's in the sale of the contents of his former home, Avenue House, Ampthill, Bedfordshire, in 2013 and fetched far lower prices on average than had been reached in 1983.
28. This collection had been placed on long-term loan to the RIBA by the architect Gerald Wellesley, 7th Duke of Wellington (1885–1972) but after his death was withdrawn for sale by his son and successor, the 8th Duke.
29. Frank Lloyd Wright, *Architectural Drawings and Decorative Art*, Fischer Fine Art (London, 1985).
30. Peter Fuhring, *Design into Art: Drawings for architecture and ornament: the Lodowijk Houthakker Collection* (London, 1989).
31. I remember visiting Houthakker in Amsterdam in the late 1980s. He was a stout figure wreathed in cigar smoke and he pulled his collection out of an enormous eighteenth-century Dutch cabinet, before dragging me off to drink neat gin in a gin shop straight out of a painting by Hogarth.
32. He and his wife Clare Eddy Thaw's collection of antique staircase models was donated to the Cooper Hewitt, Smithsonian Design Museum, New York, in 2006.
33. Fred's interests ran to British and American drawings. The walls of his Park Avenue apartment were mostly hung with drawings of New York buildings, while the British drawings were divided between Boston and Palm Beach. The basement of his Boston house was racked out like a museum store.
34. The Getty Research Institute has concentrated on acquiring historic rather than contemporary drawings, with the exception of the Gehry Archive.
35. One instance is Jeffrey Keil, then (from 1985 till its sale ca. 1999) head of Republic National Bank (a Safra bank before its sale to HSBC), who commissioned Jeffrey Hoffeld, a medievalist, to help him form a collection of architectural drawings about commerce to decorate the offices at 425 Park Avenue, designed by MAC II, as Keil told Maureen Cassidy-Geiger. When the bank was sold, the drawings were offered for sale by Stair Galleries in Hudson, NY, which still has some of the unsold framed drawings. Hoffeld's mandate was to collect drawings of retail shops, automobile showrooms, exchanges, and banks, and he traveled extensively to amass the collection.
36. The RIBA, for example, put in a dismal showing at the 1983 Richardson sale, although it bought a number of items later from the trade.
37. Mylne's building was demolished in the 1950s.
38. The best and most entertaining account of Protetch's career is given by Jordan Kauffman, *Drawing on Architecture. The Object of Lines, 1970–1990* (Cambridge, MA, 2018). Kauffman also gives an excellent and well-researched description of the development of the contemporary drawings market in the late twentieth century, upon which I have drawn.
39. The Barragan archive was sold on to the Vitra Design Museum in Switzerland in 1993 and later transferred to the Barragan Foundation.
40. The only one still in business focusing on architecture, but, as Antonia observed to me at an art fair in 2019, not likely to last much longer. "There are no collectors now," she said.
41. Antonia Jannone in Milan, Luce van Rooy in Amsterdam, and Kristine Feiress in Berlin.
42. She is a generous lender of individual drawings and several exhibitions have derived entirely from her collection in London as well as in the USA.
43. His draughting abilities are such that an entire exhibition on his own drawings ran from February to May 2019 at Sir John Soane's Museum, London.
44. A group of British and American architectural drawings, mostly perspectives, were sold anonymously from the late Fred Sharf's collection at Skinner, Marlborough, MA, on January 16, 2019, some for perhaps 10–20% of what they would have cost thirty years earlier.
45. Wealthy institutions have been reluctant to reveal what their purchases cost. The Stirling archive purchased by the CCA was rumoured to have cost nearly £1 million. As the RIBA received the archives of Sir Leslie Martin and Sir Denys Lasdun through a tax break system, their 'real' value was never tested in the marketplace.
46. Koolhaas was offered £900,000 in 2006, in one lump sum for everything to date and in another lump sum against everything the office produced in the future (*Building Design*, issue 1730, July 14, 2006, p. 1). A member of his staff said that they had received a higher offer from the Canadian Center for Architecture in 2004.
47. Despite a vigorous campaign against its export, a licence was granted because the content straddled the fifty-year old divide between material that could be stopped and material that could not. The decision to allow export was taken to avoid splitting the archive and because to some extent, though British in origin, the archive was considered to be international rather than national in its importance.

CARPENTERS AND CRAFTSMEN, ARCHITECTS AND COLLECTORS

A Short History of the Architectural Model

MATTHEW WELLS

WHETHER PHYSICAL OR DIGITAL, MADE TO scale or replicating parts of a building at full size, architectural models have always played a critical role for architects, clients, and the wider public as easily understood representations of two-dimensional designs. Models have served as visualizations of individual elements, such as a staircase or a mantelpiece, or they might present a proposed building, a ruined monument, or a whole city in miniature. Before CAD (computer-aided design; fig. 2) led architects to produce digital models that could be produced through new technologies such as 3D printing, physical models were made by architects from cardboard, plaster, wood, or stone. While particular models might have had an empirical character, by being used to test and develop new structural solutions, most models served as immediate aesthetic and spatial visualizations for clients prior to the construction of a building. By scaling proposed buildings (or portions of their fabric) to a conceivable size, models allow viewers to experience the designs of an architect from multiple viewpoints in a way that is impossible in two-dimensional orthographic or perspective drawings.

From the beginning of architectural culture models have had a dual function. On the one hand they serve as a creative process and allow for communication with non-specialists. On the other, models have often held a ceremonial and political function as three-dimensional testaments to the political visions of individuals, institutions, and states. This representational function can be seen in the traces of material culture from the earliest periods of human civilization, for instance in a series of models from ancient Egypt that can now be seen at The Metropolitan Museum of Art (fig. 3).[1] Alongside this ceremonial role, later in Antiquity models began to take on the task of representing an as yet unbuilt design. For instance, the mention by Herodotus in Book 5 of *The Histories* that a model (or plan) existed for the construction of the Temple of Apollo at Delphi[2] may indicate the use of models as visualizations of buildings in ancient Greece, though most scholars believe the phenomenon emerged during the later stages of the Roman Republic (338–27 BCE).[3] However, archaeological evidence and written sources, such as Vitruvius or Suetonius, do not offer us a clear picture of the primacy, frequency, or practical use of models during Antiquity.[4]

In medieval Europe we can see that models functioned more as a visual tribute than a tool for the conception of a design.[5] Often the motif of a model in the hands of a saint or a patron can be seen in the sculptural program of religious buildings. Particularly prevalent in medieval Rome and the Holy Roman Empire, the representation of a model conveyed the role of the patron or founder in the construction of an edifice and their devotion to the Christian faith (fig. 4).

FIG. 1
Model of a temple in situ in Peter May's office, New York City, beneath his Prosper Étienne Bobin competition drawing for the expansion of the Sorbonne, 1880 (May Collection 1989.220; cat. M2 and 1991.360; cat. 2.17)

FIG. 2
CAD rendering of the May Residence, Palm Beach, Florida, by Ferguson & Shamamian Architects, New York City

FIG. 3
Ancient Egyptian model of a porch and garden, ca. 1981–1975 BCE (The Metropolitan Museum of Art, New York, 20.3.13)

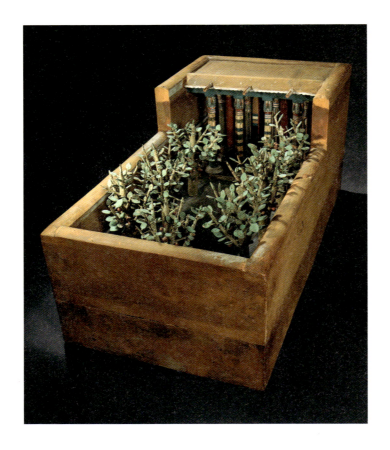

In Renaissance Italy a major change in the use of the model came about due to the reassignment of architectural projects to the municipal authorities rather than the Catholic Church.[6] Formerly, a stonemason was assigned to run the building site on behalf of the Church's authorities. Under the new system, a building site would come under the control of foremen appointed by the guild and selected on the basis of their ability to *think* about buildings rather than the practical ability to *execute* them. These foremen were from different trades, including painters, sculptors, and carpenters. It was in this context that the model as a tool for design emerged in mid-fourteenth-century Florence, with many examples produced of iterative designs for the dome, choir, and piers of the city's cathedral (fig. 5).

It was in this setting that the architectural model was refined and became integral to the design process. Models both allowed 'architects' to develop three-dimensional ideas intellectually and present those ideas visually to building committees.[7] In fifteenth-century Florence, where many important architects had learnt their trade as *legnaioli* (joiners), wooden models were a large part of major public and private building projects, as well as now important records of unbuilt designs (fig. 6). Individuals such as Giuliano da Sangallo made timber models of his designs to illustrate work to clients and provide contractors with accurate directions

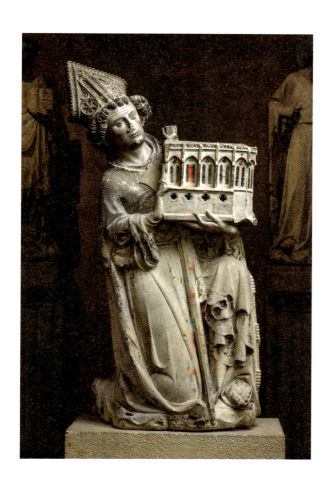
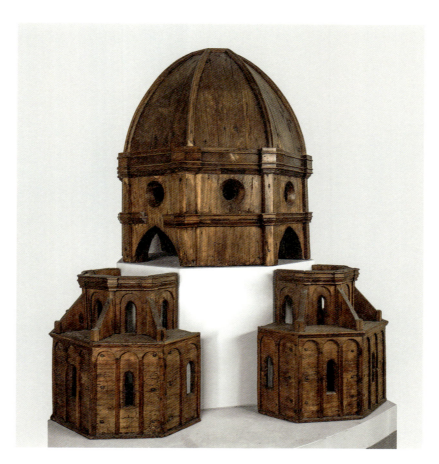

FIG. 4
Maître de Rieux, *Jean Tissendier, Bishop of Rieux-Volvestre*, ca. 1340 (Musée des Augustins, Toulouse)

FIG. 5
Wooden model of a dome, attr. Filippo Brunellesch, ca. 1418 (Museo dell'Opera del Duomo, Florence)

FIG. 6
Jacques Lemercier, Michelangelo's model of San Giovanni dei Fiorentini, Rome, engraving, 1607 (Bibliothèque nationale de France, Paris)

FIG. 7
Model of Palazzo Strozzi, architect Giuliano da Sangallo, 1490 (Fondazione Palazzo Strozzi, Florence)

for construction. For example, the model of Palazzo Strozzi, the only example of one for a private building that survives from this period, could be disassembled both vertically and horizontally to allow views of the interior spaces at each level (fig. 7).⁸ On the facades small timber pieces were added to depict *all'antica* architectural details including the cornice, rusticated blocks, and window details. However, the model of Palazzo Strozzi was a deliberately unfinished work, more akin to a series of possible options for a building that was still in the process of being developed by the architect and patron.

Architects, like artists and scientists, were critical to the representation of status and achievements of the European monarch and his court, designing buildings that expressed a ruler's ambitions and refinement. Consequently, the same individuals began to collect and display both existing and specially commissioned architectural models. In the large imperial cities of the Holy Roman Empire such as Augsburg and Regensburg, special chambers were established to hold and display models. Many of these models were related to the contemporary construction of new fortification structures across Bavaria (fig. 3).⁹ Across Europe, collections of models of towers and fortifications were essential for the military planning of particular cities. The collection assembled for Louis XIV (1638–1715) survives as the Musée des Plans-Reliefs housed in

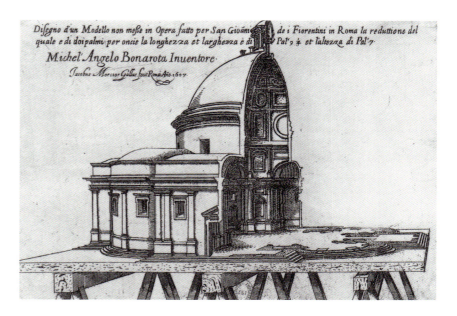
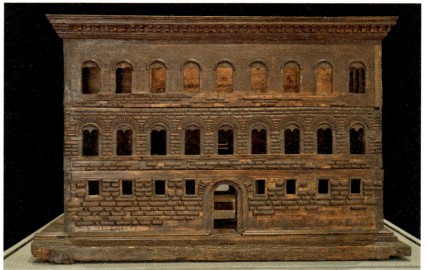

HISTORY OF THE ARCHITECTURAL MODEL 79

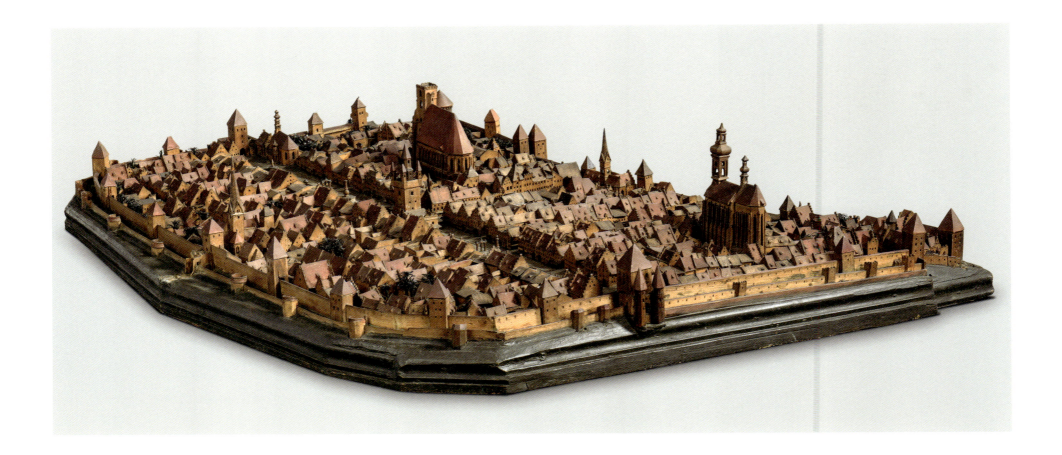

FIG. 8
Jakob Sandtner (model-maker), Model of the city of Straubing, 1568 (Bayerisches Nationalmuseum, Munich)

FIG. 9
View of the Plan-Relief Gallery at the Louvre, 1749 (Bibliothèque de l'Arsenal, Paris, MS 4426)

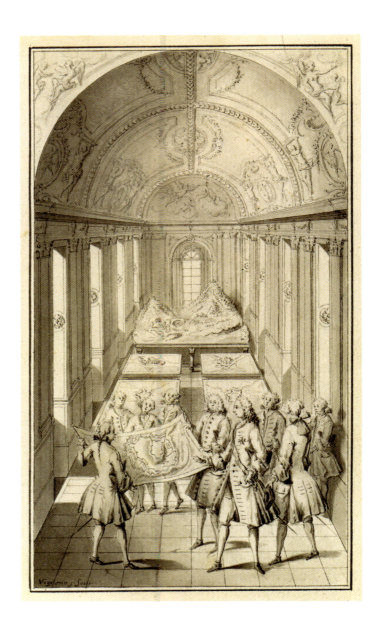

Paris at the Hôtel des Invalides. Often related to newly acquired French towns in Belgium (then Spanish Flanders), the models were 'plans in relief' that showed the urban setting and surrounding countryside within the range of artillery fire. These models had several uses: they enabled the king to assess the strengths and weakness of his kingdom's fortifications, to plan improvement work, and to train the army (fig. 9).

In seventeenth-century France, the repertoire of models extended to complexes of buildings as well as single architectural elements such as staircases and columns presented to clients or to the general public. Civic buildings designed by Louis Le Vau and Claude Perrault, for example, were presented at the Académie royale d'architecture in the form of models to allow an interested public the opportunity to engage with and debate the form of the contemporary city. In contemporary painting and print culture the model took on a representational position as a signifier for architectural knowledge and the discipline's place in society. In Alexander Roslin's (1718–1793) double portrait of Jean-Rudolphe Perronet and his wife, for example, the architect is shown holding a model and a compass (fig. 10). Contained within the Académie's apartments at the Louvre, a collection of teaching models was formed from bequests and donations by architects including Jacques-François Blondel and Jean-Rodolphe Perronet, but it was lost in the French

80 PETER MAY COLLECTION I

FIG. 10
Alexander Roslin, *The Architect Jean-Rodolphe Perronet with his Wife*, 1759 (Gothenburg Museum of Art)

FIG. 11
Jean and Jean-Baptiste Courtonne, *Le Cabinet de Bonnier de la Mosson*, plate 8, *The Physics and Mechanics Cabinet* (detail), 1739–40 (Bibliothèque de l'Institut national d'histoire de l'art, Paris)

Revolution in 1789. As architectural practice became standardized through the Beaux-Arts system, various French treatises discussed the appropriate use of models for contemporary architects. Jean Courtonne's *Traité de la perspective pratique* (Treatise on the practice of perspective drawing, 1725) claimed that models enabled the viewer to perceive the designs of certain buildings more clearly than they could from contemplation of the completed edifice. The model collection of Joseph Bonnier de la Mosson (1702–1744) certainly shows an interest in such visual aids (fig. 11). In the foreword to his *Vie des architectes anciens et modernes* (The lives of ancient and modern architects, 1771), the military engineer M. Pingeron described the particular materials that could be used for model-making—wood (ash, linden tree, walnut), cardboard, plaster, and clay—and their various merits or deficiencies. Claude-Nicolas Ledoux expressed the view that models helped convince an uncertain client to finance construction.[10]

Across Europe and North America many of these ideas surrounding the practical and theoretical uses of architectural models continued until the late nineteenth century, before changes in attitude to the conceptual significance of the model in the twentieth century. Following other artistic disciplines, scale model-making became an art form akin to sculpture, where composition, volumetric relations, and the effects of light and shadow could be examined. New

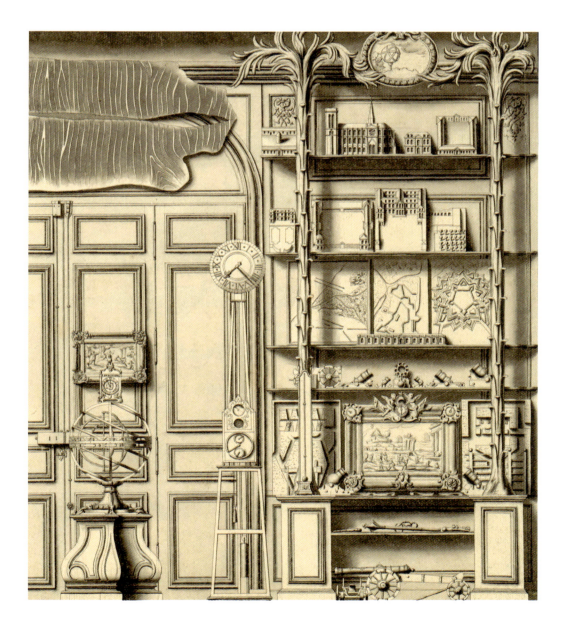

FIG. 12
Model of Seagram Building in transit, photograph, ca. 1957 (Theodore Conrad papers, Avery Architectural and Fine Arts Library, Columbia University)

FIG. 13
Model of the Zinc Mine museum situated in its surrounding terrain, Allmannajuvet, Norway, scale 1:100, styrofoam, charcoal, and modeling clay, 2004 (Kunsthaus Bregenz)

media such as photography and film emerged and, supported by developments in material technologies including Plexiglass (used to simulate the effect of glazed windows), a 'miniature boom' occurred in 1930s America, where the model became a medium of equal standing for both the design *and* presentation of architectural designs. In particular, the work of the model-maker Theodore Conrad, who produced models of the Metropolitan Life Building, Rockefeller Center, and Seagram Building, highlighted the impact that architectural models and their makers had on the buildings and cities of post-war America (fig. 12).[11]

In light of the emergence of digital modelling and fabrication in the twenty-first century, many practitioners have returned to the idea that a physical model remains an important part of contemporary architecture in education, practice, and public relations. At the 2018 Biennale Architettura in Venice, Peter Zumthor presented a 'workshop' of models in the central pavilion of the Giardini della Biennale. Previously Zumthor has noted that the use of the model in his practice has become even more important since the dominance of computer drawing programs in contemporary architecture, because a model can offer him a way of experiencing space and scale during the process of design.[12] In Venice the architect presented a range of projects from across his career with models made from concrete and sand, charcoal and plaster, to describe wooded landscapes, mountainous terrain, and urban quarters (fig. 13). Through their material qualities, production, and conception, these models offer a glimpse of the atmosphere of the projective building. In a return to the theories surrounding the use of models proposed by British and European architects at the end of the nineteenth century, Zumthor's models are tactile objects that are not just a representations of reality but an attempt to portray reality itself.

COLLECTING MODELS

Across Europe and North America there are a number of major collections of architectural models on public display in various institutions. Invariably these collections have always had a didactic role in directing taste and attempting to improve public knowledge of architectural styles. At Sir John Soane's Museum in London, thanks to a 2015 refurbishment, visitors can explore the Model Room (ca. 1835), where John Soane exhibited his collection of plaster, cork, and timber models (fig. 14). By displaying models of Antique subjects as both ruined (cork) and idealized (plaster) buildings alongside models of his own buildings, historians have argued that Soane sought to use the relative effects of scale and materiality in miniature to position himself in the history of global architecture.

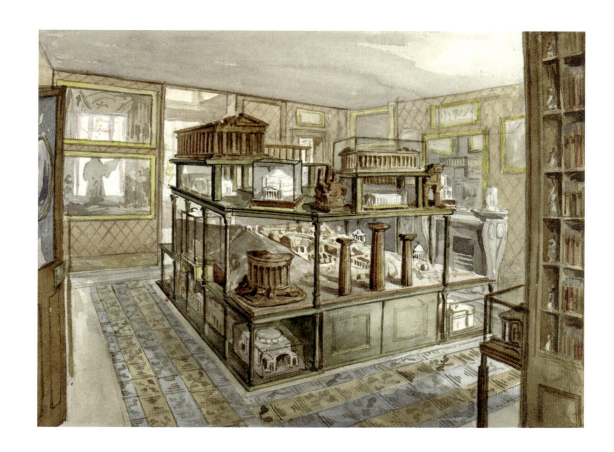

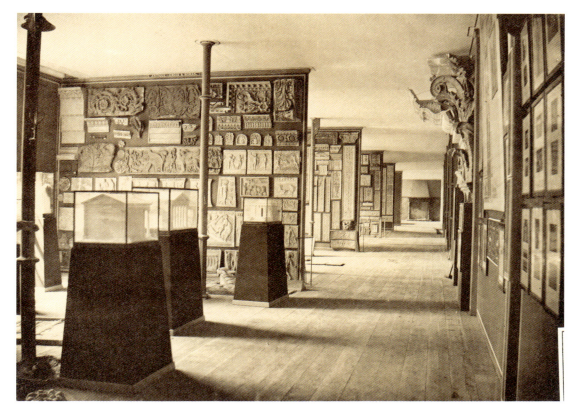

As collections of architectural models came under the direction of state institutions in the nineteenth century, the miniature versions of important buildings were often juxtaposed with stone or plaster fragments of ornament or structure, or with whole building elements. This approach could be seen in London at the South Kensington Museum and in Paris at the Musée national des Monuments Français, where the effect of the display was to historicize architecture to the public (fig. 15).[13]

Alongside the models, cast collections featuring huge fragments of buildings were made possible by new casting techniques developed by Alexandre de Sachy, the chief moulder at the École des Beaux-Arts in Paris 1858.[14] In America in the late 1860s, following the conclusion of the American Civil War, public museums were opened according to European examples and were active in the acquisition of objects, models, and casts for display. Architectural displays were to become a key component of The Metropolitan Museum of Art and the Carnegie Museum of Art. The businessman Levi Hale Willard bequeathed a large sum of money to the Met in 1883 for the establishment of a permanent Architecture Museum, to encourage popular interest in the subject. Pierre Le Brun was appointed to oversee Willard's bequest. Highly critical of the architectural models on display in European museums, Le Brun commissioned a number of plaster models of Antique buildings (and

FIG. 14
C. J. Richardson, Model Room at Sir John Soane's Museum, 1834–35
(British Library, London)

FIG. 15
Museum of Ornamental Art, South Kensington Museum, ca. 1857
(Victoria and Albert Museum, London, MA/32/804, Guard Book)

FIG. 16
The Metropolitan Museum of Art, Architecture Hall, 1910 (source: Mari Lending, *Plaster Monuments*, 2017, pp. 118–19)

Notre-Dame Cathedral) at a variety of scales, under the supervision of the noted architect and archaeologist Charles Chipiez. Presented in a purpose-built Grand Hall with an iron and glass roof in November 1889, each of the models was installed on a pedestal with wheels in order to move them around the gallery and contextualize the full-sized plaster casts of the buildings they represented (fig. 16).

In addition to public interest and taste, models formed part of a didactic method of education as architecture became a university subject. In London at King's College, the British architect and historian Banister Fletcher gathered a collection of structural models for the students for the purpose of providing practical support for the students' education. In Munich, at the foundation of the architecture school at the Polytechnische Schule (now TU Munich) in 1868, several large cork models were lent to the school by King Ludwig I. With drawings, cork models and plaster casts arranged in a series of study rooms, the purpose of the model collection was to provide students with examples for copying Antique and classical designs (fig. 17). While many of the models in Britain and Europe were deaccessioned from teaching collections in the 1920s, in the post-war era an Architekturmuseum was formed at TU Munich, with a focus on both contemporary and historical architecture.

Later in the twentieth century, in the 1980s, the conceptual role of models continued to be explored through the interaction of artists and architects. For instance, artists such as Ludger Gerdes and Thomas Schütte produced scale models that did not present a proposed or existing building, and in doing so questioned the value and role of the medium itself.[15] Similarly in works such as *Things from the Room in the Back* (1999–2000) the Swiss artists Peter Fischli and David Weiss adopted the 1:1 scale model in an idiosyncratic manner, questioning the way models and their materials simulate reality and our assumptions about the nature of objects. Also in the 1980s, with the foundation of new architecture museums in Frankfurt (Deutsches Architekturmuseum, DAM) and Montreal (Canadian Centre for Architecture, CCA), new collections of architectural models have become available for public enjoyment. The first director of the Deutsches Architekturmuseum, Heinrich Klotz, was well known for his mission to save models from the rubbish bin and accession them into the collection.[16] The Canadian Centre for Architecture has an ever-growing collection, has supported excellent research, and stimulated public interest in the architectural model. Today in the recently opened Architecture Gallery at the Victoria and Albert Museum (as the South Kensington Museum is now called), models are a key part of the museum's curatorial strategy. As objects

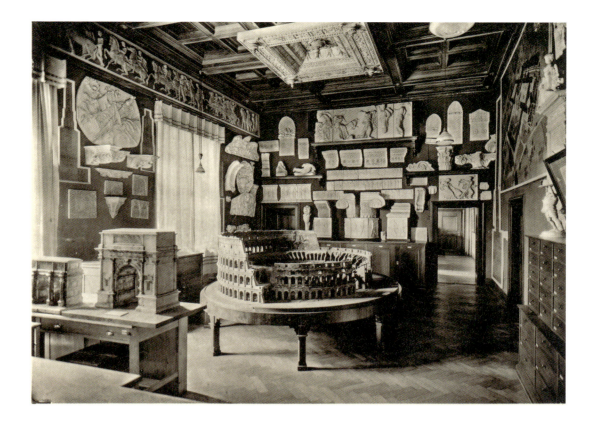

the models allow the public to comprehend buildings from around the world that for reasons of size and site-specificity cannot be present in the gallery. Additionally, by providing a three-dimensional visualization the models support public understanding of how to 'read' the original architectural drawings on display.

More recently there has been increased interest in the practice and role of the model-makers themselves. The Avery Library at Columbia University has recently acquired Theodore Conrad's archive, which includes photographs of models, account records, and press clippings. In Britain the Thorp Modelmakers archive is in the process of being consolidated, with John Thorp, as well as his wife and son, key players in the development of both model-making techniques and modern architecture in Britain and its overseas territories (fig. 18).

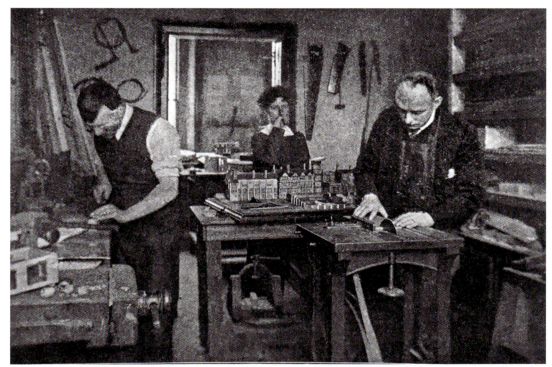

FIG. 17
Arrangement of plaster casts and cork models in the rooms of the architecture school at Gabelsberger Strasse (Architekturmuseum der TU, Munich)

FIG. 18
Illustration to Percy Collins, 'Old London: Mr Thorp and his models,' *Pall Mall Magazine*, June 1912

PETER MAY COLLECTION

Several examples in the May Collection exemplify the potential role and function of architectural models in both design practice and the history of collections. Peter May has been collecting models for several decades and has amassed some two dozen examples from around the world. These include models made from a wide variety of materials, including timber,

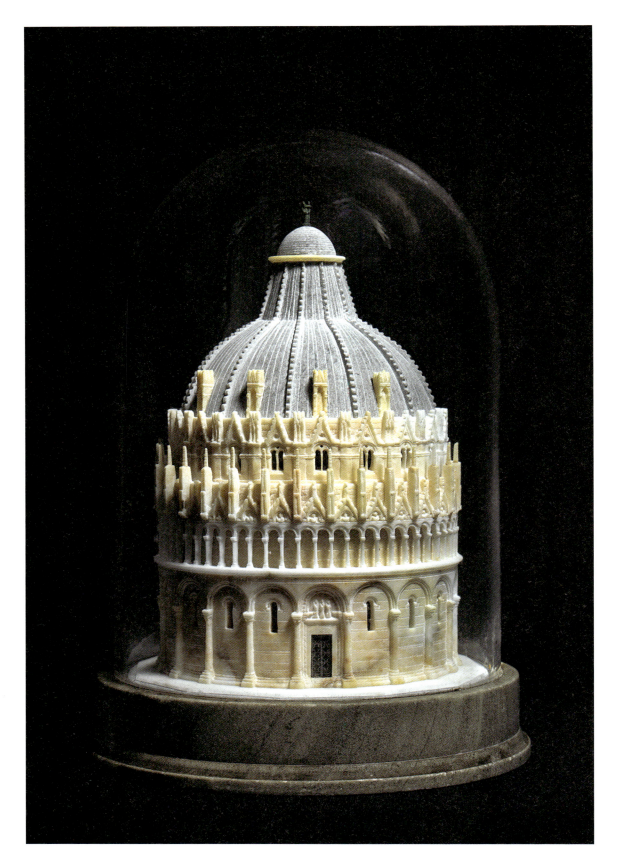

FIG. 19
Unknown maker (Italian), Model of the Baptistry at Pisa, ca. 1900 (May Collection 1990.263; cat. M12)

cardboard, plaster, alabaster, and iron. The Collection features models fabricated by both professional and amateur model-makers, young architects in training, cabinet-makers, joiners, and ornamental sculptors. In their original context the models functioned in a variety of ways, including the visualization of proposed designs, exercises to show a cabinet-maker's skill, furniture, souvenirs, and collector's items.

The alabaster model of the Baptistery at Pisa is a classic example of a Grand Tour souvenir (fig. 19). For eighteenth-century Europeans, visits to the sites of Antiquity in Europe and Western Asia were an essential part of upper-class society and artistic education. Visitors on their Grand Tour purchased models of legendary monuments in Italy, Greece, and the Middle East.[17] The Baptistery model shows us how a Grand Tour souvenir could provide an 'authentic' and elegant representation of a foreign building for a visitor returning home, complete with a glass dome to protect the item when displayed in an owner's study or library. In eighteenth-century Britain similar models appeared at the meetings of various learned societies and in the British Museum, in private displays, and in the Royal Collection. Historic photographs offer a portrayal of the way architectural models were displayed within the domestic setting of a typical English Country House (fig. 20).

While cork was often used to portray buildings in ruin, plaster models were used to show Antique and

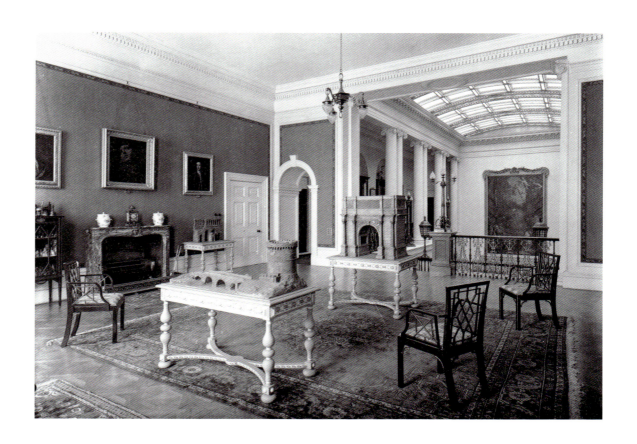

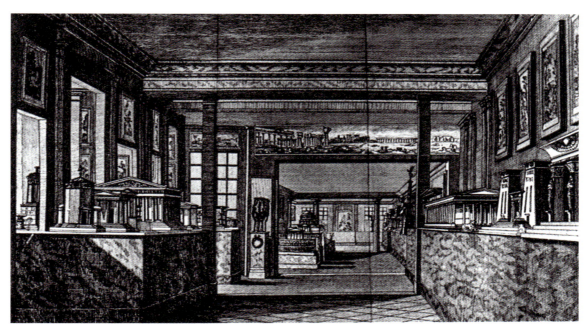

neoclassical buildings in an almost perfect state. In Paris the father and son model-makers Jean-Pierre and François Fouquet produced plaster-of-Paris models of contemporary designs for many architects, including Thomas Jefferson's 1786 design for the Virginia State Capitol at Richmond. Later, with a further expansion in the marketplace for models as decorative art objects, Jean-Pierre Fouquet produced seventy-six models of Antique buildings in cork and plaster for the collector Louis François Cassas, who exhibited them at his gallery in Paris (fig. 21).[18] Newly established institutions such as the École des Beaux-Arts in Paris or the Bodleian Library in Oxford purchased sets of Fouquet models for didactic purposes. Today examples of Fouquet models survive in Sir John Soane's Museum and in the collection of the Royal Institute of British Architects (which can be seen in the Architecture Gallery at the Victoria and Albert Museum).

Driven by the pure-white aesthetic of the Fouquet models, two model-making dynasties emerged in nineteenth-century Britain, the Days and the Mabeys. Although both dynasties were from sculptural backgrounds, Richard Day appears to have devoted himself to producing architectural models in plaster, exhibiting several times at the Royal Academy. His son, Richard Day junior, took on several of his father's commissions at his death in 1849 and went on to exhibit several examples of his work in the 1851 Great Exhibition. On the other hand, the Mabey dynasty (James, Charles Henry, Charles Henry Junior) were primarily ornamental sculptors who worked on decorative schemes for many buildings in London, including the Palace of Westminster, Hammersmith Bridge, and County Hall. Alongside stone carving and interior mouldings in plaster, the Mabeys also produced scale models for architects, including Charles Barry, Sydney Smirke, and Owen Jones.[19] Much of the work undertaken by Day, Mabey, and countless other unknown sculptors in the eighteenth and nineteenth centuries would have been to produce models of decorative elements for aristocratic patrons. Later these items would become decorative art pieces

FIG. 20
Cork models on display at Ickworth House (Suffolk), UK, *Country Life*, 1925 picture archives)

FIG. 21
Exhibition of the architectural models of Jean-Pierre Fouquet in the gallery of Louis François Cassas, ca. 1806

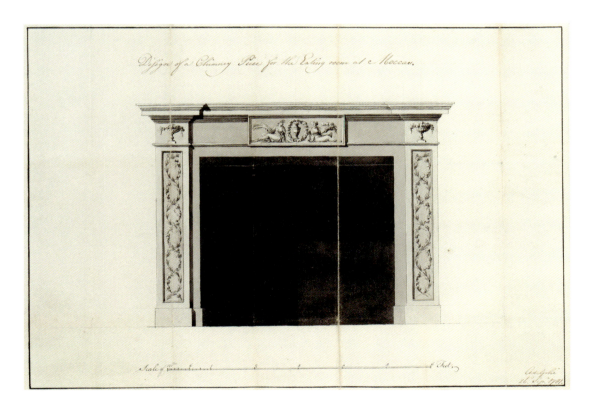

FIG. 22
Unknown maker, Model of a mantelpiece, late 18th–19th century
(May Collection 1990.287; cat. M9)

FIG. 23
Robert Adam, Presentation drawing for a mantelpiece for the Circular Room at Moccas Court, Herefordshire, UK, 1781
(May Collection 1991.389; cat. 9.5)

appealing to collectors. In the May Collection there are two good examples of this sort of practice. In addition to drawings of ornamental elements such as the mantelpieces by Robert Adam for Moccas Court in Herefordshire (fig. 23 and cat. 9.5), cast-plaster models were used to show patrons the three-dimensional relief and ornamental surface treatment proposed by their architects and craftsmen (figs. 22–23).

Other types of plaster models, such as that of an unknown classical facade with Ionic pilasters (fig. 24), were built from layers of plaster and separately cast elements applied to a thin, often lightweight timber base. Clearly produced by a highly skilled craftsman, this model shows the depth of relief on the facade, as well as the elaborate mouldings, cornices, and decoration around the two openings. Despite its representation of the facade at scale, the model aims for a level of reality in its depiction: lines have been incised on to the surface to indicate the coursing of individual stones, and blue-grey strokes have been applied to the surface to describe the marble of the real building naturalistically. Whether a scale model should aim to represent the building's materials in a realistic way is one of the recurring issues in the production and function of models: while notable individuals including Leon Battista Alberti, John Soane, and Mies van der Rohe all discussed this issue in their own writing and designs, there has never been a consensus on the question among architects.

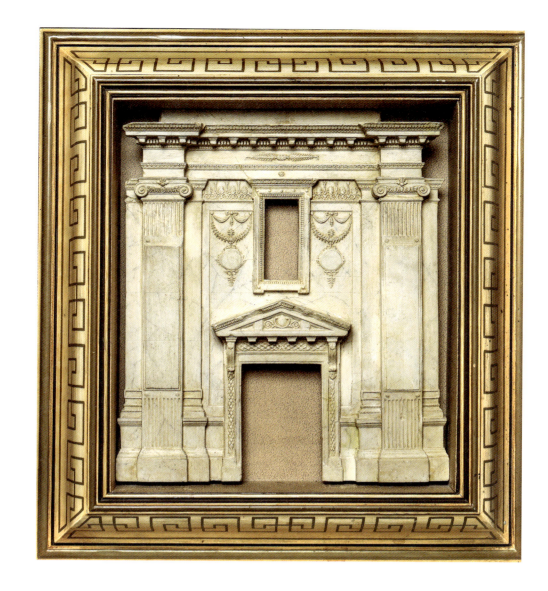

As a rule, however, the detail and material depiction of a model is usually decided by its function and scale. It goes without saying that in a large-scale model more detail can be provided, while a small-scale model of a city may often rely on a uniform material or color to provide clear information on the layout of urban blocks, roads, or parks. We can see the relationship between scale and detail in a model of a chicken or poultry house by William Hayward Brakspear and William Sidney Brakspear for Bow Manor, Sale, near Manchester (fig. 25).[20] In nineteenth-century Britain architects would often design not simply lavish country houses for clients but also the layout of stables, dairies, and other pieces of essential agricultural infrastructure.[21] Surviving models that attest to these concerns can be found in the Royal Collection at Osbourne House, Isle of Wight (two models of a dairy by George Devey) and in the National Trust's collections at Scotney House, Kent (the model of a house and outbuildings by Anthony Salvin).[22]

Many nineteenth-century British architects used model-making materials as signifiers to denote particular building materials such as tiles, bricks, and stone. This approach was instigated mainly for the sake of clients of the period who could neither understand architectural drawings nor the building contracts that detailed the method and form of construction.[23] Model-making techniques and methods became codified

FIG. 24
Maker unknown, Model of a classical façade, late 18th–19th century, in a modern frame (May Collection 1993.10684; cat. M10)

FIG. 25
William Hayward Brakspear and William Sidney Brakspear, Model for a chicken house for Bow Manor, Sale, Cheshire, UK, ca. 1860 (May Collection 1991.374; cat. M8)

FIG. 26
Pattern for a residential building
Heinrich Rockstroh, *Anweisung zum Modelliren aus Papier*, Weimar, 1802, plate XV

through handbooks, initially from continental Europe, which echoed the import of anatomical models to Britain from Italy, France, and Germany in the early nineteenth century (fig. 26). Later in the nineteenth century, in response to the emergence of architectural assistants who in preparation for professional practice required practical knowledge of model-making, manuals were published in Britain that discussed techniques, material choices, and presentation styles.

Following the example set by these manuals, in the model of a poultry house (fig. 25) we can see how cardboard has been painted and cut in different ways to depict the tiles and fascia of the building's roof. Sand has been mixed with homemade glue and applied to a timber structure in order to portray the rough external walls of the poultry house.[24] While many of the manuals advised using sheets of mica purchased from a pharmacy to make windows, here the model-maker has laid a series of diagonal window bars in paper over a black sheet of cardboard. The model remained in the family until 1991, when it was sold alongside another Brakspear model, of St. Paul's Wesleyan Church, Bowdon, Cheshire, at Sotheby's in London.[25] The sale catalogue recounted that the model of St. Paul's was made by one of the architect's sons, William Sidney Brakspear, a typical turn of events for a young assistant learning to be an architect in the nineteenth century.[26] It is highly likely that the model of the poultry house was also another example made by William Sidney Brakspear as in the course of his professional training he learnt how to represent his designs in three dimensions.

Also to be found in the May Collection are a pair of elegant timber staircase models. Operating in between the disciplines of architecture and the decorative arts, this type of model was the consequence of the formalized guild system in France (and parts of central Europe) known as *compagnonnage*.[27] Within this system apprentices in carpentry, cabinetmaking, and joinery learned technical skills in the workshops of accomplished craftsmen during the day and studied design through drawing classes in the evenings. Handbooks on orthographic drawings and woodworking techniques supported this training. Once students had mastered the basic skills they were required to produce a timber model of a staircase in order to provide evidence of their abilities and commitment, in the hope of being taken on as an apprentice in one of the guilds. If accepted, apprentices would then undertake a four- to seven-year tour of master craftsmen in major French cities, learning different skills at each atelier. At the end of the *compagnonnage* process, an apprentice had to produce a *maîtrise* (masterpiece), which exhibited a highly sophisticated level of design and craftsmanship, in order to achieve the title *compagnon du tour de France* (French master artisan).

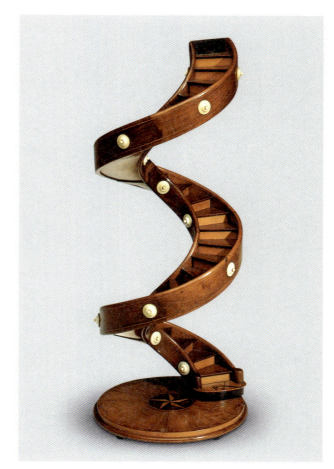
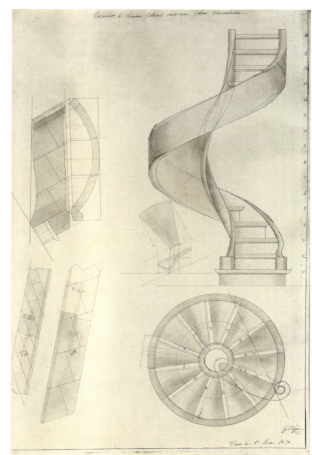

One of the *compagnonnage* pieces is a timber depiction of a spiral staircase made in Marseille by Honoré Touranjou in 1839 (fig. 27). From a circular polished timber base, a spiral staircase snakes upwards, formed from a precise set of timber pieces with white ivory flourishes on the external face of the stair's stringer. The other, an anonymous and undated nineteenth-century example made in walnut, portrays an imperial staircase: a single run of seven steps leads to a half landing from where the stair splits, curves, and curls upwards on two sides joined by single piece representing the upper landing (fig. 29).

Several examples of this type of model can also be found in the Cooper Hewitt Smithsonian Design Museum, thanks to the donation of Eugene and Clare Thaw's collection in 2006. Each staircase model took a significant amount of time to complete, at great financial cost to its maker, and these examples reveal two important aspects about the function of architectural models. First, although orthographic drawings would have been hugely important in assisting the apprentice to make a staircase model, drawings do not so effectively communicate such highly complex three-dimensional forms, which cannot easily be represented by the conventions of parallel projection (fig. 28).[28] However, as three-dimensional representations that can be moved around, studied, and explored by viewers, models are better suited for

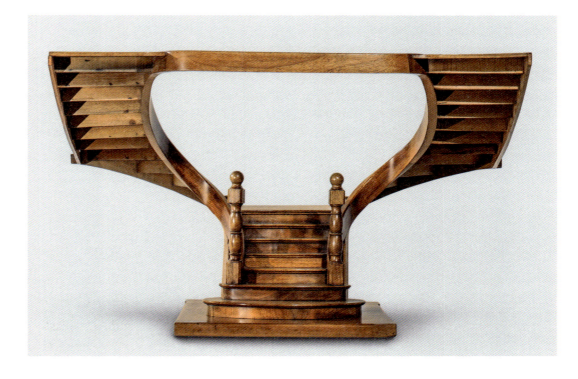

FIG. 27
Honoré Touranjou, Model of a spiral staircase, 1839 (May Collection 1989.201; cat. M7)

FIG. 28
Charles Ulysse Goureau, Construction drawing of a spiral staircase, 1870 (May Collection 1989.217a; cat. 10.6)

FIG. 29
Unknown maker (French), Model of an imperial staircase, 19th century (May Collection 1989.218; cat. M6)

FIG. 30
Masterpiece (*chef-d'œuvre emblématique*) from the Confraternity of Carpenters *compagnons* displayed outside the Les Charpentiers restaurant, Paris, ca. 1900

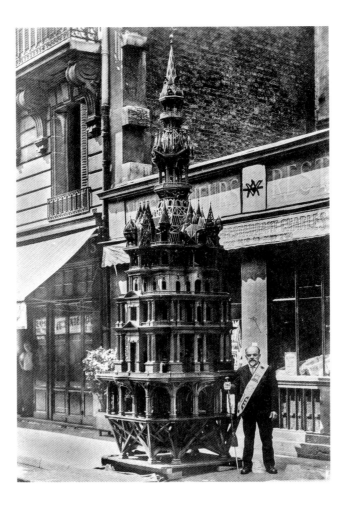

this purpose. Second, and developing on from the first idea, these models were a part of the demonstration of a master artisan's style, approach, and identity. Despite their beautiful confirmation of a maker's skill, making a model is not the same as making a 'real' staircase nor is a model an exact demonstration of the ability to make a staircase. For instance, the construction of joinery and the tensile strength of timber are different at a reduced scale. Equally if the demonstration of ability was the aim then this could be achieved in a manner more closely related to practice through the presentation of a scaled construction drawing, of examples of joints, and of full-sized samples of work. Instead these objects had a rhetorical or performative function in contemporary society. Once completed, often the models were carried in public parades that were a part of defining the *compagnonnage* system, its members, and the boundaries of artistic knowledge within local and national communities (fig. 30).

Today there is a new-found appreciation and appetite for architectural models, though this was not always the case. Despite encouraging donations from individuals or actively procuring examples themselves, in the early twentieth century museum curators focused instead on other kinds of objects at the expense notably of eighteenth- and nineteenth-century architectural models, which were often moved into storage, given away, or, occasionally, destroyed. In the twentieth century a large number of historic architectural models were lost. However, the marketplace for historic architectural models has changed considerably over the past thirty years. Notable private collectors including Peter May have been actively acquiring models that depict a wide range of subjects or were used for a wide range of purposes. The latter category includes examples such as the model-cum-cabinet (cat. M3) that represents an Ionic temple, from which various panels can open to reveal cupboards and drawers.[29] New scholarship on the history and conservation of architectural models has begun to explore the actors and processes behind their construction. Prominent temporary exhibitions and the re-establishment of permanent displays have fuelled public interest in the form. Prior to construction, through the powers of abstraction and miniaturization, the production of models allows buildings and monuments to be comprehended, understood, and discussed by a wide range of individuals and social groups. Despite advances in computer-generated images, physical models are used throughout the world to project future buildings in exhibitions, classrooms, and developers' marketing suites from Dubai to Dalston, San Francisco to Singapore, Manhattan to Mumbai.

NOTES

1. Split equally between the collections of The Metropolitan Museum of Art and the Museum of Egyptian Antiquities in Cairo are a series of twenty-four models from c. 2000 BC. Discovered in 1920, these models were found in the tomb of Meketre, a royal steward, and depict a garden, stables, and granary. Their probable role was to provide the deceased with a comfortable afterlife. Other ancient societies also used models in a similar manner. Across Mesoamerica from the Classic period until the arrival of Europeans in the fifteenth century artists produced small-scale architectural models to be placed in the tombs of important individuals. See Joanne Pillsbury, Patricia Joan Sarro, James Doyle, and Juliet Wiersema, *Design for Eternity: Architectural Models from the Ancient Americas* (London and New Haven, 2015).

2. Herodotus, *Histories*, trans. A.D. Godley (Cambridge, MA, 1920), III, p. 63: "Since they were wealthy and like their fathers men of reputation, they made the temple more beautiful than the model showed. In particular, whereas they had agreed to build the temple of tufa, they made its front of Parian marble."

3. In particular scholars cite the example of scale models of temples discovered in Ostia near Rome (1st century BC) and Niha in Lebanon (2nd century AD).

4. Despite this, historians have identified a series of functions for architectural models in antiquity including ritual and votive uses that required the depiction of existing structures in miniature. See Lothar Haselberger, "Architectural Likenesses: models and plans of architecture in classical antiquity," *Journal of Roman Archaeology* 10 (1997), pp. 77–94; Pierre Gros, "De l'exemplar vitruvien à la maquette d'un stade de la Villa Hadriana : formes et finalités du 'modello' dans la pratique des bâtisseurs romains," in Sabine Frommel and Raphaël Tassin, eds., *Les maquettes d'architecture : fonction et évolution d'un instrument de conception et de realisation* (Paris and Rome, 2015), pp. 15–24.

5. However, we know of some physical models being used as full-sized prototypes to help visualize a building's cornices or ornamental details before construction.

6. Andres Lepik, *Das Architekturmodell in Italien: 1353–1500* (Worms, 1994).

7. For ease I use the word 'architect' here to mean the individual responsible for the conception of the design and the supervision of its construction on site. As I described in the previous paragraph, these individuals came from different backgrounds and these disciplinary backgrounds affected how they conceived architecture, with sculptors and carpenters more likely to produce models as a part of their experience of the plastic arts. The classic study of the architectural profession is Spiro Kostof, ed., *The Architect: Chapters in the History of the Profession* (New York, 1986).

8. For a broader and deeper discussion of this model and the documentation that survives for it see Amanda Lillie and Mauro Mussolin, 'The Wooden Models of Palazzo Strozzi as Flexible Instruments in the Design Process,' in A. Belluzzi, C. Elam, F. Paolo Fiore, eds., *Giuliano da Sangallo* (Milan, 2017), pp. 210–29.

9. In a period when the traditional gothic language of northern European architecture was augmented by classical detailing, in sixteenth-century Augsburg wooden construction models of towers and fortifications were used to communicate between the various parities responsible for military planning, the built representation of the city, and the construction itself. In nearby Nuremberg the painter and wood-carver Hans Baier produced a large-scale model of the city for the municipal authorities in 1540. Most likely produced in relation to the contemporary construction of new fortification structures, the model is on display at the Bayerisches Nationalmuseum in Munich, where it can be seen alongside a series of similar timber models made by Jakob Sandtner between 1568 and 1574 for the other key towns of the principality of Bavaria (Straubin, Munich, Landshut, Ingolstadt, and Burghausen). Sandtner also made an urban model, of an idealized version of Jerusalem, which can be seen alongside the other examples in Munich.

10. For a discussion on this see Michel Gallet, *Claude-Nicolas Ledoux (1736–1806)* (Paris, 1980).

11. Recent work by Teresa Fankhänel has brought attention to the importance of the model-maker Theodore Conrad and his role as an active player in the development of American twentieth-century architecture. See Teresa Fankhänel, "Introducing Theodore Conrad, or Why Should We Look at the Architectural Model Maker?," in Sabine Frommel and Raphaël Tassin, eds., *Les Maquettes* (Paris and Rome, 2015), pp. 259–68. See also her forthcoming book on the topic, Teresa Fankhänel, *The Miniature Boom: A History of American Architectural Models in the Twentieth Century* (London, 2020).

12. For further discussion on these ideas I would encourage the reader to consult Mathieu Berteloot and Véronique Patteeuw, "Form / Formless: Peter Zumthor's Models," *OASE* 91 (2013), pp. 83–92, which can be read online or downloaded as a PDF.

13. For the best discussion of nineteenth-century casts as a part of architectural culture see Mari Lending, *Plaster Monuments: Architecture and the Power of Reproduction* (Princeton and Oxford, 2017).

14. Both de Sachy and his successor Eugène Arrondelle also worked in Britain, where de Sachy introduced in a workshop in Soho the technique of making fibrous plaster casts, a technique he subsequently patented. It was well known, however, that the casting process (moulding) affected the fragile surfaces of the buildings and sculpture being copied. On several occasions the gold leaf of Ghiberti's doors to the Florence Baptistry was damaged. By the end of the nineteenth century the British Museum had banned reproductions of many of its original monuments, much to the disappointment of American museum directors keen to acquire casts for their own collections.

15. Martin Hartung (ETH Zurich) and Stefaan Vervoort (Ghent) are exploring this territory in their individual doctoral work. For initial findings on the topic, see Stefaan Vervoort, "The Modus Operandi of the Model," *OASE* 84 (Spring 2011), pp. 75–81.

16. The first model saved was one of Ludwig Mies van der Rohe's Toronto Dominion Centre, which Klotz reported preserved in Spring 1969 and which became a key part of his desire to form an architectural museum: Heinrich Klotz, "The Founding of the German Architecture Museum," *Architectural Design* (1985), pp. 5–7.

17. Models such as these were first produced by individuals such as Giovanni Altieri (1766–1802), a Neapolitan craftsman, and later Richard Du Bourg, the London-based model-maker who both sold his work and held a spectacular exhibition of models for London society at the end of the eighteenth century. For more details see Richard Gillespie, "Richard Du Bourg's 'Classical Exhibition', 1775–1819," *Journal of the History of Collections* 29, 2.1 (July 2017), pp. 251–69.

18. For a discussion on the Fouquets and the exhibition see Geneviève Cuisset, "Jean Pierre et François Fouquet. Artistes modeleurs," *Gazette des Beaux Arts* 115 (May/June 1990), pp. 227–57.

19. Two of the three models for the Palace of Westminster survive in the Parliamentary Collections; these are currently on exhibition in the Architecture Gallery at the Victoria and Albert Museum.

20. Little is currently known about Brakspear's work at Bow Manor.

21. In many ways these architects were following advice from their seventeenth-century forefathers such as Roger Pratt, who provided extensive notes on the way a country house should be arranged and designed through models and with careful consideration of economic efficiency. See Simona Valeriani, "Learning about Architecture and Building in seventeenth century England. The case of Sir Roger Pratt," in *Koldewey-Gesellschaft: Bericht über die 45. Tagung für Ausgrabungswissenschaft und Bauforschung* (Stuttgart, 2010), pp. 127–36.

22. In particular Devey's models, like Brakspear's poultry house, should be noted, as they conform to the advice set out in the fifteenth century by Alberti that an architectural model should be made with plain materials in order to communicate clearly the form of a proposed design, rather than emphasizing the quality of production.

23. While I would offer this as an overall viewpoint, I should include the caveat that many clients, often well-educated members of the upper classes, were able to understand and often produce orthographic drawings. Examples of this sort of client include Edward Hussey III at Scotney Castle and Robert Holford at Dorchester House and at Westonbirt House, where as well as their discussions with the architects both individuals had a close relationship with the model-makers involved. Both viewpoints will be discussed and explored further in my forthcoming monograph on the topic of nineteenth-century architectural models in Britain. I have already published Matthew Wells, "Relations and Reflections to the Eye and Understanding: Architectural Models and the Rebuilding of the Royal Exchange, 1839–44," *Architectural History* 60 (2017), pp. 219–41.

24. These sorts of materials present a challenge for the current generation of conservators, as the study of historic model-making techniques is one important method of analysis used in contemporary conservation protocols. Due to their size, structural weaknesses in their construction, and the degradation of unstable materials, models are susceptible to damage or destruction. A collection might have to contend with conserving numerous materials in the same model, including wood and metal, paper and plastic, textiles, natural and synthetic glues.

25. *Eighteenth & Nineteenth Century British Drawings & Watercolours*, Sotheby's sale catalogue (April 11, 1991), lot 104; for a discussion of the St. Paul's model see Tim Knox, "Ecclesiastical models," *RIBA Journal* 99.8 (August 1992), pp. 30–31.

26. In one form or another the Brakspear architectural dynasty continued until the death of Sir Harold Brakspear (William Hayward Brakspear's youngest son) in 1934.

27. For an extensive account of these models see Sarah Coffin, *Made to Scale: Staircase Masterpieces, The Eugene and Clare Thaw Gift* (New York, 2018).

28. While French and British civil engineers had adopted the axonometric drawing at the end of the eighteenth century, its role was limited by the medium's inability to show multiple viewpoints in one image or mechanical assemblages rather than complicated three-dimensional forms.

29. With its sophisticated and ingenious system of opening and well-made joints, this item is almost certainly the work of a cabinet-maker rather than a model-maker. Mounted within one drawer is a print of the now demolished Independent Chapel on the East Parade in Leeds, annotated with "Mr. Hare, Surgeon," perhaps suggesting that the object was used to store medical supplies and instruments in a surgeon's practice.

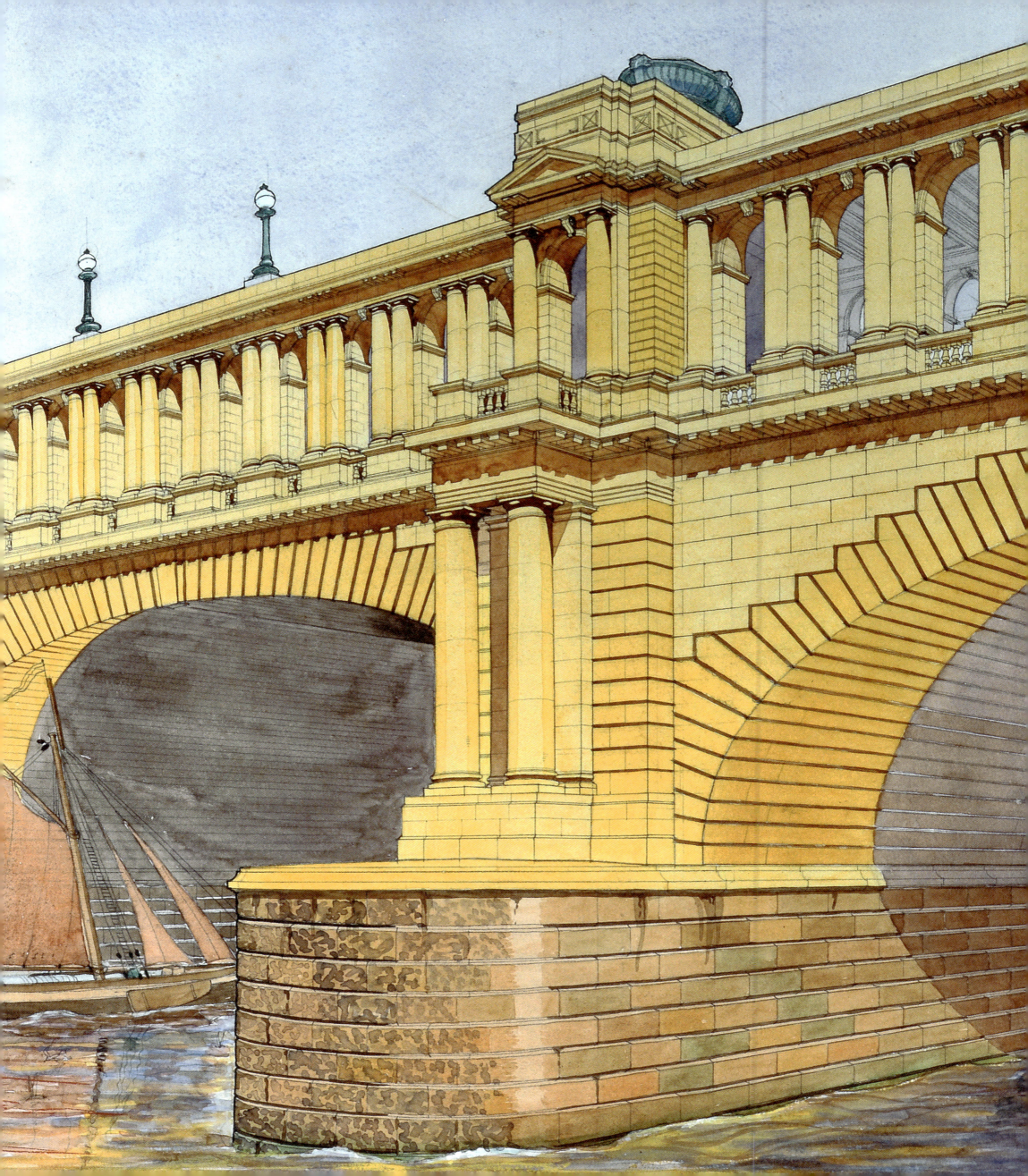

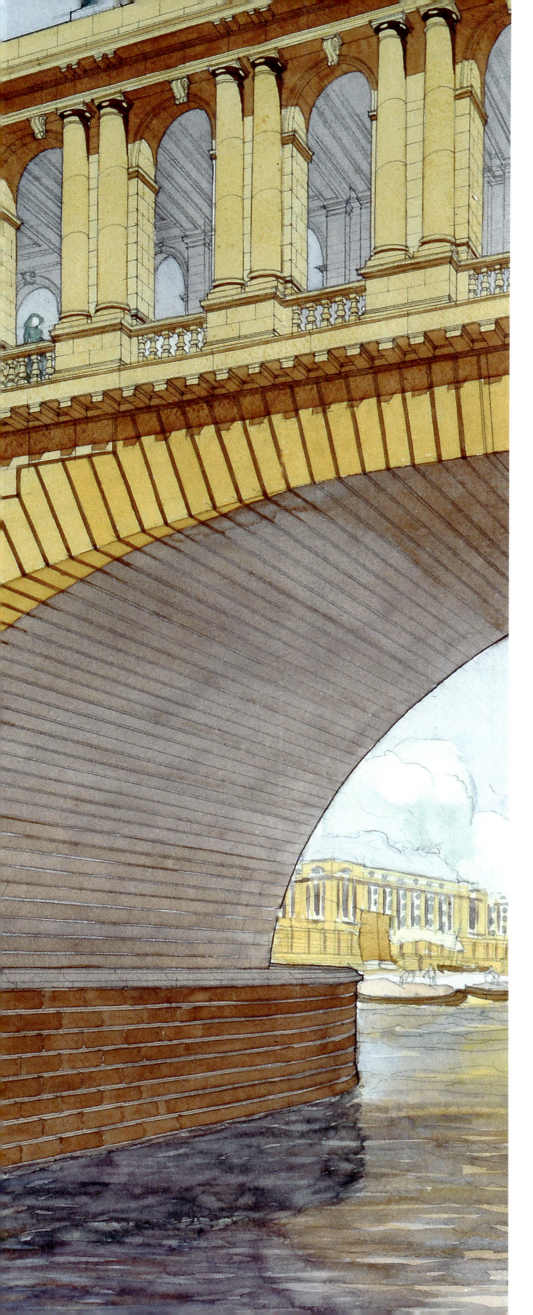

CATALOGUE
VOLUME I

NOTE TO THE READER

As desired by the collector, his architectural drawings are grouped and presented not by nationality or author but by building type. Albeit an approach advanced by Nikolaus Pevsner in his legendary 1970 A.W. Mellon lectures, later expanded and published in 1976 under the title *A History of Building Types*, May was instinctively drawn to collect thematically in ways that suited the architecture of his homes and gardens or appealed to his professional, cultural, or philanthropic interests.

Catalogue entries are numbered by section and provide basic information including architect and/or artist, nationality and life dates, if known. This information is followed by the Peter May Collection inventory number, comprised of a running intake number joined to the year of acquisition; these numbers also appear at the lower left of each illustrated work. For sets of drawings, the sheets are further distinguished by the addition of a lower-case letter or, when relevant, "recto" and "verso". The works are titled (and in some cases subtitled) according to their function or typology and dated; media and measurements are provided. Handwritten inscriptions, marginalia and stamps are transcribed for the interested reader. Provenance is given when the dealer, gallery or auction is known; agents are not named. Many entries include comparative images that show the building or interior that is the subject of the rendering, the printed architectural assignment, comparable sheets from the same competition, design sources, or a print published after the original. Notes and captions are kept to a minimum.

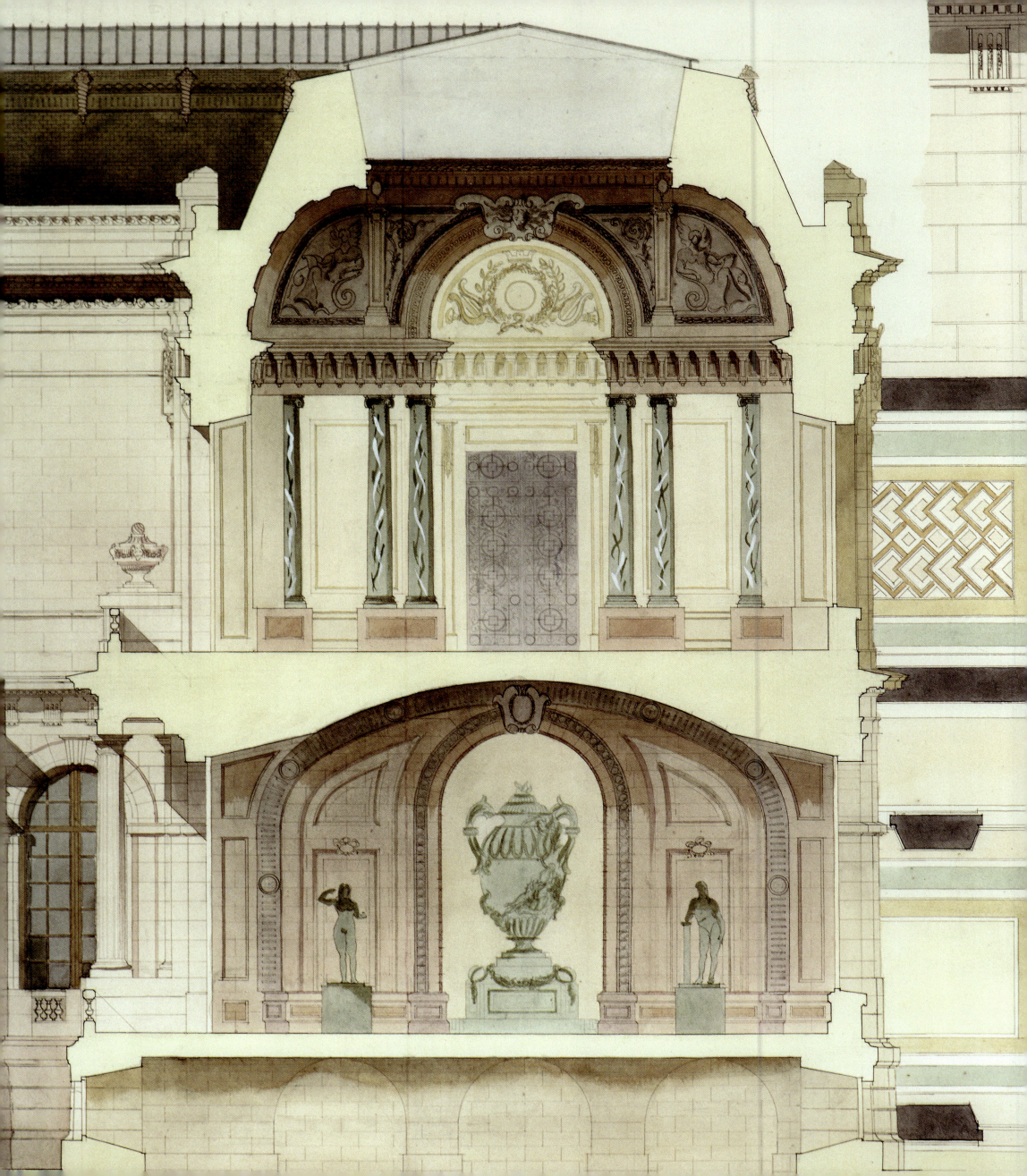

1
THEATERS, MUSEUMS, AND CLUBS

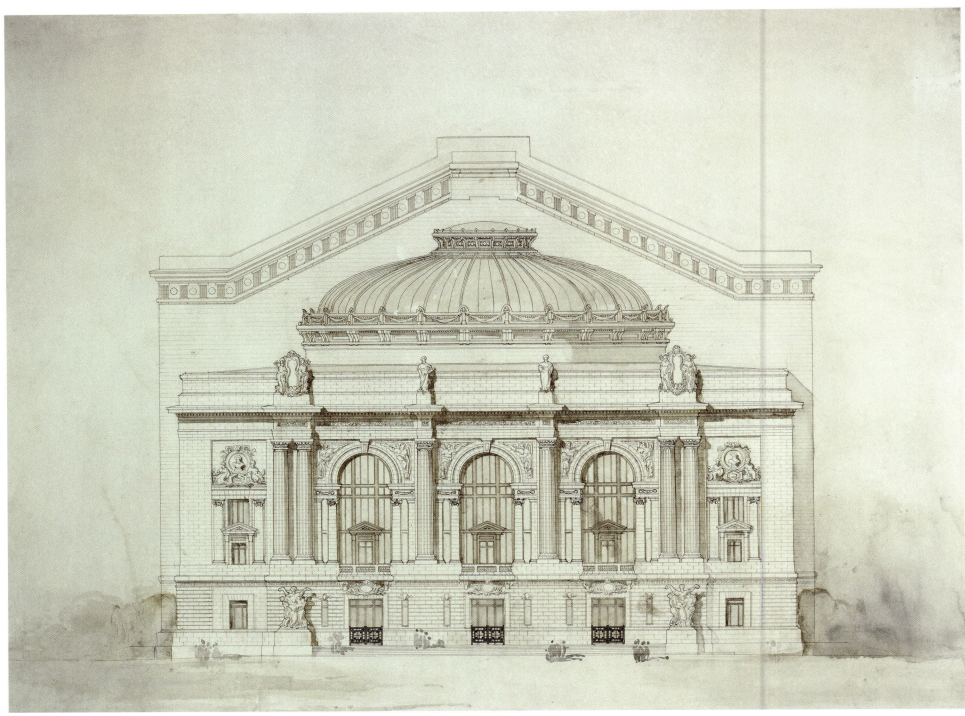

1987.7

1.1

ARCHITECT UNKNOWN (FRENCH)

1987.7: Competition drawing for a theater: frontal elevation, 19th century

Pencil, watercolor. 25¾ × 33 in. (65.4 × 83.8 cm)
PROVENANCE unknown

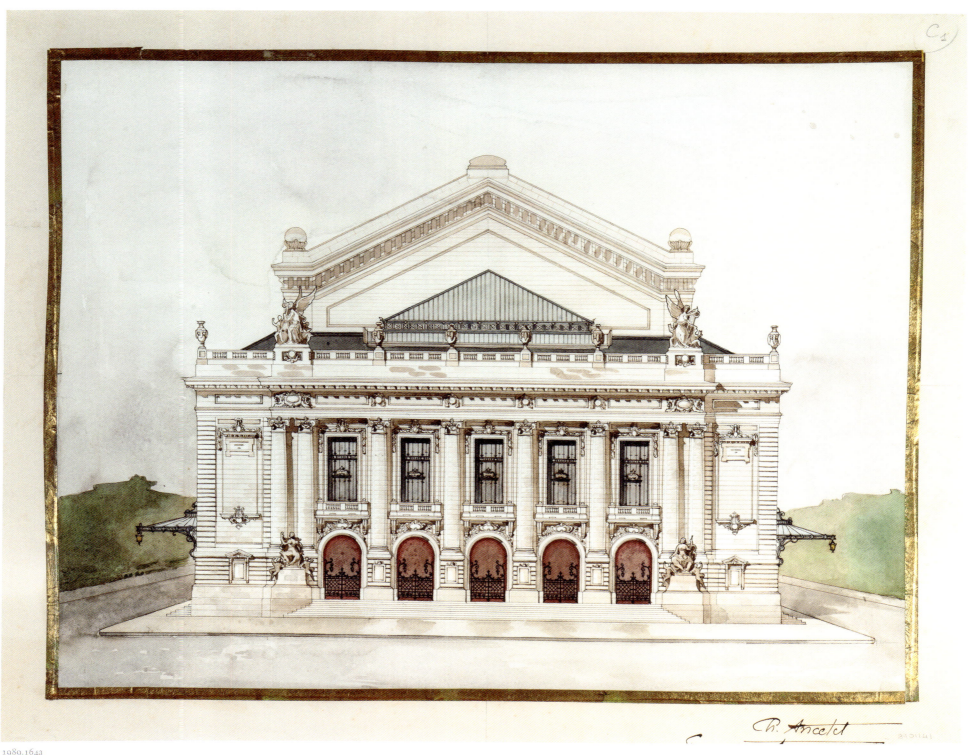

1.2

CHARLES-PROSPER ANCELET
(FRENCH, 1874–1956)

1989.164a–d: Competition drawings for a theater: elevation, two plans, and cross-section, ca. 1892

Pencil, ink, watercolor, metallic tape

1989.164a: Elevation. $20\frac{3}{8} \times 25\frac{3}{4}$ in. (51.8 × 65.4 cm)
INSCRIBED [in pencil] $C1$ / [in ink] *Ch. Ancelet*

1989.164b: Plan of the main floor. 19 × 13 in. (48.3 × 33 cm)
INSCRIBED [in pencil] $C3$

1989.164c: Plan of the mezzanine. 19 × $12\frac{3}{4}$ in. (32.4 × 48.3 cm)
INSCRIBED [in pencil] $C4$

1989.164d: Cross-section. $13\frac{3}{8} \times 19$ in. (34 × 48.3 cm)
INSCRIBED [in pencil] $C2$

PROVENANCE unknown

THEATERS, MUSEUMS & CLUBS

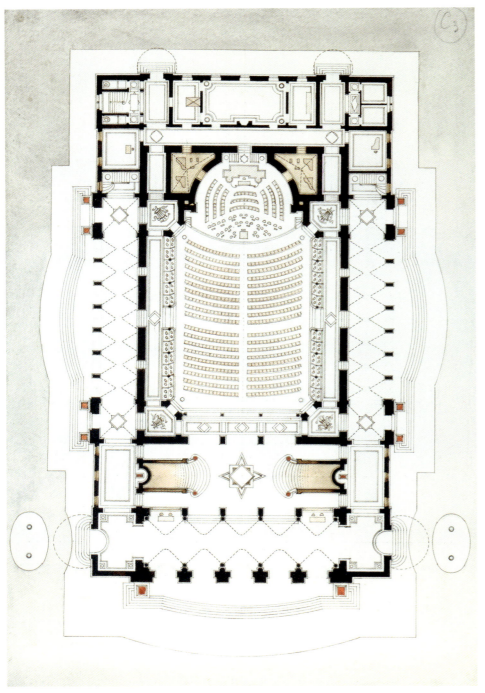

1989.164b

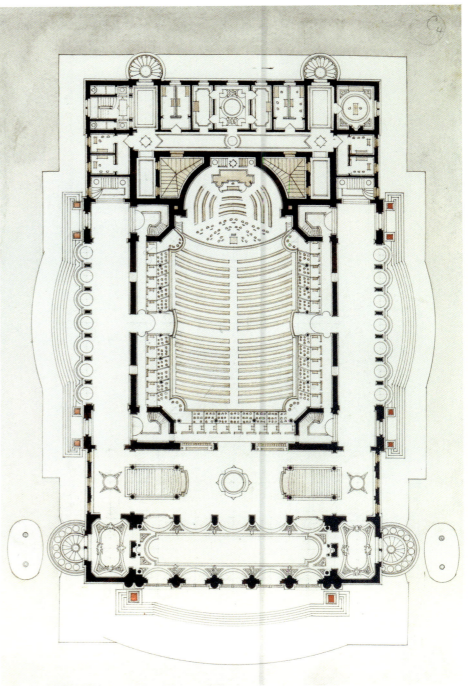

1989.164c

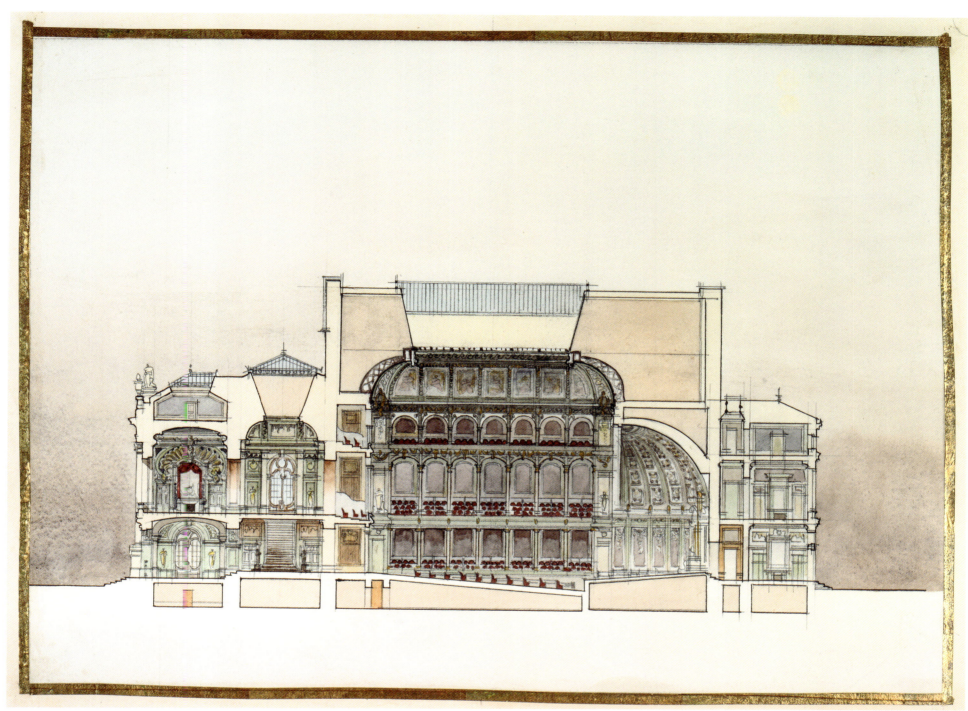

1989.164d

1.3

LUCIEN-LEON WOOG (FRENCH, 1867–1937), ATTRIBUTED TO

1989.148: Competition drawing for a theater: frontal elevation and plan, ca. 1890

Pencil, ink, watercolor. 35 × 25½ in. (88.9 × 64.8 cm)
PROVENANCE unknown

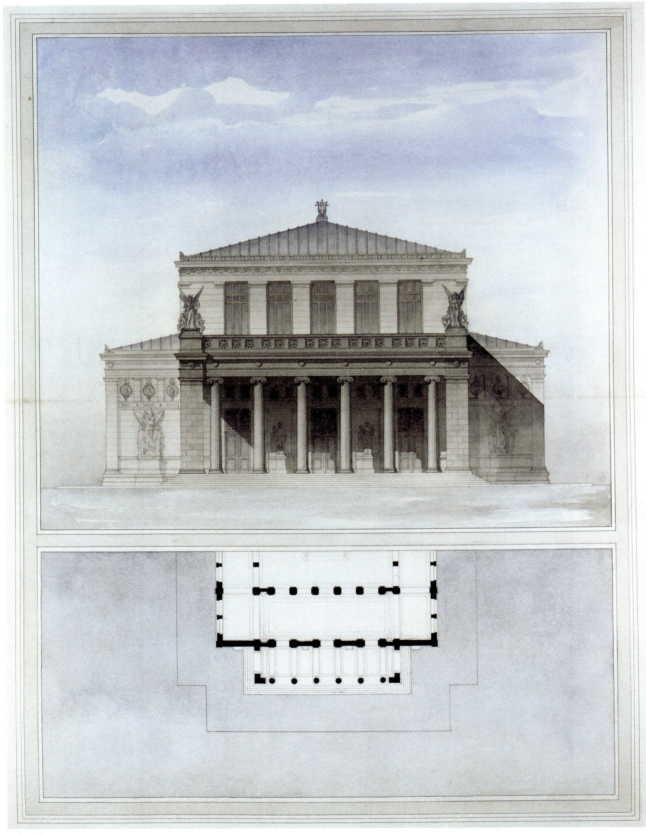

1989.148

1995.399

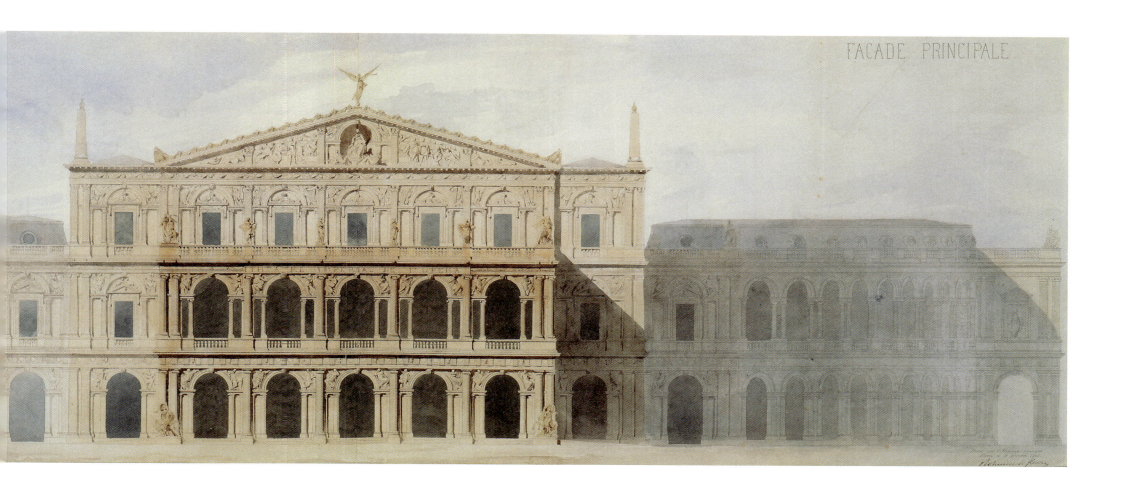

1.4

CHARLES ROHAULT DE FLEURY
(FRENCH, 1801–1875)

1995.399: Competition drawing for the Paris Opera House: elevation, 1860

Pencil, ink, watercolor. 16 7/8 × 52 1/8 in. (42.9 × 132.4 cm)
INSCRIBED [in watercolor, on entablature] [2×] *THEATRE IMPERIAL de L'OPERA. / FAÇADE PRINCIPAL* / [in ink] *Dressé par l'Architecte soussigné Paris ce 10. Décembre 1860 Rohault de Fleury* / [architectural measurements]
PROVENANCE Didier Lecointre, Paris

THEATERS, MUSEUMS & CLUBS 103

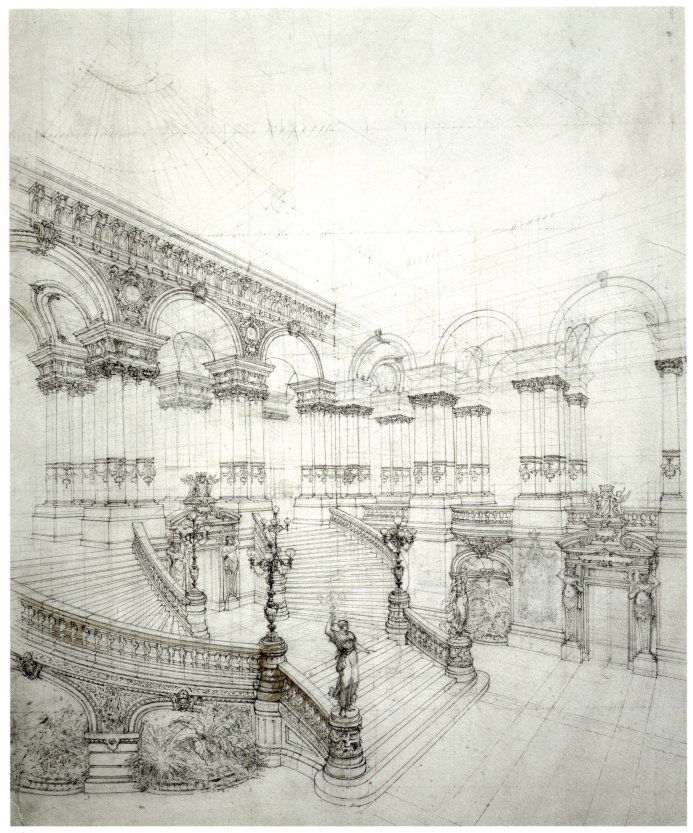

1987.20

1.5

CHARLES GOURS (FRENCH, DATES UNKNOWN), ATTRIBUTED TO

1987.20: Perspective of the staircase in the Paris Opera House, 2nd half 19th century

Pencil, ink, wash. 23 × 19½ in. (58.4 × 49.5 cm)
PROVENANCE unknown

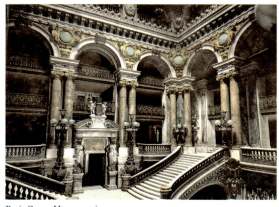

Paris Opera House, staircase

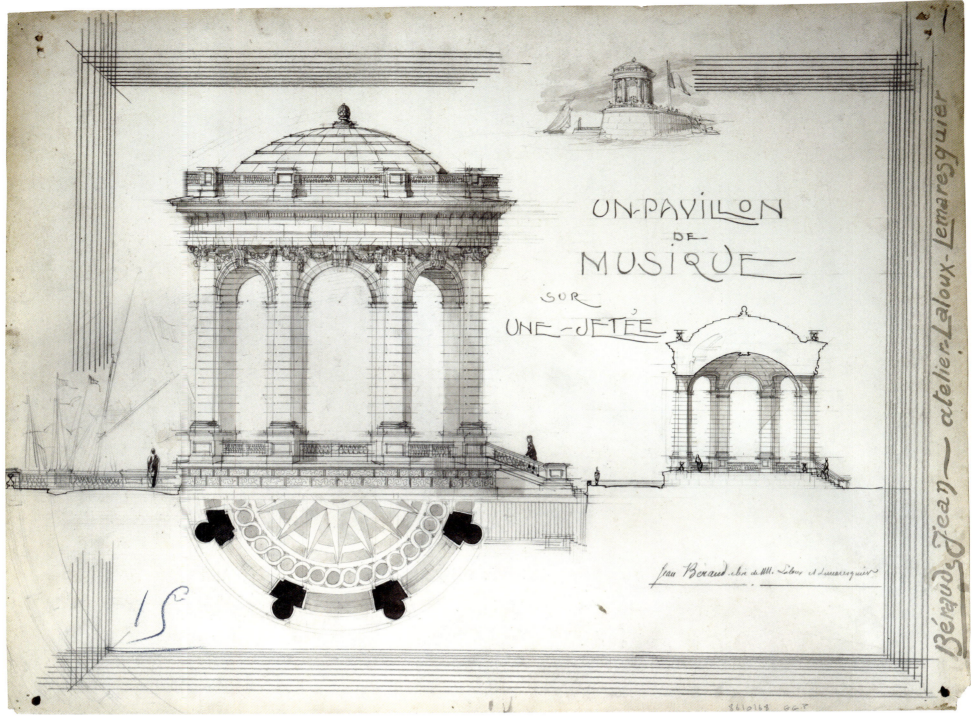

1989.237 recto

1.6

JEAN BERAUD (FRENCH, 1882–1954)

1989.237 recto: Competition drawing for an outdoor music pavilion: elevation, plan, cross-section, and perspective, ca. 1903

Pencil, ink, watercolor. 18¾ × 24⅝ in. (47.6 × 62.6 cm)
INSCRIBED [in ink] *UN – PAVILLON DE MUSIQUE SUR UNE – JETÉE / Jean Béraud eleve de MM. Laloux et Lemaresquier /* [in blue crayon] *15* / [in watercolor] *Béraud Jean atelier Laloux Lemaresquier*
PROVENANCE unknown

THEATERS, MUSEUMS & CLUBS 105

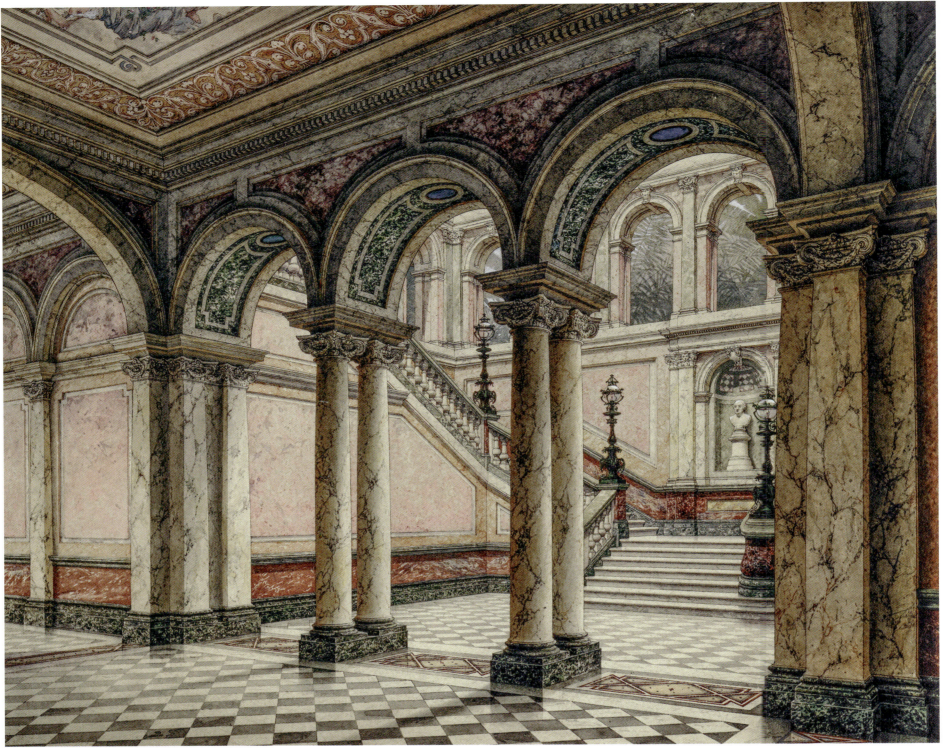

1988.123

1.7

ARCHITECT UNKNOWN (FRENCH?)

1988.123: Perspective of the interior of an opera house, 2nd half 19th century

Pencil, watercolor. 12¾ × 16 in. (32.4 × 40.6 cm)
PROVENANCE unknown

1.8

E. CHAPUIS (FRENCH, DATES UNKNOWN)

1990.307: Perspective of a staircase, 1912

Pencil, ink, watercolor. 21½ × 15 in. (54.6 × 38.1 cm)
INSCRIBED [in ink] *E. Chapuis / 1912*
PROVENANCE unknown

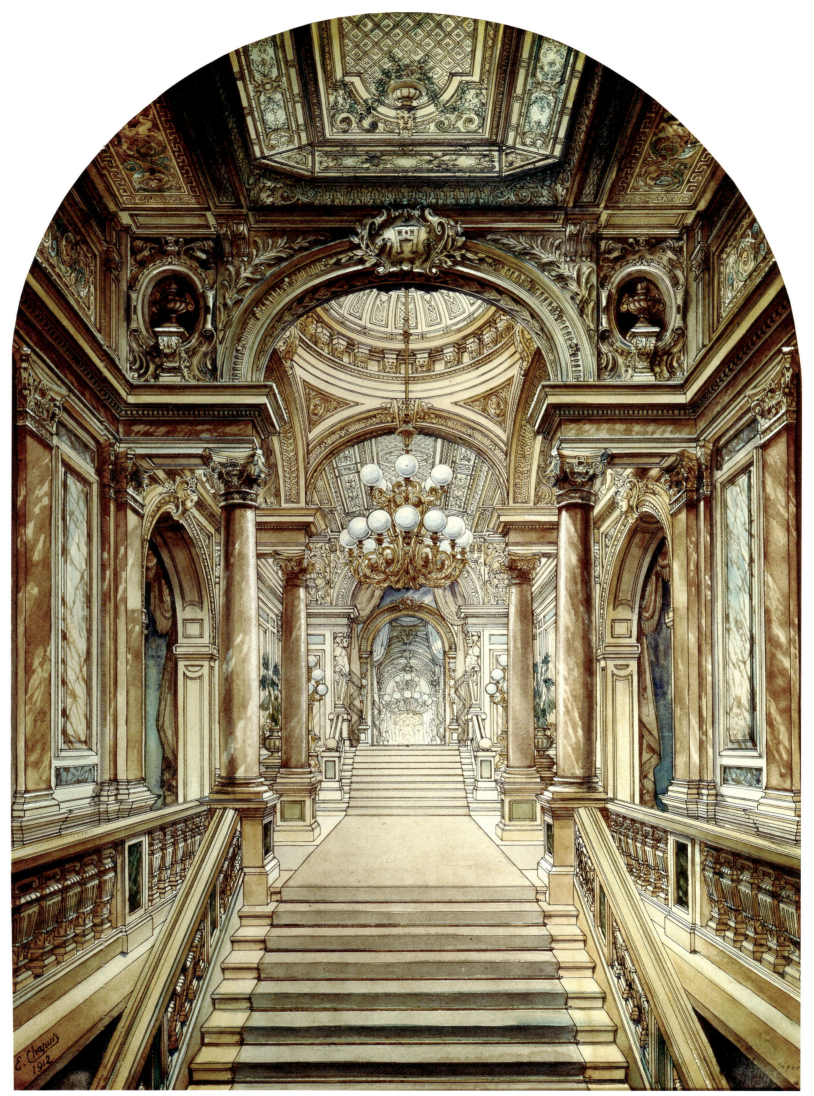

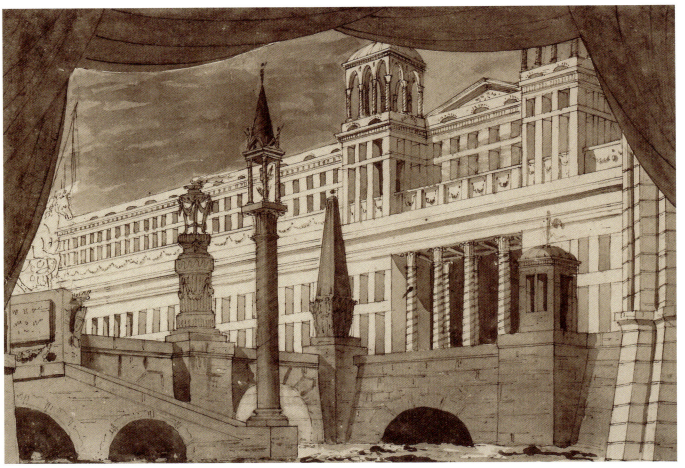

1990.326

1989.162

1.9

WORKSHOP OF GIUSEPPE GALLI OR
FERDINANDO GALLI BIBIENA (ITALIAN),
ATTRIBUTED TO

1990.326: Design for a stage set,
1st half 18th century

Pencil, ink, watercolor. 7½ × 10½ in. (19.1 × 26.7 cm)
PROVENANCE unknown

1.10

ARCHITECT UNKNOWN (FRENCH)

1989.162: Competition drawing for
the foyer of a theater: cross-section,
2nd half 19th century

Pencil, ink, watercolor, gouache. 12⅜ × 28½ in.
(31.4 × 72.4 cm)
PROVENANCE unknown

1.11

LEON ROHARD (1836–1882),
ATTRIBUTED TO

2000.468: Design for a theater:
interior elevation, 19th century

Pencil, ink, watercolor, gouache. 10¼ × 18⅞ in.
(26 × 47.9 cm)
PROVENANCE Galerie Martin du Louvre, Paris

1.12

ARCHITECT UNKNOWN (FRENCH)

1988.129: Competition drawing for a museum (?): frontal elevation, ca. 1900

Pencil, ink, watercolor. 18½ × 38 in. (47 × 96.5 cm)
INSCRIBED [in watercolor, on plaque above pediment]
CET EDIFICE A ETE ÉRIGE SOUS LE PROTECTORAT DE JESUS CHRIST CELUI QUI APPROCH.
PROVENANCE unknown

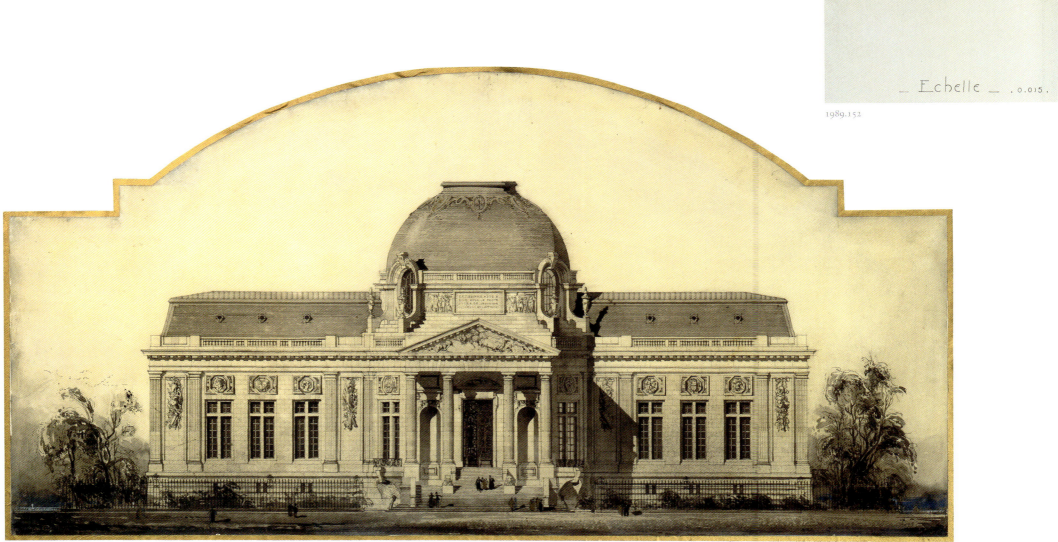

110 PETER MAY COLLECTION I

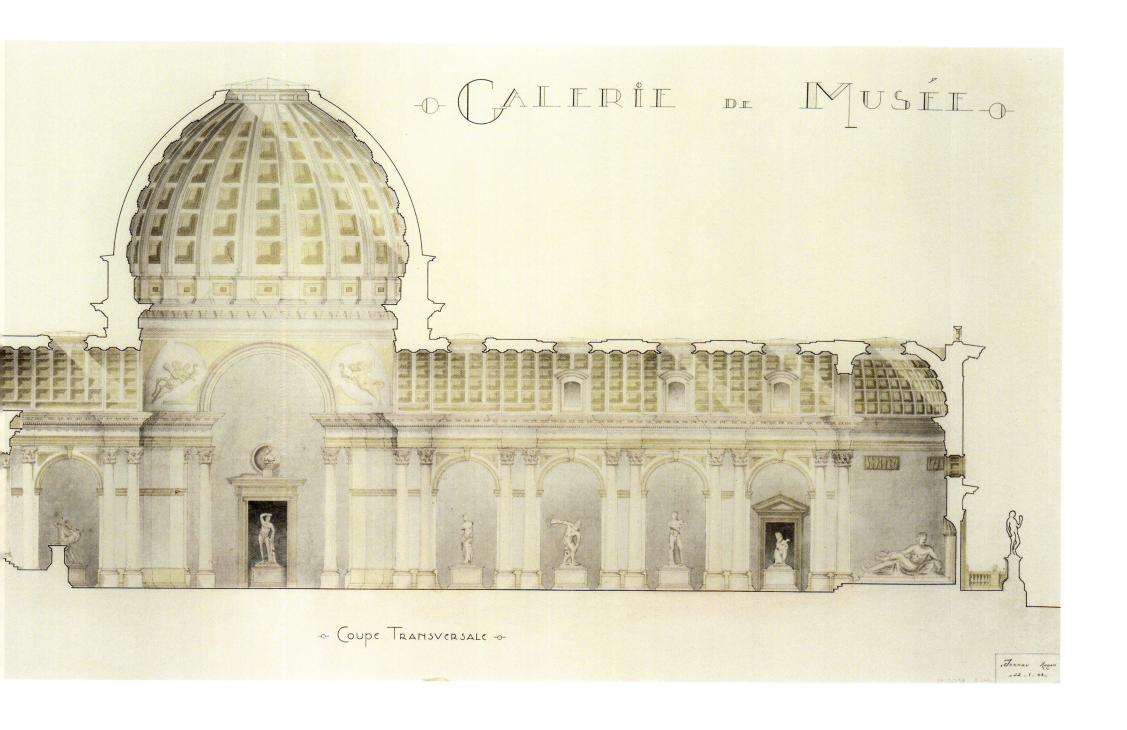

1.13

ROGER TONNAU [?]
(FRENCH, DATES UNKNOWN)

1989.152: Competition drawing for a museum: cross-section, 1943

Pencil, ink, watercolor. 24 × 49 in. (61 × 124.5 cm)
INSCRIBED [in ink and watercolor] *GALERIE DE MUSÉE* / *Coupe Transversale* / [architectural measurements] / *.Tonnau Roger. – 22.1.43 –*
PROVENANCE unknown

1987.62a

1.14

ARCHITECT UNKNOWN (FRENCH)

1987.62a–d: Competition drawings for a museum: three elevations and cross-section, 2nd half 19th century

Pencil, ink, watercolor. 16 × 28½ in. (40.6 × 72.4 cm)

 1987.62a: Side elevation

 1987.62b: Frontal elevation
 INSCRIBED [in pencil, on entablature] *MUSÉE*

 1987.62c: Side elevation

 1987.62d: Cross-section

PROVENANCE unknown

1987.62b

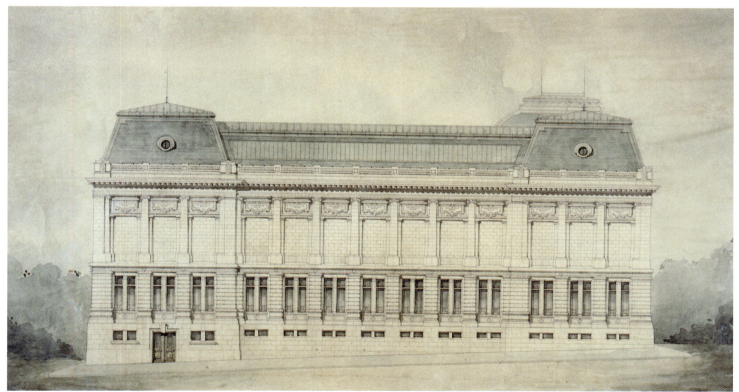
1987.62c

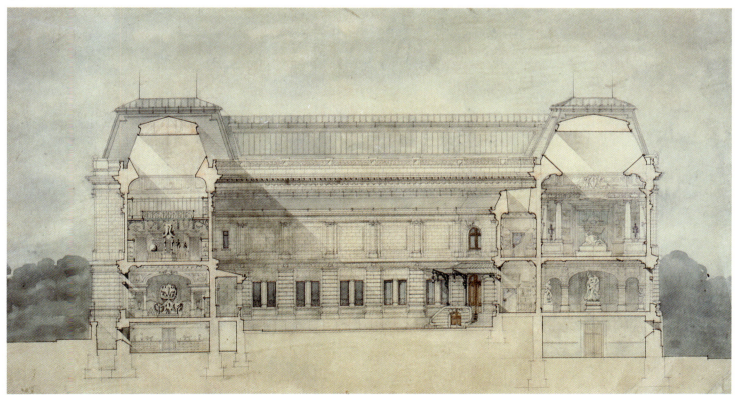
1987.62d

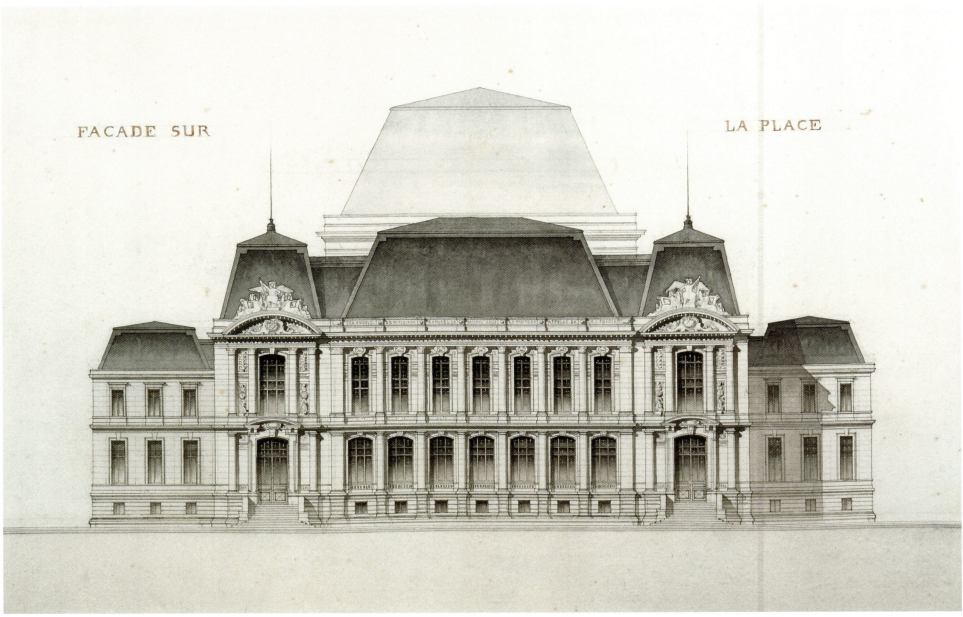

1988.102a

1.15

EDOUARD BERARD (FRENCH, 1843–1912) AND FERNAND DELMAS (FRENCH, 1852–1933), ATTRIBUTED TO

1988.102a–c: Competition drawings for an art museum for Lille, France: elevation, cross-section, and two plans, 1884

Pencil, ink, watercolor

1988.102a: Elevation. 16½ × 24 in. (41.9 × 61 cm) *COUPE* INSCRIBED *FAÇADE SUR LA PLACE / MICHELANGE / RAPHAEL / LE CORREGIO / BENEVENUTO / LE TINTORETTO* [and further indistinct lettering]

1988.102b: Cross-section. 16½ × 24 in. (41.9 × 61 cm) INSCRIBED [in pencil and watercolor] *COUPE TRANSVERSALE / FRA. ANGELO / LE TITISIANO / RAPHAEL / MICHELANGE / LE TINTORE / APPELLE* [and further indistinct lettering] /

1988.102c: Plan of the Sculpture and Antiquities Galleries 35¾ × 22 in. (90.8 × 55.9 cm)
INSCRIBED [in pencil and watercolor] *LILLE / PALAIS DES BEAUX ARTS / SCULPTURE /* [in red] *RUE Gauthier de Chatillon / Rue Nicolas Lebland / Rue d'Inkerman / Rue Jaquemars Giélée / PLACE DE LA REPUBLIQUE / LIBERTÉ BOULEVART* [sic] *DE LA LIBERTÉ / Rue Baptiste Monnoyer / PLACE RICHERBE / Rue Denis Godefray / BOULEVART* [sic] *DE LA / Rue Jeanne D'Arc / Rue de Valmy / Rue / Salle de Sculpture / Galerie /* [2×] *Vestibule / Entrée / Sortie /* [2×] *Grande Salle de Sculpture /* [2×] *Vases et Poteries /* [2×] *Musée Céramique /* [2×] *Galerie de Sculpture /* [2×] *Arts Décoratifs /* [2×] *Salle de Reunion / Vestibule /* [4×] *Cabinet /* [3×] *Galerie de Sculpture / Morceaux d'Arts Décoratifs /* [in black] *Nota La partie en noir serait à construire actuellement*

1988.102d: Plan of the Painting Galleries. 35¾ × 22 in. (90.8 × 55.9 cm)
INSCRIBED [in pencil and watercolor] *LILLE / PALAIS DES BEAUX ARTS / PEINTURE /* [in red] *RUE Gauthier de Chatillon / Rue Nicolas Lebland / Rue d'Inkerman / Rue Jaquemars Giélée / PLACE DE LA REPUBLIQUE / LIBERTÉ BOULEVART* [sic] *DE LA LIBERTÉ / Rue Baptiste Monnoyer / PLACE RICHERBE / Denis Godefray / Rue Jeanne / Valmy / Rue de Valmy /* [2×] *Rue / Collection WICAR /* [2×] *Vestibule /* [2×] *Salle /* [14×] *Salle de Peinture /* [2×] *Grand Salle de Sculpture /* [29×] *Salon / Grand Salon Boiseries de Conclave de Peinture /* [2×] *Petite Salle /* [2×] *Rentoilage / Salle Galerie de Peinture / Magasin* [in black] *Nota La partie en noir serait à construire actuellement*

PROVENANCE unknown

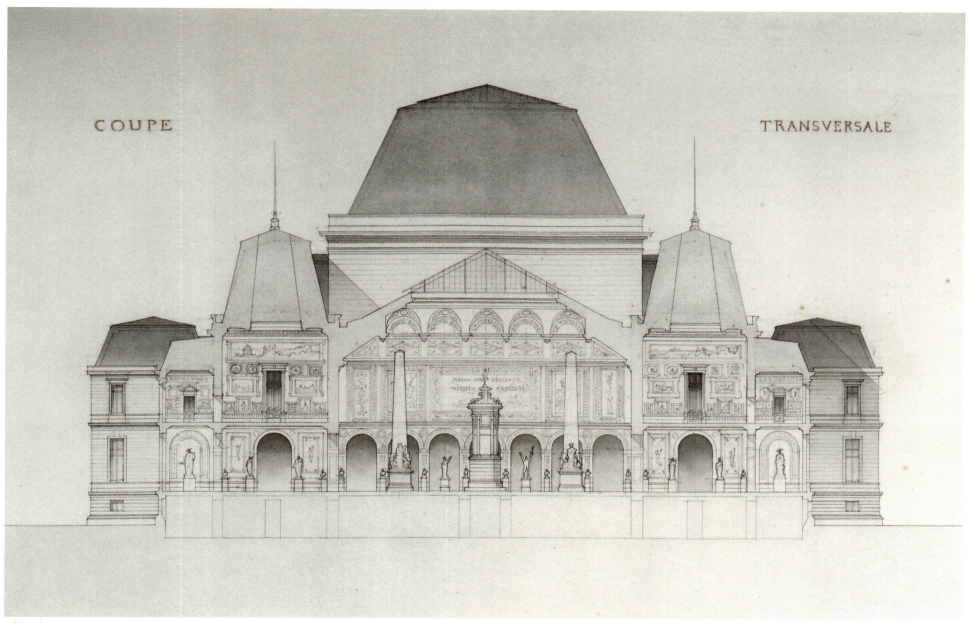

1988.102b

❧ Bérard and Delmas won 1st prize in the 1884 competition and designed the structure finally built between 1889 and 1892 with money raised by lottery. Two photographs of the exterior and two drawings of the interiors were published in the magazine *La Construction Moderne*, 2 July 1892, p. 463 and plates 85–87.

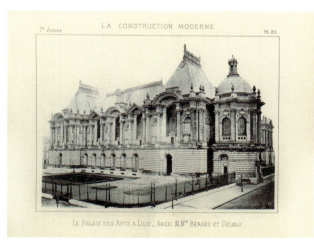

'Le Palais des Arts a Lille,' *La Construction Moderne*, 2 July 1892, pls. 85, 87

THEATERS, MUSEUMS & CLUBS

1988.102c

1988.102d

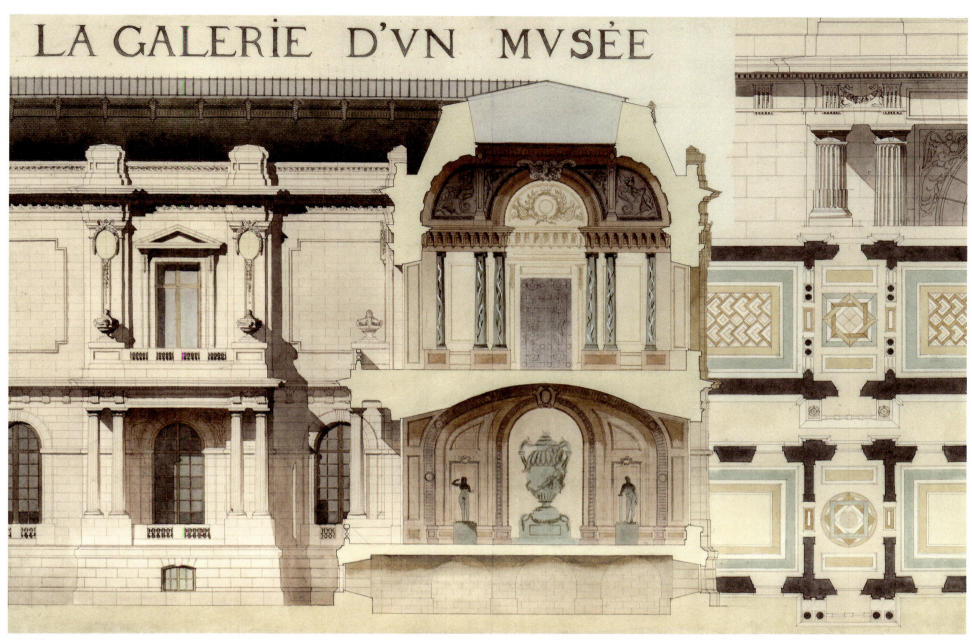

1989.166

1.16

ARCHITECT UNKNOWN (FRENCH)

1989.166: Student assignment: composite study for a museum gallery, late 19th century

Pencil, ink, watercolor, metallic tape. 25 ⅜ × 38 ¼ in. (65.1 × 97.2 cm)
INSCRIBED [in watercolor] *LA GALERIE D'UN MUSÉE*
PROVENANCE unknown

1.17

ARCHITECT UNKNOWN (FRENCH)

2000.472: Competition drawing for a museum for Monaco: frontal elevation, ca. 1900

Pencil, ink, watercolor. 14 × 25¾ in. (35.6 × 65.4 cm)
INSCRIBED [in watercolor] *MUSEE · NATIONAL · S · ELEVÉ · PAR · LES · SOINS · DU · CONSEIL · MUNICIPAL · DE · LA VILLE · DE · MONACO / ARCHITECTURE · PEINTURE · SCULPTURE /* [and further indistinct lettering]
PROVENANCE Alain Cambon, Paris

2000.518

2000.472

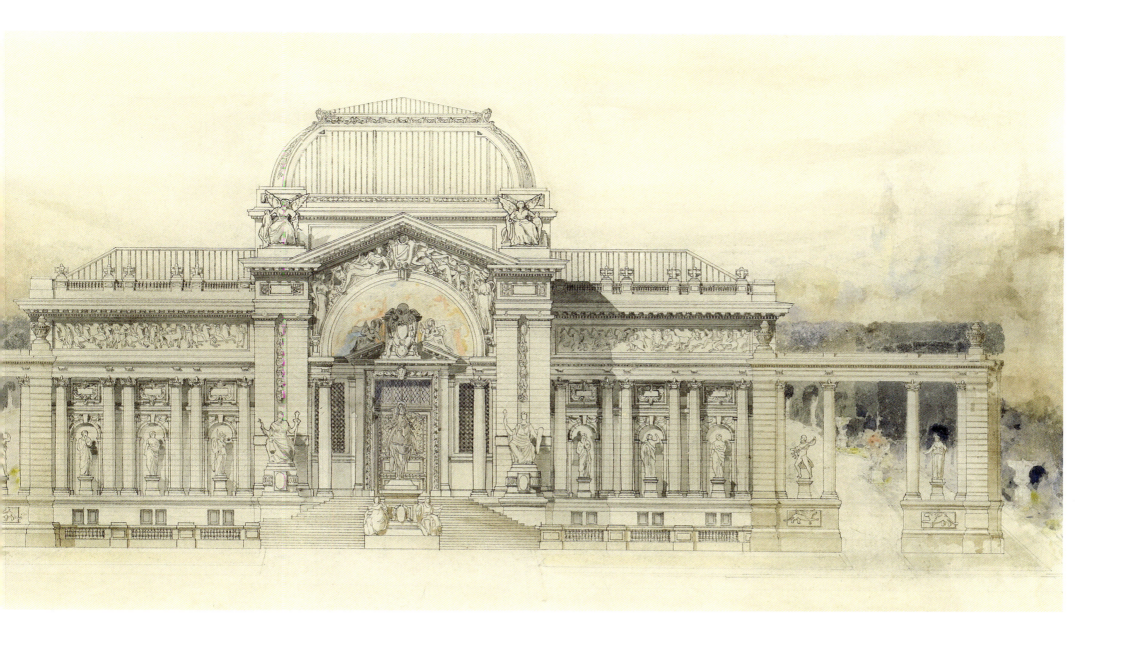

1.18

LÉON-PHILIBERT ROSTAING (FRENCH, 1872–1923), ATTRIBUTED TO

2000.518: Competition drawing for a museum: frontal elevation, late 19th century

Pencil, ink, watercolor. 17 × 34⅞ in. (43 × 88.5 cm)
PROVENANCE D. & R. Blissett, UK

1.19

ARCHITECT UNKNOWN (FRENCH)

1987.49a–c: Competition drawings for a museum dedicated to sculptor Pierre Puget (1620–1694): elevation, plan, cross-section, and detailed perspectives, early 20th century

Pencil, ink, watercolor

1987.49a: Frontal elevation. 46 × 62 in. (116.8 × 157.5 cm)
INSCRIBED [in ink and watercolor] *MILON DE CROTONE* / *FAÇADE SUR LA PLACE* / [on building] *ARTIUM INGENUARUM – AD MICXX SCULTOR – PICTORES ET – FRANCISCO – PIERRE – PUGET – ANTICHITA – DI – CORAN DESCRITTED – INCISE – E D-D-D* / [beneath rendering of sculpture] *MILON DE CROTONE*

1987.49b: Cross-section and six detailed perspectives 62 × 46 in. (116.8 × 157.5 cm)
INSCRIBED [in ink and watercolor] *LA CHAPELLE* / *L'HERCULE* / *LE PALLADIO* / *COUPE SUR LE PATIO* / *LA SALLE DES GALERES* / *LES BAS-RELIEFS DU PATIO* / *LA SALLE DES BRONZES* / [beneath rendering of sculpture] *MILON DE CROTONE*

1987.49c: Plan. 62 × 46 in. (116.8 × 157.5 cm)
INSCRIBED [in ink and watercolor] *LE CHRIST EN BOIS* / *LES GALERES* / *DESSINS* / *PEINTURES* / *BRONZES* / *SALLE DES MARBRES* / *CONSERVATEUR* / *LA PLACE* / *LA MAISON DU SCULPTEUR* / [beneath rendering of sculpture] *MILON DE CROTONE*

PROVENANCE unknown

❧ The student has placed a sketch of Puget's celebrated sculpture representing the violent death of the ancient wrestler Milo of Croton (Milone de Crotone) on each sheet, evidently after a print in which the group is reversed. A bust of the 17th-century sculptor flanks the entrance to the École.

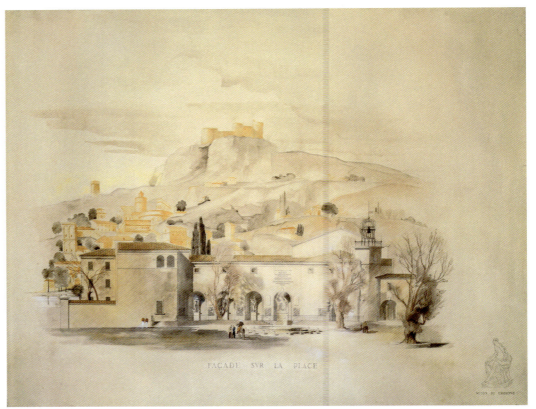

1987.49a

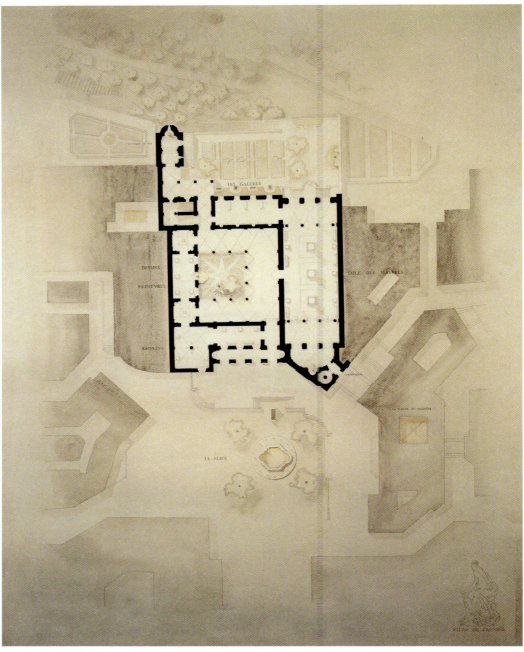

1987.49c

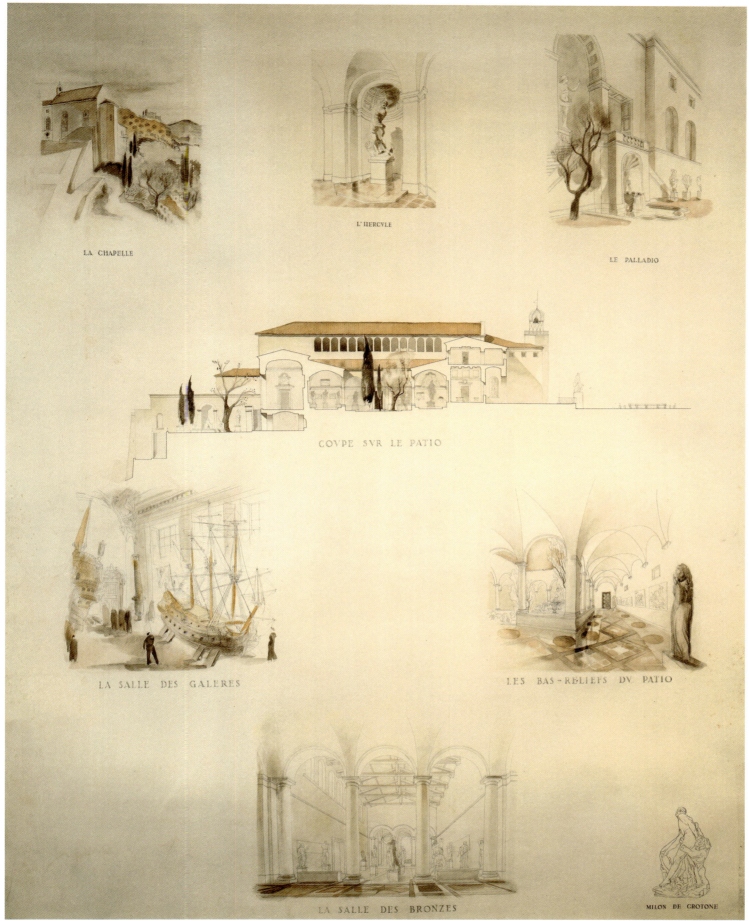

S. Thomassin, *Milon Crotoniate*, engraving, 1695

Pierre Puget, *Milo of Croton*, 1682
(Musée du Louvre, Paris)

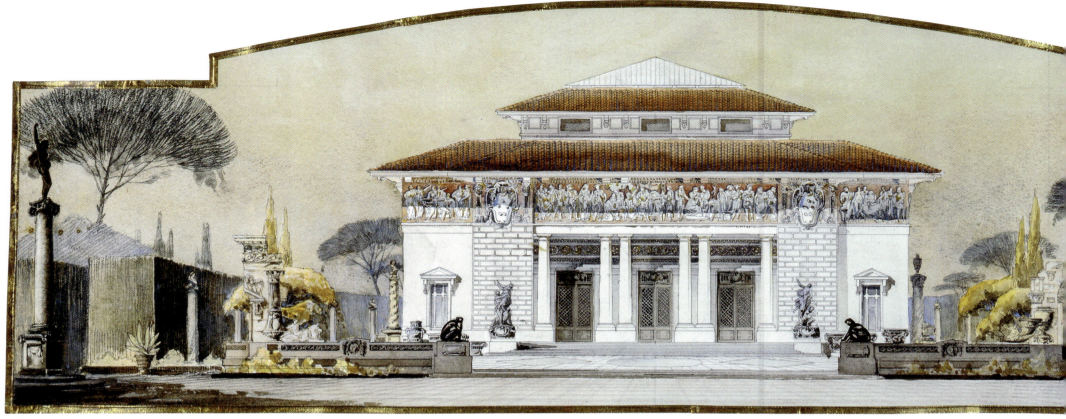

1.20

ARCHITECT UNKNOWN (FRENCH)

1988.127: Competition drawing for a museum: frontal elevation, early twentieth century

Pencil, ink, watercolor, metallic tape. 12¾ × 39 in. (32.4 × 99.1 cm)
INSCRIBED [in watercolor, on bust on pedestal in garden] *WINCKELMANN*
PROVENANCE unknown

1.21

ARCHITECT UNKNOWN (SPANISH)

1990.304: Competition drawing for a museum: frontal elevation, early 20th century

Pencil, ink, watercolor. 24¾ × 49¾ in. (62.9 × 126.4 cm)
INSCRIBED [in watercolor] *FRENTE SOBRE EL PATIO DE LOS MUSEOS. / MUSEO DE MECANICA.*
LITERATURE Sotheby's, London, 26 April 1990, p. 142, lot 457 (illustration mislabeled 456)
PROVENANCE Sotheby's, London, 26 April 1990, lot 457

E SOBRE EL PATIO DE LOS MVSEOS.

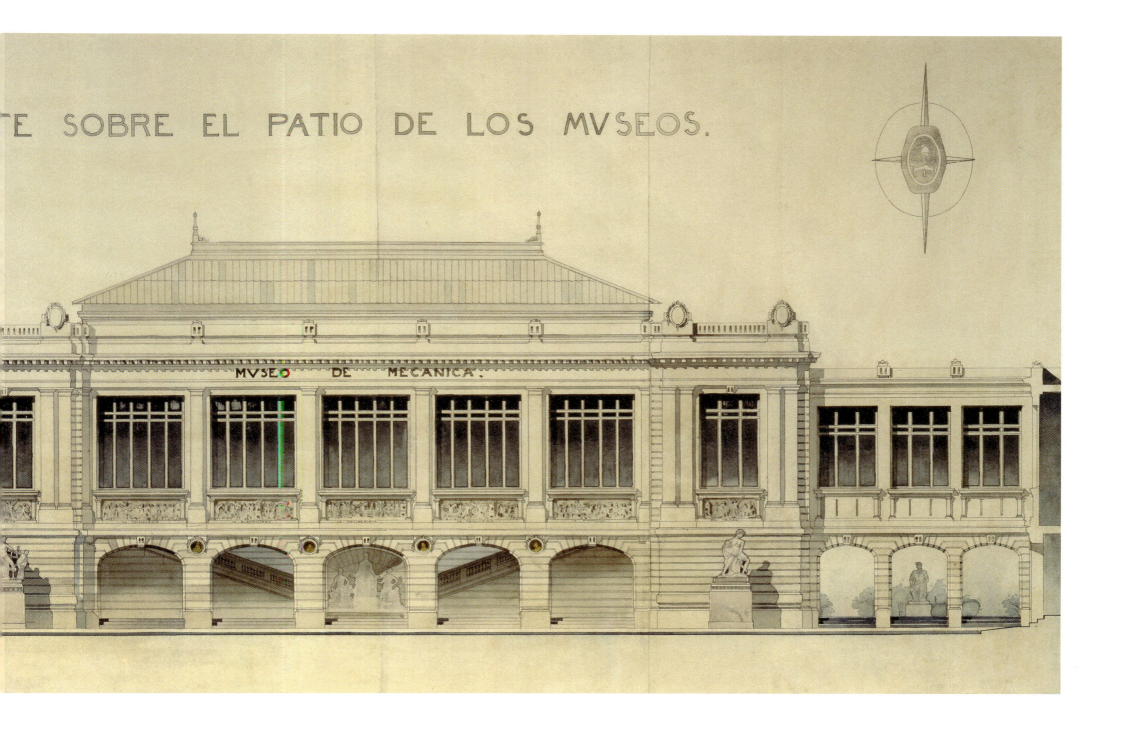

MVSEO DE MECANICA.

1.22

LEON KEACH (AMERICAN, 1893–1991)

1996.401 a, d–e: Competition drawings for museums: elevations and cross-section, ca. 1915

Pencil, ink, watercolor

1996.401a: Frontal elevation detail. 32 × 25¼ in. (81.3 × 64.1 cm)
INSCRIBED [in red crayon] *2nd mention*
STAMPED [in red] *DEPARTMENT OF ARCHITECTURE / M.I.T.* […]

1996.401d: Frontal elevation detail. 29¼ × 23 in. (74.3 × 58.42 cm)
INSCRIBED [in watercolor] *ART MUSEUM / R /* [in red crayon] *Medal*
STAMPED [in red] *DEPARTMENT OF ARCHITECTURE / M.I.T.* […]

1996.401e: Cross-section. 14½ × 23 in. (36.8 × 58.4 cm)
STAMPED [in red] *DEPARTMENT OF ARCHITECTURE / M.I.T.* […]

PROVENANCE Gwenda Jay Gallery, Chicago

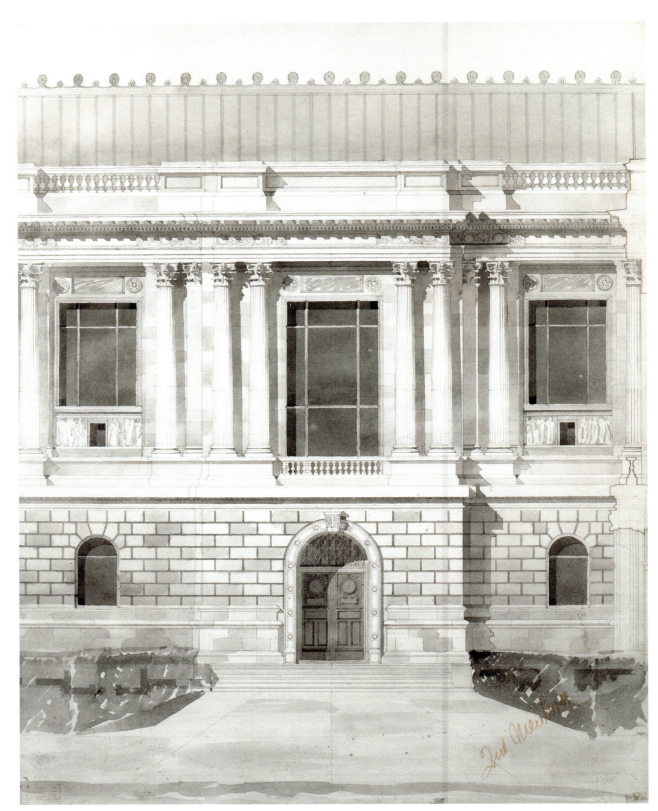

1996.401a

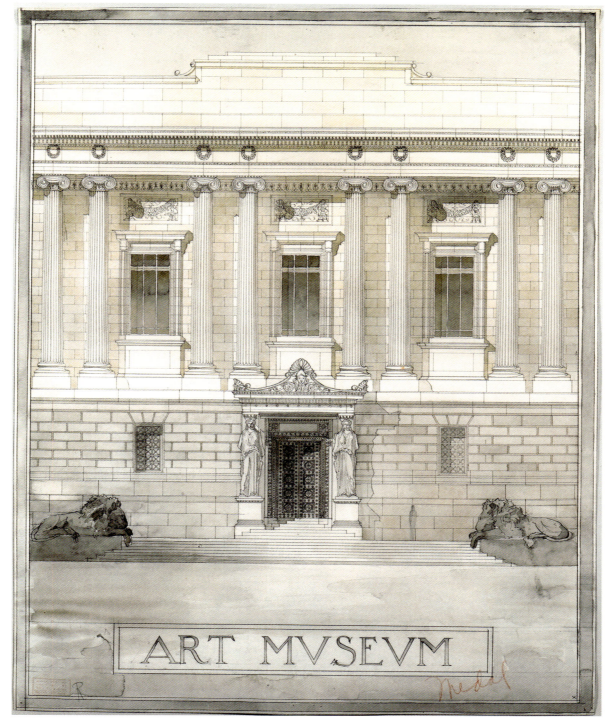

ART MVSEVM

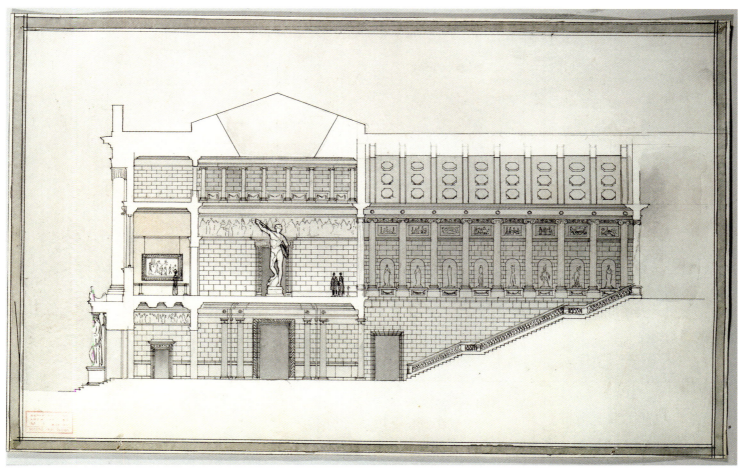

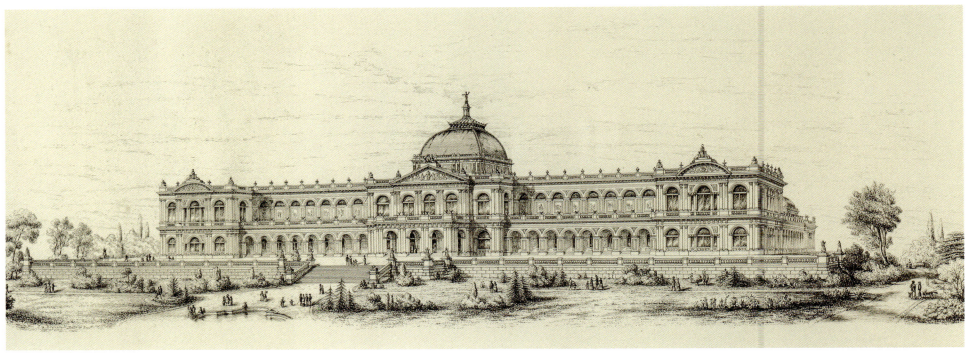

1987.69

1.23

JOHN A. BRYSON (BRITISH, d. 1890)

1987.69: Presentation drawing for a cultural center, Newcastle upon Tyne, ca. 1877–86

Pencil, ink. 12 × 31 in. (30.5 × 78.7 cm)
INSCRIBED [in ink, on mount] *Design for a Public Building on the Terrace at Leazes Park, Newcastle upon Tyne, to contain Natural History Museum, Fine Arts Gallery, Aquaruim* [sic]*, Winter Garden, Large Concert Hall, Etc. / John A. Bryson, Deputy Borough Engineer, Architect, Town Hall, Newcastle upon Tyne*
LITERATURE *Softs and Hards: An Exhibition of Drawings by Victorian and Edwardian Architects* (Gallery Lingard, London, 1986), cat. 16, pp. 21 and 13 (ill.)
PROVENANCE Gallery Lingard, London

🔴 The project was abandoned following Bryson's death in 1890.

1.24

HAROLD BRAMHILL
(BRITISH, 1905–1997)

2000.528: Competition drawing for an art gallery in a public park: elevation, four plans, cross-section, 1928

Pencil, ink, watercolor. 25 3/8 × 35 1/2 in. (64.5 × 90 cm)
INSCRIBED [in ink] *AN ART GALLERY IN A PUBLIC PARK / – Front – Elevation – / – Ground – Floor – Plan – / Entrance Hall / Cloaks & Postcards / Porter / Ladies Lavs. / Office / Lift* [4×] *Gallery / Sculpture Hall / First Floor Plan /* [7×] *Gallery / Work / Basement Plan /* [2×] *Storage Space / Unpack Room / Common Room / Lift / Store Room / Boiler Room / Coal / Tools / Layout Plan / Bramhill /* [in pencil] *Mention* [indistinct] *9 Feb. 1928*
STAMPED [in red] *FOURTH YEAR / SCHOOL OF ARCHITECTURE / UNIVERSITY OF LIVERPOOL / SCHOOL OF ARCHITECTURE / UNIVERSITY OF LIVERPOOL ; SIGNATURE /* [in ink] *C. H. Reilly 1928* [indistinct] */* [architectural measurements]
PROVENANCE Gallery Lingard, London

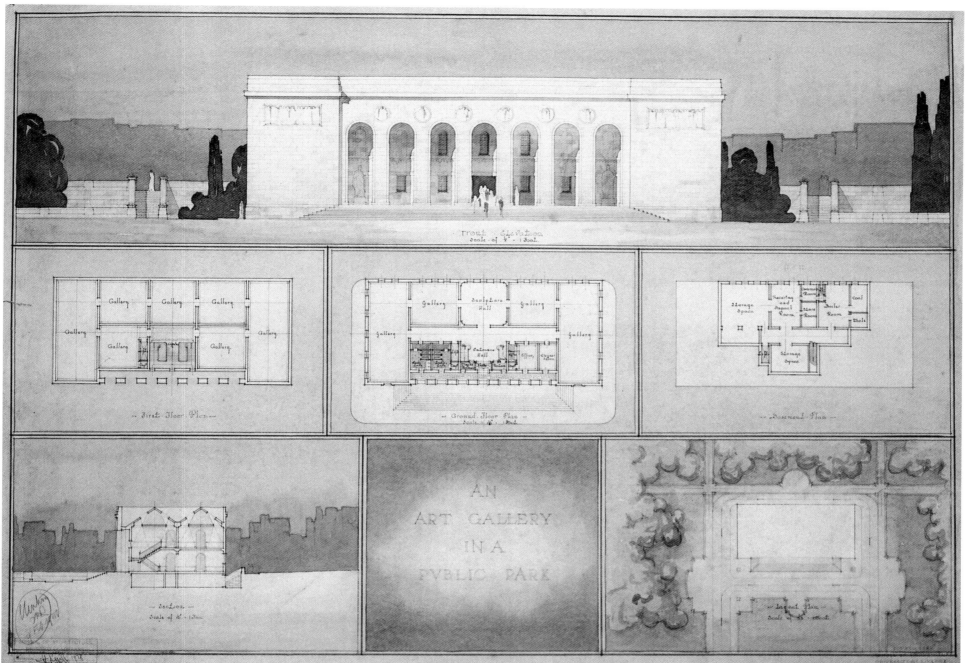

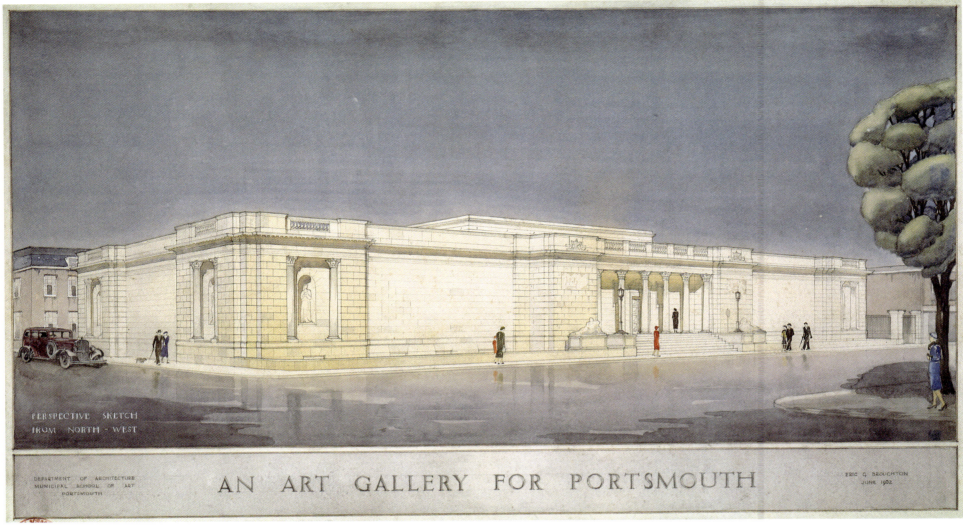

1.25

ERIC BROUGHTON
(BRITISH, DATES UNKNOWN)

2000.471a,b: Competition drawings for an art gallery for Portsmouth: perspective and elevation, 1932

Pencil, ink, watercolor

2000.471a: Perspective. 16¼ × 28 in. (41.3 × 71.1 cm)
INSCRIBED [in watercolor] *AN ART GALLERY FOR PORTSMOUTH / PERSPECTIVE SKETCH FROM NORTH-WEST / ERIC G. BROUGHTON June 1932 / DEPARTMENT OF ARCHITECTURE MUNICIPAL SCHOOL OF ART PORTSMOUTH.*
STAMPED [in red ink] *MUNICIPAL SCHOOL OF ARCHITECTURE […] OCT. 1933*

2000.471b: Elevation detail of entrance. 20½ × 28½ in. (52.1 × 72.4 cm)
INSCRIBED [in watercolor] *AN ART GALLERY FOR PORTSMOUTH / HALF-INCH DETAIL OF ELEVATION TO GUILDHALL SQUARE / ERIC G. BROUGHTON MAY 1932 / DEPARTMENT OF ARCHITECTURE PORTSMOUTH MUNICIPAL SCHOOL OF ART* [architectural measurements]
STAMPED [in red ink] *MUNICIPAL SCHOOL OF ARCHITECTURE […] OCT. 1933.*

LITERATURE *Prize Papers / Architectural Drawings for Examination, Competition and Exhibition, 1800–1940* (Gallery Lingard, London, 1988), cat. 46, pp. 35 and 39
PROVENANCE Gallery Lingard, London

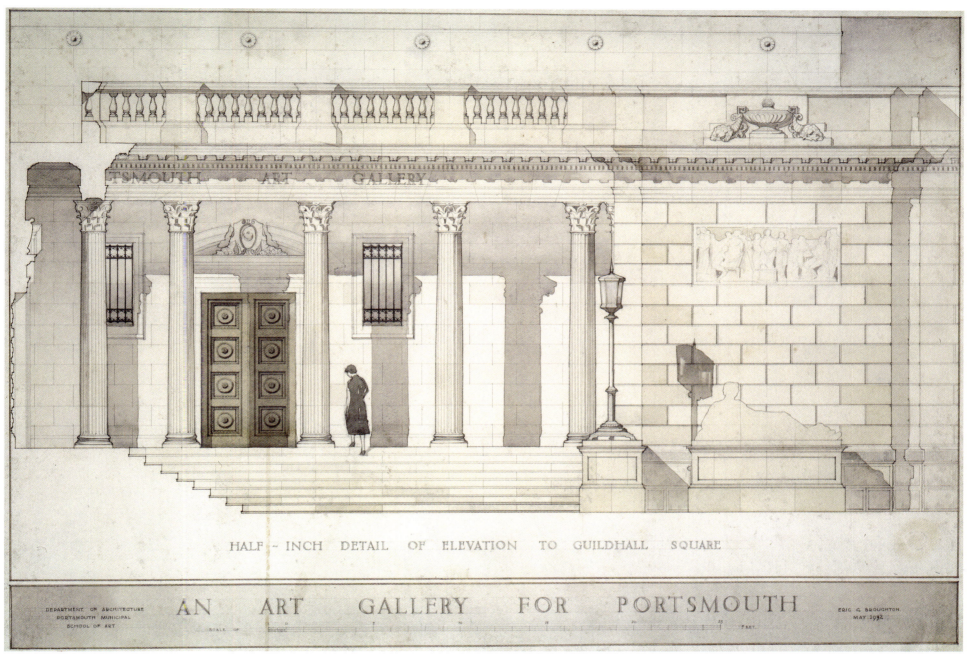

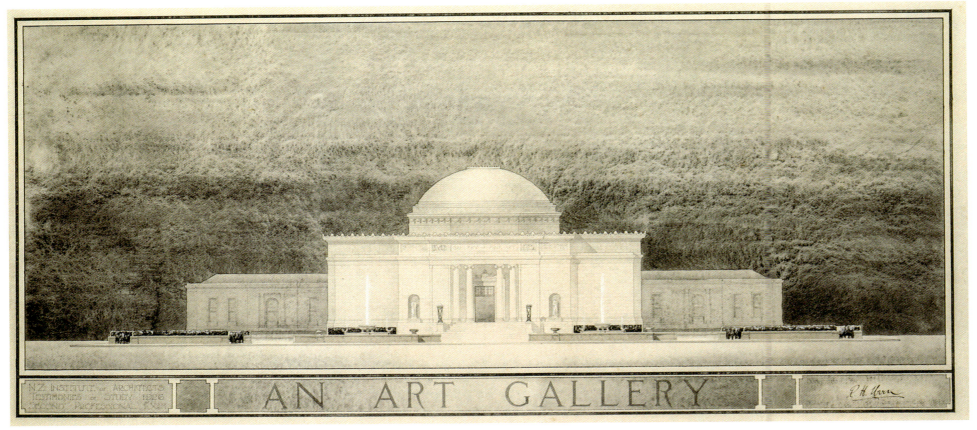

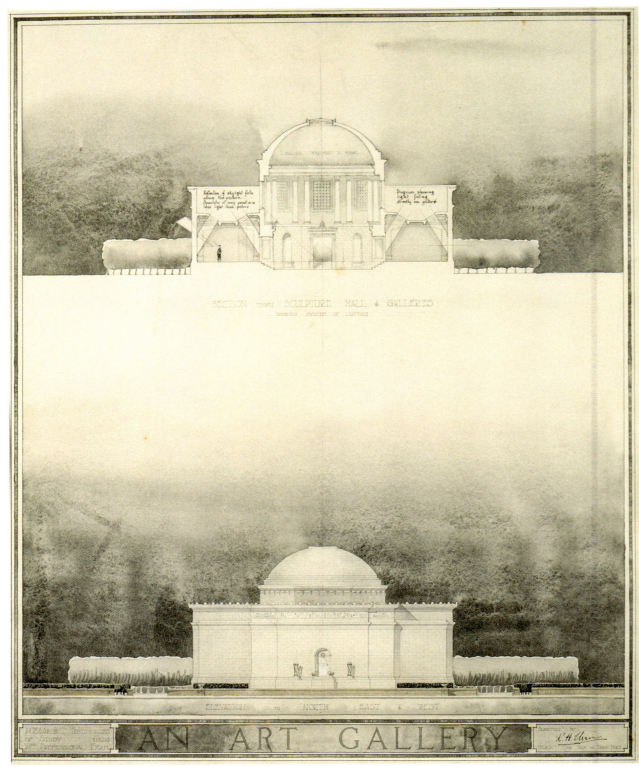

1.26

REGINALD HAROLD UREN
(NEW ZEALANDER, 1903–1988)

2000.545a–c: Examination drawings for an art gallery: two elevations, cross-section, and plan, 1926

Pencil, ink, watercolor

2000.545a: Frontal elevation. 13½ × 30¾ in. (34.3 × 78 cm)
INSCRIBED [in watercolor] *AN ART GALLERY / NZ INSTITUTE OF ARCHITECTS TESTIMONIES OF STUDY 1926 SECOND PROFESSIONAL EXAM / SUBMITTED BY* [in ink] *R.H. Uren* / [architectural measurements]

2000.545b: Cross-section and side elevation. 29½ × 24 in. (74.9 × 61 cm)
INSCRIBED [in watercolor] *AN ART GALLERY / SECTION THRU SCULPTURE HALL & GALLERIES SHOWING SYSTEM OF LIGHTING / COLOUR TREATMENTS IN MOSAIC / Reflection of skylight falls above the picture. Spectator at any point is in less light than picture. / Diagram showing light falling directly on picture. / ELEVATION TO NORTH EAST & WEST / NZ ARCH. TESTIMONIES OF STUDY 1926 2ND PROFESSIONAL EXAM / SUBMITTED BY* [in ink] *R.H. Uren* / [architectural measurements]

2000.545c: Plan. 29½ × 24 in. (74.9 × 61 cm)
INSCRIBED [in watercolor] *AN ART GALLERY / [3×] GALLERY / JANITOR / STAIR / MEN / WOMEN / NZ ARCH. TESTIMONIES OF STUDY 1926 2ND PROFESSIONAL EXAM / SUBMITTED BY* [in ink] *R.H. Uren* / [architectural measurements]

LITERATURE *Two Pioneer Modernists/ Reginald Uren (1903–1988) and Tom Ellis (1911–1988) / An Exhibition of Early Architectural Designs* (Gallery Lingard, London, 1989), cat. 1 and 2, inside cover (ill.) and p. 10 (ill.)
PROVENANCE Gallery Lingard, London

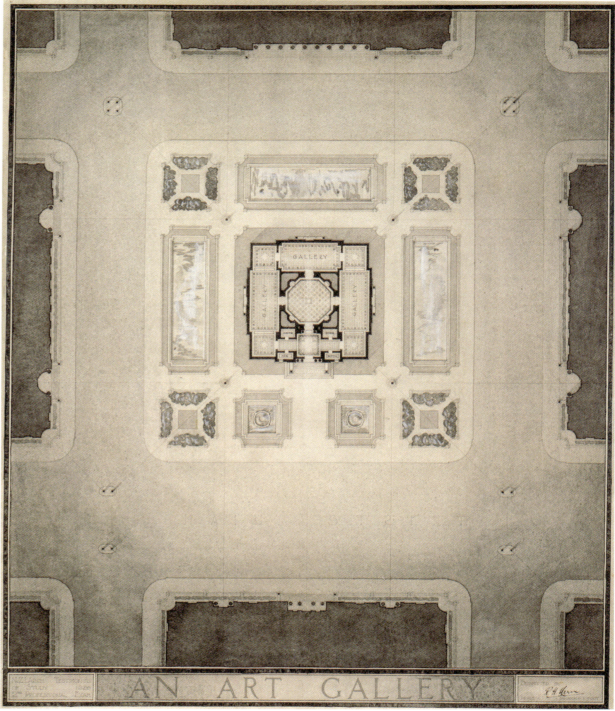

2000.545c

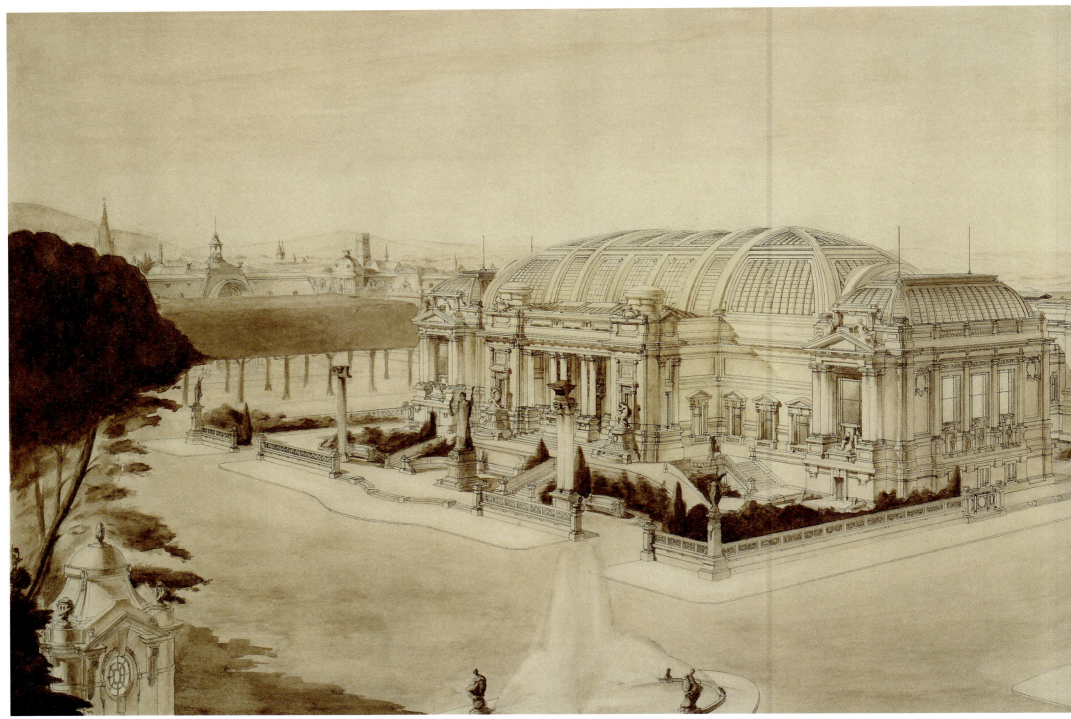

2000.441

1.27

HENRI VAN DIJK (BELGIAN),
ATTRIBUTED TO

2000.441: Competition drawing for
a museum: perspective, ca. 1900

Pencil, ink, watercolor. 30½ × 59 in. (77.5 × 149.9 cm)
INSCRIBED (in ink) *Perspective générale de l'Ensemble*
PROVENANCE Shepherd Gallery, New York

1.28

ARTIST UNKNOWN

1988.85: View of the Tribuna Gallery in the Uffizi, Florence, ca. 1880

Oil on canvas. 10½ × 7 in. (26.7 × 17.8 cm)
PROVENANCE unknown

🖌 Judging by period photographs, the arrangement of paintings behind the famous Medici *Venus* and the *Arrotino* represents a hanging of around 1880.

Tribuna Gallery, Uffizi, Florence, ca. 1880

1988.85

THEATERS, MUSEUMS & CLUBS

1.29

ARCHITECT UNKNOWN (FRENCH)

1987.25a–c: Competition drawings for an aquarium: elevations, cross-section, and plans, ca. 1884

Pencil, ink, watercolor, metallic tape

1987.25a: Frontal elevation, side elevation and cross-section
30½ × 44½ in. (77.5 × 113 cm)
INSCRIBED (in ink and watercolor, on entablature) *AQUARIUM*

1987.25b: Plan of the upper floor
INSCRIBED (in ink) *Le Boulevard Maritime / Le Musée / La Bibliothèque / La Salle de Cours / [2×] Prof^r / [4×] Eleve*

1987.25c: Plan of main floor
INSCRIBED (in ink) *Le Boulevard Maritime / Vestibule / L'Aquarium / Concierge / Le Laboratoire / La Salle des Bacs*

PROVENANCE unknown

🍎 *Aquarium Maritime* was an assignment at the École in 1884 and 1899.

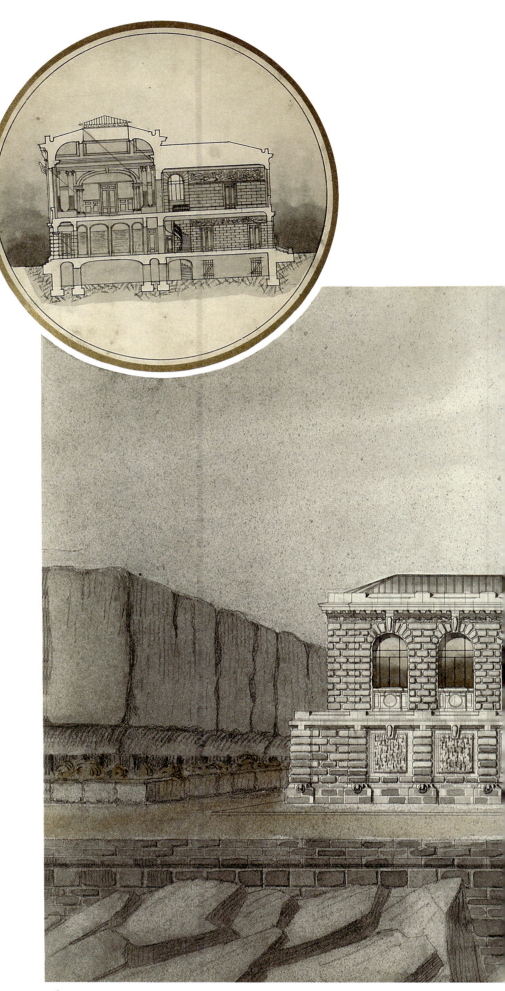

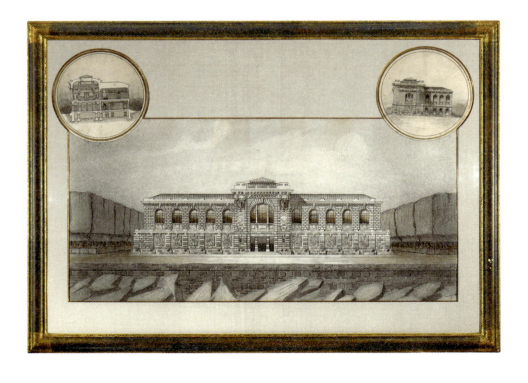

1987.25a

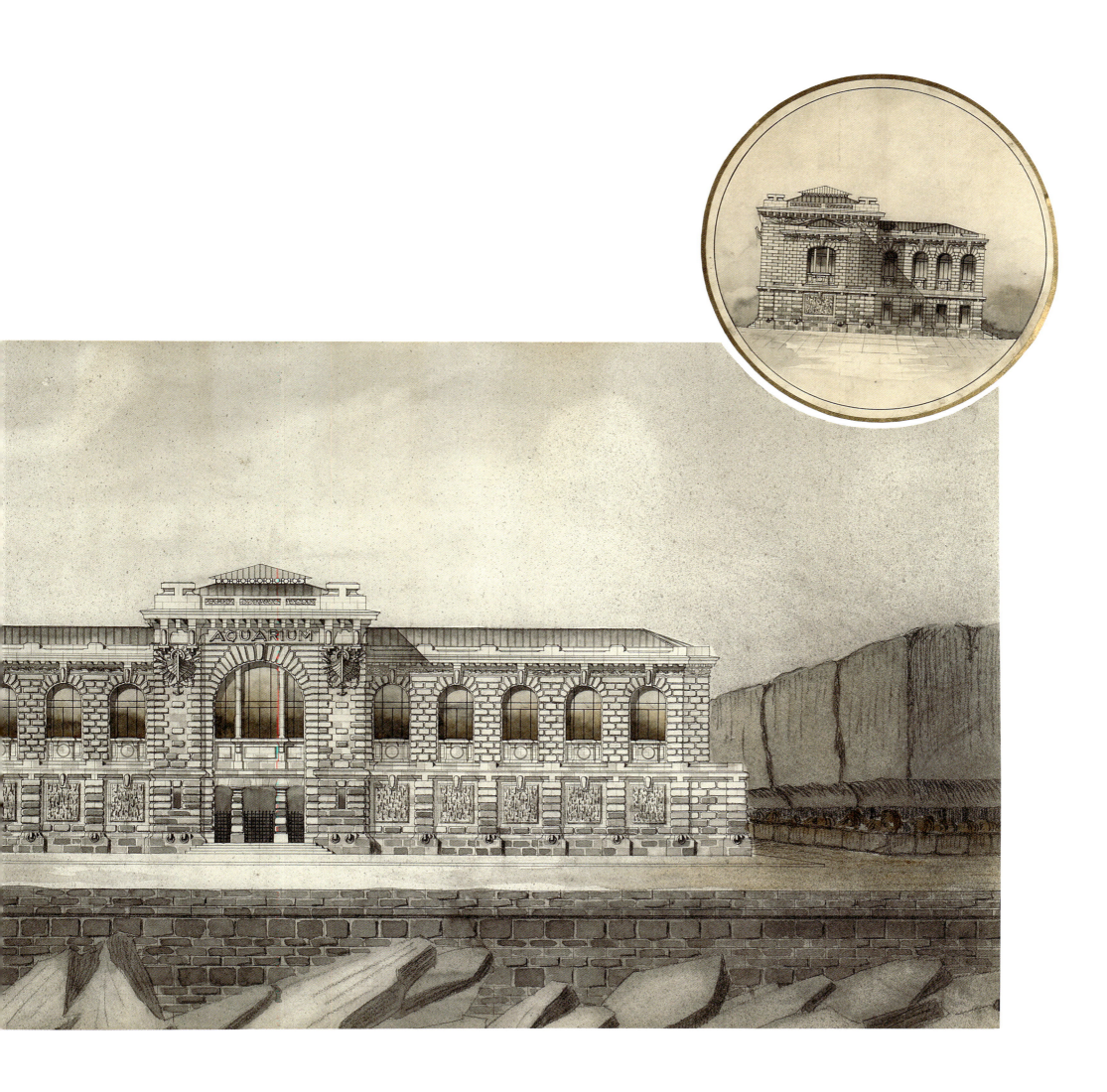

Le Boulevard Maritime

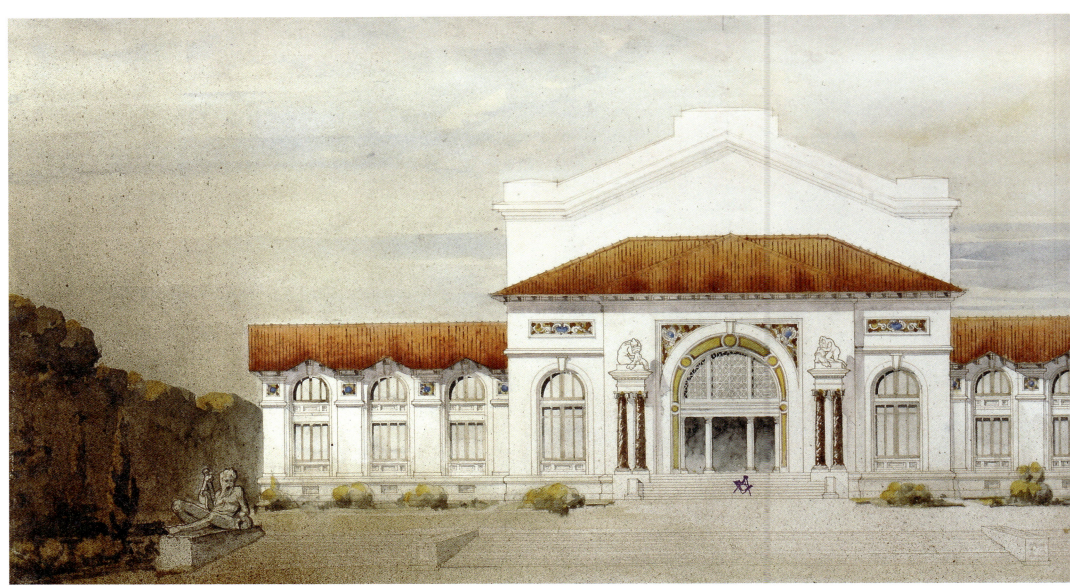

1989.231

1.30

ARCHITECT UNKNOWN (FRENCH)

1989.231: Competition drawing for a museum, frontal elevation, ca. 1900

Pencil, ink, watercolor. 14⅞ × 36⅝ in. (37.8 × 93 cm)
INSCRIBED (in purple) [masonic symbol or cipher on steps]
PROVENANCE unknown

1.31

ARCHITECT UNKNOWN (FRENCH)

1989.229: Competition drawing for an amphitheater: frontal elevation, 2nd half 19th century

Pencil, ink, watercolor. 18¼ × 33⅜ in. (46.4 × 84.8 cm)
INSCRIBED [in watercolor, on entablature]
CIRQUE NATIONAL
PROVENANCE unknown

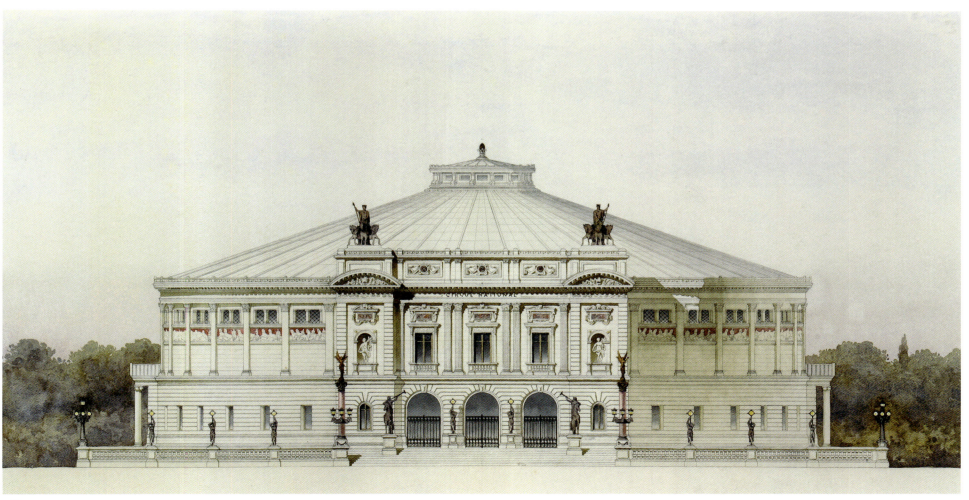

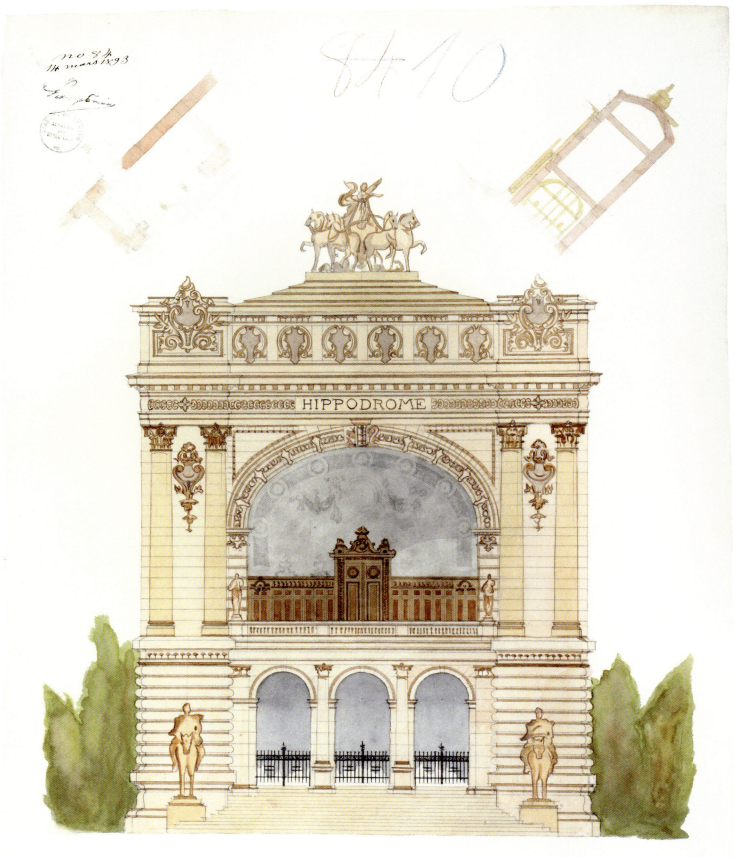

1.32

ACHILLE-LAURENT PROY
(FRENCH, 1864–1944)

1989.228a–c: Competition drawings for a hippodrome: elevations, cross-sections, and plans, 1893

Pencil, ink, watercolor

1989.228a: Frontal elevation and two details. 25 × 20 in. (63.5 × 50.8 cm)
INSCRIBED [in watercolor, on entablature] *HIPPODROME* / [in ink] *no. 84 / 14 mars 1893* [indistinct name] / *A. Proy Eleve de Mr. Raulin* / [in red] *84* / [in blue] *10* / [in pencil] *Proy*
STAMPED *1 JUIL 1893* / [inside circle] *INSTITUT DE FRANCE ACADEMIE DES BEAUX ARTS*

1989.228b: Elevation, cross-section, and plan. 25 × 20 in. (63.5 × 50.8 cm)
INSCRIBED [in ink] *No. 25* [indistinct name] / *A. Proy Eleve de Mr. Raulin* / [in blue] *2me mention* / [in red] *20*
STAMPED *1 JUIL 1893* / [inside circle] *ECOLE DES BEAUX ARTS / CONCOURS D'EMULATION*

1989.228c: Cross-sections and plan. 20 × 25 in. (50.8 × 63.5 cm)
INSCRIBED [in ink] *A. PROY Eleve de Mr. Raulin / No. 40* [indistinct name] / [in red] *23*
STAMPED *29 NOV 1893* / [inside circle] *INSTITUT DE FRANCE ACADEMIE DES BEAUX ARTS*

PROVENANCE unknown

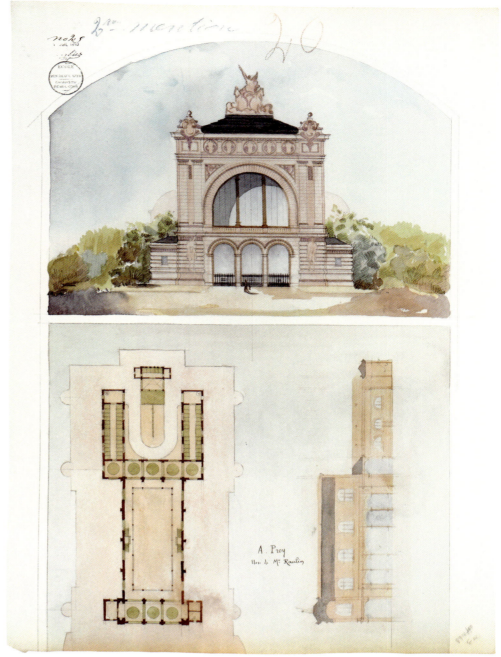

1989.228b

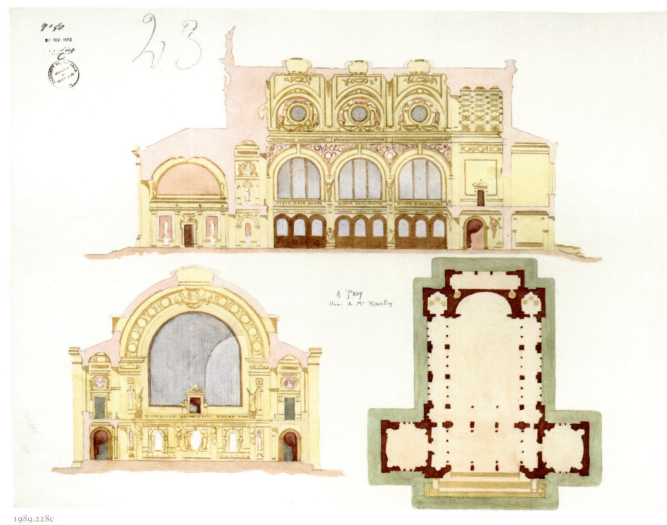

1989.228c

1.33

MARIE ANTOINE DELANNOY
(FRENCH, 1800–1860)

1999.414: Competition drawings for a national library: elevation and cross-section, ca. 1828

Pencil, ink, watercolor, metallic tape.
6¼ × 27½ in. (15.9 × 69.9 cm)
PROVENANCE Marc Dessauce, New York

❧ This is a small-scale copy of Delannoy's submission to the 1823 Prix de Rome competition, for which he won 1st prize; the larger original drawings were according to tradition retained by the École (inv. PRA 187-1a,b, 187-2 and 187-3)

Delannoy's original prize-winning submission, Prix de Rome 1823 (ENSBA, inv. PRA 187-1-a,b)

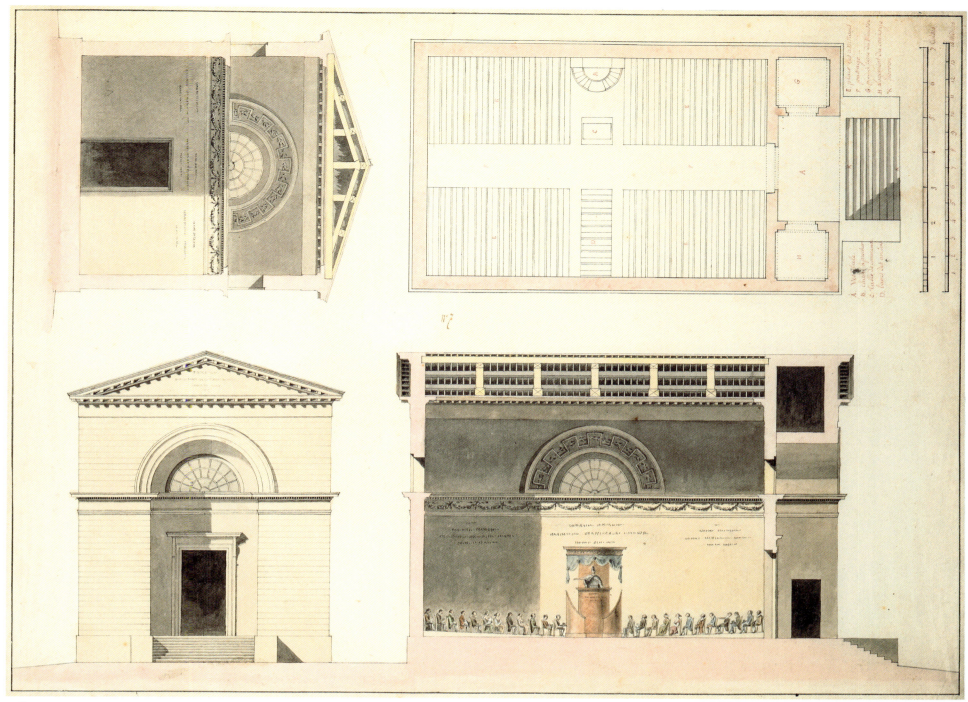

1.34

ARCHITECT UNKNOWN (FRENCH)

1998.405: Competition drawing for a meeting hall for the Friends of Liberty, incorporating elevations, cross-section, plan, early 19th century

Pencil, ink, watercolor. 17¾ × 24 in. (45.1 × 61.9 cm)
INSCRIBED [in brown] *No. 7* [in red] *A. Vestibule / B. Chaire à precher / C. Table de Communion / D. bancs des anciens / E. place des assistans / F. passage / G. pied-à-terre du Ministre / Logement du concierge / K. Perron* / [architectural measurements]
PROVENANCE Shepherd Gallery, New York

THEATERS, MUSEUMS & CLUBS 143

1.35

FRANCIS FOWKE (BRITISH, 1823–1865)

2000.516: Design for the board room, (Royal) Horticultural Society: cross-section, 1860

Pencil, ink, watercolor. 26¾ × 47⅝ in. (65 × 121 cm)
INSCRIBED [in ink] *Francis Fowke Capt. R.E. / 17 – Mar – 60 / John Kelk / – BOARD – ROOM – AND – OFFICES. – / for . construction . of . the . cove. See . detail . drawing . [2×] / Present . level . of . Ground / Concrete [6×] / Concrete bed [2×] / Fill . in . and . make . solid . [2×] / Bond to consist of three Courses of Brick in cement, and two courses of hoop iron.* / [architectural measurements]
STAMPED [on paper labels attached to drawing] *HORTICULTURAL SOCIETY. / SCALE OF AN INCH TO A FOOT. / SECTION OF LINE CD.*
PROVENANCE D. & R. Blissett, UK

🌺 The Horticultural Society was founded in 1804 and, with Prince Albert its President from 1858, was able to finance a headquarters in Kensington Gardens in 1860, becoming the Royal Horticultural Society a year later. The headquarters closed in 1882 and Fowke's building was subsequently torn down. Other plans for the Board Room are held by the Royal Horticultural Society archive located in Woking, Surrey.

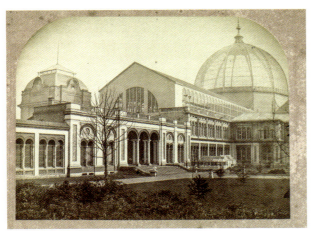
Royal Horticultural Society council room, Kensington Gardens, photograph ca. 1862

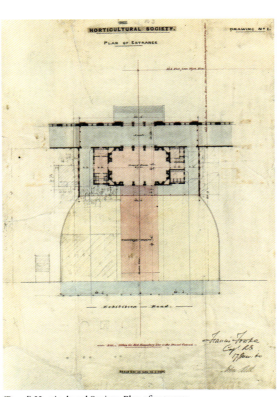
(Royal) Horticultural Society, Plan of entrance, drawing no. 1, 1860

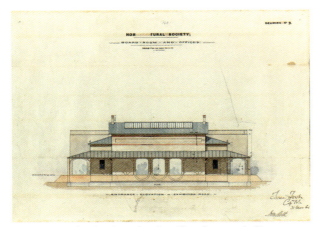
(Royal) Horticultural Society, Elevation of board room and offices, drawing no. 9, 1860

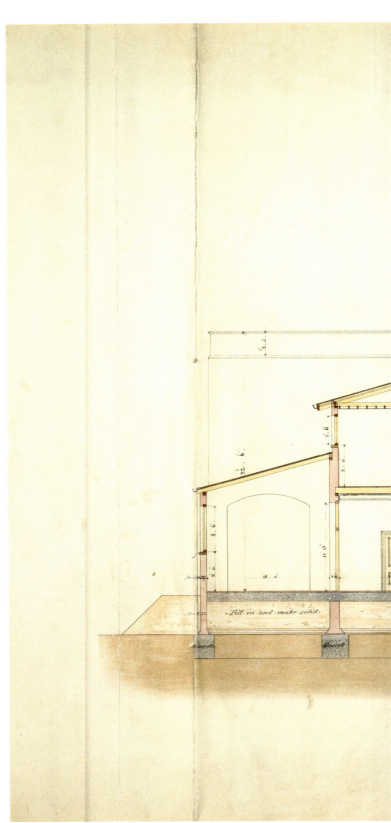
2000.516

HORTICULTURAL SOCIETY.

— BOARD — ROOM — AND — OFFICES. —

SCALE ½ OF AN INCH TO A FOOT.

DRAWING Nº 5.

SECTION ON LINE CD.

Francis Fowke
Capt. R.E.
17 - Mar - 60

1.36

ARCHITECTS: WILSON, WILLCOX & WILSON (BRITISH, 19TH CENTURY)
ARTIST: EDWARD BELL (BRITISH, 1844–1926)

1992.395: Designs for the decoration of the Octagon Assembly Room, Bath, 1879

Pencil, ink, watercolor. 18½ × 26 in. (47 × 66 cm)
INSCRIBED [in ink] *Edward Bell / Assembly Rooms. Bath. / Decorations / Wilson Willcox & Wilson Architects Bath / 10th. June 1879 / [2×] one Bay of Octagon Lobby / The square lobbies opening out of this octagon Lobby abc & D are to be similarly treated / Soffit & centre flower at B / Distemper color / octagon lobby / [4×] door / octagon room / Ball Room / Tea Room / X these doors end the decorators work. The work to doors* [indistinct] */ Plan of soffit C /* [in red] *oils to here distemper above / omit this lower color one time only & twice varnish. / [4×] wash 2 oils & distemper /* [in pencil, indistinct] *[…] subject to the […] color of pilloars June 10th.*
PROVENANCE Charles Plante, London

Assembly Rooms, Bath, ground floor plan

Octagon Assembly Room, Bath, ca. 1920

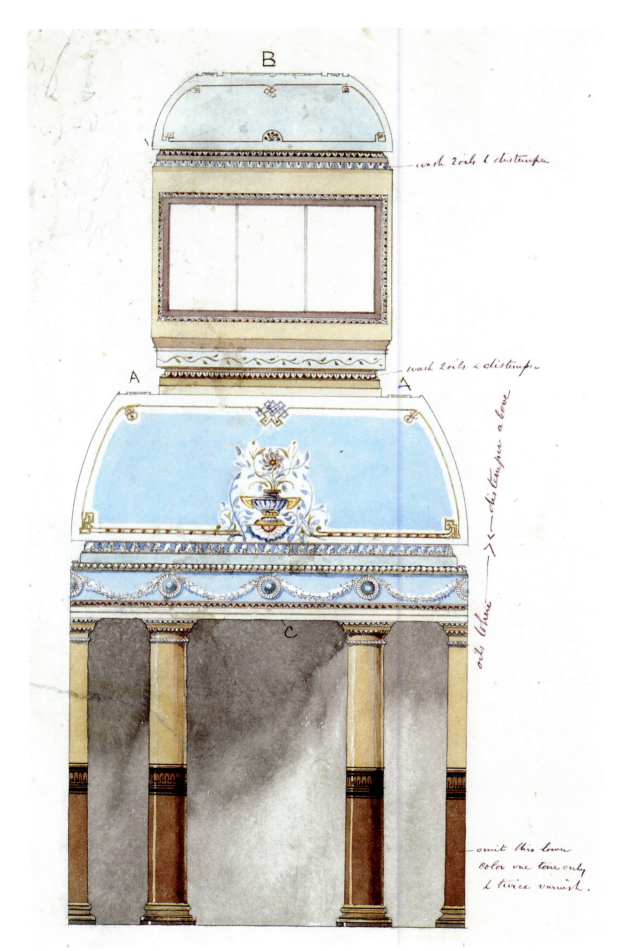
1992.395 detail

146 PETER MAY COLLECTION I

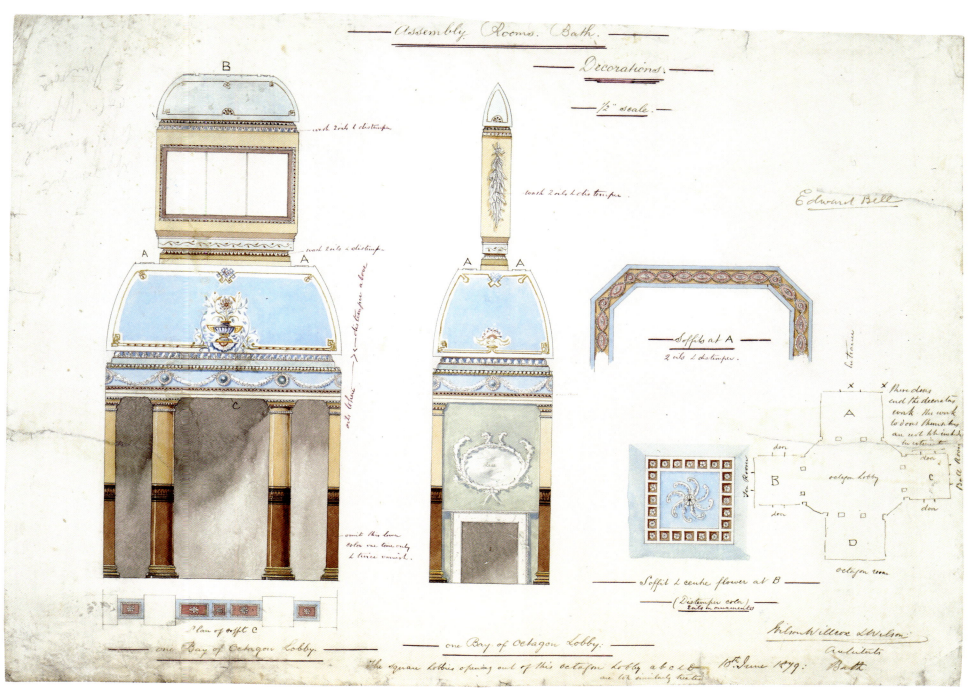

1.37

LEON KEACH (AMERICAN, 1893–1991)

1996.401c,h: Competition drawings for club houses: plans and elevations, ca. 1915

Pencil, ink, watercolor

1996.401c: Frontal elevation and two plans for a club house
37¼ × 21¼ in. (94.6 × 54 cm)
INSCRIBED [in ink] *VESTIBULE / DOOR KEEPER / COAT ROOM / LOBBY / WAITING-ROOM / ANTE ROOM / GRAND SALON* [in red crayon] *I* / [in black crayon] *11*

1996.401h: Elevation, cross-section and two plans for a club house. 23½ × 36½ in. (59.7 × 92.7 cm)
INSCRIBED [in ink] *A CLUBHOUSE SIDE-ELEVATION / FIRST FLOOR / VESTIBULE / COAT ROOM / STRANGERS / WASH ROOM / KITCHENETTE / LOUNGE / SHRINE /* [2×] *CLOSET /* [4×] *BEDROOM / LINEN / NOV. 10, 1915*
STAMPED [in red] *DEPARTMENT OF ARCHITECTURE / M.I.T.* […]

PROVENANCE Gwenda Jay Gallery, Chicago

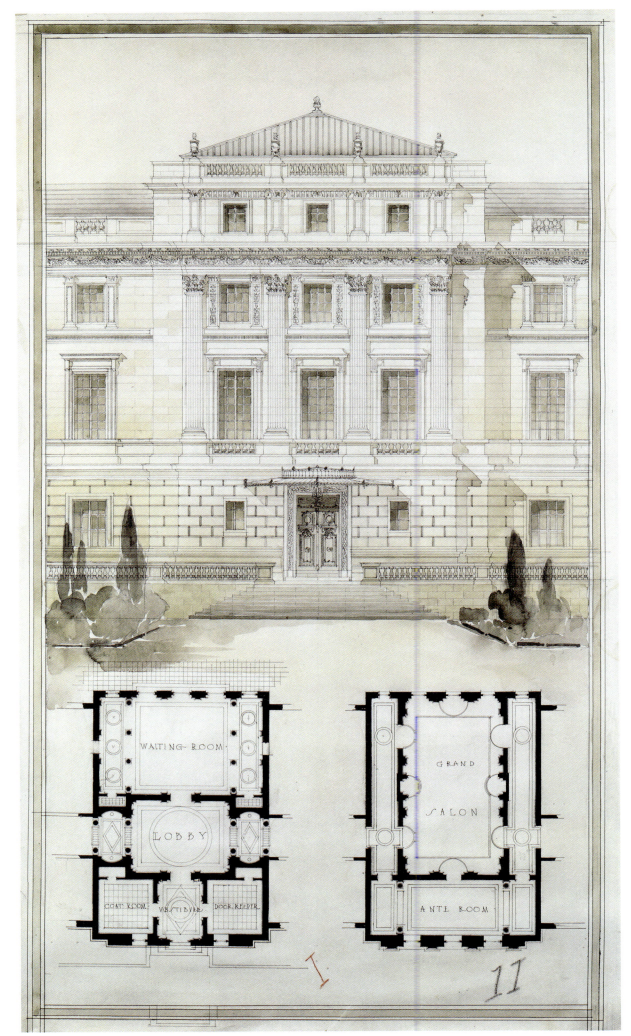

1996.401c

148 PETER MAY COLLECTION I

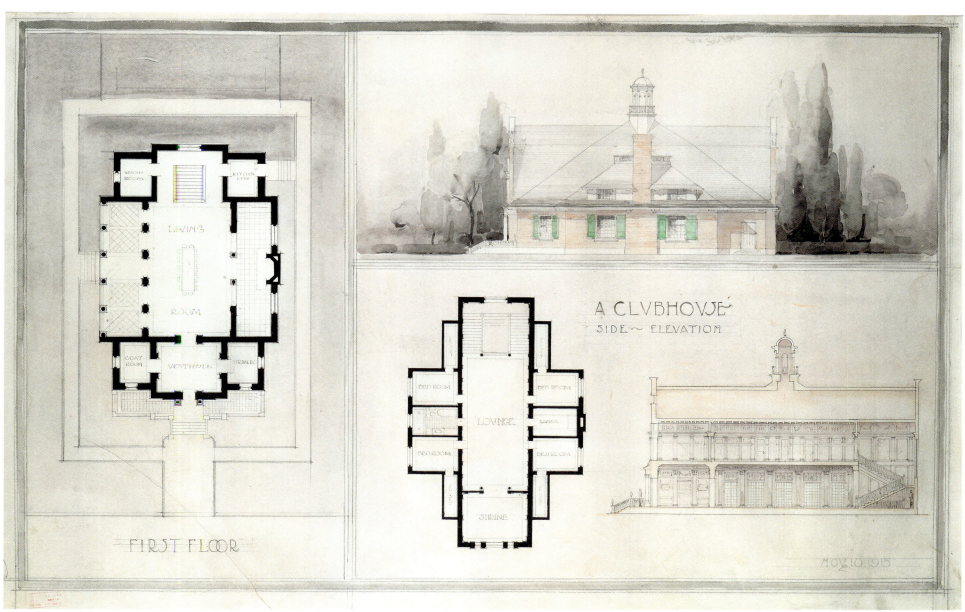

1.38

DAVID BRANDON
(BRITISH, 1813–1897)

1987.77: Perspective view of the Marlborough Club, 52 Pall Mall, London, ca. 1870

Pencil, watercolor. 25¾ × 18 in. (65.4 × 45.7 cm)
INSCRIBED [according to invoice, on mount or reverse] *Marlborough Club House / David Brandon Archt.* / [in ink, on building, in low relief] MC [Marlborough Club]
LITERATURE *The exhibition of the Royal Academy of Arts. MDCCCLXXI. The one hundred and third.* (London, the Royal Academy, 1871), no. 955: 'Perspective of the principal front of the Marlborough Club House, erected in Pall Mall, for the Committee and Members of the Marlborough Club';
Softs and Hards/ An Exhibition of Drawings by Victorian and Edwardian Architects (Gallery Lingard, London, 1986), cat. 13, pp. 6 (ill.) and 20
EXHIBITED Royal Academy, London, 1871, no. 955
PROVENANCE Gallery Lingard, London

🍂 The Marlborough Club was founded in 1868 and closed in 1953 after merging with the Windham Club in 1945; the exterior was later updated.

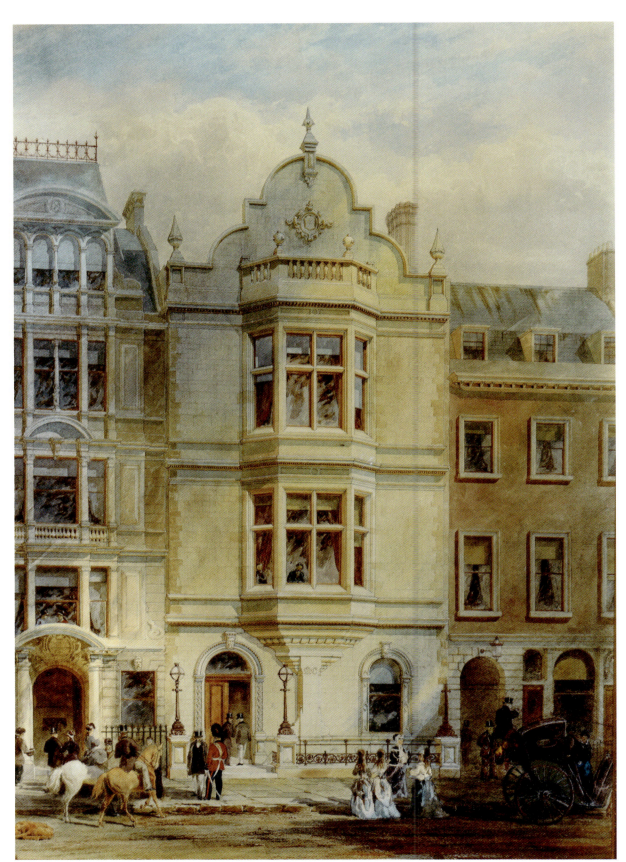

Marlborough Club, 52 Pall Mall, London

1.39

JOHN DIBBLEE CRACE
(BRITISH, 1838–1919), ATTRIBUTED TO

2000.437: The Athenaeum Club, London:
elevation detail at Pall Mall, before 1899

Pencil, watercolor. 12¾ × 9 in. (32.4 × 22.9 cm)
LITERATURE *Nineteenth Century European Architectural Drawings* (Shepherd Gallery, New York, 1994), cat. 39 (unpaginated)
PROVENANCE Shepherd Gallery, New York

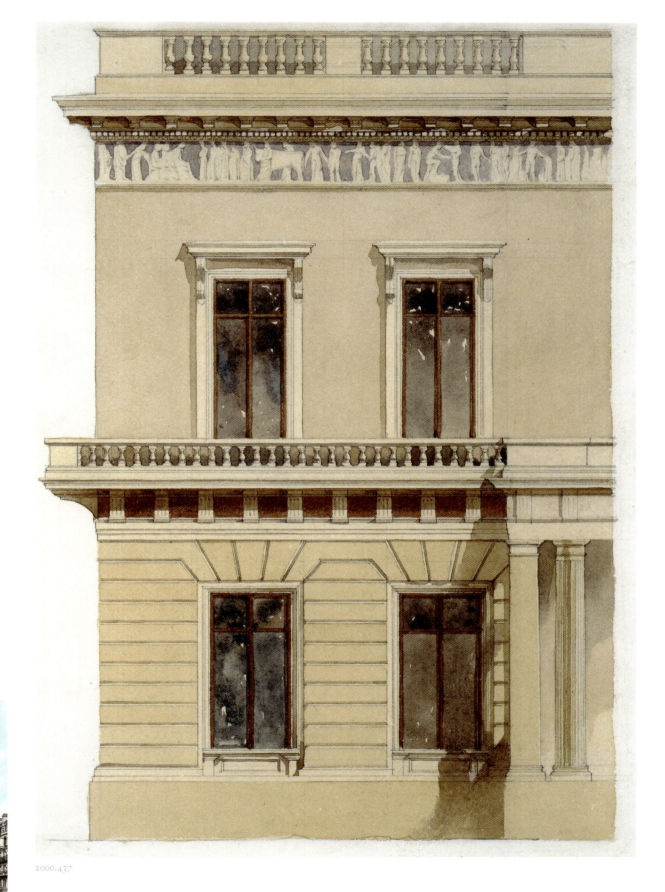

The Athenaeum Club, London

THEATERS, MUSEUMS & CLUBS 151

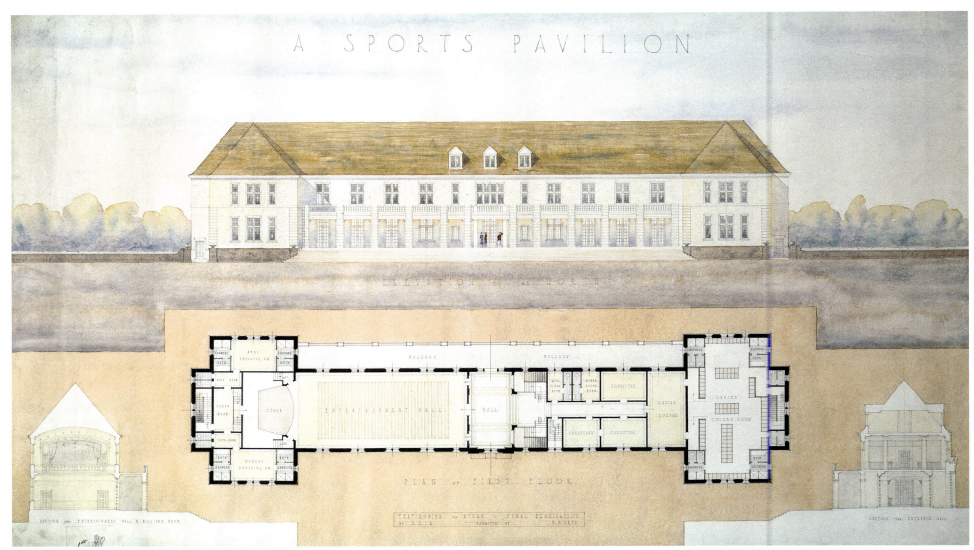

2000.469a

1.40

REGINALD HAROLD UREN
(NEW ZEALANDER, 1903–1988)

2000.469a,b: Examination drawings for a sports pavilion: elevations, cross-sections, and plans, ca. 1928

Pencil, ink, watercolor

2000.469a: Elevation, two sections and plan of 1st floor. 28 × 45 in. (71 × 114 cm)
INSCRIBED [in ink] *A SPORTS PAVILION / TESTIMONIES OF STUDY – FINAL EXAMINATION OF N.Z.I.A. SUBMITTED BY R.H. UREN / ELEVATION TO THE NORTH / PLAN OF FIRST FLOOR / HALL / ENTERTAINMENT HALL / STAGE / GREEN ROOM / [2×] ANTE-ROOM / [4×] BATH SHOWERS / MENS DRESSING RM. / WOMENS DRESSING RM. / [2×] BALCONY / [2×] COMMITTEE / MENS CLOAK ROOM / WOMENS CLOAK ROOM / SECRETARY / LADIES LOUNGE / LADIES LOCKER ROOM / [2×] SHOWERS / [2×] BATH SHOWERS / SERVICE STAIR / SECTION THRU ENTERTAINMENT HALL & BILLIARD ROOM. / SECTION THRU ENTRANCE HALL /* [in pencil] *1st* [indistinct initials]

2000.469b: Elevation and plan of ground floor. 29 × 45 in. (71 × 114 cm)
INSCRIBED [in ink] *A SPORTS PAVILION / TESTIMONIES OF STUDY – FINAL EXAMINATION OF N.Z.I.A. SUBMITTED BY R.H. UREN / ELEVATION TO THE SOUTH / PLAN OF GROUND FLOOR / TERRACE [2×] / LOGGIA [2×] / VESTIBULE [2×] / MAIN ENTRANCE / MAIN ENTRANCE HALL / MENS CLOAK RM / WOMENS CLOAK RM / ANTE ROOMS / THE LOUNGE / TEA ROOM / SERVICE / LOBBY / SERVICE ENTRANCE / ENTRY / STORAGE [2×] / KITCHEN / SERVING / COOKING / CLEAN DISHES / PREPARATION / DISH WASH / UP TO LOGGIA / WOMEN PLAYERS ENTRANCE / BILLARD & SMOKE ROOM / MENS LOCKER RM / SHOWERS [2×] / BATH ROOM [2×] / WC [4×] / LOBBY / STAGE ENTRANCE / TO THE STAGE / MEN PLAYERS ENTRANCE / TENNIS COURTS [2×] / PROMENADE [2×] /* [in pencil] *1st* [indistinct initials]

LITERATURE *Two Pioneer Modernists: Reginal Uren (1903–1988) & Tom Ellis (1911–1988). An Exhibiton of Early Architectural Designs* (Gallery Lingard, London, 1989), cat. 9 and 10, pp. 12–13 (cat. 9 ill.)
PROVENANCE Gallery Lingard, London

152 PETER MAY COLLECTION I

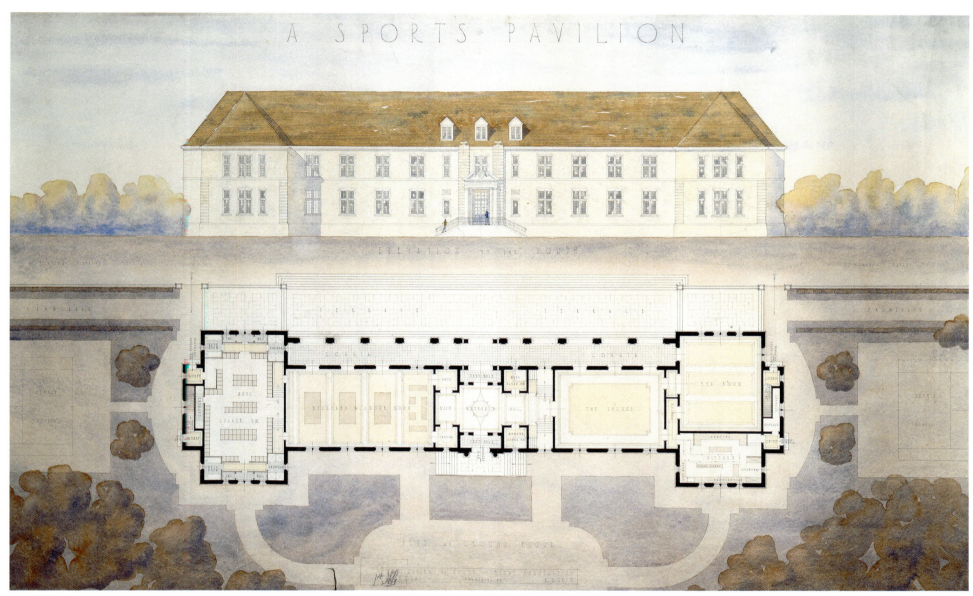

2000.470a

1.41

J. WHITFIELD LEWIS
(WELSH, 1911–2010)

2000.470a–c: Competition or examination drawings for a yacht club: elevation, cross-section and plan, 1933

Pencil, ink, watercolor

2000.470a: Frontal elevation. 19½ × 38 in. (49.5 × 96.5 cm)
INSCRIBED [in pencil and watercolor] *A YACHT CLUB*
STAMPED [in black rectangle] *RETAINED DRAWING FIFTH YEAR / CARDIFF TECHNICAL COLLEGE / THE WELSH SCHOOL OF ARCHITECTURE / HEAD OF DEPARTMENT:* [in ink] *W.S. Pines / Date:* [in ink] *14.7.33* / [on paper label] *2*

2000.470b: Cross-section. 14½ × 38 in. (36.8 × 96.5 cm)
INSCRIBED [in pencil and watercolor] *A YACHT CLUB / ELEVATION TO MAIN ROAD / HIGH WATER LEVEL / LOW WATER LEVEL / SEA WALL / CROSS SECTION AA*
STAMPED [in black rectangle] *RETAINED DRAWING FIFTH YEAR / CARDIFF TECHNICAL COLLEGE / THE WELSH SCHOOL OF ARCHITECTURE / HEAD OF DEPARTMENT:* [in ink] *W.S. Pines / Date:* [in ink] *14.7.33* / [on paper label] *1*

2000.470c: Plan of main and basement floor. 25 × 38½ in. (63.5 × 97.8 cm)
INSCRIBED [in pencil and watercolor] *A YACHT CLUB / CAR HALL / SELVIGE YARD / WC / L / WASHUP / CHINA / GLASS / CUTLERY / KITCHEN / OVEN / BAR / DINING ROOM / LOUNGE / LADIES / SECRETARY / TYP / WAITING ROOM / MEN / LOUNGE / BAR / SMOKE ROOM / BOWLING GREEN / BASEMENT FLOOR PLAN / BOATHOUSES / CHANGING ROOMS / FAN / SAIL ROOMS*
STAMPED [in black rectangle] *RETAINED DRAWING FIFTH YEAR / CARDIFF TECHNICAL COLLEGE / THE WELSH SCHOOL OF ARCHITECTURE / HEAD OF DEPARTMENT:* [in ink] *W.S. Pines / Date:* [in ink] *14.7.33* / [on paper label] *3*

PROVENANCE Gallery Lingard, London

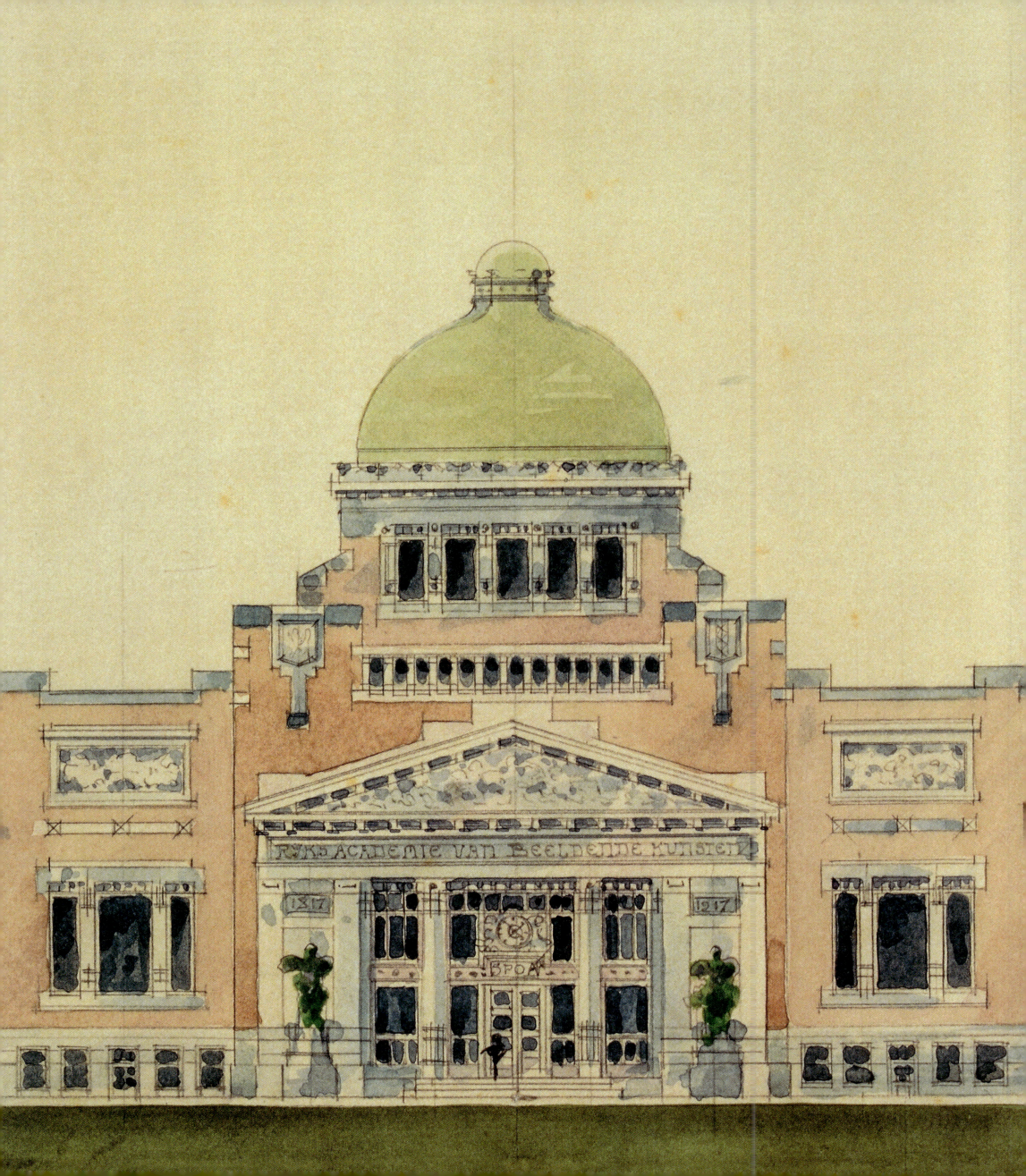

2
SCHOOLS AND CENTERS OF LEARNING

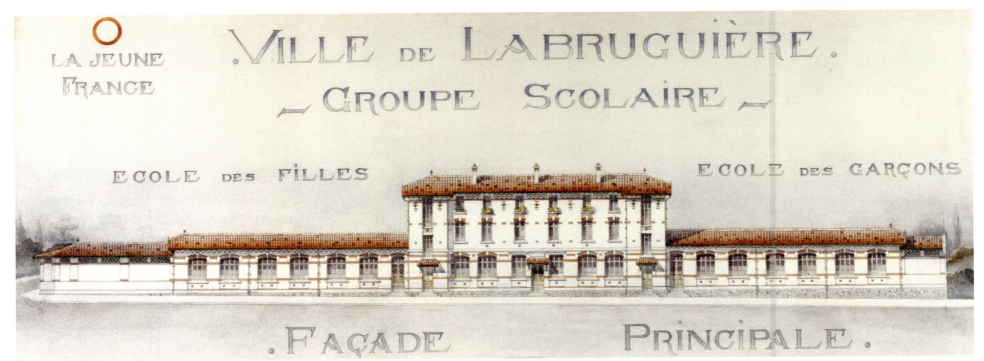

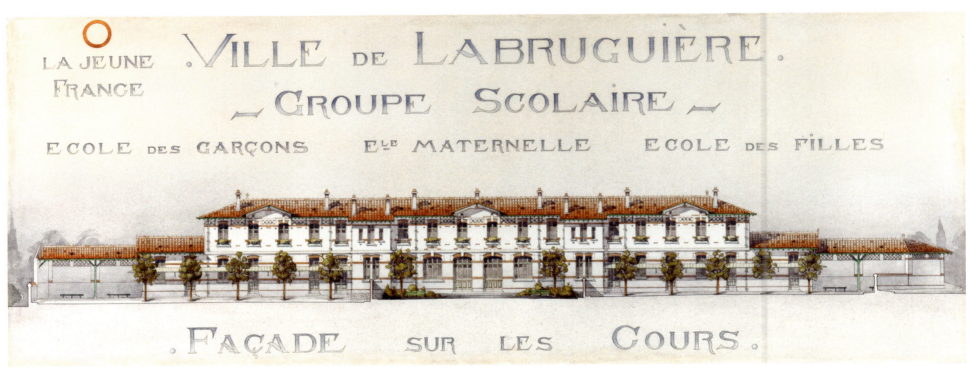

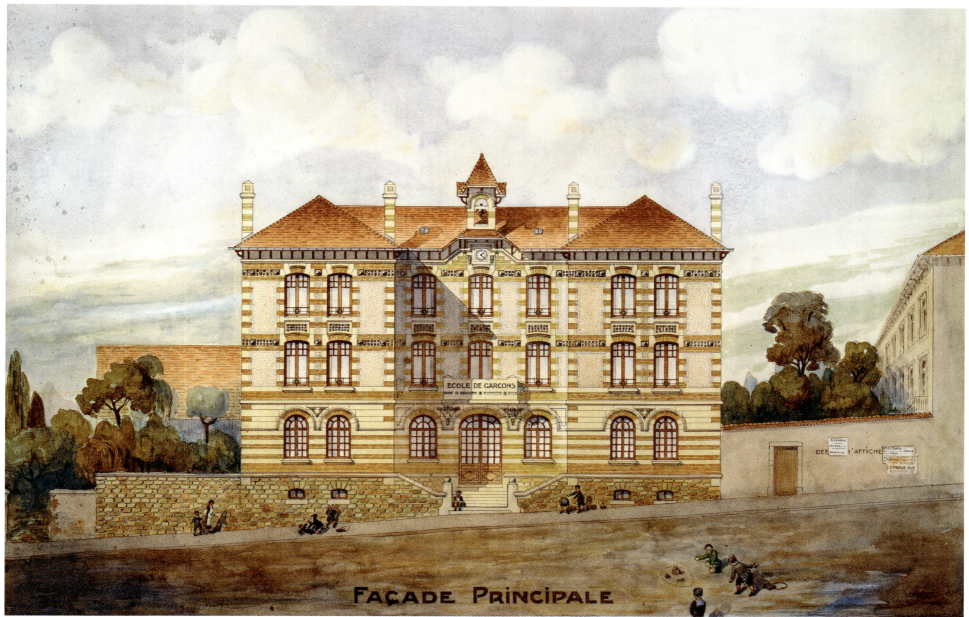

2.1

ARCHITECT UNKNOWN (FRENCH)

1991.376a,b: Presentation drawings for a school for Labruguière, France: frontal and courtyard elevations, ca. 1900

Pencil, ink, watercolor. 15¼ × 39⅜ in. (33.7 × 100 cm)

1991.376a
INSCRIBED *LA JEUNE FRANCE / – VILLE DE LABRUGUÈRE – / – GROUPE SCOLAIRE – / ÉCOLE DES FILLES / ECOLE DES GARÇONS / – FAÇADE PRINCIPALE –*

1991.376b
INSCRIBED *LA JEUNE FRANCE / – VILLE DE LABRUGUÈRE – / ECOLE DES GARÇONS / E^{LE} MATERNELLE / ÉCOLE DES FILLES / – FAÇADE SUR LES COURS –*

PROVENANCE Galerie Gasnier-Kamien, Paris

2.2

FERNAND VALÈRE MARIE ALEXANDRE CÉSAR (FRENCH, 1879–1969)

1987.18: Presentation drawing for a boys' school in Maxeville, France: frontal elevation, early 20th century

Pencil, ink, watercolor. 25 × 37 in. (63.5 × 94 cm)
INSCRIBED *FAÇADE PRINCIPALE* / [over entrance] *ECOLE DE GARÇONS*
PROVENANCE unknown

🖋 According to the invoice, the reverse is inscribed with the architect's name as well as 'architecte à Nancy' and the location of the school is given as Maxeville, France.

SCHOOLS & CENTERS OF LEARNING

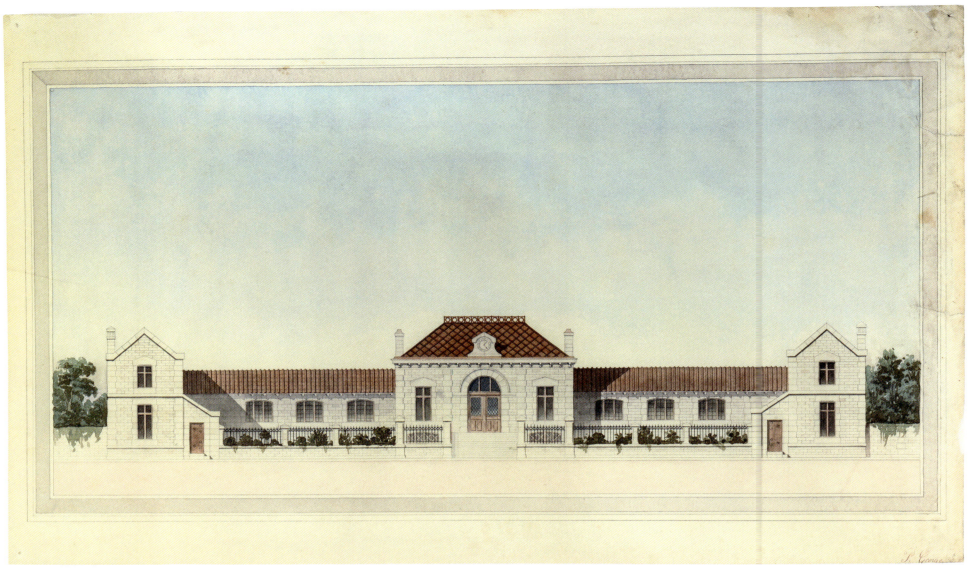

1990.312

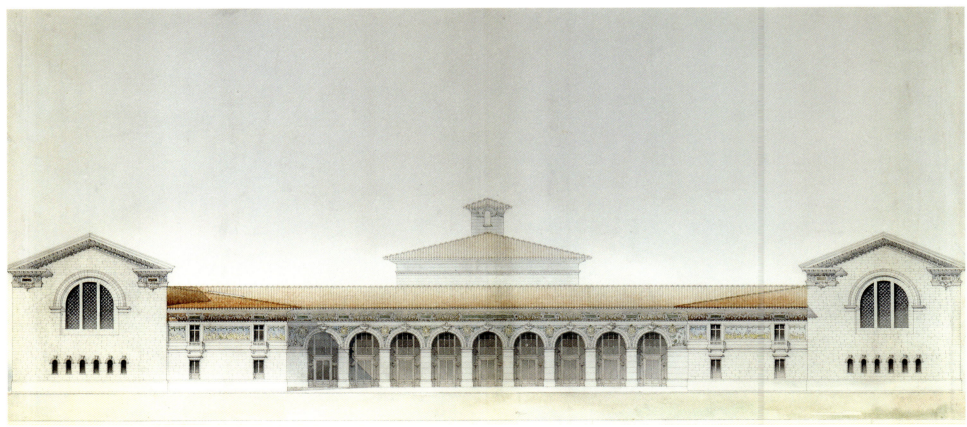

1990.302

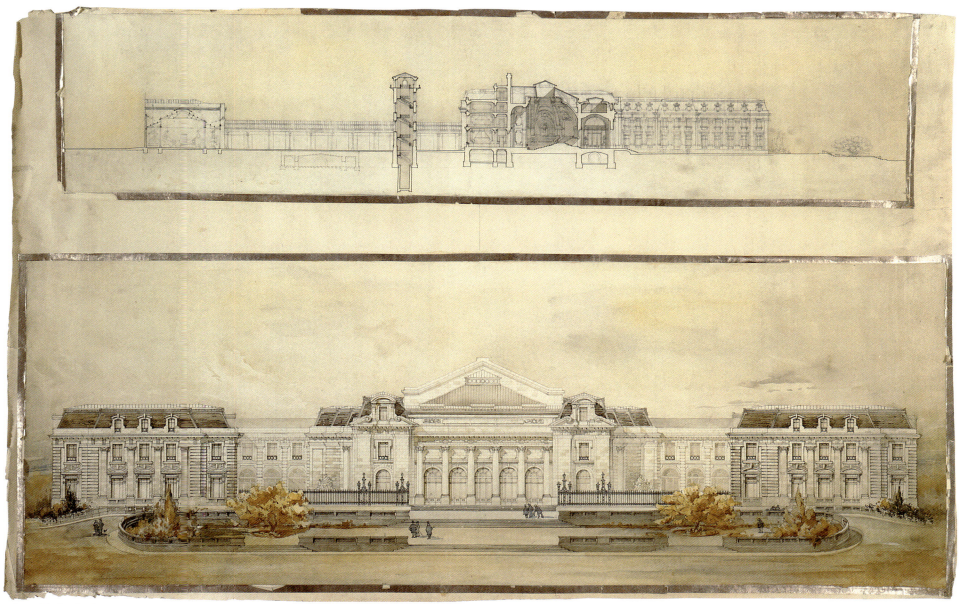

1987.2a–b before framing

2.3

P. GEORGE (FRENCH, DATES UNKNOWN)

1990.312: Competition drawing for a school: frontal elevation, ca. 1900

Pencil, ink, watercolor. 11 × 22⅝ in. (28.3 × 57.5 cm)
INSCRIBED [in red ink] *P. George*
PROVENANCE unknown

2.4

PAUL JOSEPH LEBRET (FRENCH, 1875–1933)

1990.302: Competition drawing for a school: frontal elevation, 1892

Pencil, ink, watercolor. 19 × 39¾ in. (47.5 × 99.5 cm)
LITERATURE *Architectural Drawings* (The Clarendon Gallery at the Shepherd Gallery, 1987), cat. 33, pp. 14 and 24 (ill.)
PROVENANCE Clarendon Gallery, London, at Shepherd Gallery, New York

2.5

ARCHITECT UNKNOWN (FRENCH)

1987.2a,b: Competition drawings for a school of arts and design (*école des arts et métiers*): elevation and cross-section, 1894

Pencil, ink, watercolor, metallic tape

1987.2a: Frontal elevation. 15 × 41 in. (38.1 × 104.1 cm)

1987.2b: Cross-section. 8 × 35½ in. (20.3 × 90.2 cm)

PROVENANCE unknown

SCHOOLS & CENTERS OF LEARNING

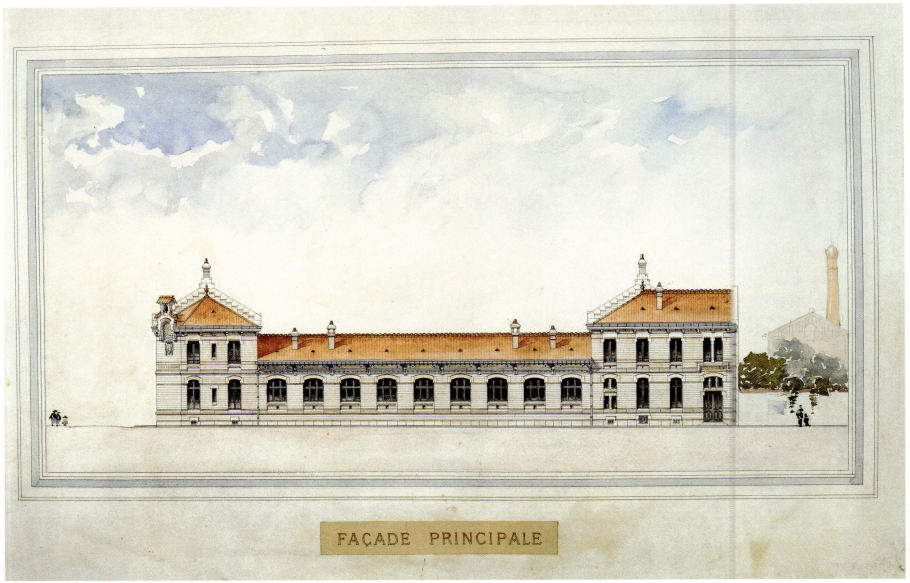

FAÇADE PRINCIPALE

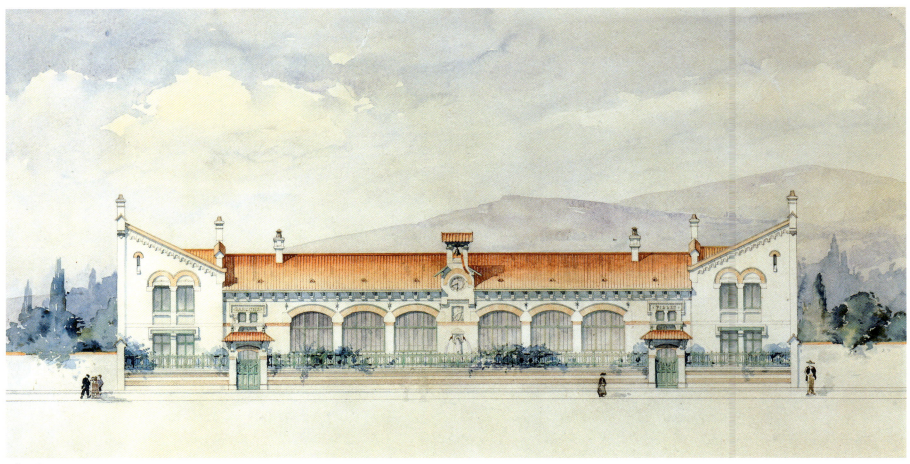

2.6

LUCIEN-LEON WOOG
(FRENCH, 1867–1937)

1987.21a–f: Competition drawings for a school: four elevations and two cross-sections, ca. 1900

Pencil, ink, watercolor

1987.21a: 13¼ × 24¾ in. (33.7 × 62.9 cm)
INSCRIBED [in ink and watercolor] *VILLE DE COUR…* [indistinct] / *ECOLE DES GARCONS* / [on paper label] *FAÇADE PRINCIPALE*

1987.21b: 15½ × 29½ in. (39.4 × 74.3 cm)
INSCRIBED [in ink and watercolor] *GARCONS / FILLES*

1987.21c: 15½ × 31 in. (39.4 × 78.7 cm)
INSCRIBED [in ink and watercolor] *VILLE DE COUR…* [indistinct] / *ECOLE DES GARCONS*

1987.21d: 15½ × 29½ in. (39.4 × 74.3 cm)
INSCRIBED [in ink and watercolor] *ECOLE DES FILLES / ECOLE MATERNELLE*

1987.21e: 15½ × 29½ in. (39.4 × 74.3 cm)
INSCRIBED [architectural measurements]

1987.21f: 15½ × 31 in. (39.4 × 78.7 cm)
INSCRIBED [architectural measurements]

PROVENANCE unknown

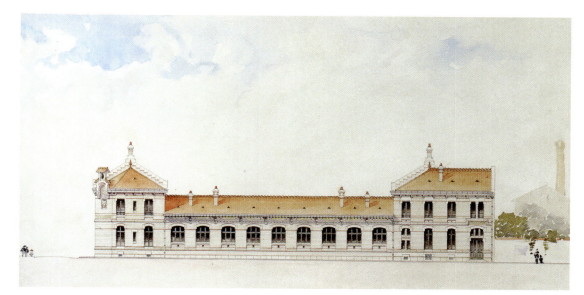

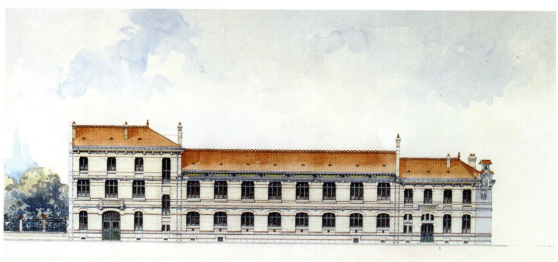

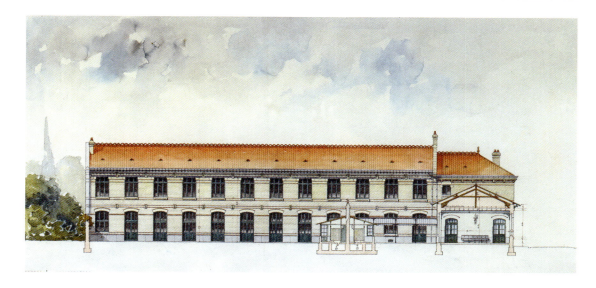

1987.21c–f

2.7

JAMES WILSON (BRITISH, 1816–1900)

2010.538: Presentation drawing: perspective of the Royal School, Bath, 1857

Pencil, ink, watercolor. 15½ × 24½ in. (39.5 × 62.5 cm)
PROVENANCE Private collection, Nashville, TN; D. & R. Blissett, UK

Now the Royal High School, it stands on Lansdown Road.

1988.128

2.8

ARCHITECT UNKNOWN (BRITISH)

1988.128: Presentation drawing: perspective of a British school with important visitors in the foreground, 19th century

Pencil, pen, watercolor. 28 × 48½ in. (71.1 × 123.2 cm)
PROVENANCE Sotheby's, London, 17 May 1984, lot 61

1987.92

2.9

JOHN NEWMAN (BRITISH, 1786–1859)

1987.92: View of the School for the Indigent Blind, London, ca. 1838

Pencil, ink, watercolor. 20¼ × 35¾ in. (51.4 × 90.8 cm)
INSCRIBED [in watercolor] *INDIGENT BLIND SCHOOL / J. NEWMAN. ARCHT.*
EXHIBITED Gallery Lingard, London, 1987
LITERATURE *Capital Buildings: An Exhibition of Architectural Designs and Topographical Views of London* (Gallery Lingard, London, 1987), cat. 4, p. 14 (ill.)
PROVENANCE Gallery Lingard, London

❧ Prints were issued after this watercolor and possibly sold to raise funds for the charity. Founded in 1799, completed in 1838, the building in St. George's Fields has not survived, though the obelisk in the foreground remains.

The Blind Asylum, Southwark, London, lithograph, ca. 1840

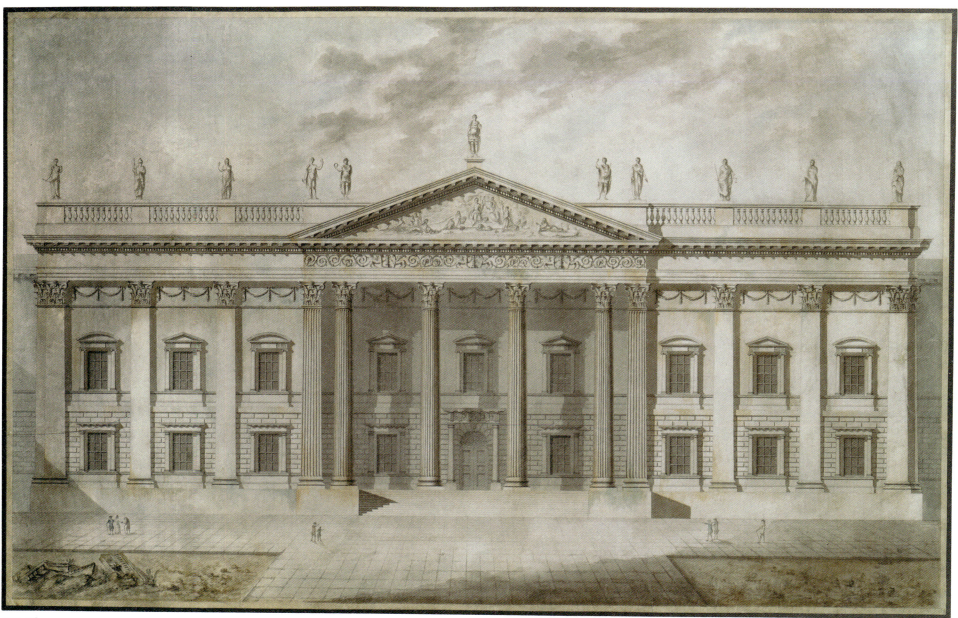

2.10

THOMAS HARDWICK, JR.
(BRITISH, 1752–1829)

1999.416: Elevation for a University Senate House, ca. 1800

Pencil, ink, watercolor. 28 × 42 in. (71.1 × 106.7 cm)
PROVENANCE Charles Plante, London

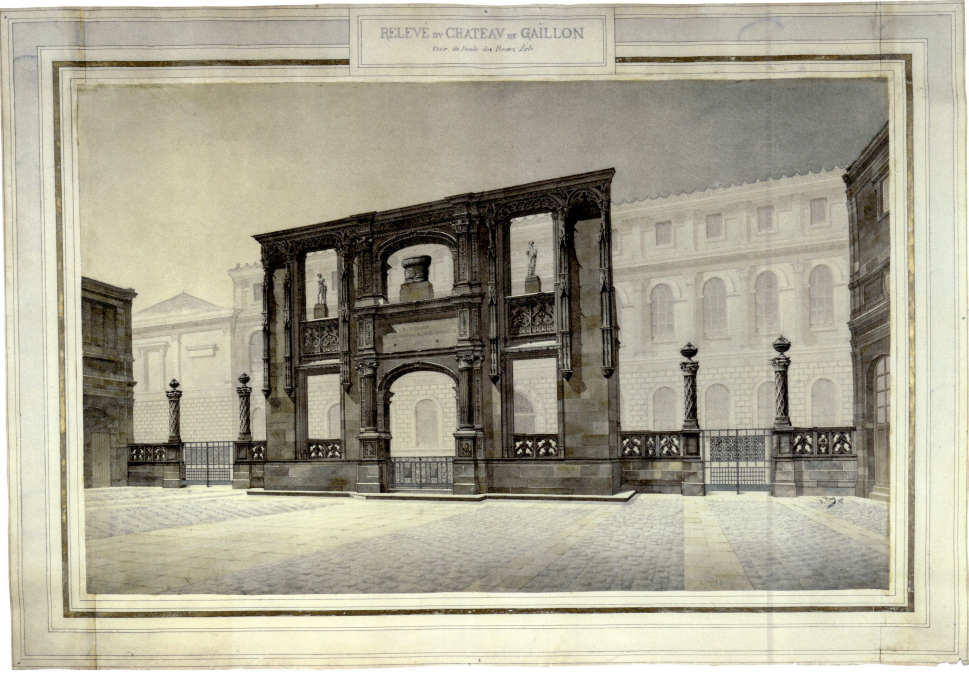

2.11

ACHILLE-LAURENT PROY
(FRENCH, 1864–1944)

1990.221: View of the portal of the Château de Gaillon installed in the courtyard of the Ecole des Beaux-Arts, 1890

Pencil, ink, watercolor, metallic tape. 32½ × 45½ in. (81.9 × 115.6 cm)
INSCRIBED [in watercolor] *A. Proy 1890* / [in ink and watercolor] *RELEVE DU CHATEAU DE GAILLON / Cour de l'ecole des Beaux Arts*
PROVENANCE unknown

This architectural feature from the decaying Château de Gaillon in Normandy was relocated to the courtyard of the École des Beaux-Arts in Paris in 1834 to serve as a teaching model for the students. When the château was restored in the 1970s, the portal was returned to its original location.

Israel Silvestre, *View of the Château de Gaillon in Normandy*, etching, 1658

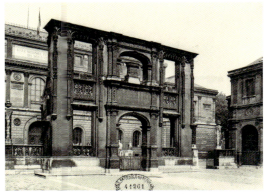

Ruined portal of the Château de Gaillon in the courtyard of the École des Beaux-Arts

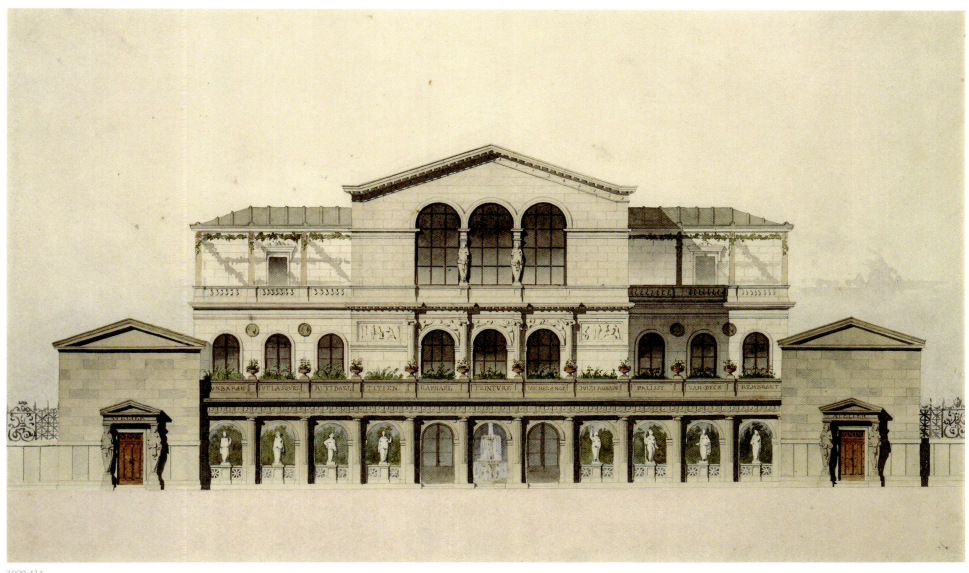

2.12

ARCHITECT UNKNOWN (FRENCH)

2000.434: Competition drawing for
an art school: frontal elevation, 1847

Pencil, ink, watercolor. 12⅝ × 19¼ in. (32.1 × 48.9 cm)
INSCRIBED [in pencil] *1847* / [in watercolor, over entrances
and balustrade] *ATELIER / ZURBARAN / VELASQUE /
RVYSDAEL / TITIEN / RAPHAEL / PEINTURE /
MICHELANGE / JULES ROMAN / PALISSY / VAN DYCK /
REMBRANT / ATELIER*
PROVENANCE Shepherd Gallery, New York

2.13

ARCHITECT UNKNOWN (FRENCH)

1991.324: Competition drawing for a postage stamp commemorating a Beaux-Arts Exposition, early 20th century

Pencil, ink, watercolor. 25½ × 14 in. (64.8 × 33.6 cm)
INSCRIBED *EXPOSITION NATIONALE BEAUX ARTS / 10ᶜ*
APPLIED STAMPS [in purple ink, in circle] *ÉCOLE NATIONALE DES BEAUX-ARTS CONCOURS D'EMULATION*
PROVENANCE unknown

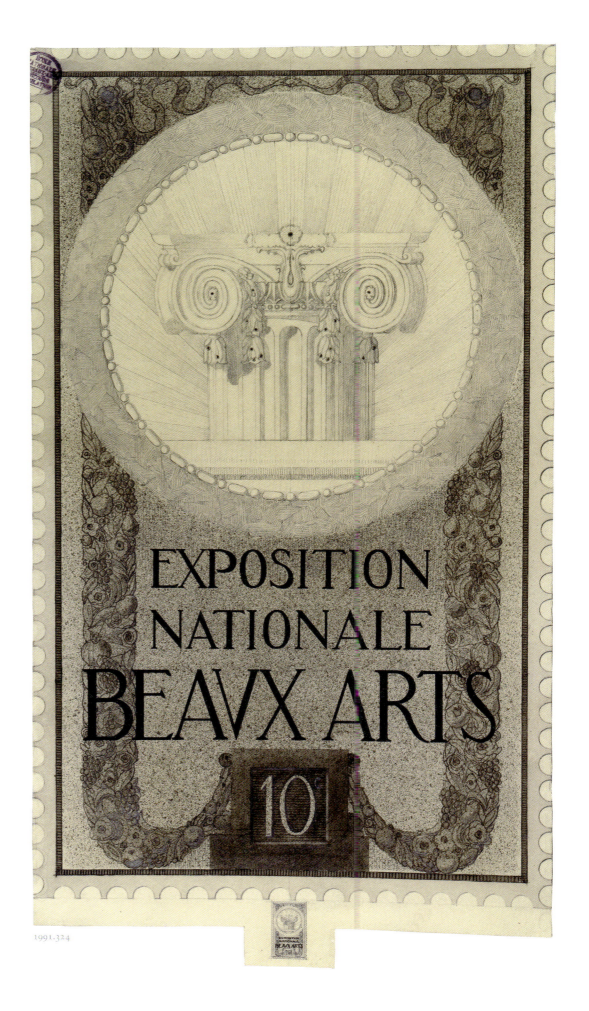

2.14

JEAN MARCEL CARTERON
(FRENCH, BORN 1905)

1990.282: Competition drawing
for a postage stamp commemorating
the Beaux-Arts Exposition, 1930

Pencil, ink, watercolor. 26½ × 16 in. (67.3 × 40.6 cm) approx.
INSCRIBED *REPUBLIQUE FRANÇAISE / HOTEL DES INVALIDES / J. HARDOUIN MANSART. ARCH / EXPOSITION NATIONALE DES BEAUX-ARTS / 1930 / 1931 / 1F*
STAMPED [in black ink] *Jean CARTERON Architecte*
PROVENANCE unknown

Hôtel national des Invalides, Paris

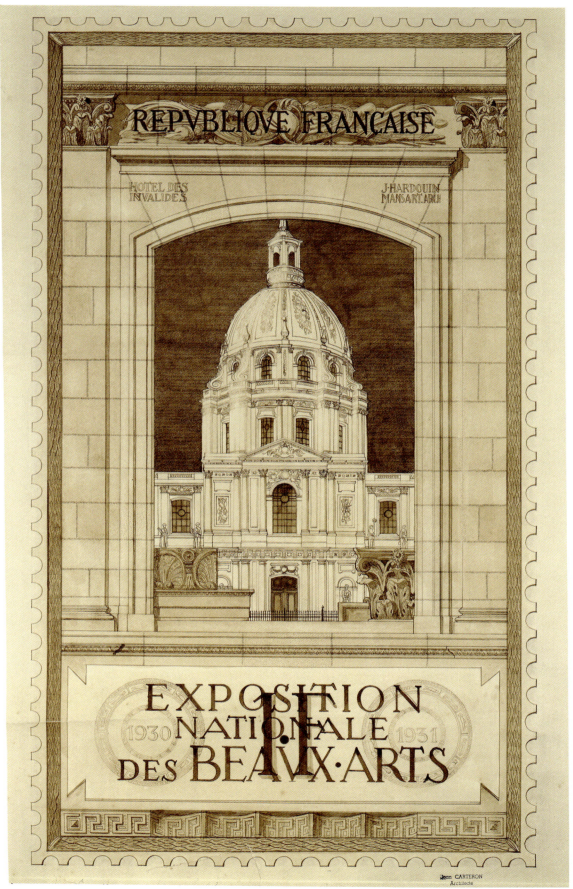

1990.282

SCHOOLS & CENTERS OF LEARNING 171

1987.14

2.15

ARCHITECT UNKNOWN (DUTCH)

1987.14: Competition drawing for the Royal Dutch Academy of Art: frontal elevation, ca. 1917

Pencil, ink, watercolor. 9 × 13⅜ in. (22.8 × 79.6 cm)
INSCRIBED [in watercolor] *RJKS ACADEMIE BEELDDENDE KUNSTEN / 1817 / 1917*
PROVENANCE unknown

🌹 This was doubtless a submission to the 1917 competition for a new Academy building.

2.16

ARCHITECT UNKNOWN (FRENCH)

1991.370: Competition drawing for a music school, late 19th century

Pencil, ink, watercolor. 27 × 41 in. (68.6 × 104.1 cm)
INSCRIBED [on pediment] *ACADEMIE DE MUSIQUE / L. Peigl* [?]
PROVENANCE unknown

SCHOOLS & CENTERS OF LEARNING 173

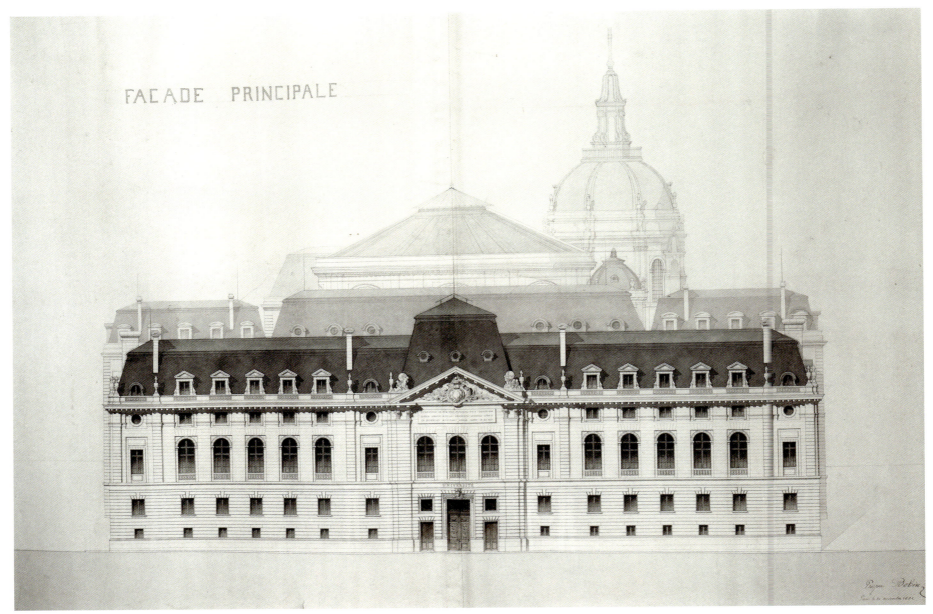

1988.101a

2.17

PROSPER-ETIENNE BOBIN
(FRENCH, 1844–1923)

1988.101a–c and 1991.360:
Competition drawings for an expansion to the Sorbonne: two facades and two cross-sections, 1882, exhibited at the Salon of 1890

Pencil, ink, watercolor

1988.101a: Elevation of frontal facade. 29 × 42¾ in. (73.7 × 108.6 cm)
INSCRIBED *FAÇADE PRINCIPALE 1882* / [on entablature] *LUDOVICUS – IX – SUB – QUO – FUNDATA – FUIT – DOMUS- BON – CIRCA – ANNUM – M CC LII – ARMANDUS – IOANNES – CARD – DE RICHELIEU OEDIFICAUIT DOMUM ANNO M.DC .XLII* / [over entrance] *UNIVERSITÉ* / [in red ink] *Prosper Bobin / Paris le 30 novembre 1882*

1988.101b: Transverse cross-section. 25¼ × 35¾ in. (64.1 × 90.8 cm)
INSCRIBED [in pencil and watercolor] *COUPE TRANSVERSALE* [in red ink] *Prosper Bobin / Paris le 30 novembre 1882*

1988.101c: Elevation of rear façade. 22 × 35¼ in. (55.9 × 89.5 cm)
INSCRIBED [in pencil and watercolor] *FACADE POSTERIEURE* / [in red ink] *Dressé par l'architecte sousigne / Paris le 30 novembre 1882 / Prosper Bobin*

1991.360: Longitudinal cross-section. 34⅝ × 108 in. (88 × 274.3 cm)
INSCRIBED [in pencil and watercolor] *PROJET DE RECONSTRUCTION DE LA SORBONNE / COUPE LONGITUDINALE* / [in red ink] *Dressé par l'architecte sousigne / Paris le 30 novembre 1882 / Prosper Bobin* / [other notations in red]

PROVENANCE unknown

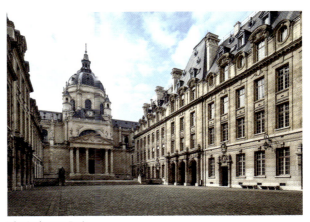

The Sorbonne, Paris

174 PETER MAY COLLECTION I

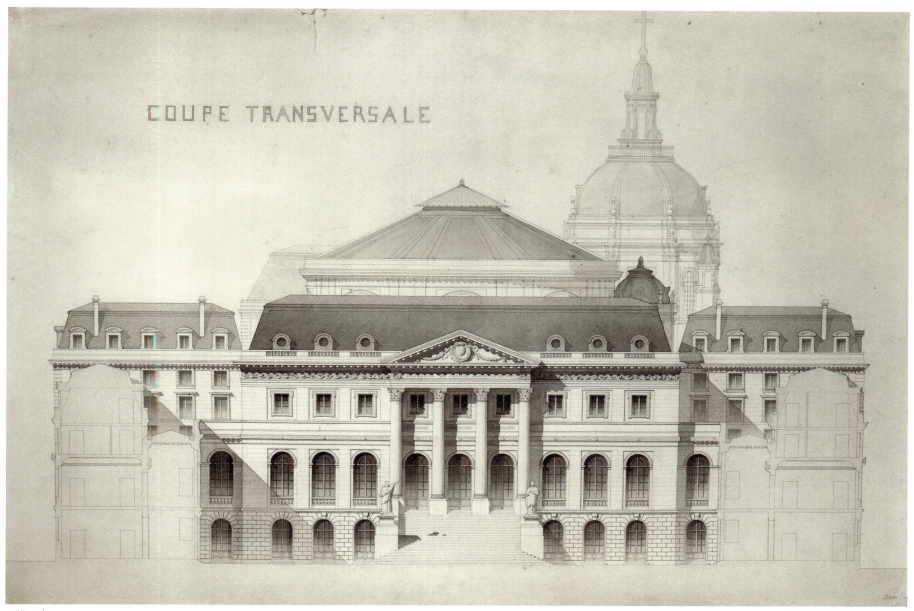

COUPE TRANSVERSALE

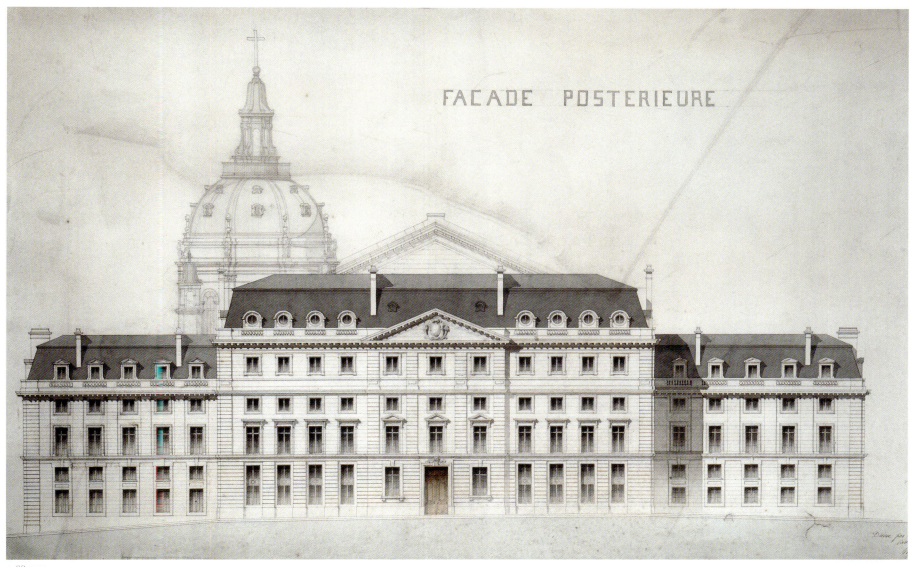

FACADE POSTERIEURE

PROJET DE RECONSTRUCTION DE LA SORBONNE

COUPE LONGITUDINALE

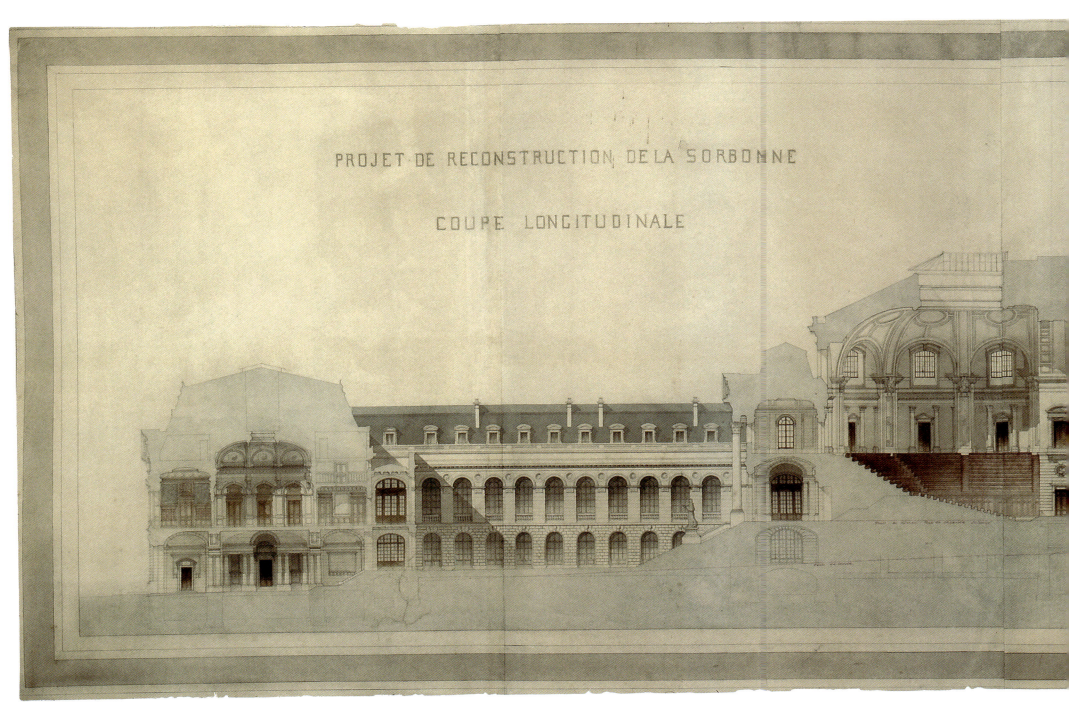

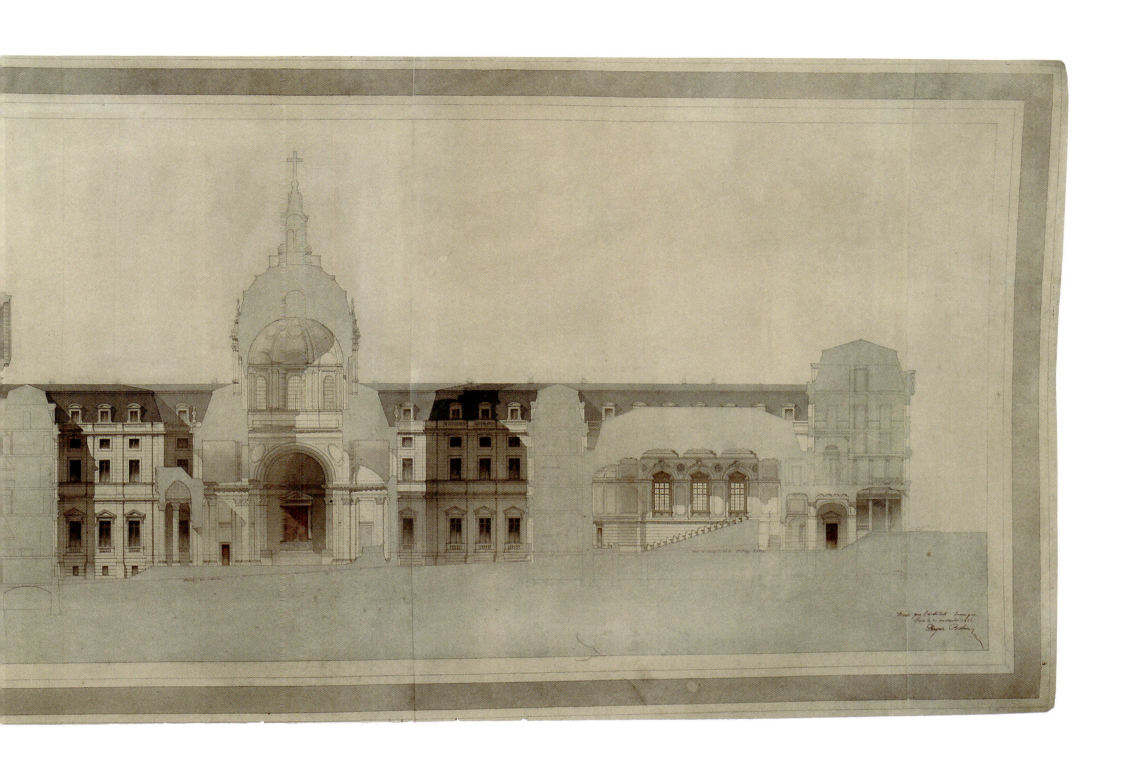

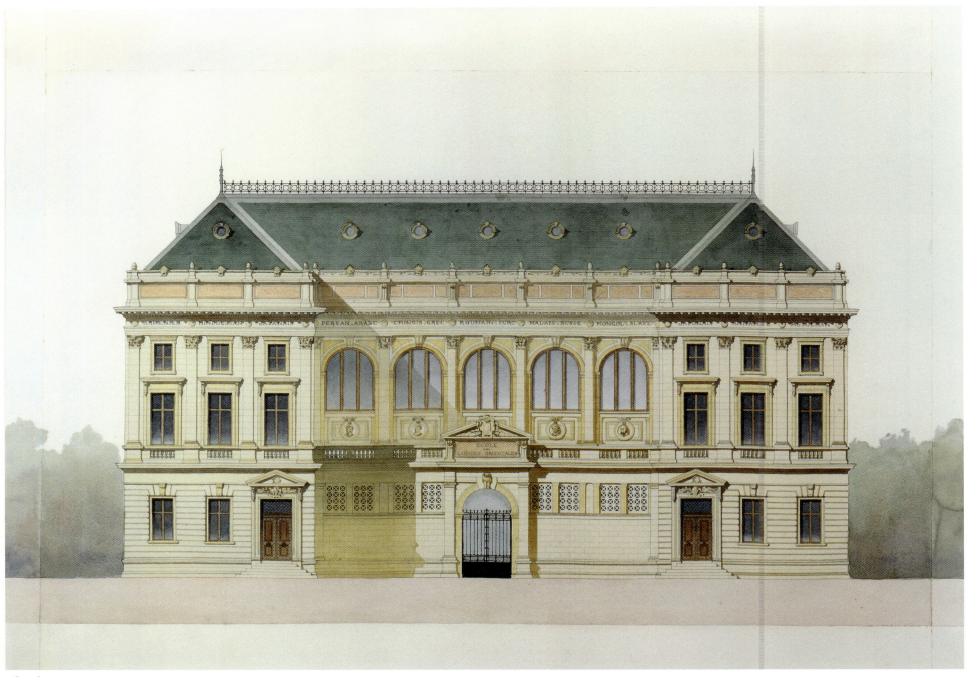

1989.248

1991.361

2.18

ARCHITECT UNKNOWN (FRENCH)

1989.248: Competition drawing for a school of Oriental languages: frontal elevation, 1886

Pencil, ink, watercolor. 31 ¼ × 42 ¾ in. (79.4 × 108.6 cm)
INSCRIBED [in watercolor] *ECOLE DES LANGUES ORIENTALES*
PROVENANCE unknown

2.19

ARCHITECT UNKNOWN (FRENCH)

1991.361: Rome Prize competition drawing for a medical school: frontal elevation, 1870

Pencil, ink, watercolor. 23 ¾ × 138 ¼ in. (60.3 × 351.2 cm)
INSCRIBED [in pencil and watercolor] – *ECOLE DE MEDECINE ET DE CHIRURGIE* –
PROVENANCE unknown

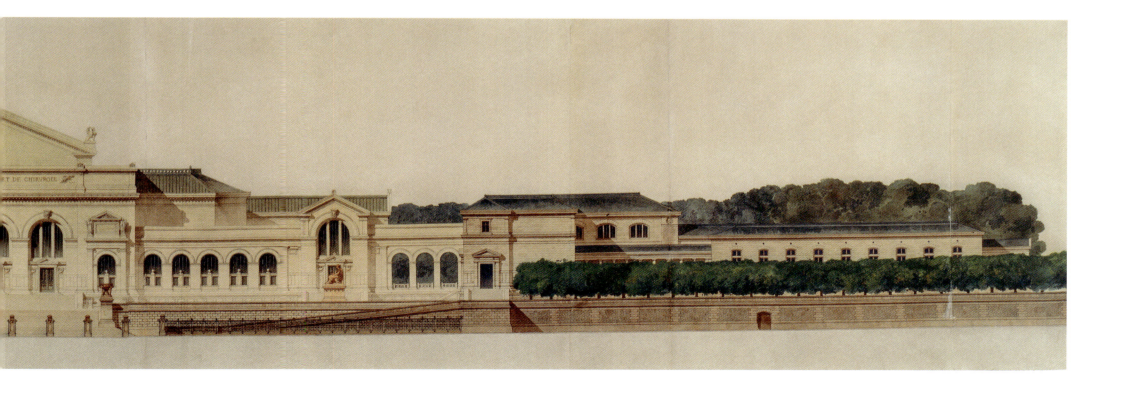

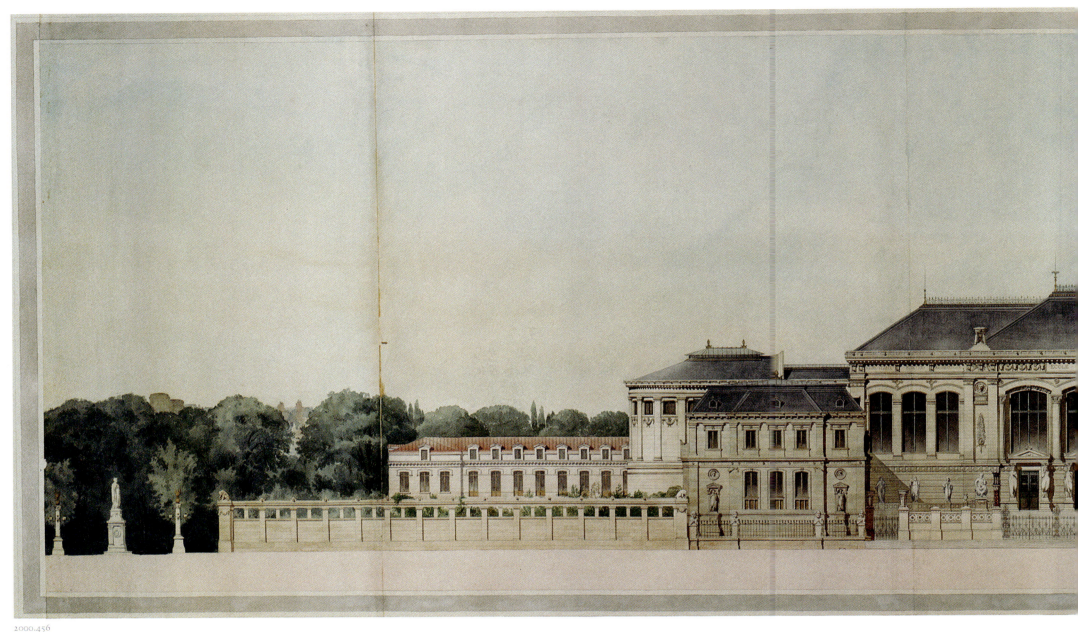

2.20

JEAN-CAMILLE FORMIGÉ (FRENCH, 1845–1926), ATTRIBUTED TO

2000.456: Rome Prize competition drawing for a medical school: frontal elevation, 1870

Pencil, ink, watercolor. 38 × 108⅝ in. (96.5 × 375.9 cm)
INSCRIBED [in pencil and watercolor] *ECOLE – DE – MEDECINE / VELBEAU – D – HARVEY – LAVOISIER – BROUSSAIS – CRULCHER – BOUILLAUD – LOUIS – VINCHOUX – HEMOL – BICHAT*
PROVENANCE Marc Dessauce, New York

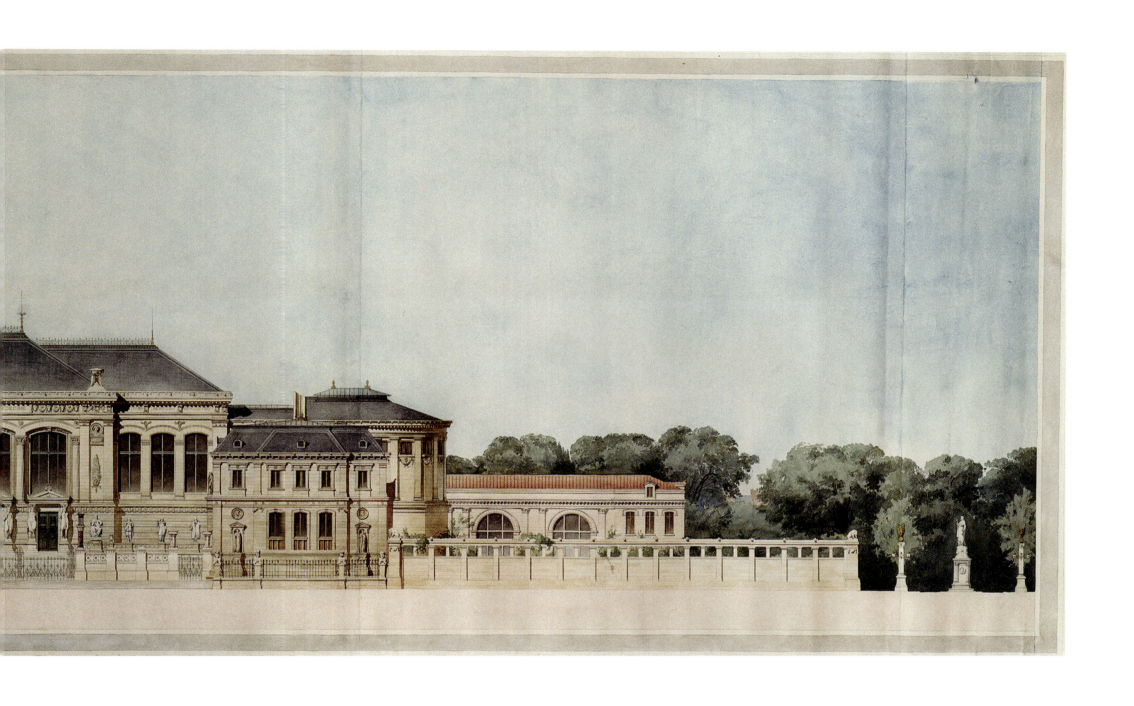

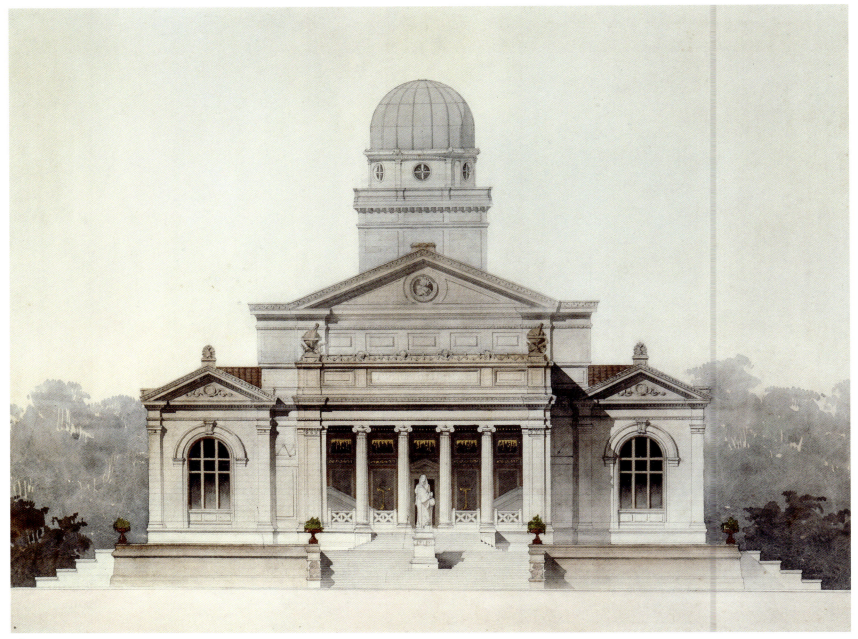

1989.174a

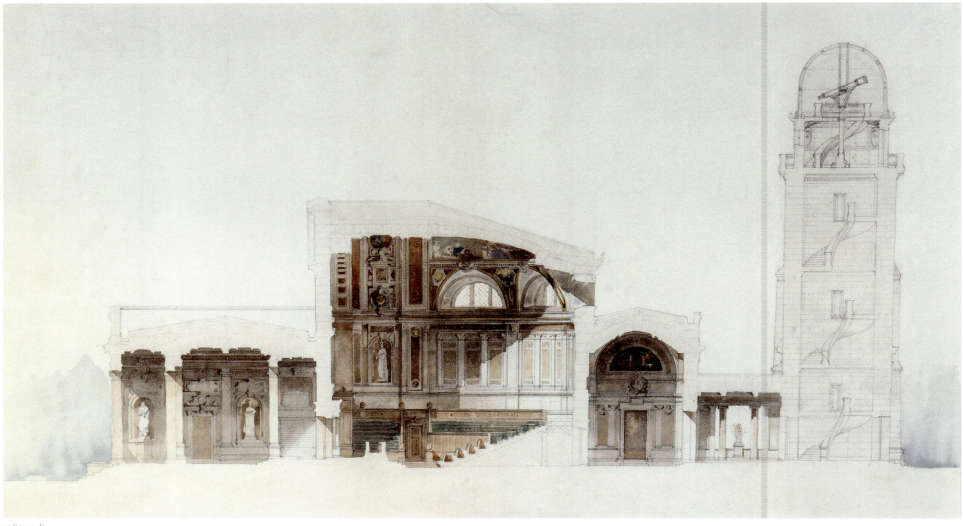

1989.174b

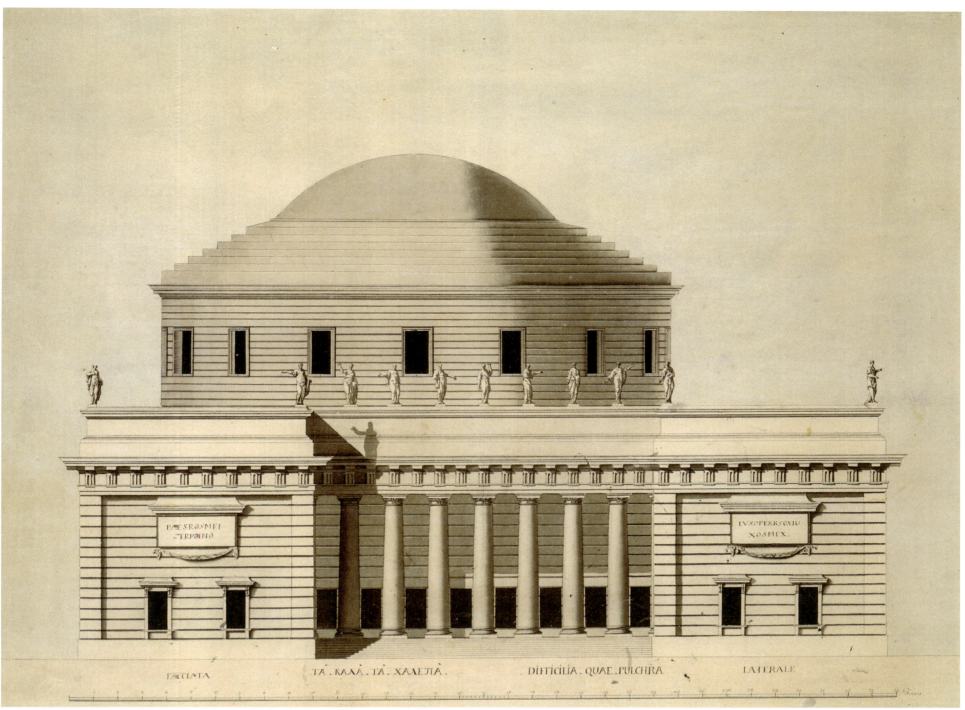

2.21

ARCHITECT UNKNOWN (FRENCH)

1989.174a,b: Competition drawings for an observatory: frontal elevation and cross-section, ca. 1900

Pencil, ink, watercolor, gilding
1989.174a. 21¼ × 27½ in. (54 × 69.9 cm)
1989.174b. 21¼ × 35 in. (54 × 88.9 cm)
PROVENANCE unknown

ᛞ *Une Observatoire de Plaissance* was the subject of a *concours* of 1879 and an observatory in the mountains was the Prix de Rome assignment in 1907 (see cat. 2.23).

2.22

ARCHITECT UNKNOWN (ITALIAN)

2000.543: Competition drawing for a medical school, assigned by the Accademia di Belle Arti, Parma, 1778

Pencil, ink, watercolor. 20 × 25½ in. (51 × 65 cm)
INSCRIBED *PÆSROSMEI SERPOINO / LUXOPEXRSOXIU XOSMEX / FACCIATA / ΤΑ . ΚΑΛΑ . ΤΑ . ΧΑΛΕΠΑ . / DIFFICILIA. QUÆ. PULCHRA. / LATERALE /* [architectural measurements in *toises*]
LITERATURE *Dessins du XVIᵉ au XIXᵉ Siecle* (Galerie Daniel Greiner, Paris, 1997), p. 57
PROVENANCE Galerie Martin du Louvre, Paris; Galerie Daniel Greiner

SCHOOLS & CENTERS OF LEARNING

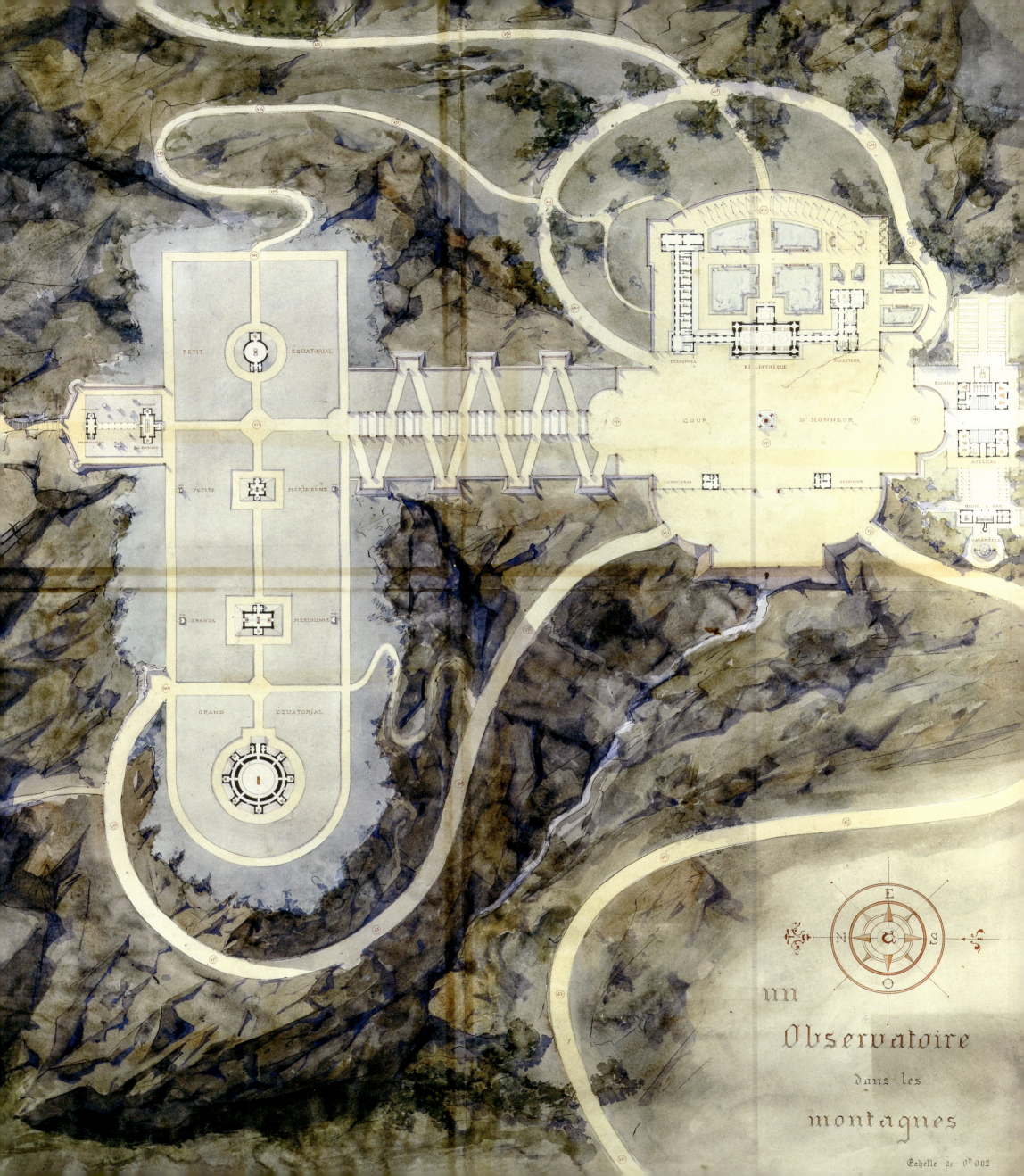

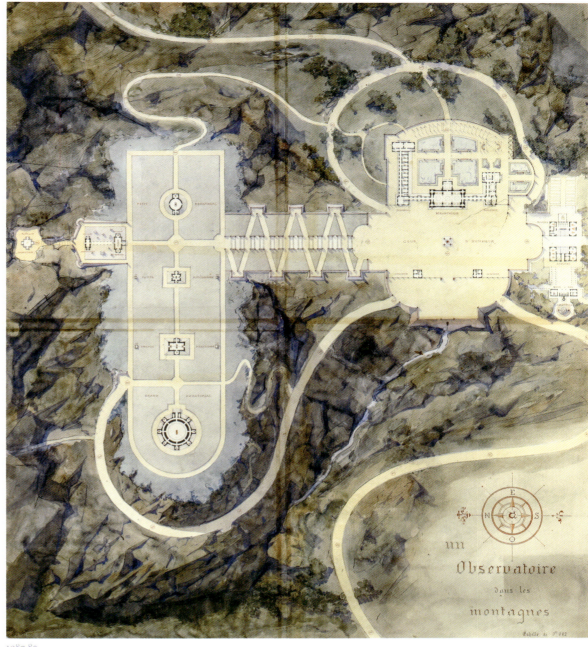

1987.80

2.23

ARCHITECT UNKNOWN (FRENCH)

1987.80: Prix de Rome competition drawing for an observatory and scientific station: plan, 1907

Pencil, ink, watercolor. 54 × 48 in. (137.2 × 121.9 cm)
INSCRIBED *un Observatoire dans les montagnes* COUR D'HONNEUR / CONCIERGE / JARDINIER / BIBLIOTHEQUE / PERSONNEL / DIRECTEUR / ÉCURIES / ATELIERS / USIZE À GAZ. / GAZOMÈTRE / PETIT ÉQUATORIAL / PETITE MÉRIDIENNE / GRANDE MÉRIDIENNE / GRAND ÉQUATORIAL / PAVILLON DE PHYSIQUE / PAVILLON SPECTROSCOPIQUE / PAVILLON MAGNETIQUE / [driveway with intermittent encircled numbers] / [compass and architectural measurements]
PROVENANCE unknown

🍁 Three sets of winning drawings by Charles-Henri Nicod, Edouard-Julien Deslandes and Charles-Louis Boussois are in the ENSBA (PRA 372, 373 and 374).

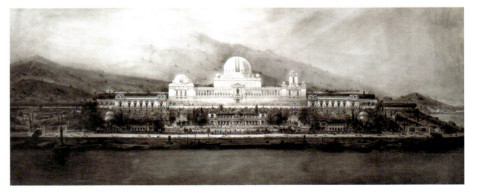

Prize-winning submissions by Edouard-Julien Deslandes, Observatory and scientific station: cross-section and elevation, Prix de Rome 1907, PRA 373-3 and 373-2

SCHOOLS & CENTERS OF LEARNING 185

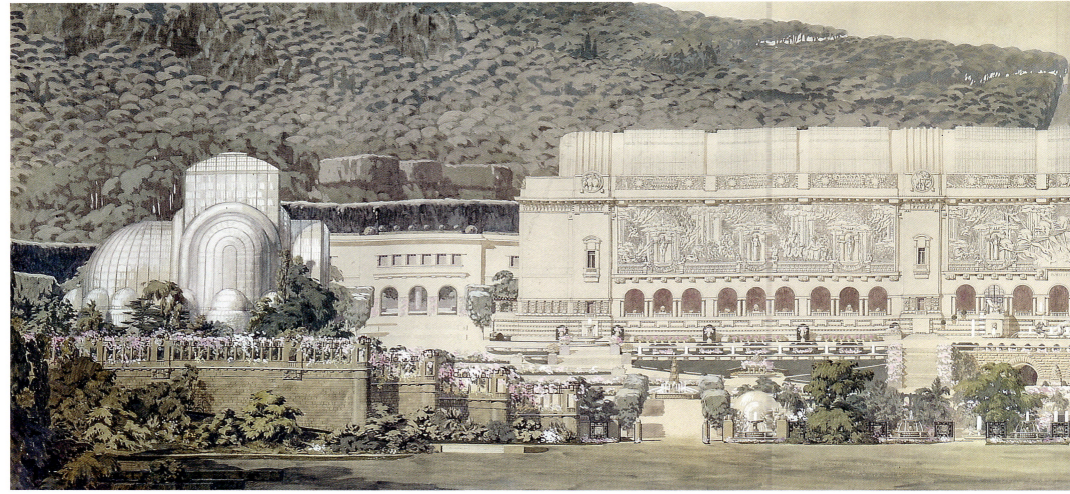

1990.264

2.24

ARCHITECT UNKNOWN (FRENCH)

1990.264: Prix de Rome competition drawing for a National Botanical Institute: frontal elevation, 1924

Pencil, ink, watercolor. 38⅛ × 154½ in. (96.8 × 392.4 cm)
INSCRIBED *INSTITUT NATIONAL DE BOTANIQUE*
PROVENANCE Private collection, France

🌹 Although attributed to Maurice Boutterin (1882–1970) when acquired, this unsigned sheet is clearly a submission for the 1924 Prix de Rome, an honor Boutterin had already won in 1909.

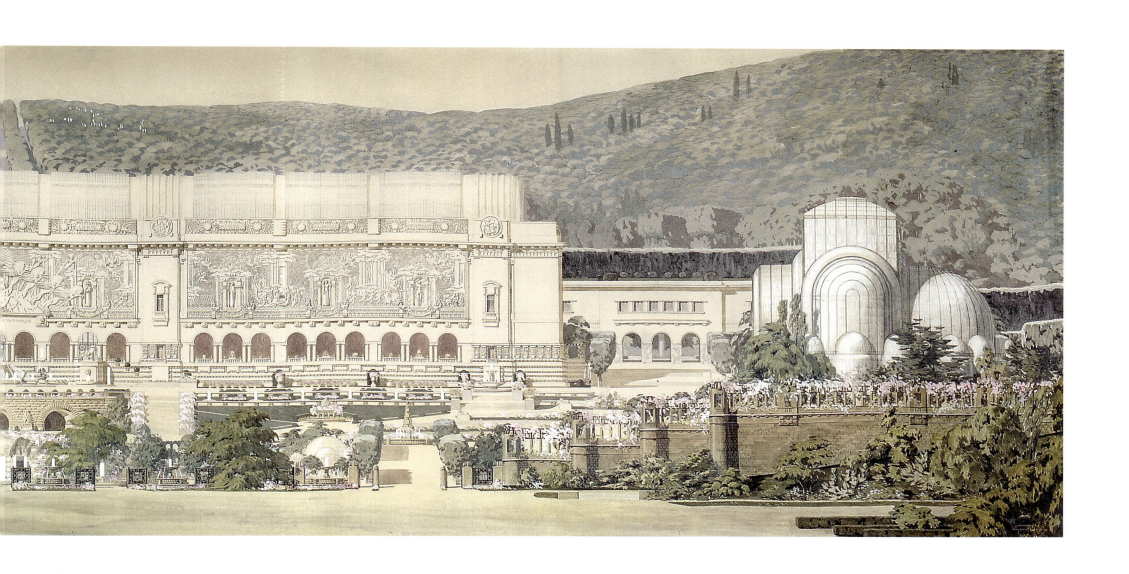

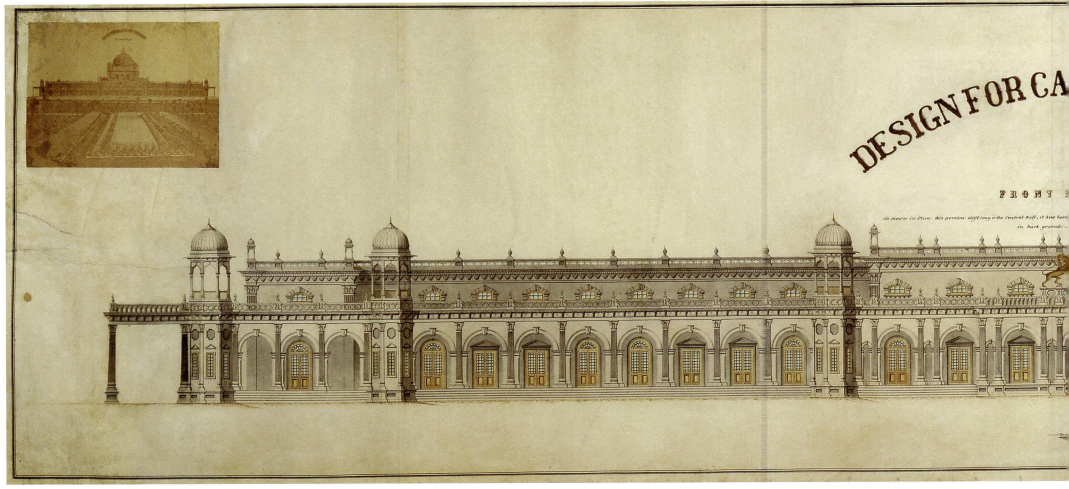

2.25 (1)

KÁMÁLUDDIN (INDIAN, DATES UNKNOWN)

1990.295a–f: Six designs for Canning College, Lucknow, India, ca. 1870

1990.295a: Frontal elevation mounted with two photographs
29¼ × 124½ in. (74.3 × 316.2 cm)
INSCRIBED *DESIGN FOR CANNING COLLEGE / No. 2 / FRONT ELEVATION / As shewn in Plan this portion 100 ft long is the Central Hall, it has been kept low purposely, so as not to interfere with the effect of Suadut Ali Kahn's Tomb in background; see photographic general view / CANNING COLLEGE /* [architectural measurements]
LABELED [in ink, on paper] *Design by Kámáluddin draftsman in the Office of the Chief Engineer O. and R. Ry Co.*

1990.295b: Preparatory elevation
Pencil, watercolor. 27 × 41 in. (68.6 × 104.1 cm)

1990.295c: Preparatory elevation
Pencil. 17 × 38 in. (43.2 × 96.5 cm)

1990.295d: Preparatory sketches
Pencil. 27 × 41 in. (68.6 × 104.1 cm)

1990.295e: Preparatory sketches
Pencil. 34 × 26 ½ in. (86.4 × 67.3 cm)

1990.295f: Preparatory cross-section
Pencil. 31 × 27 in. (78.7 × 68.6 cm)

PROVENANCE Sotheby's, London, *Sale of Architectural Drawings and Watercolors*, 26 April 1990, p. 122, lot 398 (ill.)

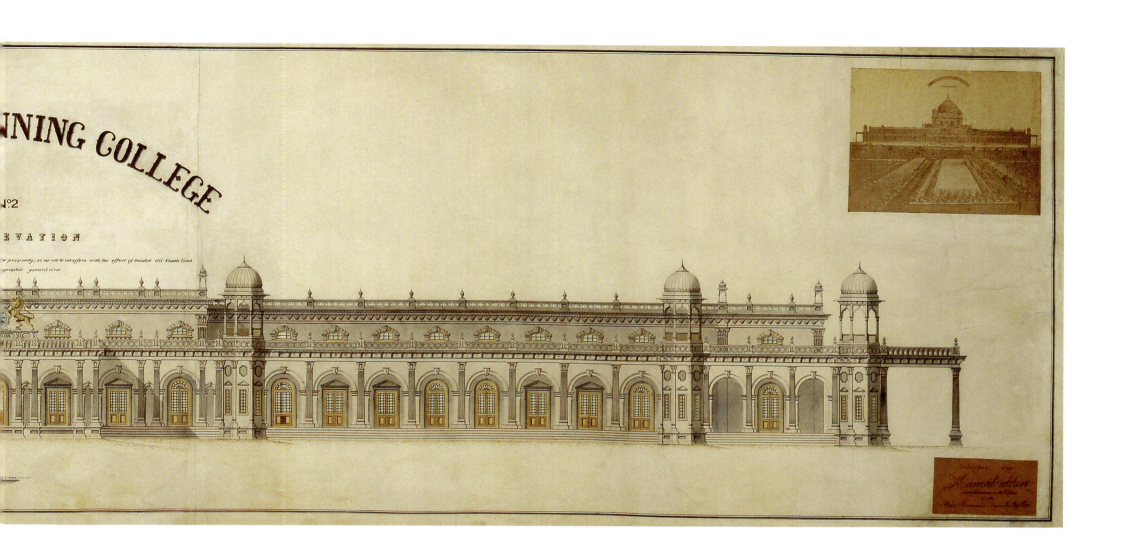

2.25 (II)

KÁMÁLUDDIN (INDIAN, DATES UNKNOWN)

1990.322: Presentation drawing for Canning College, Lucknow, India: elevation, ca. 1870

Pencil, ink, watercolor. 26 ¼ × 113 in. (68 × 280 cm)
INSCRIBED [in watercolor] *CANNING COLLEGE* / [architectural measurements]
PROVENANCE Sotheby's, London, *Sale of Oriental Manuscripts*, 26 April 1990, p. 38, lot 91 (ill.)

Canning College, Lucknow, vintage postcard

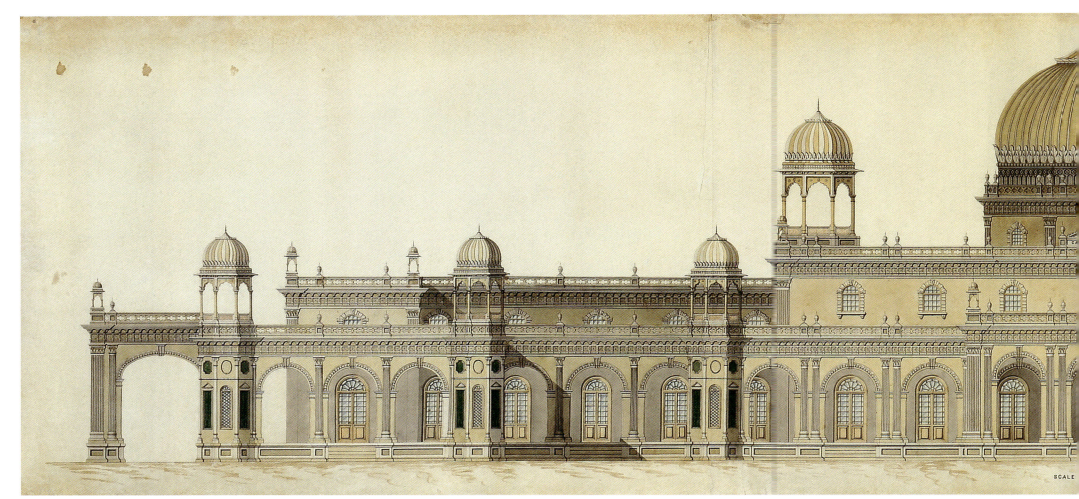

190 PETER MAY COLLECTION I

1990.295e

1990.295f

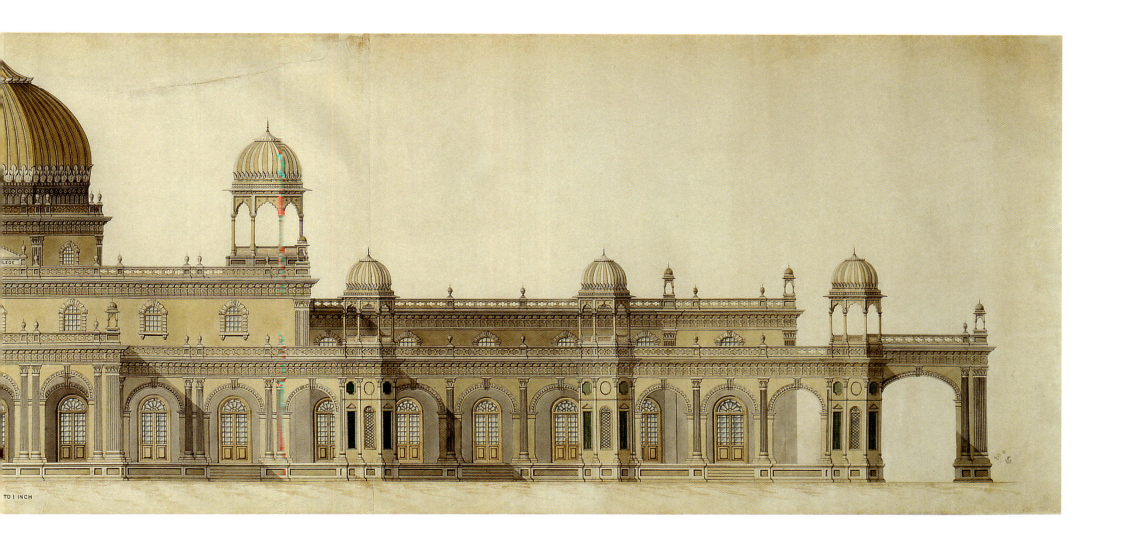

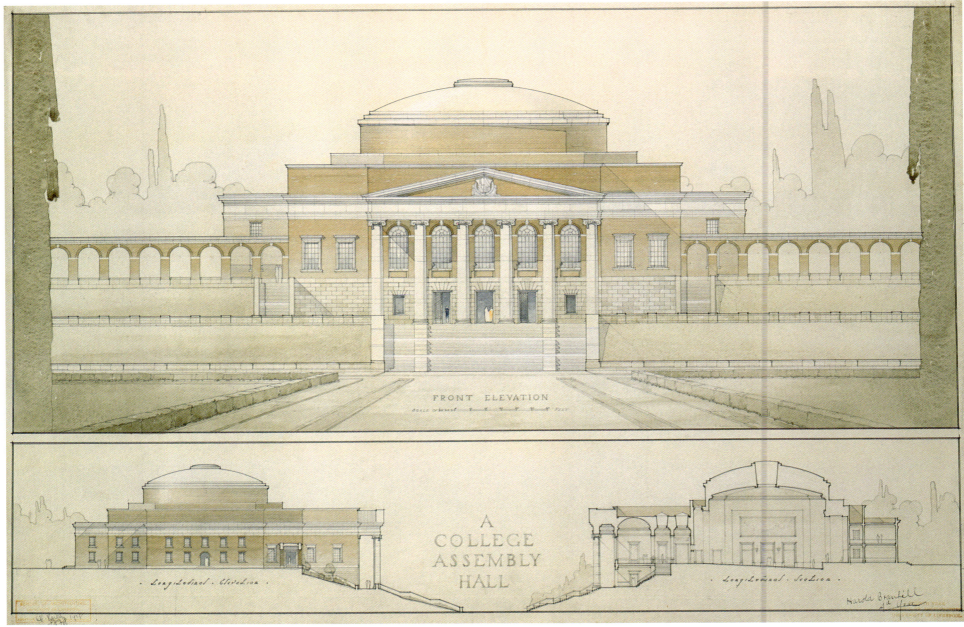

2.26

HAROLD BRAMHILL
(BRITISH, 1905–1997)

2000.521: Competition drawing for a college assembly hall: two elevations and a cross-section, 1928

Pencil, ink, watercolor. 26½ × 39⅝ in. (67.3 × 100.6 cm)
INSCRIBED *A COLLEGE ASSEMBLY HALL / FRONT ELEVATION / – Longitudinal – Elevation – / – Longitudinal – Section – / Harold Bramhill / 4th Year /* [architectural measurements]
STAMPED [in red] *FOURTH YEAR / SCHOOL OF ARCHITECTURE / UNIVERSITY OF LIVERPOOL / SCHOOL OF ARCHITECTURE / UNIVERSITY OF LIVERPOOL / SIGNATURE /* [in ink] *C.H. Reilly 1928* [indistinct]
PROVENANCE Gallery Lingard, London

2.27

LEON KEACH (AMERICAN, 1893–1991)

1996.401g: Competition drawing for a dining hall: frontal elevation, plan and cross-section, 1916

Pencil, ink, watercolor. 37¾ × 25 in. (95.9 × 63.5 cm)
INSCRIBED *Dining Hall / Private* [2×] */ Service* [2×] */ Tables* [2×] */ Tables Outside / Leon Keach Nov. 17, 1916 /* [shield with profile] *GRAND NÈGRE W.W.D. /* [in red crayon] *4.*
PROVENANCE Gwenda Jay Gallery, Chicago

🌶 Based on the Villa Medici in Rome.

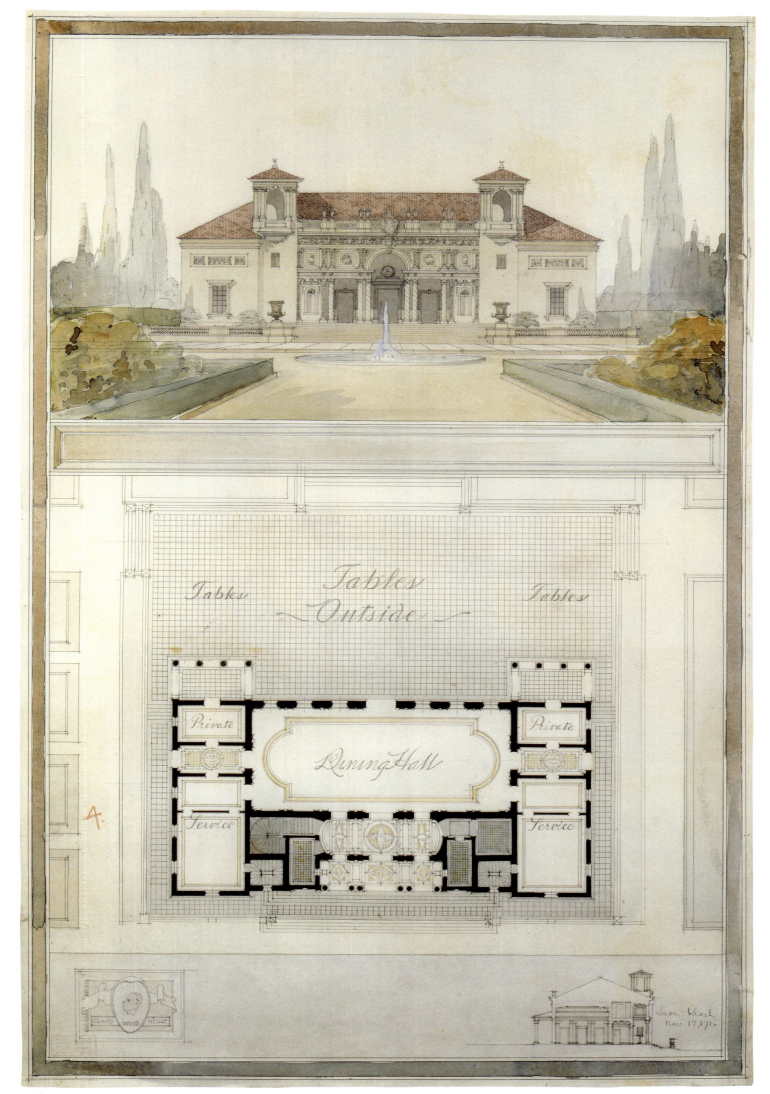

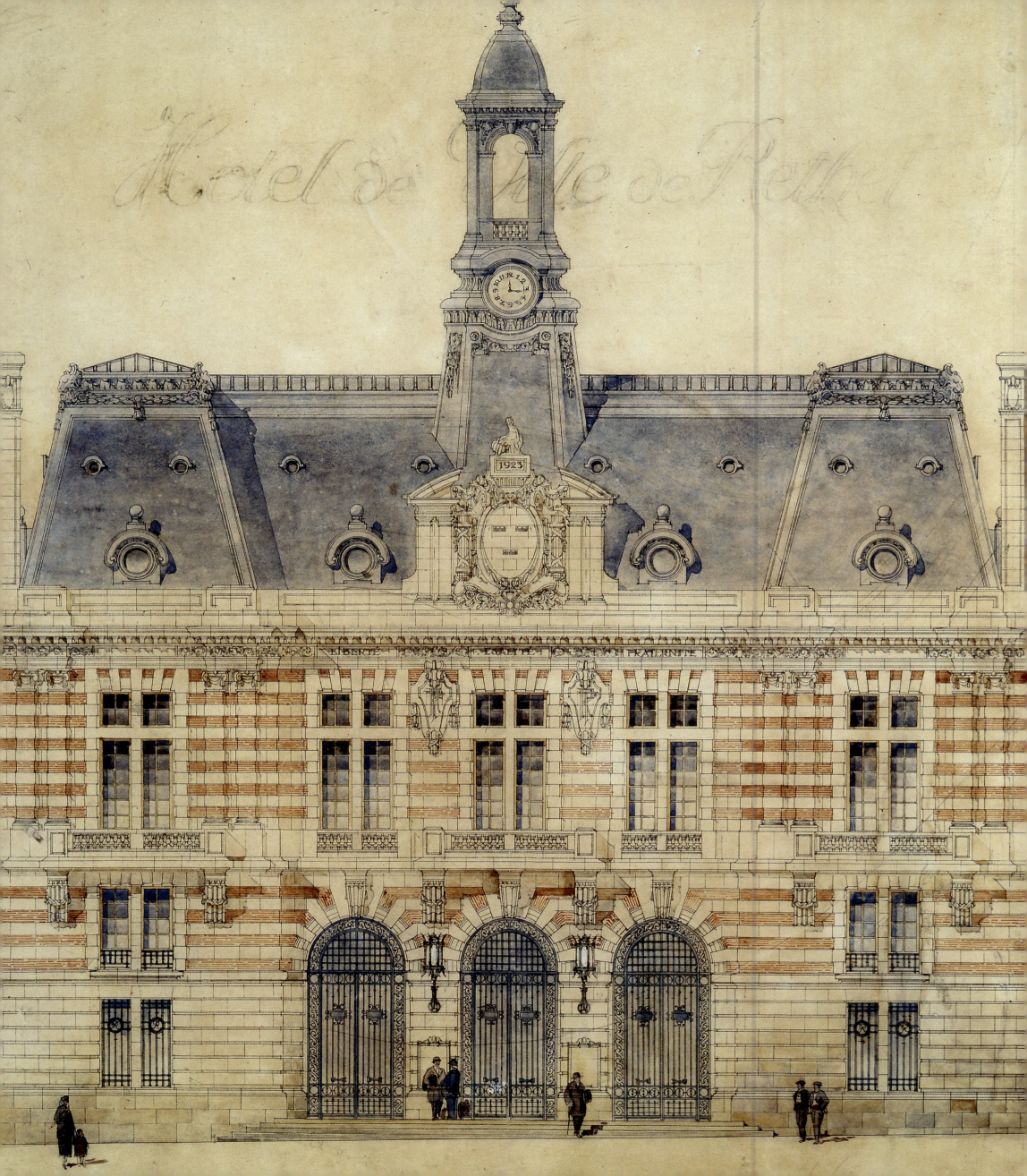

3
GOVERNMENT BUILDINGS

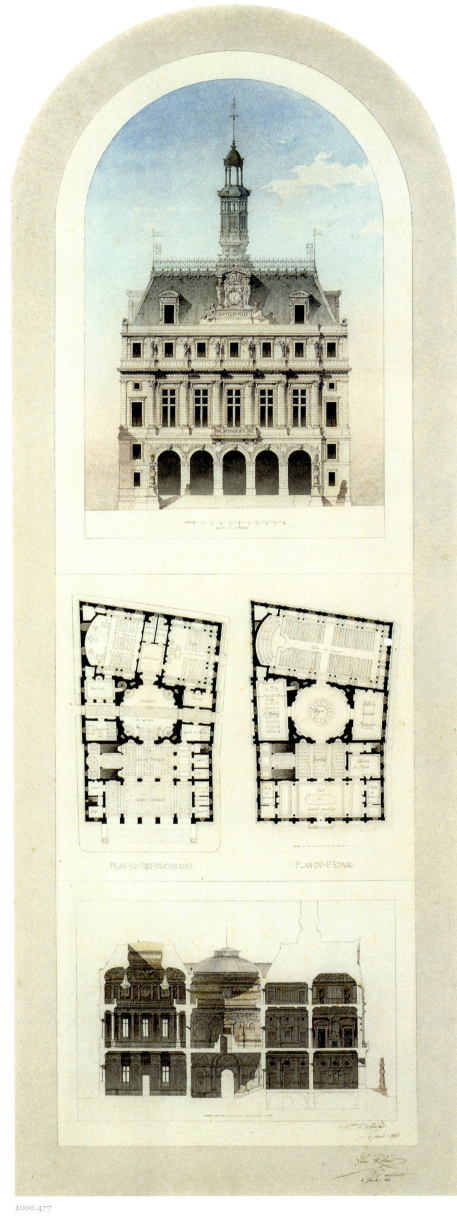

3.1

LEON ROHARD (FRENCH, 1836–1882)

2000.477: Competition drawings for the City Hall in Tourcoing, France: elevation, two plans and cross-section, 1863

Pencil, ink, watercolor. 29⅛ × 9 in. (74 × 22.9 cm)
INSCRIBED *HOTEL DE VILLE PLAN* / *- DU - REZ - DU - CHAUSSEE* / *Grand Vestibule* [2×] / *Loge* / *Cuisine* / *Inspectr* / *Archives* / *Commisre Central* / *Dépôt* / *Livrets* / *Agents de Police* / *Pompiers* / *Descent à Couvert* / *Vestibule* / *Cabinet* / *Antichambr* / *Cabinet du Juge* [2×] / *Salle d'Audience de la Justice de Paix* / *Salle de recrutement* / *PLAN – DU – 1r – ETAGE* / *Salle du Conseil municipal* / *Saion de Commissier* [2×] / *Vestibule* / *Cabinet du Maire* / *Foyer* / *Salle de marriage* / *Salle de l'adminon Municipale* / *Salle de Concert* / *Léon Rohard 8 Janvier 1863* / [architectural measurements]
PROVENANCE Alain Cambon, Paris

3.2

ARCHITECT UNKNOWN (FRENCH)

1987.45: Competition drawing for a city hall: frontal elevation, late 19th century

Pencil, ink, watercolor. 30 × 23 in. (76.2 × 58.4 cm)
INSCRIBED [on each chimney, cipher] *RF* [République Francais]
PROVENANCE unknown

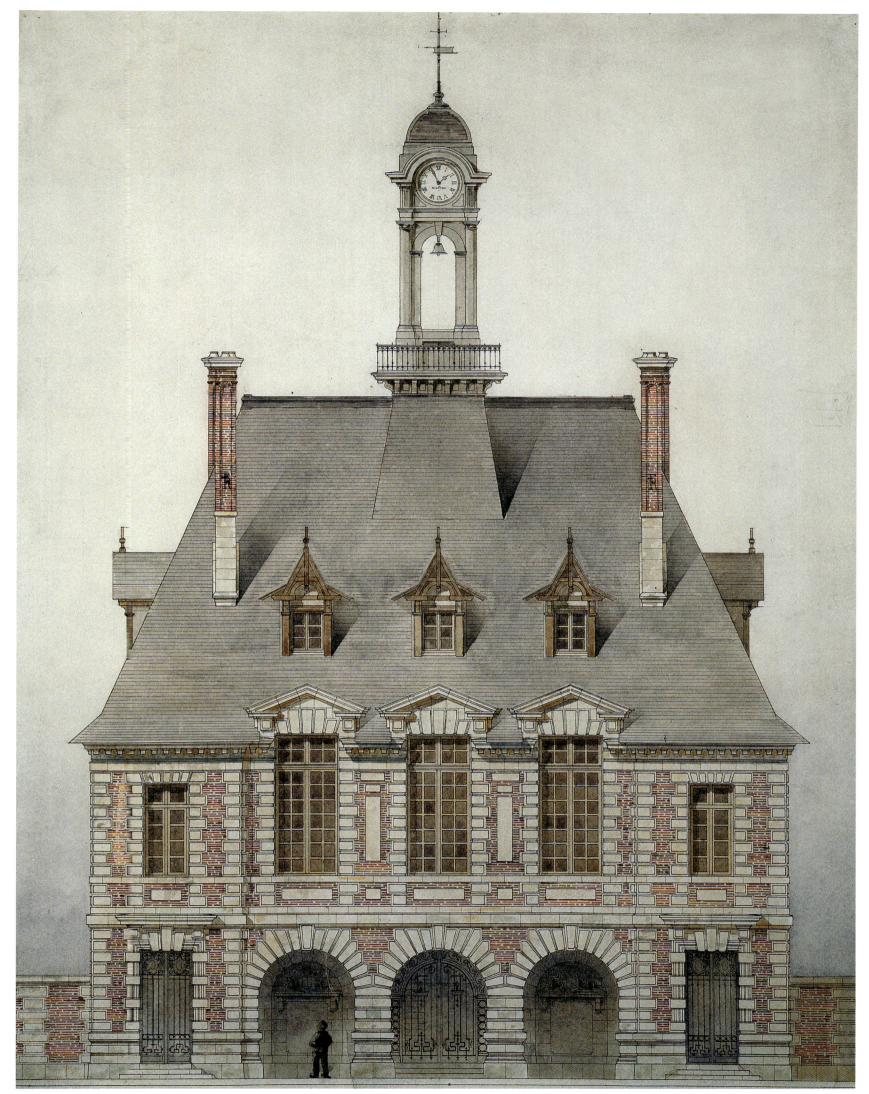

3.3

ARCHITECT UNKNOWN (FRENCH)

1999.410, 411, 412: Competition drawings for the City Hall in Rethel, Ardennes, France: three elevations and one cross-section, 1923

Pencil, ink, watercolor

1999.410: Frontal elevation. 30¼ × 25¾ in. (76.8 × 65.4 cm)
INSCRIBED [in pencil] *Hotel de Ville de Rethel* / [in ink] *1923* / [in ink, 2×, cipher] *RF* [République Française]

1999.411: Rear elevation. 30¼ × 26 in. (76.8 × 66 cm)
INSCRIBED [in pencil] *Hotel de Ville de Rethel* / [in ink, 4×, cipher] *RF* [République Française]

1999.412: Side elevation and cross-section. 31¼ × 26½ in. (79.4 × 67.3 cm)
INSCRIBED [in pencil] *Hotel de Ville de Rethel* / *façade laterale* / [in ink, 3×] *R* [Rethel] / [architectural measurements]

PROVENANCE unknown

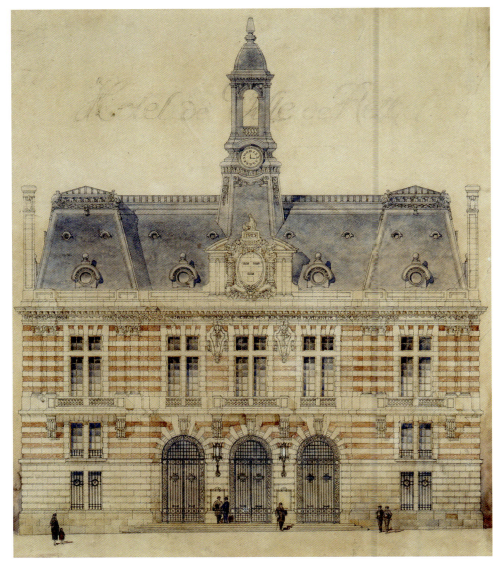

1999.410

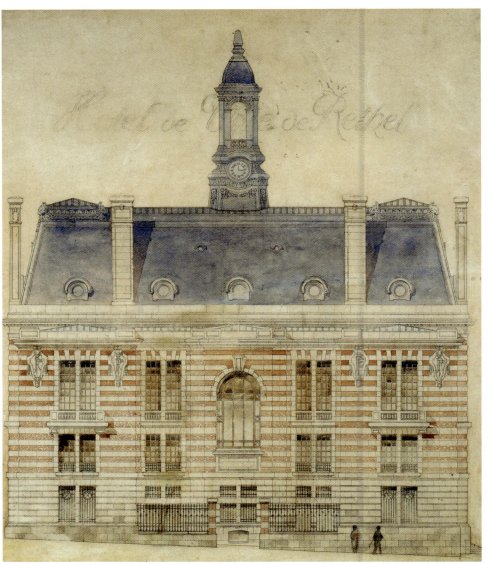

1999.411

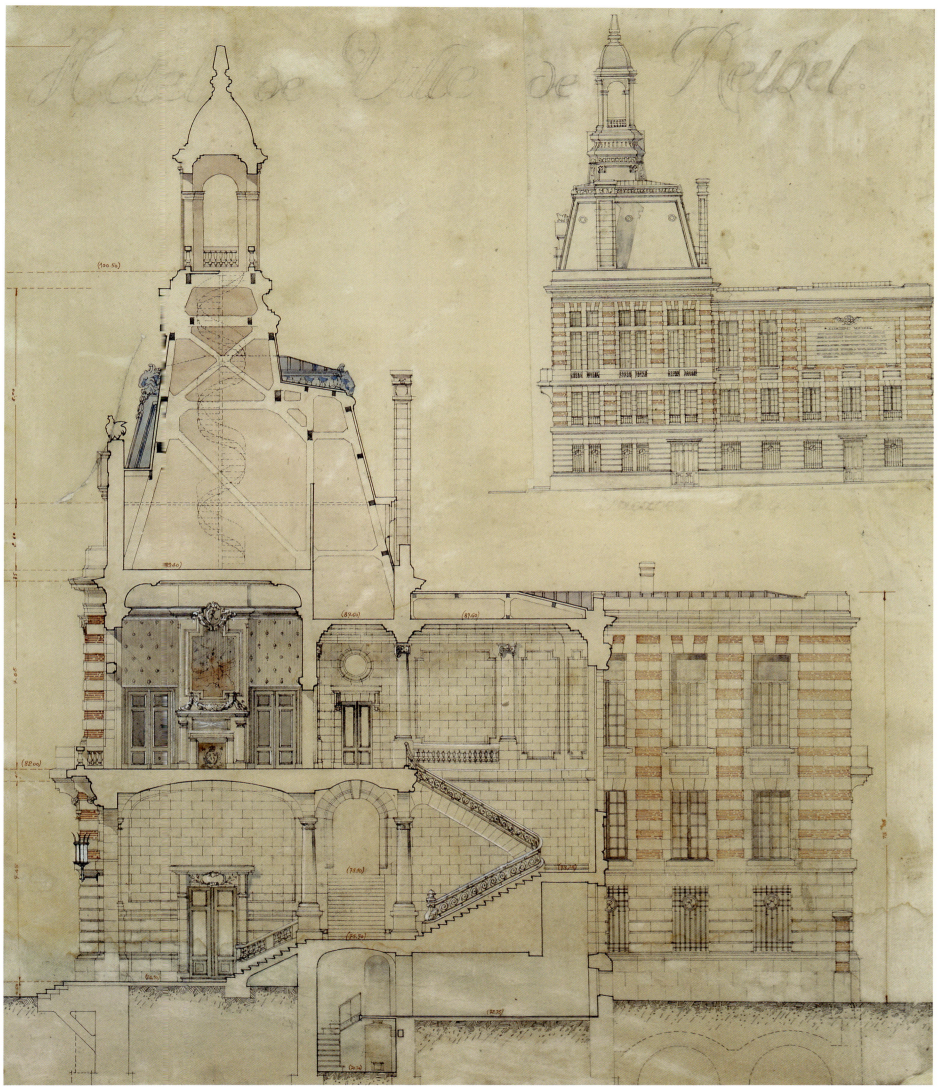

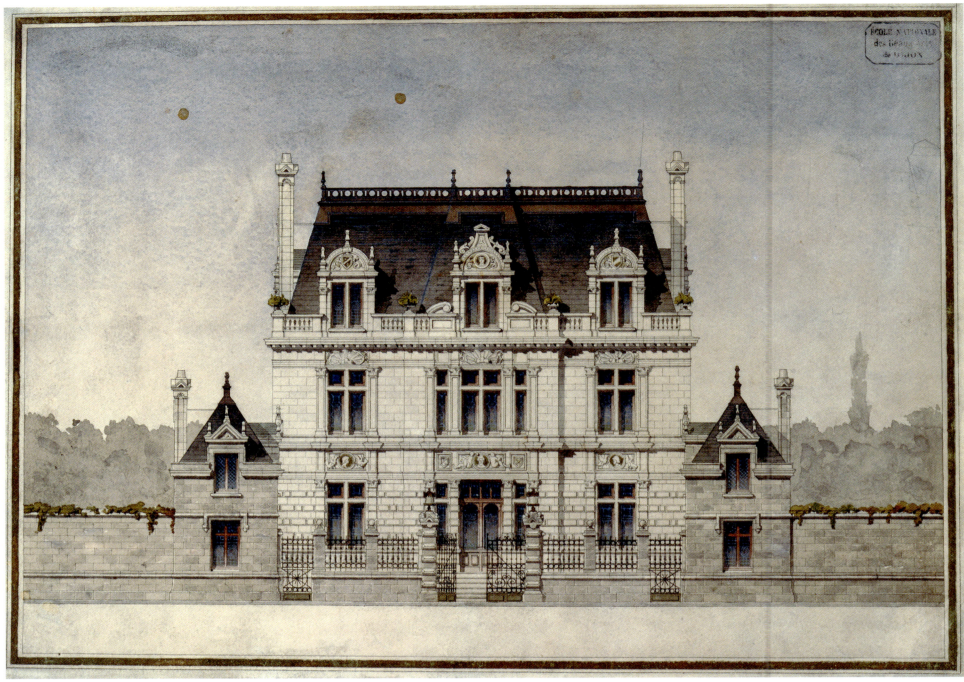

1990.354

3.4

ARCHITECT UNKNOWN (FRENCH)

1990.354: Competition drawing for a city hall: frontal elevation, 19th century

Pen, ink, watercolor, metallic tape. 14⅜ × 19½ in. (36.5 × 49.5 cm)
STAMPED [in blue] *ECOLE NATIONALE des Beaux Arts de Dijon*
PROVENANCE Charles Plante, London

3.5

ARCHITECT UNKNOWN (FRENCH)

1989.165: Composite study for a stonework ceiling, ca. 1900

Pencil, ink, watercolor, 38 × 25½ in. (96.5 × 64.8 cm)
INSCRIBED [in watercolor] *UN PLAFOND EN PIERRE*
PROVENANCE unknown

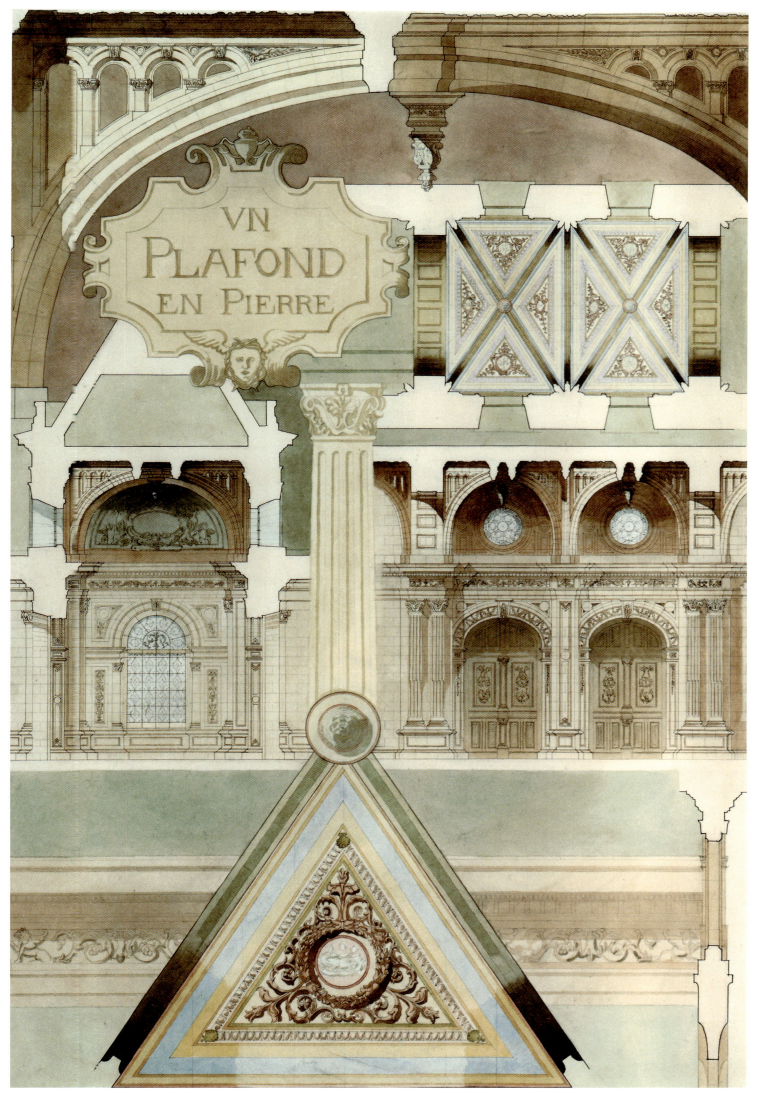

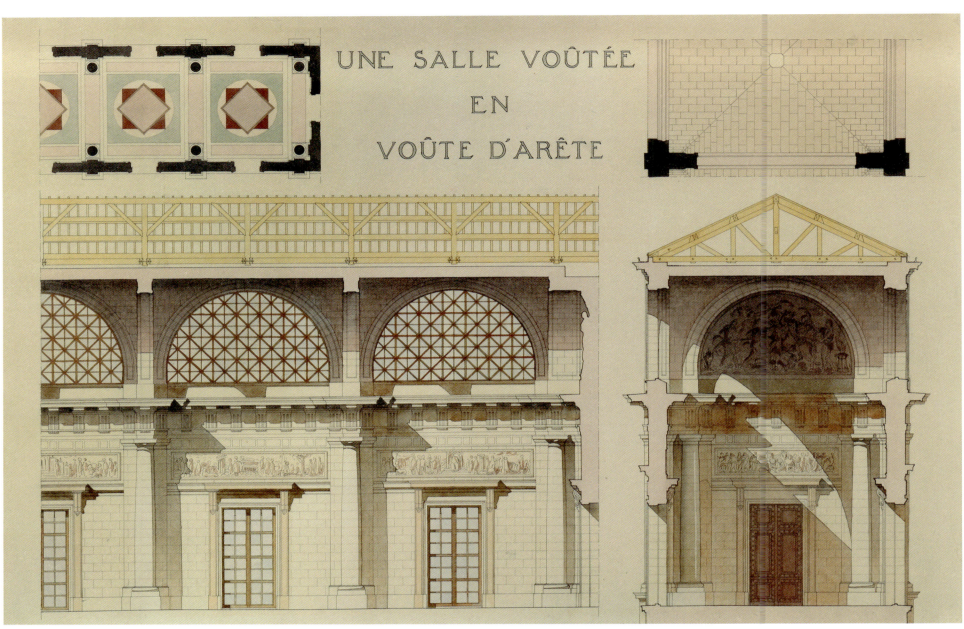

1990.233a

3.6

ARCHITECT UNKNOWN (FRENCH)

1990.233a–c: Three competition drawings for vaulted municipal rooms comprising sections, plans and construction details, ca. 1900

Pencil, ink, watercolor

1990.233a: 27⁵⁄₃₂ × 41⁵⁄₁₆ in. (69 × 104.9 cm)
INSCRIBED *UNE SALLE VOÛTÉE EN BERCEAU*

1990.233c: 26¹¹⁄₁₆ × 40¾ in. (67.8 × 103.5 cm)
INSCRIBED *UNE SALLE VOÛTÉE EN VOÛTE D'ARÊTE*

1990.233c: 29 × 44¾ in. (73.7 × 113.7 cm)
INSCRIBED *UNE SALLE DE PAS PERDUS*

PROVENANCE unknown

🔖 For 'Salle de pas perdus' compare the 1903 concours assignment, cat. 3.7.

202 PETER MAY COLLECTION I

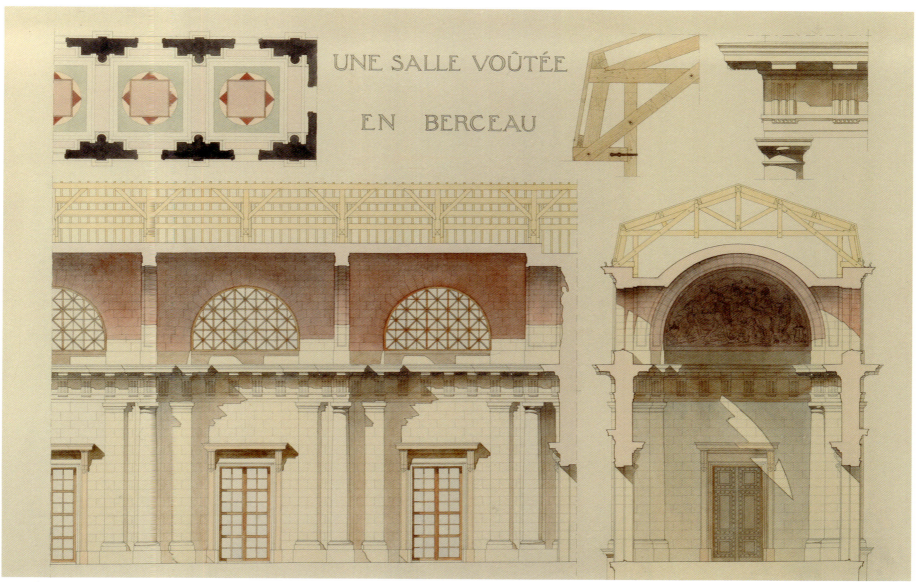

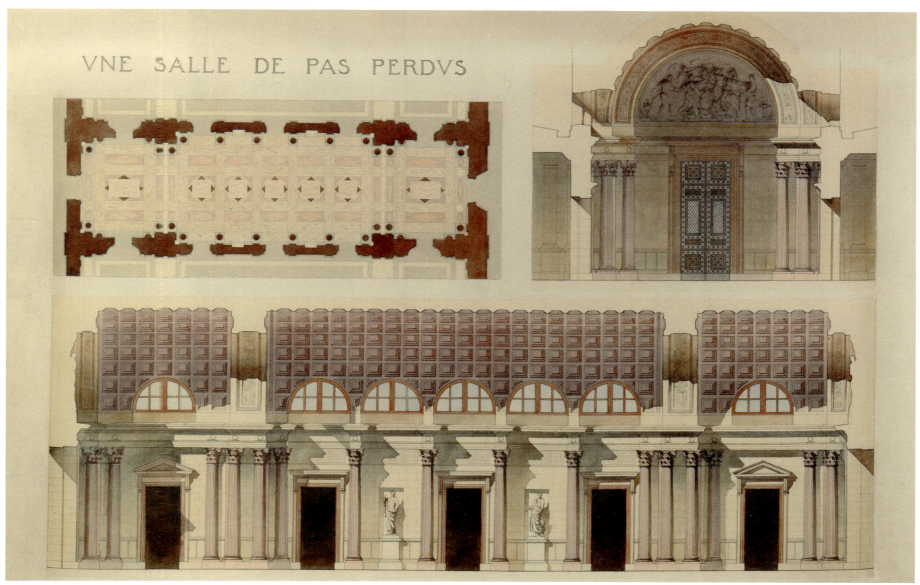

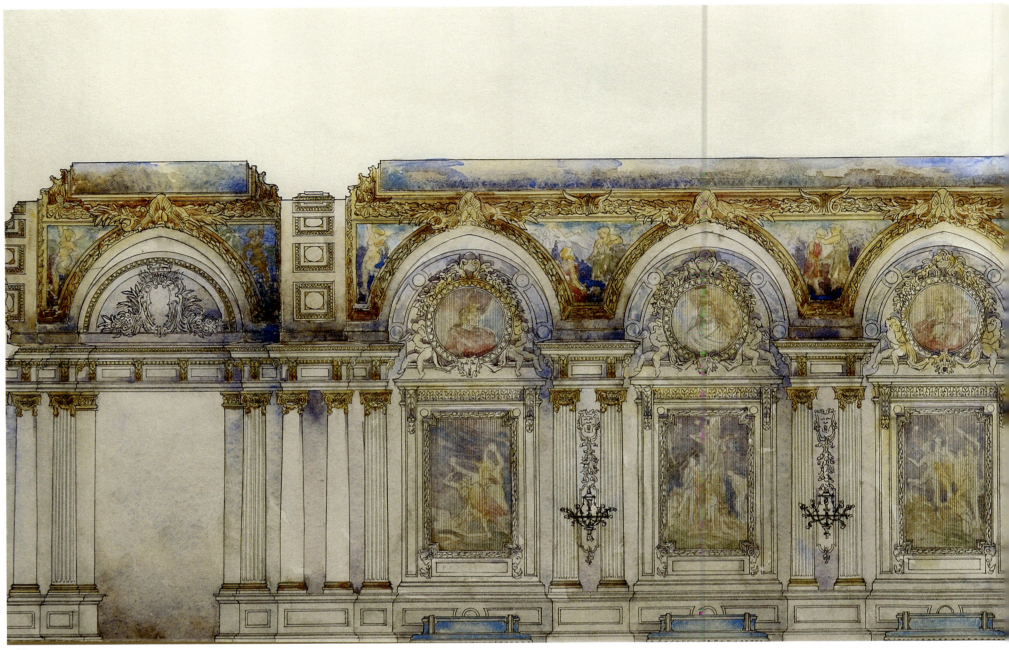

3.7

ARCHITECT UNKNOWN (FRENCH)

1988.121a–d: Four competition drawings for a Parliamentary public space: two cross-sections, one elevation, one partial floorplan, 1903

Pencil, ink, watercolor

1988.121a: Cross-section. 11½ × 37 in. (29.2 × 94 cm)
INSCRIBED [in ink and watercolor] *SALLE DES SEANCES* / [cipher] *RF* [République Francais]

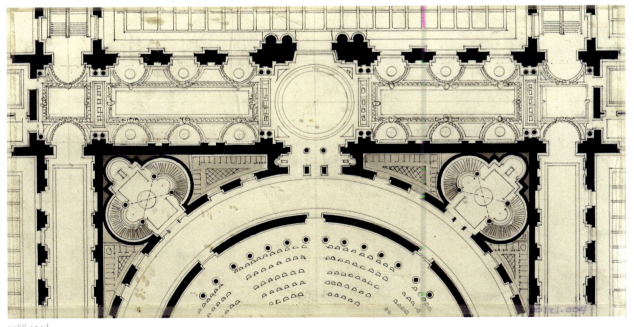

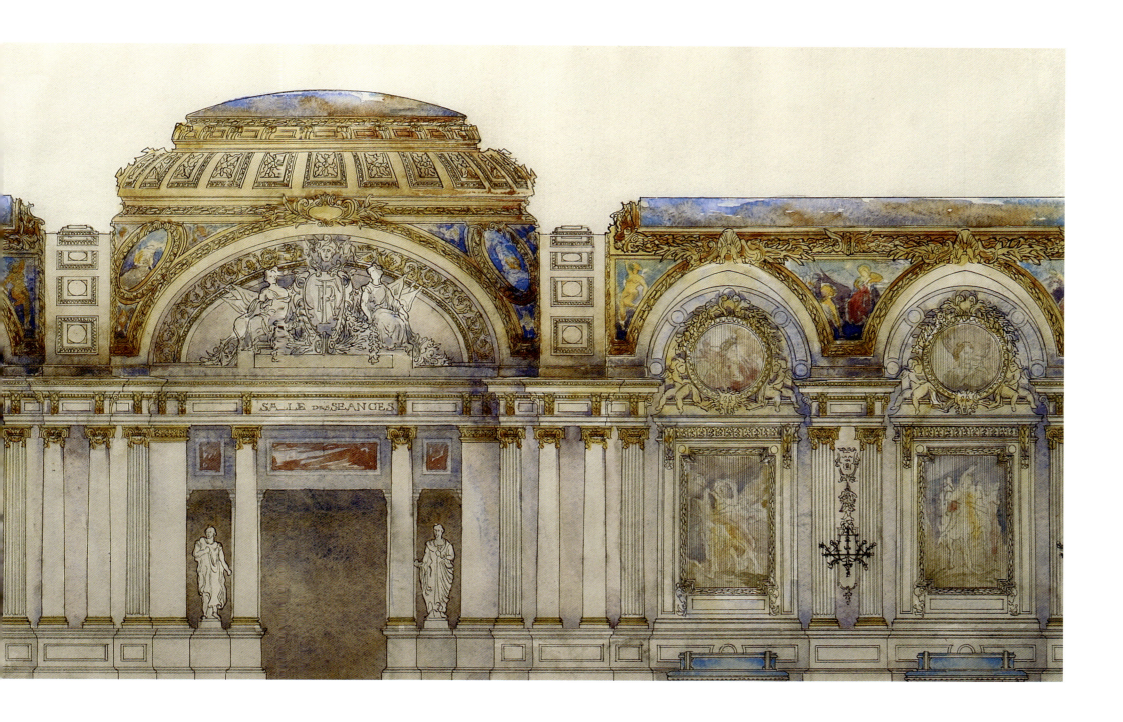

1988.121b: Interior elevation detail. 8¾ × 8½ in. (22.2 × 21.6 cm)

1988.121c: Interior elevation detail. 12 × 11½ in. (30.5 × 29.2 cm)

1988.121d: Partial floorplan. 5⅝ × 10⅞ in. (14.3 × 27.6 cm)

PROVENANCE unknown

🍎 The printed assignment for the *Concours d'émulation* of 4 February 1903, due 28 March 1903, was *La Salle des Pas-perdus d'un Palais parlementaire* (main concourse of a Parliament building).

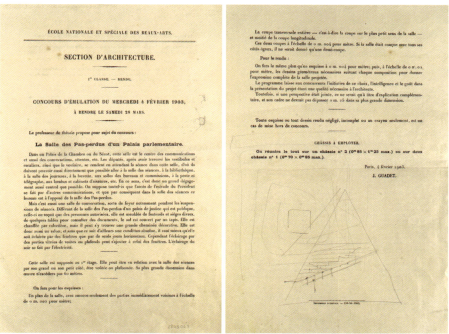

Printed assignment for the *Concours d'émulation* of 4 February 1903 (May Collection)

GOVERNMENT BUILDINGS 205

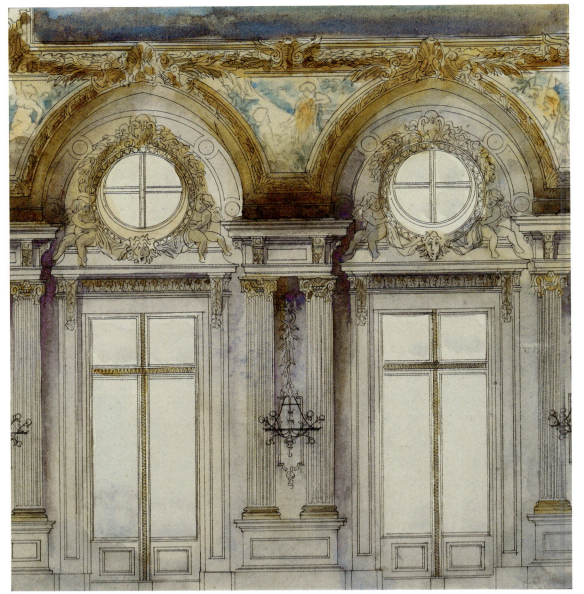

1988.121b

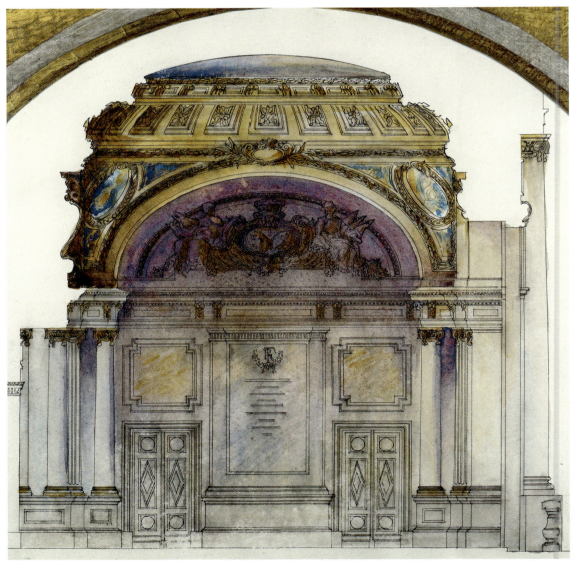

1988.121c

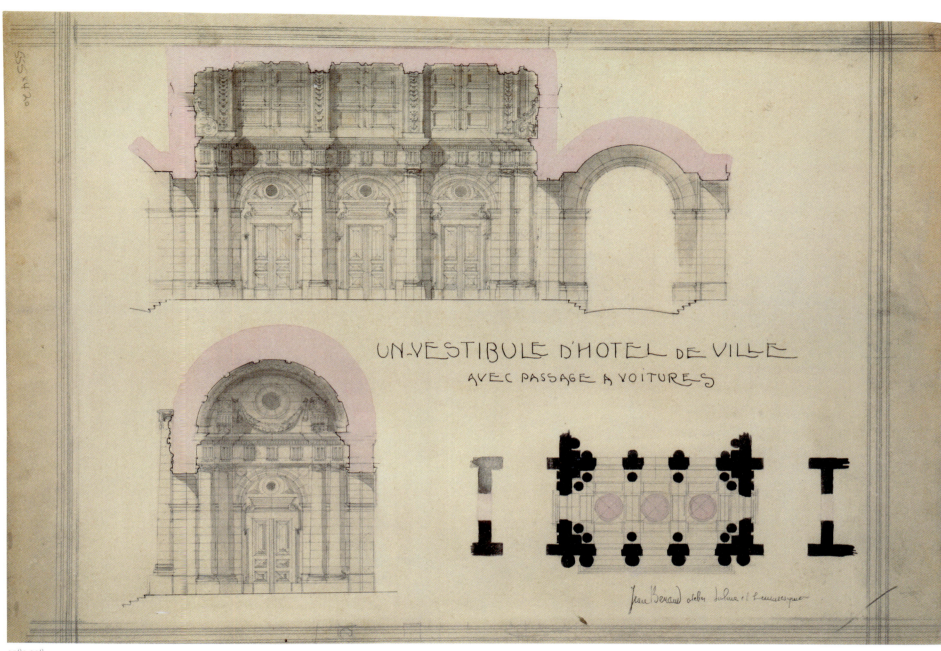

3.8

BERAUD, JEAN (FRENCH, 1882–1954)

1989.238: Competition drawing for the porte-cochère and vestibule of a city hall: two cross-sections and plan, ca. 1900

Pencil, ink, watercolor. 17 × 24⅝ in. (43.2 × 62.5 cm)
INSCRIBED *UN – VESTIBULE D'HOTEL DE VILLE AVEC PASSAGE A VOITURES* / *Jean Béraud atelier Laloux et Lemaresquier*
PROVENANCE unknown

GOVERNMENT BUILDINGS 207

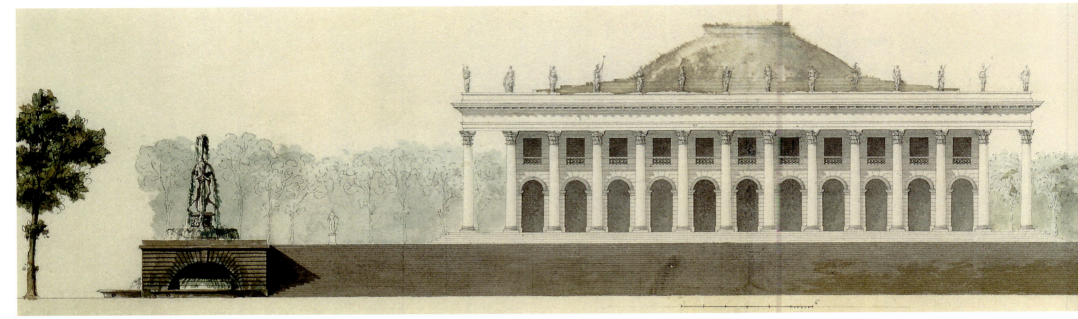

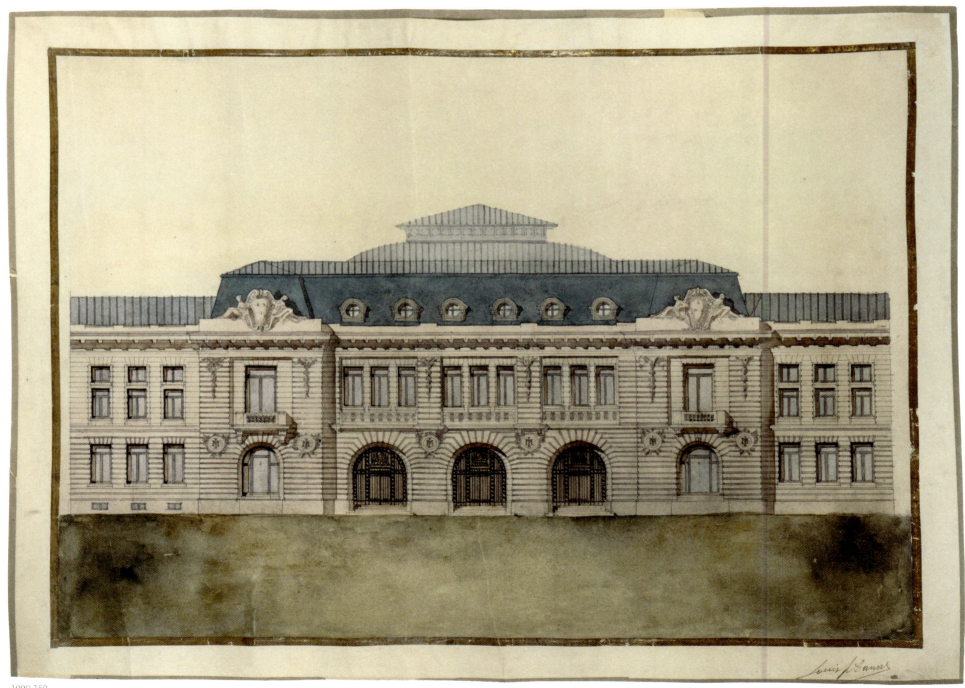

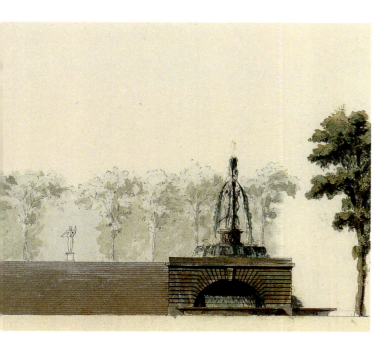

3.9

ARCHITECT UNKNOWN (FRENCH)

2000.475: Competition drawing for a government building: frontal elevation, 19th century

Pencil, ink, watercolor. 13 3/8 × 41 in. (34 × 104.1 cm)
PROVENANCE Martin du Louvre Gallery, Paris

3.10

LOUIS STANSES [?]
(FRENCH, DATES UNKNOWN)

1990.259: Competition drawing for a government building: frontal elevation, 19th century

Pencil, ink, watercolor, metallic tape. 20 1/8 × 27 1/2 in. (51.1 × 69.9 cm)
INSCRIBED [in ink] *Louis Stanses* [?] , [in watercolor, 6× cipher] *MI*
PROVENANCE unknown

3.11

LUDWIG [?] ERBEN (NATIONALITY AND DATES UNKNOWN)

1991.367: Design for a government building: cross-section, ca. 1830

Pencil, ink, watercolor. 14 1/8 × 18 13/16 in. (35.9 × 47.8 cm)
INSCRIBED [in ink] *Lud. Erben*
PROVENANCE Shepherd Gallery, New York

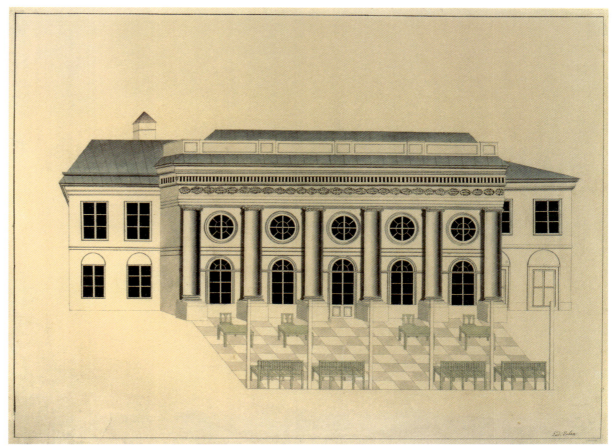

1991.367

GOVERNMENT BUILDINGS

1988.143

3.12

ARCHITECT UNKNOWN (FRENCH)

1988.143: Competition drawing for a courthouse: frontal elevation, ca. 1900

Pencil, ink, watercolor. 11½ × 32 in. (29.2 × 81.3 cm)
INSCRIBED [in ink and watercolor] *PALAIS DE JUSTICE*
PROVENANCE unknown

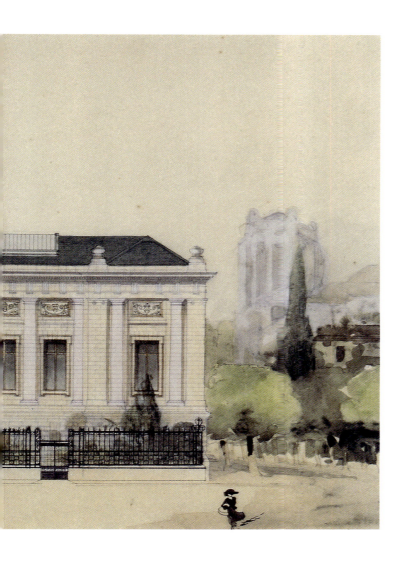

3.13

ERNEST CHARDON DE THERMEAU
(FRENCH, 1836–1896), ATTRIBUTED TO

1989.223: Competition drawing for a judicial building: frontal elevation, plan and cross-section, 1863

Pencil, ink, watercolor, gouache. 19⅛ × 12⅝ in. (48.6 × 32.1 cm)
INSCRIBED [in ink] *12 / 7 Janvier 1863 / Duvivier /* [in ink and watercolor] *JUSTICE DE PAIX.*
STAMPED [in black] *ECOLE DES BEAUX ARTS / CONCOURS D'EMULATION*
PROVENANCE Alain Brieux, Paris

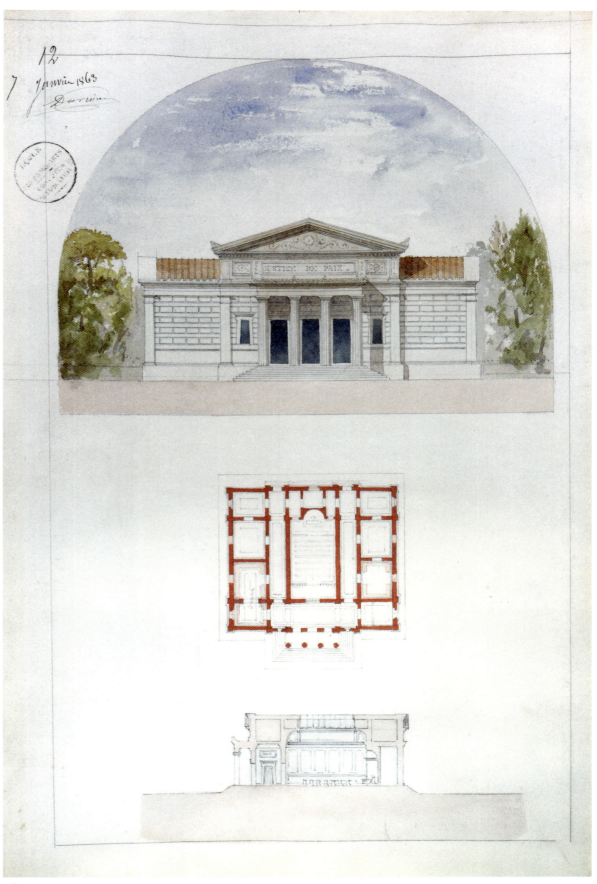

GOVERNMENT BUILDINGS 211

3.14

ARCHITECT UNKNOWN (FRENCH)

1988.150: Competition drawing for a military headquarters: frontal elevation, 19th century

Pencil, ink, watercolor. 17¼ × 37½ in. (43.8 × 95.3 cm)
INSCRIBED [in watercolor] *CONSEIL DE GUERRE*
PROVENANCE unknown

3.15

PAUL JOSEPH LEBRET
(FRENCH, 1875–1933)

1990.298: Competition drawing for a fire station: frontal elevation and cross-section, ca. 1892

Pencil, ink, watercolor. 18 × 43 in. (45.7 × 109.2 cm)
INSCRIBED [in black ink] *PAUL LEBRET / Eleve de Messieurs GUADET & PAULIN* / [in brown ink] *CASERNE DE SAPEURS POMPS / SALLE D'ENSEIGNEMENT / [2×] CHAMBRÉE / REMISES / FOURRAGE / ECURIES / PANSAGE*
LITERATURE Sotheby's, London, sale cat. 26 April 1990, pp. 135–36, lot 439
PROVENANCE Sotheby's, London, 26 April 1990, lot 439; Shepherd Gallery, New York

GOVERNMENT BUILDINGS 213

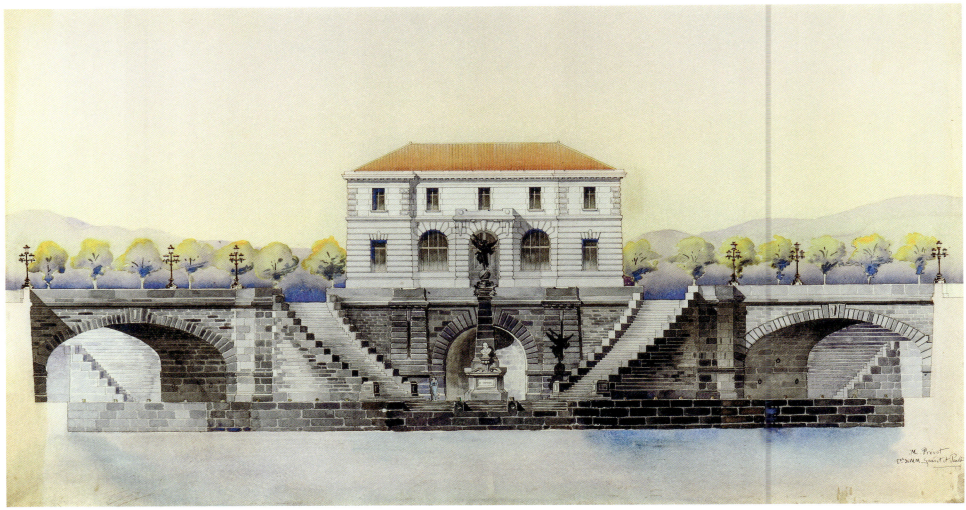

1991.385a

3.16

JACQUES MAURICE PREVOT
(FRENCH, 1874–1950)

1991.385a–c: Competition drawings for a customs house: elevation, plans, and cross-section, ca. 1893

Pencil, ink, watercolor

1991.385a: frontal elevation. 21⅜ × 39 in. (54.3 × 99.1 cm)
INSCRIBED [in brown ink] – *M. Prévot – Ev^e de MM^s Guadet et Paulin* –

1991.385b: two plans. 31¼ × 23½ in. (79.4 × 59.7 cm)
INSCRIBED [in red ink] *Chauffoir / Bureau de Péage / Telegraphe / Dégagement / [2×] Vestibule / Dépot / Service / Administr. / [6×] Ch. [Chambre] [3×] Cuisine [4×] Dégagmt. / Salle à Manger / Vestibule / Toilette / [in brown ink] – M. Prévot – Ev^e de MM^s Guadet et Paulin* –

1991.385c: Cross-section. 19 × 23¾ in. (48.3 × 60.3 cm)
INSCRIBED [in brown ink] – *M. Prévot – Ev^e de M^e Guadet et Paulin* –

PROVENANCE unknown

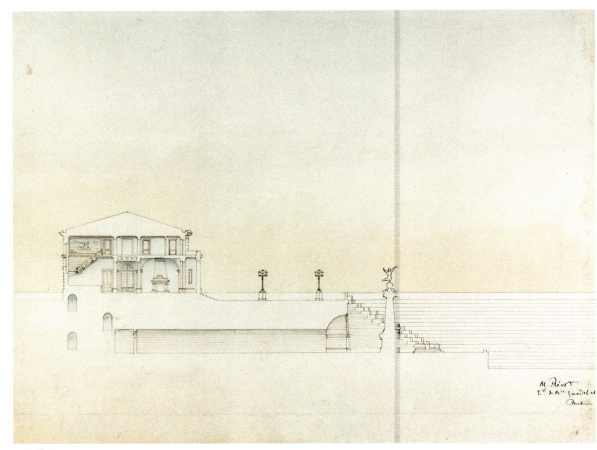

1991.385c

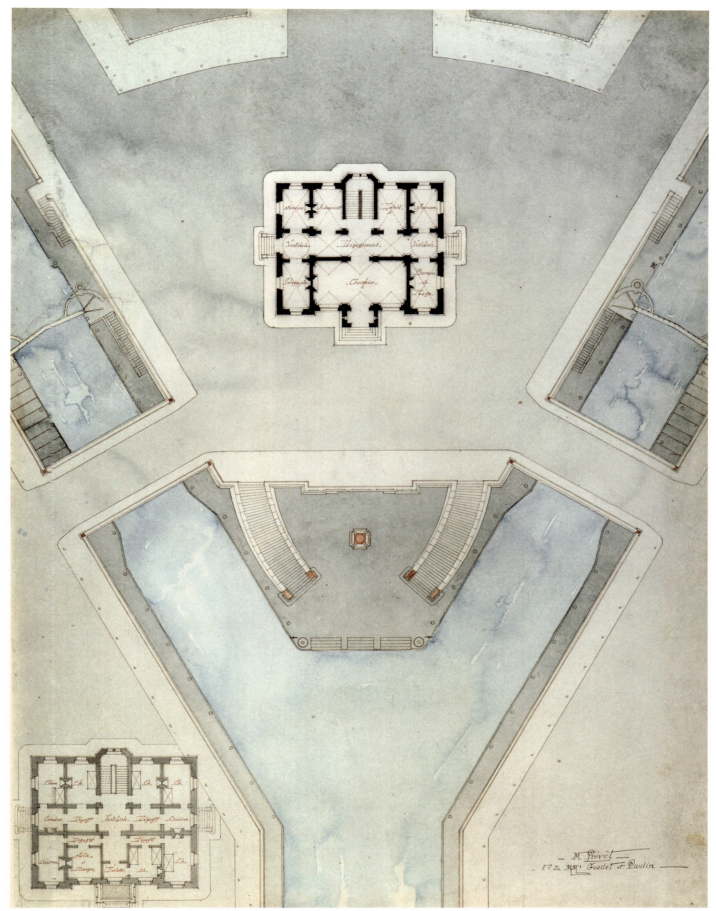

3.17

LOUIS ALFRED PERROT
(FRENCH, 1828–1870)

2000.428, 429: Competition drawings for two hospital buildings: elevations, plans, and cross-sections, 1848–51

Pencil, ink, watercolor

2000.428: Frontal elevation, plan and cross-section of a morgue. 18½ × 12⅝ in. (47 × 32.1 cm)
INSCRIBED [in ink] *44. / 5 Janvier 1848.* [indistinct] / [4×] *Cour / Depot des Mortes / Grande Salle d'autopsie / Veillent / Chirurgien / Hospice / Entrée / ALP / FF /* [on verso] *A Perrot Alfred élève du Mr. Bonneau*
STAMPED *ÉCOLE ROYALE DES BEAUX-ARTS CONCOURS D'EMULATION*

2000.429: Frontal elevation, two plans and cross-section of a hospital. 19¾ × 12¾ in. (50.2 × 32.4 cm)
INSCRIBED [in ink] *52. / 7. Mai 1851.* [indistinct] / *CUISINE / ST. VINCENT. PAUL / MARBEAU . / CHARITE. / Perrot / 1er ETAGE / lavabo / VESTIBULE / PORTIQUE / COUVERT /* [2×] *Cuisine / BUANDERIE / Sechoirs ordinaires /* [on verso] *A Perrot (Louis Alfred) élève du Mr. Bonneau*
STAMPED *ÉCOLE ROYALE DES BEAUX-ARTS CONCOURS D'EMULATION*

PROVENANCE Shepherd Gallery, New York

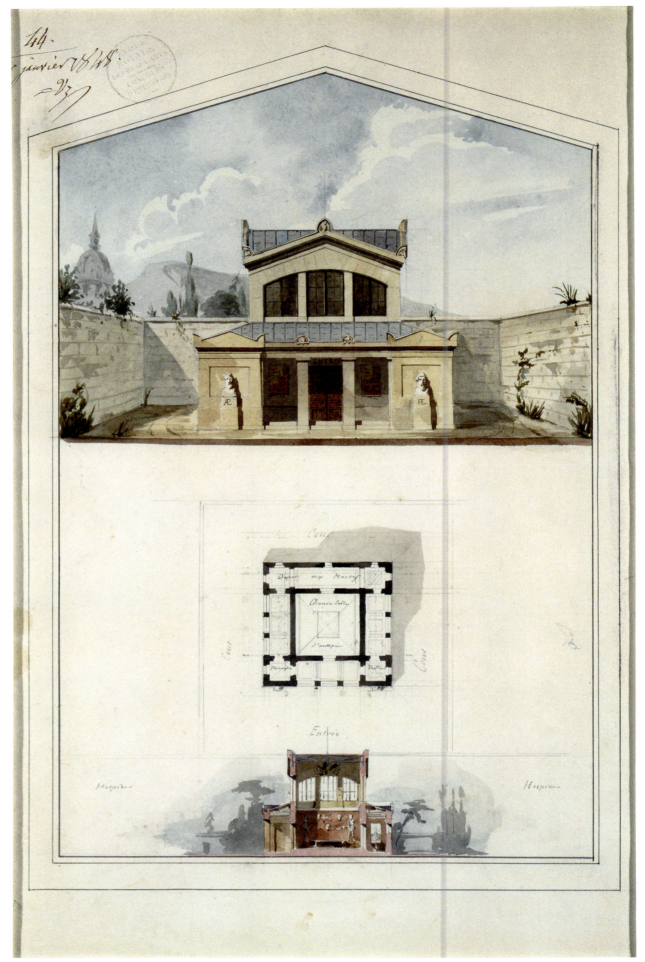

2000.428

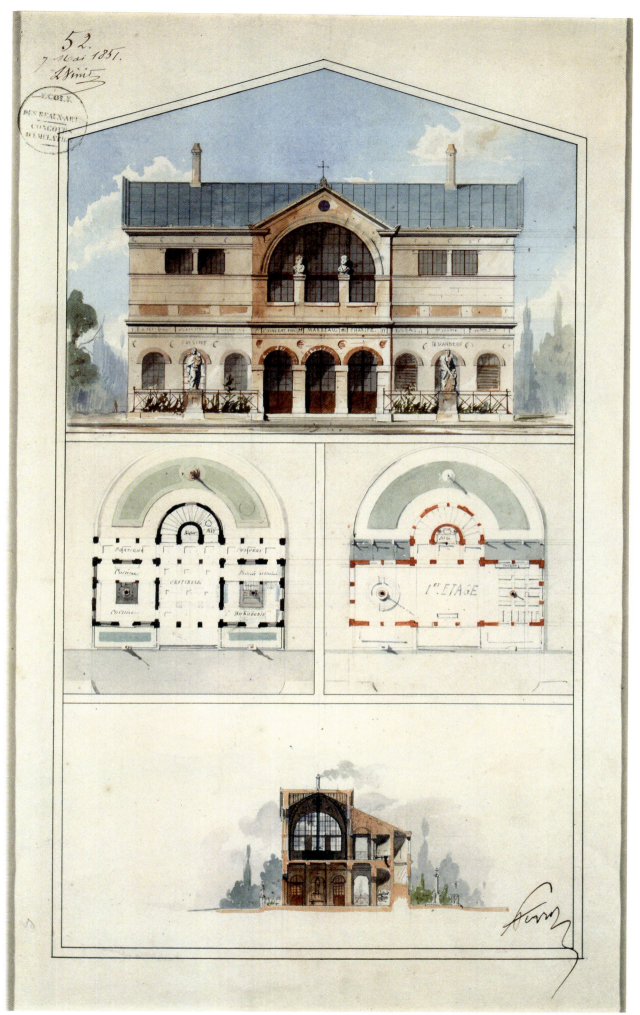

3.18

ARCHITECT UNKNOWN (FRENCH)

1991.386: Competition drawing for a surgical hospital: frontal elevation, ca. 1900

Pencil, ink, watercolor. 13⅝ × 42⅞ in. (34.6 × 108.9 cm)
INSCRIBED [in ink and watercolor] _ PAVILLON _ DE _ CHIRURGIE _ / FAÇADE PRINCIPALE / [architectural measurements]
PROVENANCE unknown

NCIPALE ECHELLE DE 0,02 P?M

3.19

ARCHITECTS: BENJAMIN CHAIKIN
(BRITISH, 1885–1950)
AND D.H. WINTER
(BRITISH?, DATES UNKNOWN)
ARTIST: WILLIAM WARMAN
(BRITISH, 1881–1977)

1987.71: Presentation drawing for an addition to the St. John Opthalmic Hospital, Jerusalem, 1938

Pencil, watercolor. 16¾ × 34¼ in. (42.5 × 87 cm)
INSCRIBED [in ink, on mount] ST. JOHN OPTHALMIC HOSPITAL JERUSALEM / ADDITIONAL BLOCK. / MAJOR. B. CHAIKIN. F.R.I.B.A. ARCHITECT. D.H. WINTER, A.R.I.B.A., F.S.I. HON' CONSULTING ARCHITECT. / W.WARMAN DELT.
LITERATURE *Trad Jazz & Mod / An Exhibition of European Architectural Drawings of the 1920s and 1930s* (Gallery Lingard, London, 1986), p. 31, cat. 42
PROVENANCE Gallery Lingard, London

❧ Established in the late 19th century by members of the Order of St. John, the hospital was damaged during World War I and by an earthquake in the 1920s but served its function until 1948. Today, it is the site of the Mount Zion Hotel. The plan in lower left was applied later.

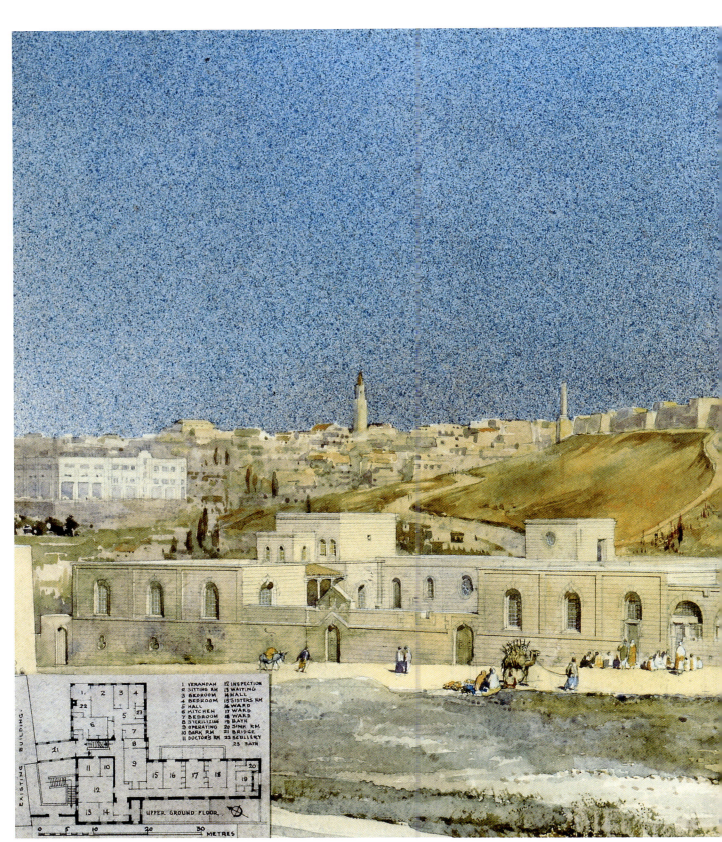

1987.71

St. John Opthalmic Hospital, Jerusalem, 1918

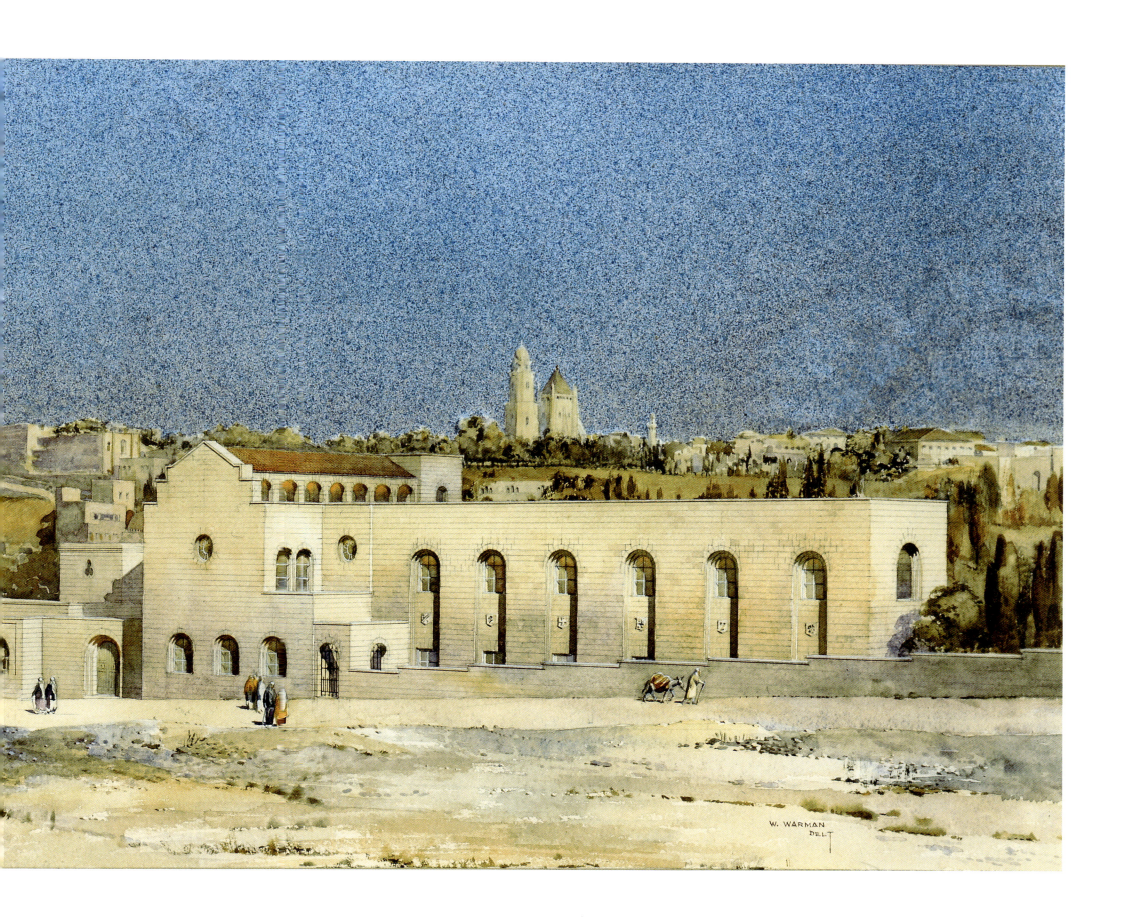

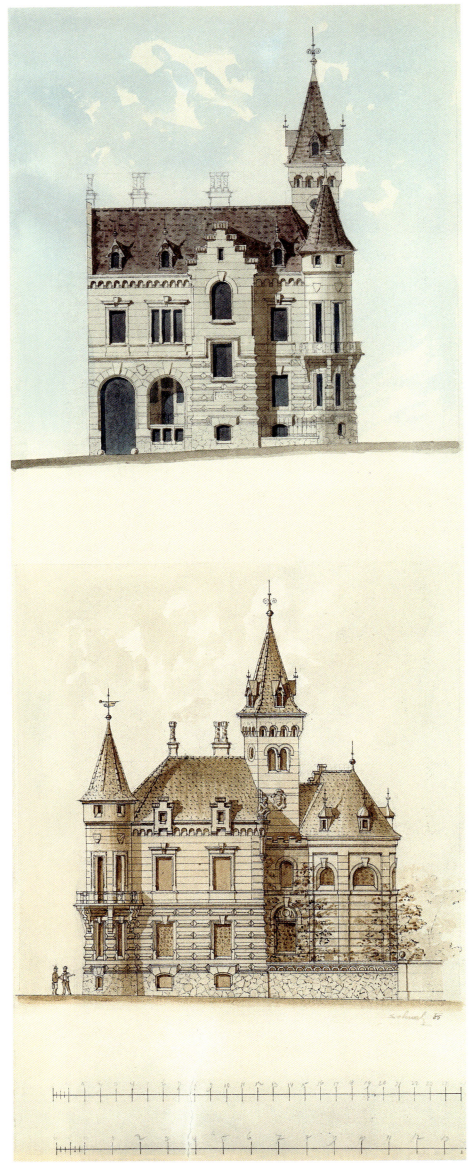

3.20

EUGENE SEHNAL (AUSTRIAN, 1851–1910)

2000.476: Designs for the Franz-Joseph Hospital in Sankt Pölten, Austria: two elevations, 1885

Pencil, ink, watercolor. 19⅝ × 8¼ in. (49.9 × 21 cm)
INSCRIBED [in ink] *Sehnal 85*
PROVENANCE Martin du Louvre Gallery, Paris

3.21

ARCHITECT: BRUCE JAMES TALBERT
(BRITISH, 1838–1881)
ARTIST: J.J. ATKINSON
(BRITISH, DATES UNKNOWN)

1987.74: Competition drawing for the Town Hall, Manchester, Lancashire, England: frontal elevation, 1866

Pencil, ink, wash. 23¼ × 16 (59.1 × 40.6 cm)
INSCRIBED [in ink] *JJ Atkinson Del*.
LITERATURE *Softs and Hards: An Exhibition of Drawings by Victorian and Edwardian Architects* (Gallery Lingard, London, 1987), cat. 9, p. 18–19 (ill.) and cover; *Greek and Goths: An Exhibition of Drawings in Revival Styles, 1800–1930* (Gallery Lingard, London, 1987), cat. 22, pp. 15 (ill.) and 29–30
PROVENANCE Gallery Lingard, London

❧ Over 100 architects participated in the 1866 Manchester Town Hall competition.

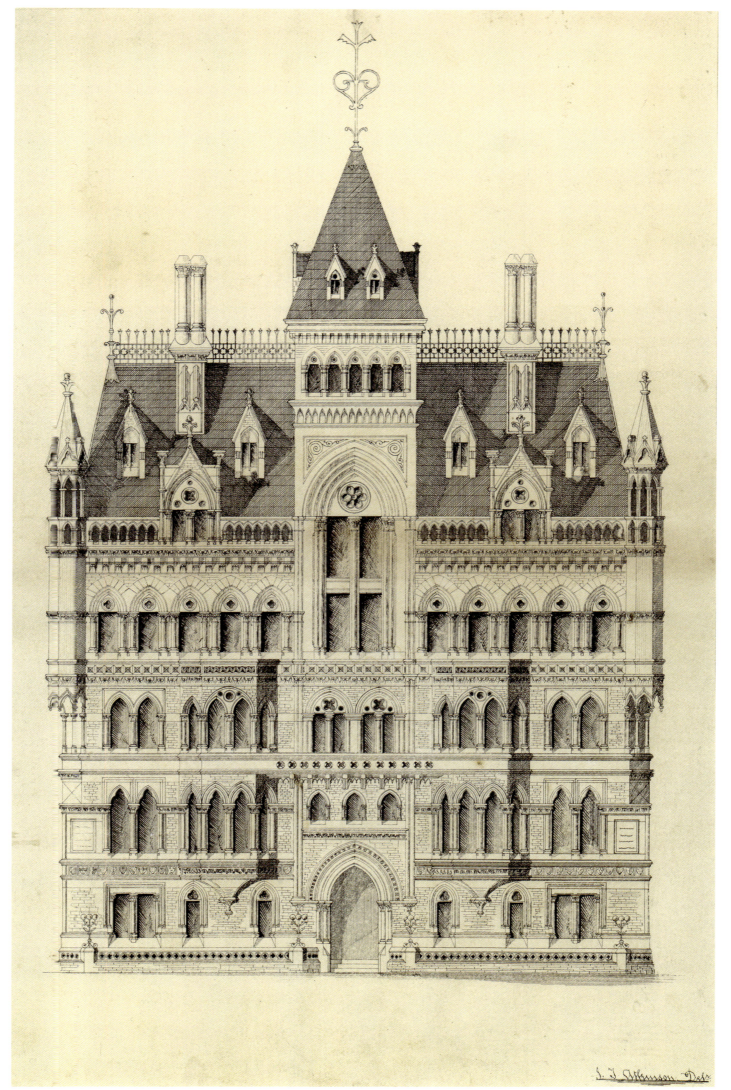

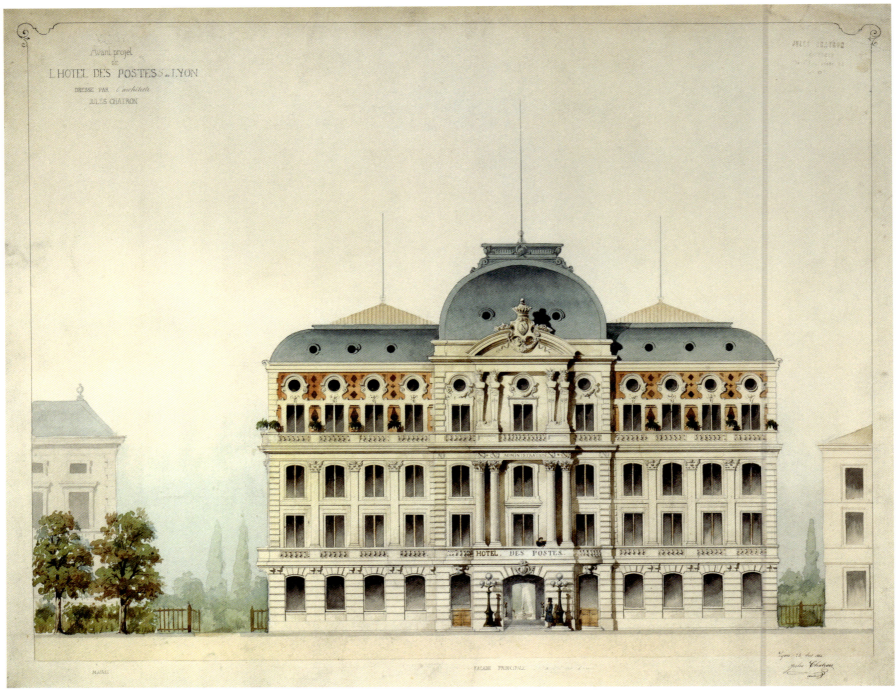

3.22

JULES CHATRON (FRENCH, 1831–1884)

1989.200: Competition drawing for a post office building in Lyon: frontal elevation, 1864

Pencil, ink, watercolor. 18⅝ × 24 in. (47.3 × 61 cm)
INSCRIBED *Avant projet de L'HOTEL DES POSTES de LYON DRESSE PAR l'architecte JULES CHATRON | MAIRIE | FAÇADE PRINCIPALE | HOTEL DES POSTES | ADMINISTRATION |* [on central crowned shield] *N | Lyon 23. Sept. 1864 | Jules C*
EMBOSSED STAMP *Jules Chatron ARCHITECTE Place Imperiale, 44 LYON*
PROVENANCE unknown

3.23

LEON KEACH (AMERICAN, 1893–1991)

1996.401b: Competition drawing for a post office: cross-section and plan, ca. 1915

Pencil, ink, wash. 31 × 24 in. (78.7 × 61 cm)
INSCRIBED [in ink] *LOBBY / WORKING SPACE / RECEIVING AND SHIPPING / WORKING ROOM / MONEY ORDER WORKING ROOM ;̊ MONEY ORDER LOBBY / POSTMASTER / ASSISTANT POSTMASTER / VAULT / EMPLOYEES*
PROVENANCE Gwenda Jay Gallery, Chicago

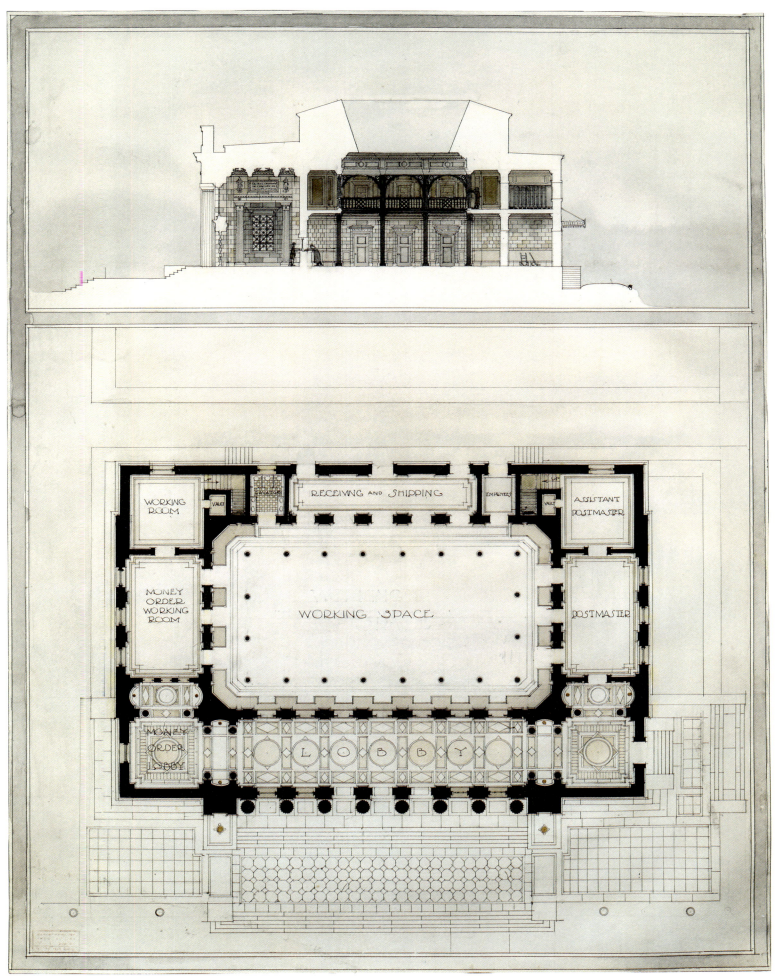

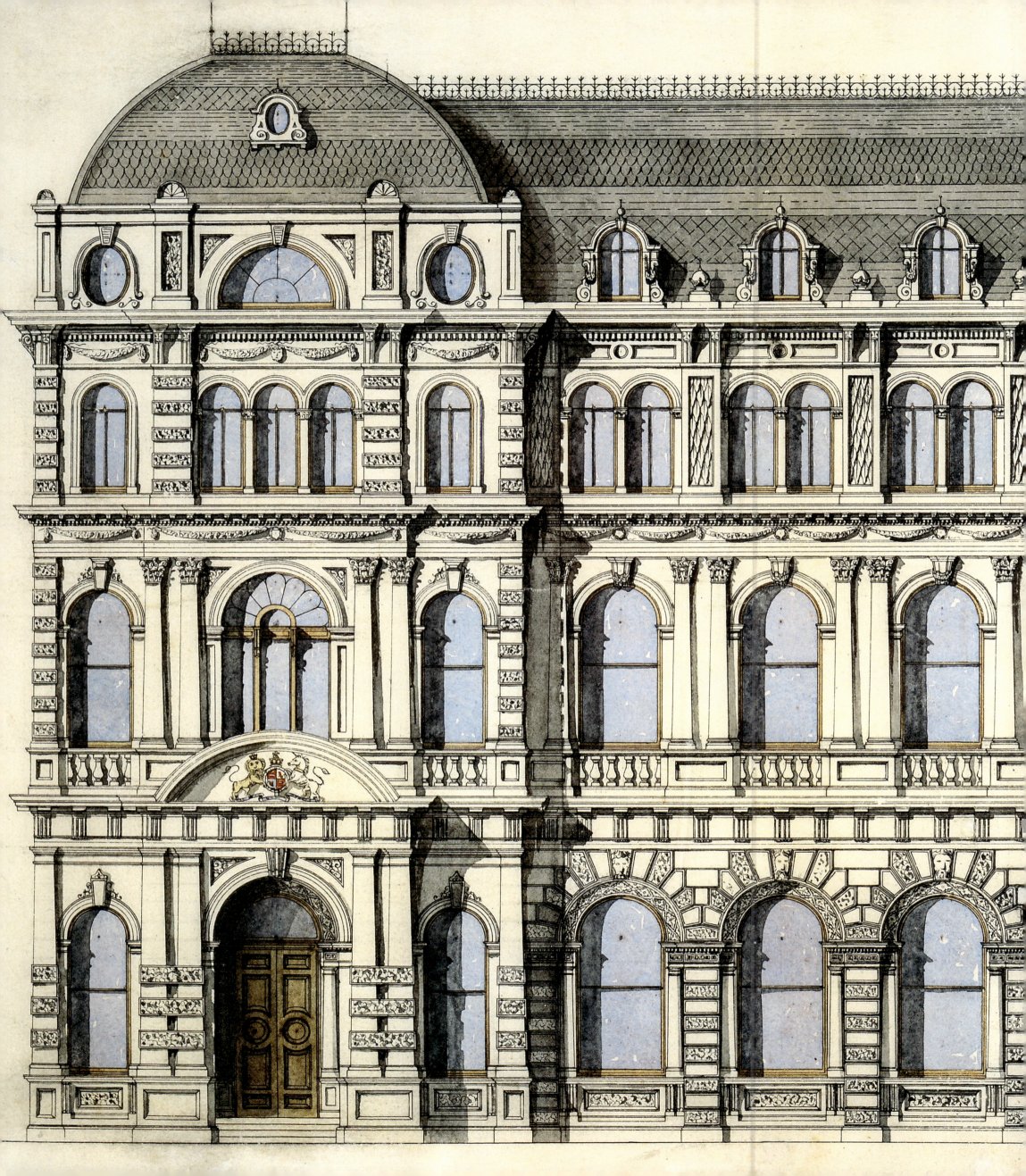

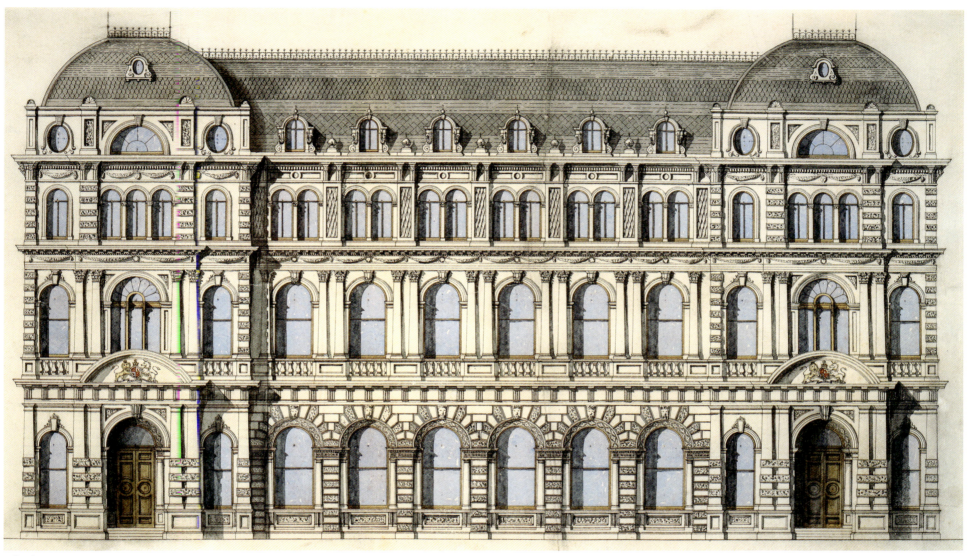

3.24

G. BURTON (BRITISH, DATES UNKNOWN)

1987.46: Competition drawing for a post office building: frontal elevation, 19th century

Pencil, pen, ink, watercolor. 13½ × 23¾ in. (34.3 × 60.3 cm)
PROVENANCE unknown

GOVERNMENT BUILDINGS 227

3.25

SQUIRE JOSEPH VICKERS
(AMERICAN, 1872–1947)

1993.396: Competition drawing for a State Capitol: frontal elevation, 1900

Pencil, ink, watercolor. 31½ × 47 in. (80 × 119.4 cm)
INSCRIBED [in crayon] *S. J. Vickers / June 9, 1900*
LITERATURE Elisabeth Kashey and Robert Kashey, *Paintings by Squire Vickers 1872–1947. Designing Architect of the New York Subway System* (New York, 1992), p. 20, cat. 2; Eli Spindel, *An Imagined Metropolis* (http://elispindel.com/an-imagined-metropolis), fig. A
PROVENANCE Shepherd Gallery, New York

❧ The design of a State Capitol was the assignment for Cornell architecture students in the spring semester of 1900, the year Vickers graduated.

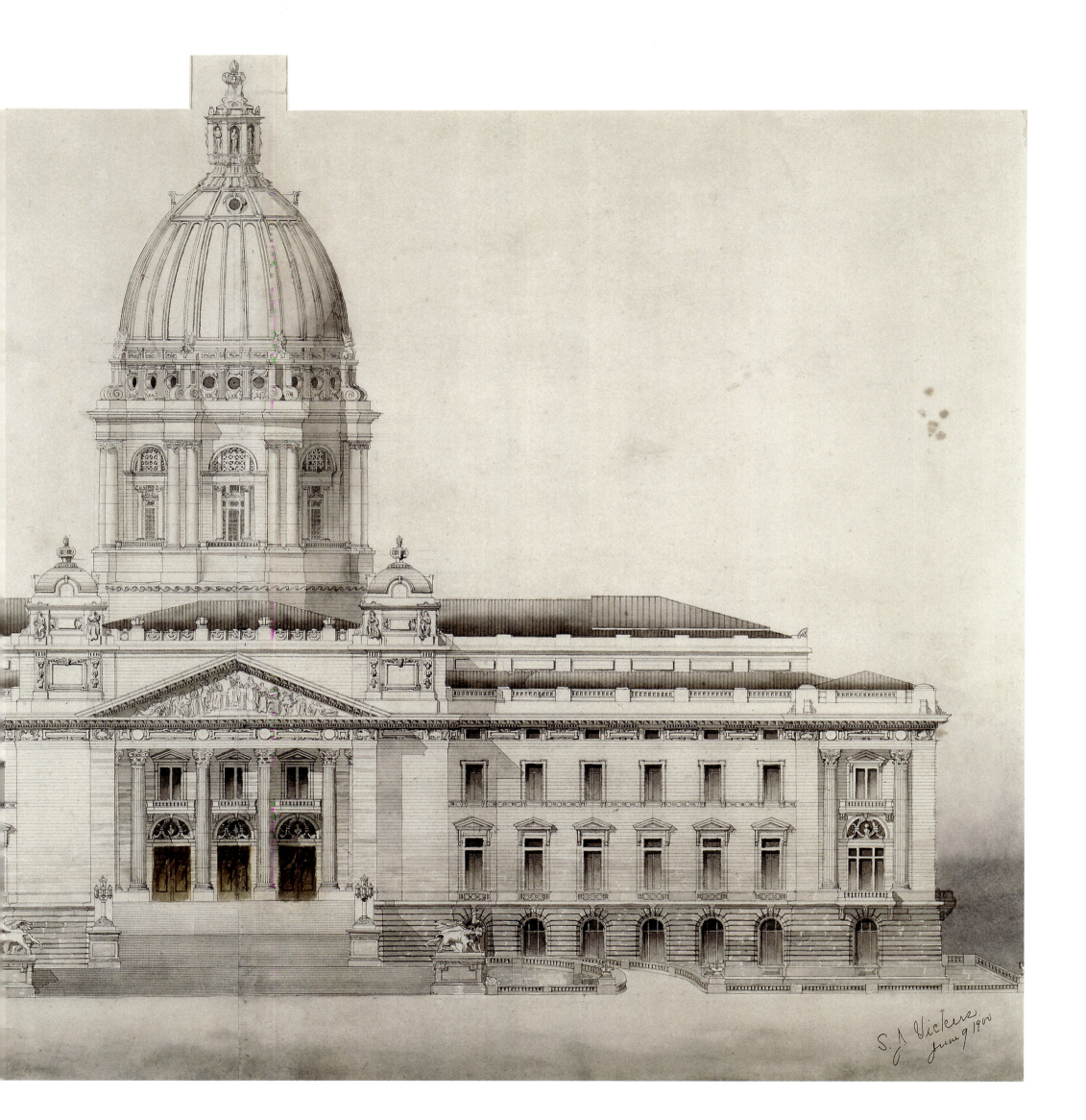

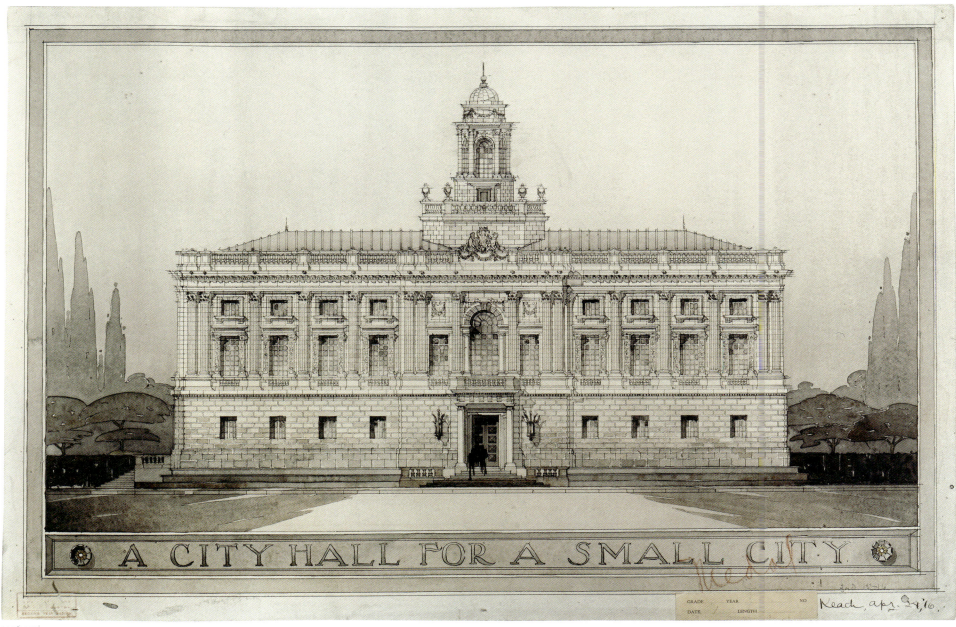

3.26

LEON KEACH (AMERICAN, 1893–1991)

1996.401i–j: Competition drawings for a city hall: two elevations and a cross-section, 1916

Pencil, ink, watercolor

1996.401i: Frontal elevation. 16¾ × 25¼ in. (42.6 × 64.1 cm)
INSCRIBED *A CITY HALL FOR A SMALL CITY* / *Keach Apr. 24, '16* / [in red] *Medal*
STAMPED [in red] *DEPARTMENT OF ARCHITECTURE / M.I.T.* […]

1996.401j: Elevation and cross-section. 28¼ × 14¼ in. (71.8 × 35.6 cm)
INSCRIBED *Keach Apr. 24, '16* / *3ʳᵈ Yr. 1915–16*
STAMPED [in red] *DEPARTMENT OF ARCHITECTURE / M.I.T.* […]

PROVENANCE Gwenda Jay Gallery, Chicago

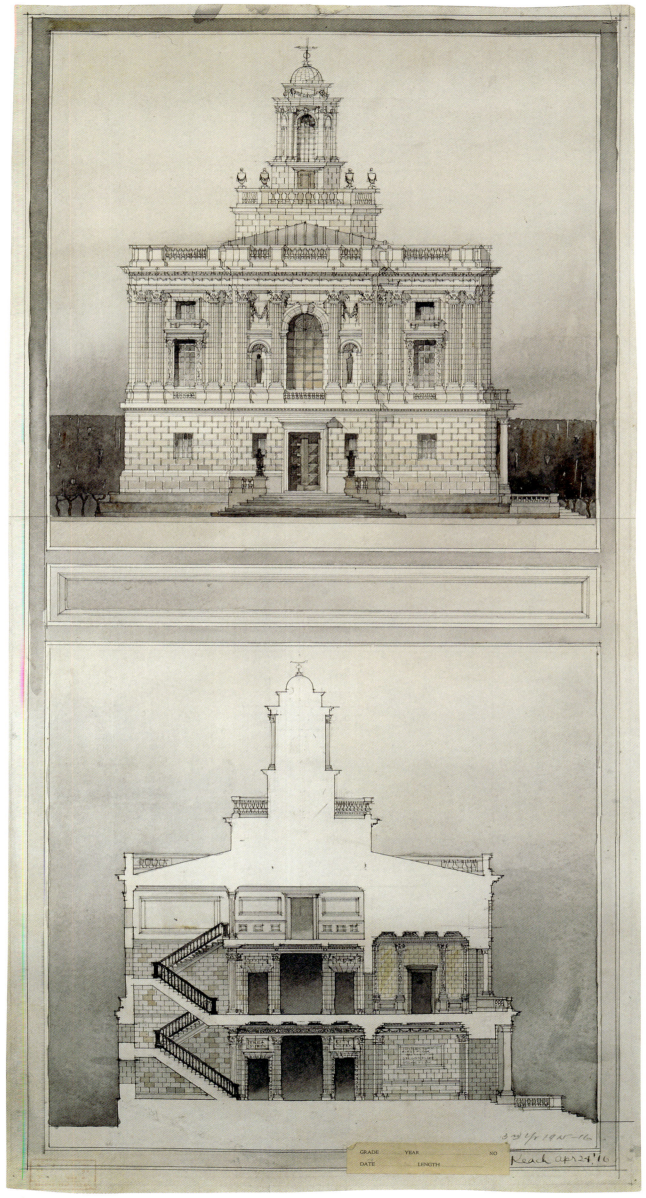

1987.70

3.27

ARCHITECT: THOMAS OLIPHANT
FOSTER (BRITISH, 1881–1942)

ARTIST: D. HOTTINGER (DATES UNKNOWN)

1987.70: Presentation drawings for the board room, Magistrates Court, Yangon, Myanmar: two interior elevations, ca. 1926

Pencil, watercolor, gilding. 17 × 22½ in (43.2 × 57.2 cm)
INSCRIBED *BOARD ROOM / MAGISTRATES COURT RANGOON* [architectural measurements] / *DRAWING BY D. HOTTINGER / DESIGN BY T.O. FOSTER, F.R.I.B.A.*
LITERATURE *Trad Jazz & Mod: An Exhibition of European Architectural Drawings of the 1920s and 1930s* (Gallery Lingard, London, 1986), cat. 7, p. 19 (not ill.)
PROVENANCE Gallery Lingard, London

🌶 The building was restored and converted into a hotel by Rosewood Hotels & Resorts.

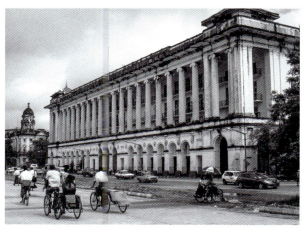

Rosewood Yangon hotel, Myanmar

232 PETER MAY COLLECTION I

3.28

ARCHITECT UNKNOWN (BRITISH)

1990.337: Competition drawing for a colonnaded building: detail, two plans, and cross-section, early 20th century

Pencil, ink, wash. 21 × 13½ in. (53.3 × 34.3 cm)
INSCRIBED [in ink] *PLAN LOOKING DOWN 1/3 SCALE OF ELEVAN* [sic] / *SECTION 1/3 SCALE OF ELEVATION* / *PLAN LOOKING UP 1/3 SCALE OF ELEVATION* / [in red crayon inside circle] *1ST M* [first mention]
LITERATURE Sotheby's, London, sale cat. 15 Nov. 1990, p. 26, lot 22 (from a portfolio of drawings)
PROVENANCE Sir John Summerson, Sotheby's, London, 15 Nov. 1990, lot 22; Charles Plante, London

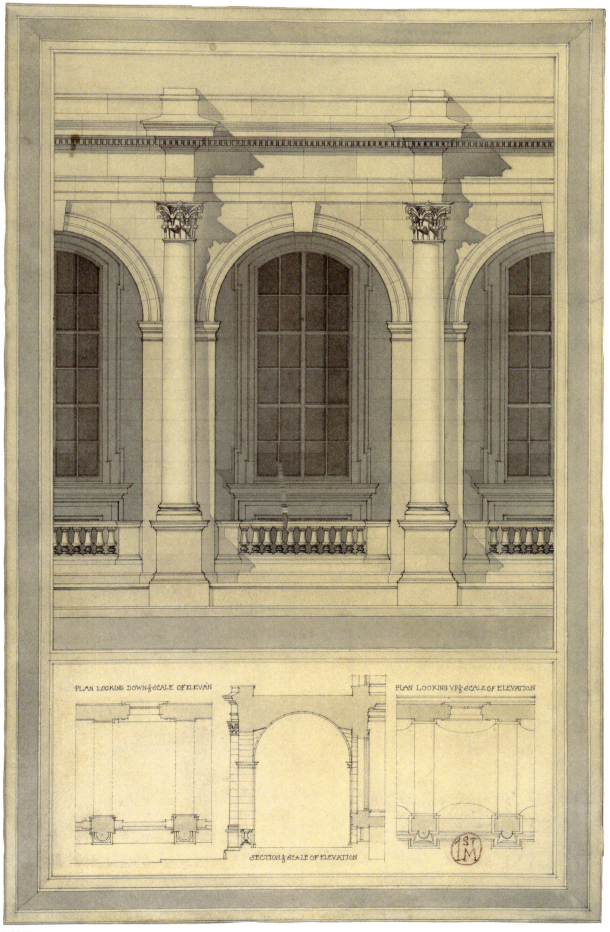

1990.337

GOVERNMENT BUILDINGS 233

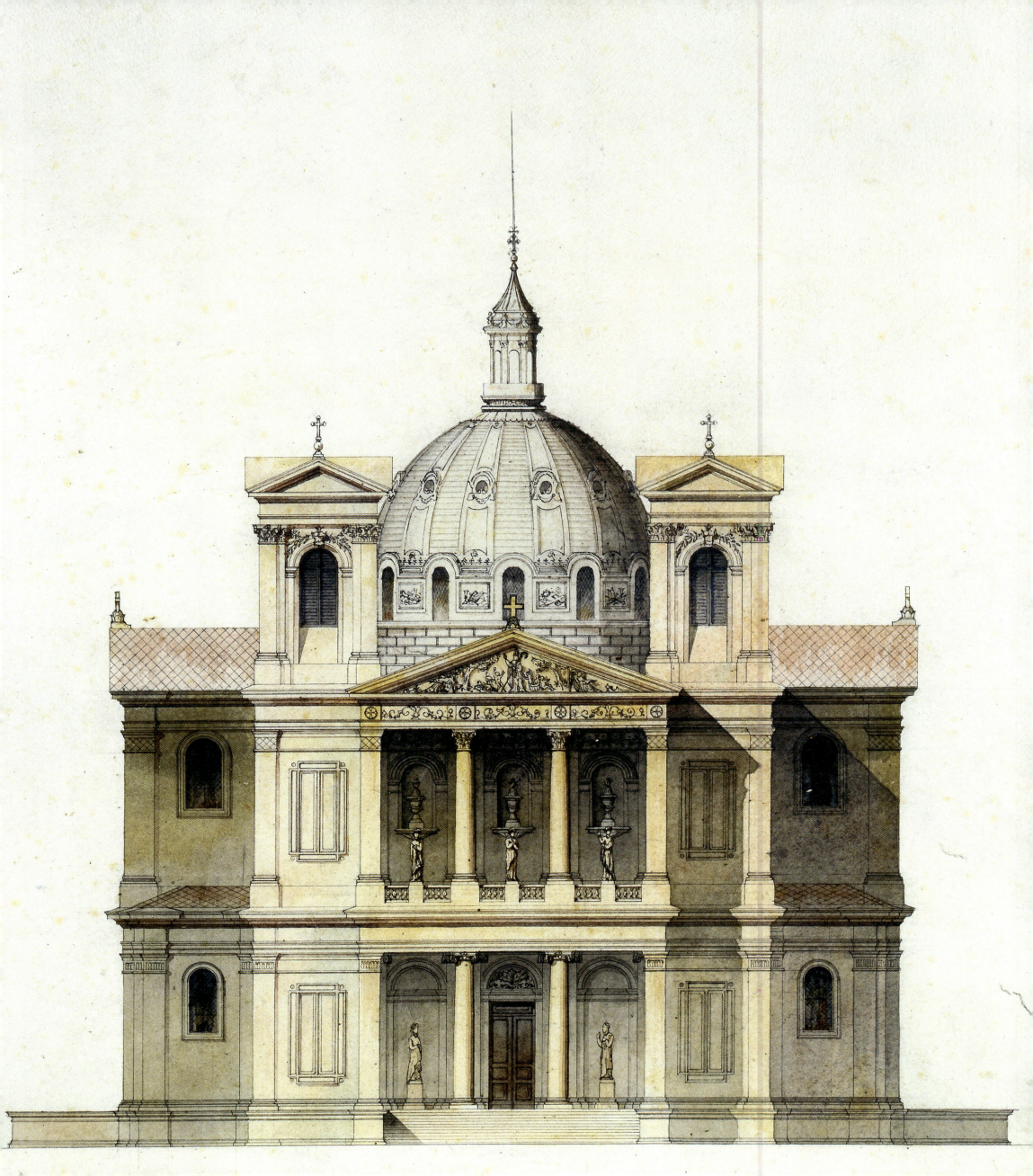

4
PLACES OF WORSHIP

1988.140 detail

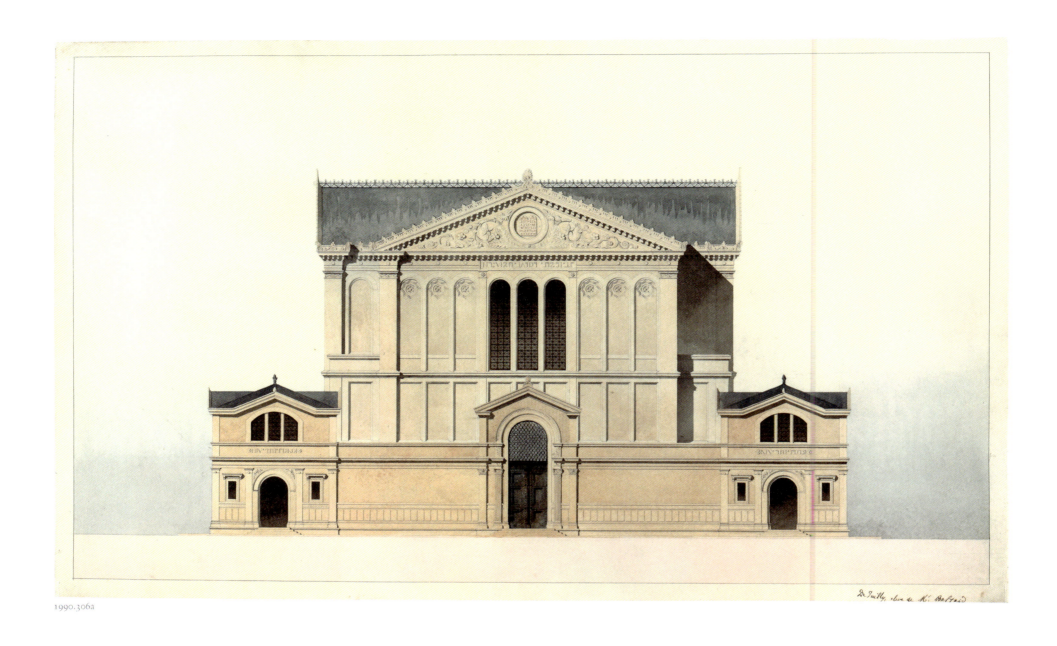

4.1

HENRY GUILLOT DE JUILLY
(FRENCH, 1822– BEFORE 1906)

1990.306a–c: Competition drawings for a synagogue: frontal elevation and two cross-sections, 19th century

Pencil, ink, watercolor

1990.306a: Elevation. 21 × 31¼ in. (53.3 × 79.4 cm)
INSCRIBED [in ink] *De Juilly, eleve de M*ʳ*. Baltard* /
[in crayon] *123*

1990.306b: Cross-section. 21½ × 35⅝ in. (54.6 × 90.5 cm)

1990.306c: Cross-section. 18¾ × 24⅝ in. (47.6 × 62.6 cm)

PROVENANCE Jacques Fischer – Chantal Kiener, Paris

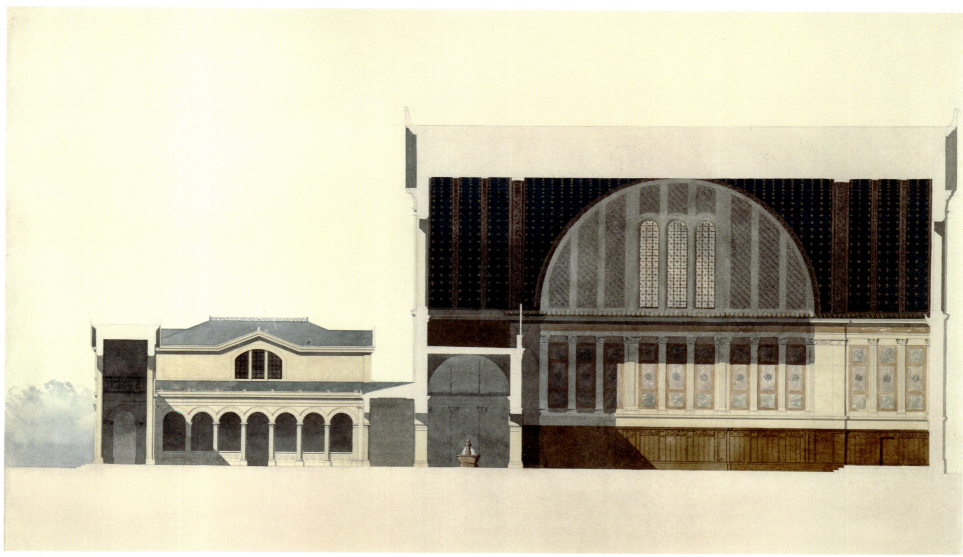

1990.306b

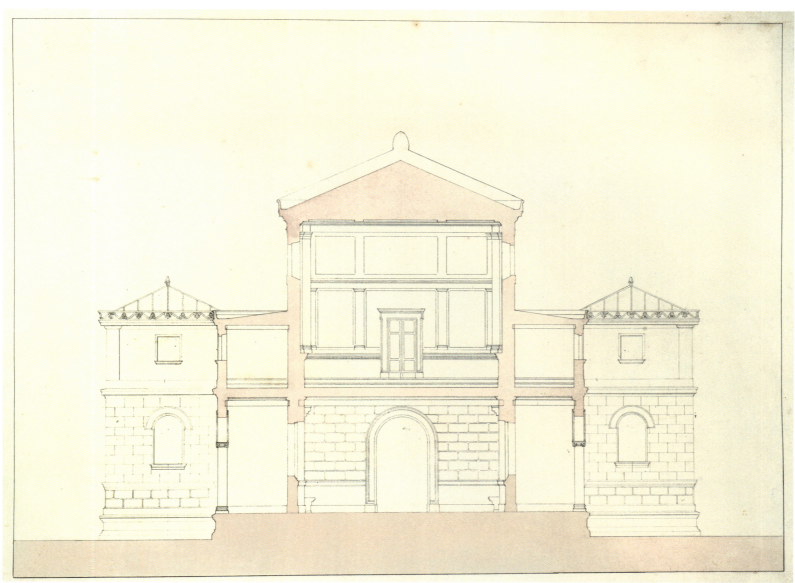

1990.306c

4.2

MARIANO FALCINI (ITALIAN, 1804–1885),
VICENZO MICHELI (ITALIAN, 1833–1905),
AND MARCO TREVES (ITALIAN, 1814–1898)

1996.402: Presentation drawing for the Great Synagogue (Tempio Maggiore) of Florence: elevation, ca. 1874–82

Pencil, ink, watercolor. 38 × 25½ in. (96.5 × 65 cm)
INSCRIBED [in ink] *Vittorio Levi*
LITERATURE *Rooms with Views* (Shepherd Gallery presented by Christopher Wood Gallery, London, 1995), cat. no. 63 (ill.)
PROVENANCE Mallett, London

❧ The synagogue was completed in 1882. It was financed by David Levi, perhaps a relation of Vittorio Levi.

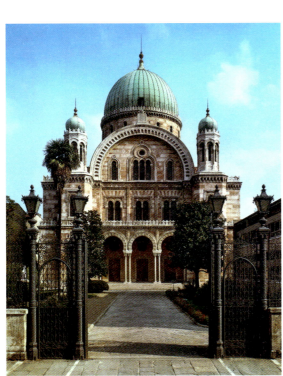

Great synagogue of Florence (1874–82), design by Marco Treves

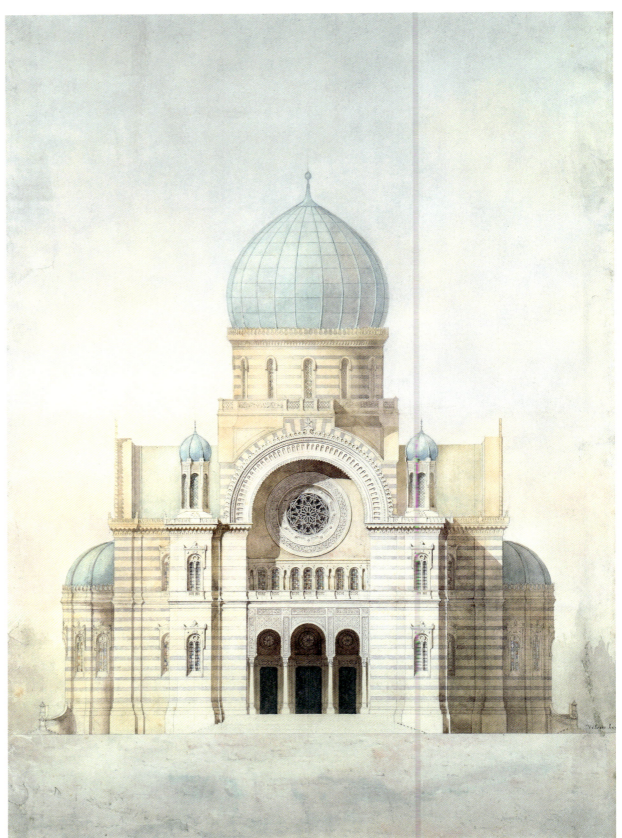

1996.402

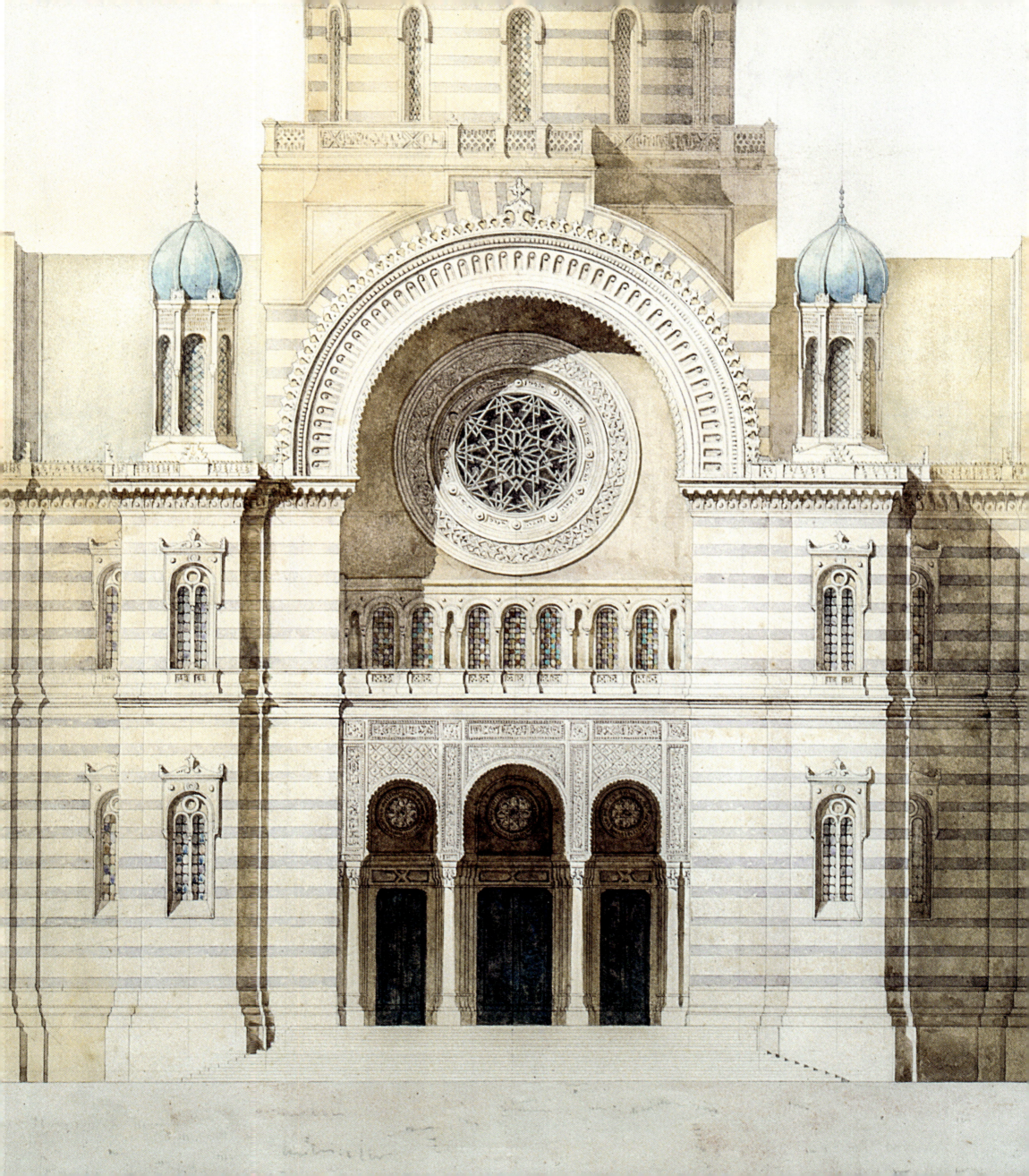

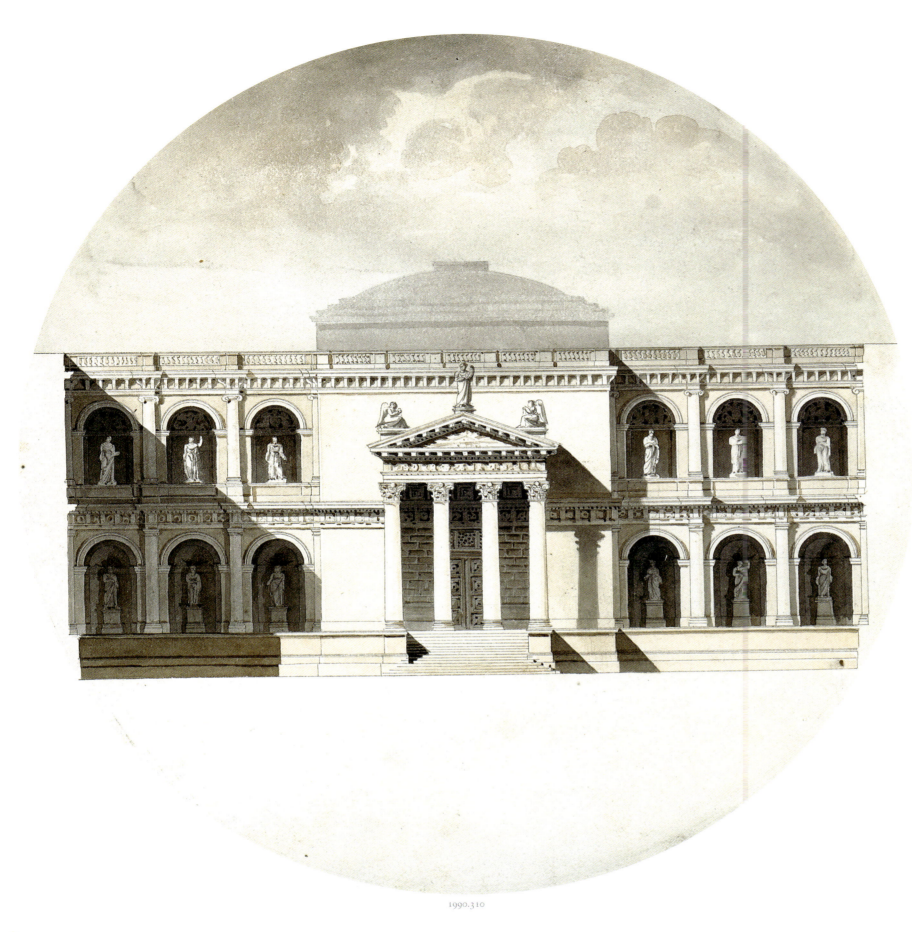

4.3

ARCHITECT UNKNOWN (FRENCH?)

1990.310: Elevation of a church, 19th century

Pencil, ink, watercolor. 7¾ in. (19.7 cm) diameter
PROVENANCE unknown

🔴 The identification of the building as a church derives from the winged angels on the portico.

4.4

JEAN ANTOINE CARISTIE (FRENCH, 1719–1770), ATTRIBUTED TO

1990.281a–c: Three elevations for churches, two with plans for the porches

Pencil, ink, watercolor

1990.281a: 17½ × 10½ in. (44.5 × 26.7 cm) approx.

1990.281b: 19 × 13½ in. (48.3 × 34.3 cm) approx.

1990.281c: 18 × 14¼ in. (45.7 × 36.2 cm) approx.

PROVENANCE unknown

❧ ENSBA database Cat'zArts gives only an architectural student named Augustin-Nicolas Caristie (1783–1862), who won the Prix de Rome in 1818. Jean Antoine Caristie, however, was apparently an architect practicing in Dijon in the 18th century.

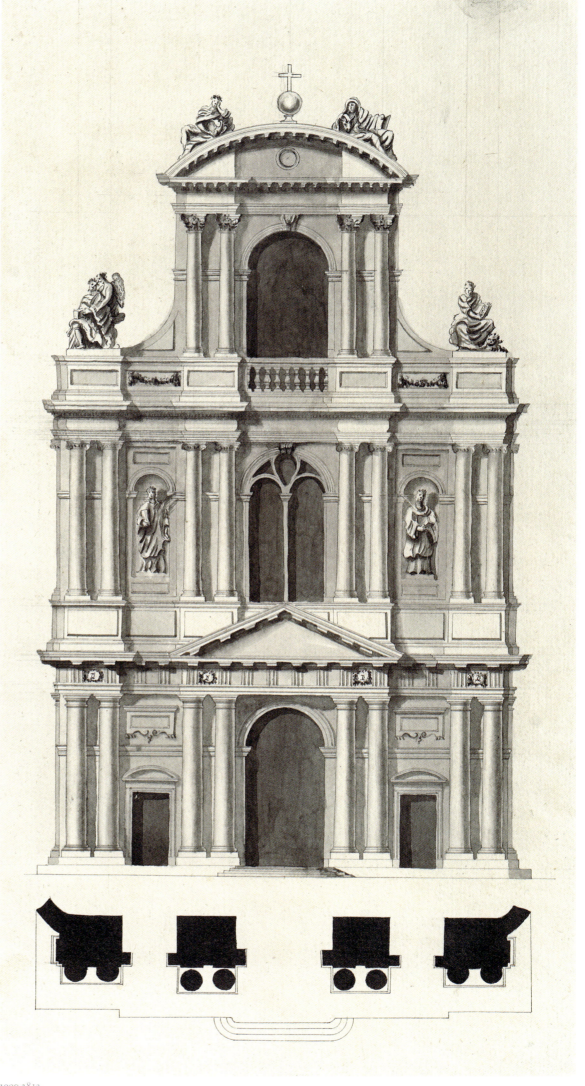

1990.281a

PLACES OF WORSHIP 241

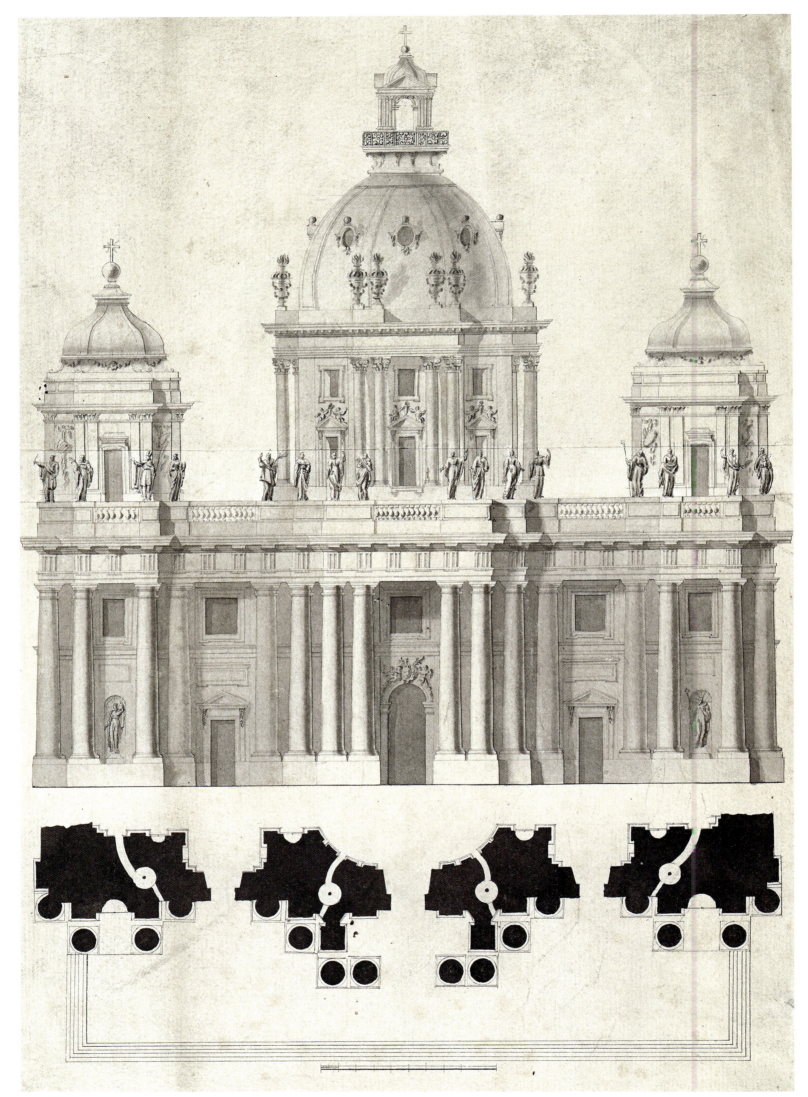

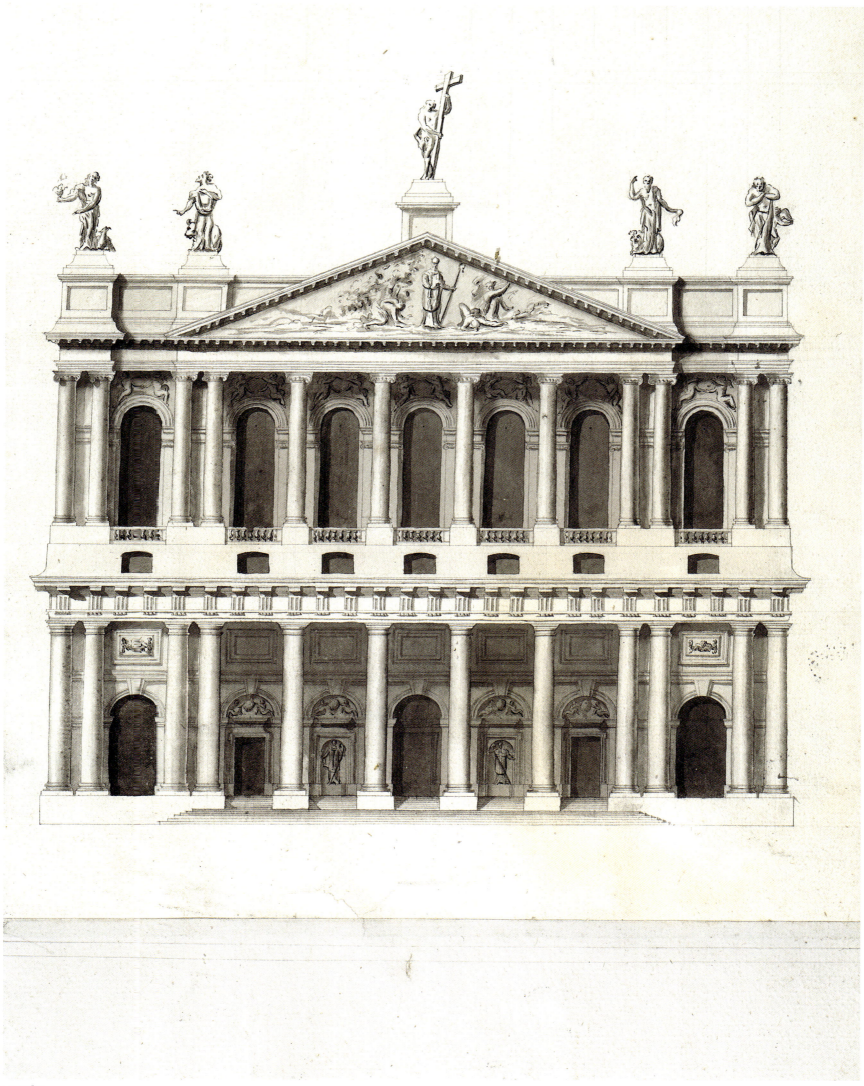

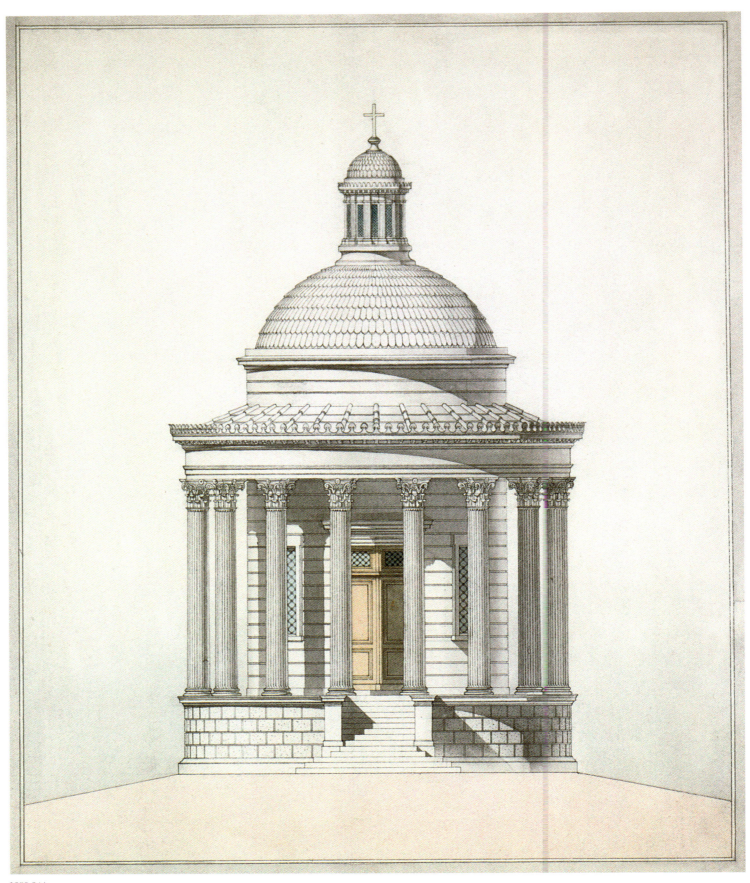

4.5

ARCHITECT UNKNOWN (FRENCH)

2000.544: Elevation for a church in the form of a *tempietto*, 19th century

Pencil, ink, watercolor. 23⅝ × 20 in. (60 × 51 cm)
PROVENANCE Galerie Martin du Louvre, Paris

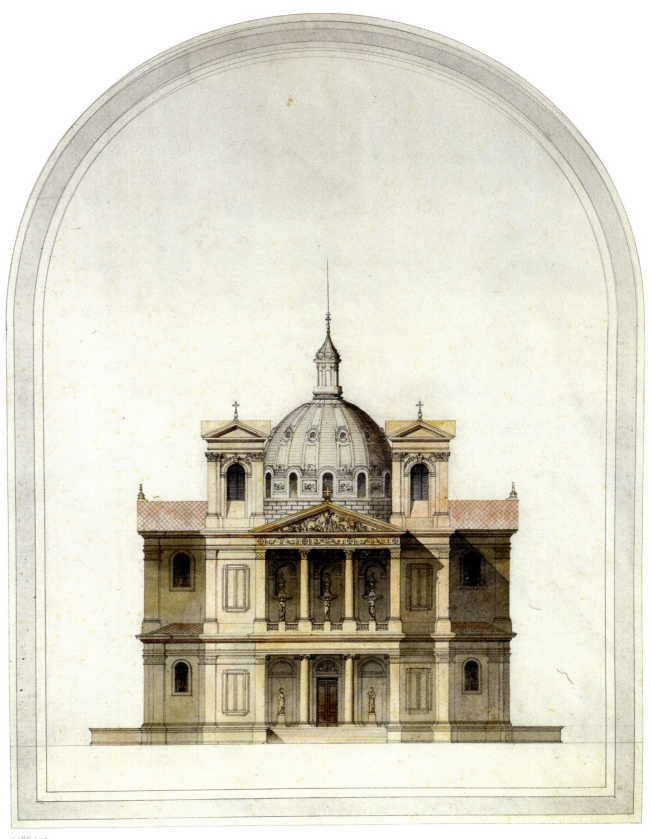

4.6

A. COURAY [?] (FRENCH, DATES UNKNOWN)

1988.140: Competition drawing of a church: frontal elevation, 1864

Pencil, ink, watercolor. 21½ × 15 in. (54.6 × 38.1 cm)
INSCRIBED *PROJET DU L'ÉGLISE PARCISS=ALE / ELEVATION PRINCIPALE* / [in pencil] *3 ⊃ Mars 1864* / [in ink] *A. Couray* [?] / [architectural measurements]
PROVENANCE unknown

PLACES OF WORSHIP 245

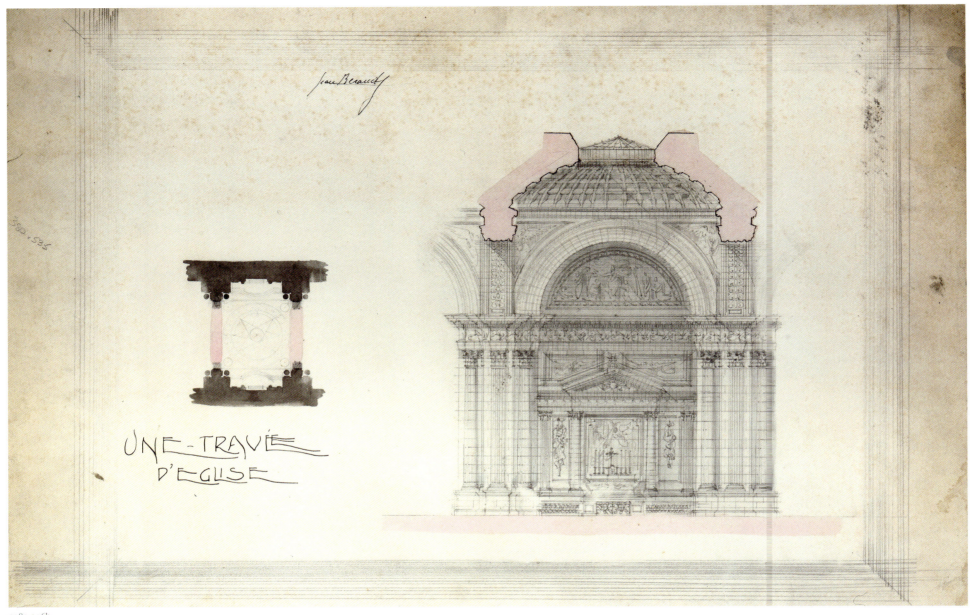

4.7

JEAN BERAUD (FRENCH, 1882–1954)

1989.236b: Competition drawing for the bay of a church: cross-section and plan, ca. 1903

Pencil, ink, watercolor. 16⅛ × 24⅝ in. (41 × 62.5 cm)
INSCRIBED [in ink] *UNE – TRAVÉE D'EGLISE / Jean Béraud*
PROVENANCE unknown

4.8

ARCHITECT UNKNOWN (FRENCH?)

2016.540: Competition drawing for a cathedral: frontal elevation, ca. 1900

Pencil, ink, watercolor. 39¼ × 26⅛ in. (99.7 × 66.4 cm)
PROVENANCE unknown

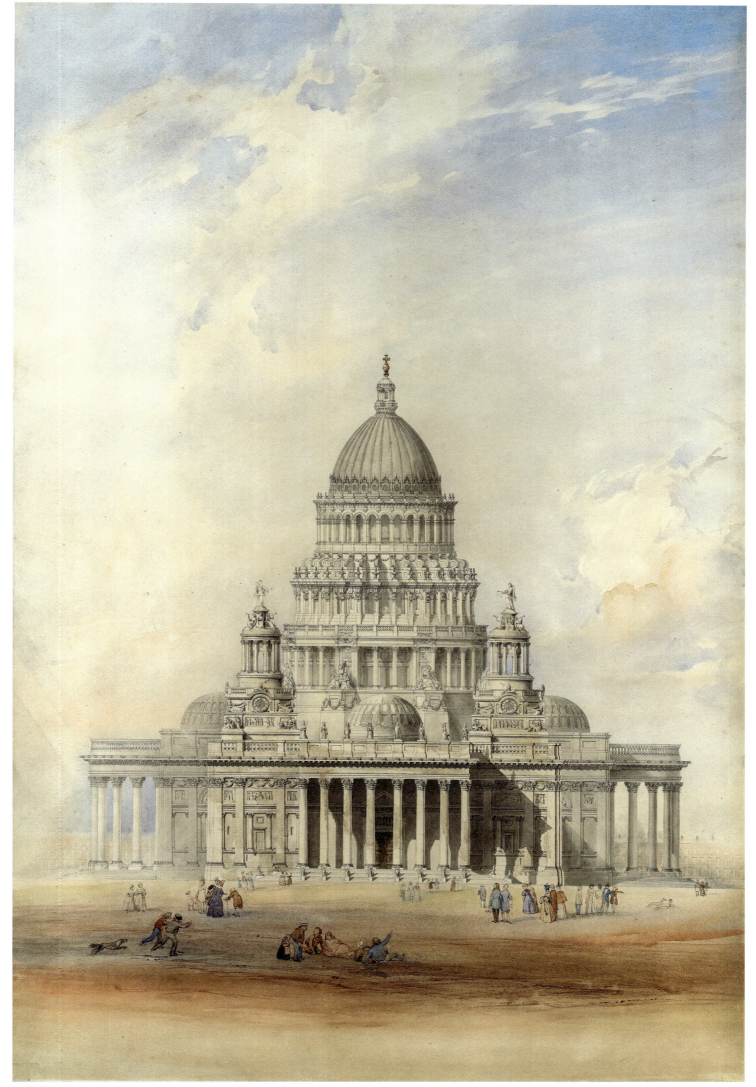

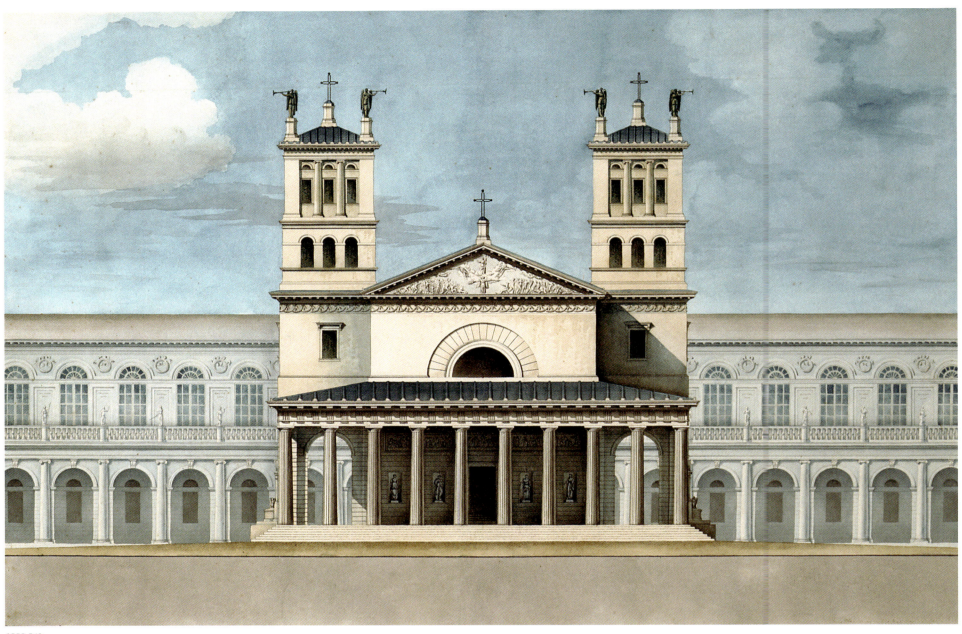

4.9

MARIO/MARCO [?] MANCINI/MARINI [?]
(ITALIAN, DATES UNKNOWN)

2000.542: Elevation of a church, 1829

Pencil, ink, watercolor. 20⅞ × 30⅛ in. (53 × 76.5 cm)
INSCRIBED *Mancini* [or *Marini*] *invente et fece Anno 1829*
PROVENANCE unknown

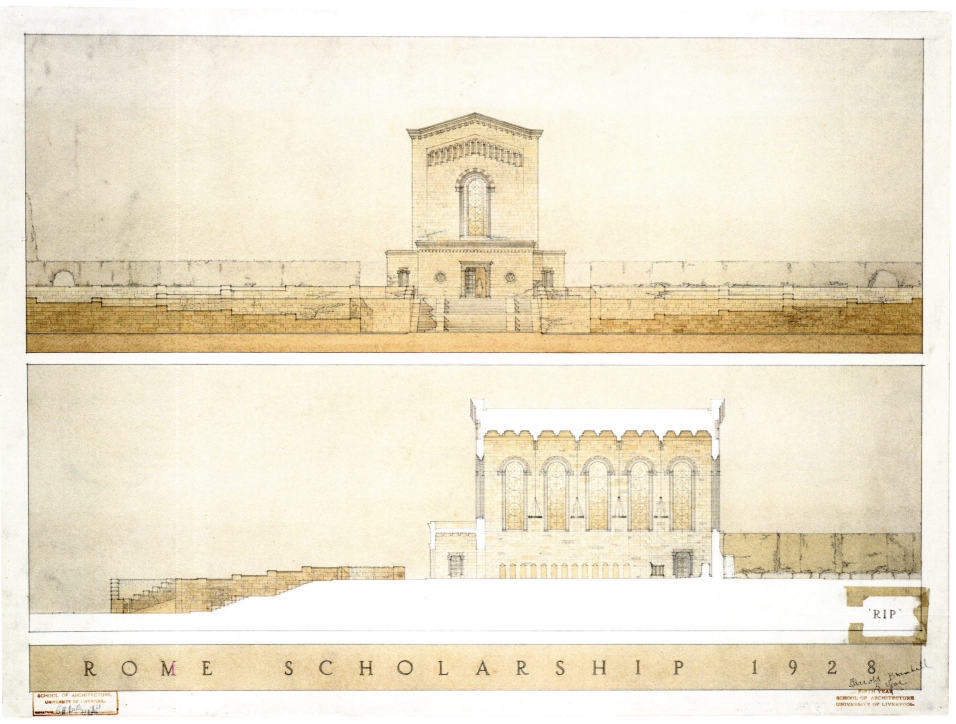

2000.522

4.10

HAROLD BRAMHILL (BRITISH, 1905–1997)

2000.522: Rome Scholarship competition drawings for a memorial chapel and crematorium: elevation and cross-section, 1928

Pencil, ink, watercolor. 26⅛ × 35½ in. (66.4 × 90.2 cm)
INSCRIBED [in pencil and ink] *ROME SCHOLARSHIP 1928 / 'RIP'* / [in ink] *Harold Bramhill 5 year*
STAMPED [in red] *FIFTH YEAR / SCHOOL OF ARCHITECTURE UNIVERSITY OF LIVERPOOL / SCHOOL OF ARCHITECTURE / UNIVERSITY OF LIVERPOOL / SIGNATURE* / [in ink] *C.H. Reilly 1928* [indistinct]
PROVENANCE Gallery Lingard, London

According to the *Journal of the Royal Institute of British Architects*, vol. XXXV, no. 1, 12 Nov. 1997, p. 133, this was the subject for the Tite Prize: "A Crematorium. To consist of a chapel, furnaces, columbarium and service buildings [...]." Bramhill, however, has labeled his drawing, "Rome Scholarship 1928." 'RIP' is presumably Bramhill's jocular alias for this blind submission to a juried competition.

Detail showing stamps and inscription *'RIP'* and *Harold Bramhill 5 year*

PLACES OF WORSHIP 249

4.11

PROSPER-ETIENNE BOBIN
(FRENCH, 1844–1923)

1989.197 (Bobin archive): Material relating to designs for the Church of Sainte Anne de la Butte aux Cailles, 188 rue de Tolbiac, Paris, designed and constructed 1892–1900

Pencil, ink, watercolor, photography, of various sizes
LITERATURE Sotheby's, London, sale cat. 27 April 1989, p. 156, lot 653 (not ill.)
PROVENANCE Sotheby's, London, 27 April 1989, lot 653

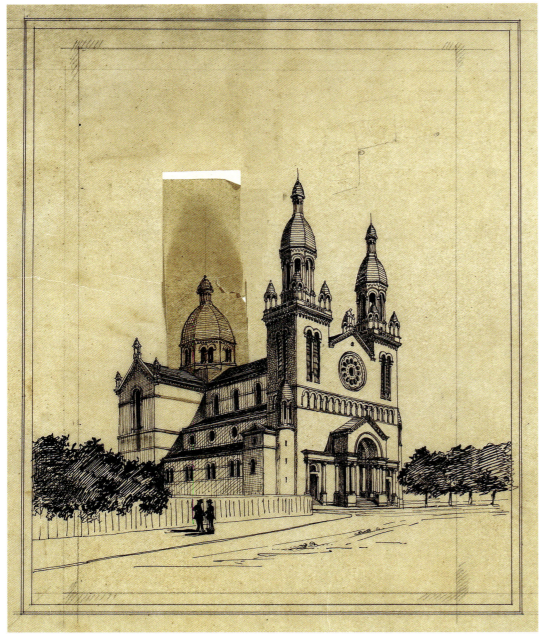
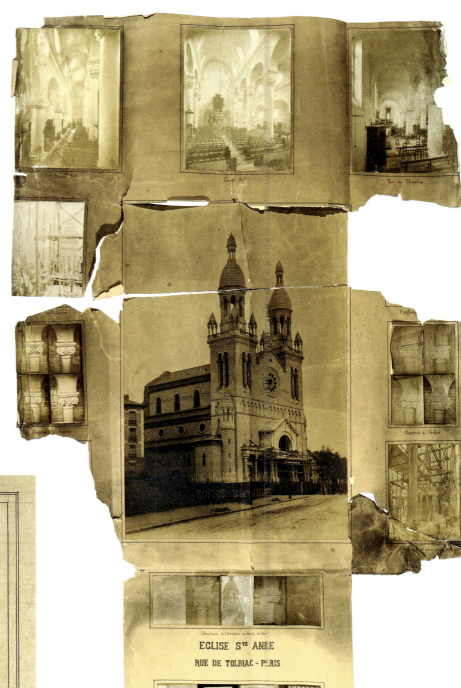

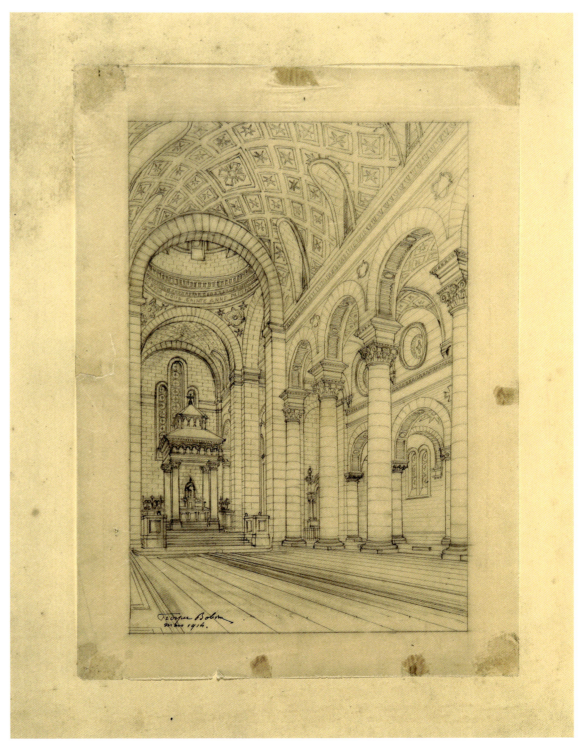

4.12

ARCHITECT: CHRISTOPHER WREN
(BRITISH, 1632–1723)
ARTIST: JOHN GWYNN
(BRITISH, 1713–1786)
ENGRAVER: EDWARD ROOKER
(BRITISH, ca. 1712–1774)

1987.93: Cross-section of St. Paul's Cathedral, London, 1801

Engraving. 33½ × 25½ in. (85.1 × 64.8 cm)
INSCRIBED [on plate] *To his Royal Highness George Prince of Wales This SECTION of St. Paul's Cathedral; decorated agreeably to the INTENTION of Sr. Christopher Wren; Is, with all humility, inscribed, by his Royal Highness' most devoted, and most Obedient Humble Servants SAM. WALE JNO. GWYN / LONDON. Published March 25th 1801 for the Proprietor Alexr. Poole Moore No. 54 Lombard Street / 50 English Feet. / 50 French Feet.*
EXHIBITED Gallery Lingard, London, 1987
LITERATURE *CAPITAL BUILDINGS / An Exhibition of Architectural Designs and Topographical Views of London* (Gallery Lingard, London, 1987), cat. 2, p. 4 (ill.) and p. 13
PROVENANCE Gallery Lingard, London

❧ The original plate, published in 1755, was reissued in 1801.

4.13

FRANK MYERS BOGGS
(AMERICAN, 1855–1926)

1990.262a: Mosque interior, 1895 (?)

Watercolor. 21¼ × 17⅝ in. (54 × 44.8 cm)
INSCRIBED [in brown watercolor] *A Mo1sr. [?] Walter [?] Souvenir de St. Louis '95 [?] de son ami BOGGS / 7*
PROVENANCE unknown

❧ Boggs's itinerary in Spain is not known, though he spent time in Granada (see cat. 13.42). This view is similar, but does not correspond precisely, to the interior of the Great Mosque of Córdoba (Mezquita de Córdoba) and may represent another mosque.

1990.262a

PLACES OF WORSHIP 253

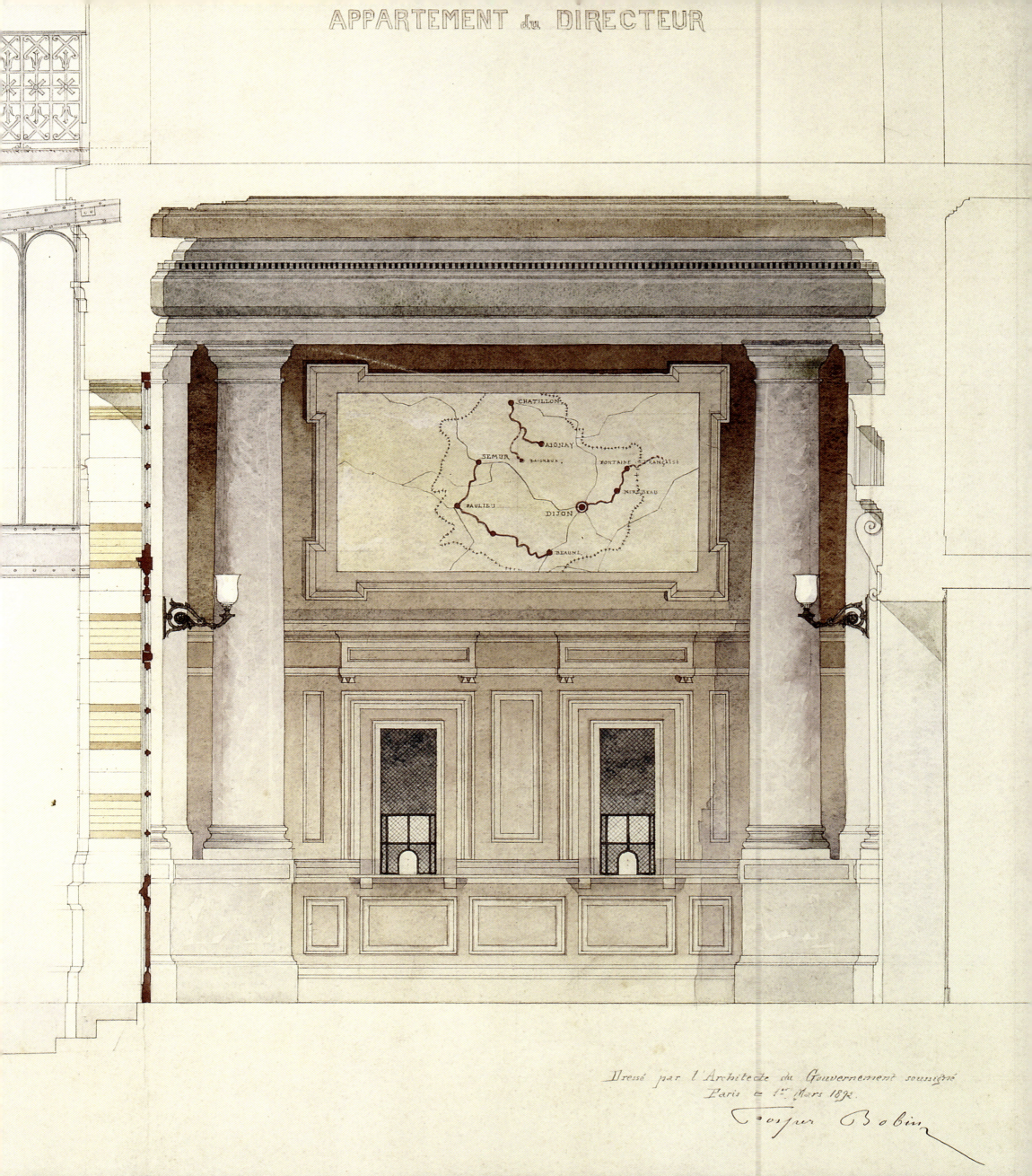

5
TRAIN STATIONS

1987.51

5.1

ARTIST: ALFRED DELOUVRIER
(FRENCH, DATES UNKNOWN)

1987.51: Drawing of the 'Antée'
locomotive, 1901

Pencil, ink, watercolor. 32¾ × 49½ in. (83.2 × 125.7 cm)
INSCRIBED *ANTEE. / LOCOMOTIVE / Firmy le 16 Aout 1901
Alfred Delouvrier*
PROVENANCE unknown

🔥 The legendary Antée train engine was introduced by the Batignolles-based atelier Ernest Gouin et Cie in 1849, for the Saint Germain Railway. Its fame led to its becoming the model for a children's train set.

256 PETER MAY COLLECTION I

5.2

PROSPER ETIENNE BOBIN
(FRENCH, 1844–1923)

1988.107a–d: Presentation drawings of the tram station in Dijon, France: plan and three elevations, 1892

Pencil, ink, watercolor

1988.107a: Plan. 50¾ × 36½ in. (128.9 × 92.7 cm)
INSCRIBED CHEMINS DE FER DU SUD DE LA FRANCE / RÉSEAU DE LA CÔTE D'OR / GARE CENTRALE DE DIJON / PLAN / AUX REZ-DE-CHAUSSEE: SERVICE du PUBLIC ET ADMINISTRATION – BUREAUX DANS LA PARTIE ENTRESOLÉE SUR JARDIN ET PAN COUPÉ – AU PREMIER ÉTAGE: APPARTEMENT DE LA DIRECTION – AU 2E ÉTAGE: BUREAUX – / [and architectural measurements] / BOULEVARD SÉVIGNÉ / GRAND HALL VITRÉ DU PUBLIC / VESTIBULE DU PUBLIC / Administration / Billets / Salles d'attente / SERVICE DES BILLETS / [2×] Guichet / BAGAGES / CONSIGNE / Abri pour les bagages / ENTRÉE SPÉCIALE POUR LE DIRECTEUR / Escalier du Directeur / TÉLÉPHONES / BUREAU DU DIRECTEUR / SALLE D'ATTENTE / CHEF DE CUREAU / SOUS-CHEF / Escalier du Bureaux / SALLE D'ATTENTE DES 2E CLASSE / SALLE D'ATTENTE DES 1E CLASSE / PASSAGE DES WATER-CLOSETS / JARDIN du DIRECTEUR / Lavabo / DAMES / HOMMES / BUANDERIE / [and additional minor inscription]
STAMPED PROSPER BOBIN / Architecte du Gouvernement et de la cie des Chemins de fer du Sud de la France / 14 Rue Le Verrier

1988.107b: Frontal façade. 23¾ × 33½ in. (60.3 × 85 cm)
INSCRIBED CHEMINS DE FER DU SUD / RÉSEAU DE LA CÔTE D'OR. – GARE CENTRALE DE DIJON / FAÇADE / Dressé par l'architecte du Gouvernement soussigné 1er Mars 1892 / Prosper Bobin / [architectural measurements]

1988.107c: Cross-section. 24½ × 37 in. (63.2 × 93.9 cm)
INSCRIBED CHEMINS DE FER DU SUD DE LA FRANCE / GARE CENTRALE DE DIJON / COUPE SUR LE GRAND HALL ET LE VESTIBULE / APARTEMENT du DIRECTEUR / ABRI DES VOITURES / ABRI DES VOYAGEURS / Axe de la Voie / [architectural measurements] / Dressé par l'architecte du Gouvernement soussigné / Paris le 1er Mars 1892 / Prosper Bobin
STAMPED PROSPER BOBIN / Architecte du Gouvernement et de la cie des Chemins de fer du Sud de la France / 14 Rue Le Verrier

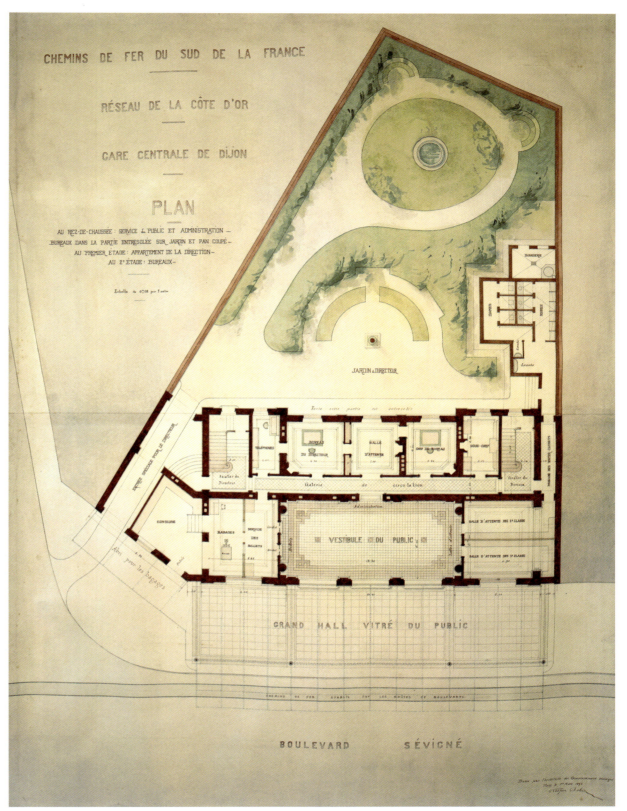

1988.107a

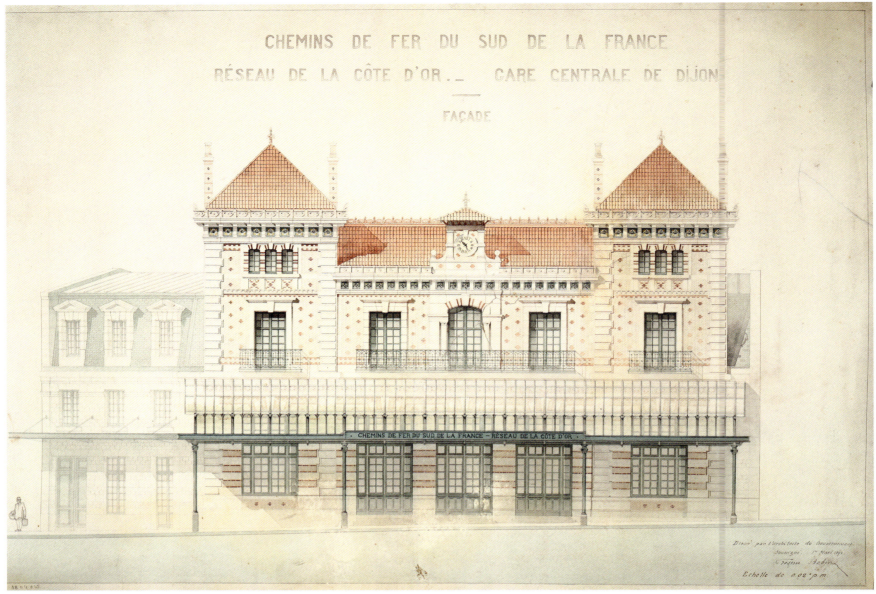

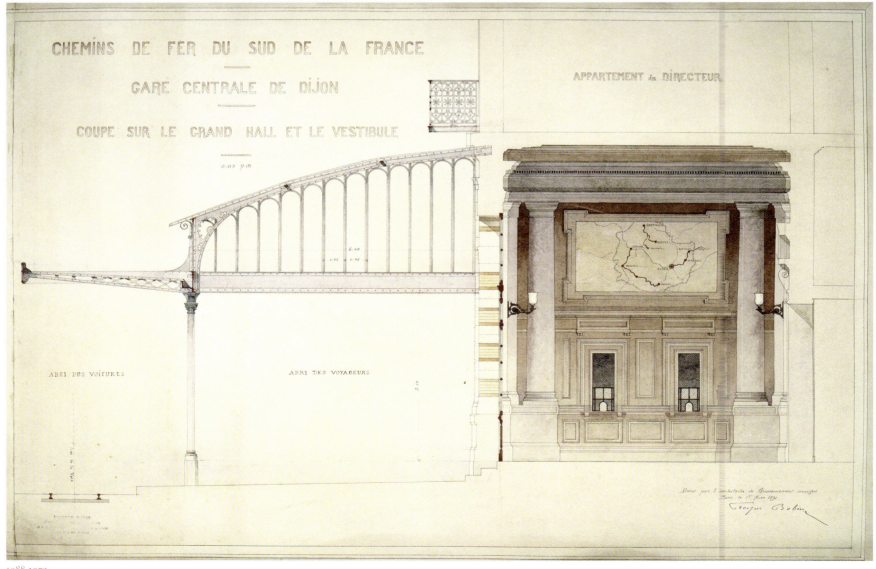

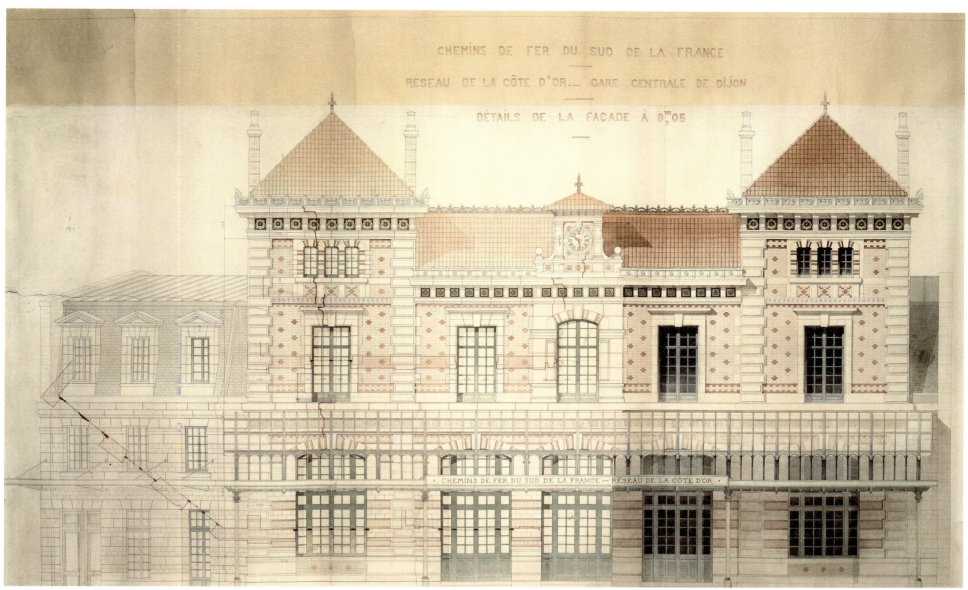

1988.107d

1988.107d: Exterior elevation and profile. 46 × 73¾ in. (116.8 × 187.3 cm)
INSCRIBED *RÉSEAU DE LA CÔTE D'OR – GARE CENTRALE DE DIJON / DÉTAILS DE LA FAÇADE* [architectural measurements] / [on glazed walkway] – *CHEMINS DE FER DU SUD DE LA FRANCE – RÉSEAU DE LA CÔTE D'OR –* / [architectural measurements]

PROVENANCE unknown

🌿 Described in *La Construction Moderne*, 18 June 1892, p. 435; a portion of 1988.107d printed on pl. 36bis.

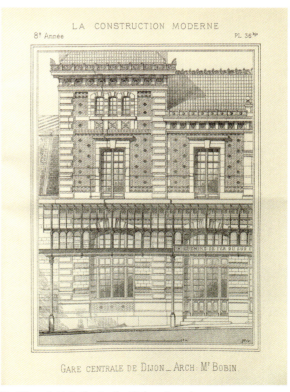

Paul Planat (ed.), *La Construction Moderne, Journal Hebdomadaire Illustré*, 18 June 1892, pl. 36bis.

TRAIN STATIONS 259

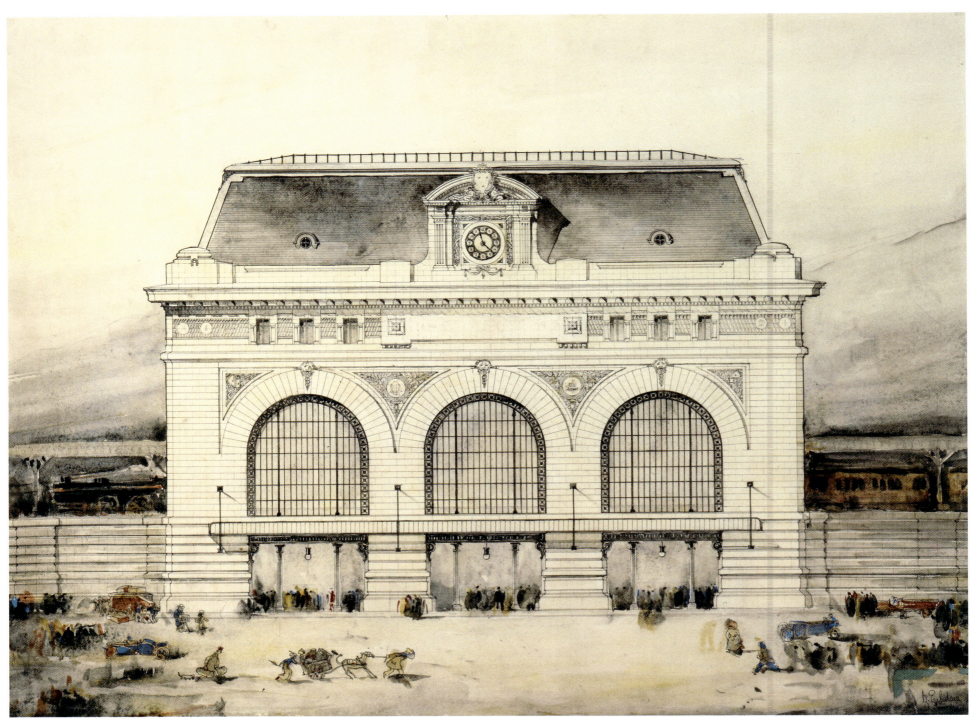

1987.8

5.3

BERNARD TABUTEAU
(FRENCH, 1892–1977)

1987.8: Competition drawing for
a train station, 1913

Pencil, ink, watercolor. 27½ × 36¾ in. (69.9 × 93.4 cm)
INSCRIBED [in ink] *B. Tabuteau at. Senès Marseille*
STAMPED [indistinct] 1913
PROVENANCE unknown

5.4

PROSPER ETIENNE BOBIN
(FRENCH, 1844–1923)

1988.104a–g: Presentation drawings for the train station in Nice, France, 1892–93

Pencil, ink, watercolor

1988.104a: Frontal elevation. 70½ × 53 in. (179.1 × 134.6 cm)
INSCRIBED [on entablature] *CHEMINS DE FER DU SUD DE LA FRANCE* / [above entrance] *ANNEE 1892*

1988.104b: Cross-sections. 46¼ × 28½ in. (117.5 × 72.4 cm)
INSCRIBED *CHEMINS DE FER DU SUD DE LA FRANCE / GARE DE NICE / COUPE TRANSVERSALE / COUPE SUR LA LONGUEUR DU VESTIBULE* / [in red ink] *Dressé par l'Architecte des Batiments civils et de la Compagnie des Chemins de Fer du Sud de la France soussigné / Paris le 23 Fevrier 1893* / [in black ink] *Prosper Bobin* / [architectural measurements]
STAMPED *PROSPER BOBIN / Architecte du Gouvernement et de la cie des Chemins de fer du Sud de la France / 14 Rue Le Verrier*

1988.104c: Frontal elevation. 32.5 × 67 in. (82.6 × 170.2 cm)
INSCRIBED *CHEMINS DE FER DU SUD DE LA FRANCE / GARE DE NICE / FAÇADE PRINCIPALE SUIVANT L'ÉXÉCUTION* / [in red ink] *Dressé par l'Architecte des Batiments civils et de la Compagnie des Chemins de Fer du Sud de la France soussigné / Paris le 23 Fevrier 1893* / [in black ink] *Prosper Bobin*
STAMPED *PROSPER BOBIN / Architecte du Gouvernement et de la cie des Chemins de fer du Sud de la France / 14 Rue Le Verrier*

1988.104d: Plan. 35¾ × 47½ in. (90.8 × 120.7 cm)
INSCRIBED *CHEMINS DE FER DU SUD DE LA FRANCE / GARE DE NICE / PLAN DU REZ-DE-CHAUSSÉE / COUR DE DÉPART DES VOYAGEURS / VESTIBULE DU PUBLIC / SF / SALLE DES BAGAGES / INSPECTEUR DE L'EXPLOITATION / SALLE D'ATTENTE DES 1ERS CLASSES / ENTRÉE / SALLE D'ATTENTE DES 2MES CLASSES / ANTICHAMBRE / BUREAU DU DIRECTEUR / CHAMBRE / CHAMBRE / GRAND HALL / QUAI DE DÉPART / QUAI D'ARRIVÉE / Bascule / CHEF DE GARE / PASSAGE / BUREAU DES BAGAGES / TÉLÉGRAPHE ET EMPLOYÉS / CONSIGNE / ARCHIVES / BILLETS / COMMISSAIRE DE SURVEILLANCE* / [in red ink] *Dressé par l'Architecte des Batiments civils et de la Compagnie des Chemins de Fer du Sud de la France soussigné / Paris le 23 Fevrier 1893* / [in black ink] *Prosper Bobin* / [architectural measurements]
STAMPED *PROSPER BOBIN / Architecte du Gouvernement et de la cie des Chemins de fer du Sud de la France / 14 Rue Le Verrier*

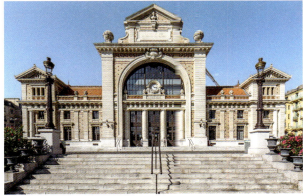
La Gare du Sud, Nice

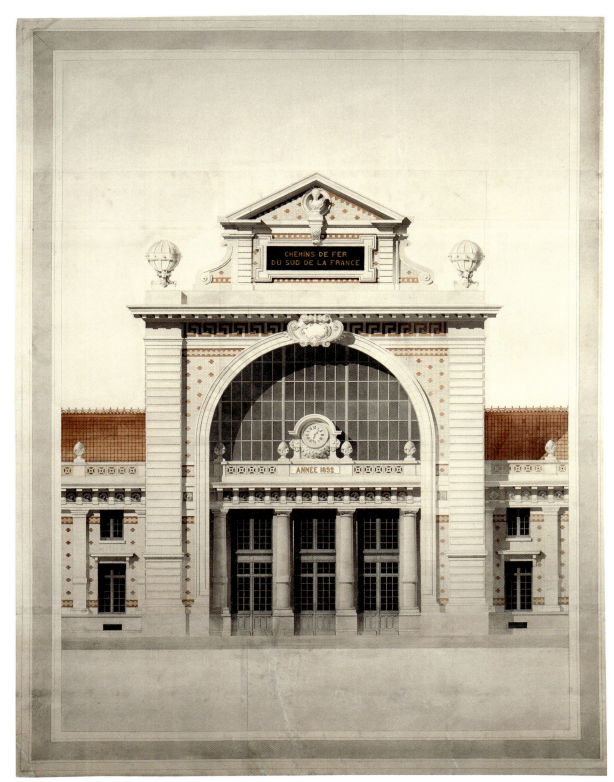
1988.104a

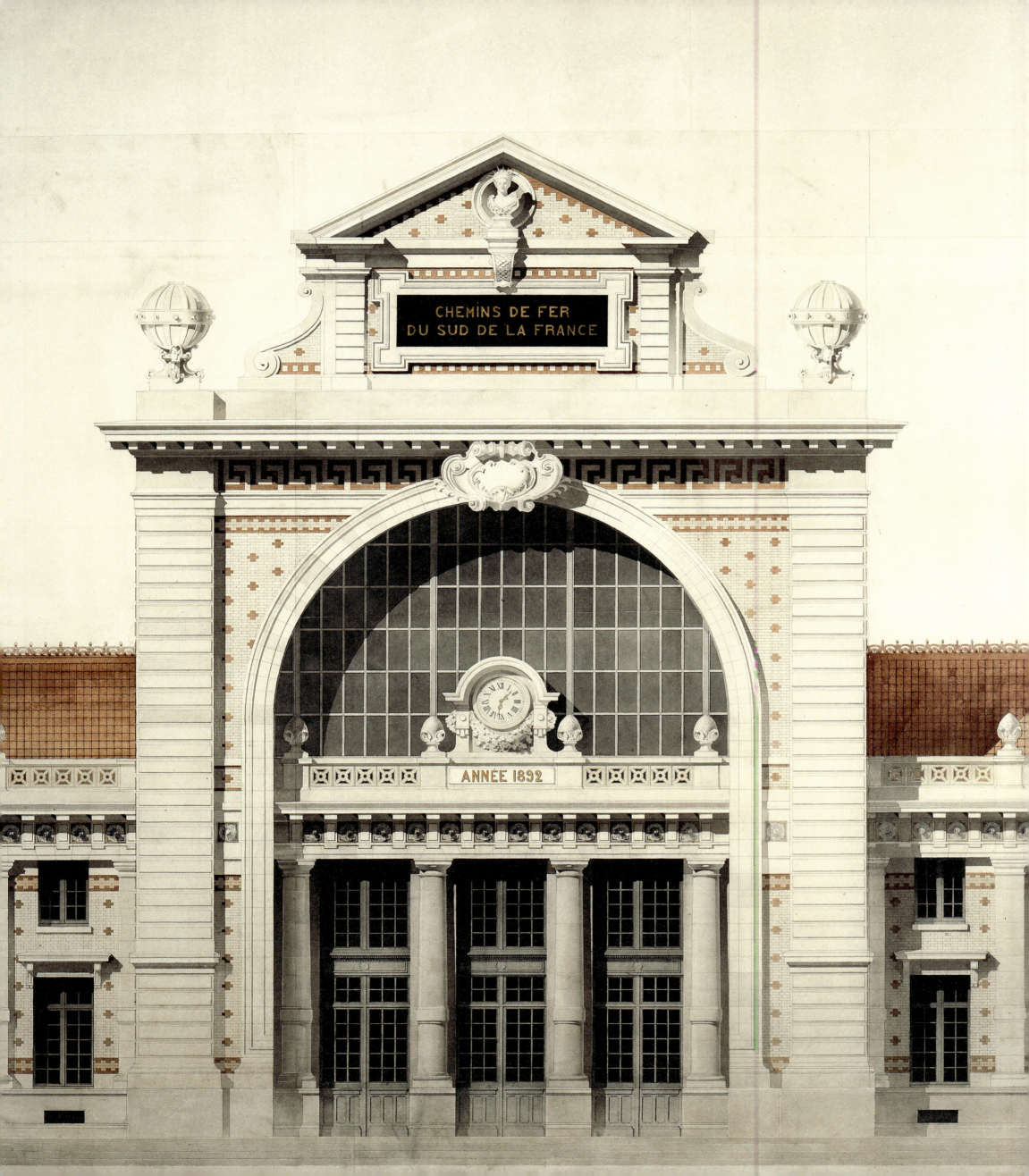

1988.104e: Plan. 42¾ × 30¼ in. (108.6 × 76.8 cm)
INSCRIBED *CHEMINS DE FER DU SUD DE LA FRANCE / GARE DE NICE / PLAN GÉNÉRAL / AVENUE DE LA GARE PROLONGÉE / COUR DE DÉPART DES VOYAGEURS / COUR D'ARRIVEE DES VOYAGEURS / GRAND HALL VITRÉ POUR LES TRAINS / RUE NOUVELLE / Cour des Marchandises / Hall aux Marchandises / [3×] Abri p. Expéditions / Quai de Départ des Voyageurs / Quai d'Arrivée des Voyageurs / [2×] Consigne / Billets / Archives / Salle d'Attente / Distribution des Bagages / Lampisterie / W.C. & Urinales / Chef de Gare / Buvette / Cuisine / Buffet / Terrasse / Salle du Bagages / Passage / Bureau des Bagages / Inspecteur de l'Exploitation / Attende des 2e. Classes / 1e. Classes / [2×] Chambre / Antichambre / Commisaire de Surveillance / Bureau du Directeur / Grand Vestibule du Public / Telegraphe et Employes /* [in red ink] *Dressé par l'Architecte des Batiments civils / et de la Compagnie des Chemins de fer du Sud de la France soussigné / Paris le 23 Fevrier 1893 /* [in black ink] *Prosper Bobin*
STAMPED *PROSPER BOBIN / Architecte du Gouvernement et de la cie des Chemins de fer du Sud de la France / 14 Rue Le Verrier*

1988.104f: Elevation. 31½ × 27¾ in. (80 × 70.5 cm)
INSCRIBED *CHEMINS DE FER DU SUD DE LA FRANCE / GARE DE NICE / FAÇADE LATÉRALE /* [in red ink] *Dressé par l'Architecte des Batiments civils / et de la Compagnie des Chemins de Fer du Sud de la France soussigné / Paris le 23 Fevrier 1893 /* [in black ink] *Prosper Bobin*
STAMPED *PROSPER BOBIN / Architecte du Gouvernement et de la cie des Chemins de fer du Sud de la France / 14 Rue Le Verrier*

1988.104g: Perspective. 28½ × 21¾ in. (72.3 × 55.2 cm) Pencil and watercolor. Inscribed [in pencil and watercolor] *CHEMINS DE FER DU SUD DE LA FRANCE / VUE PERSPECTIVE DE LA GARE DE NICE / PROSPER BOBIN Architecte du Gouvernement* [indistinct]

PROVENANCE unknown

❦ A metal and glass train shed was designed by Gustave Eiffel for the Russian and Austro-Hungarian Pavilion at the 1889 Paris Exposition Universelle and relocated to Nice in 1891. The station was closed in 1991, listed as an historic monument in 2002, and in recent years restored and repurposed as a public space.

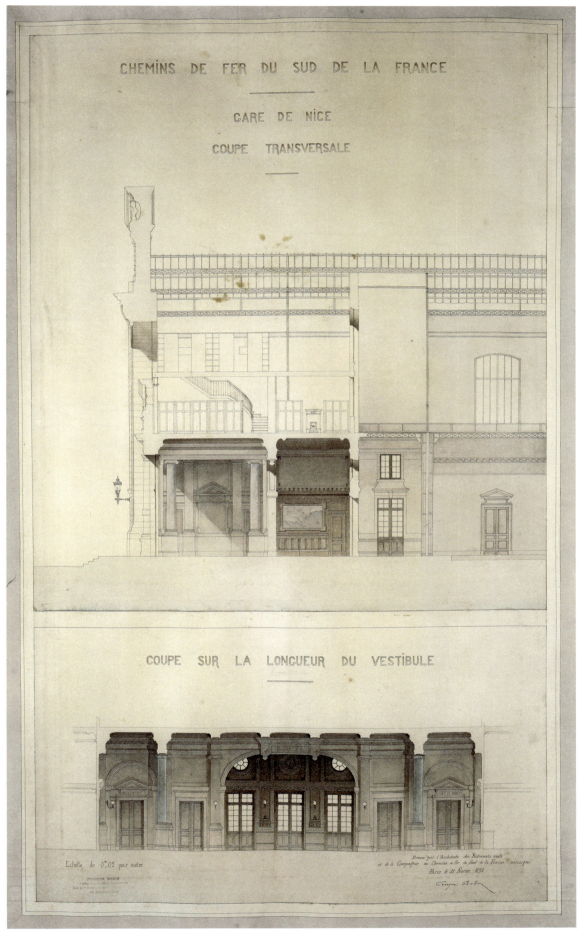

1988.104b

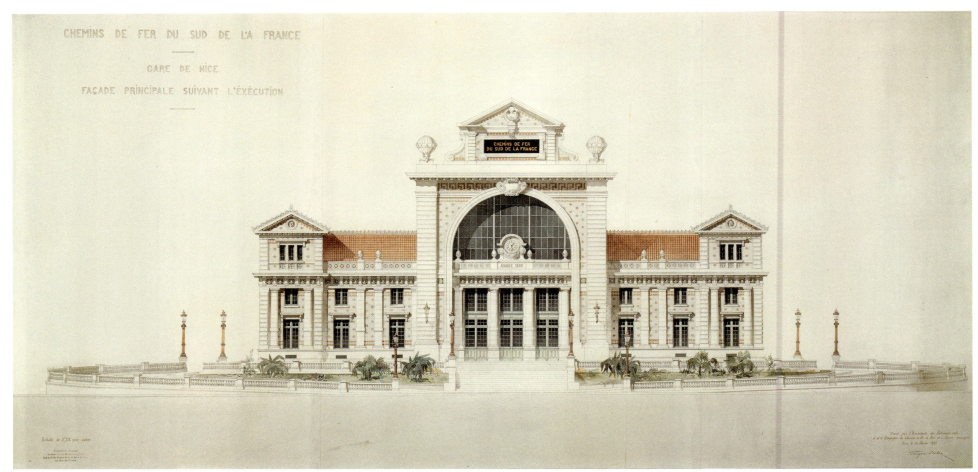

1988.104c

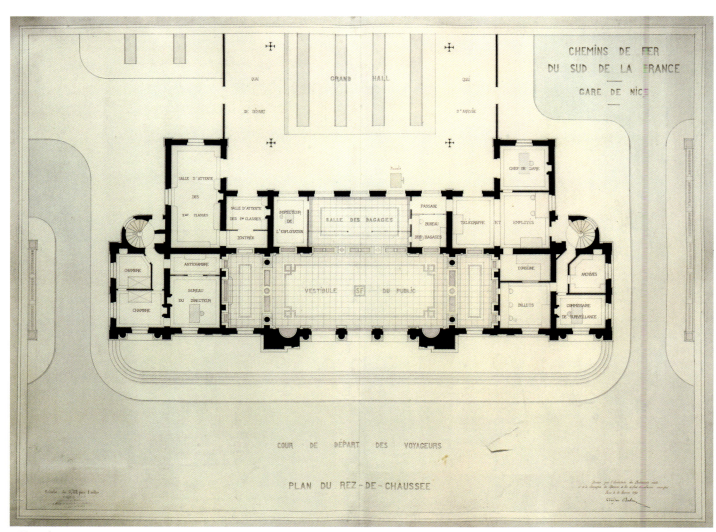

1988.104d

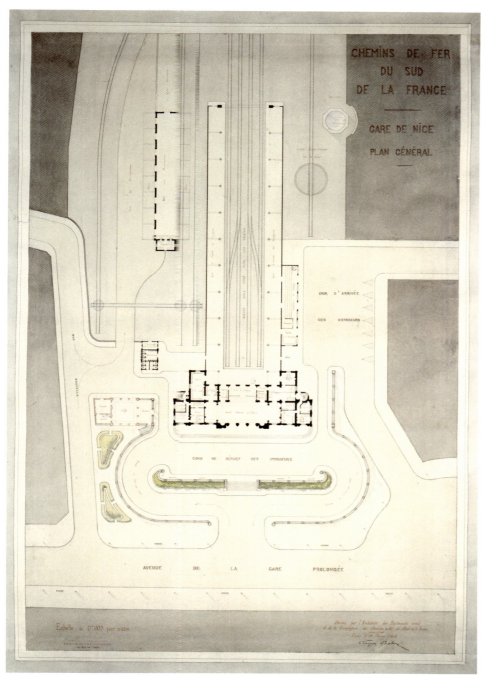

1988.104e

1988.104f

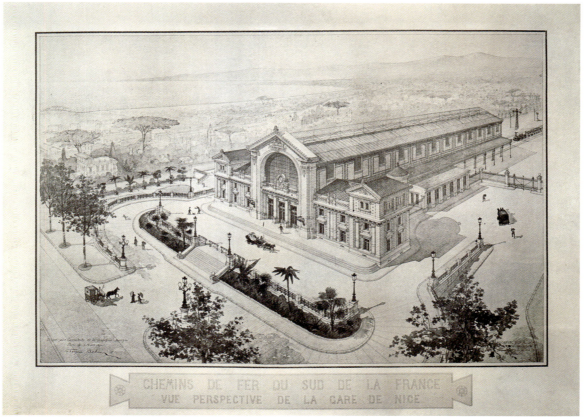

1988.104g

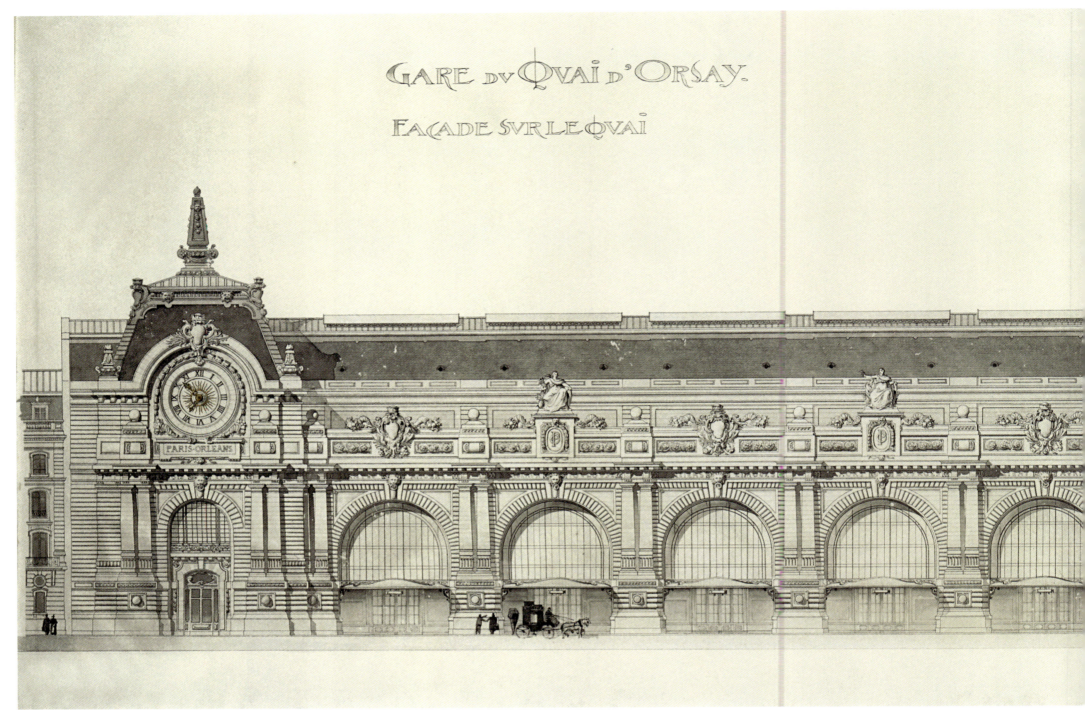

5.5

ALEXANDRE VICTOR LALOUX
(FRENCH, 1850–1937)

2000.459: Elevation drawing of the
Gare d'Orsay, Paris, 1898–1900

Pencil, Ink, watercolor. 46 3/8 × 75 5/8 in. (67 × 192.1 cm)
INSCRIBED *GARE DU QUAI D'ORSAY / FAÇADE SUR LE QUAI* / [2×] *PARIS – ORLEANS* / [2 × cipher] *PO* [Paris Orleans] / [architectural measurements]
PROVENANCE Alain Cambon, Paris

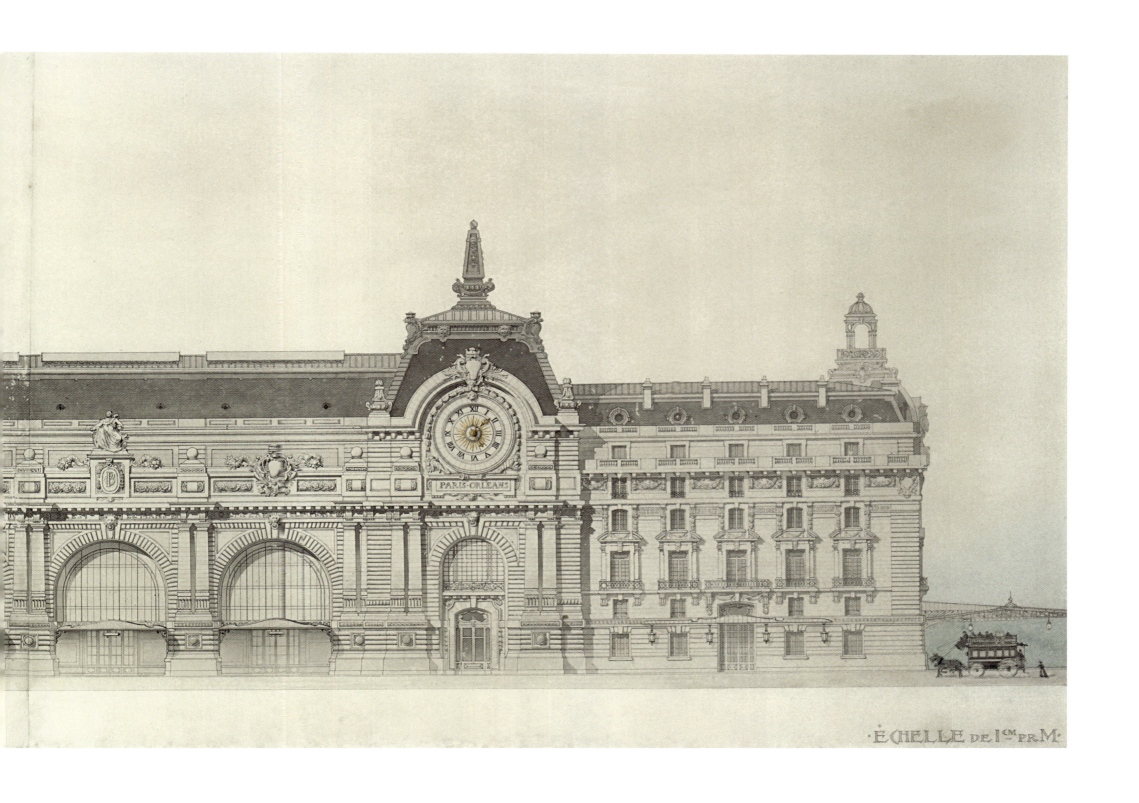

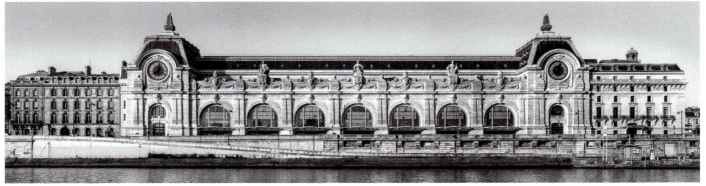

Gare d'Orsay, Paris

TRAIN STATIONS

5.6

ARCHITECT UNKNOWN (FRENCH)

1991.380: Competition drawing for a Paris train station: frontal elevation, ca. 1900

Pencil, ink, watercolor. 15 × 39¾ in. (38 × 101 cm)
PROVENANCE Galerie Gasnier-Kamien, Paris

5.7

ARCHITECT UNKNOWN (FRENCH)

1989.173: Competition drawing for a Paris train station: frontal elevation, ca. 1900

Pencil, ink, watercolor. 12 × 39 in. (30.5 × 99.1 cm)
INSCRIBED [on entablature left] *CHEMIN DE FER DE PARIS – STRASBOURG – BERLIN – VIENNE* [on entablature right] *CHEMIN DE FER DE FANTIN – ASNIERES – BOIS-DE-MEUDON – SEVRES*
PROVENANCE unknown

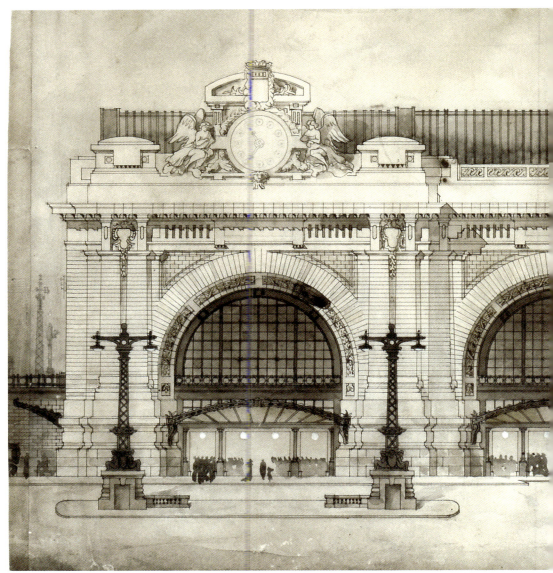

1991.380

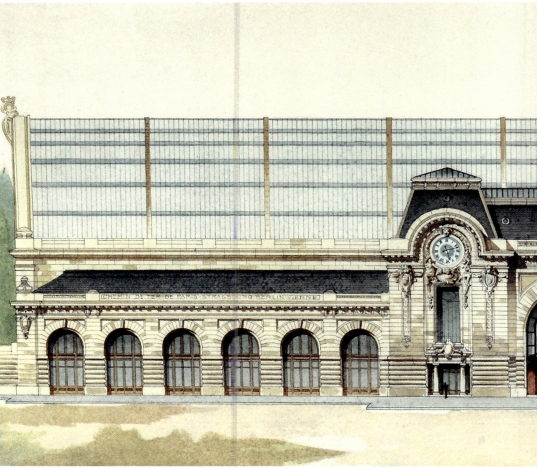

1989.173

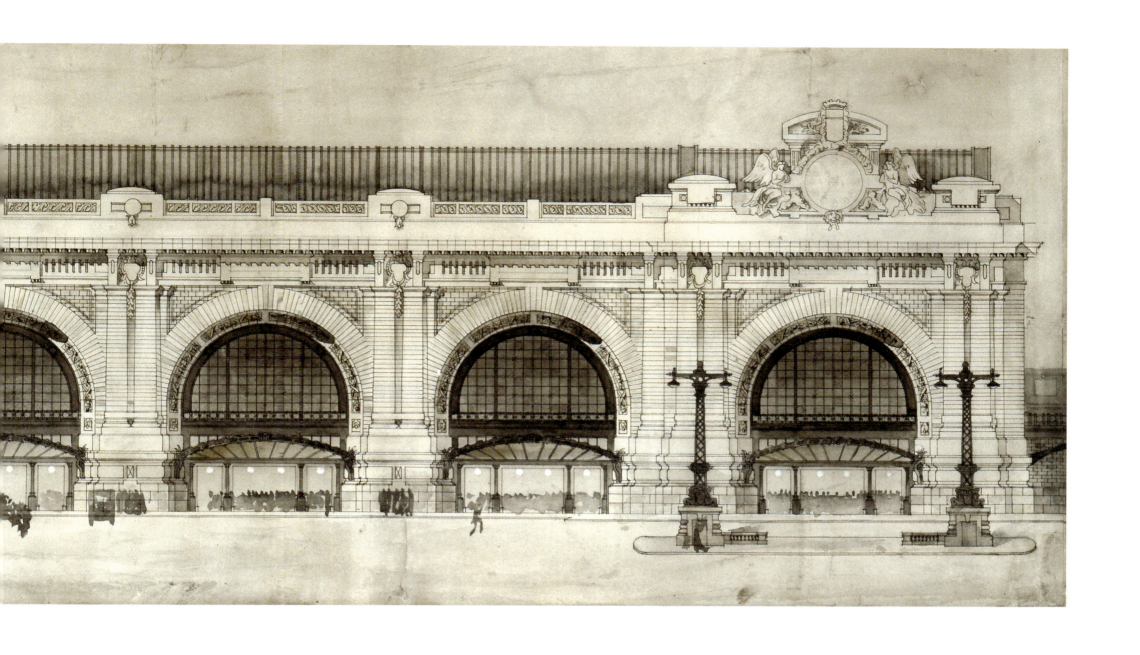

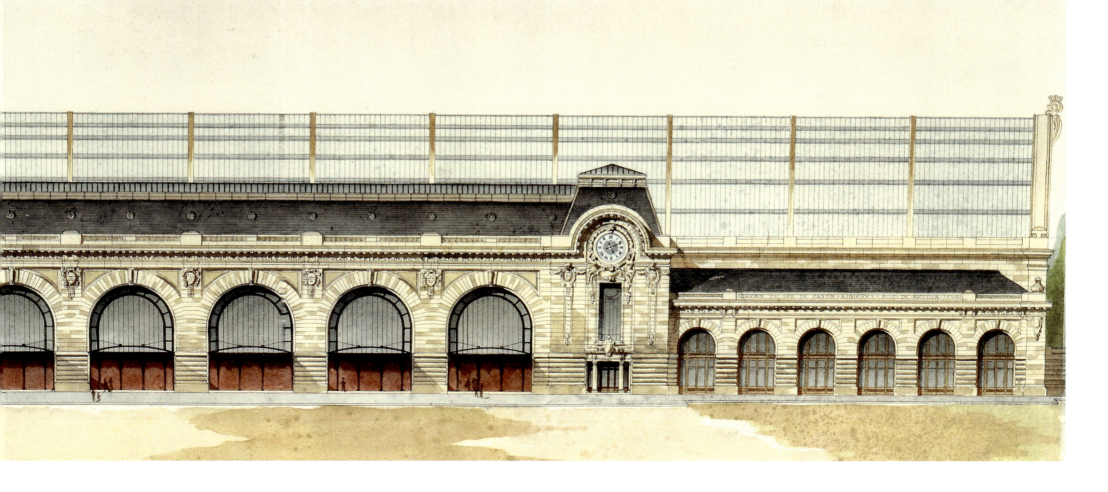

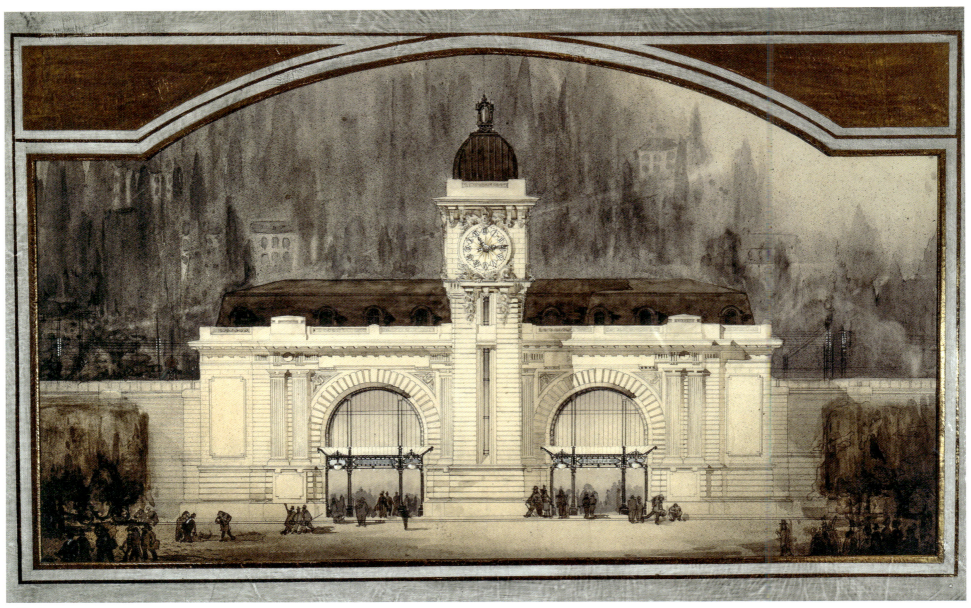

1988.126

5.8

ARCHITECT UNKNOWN (FRENCH)

1988.126: Competition drawing for a train station: frontal elevation, ca. 1900

Pencil, ink, watercolor, metallic tape. 27½ × 43½ in. (69.9 × 110.5 cm)
PROVENANCE unknown

5.9

LUCIEN-LEON WOOG
(FRENCH, 1867–1937)

1987.147: Competition drawing for a train station waiting room: two interior elevations, ca. 1890

Pencil, ink, watercolor. 18½ in × 24¼ in. (47 × 61.6 cm)
INSCRIBED *PROJET DE SALLE D'ATTENTE de Chemin de Fer / LWoog*
PROVENANCE unknown

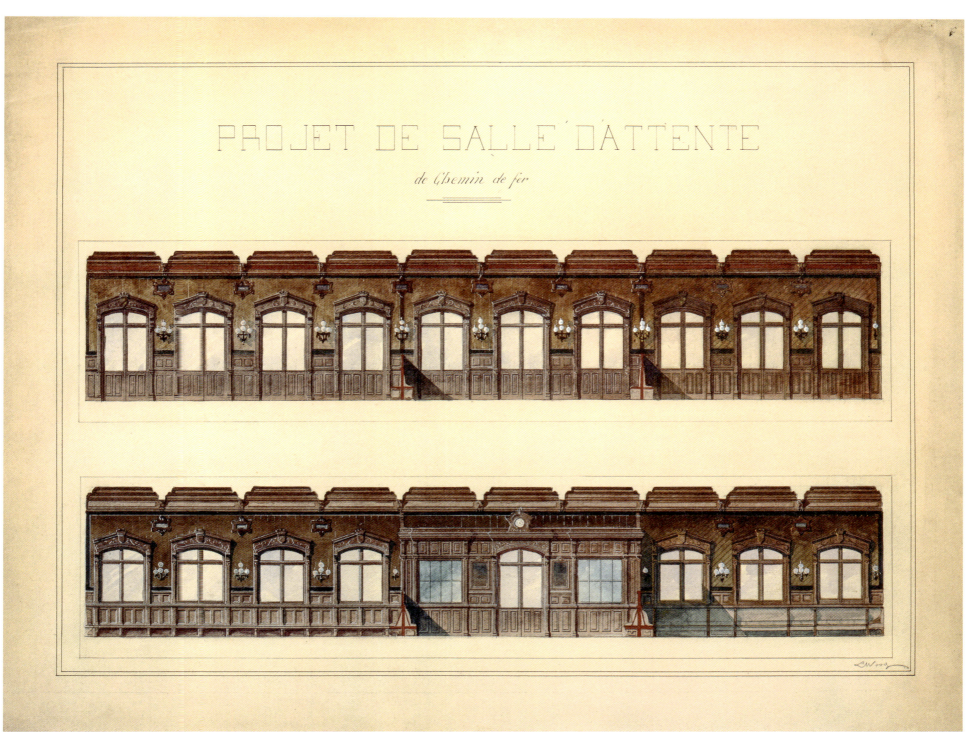

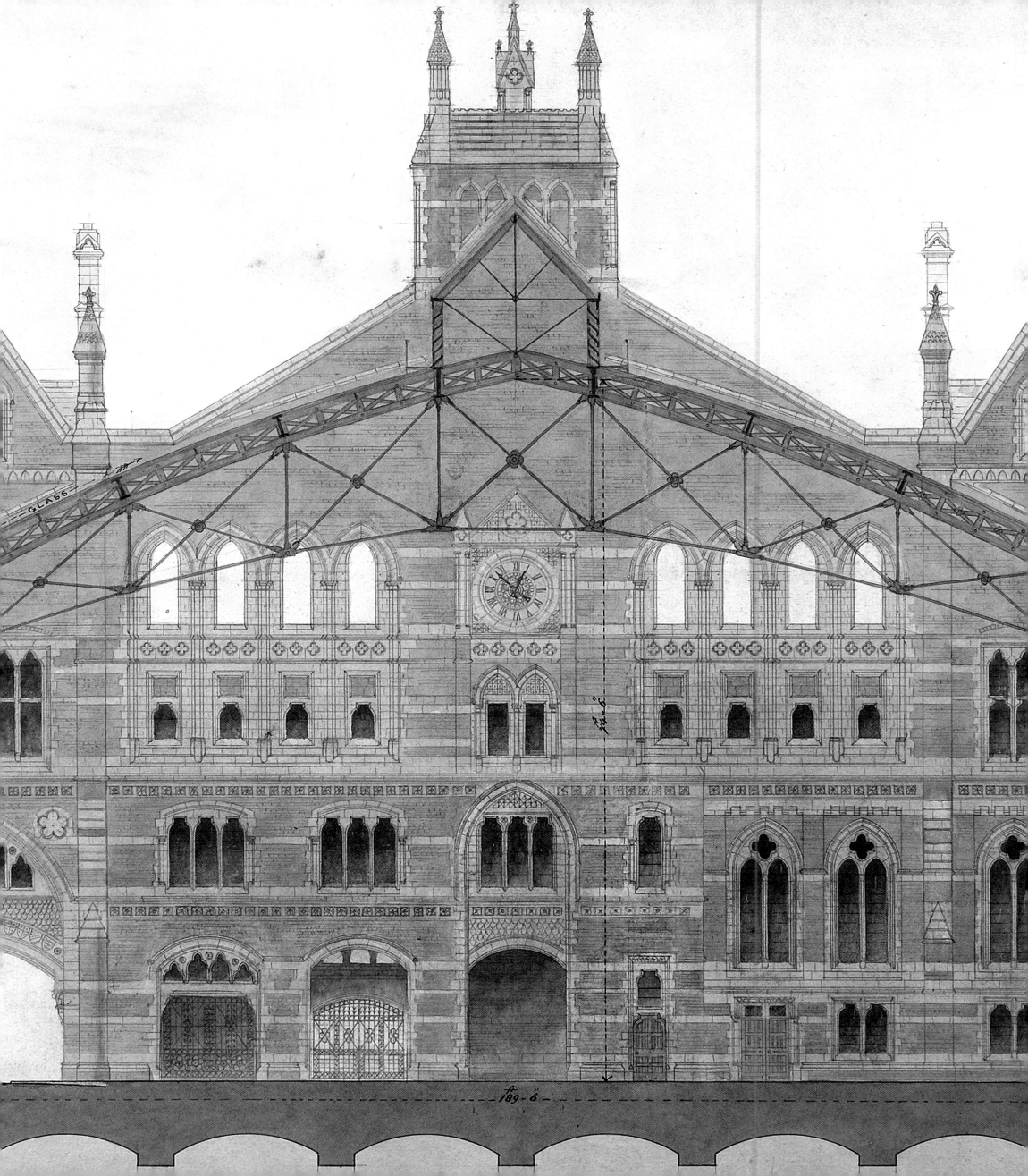

5.10

ARCHITECT UNKNOWN (BRITISH)

2000.517a–d: Competition drawings for a London train station: plan, cross-section and two elevations, 1869–70

Pencil, ink, wash

2000.517a: Plan. 24¼ × 38⅛ in. (61.6 × 96.8 cm) INSCRIBED – *SOANE – MEDALLION – COMPETITION – / – METROPOLITAN – RAILWAY – STATION – / – GROUND – PLAN – / Nº. 1 – / DEPARTURE PLATFORM FOR THROUGH TRAINS / DEPARTURE PLATFORMS FOR LOCAL TRAINS / ARRIVAL PLATFORM / CABS AND CARRIAGES / OUT PARCELS OFFICE / [2×] LIFT / [2×] ROOMS OVER SHOPS / [2×] STEPS LEADING TO THE BRIDGE / [2×] TOLL KEEPER / [2×] FIRE ENGINE AND WAY TO ROOF AND TANK / SHOP / REFRESHMENT ROOM / LAVATORY / [8×] WC / [2×] URINALS / GENERAL WAITING ROOM / LADIES 1ST. CLASS WAITING ROOM / TELEGRAPH OFFICE / LAVATORIES / [4×] WC / GENERAL BOOKING OFFICE / CLERKS / LADIES 2ND. CLASS WAITING ROOM / LAVATORIES / [4×] WC / LABELS / SPACE FOR WEIGHING LUGGAGE / LUGGAGE ENTRANCE / CLOAK ROOM / CAB AND CARRIAGE EXIT / CLERKS / EXCURSION AND SPECIAL BOOKS OFFICE / LADIES WAITING ROOM / WAITING ROOM / [4×] WC / LAVATORIES / POLICE / STATION INSPECTOR / REFRESHMENT ROOM / PORTERS / UNCLAIMED LUGGAGE / [2×] URINALS / LAVATORY / [8×] WC / [2×] ROOMS OVER SHOPS / IN PARCELS OFFICE / [2×] LIFT / BOOKING OFFICE FOR HORSES AND CARRIAGES / BOOK STALL / HORSE AND CARRIAGE ARRIVAL AND DEPARTURE / The rooms above this floor are intended to provide accommodation for Board and Committee Meetings, General Shareholders Meetings, Secretary and Assistant Secretary, Engineers, Receivers, Auditors &c &c with their accompanying offices.* / [architectural measurements]

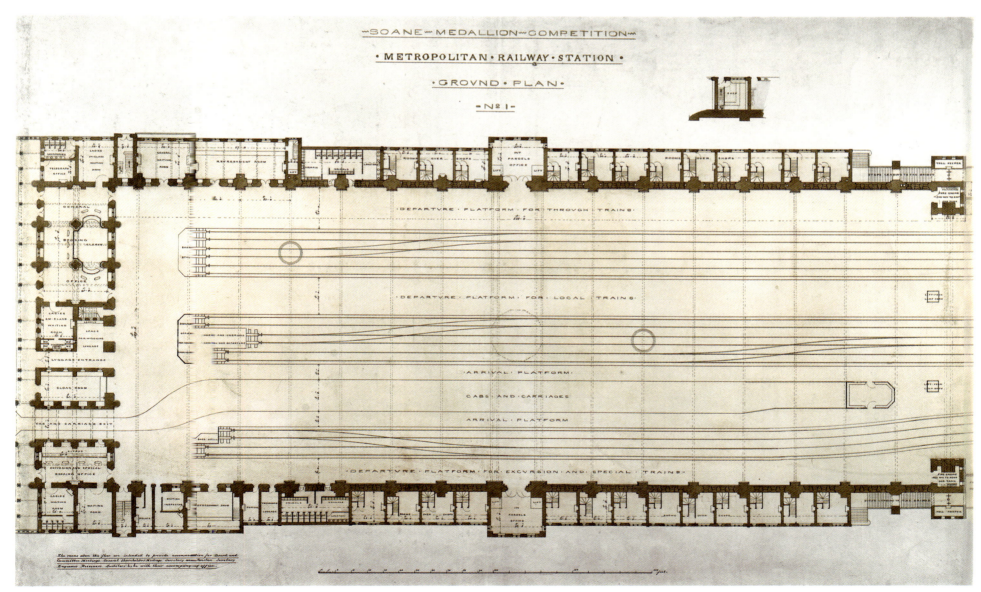

2000.517a

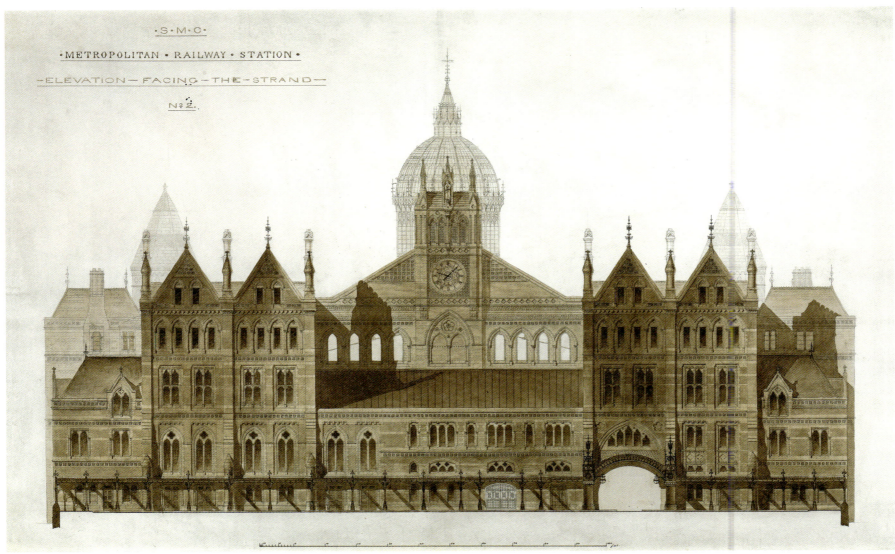

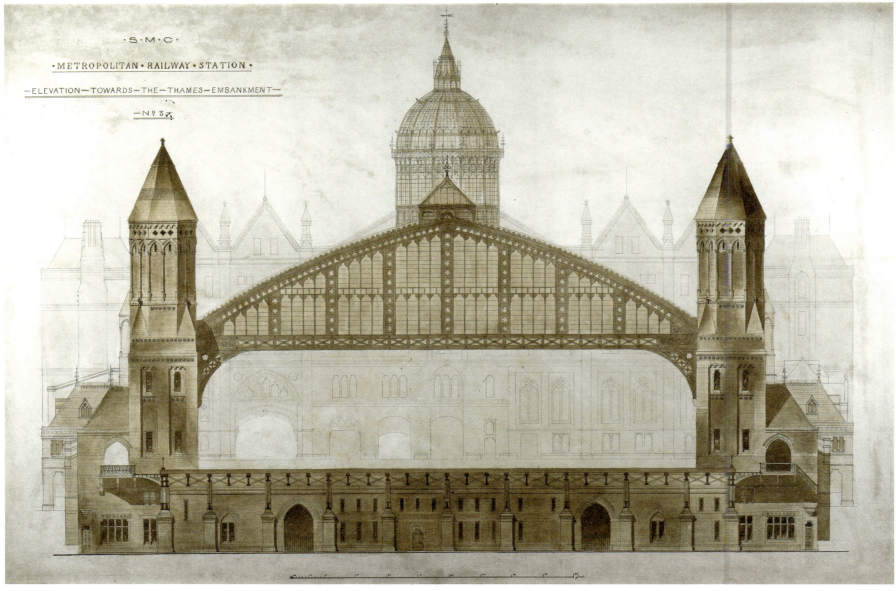

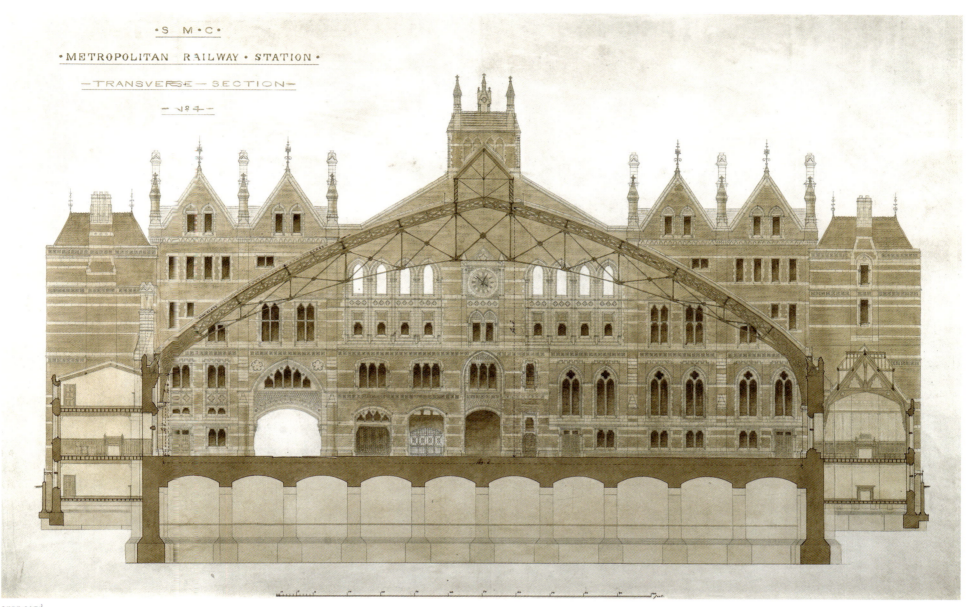

2000.517b: Elevation. 24⅝ × 37¾ in. (55.6 × 95 cm)
INSCRIBED – S – M – C – [Soane Medallion Competition] / METROPOLITAN – RAILWAY – STATION / – ELEVATION – FACING – THE – STRAND / Nº. 2. – / [architectural mesurements]

2000.517c: Elevation. 24⅝ × 37⅝ in. (55.6 × 95.6 cm)
INSCRIBED – S – M – C – / – METROPOLITAN – RAILWAY – STATION – / – ELEVATION – TOWARDS – THE – THAMES – EMBANKMENT / – Nº. 3 – / [architectural measurements]

2000.517d: Cross-section. 24½ × 38 in. (62.2 × 96.5 cm)
INSCRIBED – S – M – C – / – METROPOLITAN – RAILWAY – STATION / TRANSVERSE – SECTION – / Nº. 4. – / [architectural measurements]

PROVENANCE D. & R. Blissett, UK

According to the published papers read at The Royal Institute of British Architects, section 1869-69 (London, 1869), assignment for the 1869–70 £50 Soane Award for travel abroad was "A Metropolitan Railway Station of the dimensions of that at Charing Cross [John Harkshaw, 1864], showing the architectural treatment of the façade towards the Thames Embankment, and of the interior of the Terminus Shed, where the roof is required to be in one span. The Drawings to be in sepia or Indian ink: […] It will be deemed sufficient, if two plans (viz. of the platform and roof) with elevations, one section, one perspective view, and one sheet of details – in all 7 drawings – be supplied. […] The competition for the Soane Medallion is open to all Members of the profession under the age of Thirty years." The winner was Ernest C. Lee, whose device was "A Comma within a Circle."

TRAIN STATIONS

WEST ELEVATION.

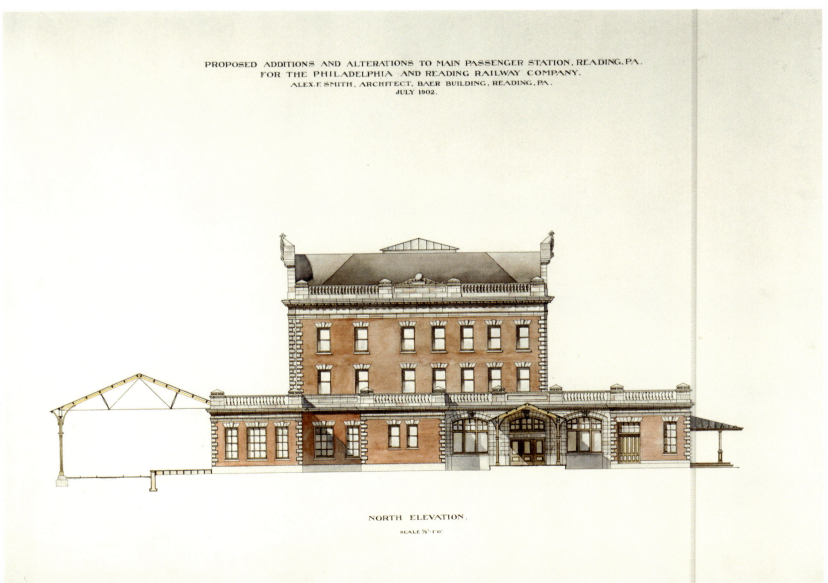

NORTH ELEVATION.

5.11

ALEX F. SMITH (AMERICAN, D. 1939)

1989.239a–h: Drawings for proposed additions and alterations to the main train station in Reading, Pennsylvania, 1902

Pencil, ink, wash

1989.239a: West elevation. 26 × 35 in. (66.0 × 91.4 cm), framed
INSCRIBED *PROPOSED ADDITIONS AND ALTERATIONS TO MAIN PASSENGER STATION, READING, PA. FOR THE PHILADELPHIA AND READING RAILWAY COMPANY. ALEX. F. SMITH, ARCHITECT, BAER BUILDING, READING, PA. JULY 1902. / PHILADELPHIA & READING – RAILWAY COMPANY – / WEST ELEVATION /* [architectural measurements]

1989.239b: North elevation. 25 × 35 in. (63.5 × 88.9 cm), framed
INSCRIBED *PROPOSED ADDITIONS AND ALTERATIONS TO MAIN PASSENGER STATION, READING, PA. FOR THE PHILADELPHIA AND READING RAILWAY COMPANY. ALEX. F. SMITH, ARCHITECT, BAER BUILDING, READING, PA. JULY 1902 / WAITING ROOM / NORTH ELEVATION /* [architectural measurements]

1989.239c: Cross-section. 26 × 35 in. (66.0 × 88.9 cm), framed
INSCRIBED *PROPOSED ADDITIONS AND ALTERATIONS TO MAIN PASSENGER STATION, READING, PA. FOR THE PHILADELPHIA AND READING RAILWAY COMPANY. ALEX. F. SMITH, ARCHITECT, BAER BUILDING, READING, PA. JULY 1902 / TRAINS / CROSS SECTION /* [architectural measurements]

1989.239d: Cross-section. 26 × 34 in. (66.0 × 86.4 cm), framed
INSCRIBED *PROPOSED ADDITIONS AND ALTERATIONS TO MAIN PASSENGER STATION, READING, PA. FOR THE PHILADELPHIA AND READING RAILWAY COMPANY. ALEX. F. SMITH, ARCHITECT, BAER BUILDING, READING, PA. JULY 1902 / EXPRESS / EXIT / TICKETS / EXIT / BAGGAGE / LONGITUDINAL SECTION /* [architectural measurements]

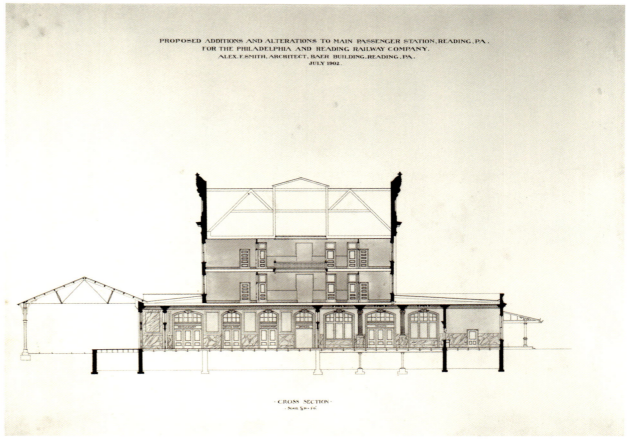

1989.239c

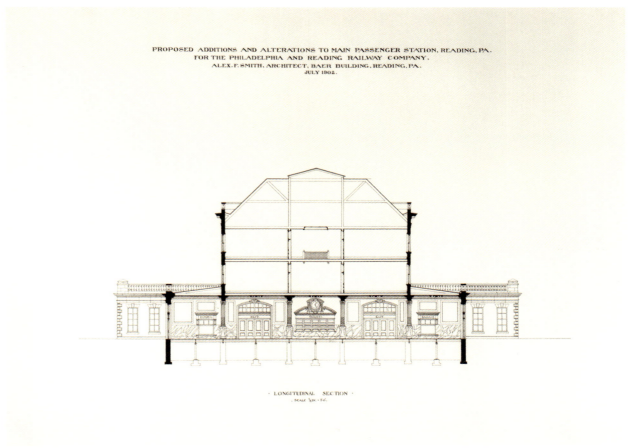

1989.239d

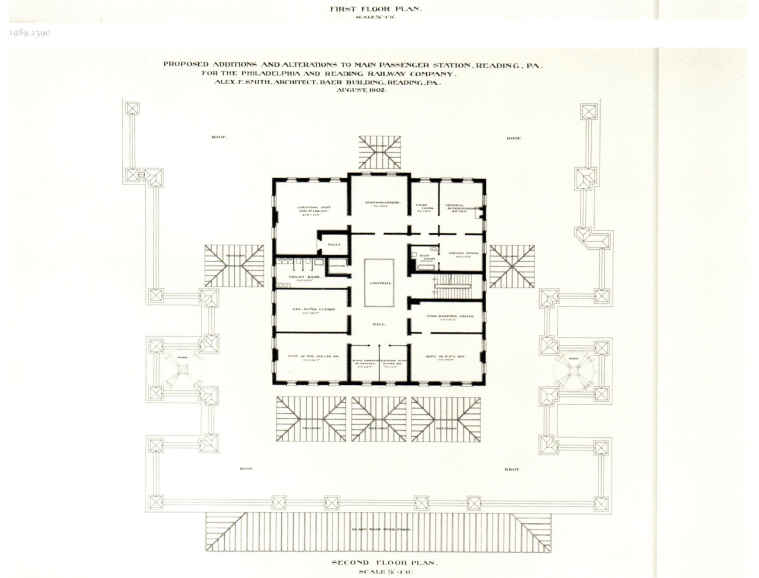

1989.239e: Plan. 27 × 36 in. (68.6 × 91.4 cm), framed
INSCRIBED *PROPOSED ADDITIONS AND ALTERATIONS TO MAIN PASSENGER STATION, READING, PA. FOR THE PHILADELPHIA AND READING RAILWAY COMPANY. ALEX. F. SMITH, ARCHITECT, BAER BUILDING, READING, PA. JULY 1902*

1989.239f: Plan. 27 × 36 in. (68.6 × 91.4 cm), framed
INSCRIBED *PROPOSED ADDITIONS AND ALTERATIONS TO MAIN PASSENGER STATION, READING, PA. FOR THE PHILADELPHIA AND READING RAILWAY COMPANY. ALEX. F. SMITH, ARCHITECT, BAER BUILDING, READING, PA. JULY 1902*

1989.239g: Plan. 24 × 34 in. (60.1 × 86.4 cm), framed
INSCRIBED *PROPOSED ADDITIONS AND ALTERATIONS TO MAIN PASSENGER STATION, READING, PA. FOR THE PHILADELPHIA AND READING RAILWAY COMPANY. ALEX. F. SMITH, ARCHITECT, BAER BUILDING, READING, PA. JULY 1902*

1989.239h: Perspective. 23 × 36 in. (63.5 × 91.4 cm), framed
INSCRIBED *PERSPECTIVE SHOWING PROPOSED ADDITIONS AND ALTERATIONS TO MAIN PASSENGER STATION, READING, PENNA. FOR THE PHILADELPHIA & READING RAILWAY COMPANY. ALEX. F. SMITH, ARCHITECT, BAER BUILDING, READING, PA. JULY 1902*

PROVENANCE Stubbs Books & Prints, New York

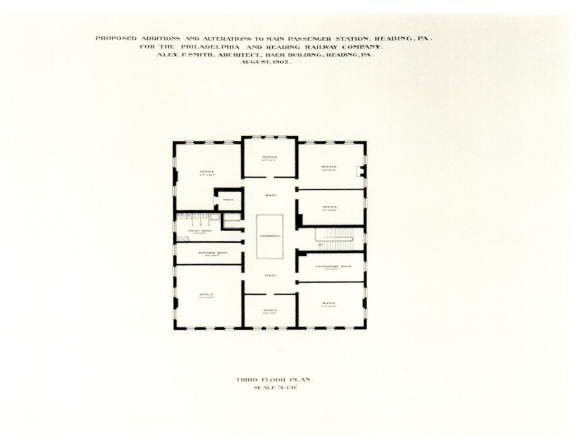

1989.239g

1989.239h

TRAIN STATIONS 279

6
HOTELS AND SPAS

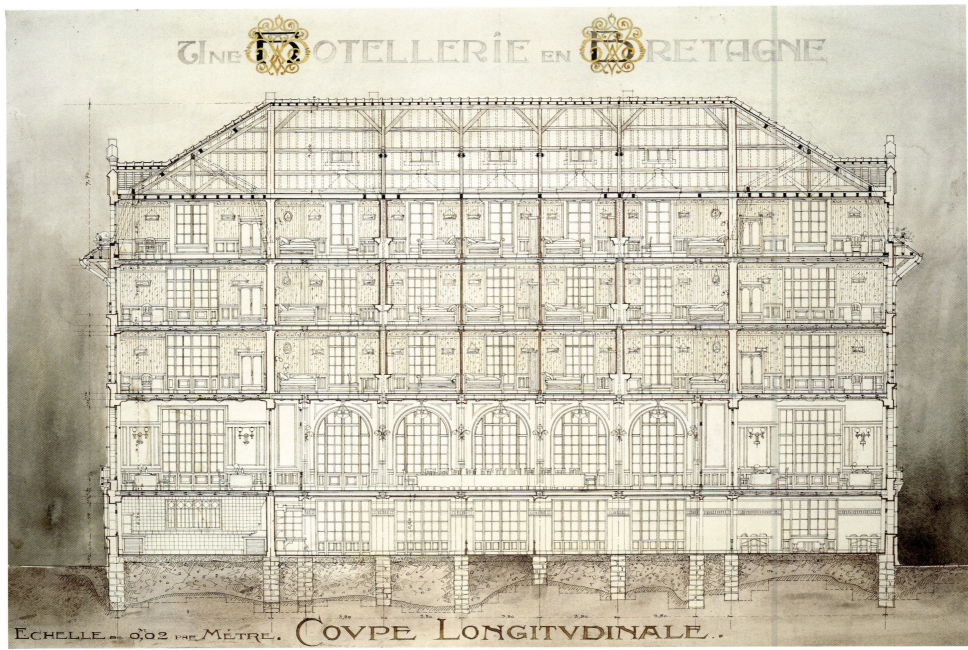

6.1

ARCHITECT UNKNOWN (FRENCH)

1988.103a,b: Competition drawings for a hotel in Brittany, France: two cross-sections, ca. 1900

Pencil, ink, watercolor

1988.103a: Longitudinal section. 26¾ × 39¾ in. (68 × 101 cm)
INSCRIBED *UNE HOTELLERIE EN BRETAGNE / . COUPE LONGITUDINALE /* [architectural measurements]

1988.103b: Transverse section. 24⅞ × 38 in. (63.2 × 96.5 cm)
INSCRIBED *UNE HOTELLERIE EN BRETAGNE / . COUPE TRANSVERSALE .* [architectural measurements]

PROVENANCE unknown

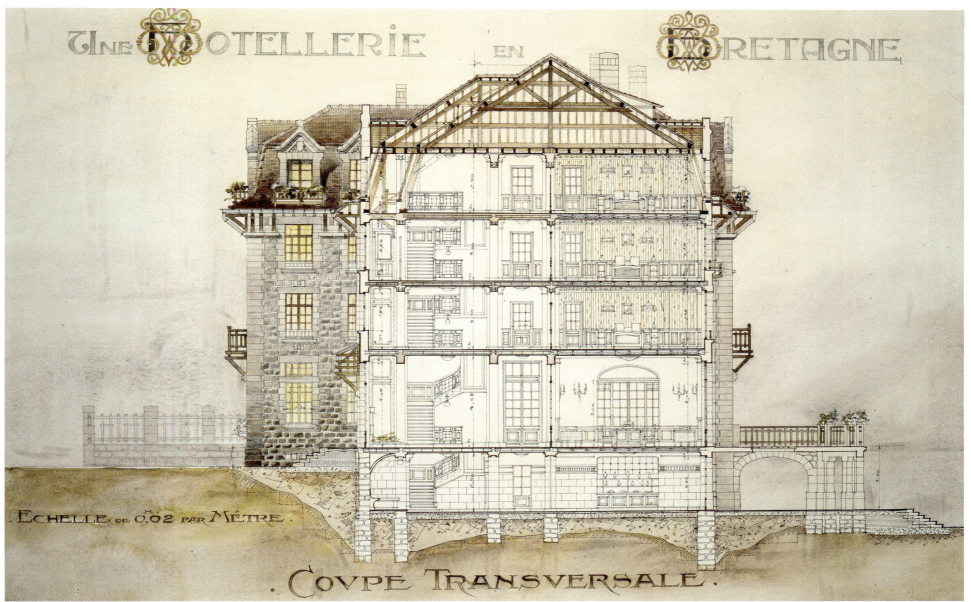

Detail of dining and guest rooms

Detail of kitchen and dining room

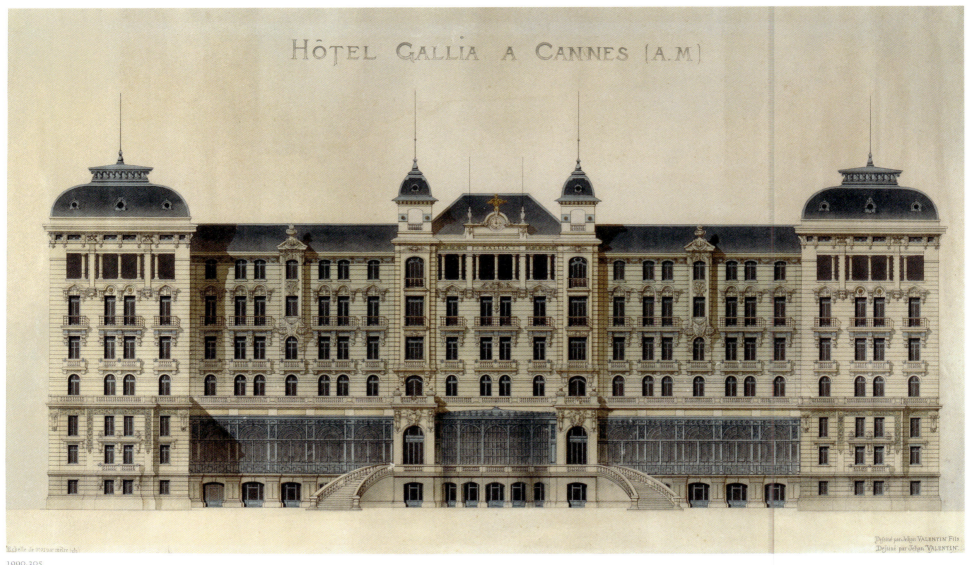

6.2

JEHAN VALENTIN (FRENCH, 1884–1965)

1990.305: Elevation of the Hotel Gallia in Cannes, ca. 1900

Pencil, ink, watercolor. 23 ¾ × 39 ½ in. (60.3 × 100.3 cm)
INSCRIBED *HÔTEL GALLIA A CANNES [A.M] / GALLIA / Dessigné par Jehan VALENTIN Fils / Dessigné par Jehan VALENTIN.*
LITERATURE Sotheby's, London, sale cat. 26 April 1990, p. 142, lot 458
PROVENANCE Sotheby's, London, 26 April 1990, lot 458

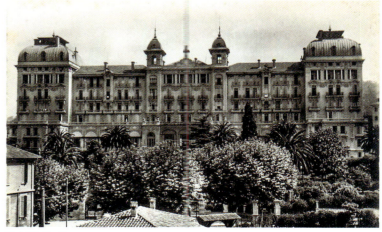

Hotel Gallia, Cannes

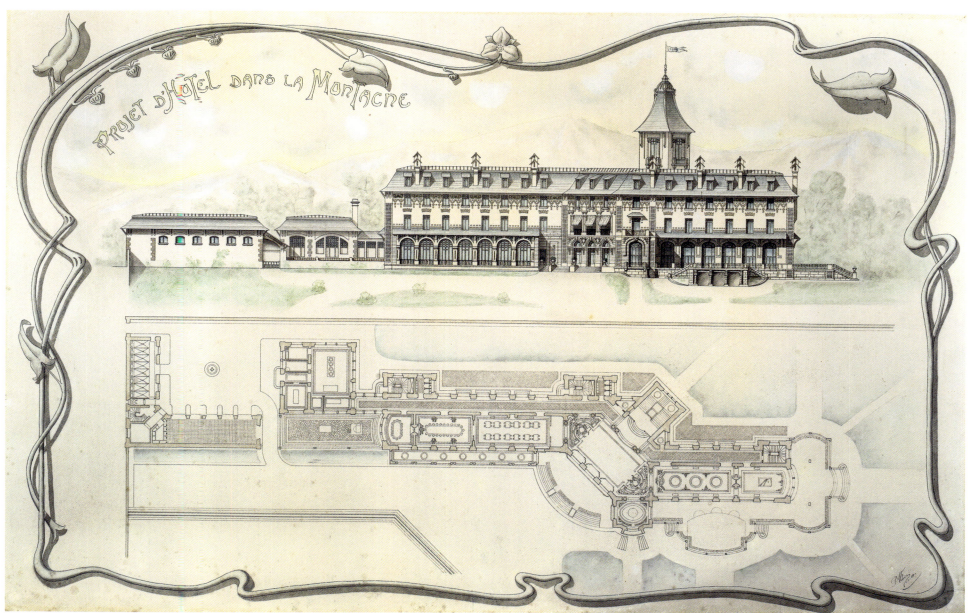

6.3

P. VILOIN [?] (FRENCH,
DATES UNKNOWN)

1987.29: Competition drawing for a hotel
in the mountains: elevation and plan, 1909

Pencil, ink, watercolor. 28½ × 44 in. (72.4 × 111.8 cm)
INSCRIBED *PROJET D'HOTEL DANS LA MONTAGNE /
P. Viloin [?] 1-09*
PROVENANCE unknown

6.4

ACHILLE PROY (FRENCH, 1864–1944)

1989.214: Competition drawing for a spa and casino: frontal elevation, 1900

Pencil, ink, watercolor, metallic tape. 50 × 85 in. (127 × 215.9 cm)
INSCRIBED *A. Proy / Eleve de Mr. Raulin*
PROVENANCE unknown

🎨 The subject of the 1900 Prix de Rome competition was *Un établissement d'eau thermal et casino*. The finished drawing is composed of at least five sheets of paper framed in metallic tape.

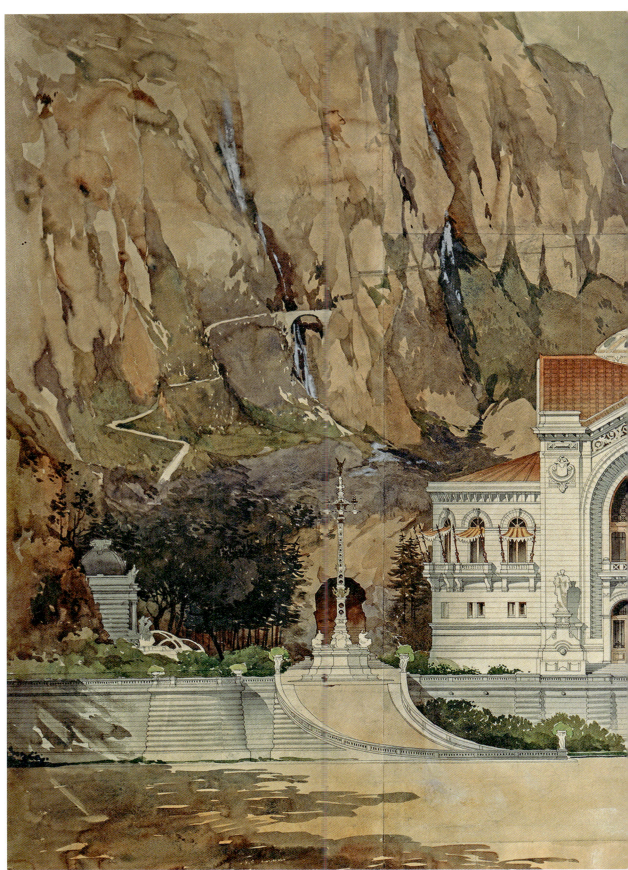

1989.214

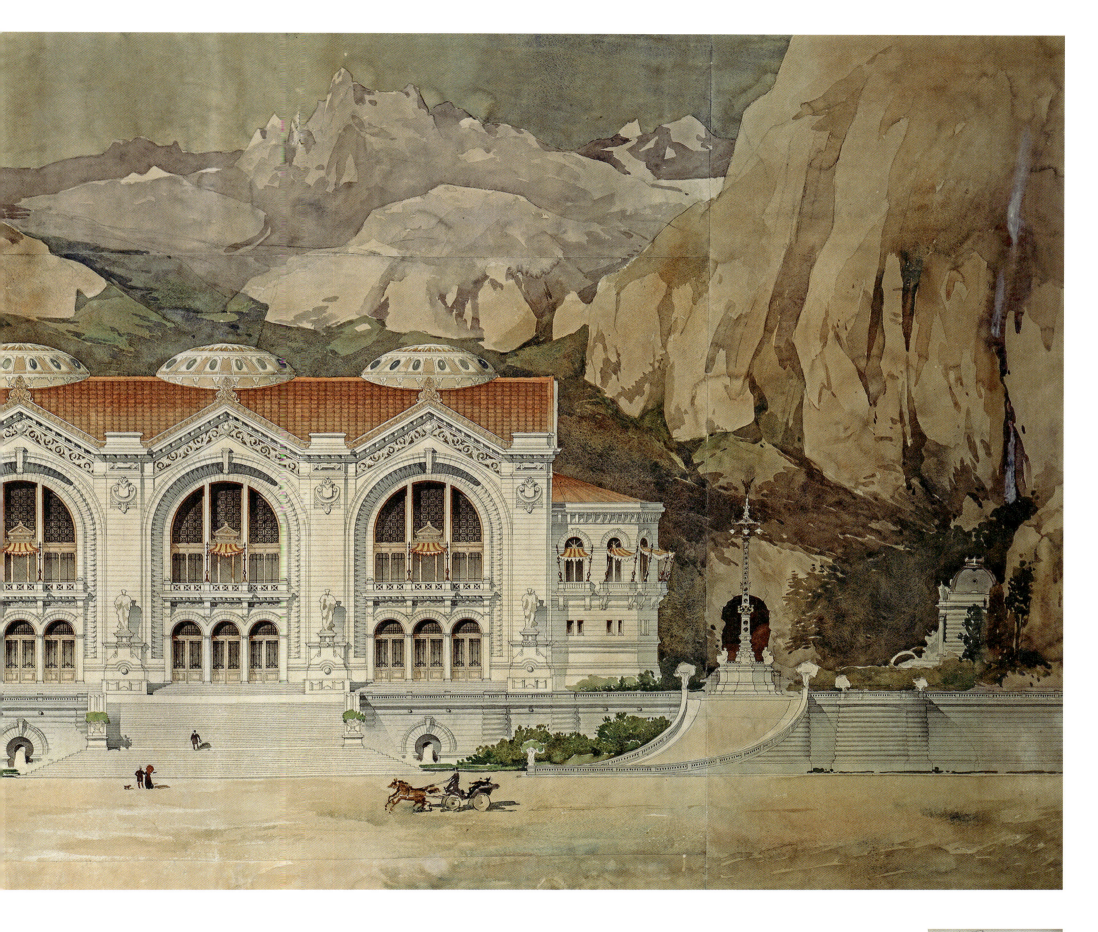

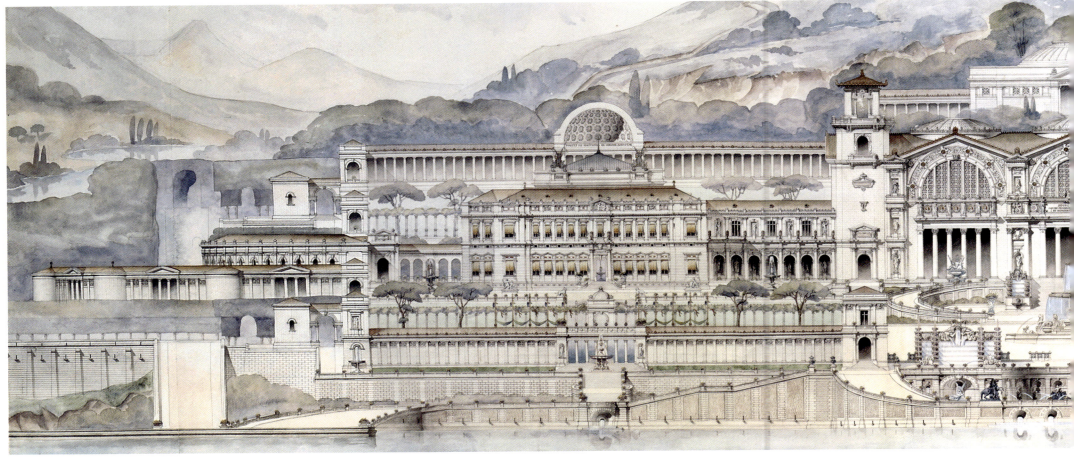

1991.388a

6.5

ALPHONSE ALEXANDRE DEFRASSE
(FRENCH, 1860–1939)

1991.388a–c: Competition drawings for a spa: elevation and cross-section, 1884

Pencil, ink, watercolor

1991.388a: Frontal elevation. 36 × 165 in. (91.4 × 419.1 cm)
INSCRIBED [on pediment above entrance] *SOURCES MINERALES / AQUAM FECUNDAM UTILEM DECREVERUNT AEDILES ET MONUMENTUM EREX ANNO MDCCCLXXXIV* / [at left] *DRAME / MUSIQUE / FONTES AD SANITATION EX MONTE ADDUCTAE* / [at right] *FORCE / COURAGE / A. Defrasse*

1991.388b: Cross-section. 21 × 80 in. (53.3 × 203.2 cm), framed
INSCRIBED *A. Defrasse*
PROVENANCE Galerie Gasnier-Kamien, Paris

1991.388c: Architectural details. 41¼ × 29½ in. (105 × 74.5 cm)
INSCRIBED *A. Defrasse*
PROVENANCE Shepherd Gallery, New York

🔸 The subject of the Prix de Rome in 1884 was an *Etablissement thermal*.

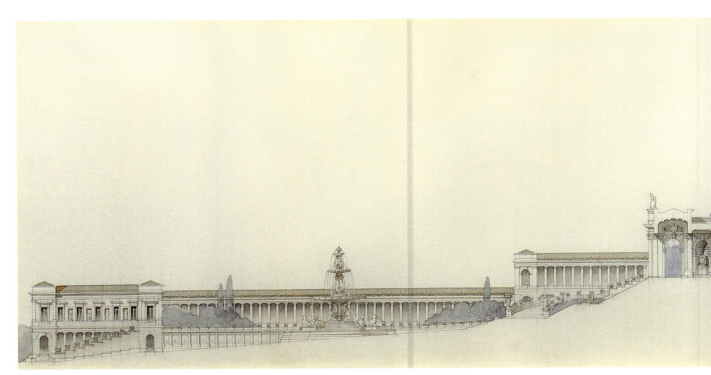

1991.388b

288 PETER MAY COLLECTION I

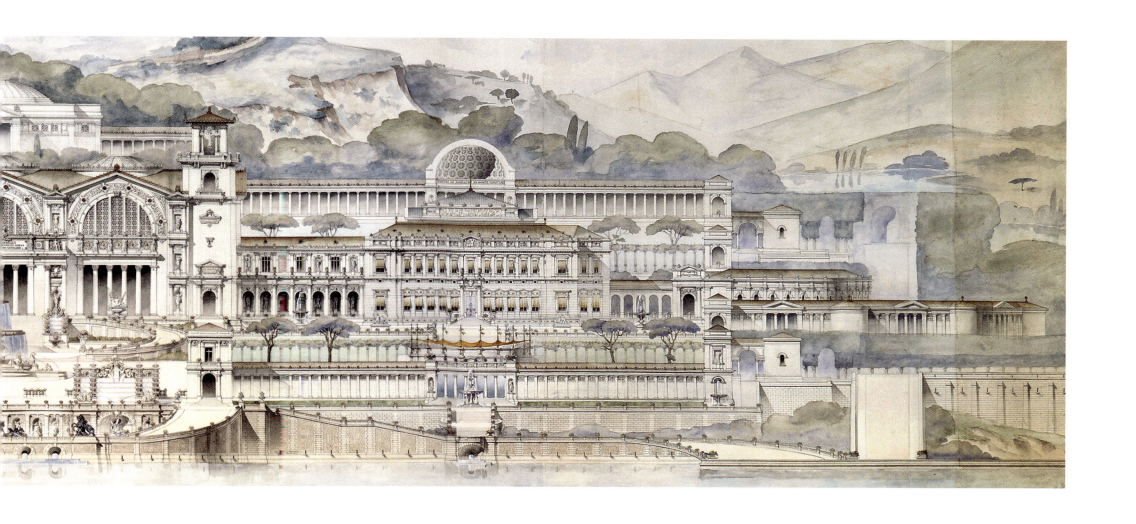
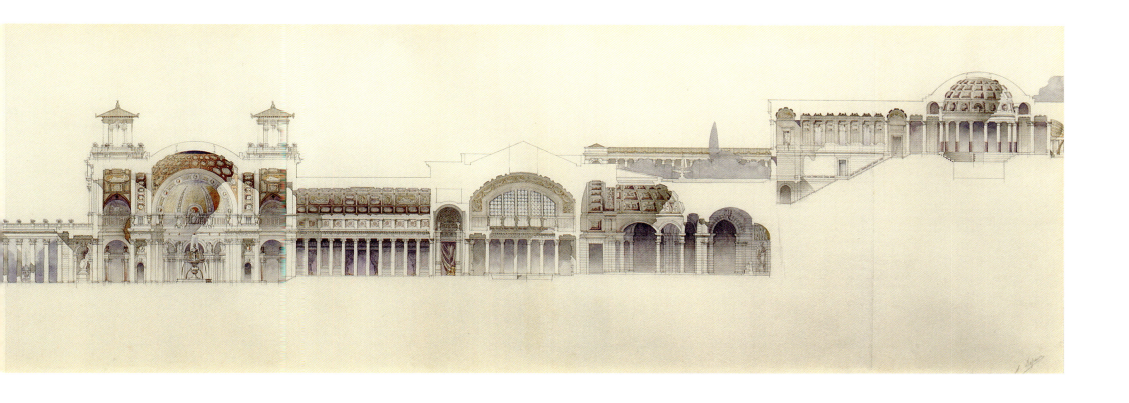

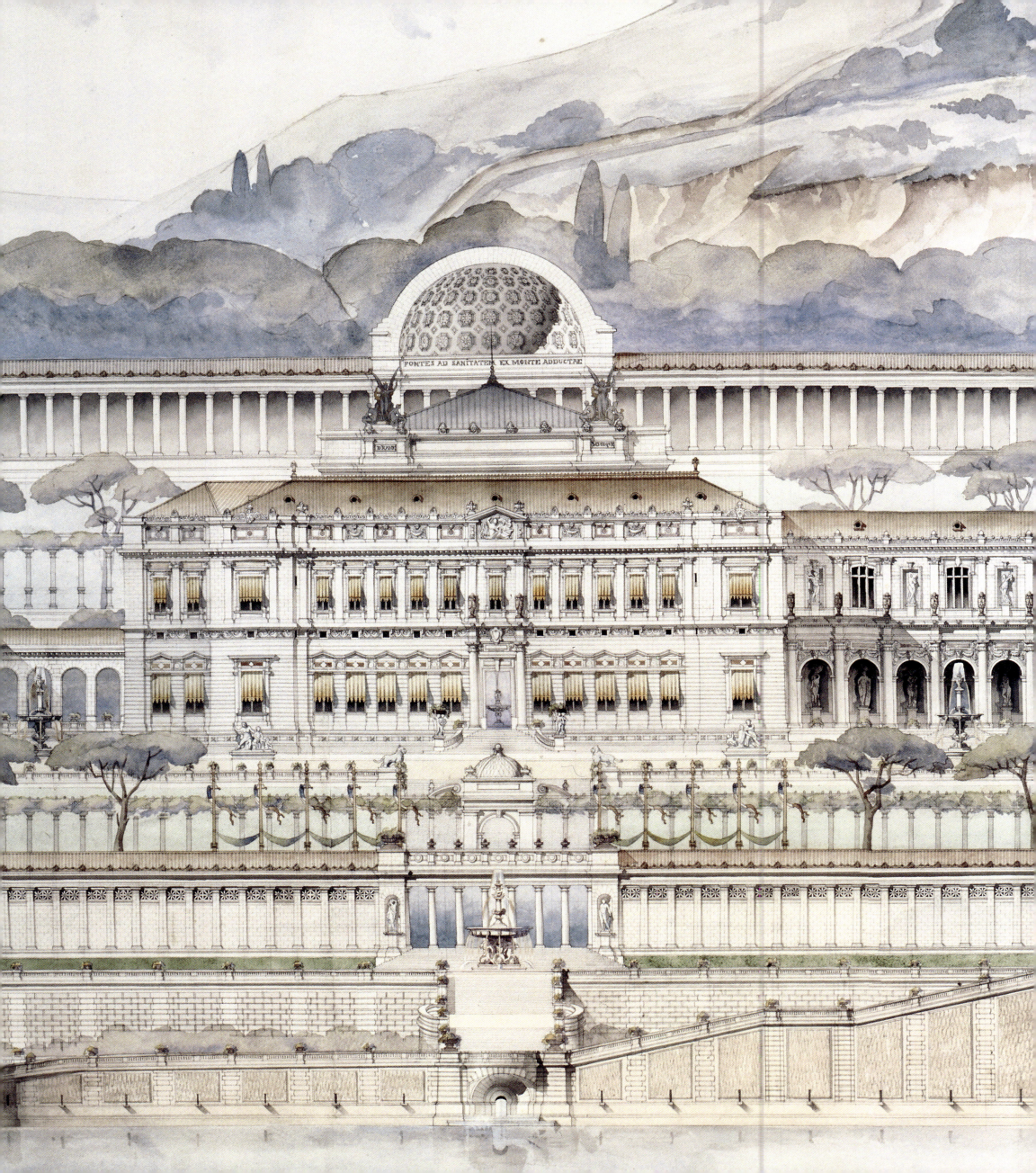

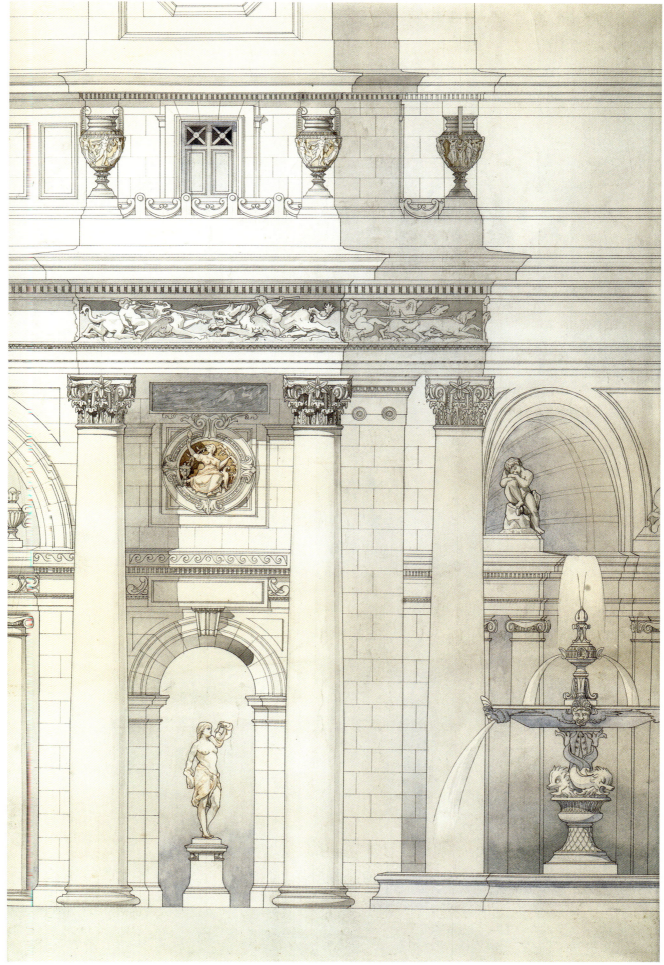

1991.388a detail

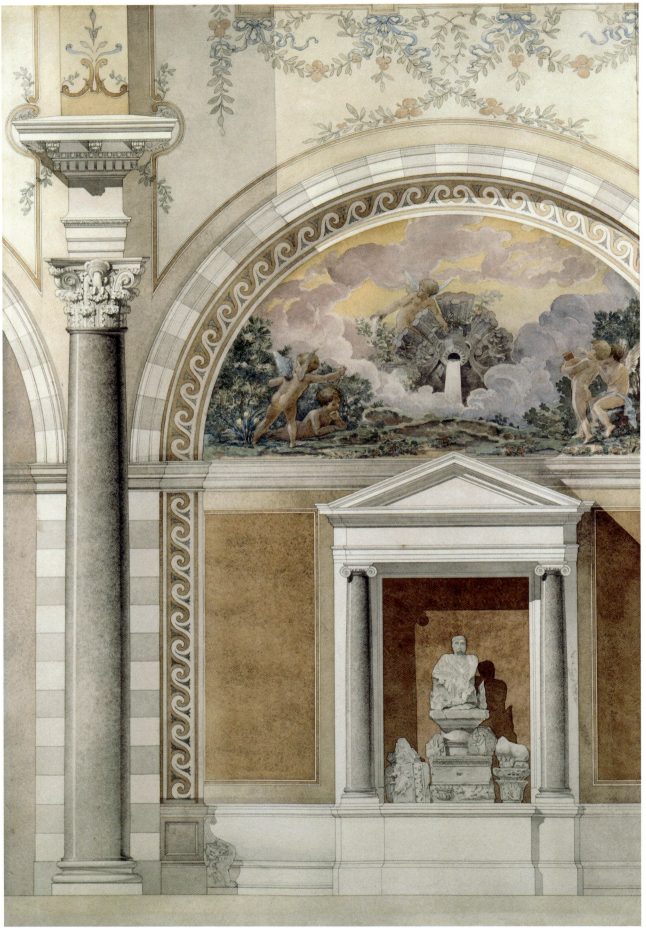

1997.403a

1997.403c

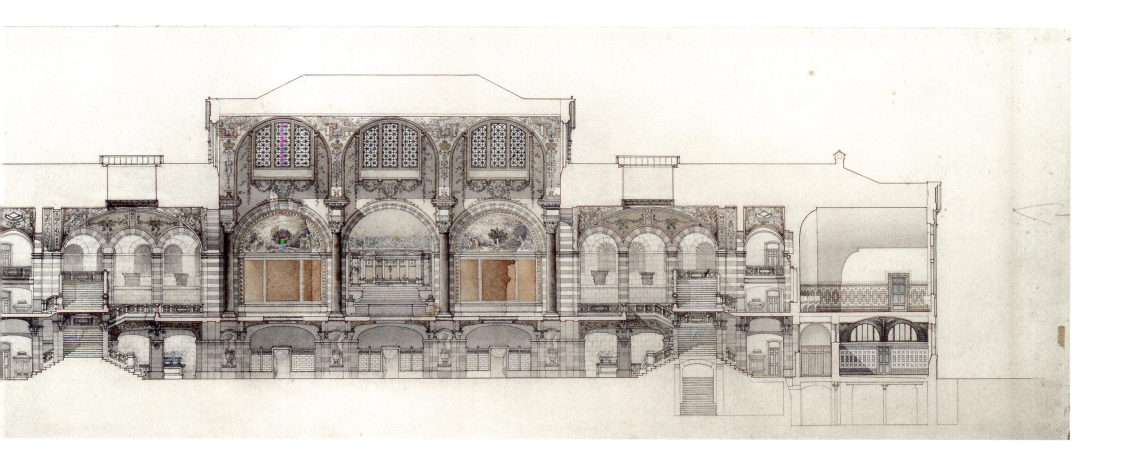

6.6

ARCHITECT: EMILE CAMUT
(FRENCH, 1849–1905)
ARTIST: LEOPOLD BEVIERE
(FRENCH, 1864–1935)

1997.403a–i: Seven drawings for the restoration and enlargement of the Thermal Baths in Le Mont-Dore, Dordogne, France, 1887–93

Pencil, ink, watercolor

1997.403a: Elevation detail of the Caesar spring in the antechamber with the (now lost) fresco by Hector d'Espouy. 51 × 36 in. (129.5 × 91.4 cm)

1997.403b: Cross-section of antechamber with two printed plans pasted on to upper right and left. 38 × 45 in. (96.5 × 114.3 cm)

1997.403c: 13 × 37 in. (33 × 94 cm)
INSCRIBED [in pencil] *No. 1c / 27 / coupe A*

1997.403d: Side elevation. 13 × 37 in. (33 × 94 cm)

1997.403e: Frontal elevation. 12 × 35 in. (30.5 × 88.9 cm)

1997.403f: Cross-section. 12 × 28 in. (30.5 × 71.1 cm)

1997.403g: Cross-section through the Caesar spring and interiors by Emmanuel Cavaillé-Coll. 10 × 28 in. (25.4 × 71.1 cm)
INSCRIBED [in pencil] *No. 1B*

1997.403h: Plan of Roman era and modern baths. 12 × 11 in. (30.5 × 27.9 cm) approx.
INSCRIBED [in pencil] *No. 9c / 28*

1997.403i: Plan of Roman era and modern baths. 12 × 11 in. (29.2 × 27.9 cm) approx.
INSCRIBED [in pencil] *No. 2e*

PROVENANCE Léopold Louis Camille Bevière (1864–1935), by descent to a grandson, Toronto; Marc Dessauce, New York

🌿 Camut was one of five candidates in the 1887 competition and won the commission unanimously; he was awarded the Prix Duc de l'Academie des Beaux-arts upon completion of the project in 1893. Reportedly, these drawings were exhibited in Glasgow ca. 1910. Emmanuel Cavaillé-Coll's (1860–1922) participation in the interior decoration has been suggested, but is not documented. Camut's interiors have been compared to the great Roman baths of Caracalla and Diocletian. The spa is still a functioning establishment.

Thermal Baths, Le Mont-Dore, Dordogne

HOTELS & SPAS 293

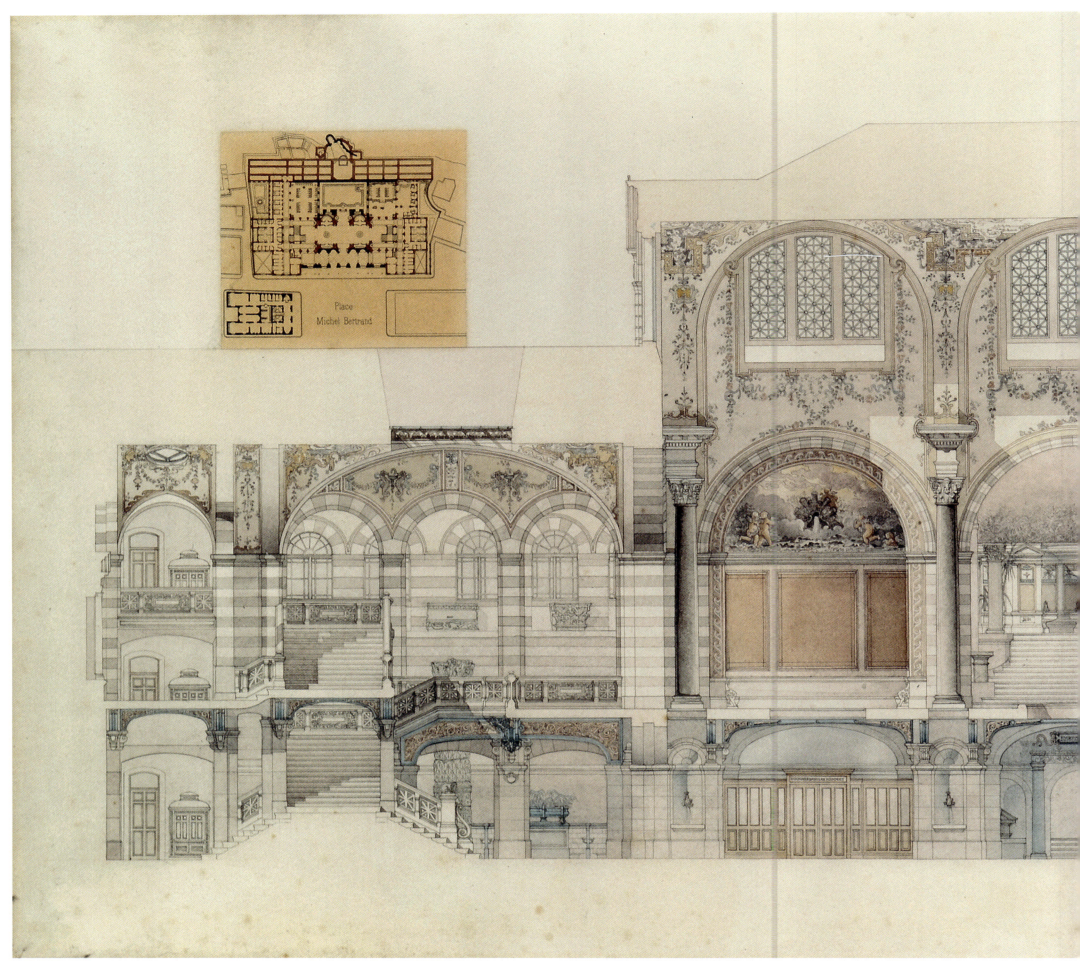

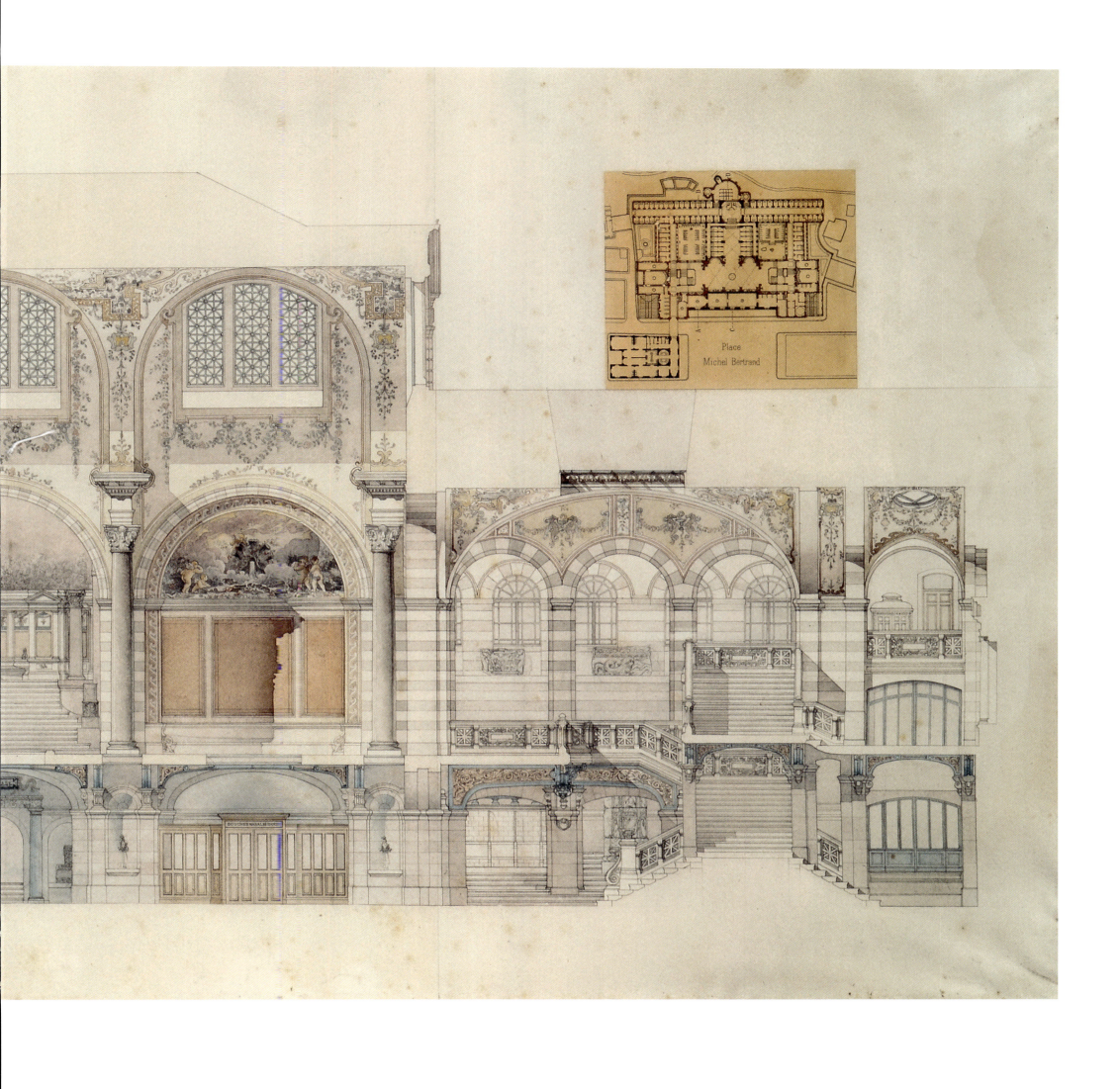

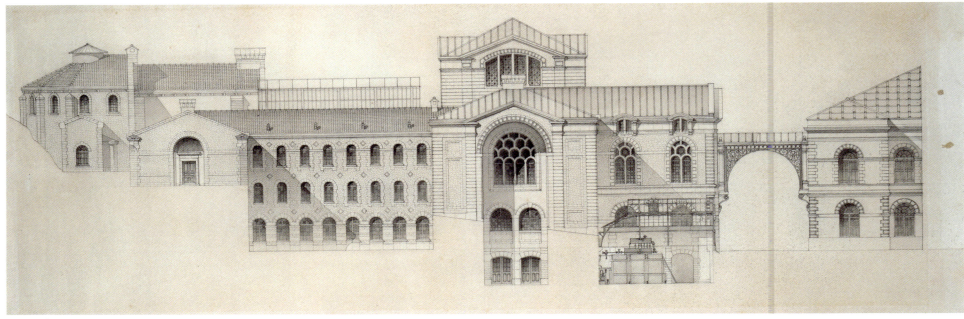

1997.403d

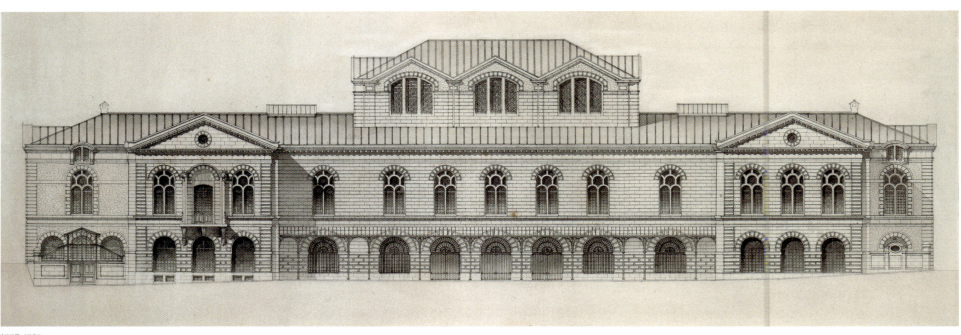

1997.403c

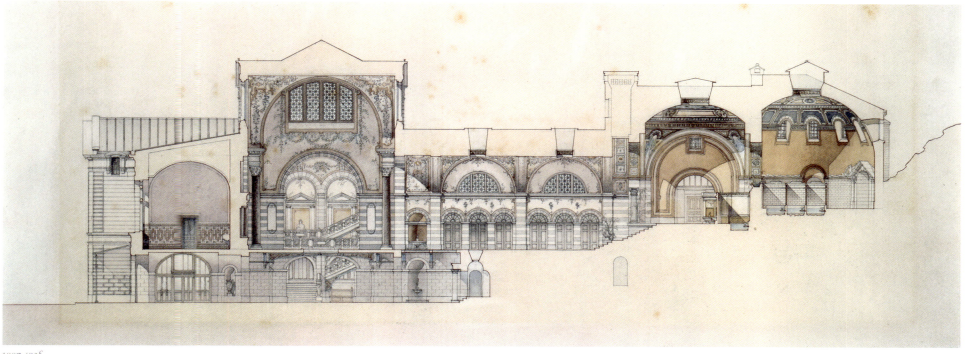

1997.403f

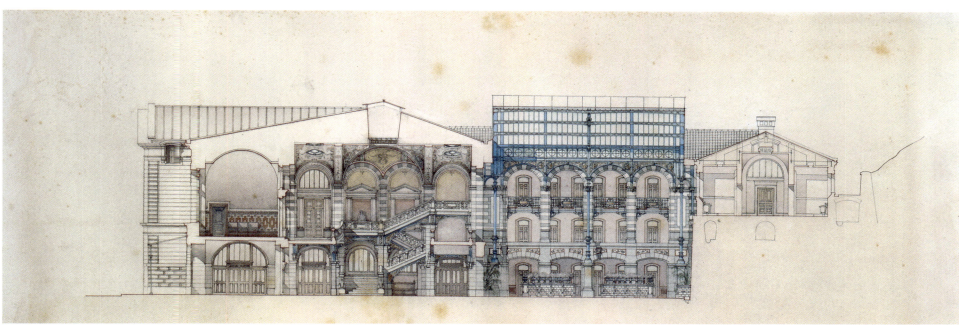

1997.403g

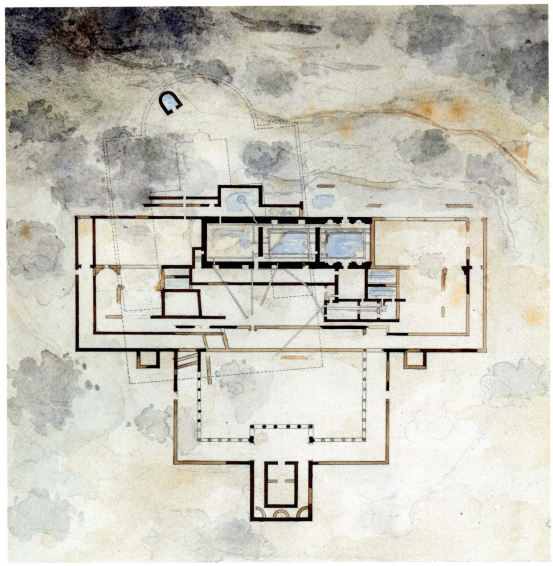

1997.403h

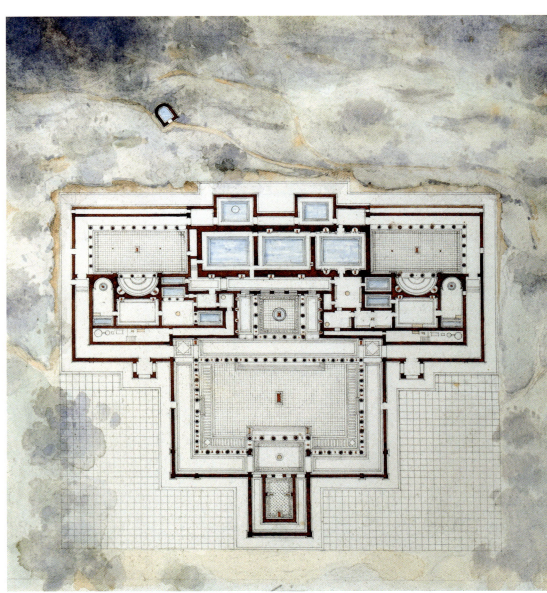

1997.403i

1991.384

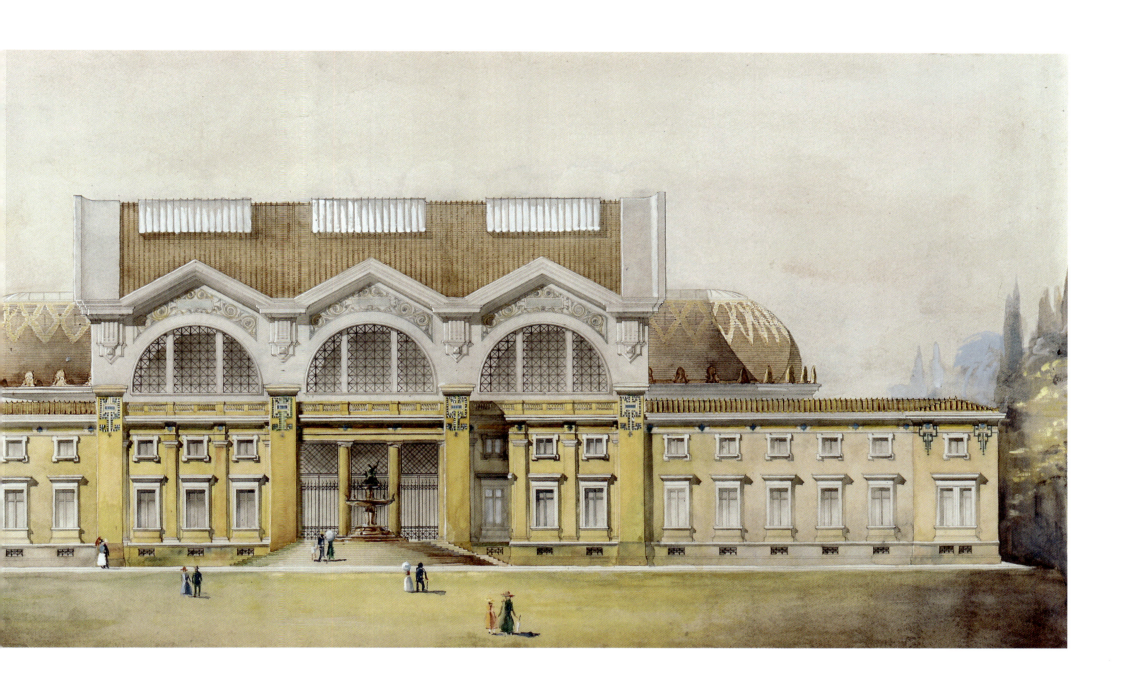

6.7

ARCHITECT UNKNOWN (FRENCH)

1991.384: Competition drawing for a spa (?), ca. 1900

Pencil, ink, watercolor. 19½ × 42 in. (49.5 × 106.7 cm)
PROVENANCE unknown

7
COMMERCE

1987.33c detail

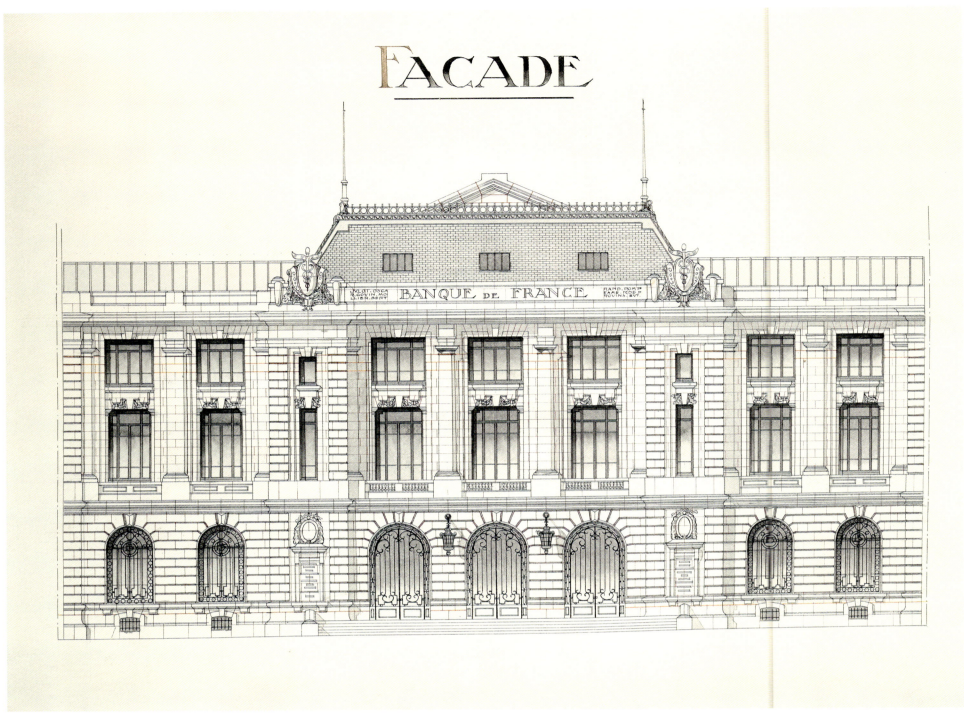

1987.33a

7.1

ARCHITECT UNKNOWN (FRENCH)

1987.33a–h: Competition drawings for a French national bank: elevations, cross-sections, and plans, 1909

Pencil, ink, watercolor

1987.33a Elevation. 16¼ × 22⅞ in. (41.3 × 58.1 cm)
INSCRIBED *FAÇADE / BANQUE DE FRANCE / JULOT . OSCAR. GOVIN. MOLLIER. BERTRAND . POMP. EAME . RDE. P. ROVINS. AVT.*[?]

1987.33b Cross-section. 18¾ × 25⅜ in. (47.6 × 64.5 cm)
INSCRIBED *COUPE TRANSVERALE* /[2×] *BANQUE* /[2×] *VALEURS* /[2×] *TITRES* / *RENTES* / *MINES DE SOCISSON* / [architectural measurements]

1987.33c Plan of the first floor. 18 × 12⅝ in. (45.7 × 31.4 cm)
INSCRIBED *PREMIER ETAGE* / *Vide du Grand Hall* / *Degagement* / *Cabinet du Directeur* / *Archives* / *Secretaire* / *Bureau* / *Central Telephonique* / [3×] *Bureaux* / [2×] *Cour* / [2×] *Chef de Service* / [2×] *WC* / *Service des Titres* / [architectural measurements]

1987.33d Plan of the main floor. 17¾ × 12½ in. (45.1 × 31.8 cm)
INSCRIBED *REZ DE CHAUSSEE* / *Porche* / *Vestibule* / *Concierge* / *Descente aux Coffres* / *Pompiers* / *Service* / *Le Grand Hall* / [2×] *Bureaux* / [2×] *Cour* / [2×] *Chef de Service* / [2×] *Bureau* / *Service des Titres* / [2×] *WC* / [architectural measurements]

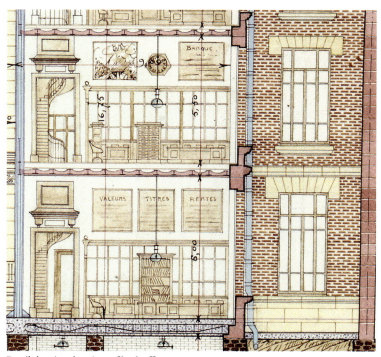

Detail showing elevations of bank offices

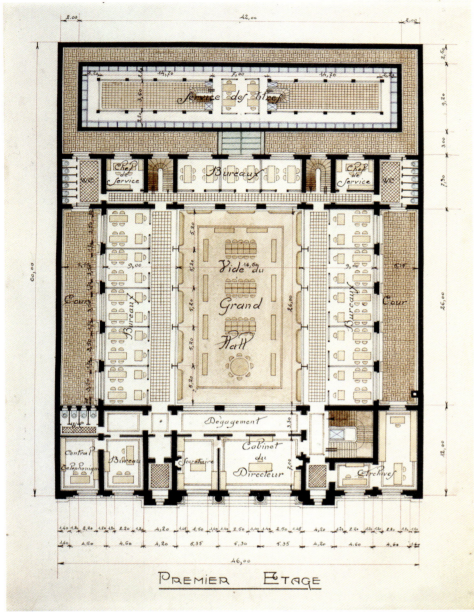

PREMIER ETAGE

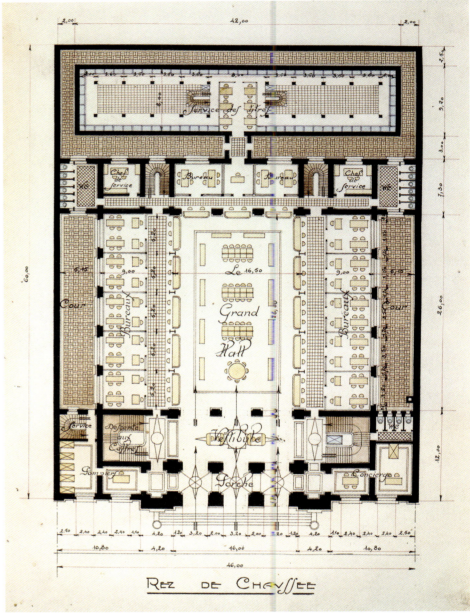

REZ DE CHAUSSÉE

304 PETER MAY COLLECTION I

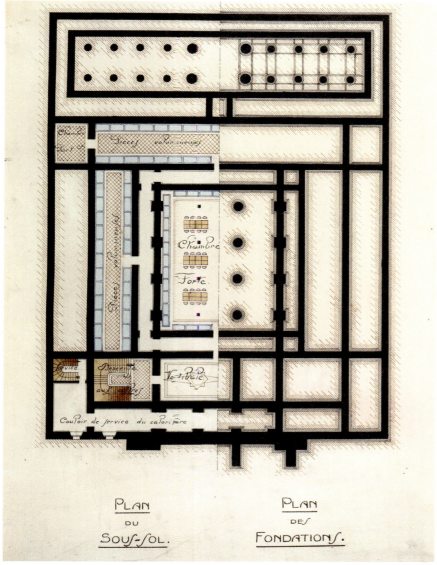

1987.33e

1987.33e Plan of the basement and foundations.
18 × 12⅜ in. (45.7 × 31.4 cm)
INSCRIBED *PLAN DU SOUS-SOL / PLAN DES FONDATIONS. / Vestibule / Couloir de service du calorifere / Descente aux coffres / [2×] Pieces volumineuses / Service / [2×] Chambre Forte*

1987.33f Plan of the main floor. 31 × 18 in. (78.7 × 45.7 cm)
INSCRIBED *Le Vestibule / [7×] Bureaux / Le Hall / La Descente aux Coffres*

1987.33g Cross-section. 9 × 26⅞ in. (22.9 × 68.3 cm)

1987.33h Cross-section. 9 × 26⅞ in. (22.9 × 68.3 cm)
INSCRIBED *VALEURS / TITRES / MINES / ACTIONS / [architectural measurements]*

PROVENANCE unknown

❧ The construction competition for 1909 was a *Banque de France*. These drawings represent the hands of at least two aspirants.

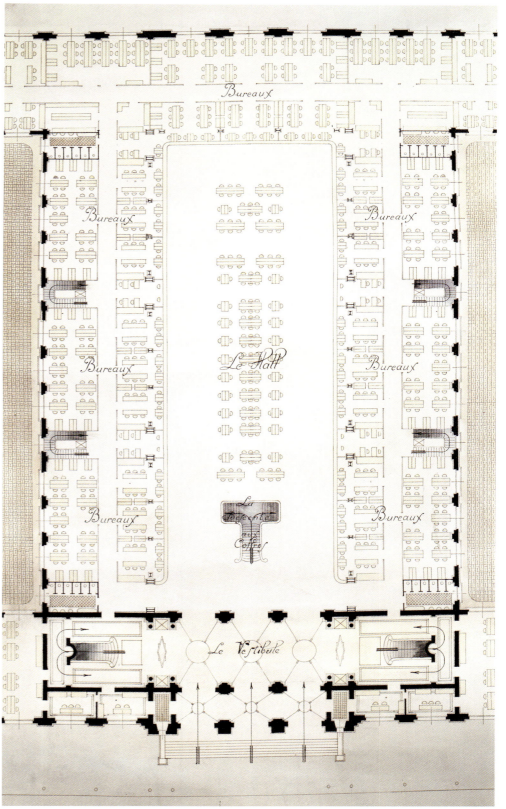

1987.33f

COMMERCE 305

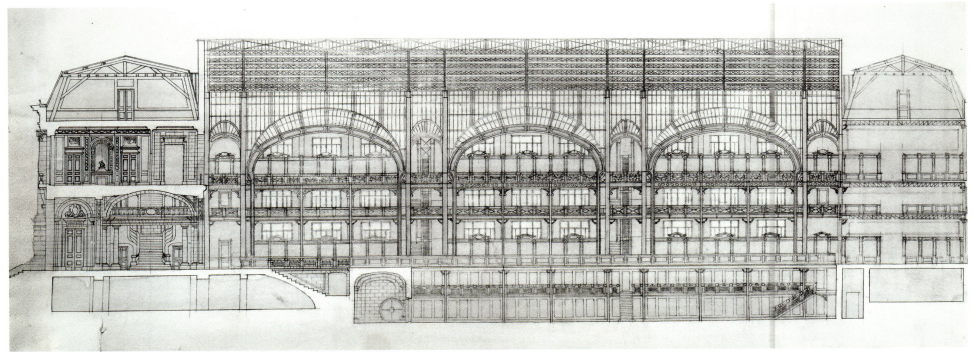

1987.33g

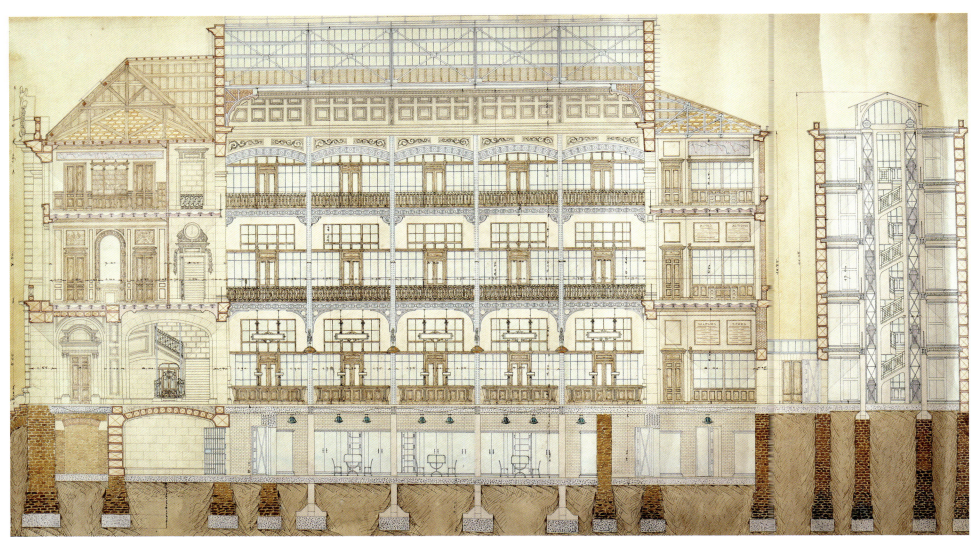

1987.33h

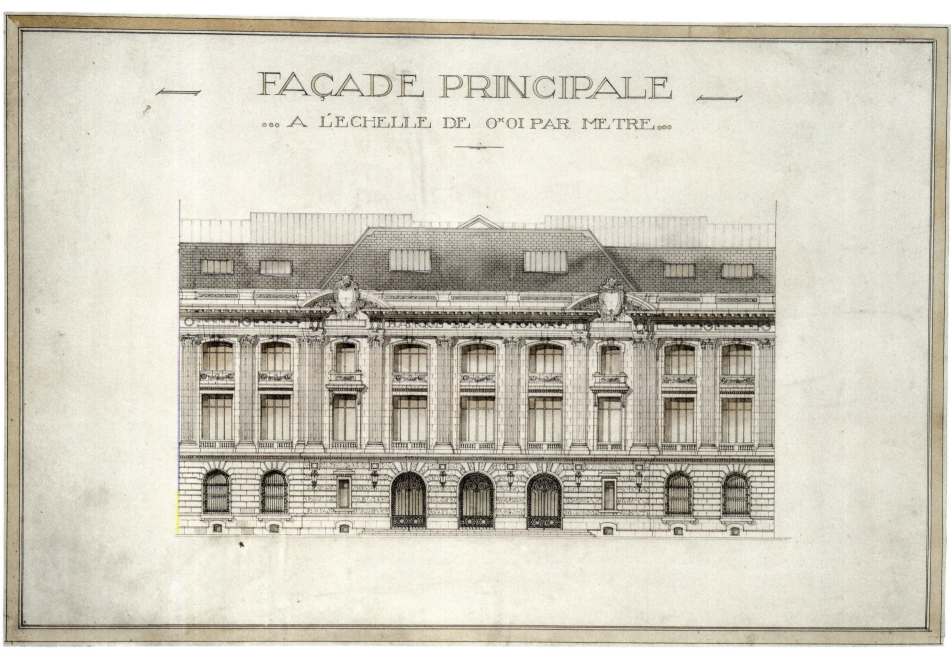

1988.119a

7.2

ARCHITECT UNKNOWN (FRENCH)

1988.119a–c: Competition drawings for a French national bank: frontal façade and two cross-sections, 1909

Pencil, ink, watercolor

1988.119a Frontal façade. 16 × 24⅜ in. (40.6 × 61.9 cm)
INSCRIBED *FAÇADE PRINCIPALE* / [architectural measurements]

1988.119b Cross-section. 16⅞ × 21¼ in. (42.9 × 54.6 cm)
INSCRIBED *COUPE TRANSVERALE* / [architectural measurements]

1988.119c Cross-section. 23⅞ × 48¾ in. (60.6 × 123.8 cm)

PROVENANCE unknown

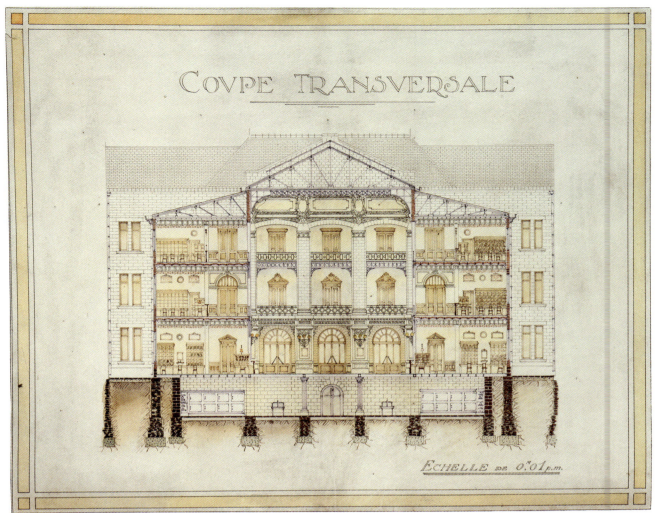

1988.119b

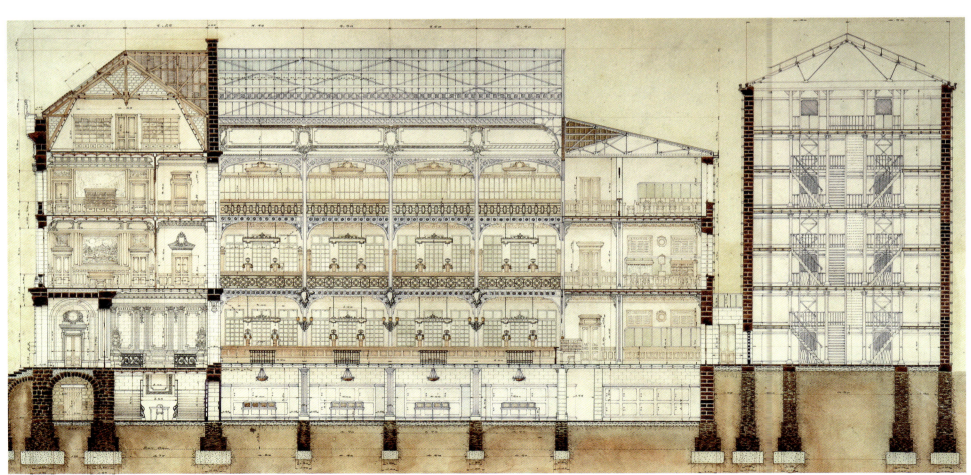

1988.119c

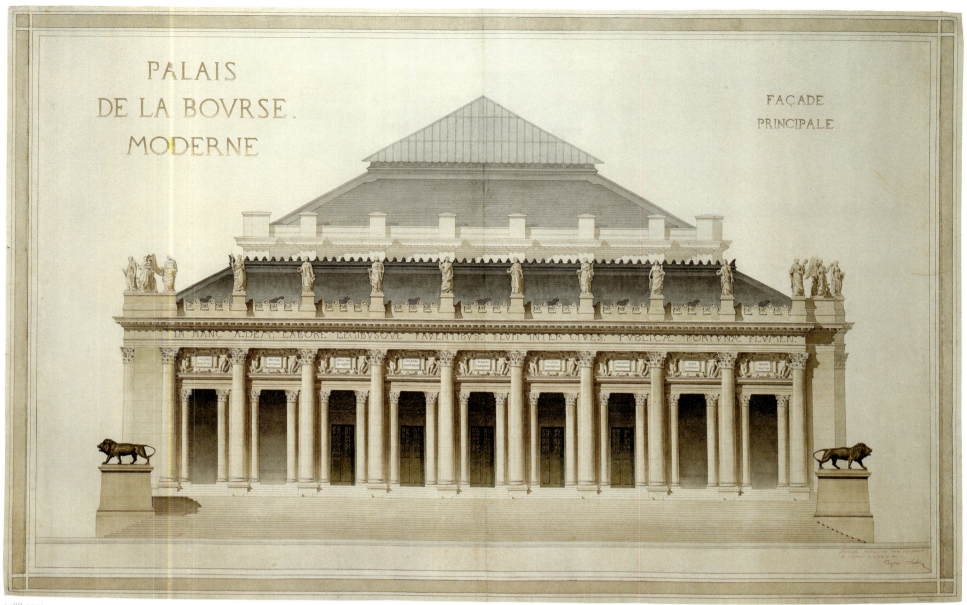

7.3

PROSPER ETIENNE BOBIN
(FRENCH, 1844–1923)

1988.100a–c: Competition drawings for a stock exchange: two elevations and a plan, 1882

Pencil, ink, watercolor

1988.100a: Frontal elevation
33 1/4 × 52 1/4 in. (84.5 × 132.7 cm)
INSCRIBED *PALAIS DE LA BOURSE MODERNE / FAÇADE PRINCIPALE / IN HANC AEDEM LABORE LEGIBUSQUE FAVENTIBUS FLUIT INTER CIVES PUBLICAE FORTUNAE FLUMEN / VALEURS AGRICOLES / BANQUE NATIONALE / INSTITUTIONS DE CREDIT / VALEURS INDUSTRIELLES / VALEURS FRANÇAISES / VALEURS COMMERCIALES / COMPAGNIES D'ASSURANCES FONDS ÉTRANGERS /* [in red ink] *Façade principale sans les grilles de clôture a 0,02ᵉ p.m. / Prosper Bobin*

1988.100b: Lateral elevation. 33 1/8 × 65 3/8 in. (84.1 × 166.1 cm)
INSCRIBED *PALAIS DE LA BOURSE MODERNE. FAÇADE LATERALE. / Façade Laterale / Paris le 30 Mars 1882 / Prosper Bobin /* [architectural measurements]

1988.100c: Plan. 45 1/8 × 32 1/4 in. (114.6 × 81.9 cm)
INSCRIBED *PALAIS DE LA BOURSE MODERNE / VESTIBULE / GDE. SALLE /* [2×] *GRAND PARVIS DALLÉ /* [2×] *GALERIE / AGENTS DE CHANGE / SALON / PLAN GENERAL /* [2×] *attente /* [2×] *vestibule / Cabinet /* [architectural measurements]

PROVENANCE unknown

🌶 Exhibited at the Salon of 1882.

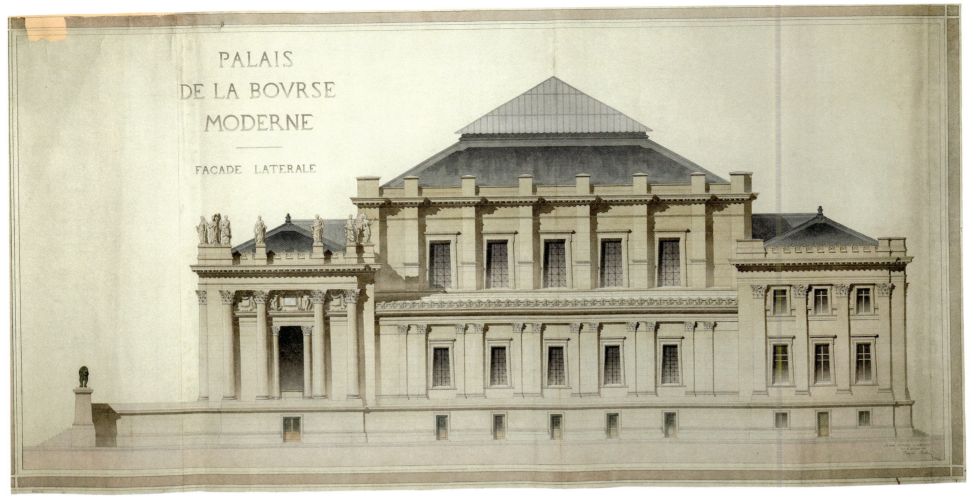
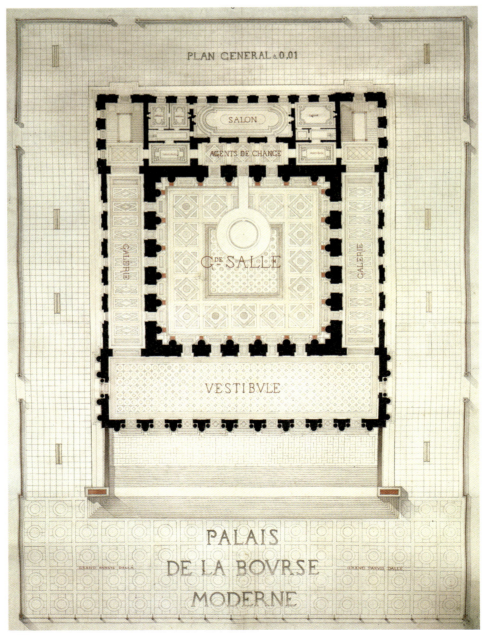

7.4

ARCHITECT UNKNOWN (FRENCH)

1987.48a,b: Competition drawings for an exchange: façade and cross-section, late 19th century

Pencil, ink, watercolor

1987.48a: Facade. 23¼ × 43½ in. (59.1 × 110.5 cm)
INSCRIBED *BOURSE DE COMMERCE*

1987.48b: Cross-section. 9¼ × 23 in. (23.5 × 58.4 cm)

PROVENANCE unknown

7.5

CHARLES PROSPER ANCELET (FRENCH 1874–1956), ATTRIBUTED TO

1989.163a,b: Competition designs for a maritime trade exchange: elevation and cross-section, late 19th century

Pencil, ink, watercolor

1989.163a: Frontal facade. 18⅞ × 30¾ in. (47.9 × 78.1 cm)
INSCRIBED *DU COMMERCE MARITIME* / [partially illegible texts to either side]

1989.163b: Cross-section. 18⅞ × 28¾ in. (47.9 × 73 cm)

PROVENANCE unknown

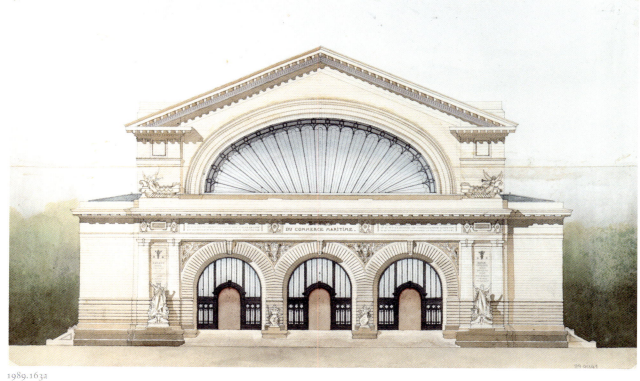

1989.163a

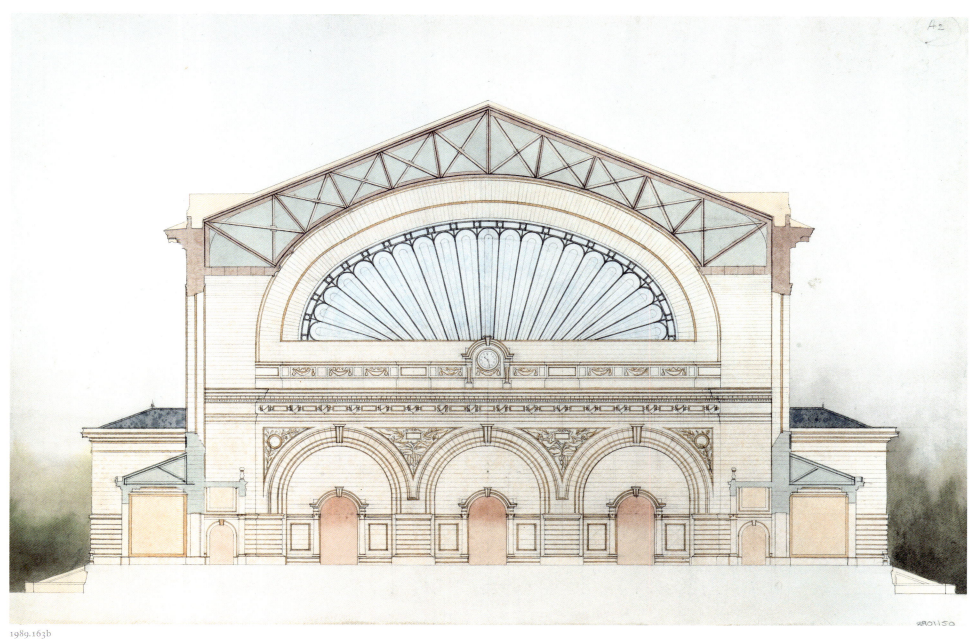

1989.163b

COMMERCE 313

1987.219

7.6

JULES CHATRON (FRENCH, 1831–1884), ATTRIBUTED TO

1987.219: Competition drawing for a department store: elevation

Pencil, ink, watercolor. 24¼ × 32½ in. (61.6 × 82.6 cm)
PROVENANCE unknown

1989.288

7.7

ARCHITECT UNKNOWN (FRENCH)

1989.288: Competition drawing for an auction house: frontal elevation, late 19th–early 20th century

Pencil, ink, watercolor. 18¼ × 26 in. (46.4 × 66 cm)
INSCRIBED *HOTEL DES VENTES*
PROVENANCE unknown

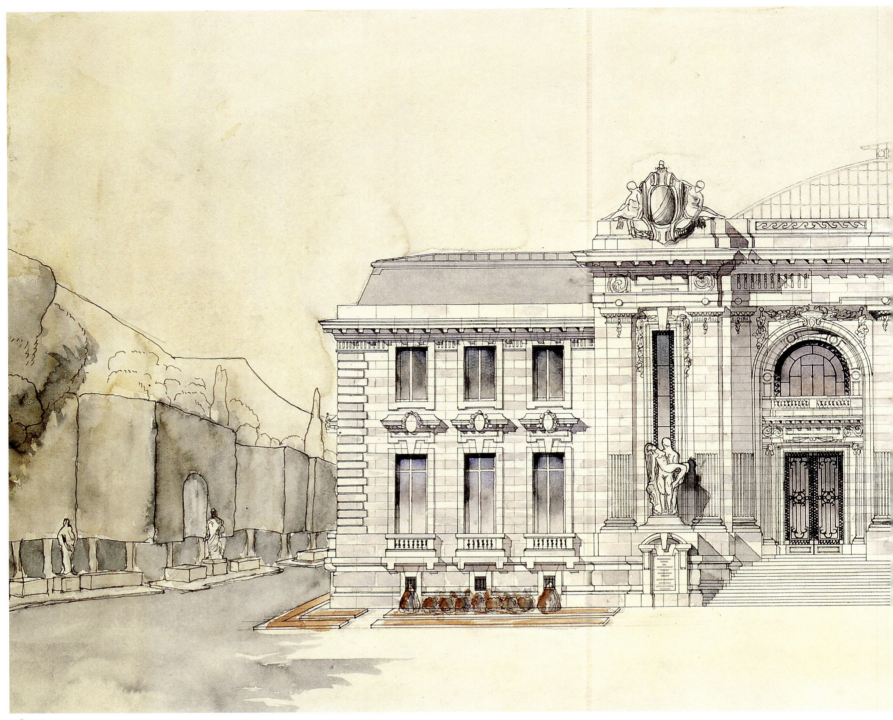

1987.47a

7.8

ARCHITECT UNKNOWN (FRENCH)

1987.47a–c: Competition drawings for an auction house: elevation, plan, and cross-section, late 19th–early 20th century

Pencil, ink, watercolor

1987.47a: Frontal elevation. 14 × 37 in. (35.6 × 94 cm)

1987.47b: Cross-section. 31¾ × 24½ in. (80.7 × 62.2 cm)

1987.47c: Plan. 7¾ × 23¾ in. (19.7 × 60.3 cm)
INSCRIBED *Concierge / Administration / [2×] Les Gros Poids / La Grande Salle / [2×] Ventes / Grandes Ventes / [4×] Expert / Guardien / [2×] Dépots / Emballage*

PROVENANCE unknown

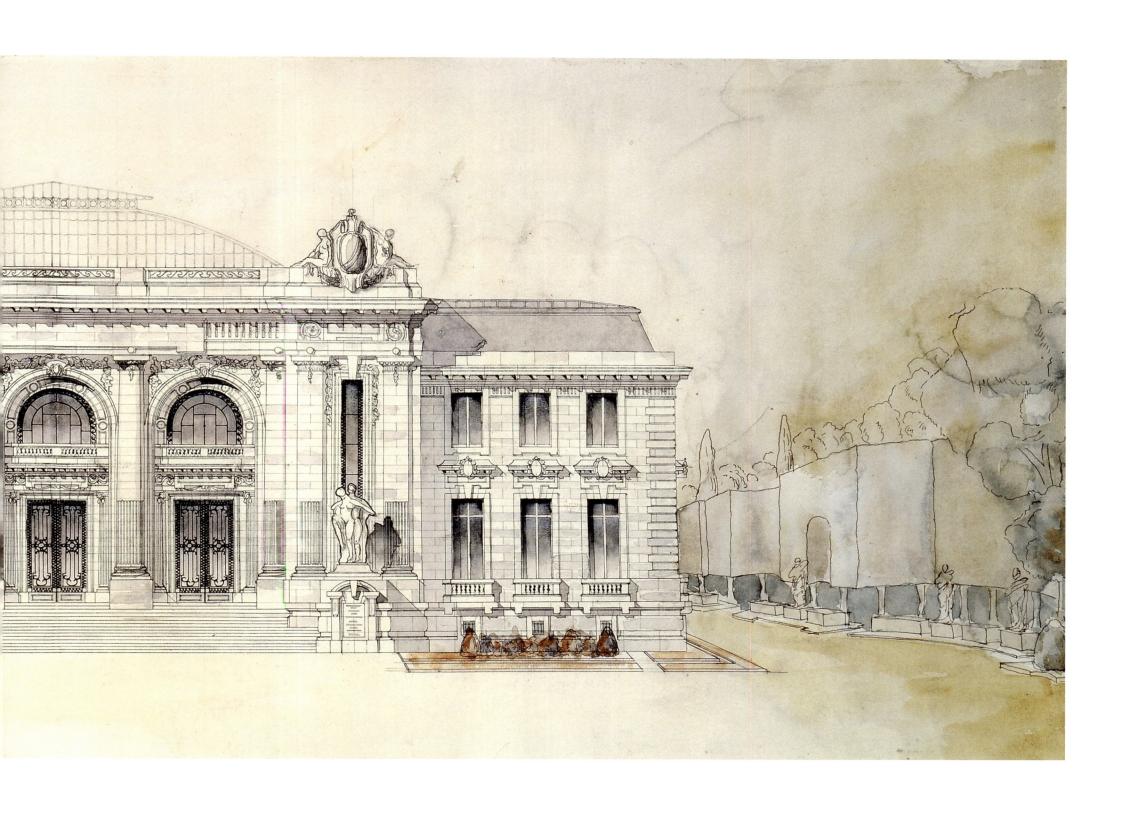

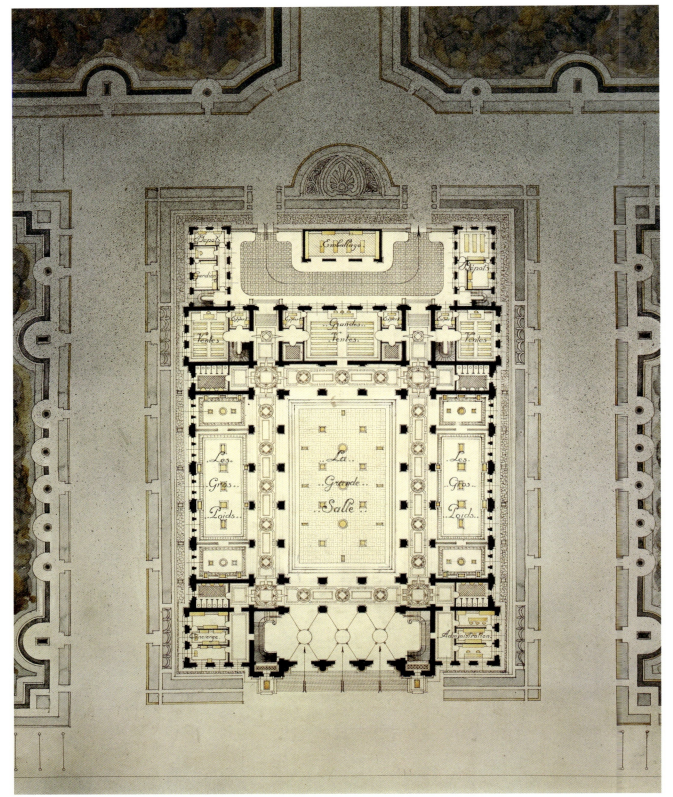

1987.47b

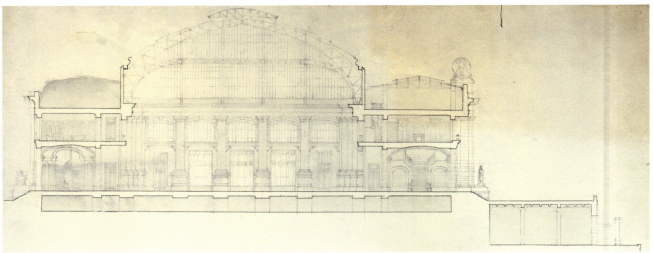

1987.47c

7.9

ARCHITECT UNKNOWN (FRENCH)

1989.212: Perspective view of the Dunod publishing house and bookshop at 92 Rue Bonaparte, Paris, ca. 1900

Pencil, ink, watercolor. 29½ × 19⅜ in. (74.9 × 49.2 cm)
INSCRIBED *LA LIBRAIRIE DUNOD, 92 RUE BONAPARTE* / [beneath coat of arms] *RIEN SANS PEINE* / *DUNOD EDITEUR* / [interwoven in trophies on upper story] *H.D.*
PROVENANCE unknown

The Dunod building is now the Balassi (Hungarian) Institute of Paris and the firm of Dunod is part of Hachette.

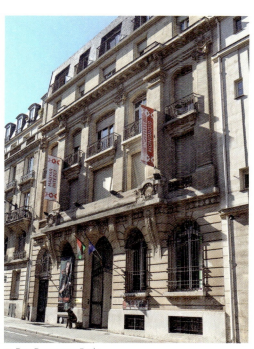

92 Rue Bonaparte, Paris

1989.212

COMMERCE 319

1988.111a

7.10

ARCHITECT UNKNOWN (FRENCH)

1988.111a,b: Two shopfronts for Fayard shoe stores

Pencil, ink, watercolor

1988.111a: 22⅞ × 30½ in. (58.1 × 77.5 cm)
INSCRIBED [2×] *CHAUSSURES FAYARD* / *ST. ETIENNE* / [2×] *45. MAISONS DE VENTE* / [2× cipher] *CF* / *SETIENNE FAYARD* [sic] / [architectural measurements]

1988.111b: 23 × 32¾ in. (58.4 × 83.2 cm)
INSCRIBED *CHAUSSURES FAYARD ST. DENIS* / *CHAUSSURES FAYARD* / *FAYARD* / [2×] *PARIS. PROVINCE.* / [cipher] *CF* / *– Coupe –* / *– ST DENIS FAYARD –* / *– Légende –* [measurements of façade, pilasters, window vitrines, etc.] / [numerical notations] / [architectural measurements]

PROVENANCE unknown

Chaussures Fayard, Rue Sainte-Catherine, Bordeaux

7.11

JOSEF KÜHN JR (AUSTRIAN, DATES UNKNOWN)

2000.450: Designs for two commercial buildings in Vienna, late 19th century

Pencil, ink, watercolor. 9⅝ × 14³⁄₁₆ in. (24.5 × 36 cm)
INSCRIBED [in ink] *Josef Kühn* [?] *Architect / NEUER – MARKT / KÄRTNERSTRASSE* [architectural measurements]
PROVENANCE Shepherd Gallery, New York

7.12

ALEXANDER EUGEN JØRGENSEN
(DANISH, 1858–1910)

1991.325: Facade of Christian IX's Gade, Copenhagen, Denmark, 1907

Pencil, ink, watercolor. 17 × 33⅞ in. (43.2 × 86 cm)
INSCRIBED [in pencil] *Eugen Jørgensen 1907* / [in ink or watercolor] *DM: 1908 / FAÇADE MOD CHRISTIAN IX'S GADE SKIBS HYPOTEK BANK* [...]
PROVENANCE unknown

❧ Christian IX's Gade was commissioned in 1906 and completed in 1920. Eugen Jørgensen designed all the buildings along the new street and was also a partner in the development of this new neighborhood outside the old city walls.

Christian IX's Gade, Copenhagen

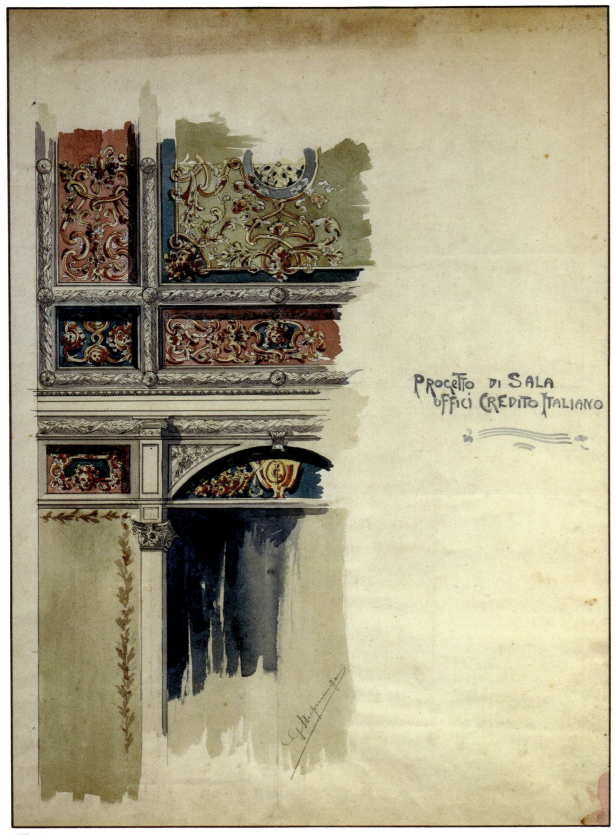

1988.122

7.13

STUPENENGO [?] (ITALIAN)

1988.122: Inter or detail of Credito Italiano bank, ca. 1900

Pencil, ink, watercolor, 23¼ × 16½ in. (59.1 × 41.9 cm)
INSCRIBED *PROGETTO DI SALA OFFICI CREDITO ITALIANO* / [cipher over doorway] *C I* [Credito Italiano]
PROVENANCE unknown

Possibly a design for the Credito Italiano (now Unicredit) headquarters on Piazza Cardusio in Milan, built by architect Luigi Broggi (1851–1926), which was completed in 1902.

7.14

THOMAS SANDBY [?] (BRITISH, 1721–1798)

1991.381, 382: Competition drawings of the facades for the Royal Exchange, Dublin, 1769

Pencil, ink, watercolor
1991.381: 8½ × 16 in (21.6 × 40.6 cm) approx.
1991.382: 9 × 19 in. (22.9 × 48.3 cm) approx.
LITERATURE Sotheby's, London, sale cat. 13 Dec. 1988, p. 22, lot 44
PROVENANCE Sir John Summerson; Sotheby's, London, 13 Dec. 1988, lot 44; Charles Plante, London

Out of 61 competitors, Sandby won third place. Further Sandby drawings for this building are held by The Frances Lehman Loeb Museum at Vassar College in Poughkeepsie, NY (1864.1.308r and -) and by RIBA (SE16/11).

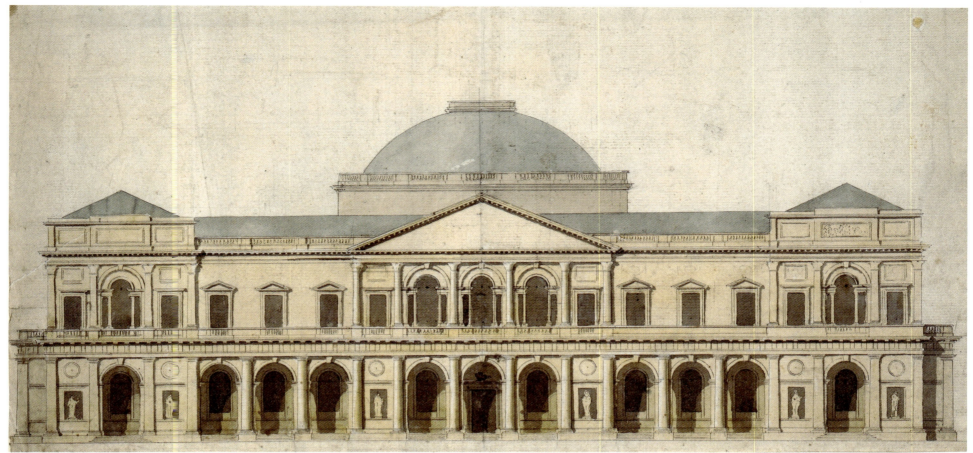

1991.381

1991.382 pre-conservation

2000.465

7.15

CYRIL FAREY (BRITISH, 1888–1954)

2000.465: Perspective for a department store, ca. 1930

Pencil, ink, watercolor. 15 × 32 7/8 in. (13 × 83.5 cm)
PROVENANCE Gallery Lingard, London

🔖 Possibly an extension for Debenham & Freebody's, Oxford Street, London.

7.16

ARCHITECTS: ARTHUR THOMAS BOLTON (BRITISH, 1864–1945) AND HENRY STOCK (BRITISH, DATES UNKNOWN), OF STOCK PAGE STOCK
ARTIST: CHARLES WILLIAM ENGLISH (BRITISH, 1862–1933)

1987.89: Perspective of the headquarters of the Hamburg Amerika Line, 16 Cockspur Street, London, ca. 1907

Pencil, watercolor. 30½ × 28½ in. (77.5 × 72.4 cm)
INSCRIBED [in watercolor] *Hamberg Amerika Line / H A H A L /* [on plinth with equestrian sculpture] KING GEORGE III
LITERATURE Gallery Lingard, *Capital Buildings: An Exhibition of Architectural Designs and Topographical Views of London* (London, 1987), p. 39, cat. 52 (ill.)
PROVENANCE Sotheby's, London, 24 Sept. 1987, lot 594; Gallery Lingard, London

🔖 The building was described and illustrated by a similar perspective in the magazine *The Builder*, March 1907, pp. 368–69. Today it houses the Brazilian Embassy.

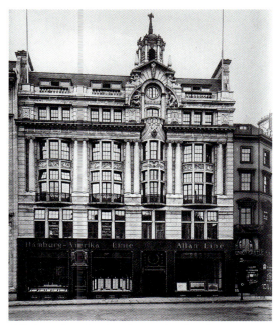

16 Cockspur Street, London, photograph early 20th century

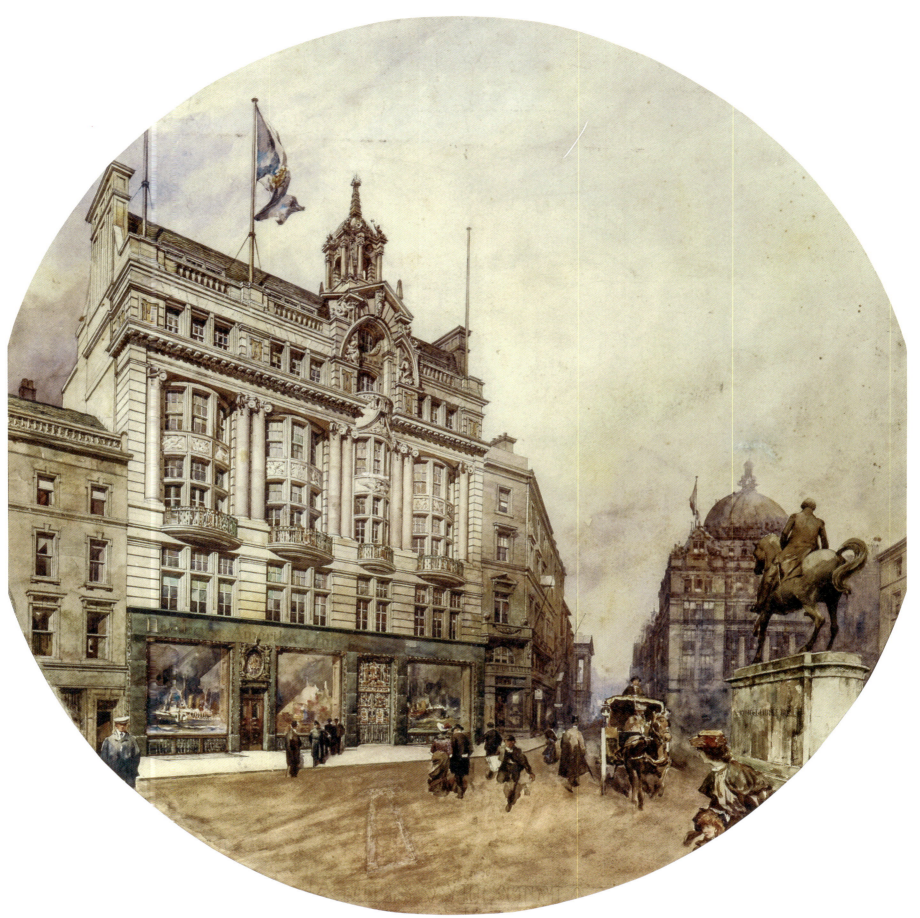

2010.539

7.17

ARCHITECT: SIR WILLIAM C. HOLFORD
(BRITISH, 1907–1975)
ARTIST: HOWARD MASON
(BRITISH, 1916–1979)

2010.539: Perspective for Woolworth's, Cornmarket, Oxford, 1957

Pencil, ink, watercolor. 25 3/8 × 38 1/4 in. (64.5 × 97 cm)
PROVENANCE D. & R. Blissett, UK

🍂 The photograph corresponds so closely to the perspective, it was perhaps the artist's visual source.

Woolworth's, Cornmarket, Oxford

328 PETER MAY COLLECTION I

7.18

TH [THOMAS?] DEFOISS
(FRENCH, DATES UNKNOWN)

1991.364a–f: Six perspective views of mines and factories, 1905

Pencil, ink, watercolor. 15 × 17¾ in. (38.1 × 45.1 cm)
INSCRIBED on 1991.364d, e, f: *Th Defoiss 1905*
PROVENANCE Galerie Ghislaine Maillard, Paris

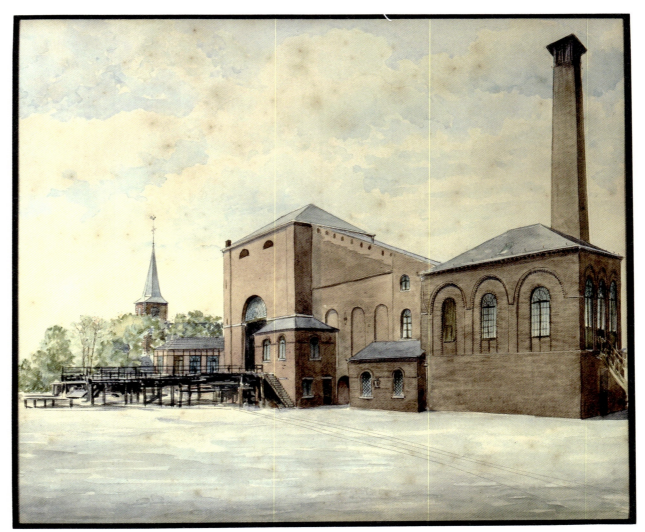

1991.364a

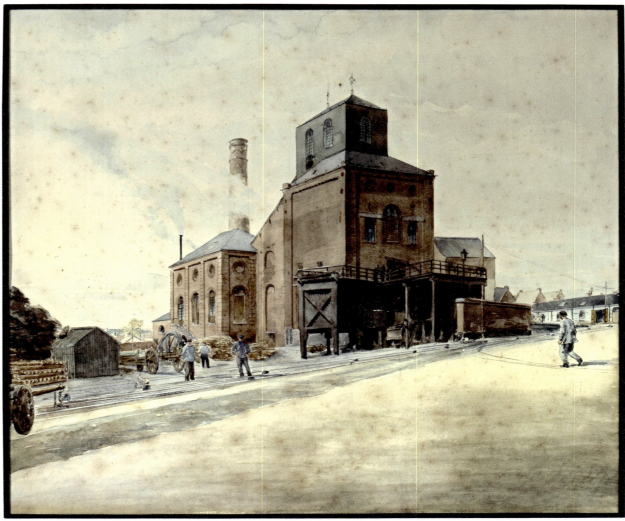

1991.364b

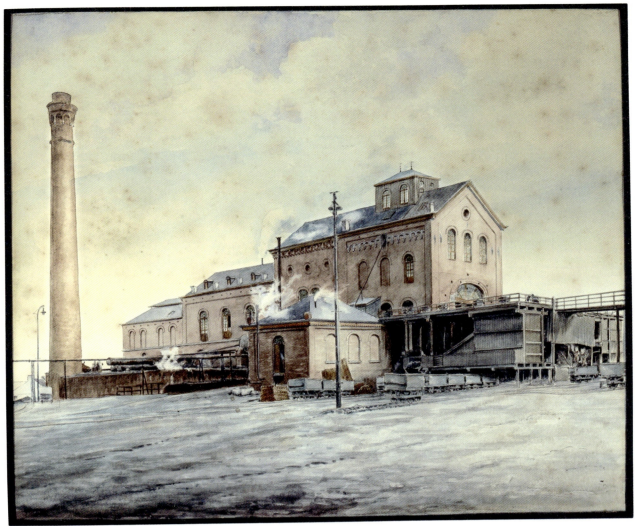

1991.364c

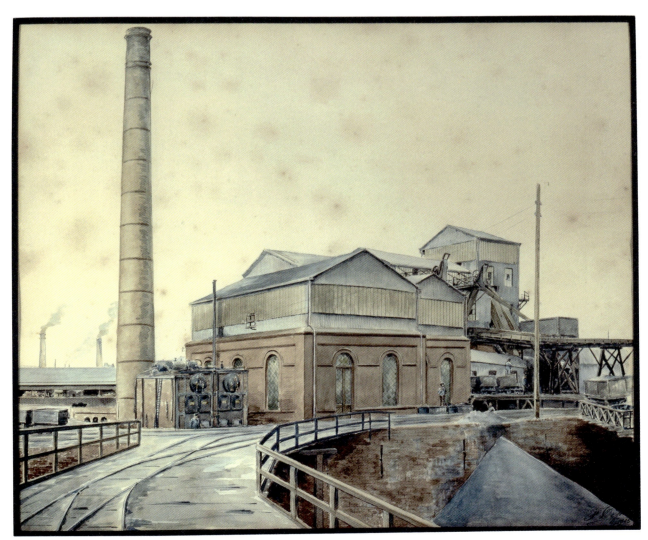

1991.364d

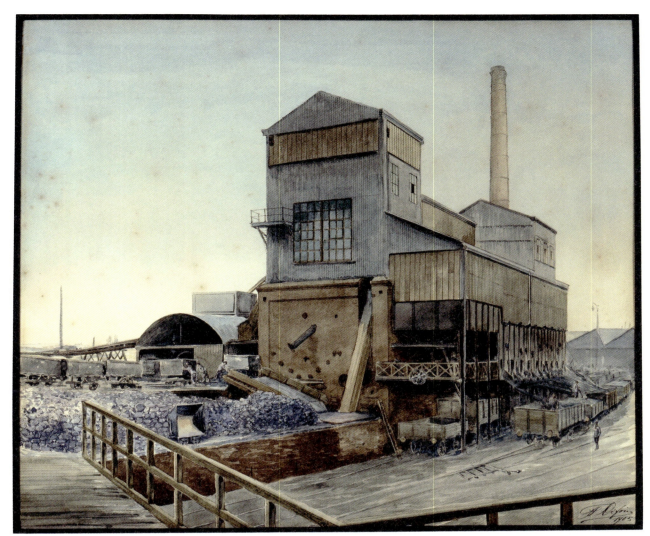

1991.364e

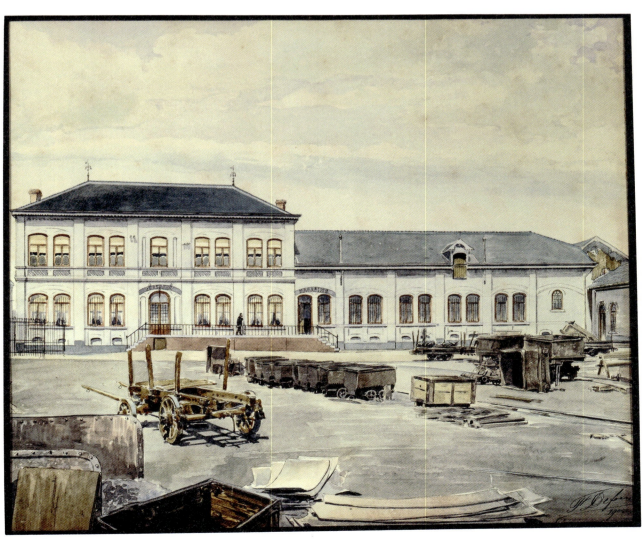

1991.364f

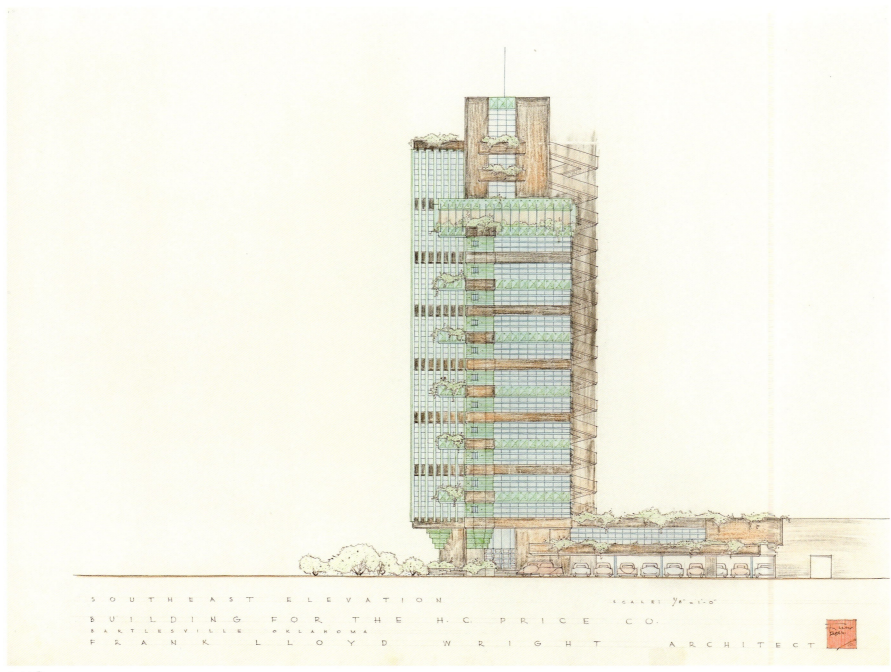

7.19

FRANK LLOYD WRIGHT
(AMERICAN, 1867–1959)

2020.548: Presentation drawing for Price Tower, Bartlesville, Oklahoma, 1952

Pencil and ink. 27 ¼ × 35 ¼ in (69 × 90 cm)
INSCRIBED [in pencil and ink] *BUILDING FOR THE H. C. PRICE CO. BARTLESVILLE OKLAHOMA / SOUTHEAST ELEVATION / FRANK LLOYD WRIGHT ARCHITECT / FLW Sept 30 52* / [architectural measurements]
PROVENANCE Collection of Roy K. Varenhorst; Erich Jon Dunwell, Kansas; Sherry Laden, Kansas; Bernard Goldberg, New York

Originally conceived in 1929 for New York City, the 19-story skyscraper was dubbed by Wright "the tree that escaped the city". Completed in 1956, it served as the headquarters of the H.C. Price Company and contained offices and residential units with furnishings designed by Wright. Acquired by Phillips Petroleum in 1981, the building was repurposed in 2000 as Price Tower Arts Center and was landmarked in 2007.

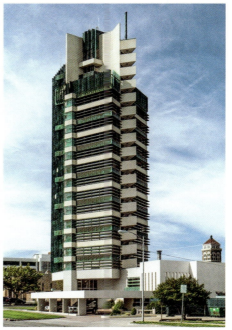

Price Tower, Bartlesville, Oklahoma

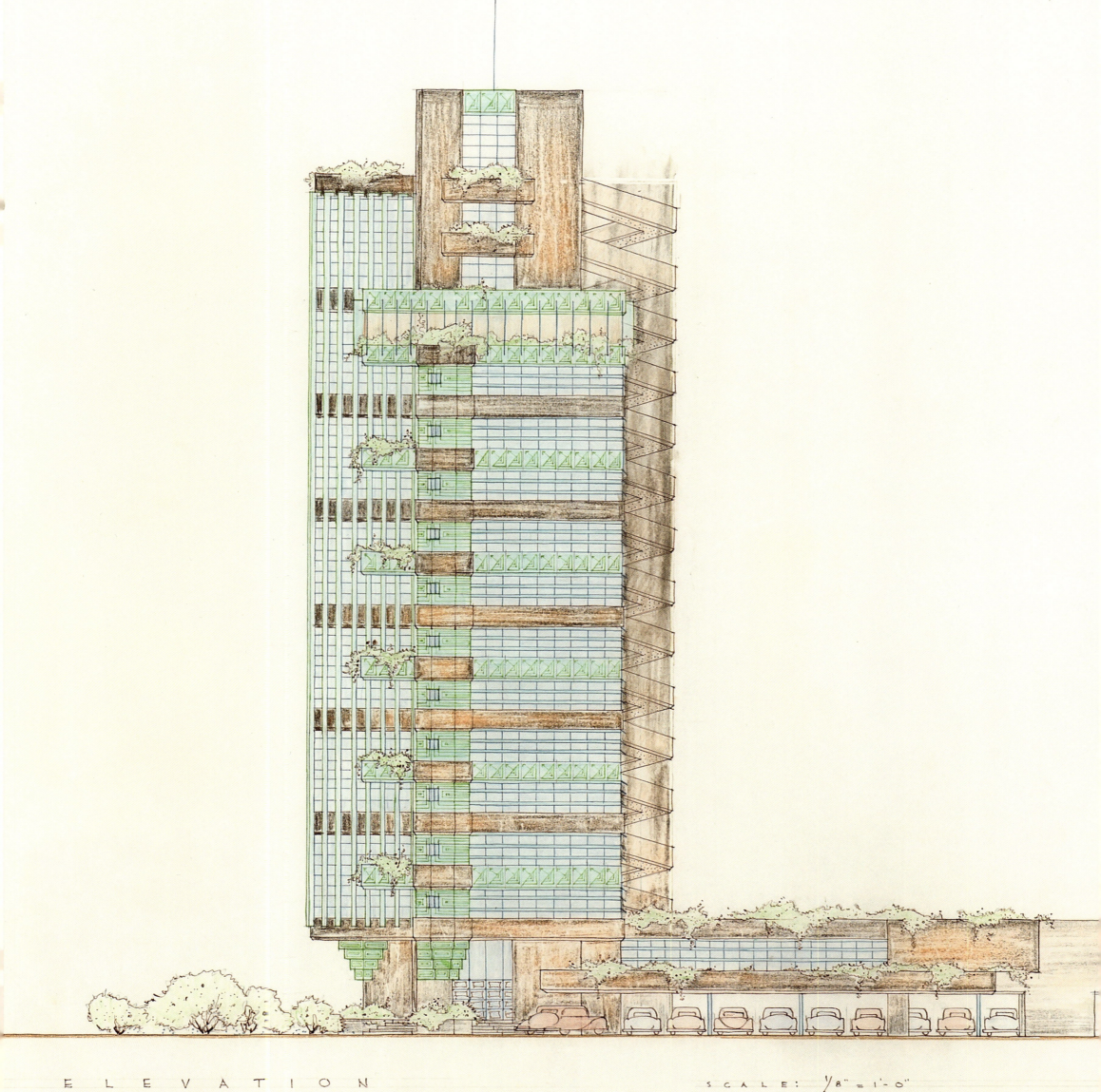

ELEVATION　　　　SCALE: 1/8"=1'-0"
FOR THE H.C. PRICE CO.
OKLAHOMA
LLOYD WRIGHT ARCHITECT

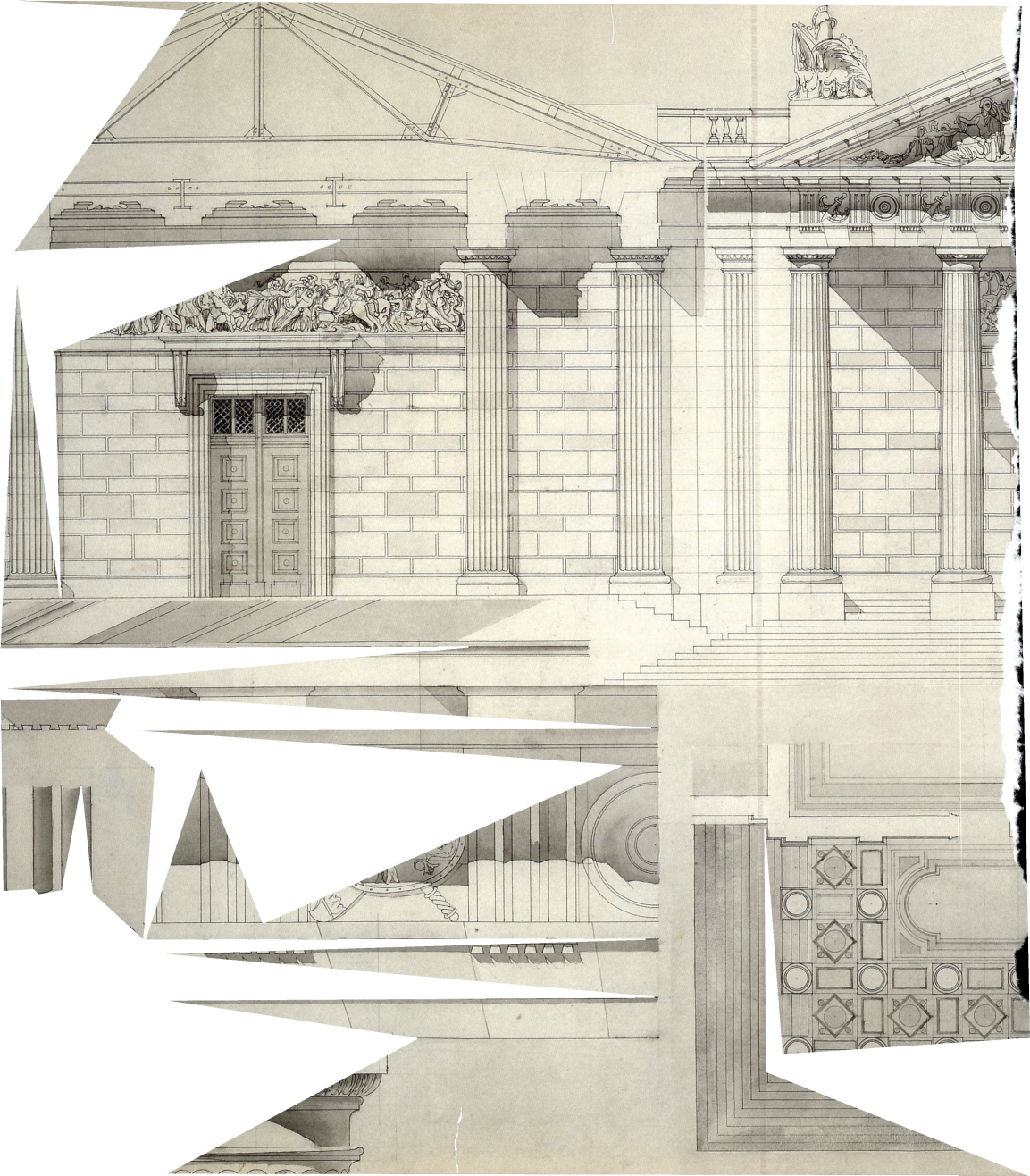